PHOTOGRAPHY

SECOND EDITION

BARBARA LONDON UPTON AND JOHN UPTON

Adapted from the LIFE LIBRARY OF PHOTOGRAPHY

LITTLE, BROWN AND COMPANY
BOSTON TORONTO

Library of Congress Catalog Card No. 80—80805

ISBN 0—316—887471

9 8 7 6 5 4 3 2 1

BP

Published simultaneously in Canada
by Little, Brown & Company (Canada) Limited

Printed in the United States of America

The Art of Photography, © 1971 Time-Life Books Inc.
The Camera, © 1970 Time-Life Books Inc.
Camera Buyer's Guide, © 1970 Time-Life Books Inc.
Caring for Photographs, © 1972 Time-Life Books Inc.
Color, © 1970 Time-Life Books Inc.
Documentary Photography, © 1972 Time-Life Books Inc.
Frontiers of Photography, © 1972 Time-Life Books Inc.
Great Photographers, © 1971 Time-Life Books Inc.
The Great Themes, © 1970 Time-Life Books Inc.
Light and Film, © 1970 Time-Life Books Inc.
Photographer's Handbook, © 1970 Time-Life Books Inc.
Photographing Children, © 1971 Time-Life Books Inc.
Photographing Nature, © 1971 Time-Life Books Inc.
Photography as a Tool, © 1970 Time-Life Books Inc.
Photography Year/1973 Edition, © 1972 Time-Life Books Inc.
Photography Year/1975 Edition, © 1975 Time-Life Books Inc.
Photography Year/1976 Edition, © 1976 Time-Life Books Inc.
Photography Year/1977 Edition, © 1977 Time-Life Books Inc.
Photography Year/1978 Edition, © 1978 Time-Life Books Inc.
Photography Year/1979 Edition, © 1979 Time-Life Books Inc.
Photography Year/1980 Edition, © 1980 Time-Life Books Inc.
Photojournalism, © 1971 Time-Life Books Inc.
The Print, © 1970 Time-Life Books Inc.
Special Problems, © 1971 Time-Life Books Inc.
The Studio, © 1971 Time-Life Books Inc.
Travel Photography, © 1972 Time-Life Books Inc.

About the cover photograph by Ken Kay: The photographer described how he made this multiple exposure simulating light forming an image inside a view camera. It began with Kay's making a color slide of an apple; unable to find a suitable apple leaf, he substituted a philodendron leaf. He then disassembled a view camera, setting on a tripod only the base rail of the camera and its front standard containing a 12-inch lens. He projected the slide of the apple onto the lens from as far as he could get across his studio, about 45 feet, so that the projected light reached the lens as parallel rays.

At first he tried to make the light rays visible by projecting them through smoke, but, not finding this practical, he achieved the same end by moving a white card at a 45° angle through the path of light during an exposure. He used the same method during additional exposures to record the rays seen within the view camera; here the process was complicated by the need to vary the speed of the moving card to compensate for the rays' extreme brightness where they concentrated and crossed behind the lens. Some people have questioned whether rays actually cross at such a distance behind a lens, but Kay says that you can see this happening if you examine the beam created by a lens focused on a very bright object, such as a candle flame, at a distance.

Proceding with more exposures, Kay added the rear standard to the camera and a film holder containing a piece of white paper on which he projected the image of the apple. He added highlights on the camera and the interior of the bellows during separate exposures. All of these exposures were made against a black velvet background. For the final exposure he set up and lit a gray background. The completed photograph, a 4 x 5-inch color transparency, consumed, among other things, 13 separate exposures, a week's full-time work by Kay and his assistant and an entire case of Polaroid film used to test his work along the way.

Picture and Text Credits: *Credits from left to right are separated by semicolons, from top to bottom by dashes.*

vi: Thomas Goertel. 1: Kathy Vargas. 2: David F. Saul—Janet Henry Hodges. 3: Debra J. Brown—Ruth C. Anderson. 4: Cynthia Dresser—Shirlee K. Loftus. 5: Lynn M. Fetterer.

CHAPTER 1 6: Joe Wrinn. 8: Lennart Nilsson. 9: Douglas Faulkner. 10: Ronald and Peggy Barnett, © 1980. 11: Bill Shrout. 12: Wally McNamee, Newsweek. 13: © The Boston Herald American, Stanley J. Forman. 14: Deborah Turbeville. 15: Helmut Newton. 16: Henry Sandbank, courtesy

Wells, Rich, Greene. 17: Reto Bernhardt, courtesy Gerstner, Gredinger & Kutter, Basel. 18: Hale Observatories—NASA, courtesy of ITEK Corporation. 19: Harold E. Edgerton. 20: © KARSH, Ottawa, 1980/Woodfin Camp. 21: "Considering Myself, 1977" by Nina Howell Starr. From *In/Sights: Self-Portraits by Women* by Joyce Tenneson Cohen. Copyright © 1978 by Joyce Tenneson Cohen. Reprinted by permission of David R. Godine, Publisher, Inc. 22: © 1976 Mark Jury. 23: Jerry N. Uelsmann.

CHAPTER 2 24: Sara Facio. 26, 27: Drawing by Nicholas Fasciano. 28: Harold Zipkowitz—drawings by John Svezia; Ken Kay. 29: Courtesy of Leica—Harold Zipkowitz—drawings by John Svezia; Ken Kay. 30: Courtesy of Pentax—Harold Zipkowitz—drawings by John Svezia; Ken Kay. 31: Harold Zipkowitz; drawings by John Svezia; Ken Kay. 32: Ken Kay. 33: Ken Kay—Harold Zipkowitz—drawings by John Svezia. 34: Ken Kay; John Upton. 35: John Upton. 36: Barbara Upton. 37: Barbara Upton. 39: Drawing by Jean Held; Ken

(Credits continued on page 376)

Preface

Photography is essentially a means of visual communication. Just as a typewriter can be used for personal letters, business correspondence, poetry or a scientific dissertation, so a camera can be used for many types of notation, from objective documentation to fantasy. Whatever *your* interest is in photography, this book is designed to teach the basic skills that you will need in order to use the medium confidently and effectively.

We have made the information you will need as accessible and as easy to use as possible. The book is organized so that each two facing pages completes a single idea, skill or technique. Concepts are explained using words, drawings, charts—but especially pictures, hundreds of them, many representing the masterworks of photography.

Photography is a skill. To learn it, or to get better at it, you need information, for example from this book, but even more you need to participate actively. The more pictures you make, the more questions you ask, the more feedback you get, the more photographs you look at, the better your own pictures will be, and probably the more pictures you will want to make. We welcome any suggestions you might have to make this book more useful to you.

For this second edition of PHOTOGRAPHY we have incorporated many of the suggestions made by users of the first edition concerning the form and content of the book. A new section, Chapter 1, Introduction to Photography, has been added to survey the variety of applications of the medium; it illustrates such areas as advertising, fashion, photojournalism, science, editorial use and so on. Another new section, Chapter 14, Camera Vision, plus additional captions throughout the book, have been added to help clarify photographers' choices and decisions concerning composition, light, tonality, focus, movement and so on. Increased interest in color photography is reflected in an expanded Chapter 13, Color, including more color reproductions and more detailed information on evaluation and correction in color printing. Since the first edition there has been a continuing increase of interest in photography as art and personal expression; Chapter 15, History of Photography, and Chapter 16, Gallery, include a number of new illustrations. Also new to this edition, and opening the book, is a section of photographs by students. Our thanks to the people who made the final selection of these works, Ansel Adams, Marie Cosindas and Jim Hughes, and to all the students and instructors who involved themselves so actively in this part of the book.

Many people have contributed to PHOTOGRAPHY. The history chapter is based in large part on the pioneer work of Beaumont Newhall. Anyone interested in the history of photography has benefited from his work, and we were fortunate to have received generous help and advice from him.

We are particularly grateful for the detailed comments made by the more than 150 instructors who read and reviewed the book. Dennis Curtin still has our appreciation since he was responsible for the original idea for a textbook of this type. Many other people freely offered valuable information and assistance to this edition and to the first one: Ansel Adams, Fred Bodin, Ed Brash, Peter Bunnell, Marie Cosindas, Eastman Kodak Company (especially John **Phelps and Paul Mulroney**), **Jim** Hughes, Barbara Kasten, Bob Korn, Ellen Land-Weber, Larry Larsen, Lee Rice, Robert Routh, Michael Simon, Rick Steadry, Jim Stone, Arthur Taussig, Dan Vandevier and George Upton. Any faults that remain are solely the responsibility of the authors.

At Little, Brown and Company, Katie Carlone was a good friend to the book and to the authors, Joan Kelly contributed valuable creative efforts, Sue Warne took a complex manuscript through the multiple rigors of production. Our grateful thanks to all who facilitated this second edition.

Dedicated to Minor White—teacher and friend

Table of Contents

Photographs by Students 1

1 Introduction to Photography 7

2 Camera 25
The Anatomy of a Camera 26
The Major Types of Cameras 28
The Camera's Controls 32
Keeping the Camera Steady 44
Buying a Camera 46

3 Lens 49
Why Lenses Are Needed 50
Types of Lenses 54
Depth of Field 64
Perspective 72
Getting the Most from a Lens 76
On Choosing Lenses 78

4 Light and Film 81
Making an Image in Silver 82
A Characteristic Response to Light 84
Choosing a Film 86
How Black-and-White Film Sees Color 94
The Polaroid Land Process 102

5 Exposure 105
Light Meters and How to Use Them 106
Out-of-the-Ordinary Exposures 118

6 Developing the Negative 121
How to Process Roll Film Step by Step 122
How Developer Chemicals Affect a Negative 132
How Time and Temperature Affect Development 134
Exposure and Development: Under, Normal, Over 136
The Need for Proper Agitation . . . 138
. . . and Fresh Solutions 139

The Importance of Careful Washing and Drying 140
Care Prevents These Darkroom Disasters 141
Special Development Techniques 142

7 Printing the Positive 145
How to Process Prints 146
How to Judge a Test Print 164
Papers That Control Contrast 166
The Versatility of Variable Contrast Paper 168
Dodging and Burning In 170
How to Make Better Prints 172
Archival Processing for Maximum Permanence 174

8 Finishing and Mounting 177
Drying Your Prints 178
Spotting and Toning 180
How to Dry Mount 182
Cutting an Overmat 185

9 Lighting 189
Direct Light 190
Directional-Diffused Light 191
Fully Diffused Light 192
Silhouette 193
Light as You Find It—Outdoors 194
Light as You Find It—Indoors 196
The Main Light: The Most Important Source 198
The Fill Light: Modifying Shadows 200
Lighting a Portrait 202
Lighting Translucent Objects 204
Lighting Textured Objects 206
Lighting Shiny Objects 207
Lighting with Flash 208
Six Ways to Use Flash 210
Calculating Exposures with Flash 212
Avoiding Common Mistakes with Flash 213

10 View Camera 215

Inside the Modern View Camera 216
The Four Camera Movements 218
Controlling Plane of Focus and Depth of Field 226
Controlling Perspective 228
Dealing with Distortion 230
What to Do First—and Next 231
Loading and Processing Sheet Film 232

11 Zone System 235

Learning the Zone Scale 236
Zone Scale and Exposure Meter for Precise Exposure 238
How Development Controls Contrast 240
A Full-Scale Print 242
A Flat or a Contrasty Print—When You Want One 244
Putting It All Together 246

12 Special Techniques 249

The World in Close-Up 250
Special Printing Techniques 256
Techniques Using High-Contrast Film 260
Xerography—Prints from an Office Copy Machine 266

13 Color 269

To Make Colors, Add or Subtract 270
Color Photographs: Three Image Layers 272
Matching Film to the Light Source 274
Filters to Balance Color 276
Color Casts 278
Shooting Color Early or Late 280
Shifted Colors from Reciprocity Effect 283
Bold Use of Direct Light/Delicate Tones in Indirect Light 284
Processing Your Own Color 286
Making a Color Print from a Negative 288
Making a Color Print from a Transparency 300
Instant Color Film 304

14 Camera Vision 307

The Frame: The Whole Scene or a Detail 308
The Frame: The Edges of the Image 310
Point of View: Seeing from Another Angle 312
Sharpness—or the Lack of It 314
Photographing the Light—or the Dark 316

15 History of Photography 319

The Invention of Photography 320
Daguerreotype: "Designs on Silver Bright" 322
Calotype: Pictures on Paper 324
Collodion Wet-Plate: Sharp and Reproducible 326
Early Portraits 328
Images of War 330
Early Travel Photography 332
Gelatin Emulsion/Roll-Film Base: Photography for Everyone 334
Time and Motion in Early Photographs 336
The Photograph as Document 338
Photography and Social Change 340
The Photograph as Art in the 19th Century 342
Pictorial Photography and the Photo-Secession 344
The Direct and Unmanipulated Image 346
The Quest for a New Vision 348
Photojournalism 350
The 1950s and After 352
The 1960s and After 354

16 Gallery 357

Glossary 377
Bibliography 383
Index 387

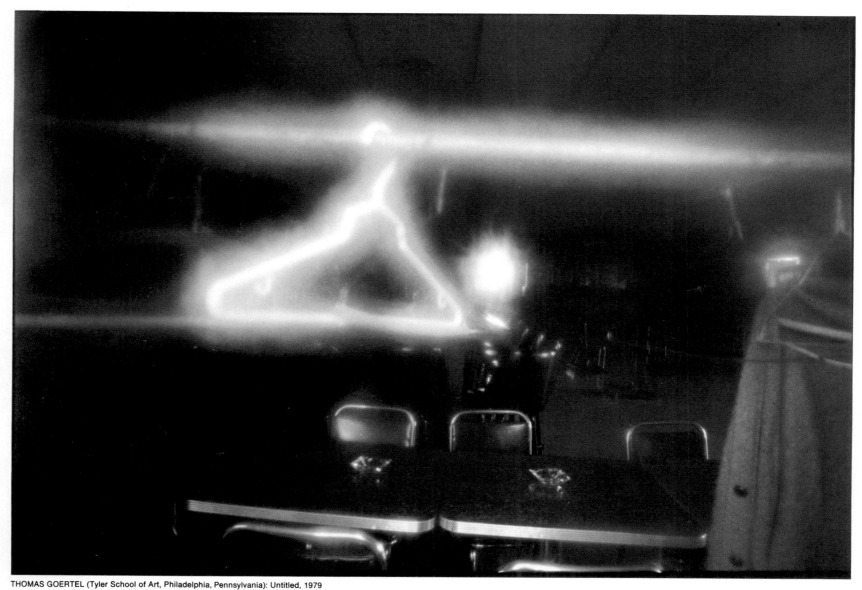

THOMAS GOERTEL (Tyler School of Art, Philadelphia, Pennsylvania): Untitled, 1979

The camera records all the objects in front of the lens, but not always the way we ordinarily see them. This otherwise prosaic scene is traversed by what could be the latest in high-tech innovation— an electric coat hanger. The photographer states that window condensation close to the lens diffused the light on the hanger, but the visual evidence is of an energy charge applied to the scene, or maybe the presence of an extraterrestrial visitor taking what it thinks is an inconspicuous body-form.

Photographs by Students

The nine photographers whose work opens this book are the finalists in a nation-wide juried selection of student work that was conducted for this edition of *Photography*. Any person who at the time of the selection was enrolled in an undergraduate course in photography was eligible to enter. The judges making the final selection were Ansel Adams, photographer, teacher and author of many books of and about photography; Marie Cosindas, renowned for her work with Polaroid materials; and Jim Hughes, editor of *Photography Annual* and *Camera Arts* magazine.

Students from Florida to Canada to Guam entered. They entered from schools that teach primarily photography, as well as from schools in which photography is only a part of the curriculum. If there is one generalization to make about the work submitted, it is that generalizations can't be made. Students today photograph in many styles from intensely personal to cool and restrained. They make portraits, landscapes, technical photographs, psychological studies, abstractions, picture postcards and more. In short, they work in all those areas in which photography has already been used, and they will undoubtedly open up some new ones as well.

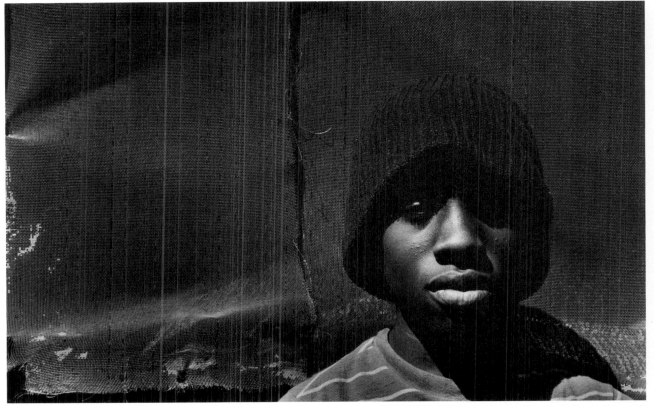

Some photographs, such as this head-on portrait, seem to be readily understandable on first glance but reveal more complicated aspects if you look at them more closely. Try to view the shadowed areas in the picture separately from the highlights. The deep shadow under the cap hides what is often the most revealing part of a portrait, the eyes; yet the eyes retain a strong presence in the picture. The torn screen behind the figure is like a curtain drawn in front of a void, while the face can be seen as emerging out of the shadows under the cap and chin. In addition to her subject's physical presence, the photographer has recorded a psychological one as well.

KATHY VARGAS (University of Texas, San Antonio, Texas): *Ridges,* 1979

1

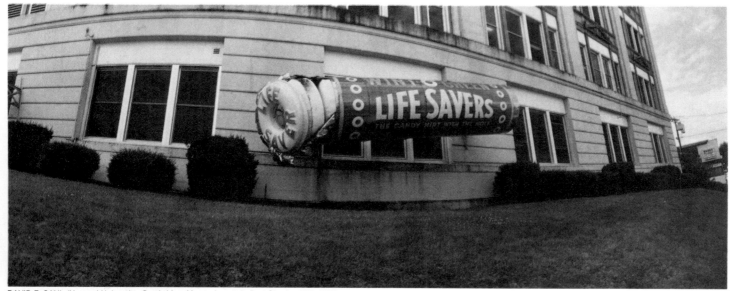

DAVID F. SAUL (Harvard University, Cambridge, Massachusetts): *Port Chester N.Y.*, 1979

The Life Savers picture (above) was made with a Widelux panoramic camera that utilizes a rotating lens to create a long, narrow image of a 140° angle of view. As a result, the scene is distorted into a rounded shape, a singularly suitable one for this subject, and one that adds to the humor of encountering a roll of Life Savers as large as a piece of monumental sculpture.

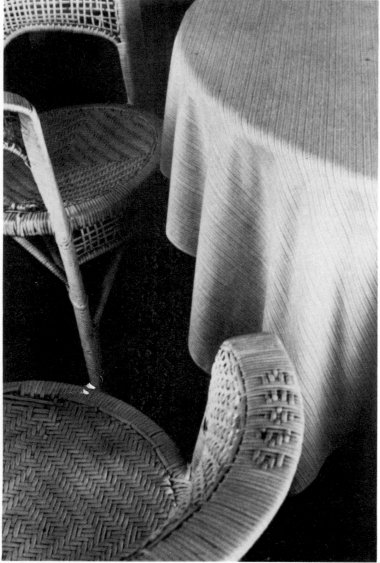

JANET HENRY HODGES (University of Missouri, Kansas City, Missouri): *Untitled*, 1980

A table and two chairs (left) bring their own rounded shapes to this simple, but satisfying composition. The eye takes pleasure in circling and then traveling once again around the curves and in examining the delicate textures. Cropping into the table and chairs and isolating them from their surroundings make them more easily seen as shapes rather than as utilitarian objects.

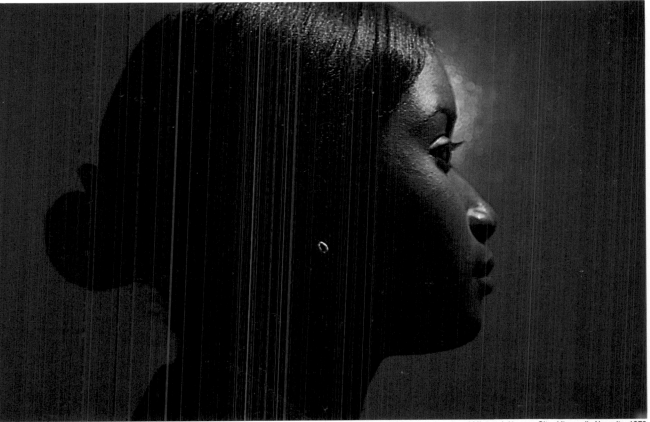

DEBRA J. BROWN (University of Missouri, Kansas City, Missouri): *Neserite*, 1979

As you learn more about photography and become more aware of what camera and film can and cannot do, you can deliberately utilize even the apparent limitations of the medium. Film can accurately record textures and colors in either bright highlights or in dark shadows, but not in both at the same time. Color slide film is particularly limited in this respect. In the picture at right, the photographer has chosen to expose correctly for the brightly lit side of the head, while letting the shadowed side go very dark. The viewer's eye is drawn to the lighter and more important part of the picture, the face, and to the bright highlight on the woman's earring, which stands out prominently against the shadows.

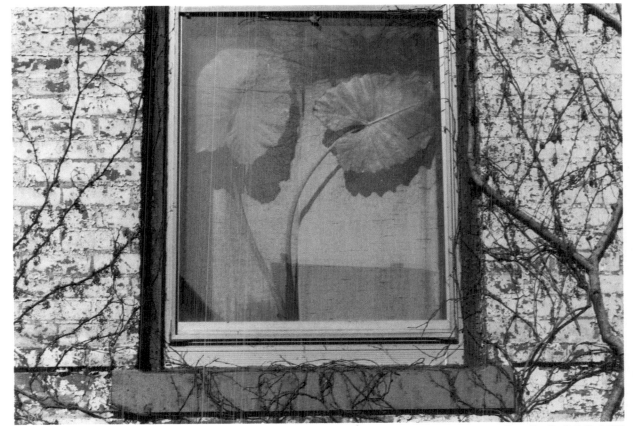

RUTH C. ANDERSON (State University of New York at Albany, Albany, New York): Untitled, 1980

The two leaves framed in the window (right) appear to be packaged in a display case like some rare and exotic specimen and seem curiously at odds with their exterior setting. The gentle curve of their stems contrasts with the active, fragmented movement of the vines on the brick wall, and the green fullness of their leaves contrasts with the bare, leafless growth outside. The reflection of a bright sky in the window glass puts a milky cast over the leaves that further separates them from the outside world.

3

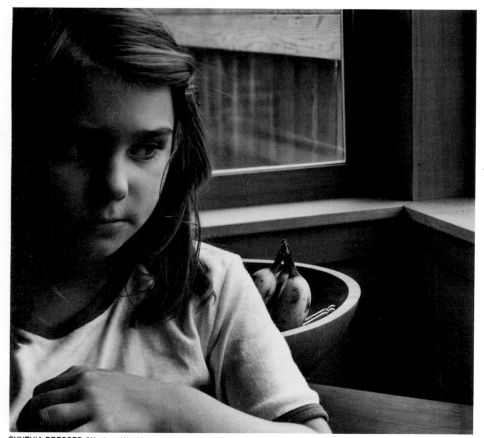

CYNTHIA DRESSER (Western Washington University, Bellingham, Washington): Untitled, 1979

Diffused window light is a soft, attractive light for interior scenes. Instead of shining directly on the subject, diffused light bounces in indirectly from surrounding sunlit areas (left) or passes through a translucent material like curtains (below). Shadow edges are softened but there is still a strong direction to the light that emphasizes the shape and texture of objects. At left, a child pensively contemplates something outside of the picture format, either an actual object or her own revery. The angles of the room and the curve of the bowl give visual interest to the space in the direction of her glance.

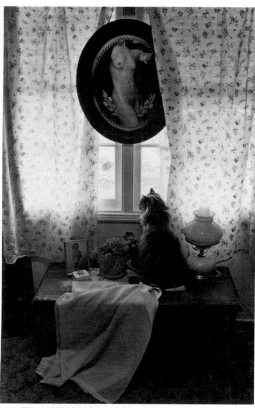

SHIRLEE K. LOFTUS (University of California at Santa Cruz, Santa Cruz, California): Untitled, 1979

The tranquil domesticity of this scene—the curtained window, the cat, the lamp and the other objects—can be viewed as an inventory of someone's personal space. The photographer does not state whether the nude image in the mirror is of another woman or is a self portrait. The enigma of the photograph, how the mirror image and the rest of the scene relate to each other, is left to the viewer to resolve.

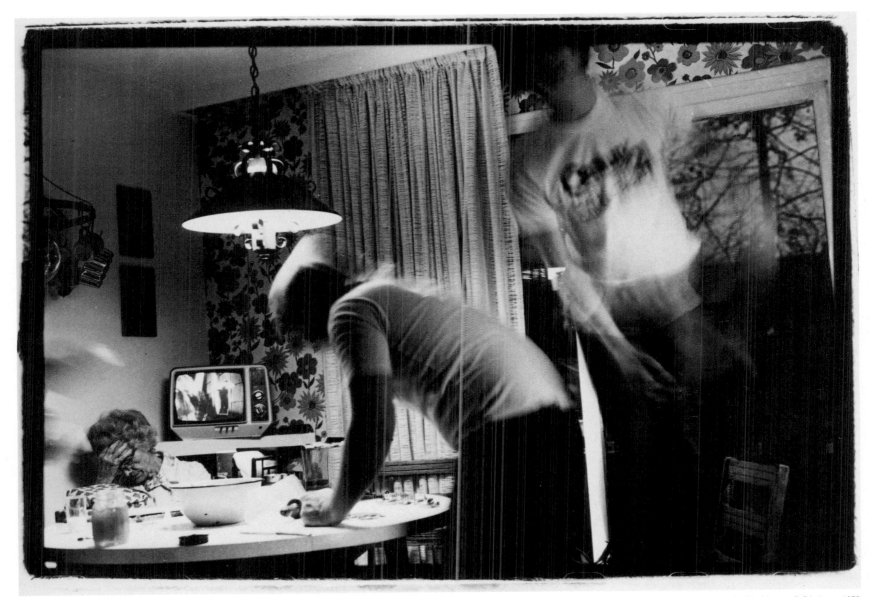

LYNN M. FETTERER (The Corcoran School of Art, Washington, D.C.): *Xmas,* 1979

Domestic chaos reigns in a photograph in which every part of the scene insistently demands attention. Nothing is at rest: wallpaper, curtains and a view through glass doors make a busy backdrop; Grandma holds her head; the television set broadcasts unwatched; two people who moved while the camera shutter was open blur in perpetual mid-movement; the table is cluttered with a dozen objects and more hang on the wall and from the ceiling; even the framing of the scene is tilted. In a contradictory fashion, the very dynamic flux of the picture gives it cohesion.

5

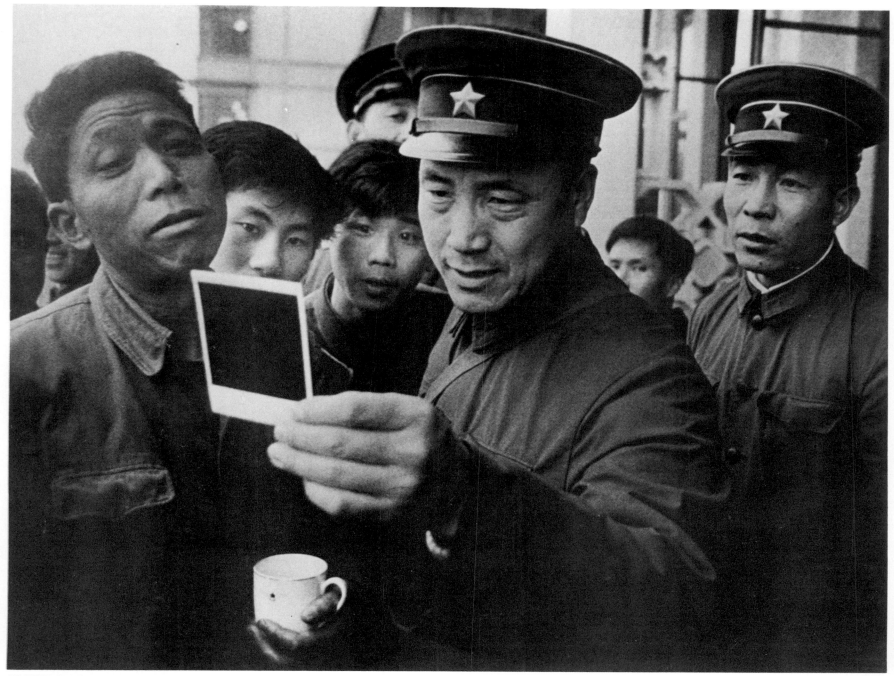

JOE WRINN: *Their First Polaroid, Peking,* 1979

1 Introduction to Photography

Photography is such a common means of communication that often we take it for granted. Only occasionally *(see opposite)* are we struck with the amazement that people in the 19th century felt when they saw their first photograph. Yet excitement and interest are there if we open our eyes to the pictures all around us. Today we use photography in many ways. Pictures communicate facts: how things look, how many there are, when it happened and other observable data *(see the scientific photographs, pages 18–19)*. Pictures also communicate, intentionally or unintentionally, ideas such as social attitudes and conventions *(see the fashion photographs, pages 14–15)*. And pictures can be combined with words or with other pictures to influence our opinions *(see the pairing of industrial pictures on pages 10–11)*. This chapter takes a look at some of the many areas in which photography is used—in science, commerce, journalism, medicine and industry, as well as for personal expression.

No matter what you know about the actual scene at which a photograph was taken, it is important to stop and look just at the picture itself. Photography transforms the passing moment of a three-dimensional event into a frozen instant reduced in size on a flat piece of paper, often in black and white instead of color. Even if the print is in color, the photographic dyes seldom match the colors and tones of the original scene. The event is abstracted, and, even if you were there and can remember how it "really" was, the image in front of you is the tangible remaining object.

Throughout this book, background information is given on some of the pictures, but more important is your reaction to the print itself. What do you actually see when you look at the print? What photographic techniques are apparent? What associations does the print call to mind? We have shared some of our reactions to the prints. You may see a photograph differently than we do; that's to be expected. You'll also find that people may have unpredictable reactions to your own pictures. Responding to photographs is a very personal art.

◀ *A group of Chinese soldiers in Canton sees for the first time a Polaroid SX-70 instant picture as it develops its image. The Polaroid is of the soldiers themselves, taken by a Western tourist just a few moments before. This scene has a naturalness and ease that is not always easy to get when the photographer is obviously a foreigner. The soldiers have forgotten the photographer and become engrossed in the instant magic of the instant picture—objects taking shape, colors brightening and getting richer while they watch. The soldier's hand is oversize because it is closer to the camera than the rest of the scene, and it gives an illusion of depth, seeming to reach forward out of the photograph. The viewer's eye glances from one soldier's face to another, then to the hand holding the Polaroid, as the viewer shares the soldiers' reaction.*

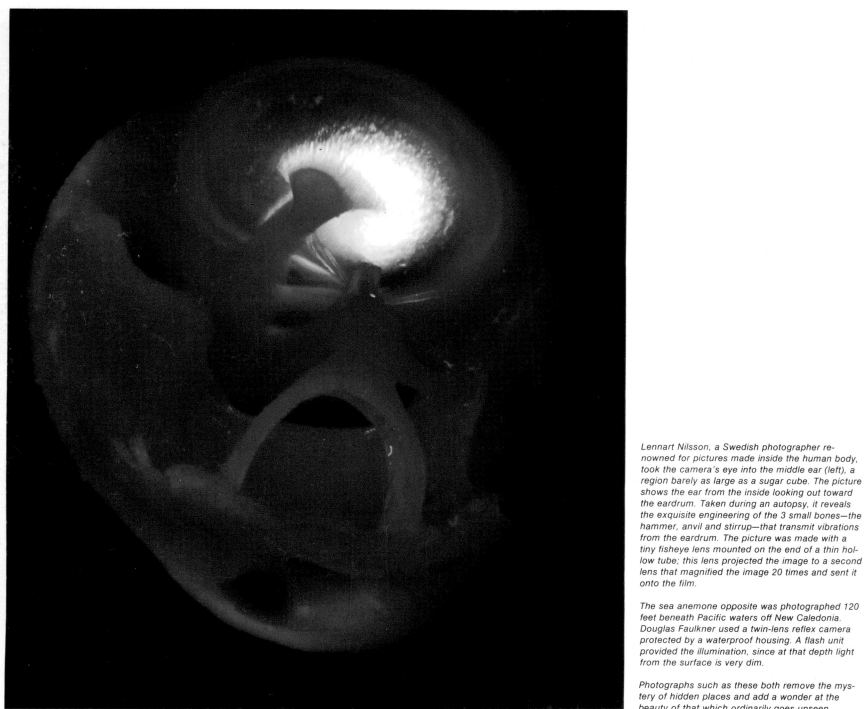

Lennart Nilsson, a Swedish photographer renowned for pictures made inside the human body, took the camera's eye into the middle ear (left), a region barely as large as a sugar cube. The picture shows the ear from the inside looking out toward the eardrum. Taken during an autopsy, it reveals the exquisite engineering of the 3 small bones—the hammer, anvil and stirrup—that transmit vibrations from the eardrum. The picture was made with a tiny fisheye lens mounted on the end of a thin hollow tube; this lens projected the image to a second lens that magnified the image 20 times and sent it onto the film.

The sea anemone opposite was photographed 120 feet beneath Pacific waters off New Caledonia. Douglas Faulkner used a twin-lens reflex camera protected by a waterproof housing. A flash unit provided the illumination, since at that depth light from the surface is very dim.

Photographs such as these both remove the mystery of hidden places and add a wonder at the beauty of that which ordinarily goes unseen.

LENNART NILSSON: *The Middle Ear*, 1969

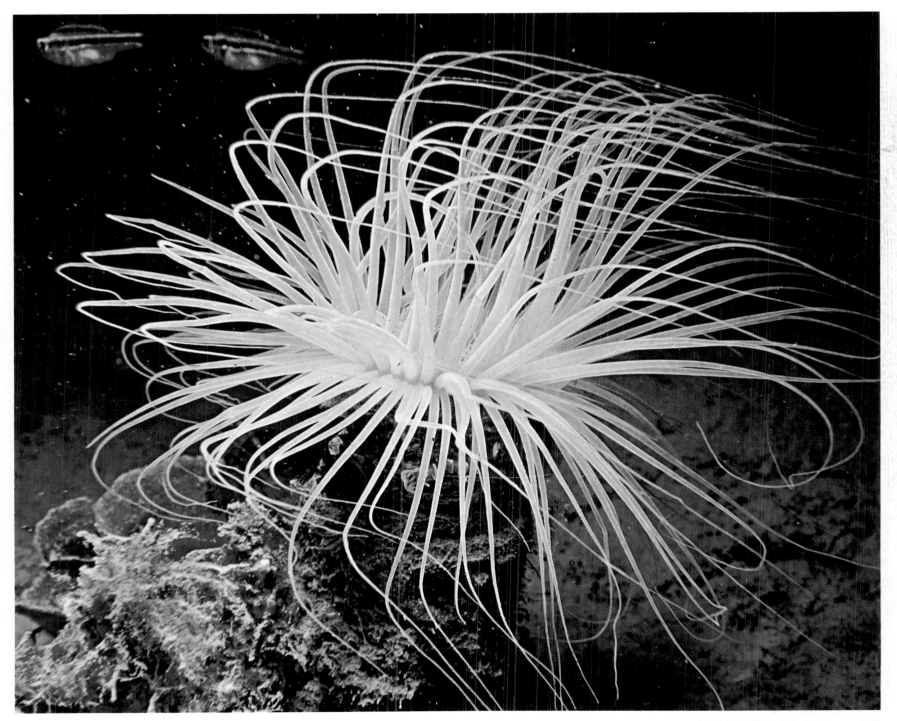

DOUGLAS FAULKNER: *Cerianthus Anemone,* 1965

9

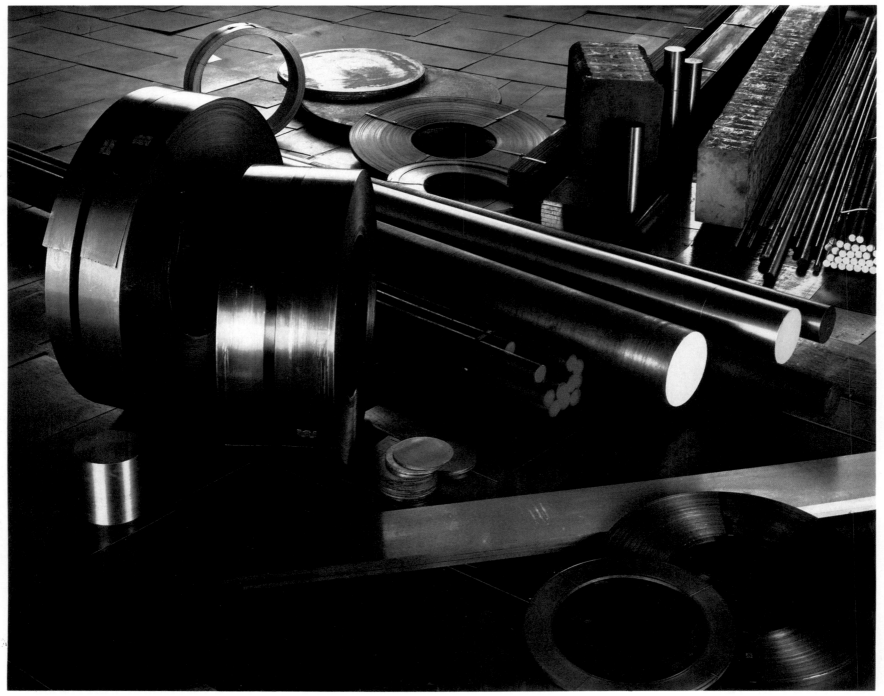

RON BARNETT: *Wallace-Murray Annual Report,* 1973

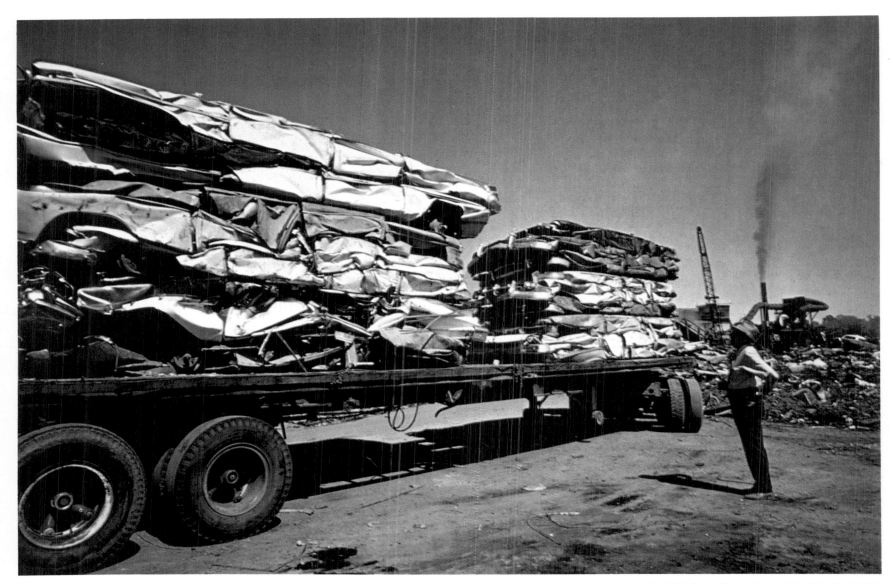

BILL SHROUT: *Cars Crushed for Recycling, Flowood, Mississippi*

◄ The apparently casual display of metal shapes on a factory floor (opposite), photographed for a corporate report to stockholders, took 2 full workdays and the assistance of an overhead crane. Ron Barnett transformed the assortment of pieces of metal into a gleaming still life that helps convey the impression of corporate weight, strength and power.

The inevitable end of all industrial products is documented above. In 1972 the Environmental Protection Agency (EPA) hired photographers to illustrate environmental problems and show what the EPA was doing about them. Pictures are affected by other images nearby: notice how placing these 2 opposite each other takes some of the gloss off the Barnett picture.

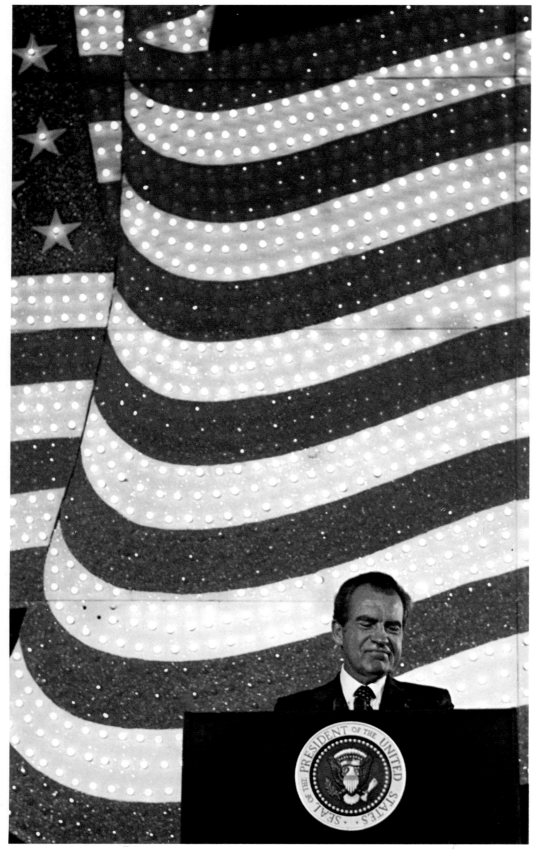

WALLY McNAMEE: "I'm not a crook," 1973

Under the bulb-studded folds of an electric Old Glory, President Nixon (left) has just assured a Washington, D.C., audience that he would not quit despite the growing Watergate scandal. The White House News Photographers named McNamee Photographer of the Year for this picture, long before the president's resignation made the photograph ironic.

A white youth wielding an American flag (opposite) jabs a black lawyer passing Boston's city hall during an anti-busing demonstration. The picture earned Forman, a staff photographer for the Boston Herald American, his second consecutive Pulitzer Prize for Spot News Photography. The slight blurring of the picture (caused by the motion of the camera during the exposure and ordinarily a fault) amplifies the chaos and violence of the scene.

Placing these 2 pictures opposite each other (done here for the purposes of illustration) makes an even more pointed comment than the pair of pictures on pages 10–11. The flag is, to begin with, a symbol charged with emotional meaning, and the eye follows the swirl of Nixon's flag across the page and then picks up the motion of the flag-as-weapon. The combination is so strong that it would have fueled critical feelings about many of our public figures if they had been photographed as Nixon is here.

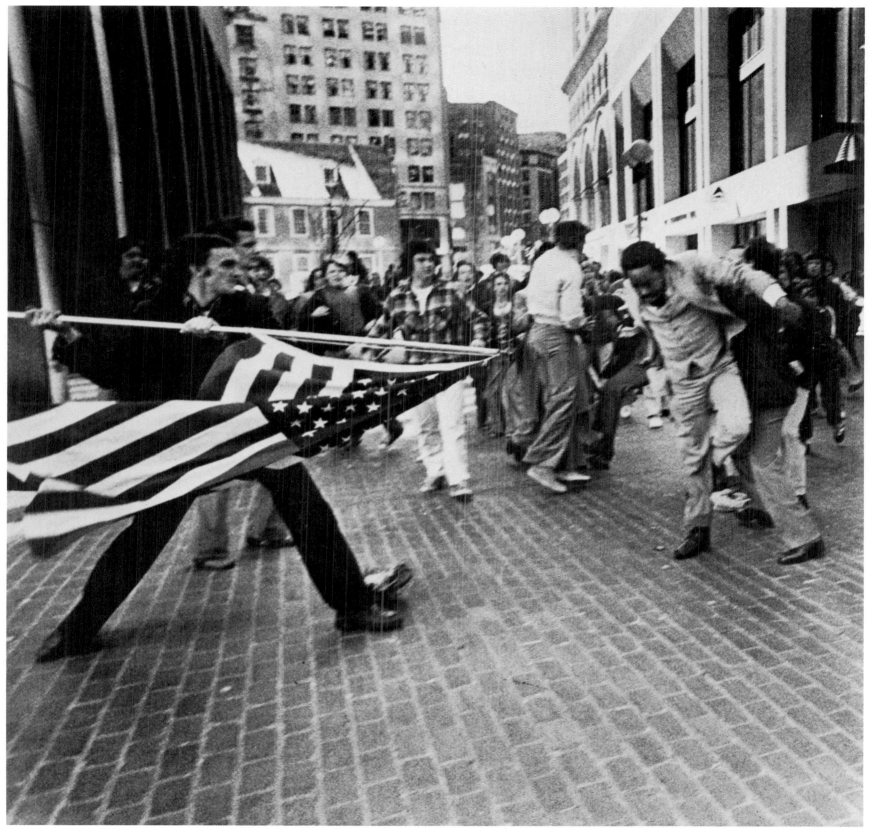

STANLEY FORMAN: *The Soiling of Old Glory,* 1976

13

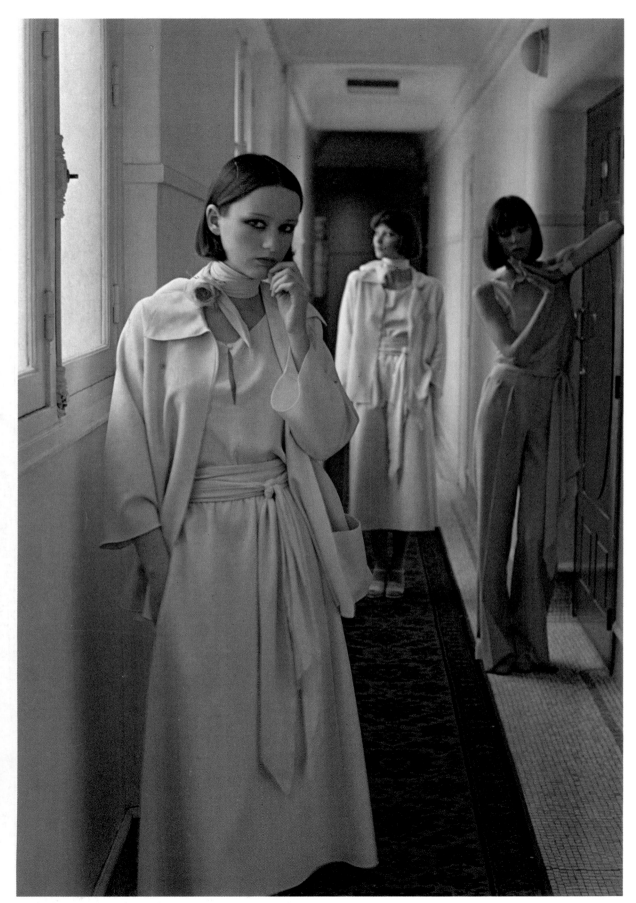

DEBORAH TURBEVILLE

Fashion photography changes in style as much as clothes do. Fashion photographs of the 1930s often showed idealized and perfectly groomed models posed like statues in elaborate studio settings. By the 1950s photographers had moved outdoors and many pictures showed exuberant models running, jumping and basking in the sun. The 1970s introduced offbeat situations, many with ambiguous sexual overtones, so that the photographs look more like sophisticated movie stills than straight records of a dress or the latest color in nail enamel.

Deborah Turbeville says she loves mysteries, and her pictures often seem like illustrations for a detective story. Her models opposite brood enigmatically in a hotel hallway. Tones are all subdued—as the models are—pale beiges, browns and oranges.

Helmut Newton often uses bright, even garish, colors to portray bold encounters between men and women. The photograph (right) illustrating a new nail polish creates an unexplained but intense situation that invites the viewer to fill in what has happened or what will happen next.

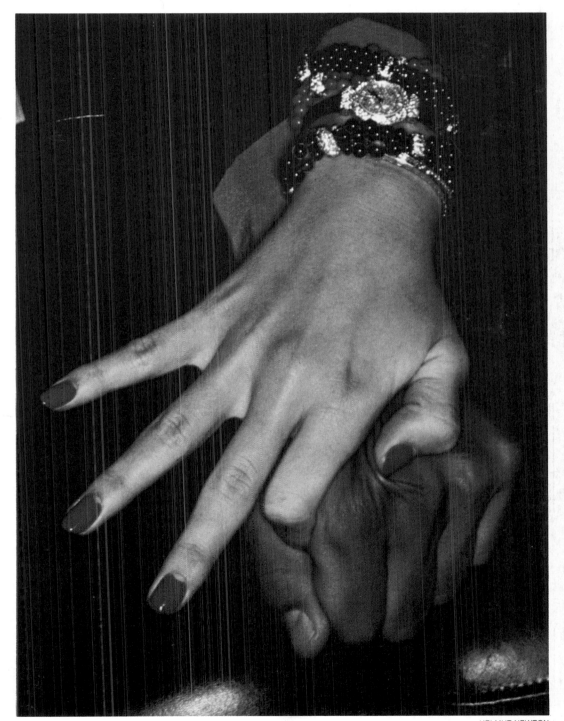

HELMUT NEWTON

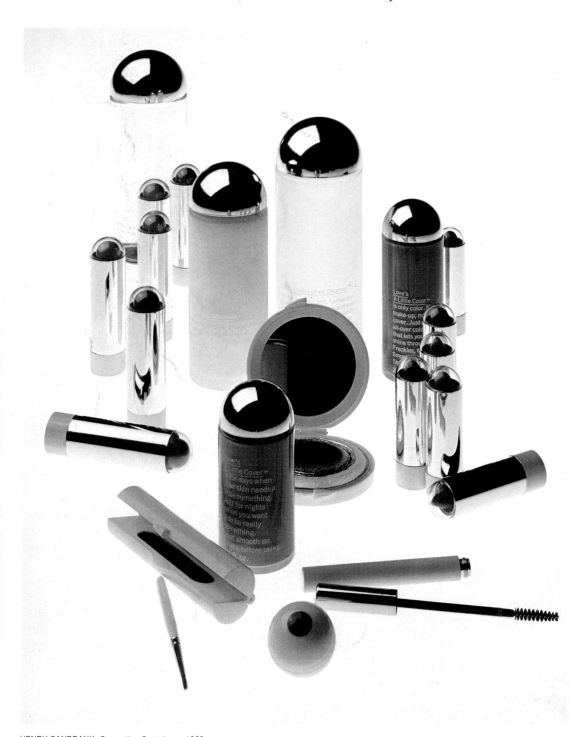

In the 19th century, commercial enterprises relied entirely on artwork for their advertisements and promotional publications. Today they go primarily to studio photographers to stimulate buyer interest, not only by showing the product but by developing certain attitudes in the viewer-consumer.

A new line of Love Cosmetics (left) was packaged in futuristic containers that the designers hoped would appeal to young women who grew up in the space age. The photographer, Henry Sandbank, worked closely with the packaging designer and advertising art director. Here the containers were placed on a large sheet of Plexiglas and lit from below with two floodlights so that the containers appear to float free of any identifiable support, like astronauts in space. A spotlight trained on them from above introduced highlights on the burnished surfaces.

In a photograph for a champagne advertisement (opposite), a sleek spout of champagne, highlighted by two electronic flash units, cascades into a pool of bubbles. The flash units, placed symmetrically on either side of the camera, created a brief burst of light that stopped the motion of the pouring champagne. Reto Bernhardt isolated the glass and bottle by placing them against a black velvet background. Choosing to feature bubbles rather than bottle, he shielded the neck of the bottle by placing pieces of cardboard between it and the lights.

HENRY SANDBANK: *Cosmetics Containers,* 1968

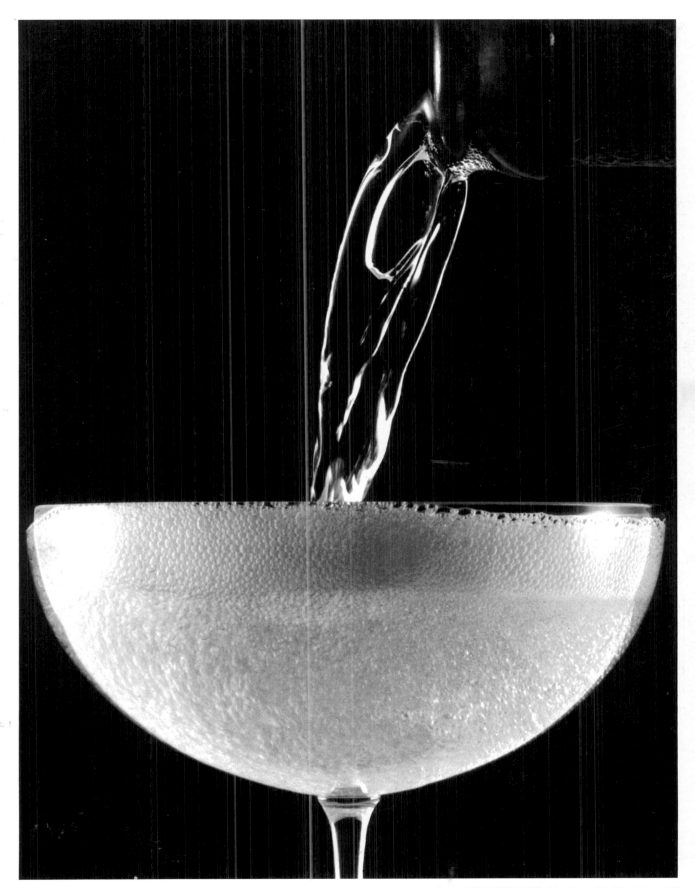

RETO BERNHARDT: *Advertisement for Champagne*, 1963

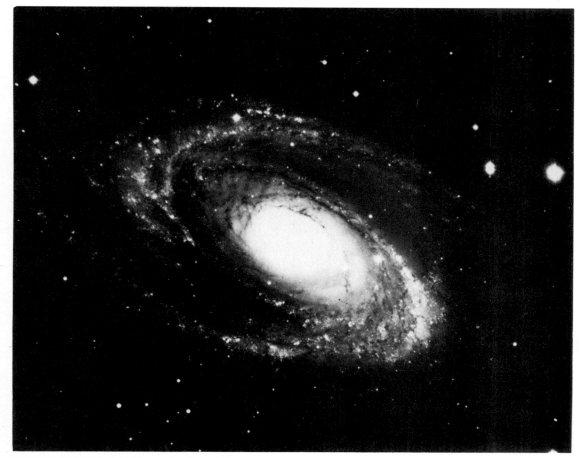

HALE OBSERVATORIES: *Spiral Galaxy in Ursa Major,* 1950

Photography was used as a tool for scientific research almost immediately after its invention; the first successful daguerreotype of the moon was made in the spring of 1840, less than a year after the invention of the process. This photograph (left) of a spiral galaxy millions of light-years away was made with the 200-inch telescope of the Hale Observatories at Mount Palomar in California. Not only have photographs like these provided astronomers with basic information about the universe, but they are spellbinding and beautiful simply as pictures—more so because we believe them to be accurate and not an artist's interpretation of the view.

As space technology became increasingly sophisticated, cameras were given the job of actually going to a place to photograph it and beam back images. The Viking I space probe sent back pictures of Mars (left) that were extremely detailed and surprisingly familiar, not unlike certain desert landscapes on earth.

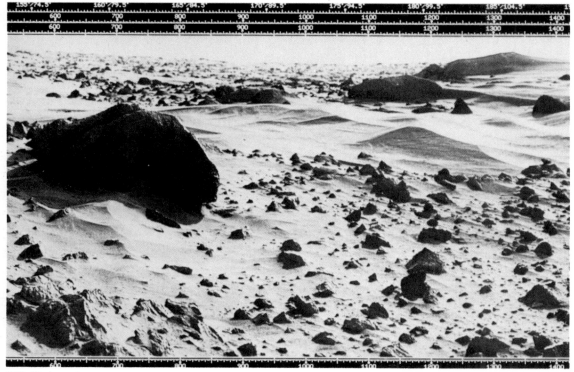

NASA: *Windswept Dunes on Mars's Golden Plain,* 1976

In the historic series of photographs (opposite) ▶ taken by Dr. Harold E. Edgerton at the Massachusetts Institute of Technology, a drop of milk splashes into a shallow saucer (1). Surface tension holding the drop together is shattered (2), and the drop breaks into droplets held together by surface tension of their own, forming a crown (3) and then a coronet pattern (4). The tips of the coronet separate (5) and finally fly free (6) as another drop falls to begin the sequence over again. To obtain these pictures Edgerton used special equipment that provided 6,000 flashes per second, each flash lasting about one millionth of a second.

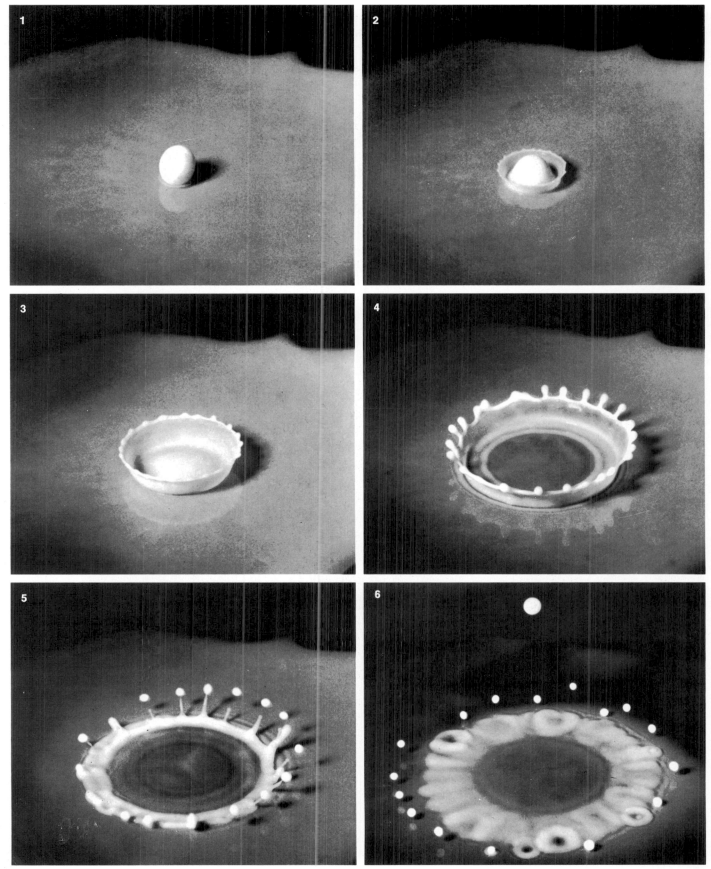

HAROLD E. EDGERTON: *Drop of Milk Splashing into a Saucer*, 1938

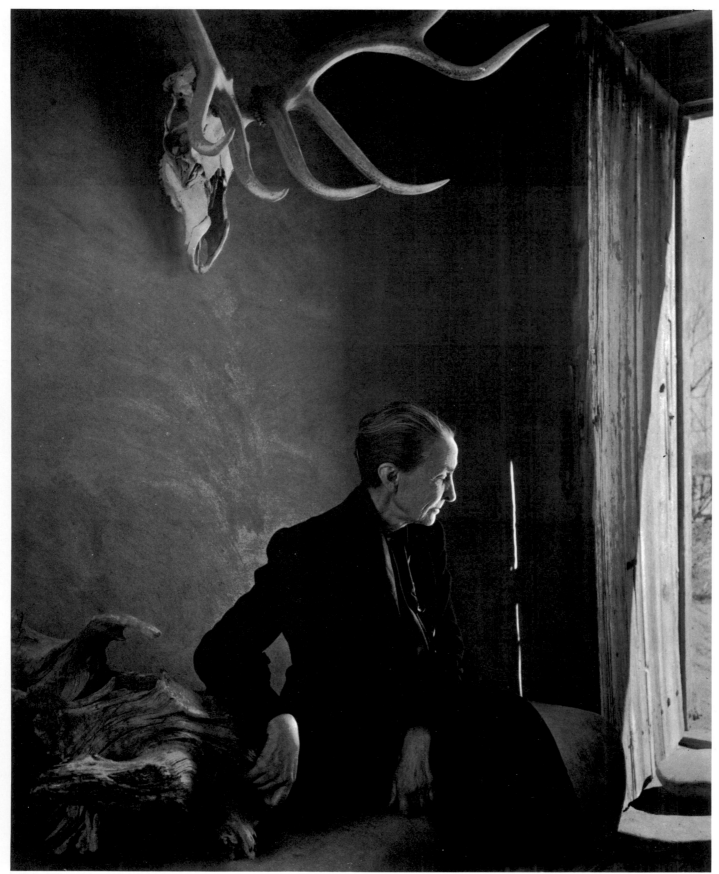

YOUSUF KARSH: *Georgia O'Keeffe*, 1956

20

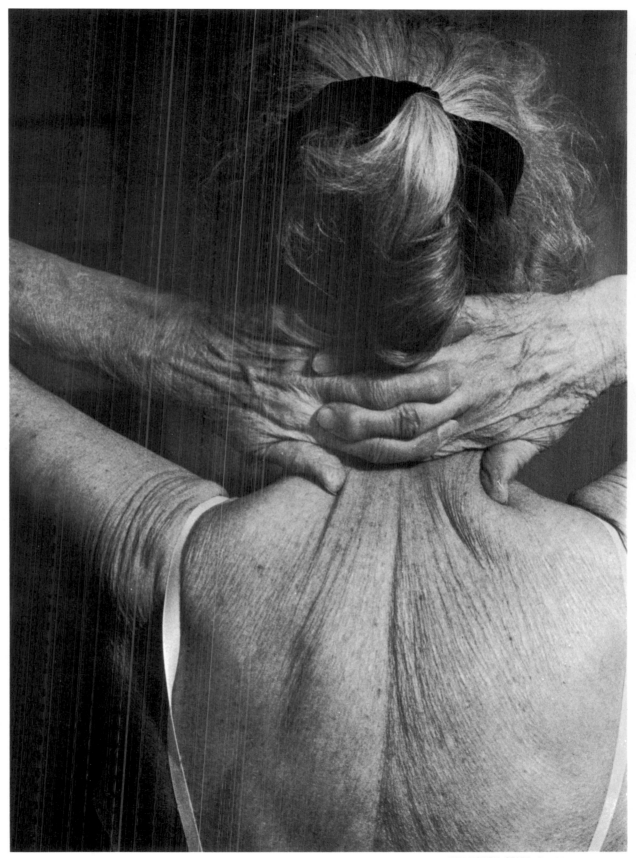

Portraits mark special events: birth, graduation, wedding, promotion and, common in the 19th century, death. They tell us what famous people look like. Sometimes they make people famous, for example fashion models who become celebrities because their faces are seen everywhere. Self-portraits can convey what we feel about ourselves.

Yousuf Karsh has probably portrayed more of the world's famous and accomplished people than any other photographer. He has photographed presidents, popes and most of the century's greatest musicians, writers and artists, including the painter Georgia O'Keeffe (opposite). This portrait is typical of Karsh's work, conveying very strongly the sitter's public image, that is, what we expect that particular person to look like. Karsh generally photographs people in their own environments but imposes on the portrait his own distinct style: carefully posed and lit setups, rich black tones, often with face and hands highlighted.

For this powerful self-portrait, Nina Howell Starr turned her back on a prefocused camera with timer set and locked her arthritic hands behind her neck, thumbs pressed into her flesh. "Those lines shooting down my back, the curl of my ponytail, the twist in the shoulder strap, the force of my thumbs and thrust of my arms, all communicate something of what I like to consider myself."

NINA HOWELL STARR: *Considering Myself*, 1977

21

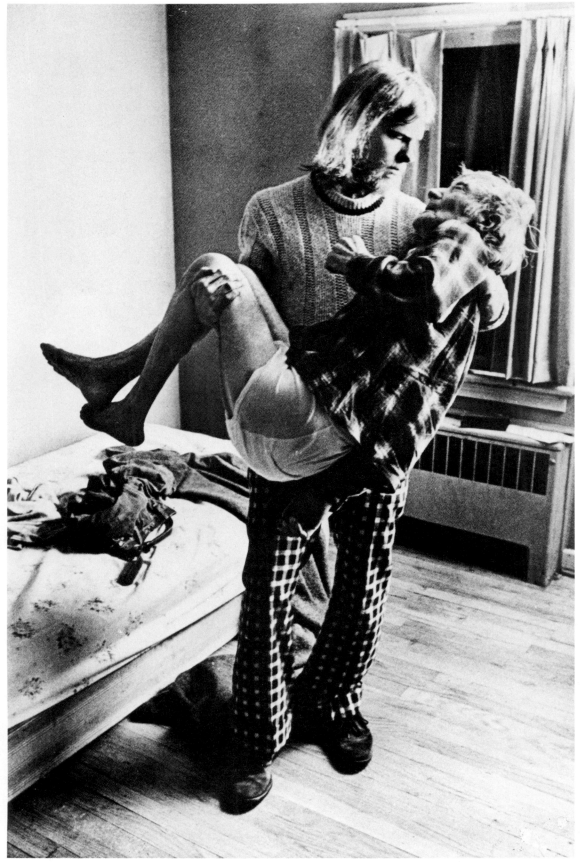

MARK AND DAN JURY: *Gramp,* 1974

In a stark room, a young man cradles his dying grandfather (left). The progressive deterioration and death of the 81-year-old retired coal miner was recorded over the course of 3 years by 2 of his grandsons and appeared in their tender and dramatic book, Gramp. This photograph is powerful in the closeness of two ages, separate but on a continuum—youth and senility.

Photographs can convey a psychological reality of dreams, fantasies and feelings, one step removed from exterior events but still quite real. Jerry Uelsmann's photographs are created in the darkroom by combining elements from several negatives (opposite). He uses as many as 7 enlargers to create the final image he wants on a single piece of paper. He does not make a copy negative of the final print, but goes through the same complicated process for each print. He does not explain his pictures; instead he lets viewers reach their own conclusions about what the picture means to them.

JERRY N. UELSMANN: *Untitled*, 1969

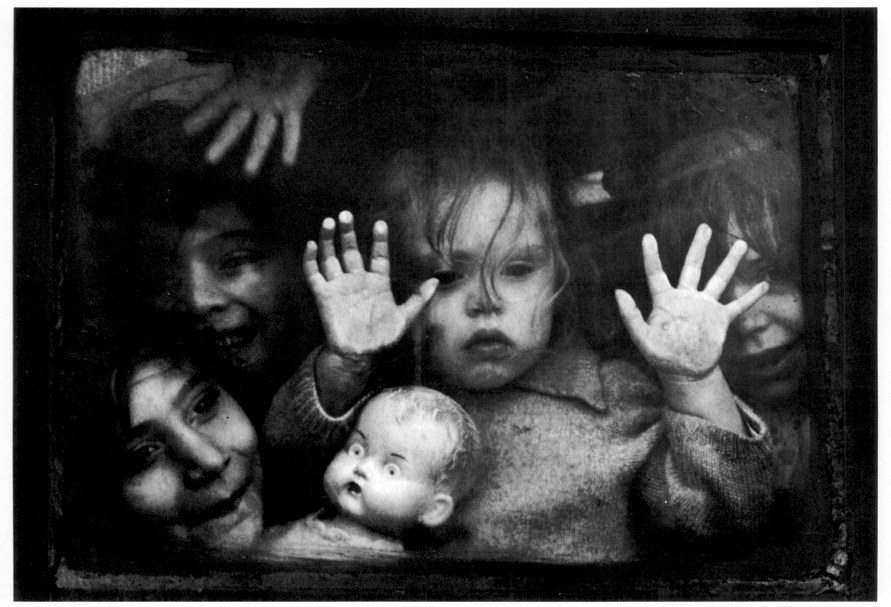

SARA FACIO: *Looking at Life, Colonia, Uruguay, 1963*

2 Camera

The Anatomy of a Camera 26
The Major Types of Cameras 28
 View Camera 28
 Rangefinder Camera 29
 Reflex Cameras 30
The Camera's Controls 32
 Focusing Systems 32
 The Shutter as a Controller of Light 34
 The Shutter as a Controller of Motion 36
 The Aperture as a Controller of Light 38
 The Aperture as a Controller of Depth of Field 40
 Using Shutter and Aperture Together 42
Keeping the Camera Steady 44
Buying a Camera 46

Why do you need to know how a camera works? Much of camera design today is based on one of the earliest camera slogans—"You press the button, we do the rest." Automatic, electronic and computerized modern cameras try to make picture taking as easy as possible by choosing the shutter speed or aperture for you or by presetting the focus. But they can make choices for you only up to a certain point. Do you want to freeze the motion of a speeding car or let it race by in a blur? Bring the whole forest into sharp focus or isolate a single flower? Exaggerate the size and strength of a man or show him dwarfed by the cement and steel of his environment? These are decisions that only you can make, and the more pictures you take the more you will want to make these decisions deliberately rather than leave them to chance. Time spent now in learning what camera equipment can do and how to control its effects will be more than repaid whether you make a snapshot, a portrait, a commercial illustration, a news photograph, a translation of how you see the world or any other kind of photograph.

◀ *Argentine photographer Sara Facio took this picture of Uruguayan children crowding the window of an old house to watch passing tourists. Even when you know the circumstances, the photograph has its own life. The glass window seems to become the surface of the print, and the girl's fingers press against that surface. The frame of the window shown within the frame of the photograph also anchors the window at the surface of the print. The children are talking and laughing, but we can't hear them. Their expressions, as well as the doll's, seem unconnected, as do the disembodied heads and the hand at the top of the frame. All these elements contribute to the dreamlike quality of the picture.*

The Anatomy of a Camera

All cameras are basically alike. Each is a box with a piece of film in one end and a hole in the other. The hole is there so that light can enter the box, strike the chemically sensitized surface of the film and make a picture. Every camera from the most primitive to the most sophisticated works this way. The job is always the same: to get light onto film to form an image. The differences are in how well and how easily this is done.

To do the job properly, certain things are needed; these are shown in the cutaway drawing at right. To begin with, there must be a viewing system, a sighting device that enables the user to aim the camera accurately at the subject. The hole that admits light to the camera—the aperture—must be made adjustable, by a device called a diaphragm, to control the amount of light that enters. There must be a lens to collect the light and project an image on the film. There must be a movable screen—the shutter—to keep all light out of the camera until the moment arrives for taking a picture. When a button is pressed, the shutter opens for an instant, just long enough to admit enough light to make a satisfactory image on the film. There must be a device for moving the exposed film out of the way and replacing it with an unexposed piece. Finally, there should be a focusing mechanism to move the lens back and forth so that it can project sharp images of both near and far objects.

All cameras except the very cheapest have all these features in some form. Why then are there so many different kinds of cameras? The reason is that cameras are asked to do so many different things, under such a wide variety of conditions, that they have had to become specialized. While a bulky view camera is ideal for taking architectural

photographs, it is not so good as a smaller camera for taking unposed pictures of people on a crowded street.

There are hundreds of different models of cameras, but all of them fit into one of four main categories according to the viewing system they use. Cameras with viewfinders and small single-lens reflex cameras are generally used at eye level; you put them up to your eye and use them as a direct extension of

your vision into the scene in front of you. Viewing with the somewhat larger twin-lens reflex camera is usually done by looking down onto a ground-glass screen. The largest, the view camera, provides the most precise, and the slowest, viewing and composition.

The next few pages describe these four types of cameras in more detail. Understanding how they work will help you decide which type is best for you.

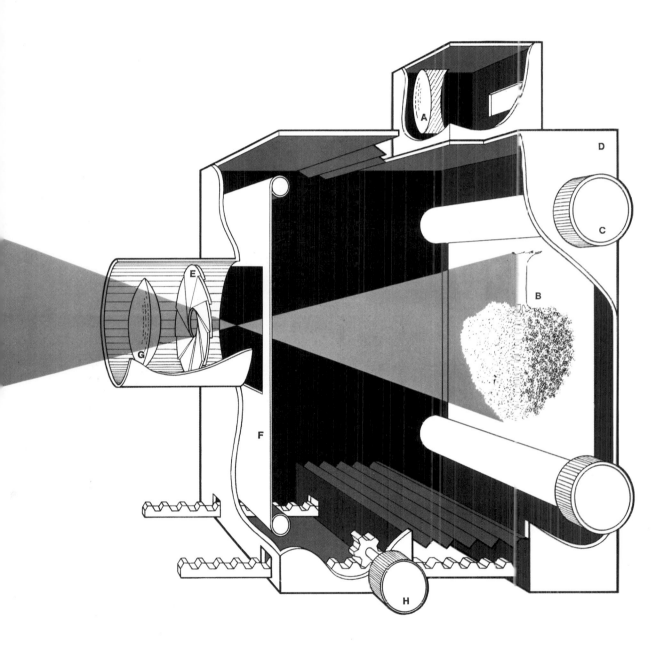

A | **The Viewing System** *shows the scene the picture will cover, usually through a set of lenses (left) or the picture-taking lens itself.*

B | **The Film** *receives the image of the object being photographed and records this image on its light-sensitive surface.*

C | **The Film Advance** *winds film from 1 spool to another in cameras using film rolls or cartridges. In other cameras, which use sheets of film, there is a slot admitting 1 sheet at a time.*

D | **The Camera Body,** *a box that houses the various parts of the camera, protects the film from all light except that which enters through the lens when a picture is taken.*

E | **The Diaphragm,** *a light-control device usually made of overlapping metal leaves, forms an adjustable hole, or aperture. It can be opened to let more light pass through the lens or partially closed—stopped down—to restrict the passage of light.*

F | **The Shutter,** *the second light-control device, is a movable, protective shield that opens and closes to permit a measured amount of light to strike the film. The shutter mechanism, a complicated one on adjustable cameras, is represented here schematically as a light-proof curtain with an opening that admits light as it passes by the lens.*

G | **The Lens** *focuses the light rays from a subject and creates a reversed, upside-down image on the film at the back of the camera.*

H | **The Focusing Control** *moves the lens back or forth to create a sharp image on the film. The gear-wheel-and-track system shown here shifts the whole camera front; more commonly the lens alone moves by turning like a screw.*

The Major Types of Cameras
View Camera

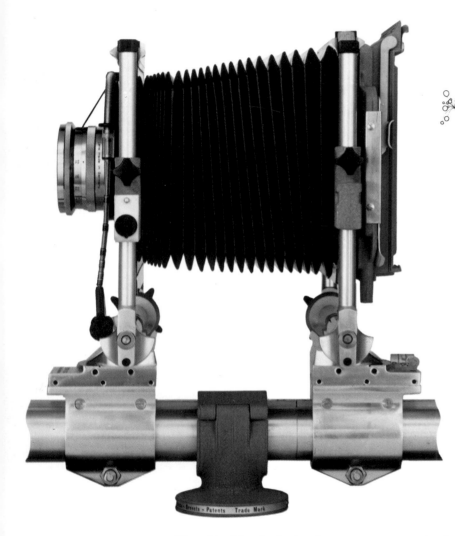

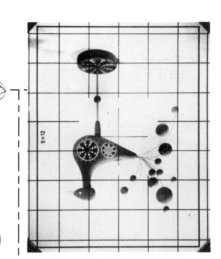

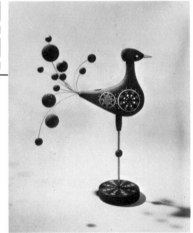

In the view camera, the light comes directly from the subject, through the lens, and falls on a viewing screen (a) at the back of the camera; since the image that the photographer sees comes directly from the lens, it is reversed and upside down, as the upper of the 2 bird photos shows. Otherwise it is identical to what will appear on the film (lower photo). As an aid in composing pictures, the viewing screen of this camera is etched with a square grid of hairlines.

The oldest basic design for a camera—direct, through-the-lens viewing and a large image on a ground-glass viewing screen—is still in use today. A view camera is built somewhat like an accordion, with a lens at the front, a viewing screen at the back and a flexible bellows in between. You focus by moving the lens, the back or the entire camera forward or back until you see a sharp image on the viewing screen.

Advantages of the view camera: The image on the viewing screen is projected by the picture-taking lens, so what you see is exactly what will be on the negative; there can be no parallax error *(see opposite).* The viewing screen is large, and you can examine it with a magnifying glass to check sharpness in all parts of the picture. The film size is also large (4 x 5, 5 x 7, 8 x 10 inches or larger) and produces sharp detail in large pictures. The camera parts are adjustable, and you can change the position of lens and film relative to each other to correct problems of focus or distortion. Each picture is exposed on a separate piece of film, so you can give a negative individual development.

Disadvantages: The most serious are the bulk and weight of the camera; you must use a tripod. Second, the image projected on the viewing screen is not very bright, and to see it clearly you must put a cloth over both your head and the back of the camera. Finally, the image appears reversed and upside down on the viewing screen. You get used to this, but it is disconcerting at first.

Rangefinder Camera

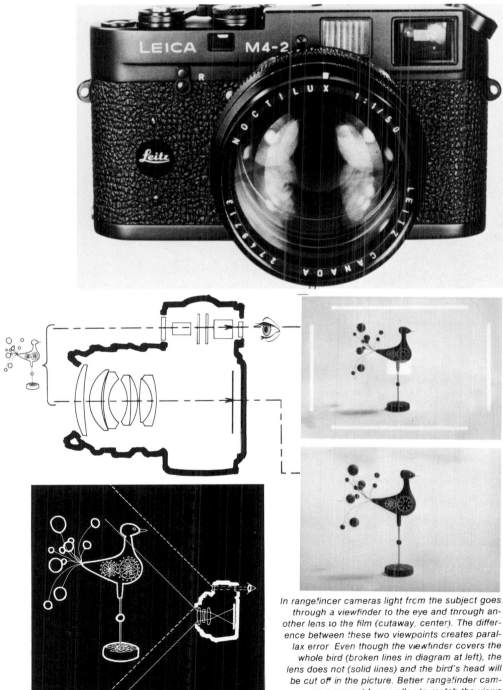

In a rangefinder the scene to be photographed is seen through a small peephole (the viewfinder) equipped with a simple lens system that gives you an image approximating what the picture will be. Cameras with this type of viewfinder (except the least expensive models) include a device called a coupled rangefinder *(page 33)* that shows when the picture is in focus.

Advantages of the rangefinder: A camera with a combined rangefinder-viewfinder (usually called a rangefinder camera) is compact, lightweight and fast handling. It has relatively few moving parts to break down and so is generally reliable. Good-quality models provide excellent focusing, particularly at low light levels where some other viewing systems do not function as well.

Disadvantages: Because the viewfinder is in a different position than the lens that exposes the negative, the camera suffers from an inherent defect called parallax error *(left)* that prevents you from seeing exactly what the lens sees. The closer the subject to the camera, the more evident the parallax error. A high-quality camera like the one shown here automatically corrects for parallax until the subject is within a few feet of the camera. But because complete correction is difficult at close range, sighting through the viewfinder is awkward when you want to do carefully composed close-up work. In addition, even when the edges of the picture are fully corrected, the alignment of objects within the picture will always be seen from slightly different angles by the viewfinder and the taking lens, which exposes the film. Also, the images seen through a low-quality viewfinder can be small and difficult to focus.

In rangefinder cameras light from the subject goes through a viewfinder to the eye and through another lens to the film (cutaway, center). The difference between these two viewpoints creates parallax error. Even though the viewfinder covers the whole bird (broken lines in diagram at left), the lens does not (solid lines) and the bird's head will be cut off in the picture. Better rangefinder cameras correct for parallax to match the views (above), except for subjects that are very near.

Reflex Cameras

Single-Lens Reflex

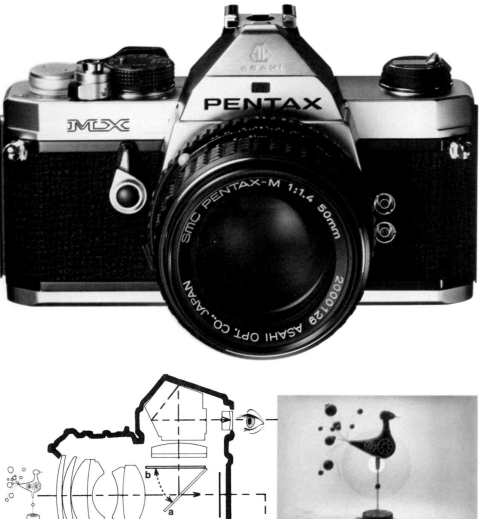

The best way to see what the camera sees is to look right through the camera lens itself. This way you can frame the subject precisely and tell how much of the scene, from foreground objects to distant background, will be in focus. This cannot be done with a viewfinder, which produces a sharp image of everything it sees, but can with a single-lens reflex camera. With a mirror and prism *(diagram, left)* it lets you use the camera lens for composing and focusing.

Advantages of the single-lens reflex. It eliminates parallax error and so is excellent for close-up work. It is easily and quickly focused. Since the viewing system uses the camera lens itself, it works equally well with all lenses—from fisheye to supertelephoto; whatever the lens sees, you see. An exposure meter built into the camera can be designed to view through the lens so that you can see the area the meter is measuring.

Disadvantages: A standard-size single-lens reflex is heavier and larger than a rangefinder camera; however, newer compact models have been considerably reduced in weight and size. The camera is relatively complex and so has more components that may need repair. Because it has a moving mirror, it makes a comparatively loud click during exposure, especially the large-format models; this is a drawback if you are stalking wild animals or self-conscious people. When the mirror moves up during exposure, it momentarily blacks out the viewing image, also a distraction in some situations. And the motion of the mirror and shutter may cause vibrations that make the camera more difficult to hold steady at slow shutter speeds, though better models damp this action to all but eliminate any vibration. Because the light travels a long path to the user's eye—through lenses, off a mirror, then to a viewing screen and usually a prism—focusing in dim light can be difficult.

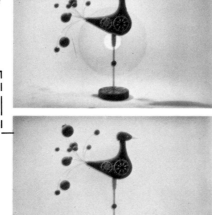

The viewing system of a single-lens reflex camera is built around a mirror (a). Light coming in through the camera lens is reflected upward by this mirror to a viewing screen, then usually through a 5-sided pentaprism that turns the inverted image right-side up and right-side round and delivers it to the eye. When a picture is taken, the mirror snaps up momentarily to position (b), permitting light to strike the film at the back of the camera. Through-the-lens viewing with pentaprism produces an image virtually identical with that produced on the film (bird pictures at right).

Twin-Lens Reflex

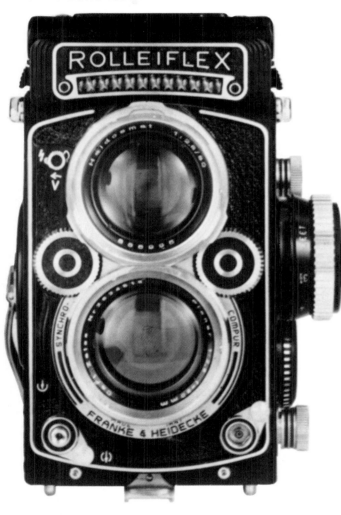

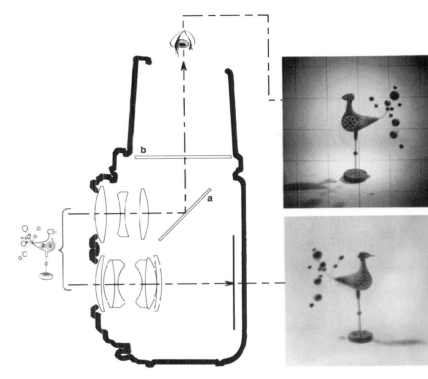

The twin-lens reflex has separate viewing and picture-taking lenses stacked one over the other. The lower lens conducts light to the film. The upper one, coupled to the lower for focusing, conducts light to a mirror (a) set at a 45° angle, whence it is reflected upward to a viewing screen (b). Like all mirror reflections, the image appears reversed left to right, as shown by the top photo. The top photo also shows a grid of hairlines, etched on the viewing screen to help compose the picture more accurately.

The twin-lens reflex camera, like the single-lens reflex camera, uses a mirror that reflects an image of the scene upward onto a viewing screen. But its mirror is fixed, and there is one lens to expose the film and a second one for viewing. These are coupled mechanically so that when one is in focus, the other is also.

A twin-lens reflex camera combines some good and some bad features of the larger view camera and the smaller rangefinder camera.

Advantages of the twin-lens reflex: The fixed mirror means simple, rugged construction and quiet operation, and the viewing screen permits convenient, accurate composition. Because you usually look into this camera from the top, you can lower it to waist level or even place it on the ground for photographing from a low angle, an awkward position for an eye-level viewfinder.

Disadvantages: The principal problem is again parallax error—the viewing lens does not see exactly the same picture as the taking lens. The best twin-lens reflexes have automatic parallax correction, but not for objects at very close range and not for the alignment of objects within the picture. Another drawback is that the image projected on the viewing screen is reversed left to right, which makes it difficult to follow moving objects. The larger size of the twin-lens reflex, while permitting larger film, does make the camera somewhat cumbersome. The camera is also somewhat limited by the fact that lenses are not interchangeable on most models.

The Camera's Controls
Focusing Systems

1 | Ground Glass

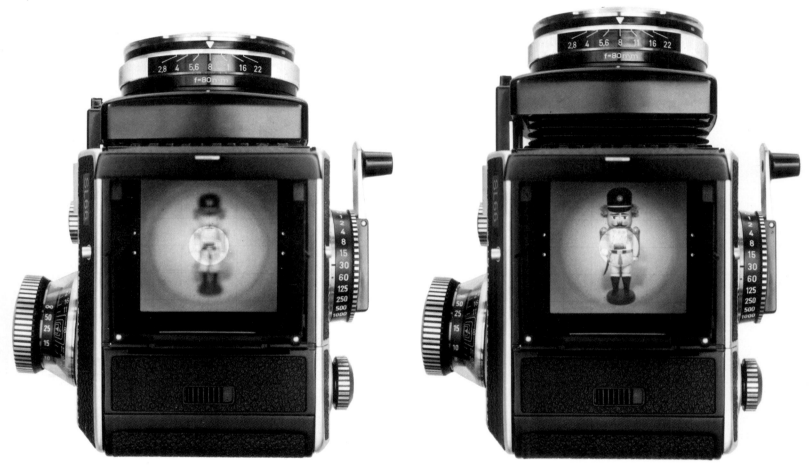

All cameras with movable controls have one or the other of two devices to help focus a picture sharply—a viewing screen or a rangefinder. In the viewing-screen system, used in single-lens reflex, twin-lens reflex and view cameras, light from the camera lens hits a pane of glass that is etched, or ground, to give it a milky, semi-opaque look. This ground glass catches part of the light, so that a viewer looking at it from the other side can see an image (above) and focus it if necessary. The image seen on a ground glass is not so bright as that in a viewfinder; in dim light you may not be able to see readily when the image is sharp.

The coupled rangefinder system (opposite) is easier to use for some people, particularly in dim light, because it only requires you to line up a double image, or two parts of a split image, in the viewfinder. The focusing mechanism of the lens is coupled with the rangefinder so that the lens is automatically focused at the same time as the rangefinder.

Don't confuse the function of the rangefinder with that of the viewfinder. The viewfinder shows the view the camera will take. The rangefinder (usually built into the viewfinder) finds the range or distance of an object and shows when it is sharply focused.

In this reflex camera a mirror reflects the image from the lens upward onto a ground-glass screen. Since the ground glass at the top and the film at the back of the camera are the same distance from the lens, the image that falls on the screen will be sharp only when the lens is also focusing the image sharply on the film plane. At left, above, the focusing knob on the left side of the camera is incorrectly set at 25 ft, producing an unclear image of a toy soldier 15 ft away. But when the knob is set for 15 ft (above right) the image the photographer sees is sharply defined.

2 | Rangefinder

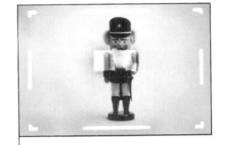

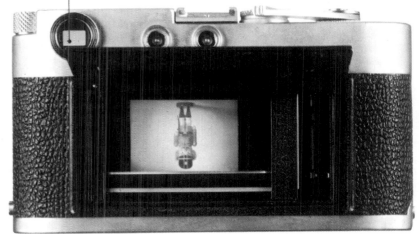

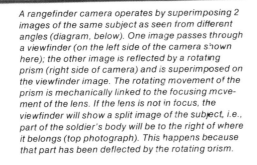

A rangefinder camera operates by superimposing 2 images of the same subject as seen from different angles (diagram, below). One image passes through a viewfinder (on the left side of the camera shown here); the other image is reflected by a rotating prism (right side of camera) and is superimposed on the viewfinder image. The rotating movement of the prism is mechanically linked to the focusing movement of the lens. If the lens is not in focus, the viewfinder will show a split image of the subject, i.e., part of the soldier's body will be to the right of where it belongs (top photograph). This happens because that part has been deflected by the rotating prism.

When the lens is sharply focused, the rotating prism will be turned to the correct angle to overlap its image directly over the viewfinder image so that the 2 images appear to be 1. As with other cameras, the subject-to-camera distance is indicated in feet or meters on a band on the lens barrel so that the lens can also be focused by measuring the distance from subject to camera and then turning the lens to the appropriate distance.

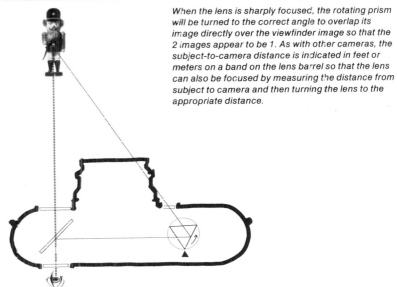

The Shutter as a Controller of Light

By controlling the amount of light that enters the camera, you can take pictures in bright sun, deep shadow or any light condition in between. Two controls make this possible: the shutter, described here, and the aperture *(pages 38–39).*

The shutter controls light by the amount of time it remains open. Each shutter setting is half (or double) that of the next one and is marked as the denominator of the fraction of a second the shutter remains open: 1 (¹⁄₁ or one second), 2 (½ second), 4 (¼ second) and so on through 8, 15, 30, 60, 125, 250, 500 and on some cameras 1000 and 2000. A slightly different sequence sometimes used is 1, 2, 5, 10, 25, 50, 100, 250. T or time setting keeps the shutter open indefinitely until the photographer closes it. B or bulb setting keeps the shutter open as long as the release button is held down.

There are two principal types of shutters: the leaf shutter *(this page)* and the focal-plane shutter *(opposite).* Each type has its own advantages and drawbacks. A focal-plane shutter is built into

The leaf or between-the-lens shutter is generally located in the lens itself at (a) above. It consists of a number of small overlapping metal blades powered by a spring. The spring is pulled tight or cocked. When the shutter release is pushed, the tension on the spring is released and the blades open up and then shut again in a preset amount of time. In the examples at right, the blades are just beginning to swing open at (1) and no perceptible light is hitting the film. At (2), with the shutter farther open, the blades are almost completely withdrawn and at (3) light pours in. Then the blades begin to close again, admitting less and less light (4, 5). The total amount of light admitted during this cycle produces the fully exposed photograph (6).

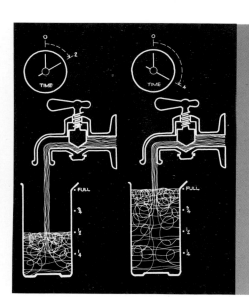

The amount of light that enters a camera, like the amount of water that pours from an open faucet into a glass, depends on how long the flow of light continues. If a glass is filled halfway in 2 sec, it will be filled to the top in 4 sec. In the same way, if the shutter is left open twice as long, the film will be exposed to twice as much light.

1 | Leaf Shutter

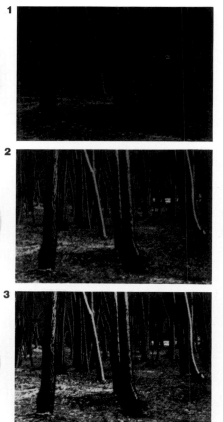

the camera itself—just in front of the film, or focal, plane—while a leaf shutter is usually located between the lens elements. This makes interchangeable lenses for a camera with a focal-plane shutter less expensive since a shutter mechanism does not have to be built into each lens. One drawback to the focal-plane shutter is that it can be used with flash only at certain shutter speeds, usually $\frac{1}{60}$ or $\frac{1}{125}$ second with 35mm cameras, even slower with larger formats (except when using special FP bulbs). This is because at faster shutter speeds the slit in the focal-plane shutter does not completely uncover the film at any one time (see diagram, right). Also, since the slit exposes one end of the film frame before the other, objects moving rapidly parallel to the film may be distorted; this is rare, but it can happen. Finally, every time you open the camera to load or unload film, the delicate shutter curtains are exposed; touching them can cause damage.

Leaf shutters are quieter than focal-plane shutters and will synchronize with flash at faster shutter speeds. But since the leaf shutter has to open, stop and then reverse direction to close again, most are limited to speeds of $\frac{1}{500}$ second or slower. The focal-plane shutter has a simpler mechanism that moves in one direction only and permits speeds of up to $\frac{1}{2000}$ second.

2 | Focal-plane Shutter

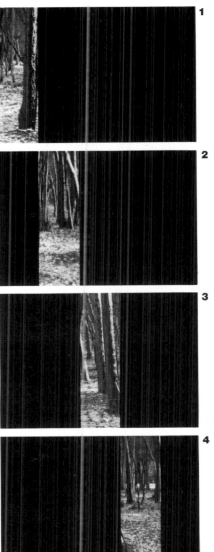

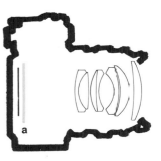

The focal-plane shutter is located directly in front of the film at (a) in the diagram above. The shutter consists of 2 overlapping curtains that form an adjustable slit or window. Driven by a spring, usually cocked by the film advance lever, the window moves across the film, exposing the film as it moves. The series at left shows how the film is exposed at fast shutter speeds. The slit is narrow and exposes only part of the film at any one time. Picture (6), below, shows the effect of the entire exposure, with all sections of the film having received the proper amount of light. At slow shutter speeds, 1 edge of the slit travels across the film until the film is completely uncovered; then the other edge of the slit travels in the same direction, re-covering the film. The shutter shown here moves from side to side across the length of the film. The Copal Square type of focal-plane shutter moves from top to bottom across the film.

The Shutter as a Controller of Motion

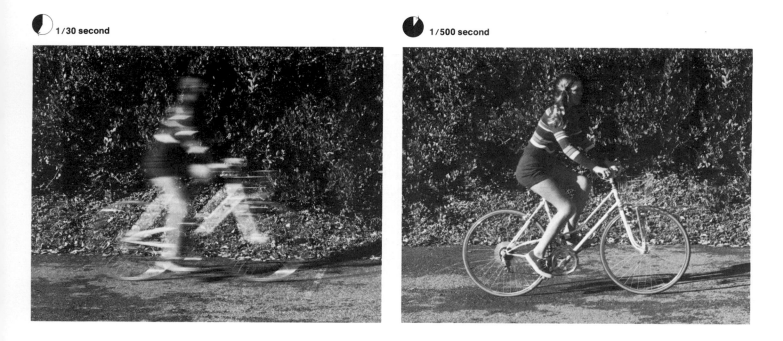

1/30 second

1/500 second

When an object moves in front of a camera that is still, the image projected onto the film by the lens will also move. If the object moves swiftly or if the shutter is open for a relatively long time, this moving image will register as blurred and indistinct. But if the shutter is speeded up, the blur can be reduced or eliminated. You can control this effect, and even use it to advantage. A fast shutter speed can freeze a moving object, showing its position at any given instant, whether it be a football player jumping for a pass or a bird in flight. A slow shutter speed, on the other hand, can be used deliberately to accentuate the blurring and suggest the feeling of motion. Another way to suggest movement is to pan, that is, to follow the motion of the object with the camera. Panning blurs the background while keeping the moving object sharp, which makes the object appear to be racing forward rapidly.

The range of effects obtainable by varying shutter speed and camera movement is shown in the four views of a bicycle rider above. In the picture at far

left the bicycle moved enough during the relatively long $\frac{1}{30}$-second exposure to leave a broad blur on the film. In the next photograph a shutter speed of $\frac{1}{500}$ stopped the motion so effectively it is hard to tell whether the bicycle was moving at all. A moving subject may vary in speed and thus affect the shutter speed needed to stop motion. For example, at the peak of a movement that reverses (such as the peak of a jump just before descent), motion slows, and a relatively slow shutter speed will record the action sharply.

The amount of blurring in a photograph, however, is not determined simply by how fast the object itself moves. What matters is how far its image actually travels across the film during the exposure. In the third photograph, with the rider moving directly toward the camera, the bicycle remains in virtually the same position on the film. Consequently there is far less blurring even at $\frac{1}{30}$ second. A slow-moving object close to the camera, such as a bicycle 10 feet (3 m) away, will cross more of the film and appear to blur

more than a fast-moving object far away, such as a jet plane in flight. A telephoto lens magnifies objects and makes them appear closer to the camera; it creates more blur than a normal lens used at the same distance.

In the final photograph *(far right)* the camera was panned in the same direction the bicycle was moving. Since the camera moved at about the same speed as the bicycle, the rider appears sharp while the motionless background appears blurred. Successful panning takes both practice and luck. Variables such as the exact speed and direction of the moving object make it difficult to predict exactly how fast to pan. Decide where you want the object to be at the moment of exposure, then start moving the camera a few moments before the object reaches that point. The longer the focal length of the lens, the less you will need to pan the camera; with a telephoto lens, a very small amount of lens movement creates a great deal of movement of the picture image. (Focal length is explained on page 54.)

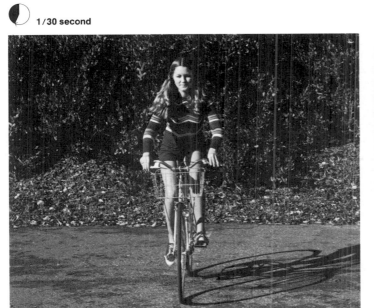

1/30 second

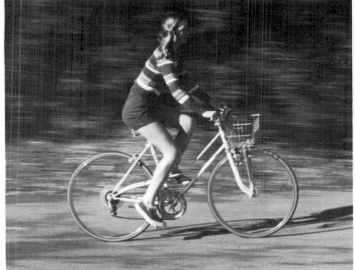

1/30 second, camera panned

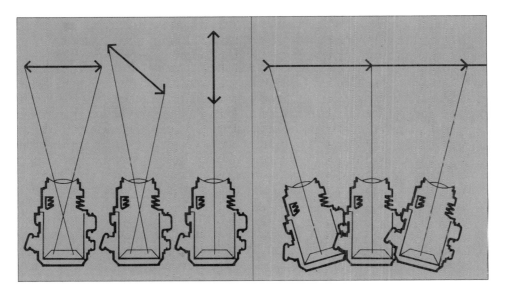

The diagram at left shows how the direction of a moving object affects the amount of blur that will result. When the object is traveling parallel to the plane of the film (first arrow), all the movement is recorded on the film. If it is moving at an angle to the film (second arrow), less left-to-right-movement will be recorded and, as a result, less blur. When the object moves directly toward the camera (third arrow), there is no left-to-right movement at all and hence a minimum of blur. When the camera is panned or moved in the same direction as the object (right arrows), the object will be sharp and the background blurred.

The Aperture as a Controller of Light

In addition to changing the shutter speed to adjust the light that reaches the film, you can use a second adjustment. This changes the size of the aperture, the lens opening through which light enters the camera.

The aperture works like the pupil of an eye; it can be enlarged or contracted to admit more light or less. In a camera, this is done with a diaphragm, a ring of thin, overlapping metal leaves located inside the lens. The leaves are movable; by turning a control on the lens, they can be rotated out of the way so that most of the light reaching the surface of the lens passes through. A turn in the opposite direction will close the aperture until it becomes very small and so passes less of the light (*see opposite*).

Aperture sizes are measured on a standard scale of numbers called f-stops. On early cameras the aperture was adjusted by individual metal stop plates that had holes of different diameters. The term "stop" is still used to refer to the aperture size, and a lens is said to be "stopped down" when the size of the aperture is decreased.

The standardized series of numbers commonly used on the f-stop scale runs as follows: f/1.4, f/2, f/2.8, f/4, f/5.6, f/8, f/11, f/16, f/22, f/32, f/45, f/64. The largest of these is f/1.4. It admits the most light and is the "fastest." Each f-stop after that is half as fast as the previous one—it cuts light flow in half. A lens that is set at f/4 admits half as much light as one set at f/2.8 and only a quarter as much as one set at f/2. The variation over the full range of f-stops is large; a lens whose aperture is stopped down to f/64 admits less than two-thousandths of the light that comes through a lens set at f/1.4.

Few lenses are built to use the whole range of apertures. A general-purpose lens for a 35mm camera, for example, might run from f/2.8 to f/22. A camera lens designed for a large view camera would not be so fast; it might stop down to f/64 but open up only to f/5.6. The widest possible aperture at which a par-ticular lens design will function well may not be a full stop from a standard setting. So a lens's f-stops may begin with a setting such as f/3.5, f/4.5 or f/7.7, then proceed into the standard sequence.

The terms "fast" and "speed" in relation to f-stops and lenses do not describe shutter speed but only the aperture size and the rate of light flow into the camera. (In the same way, the faucet on the left in the diagram below is said to be running faster than the faucet on the right.) The term "stop," however, is often used loosely to refer to a change in exposure—whatever the means by which it is changed. To give one stop more exposure means to double the amount of light reaching the film (either by opening up to the next larger aperture setting or by doubling the exposure time). To give one stop less exposure means to cut the light reaching the film in half (stopping down to the next smaller aperture setting or halving the exposure time). More about f-stops is explained on pages 40–43 and 66–67.

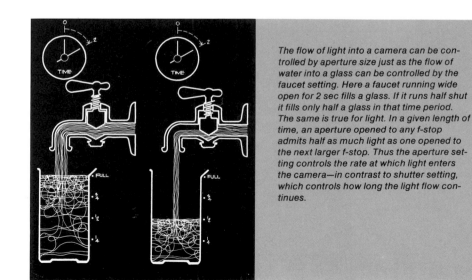

The flow of light into a camera can be controlled by aperture size just as the flow of water into a glass can be controlled by the faucet setting. Here a faucet running wide open for 2 sec fills a glass. If it runs half shut it fills only half a glass in that time period. The same is true for light. In a given length of time, an aperture opened to any f-stop admits half as much light as one opened to the next larger f-stop. Thus the aperture setting controls the rate at which light enters the camera—in contrast to shutter setting, which controls how long the light flow continues.

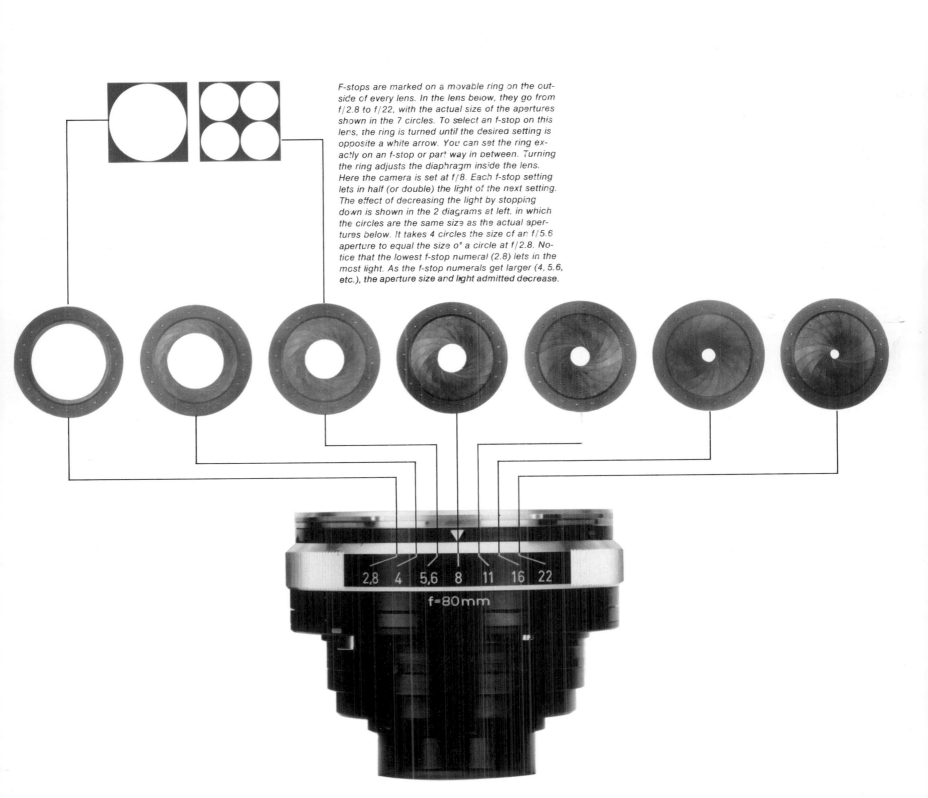

F-stops are marked on a movable ring on the outside of every lens. In the lens below, they go from f/2.8 to f/22, with the actual size of the apertures shown in the 7 circles. To select an f-stop on this lens, the ring is turned until the desired setting is opposite a white arrow. You can set the ring exactly on an f-stop or part way in between. Turning the ring adjusts the diaphragm inside the lens. Here the camera is set at f/8. Each f-stop setting lets in half (or double) the light of the next setting. The effect of decreasing the light by stopping down is shown in the 2 diagrams at left, in which the circles are the same size as the actual apertures below. It takes 4 circles the size of an f/5.6 aperture to equal the size of a circle at f/2.8. Notice that the lowest f-stop numeral (2.8) lets in the most light. As the f-stop numerals get larger (4, 5.6, etc.), the aperture size and light admitted decrease.

2,8 4 5,6 8 11 16 22

f=80mm

The Aperture as a Controller of Depth of Field

aperture setting: f/2

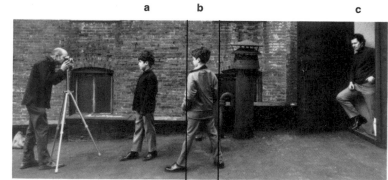

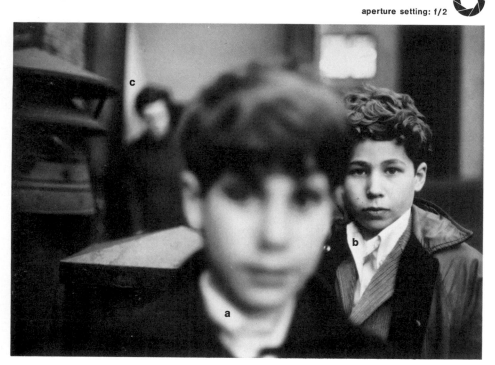

depth of field: 1 foot

distance (feet)

depth of field scale (f-stops)

aperture (f-stops)

At its widest setting of f/2, marked by the bottom ring, the depth of field on this lens when focused at 7 ft (2.1 m) is barely deep enough to include the middle boy at (b) in the side view of the scene above. The bracketing marks—i.e., the vertical lines—on the center ring, when read against the camera's distance scale on the top ring, indicate that at f/2 on this lens only objects slightly more than 6 ft (1.8 m) but less than 8 ft (2.4 m) from the lens will be sharp in the photograph.

A change in aperture size affects not only the amount of light entering the camera, but also the focus. As the aperture decreases in size, more of the background and foreground in a given scene becomes sharper. This area of acceptable focus is known as depth of field. (See also pages 64–71.)

The two large photographs shown on these pages were taken under identical conditions but with different aperture settings. In the photograph above, the diaphragm was opened to its widest aperture, f/2, and the lens was focused on a boy about seven feet (2.1m) away *(see side view of the photographer and his subjects, above right)*. The resulting photograph shows a shallow depth of field; only the middle boy (b) is sharp, while both the boy in front (a) and the man behind (c) appear out of focus. Using a small aperture, f/16, gives a dif-ferent picture *(opposite page)*. The lens is still focused on the middle boy but the depth of field is now great enough to yield sharp images of the other figures as well.

With some cameras, checking depth of field is relatively simple. A view camera views directly through the lens. As the lens is stopped down, the increasing depth of field is shown on the ground-glass viewing screen. A single-lens reflex camera also views through the lens. Most models automatically show the scene through the widest aperture, but some also provide a preview button that stops down the lens to the aperture at which you have set the camera.

Examining depth of field is somewhat more difficult with a twin-lens reflex camera or a camera with a viewfinder. A twin-lens reflex shows the scene only at the widest aperture of the viewing lens.

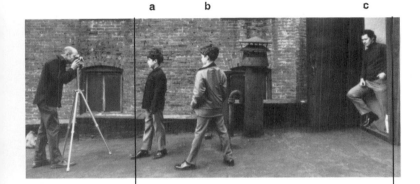

a b c

<------- depth of field: 8 feet ------------------------->

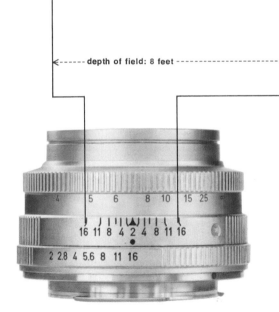

When the lens is closed down to its smallest aperture, f/16, almost the entire scene before the camera becomes sharp at the same focusing distance of 7 ft (2.1 m). The photographer can check this on the depth-of-field and distance scales. For, as the bracketing marks for f/16 show, everything between 5 ft (1.5 m) and 13 ft (4 m) will now appear distinct. Subjects outside these limits cannot be photographed in detail without altering the focus of the lens.

aperture setting: f/16

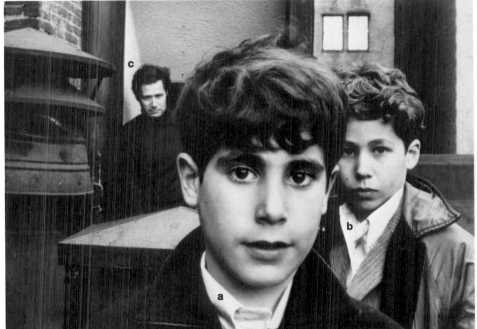

There is no way to stop it down to check depth of field at other apertures. Through a viewfinder, objects at all distances appear equally sharp.

However, there is another way to predict depth of field in addition to visually checking through the lens. Many lenses incorporate a depth-of-field scale. This often appears printed on the lens as a scale of paired numbers that bracket the distances of the nearest and farthest points of the depth of field. As the lens is focused and the f-stop set, the scale changes to show what part of the picture will be in focus and what part will not.

The lens shown here has such a scale. The bottom row of numbers shows the f-stops. The top row shows the distance from the lens to the object on which it is sharply focused. If the photographer wishes to take a picture at f/2 (lens at left), he turns the bottom ring until the f-stop setting is beneath the fixed indicator dot. Then he looks at the middle row (depth-of-field scale), noting the small vertical bracketing marks. When read against the top row of numbers, these marks show in feet (and often in meters) what will be in focus. Since his lens setting is f/2, he takes his reading from the figure 2 in the middle row. The bracketing marks for f/2 show that only a narrow range between six and eight feet (1.8–2.4 m) away will be in focus. At f/16 (lens at right) the scale shows a considerably increased depth of field—objects between 5 and 13 feet (1.5–4 m) will be in focus. When the camera is focused on a relatively far distance—infinity in photographic terminology (marked ∞ on the lens)—all objects at that distance or farther from the camera will be in sharp focus.

The Camera's Controls: continued

Using Shutter and Aperture Together

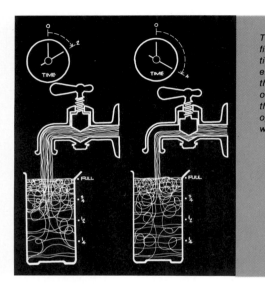

The quantity of light that reaches a piece of film inside a camera depends on a combination of aperture size (f-stop) and length of exposure (shutter speed). In the same way, the water that flows from a faucet depends on how wide the valve is open and how long the water flows. If a 2-sec flow from a wide-open faucet fills a glass, then the same glass will be filled in 4 sec from a half-open faucet.

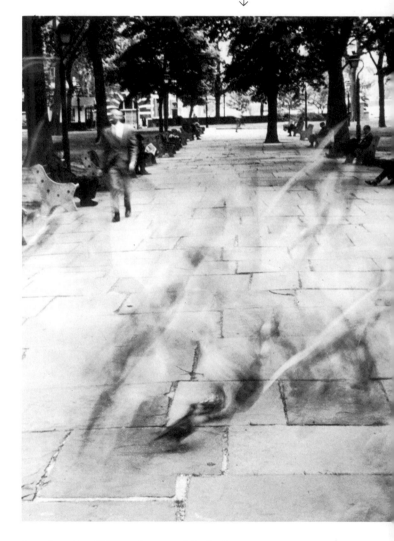

A small aperture (f/16) produces great depth of field; in this scene even distant trees are sharp. But to admit enough light, a slow shutter speed (1/5 sec) was needed; it was too slow to capture the pigeons in flight.

Although the aperture size and the shutter speed both control light, their effects in making photographs are basically different, as the preceding pages have shown. These different effects can be combined to produce various results.

The photographer can select any combination of shutter speed and aperture that delivers the proper amount of light, since each size smaller f-stop and each increase in shutter speed both cut the amount of usable light in half. Therefore, the two work together very simply: the same exposure is maintained by increasing the shutter speed while at the same time increasing the diameter of the aperture (or by decreasing the shutter speed and closing down the aperture). The same amount of light will be admitted by f/22 at one second, f/16 at ½ second, f/11 at ¼ second and so on.

What such combinations can produce may be seen in the three photographs at right. In each of them focus was kept constant while shutter and aperture settings were balanced to admit the same total amount of light into the camera, producing three correct exposures. But the three identical exposures resulted in three very different photographs. In the first picture, a small aperture produced a photograph with considerable depth of field that included background details in sharp focus; but the shutter speed needed to compensate for this tiny aperture had to be so slow that the rapidly moving flock of pigeons showed up on the film only as indistinct ghosts. In the center photograph, the aperture was enlarged and shutter speed increased; the background is less sharp but the pigeons are visible, though still blurred. At far right, a still larger aperture and faster shutter speed produced yet another kind of picture: almost all background detail has been sacrificed, but the birds are now very clear, with only a few wing tips still blurred.

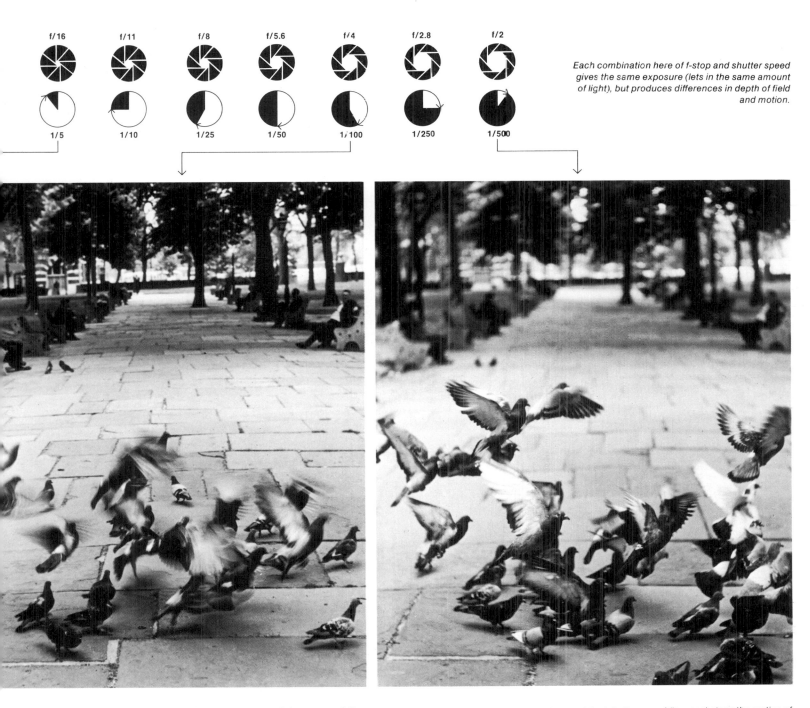

f/16	f/11	f/8	f/5.6	f/4	f/2.8	f/2

Each combination here of f-stop and shutter speed gives the same exposure (lets in the same amount of light), but produces differences in depth of field and motion.

1/5	1/10	1/25	1/50	1/100	1/250	1/500

A medium aperture (f/4) and shutter speed ($^1/_{100}$ sec) sacrifice some background detail to produce recognizable images of the birds. But the exposure is still too long to freeze the motion of the birds' wings.

A fast shutter speed ($^1/_{500}$ sec) stops the motion of the pigeons so completely that the flapping wings are frozen. But the wide aperture (f/2) needed gives so little depth of field that the background is now out of focus.

Keeping the Camera Steady

Even with the finest camera and lens, you won't be happy with the pictures you take if the camera is not kept steady enough during exposure. Too much camera motion during exposure will cause problems ranging from a slight lack of sharpness to hopeless blurring. But how much camera movement is too much? That depends partly on how much the image is enlarged, since any blur is more noticeable in a big enlargement. It also depends on the shutter speed and the focal length of the lens. The faster the shutter speed, the less you have to worry about camera movement. The longer the focal length of the lens, the more that movement becomes apparent because the longer the focal length, the more that objects—and camera movements—are magnified.

A general rule when hand holding a camera is to use a shutter speed at least as fast as the focal length of the lens: $\frac{1}{60}$ second with a 50mm lens, $\frac{1}{250}$ second with a 200mm lens and so on. When hand-holding, squeeze the shutter release gently and smoothly. If you can, brace your body in some way—put your back against a wall or your elbows on a table, fence or other object (see right).

Putting the camera on a tripod and using a cable release to trigger the shutter (opposite, far right) is the surest way to prevent camera movement. Be sure the tripod is sturdy enough for the camera; if you balance a large, heavy camera on a tippy, light-weight tripod, your camera can end up on the floor. Miniature tripods are sometimes useful; their very short legs can be steadied on a table, car fender or even against a wall. A monopod (single-leg support) or a hand grip gives extra stability if you have to keep moving, for example, along a football sideline.

holding an eye-level viewing camera

To hold an eye-level camera, cup the lens in your left hand, supporting the camera's weight yet leaving fingers free to adjust focus and f-stops. The right hand helps steady the camera while the right index finger works the shutter release. The strap wound around the wrist helps hold the camera and guard against dropping it.

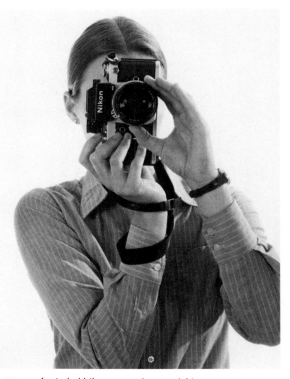

You may prefer to hold the camera in your right hand. Your right arm pressed against your ribs helps steady the camera.

holding a waist-level viewing camera

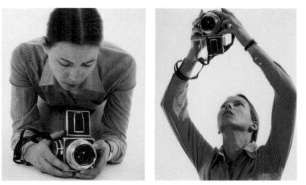

The bigger viewing screen of a large-format reflex camera lets you focus with your eye some distance from the screen. For a shot requiring a slow shutter speed, you can brace the camera against a steady surface (left). To shoot over a crowd (right) try holding the camera at arm's length, upside down.

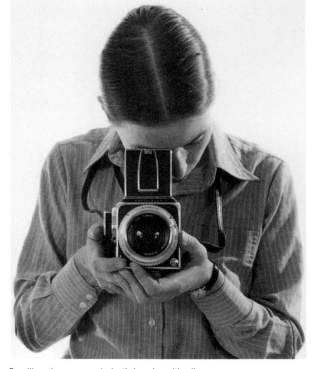

Cradling the camera in both hands, with elbows against sides, is a standard position for working with a large-format reflex camera. Your entire body helps steady the camera, which is held close to the eye for precise composition and focusing.

holding a camera with a long lens

With a long lens, such as this 300mm one, attached to your camera, try to find some extra support such as a wall or other steady object to lean against. Kneeling, you can brace your elbow on one knee.

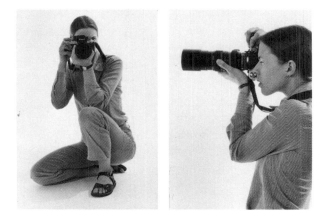

Place yourself in as stable a position as possible when kneeling without a back support (left). For a standing shot with a long lens (right) tuck your elbow firmly against your ribs to hold camera and lens steady. Particularly when using a long lens and slow shutter speed, be careful to squeeze the shutter release gently to avoid jerking the camera.

using a tripod

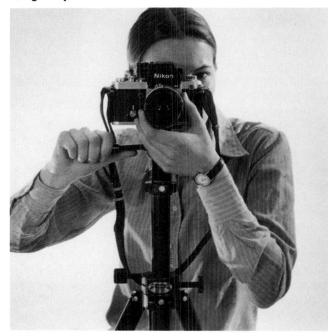

A tripod is the best way to prevent unwanted camera movement. Camera height is adjusted by raising or lowering the tripod legs or center shaft, camera angle by tilting or swiveling the tripod head. Some tripods have a center shaft that can be removed and reversed; the tripod head and camera then hang upside down and the camera can photograph from a low angle.

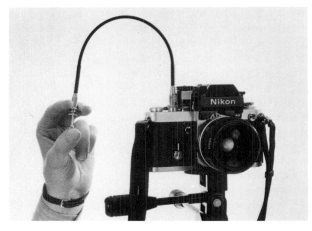

A cable release lets you trigger the shutter release without jarring the camera. Be sure to choose one that fits your camera. Some fit over, others screw into the shutter release button.

Buying a Camera

Choosing a camera will be easier if you first decide what you want it for—what kind of pictures you want to take—then think about which basic camera design best fits your needs.

If your picture taking consists of occasional snapshots of family, friends or sightseeing views, then an inexpensive, nonadjustable camera like the Kodak Instamatic will be satisfactory. The user simply aims it at the subject by looking through a viewfinder window and then pushes the shutter release to make the exposure; the focusing distance, aperture and shutter speed are all preset. But the very simplicity of this type of camera limits the things you can do with it, and as soon as you begin to be more than casually interested in photography your needs outstrip the camera's potential.

If you are a photography student, a serious amateur or just someone who would like to learn more about photography, you will want an adjustable camera. Unless you have a specialized need (for stereo photographs, for example) you will probably choose one of the five basic designs shown and described at right.

Once you have decided on a basic design, shop around to compare prices, accessories and service. Try handling various cameras; if you wear glasses, make sure you can see the entire image. You may be able to find a good used camera at a considerable saving. But look over used equipment carefully: avoid cameras with dents, scratched lenses, rattles or gouged screw heads that could indicate a home repair job. If a dealer is reputable, you will be able to exchange a camera, new or used, if your first roll of film is unsatisfactory. Examine that first roll carefully for scratches, soft focus or other signs of trouble.

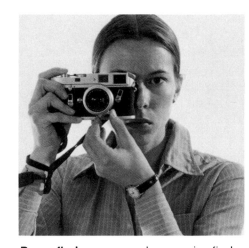

Rangefinder cameras have a viewfinder for sighting and a rangefinder for focusing the image. Interchangeable lenses are available (for more expensive models), although not so great a variety as for single-lens reflex cameras. Most use 35mm film; a few are designed for larger film sizes. The rangefinder has long been a favorite with photojournalists who value its eye-level viewing, quick focusing even at low light levels, light weight, small size, durability and quiet operation. It is an ideal camera for any fast-moving situation that requires the photographer to seize, as Henri Cartier-Bresson said, the ''decisive moment.'' Canon, Konica, Leica and Minolta are some of the available brands.

Disadvantages include some parallax error, which is unavoidable in viewfinder sighting, especially at close range. It is also impossible to evaluate depth of field visually through a viewfinder. This type of camera is not your best choice if you want to make extreme close-ups, align objects within the picture precisely, experiment with special filters or other optical effects or preview the image for other reasons.

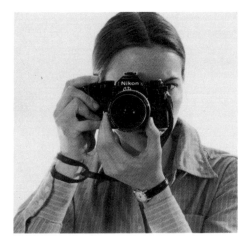

Single-lens reflex cameras offer the greatest variety of interchangeable lenses plus options such as through-the-lens metering. Since these cameras view directly through the lens you get an exact view of the scene, an advantage with close-ups, microphotography or other work where you want to see in advance exactly how the image will look. New designs are compact and increasingly automated, measuring the light, then automatically selecting shutter speed, aperture or both.

Most single-lens reflex cameras use 35mm film, although a few are designed for larger film sizes. The 35mm format produces a rather small negative, 1 x 1½ inches. It is quite possible to make large-size, high-quality enlargements from 35mm negatives, but they require careful exposure and processing. Many types of film, both black and white and color, are available in 35mm, and this format also has the advantage of being relatively inexpensive.

The single-lens reflex is the dominant design in the advanced amateur market; many brands are available, including Canon, Konica, Leica, Mamiya, Minolta, Nikon, Olympus, Pentax, Rollei, Yashica and Zeiss.

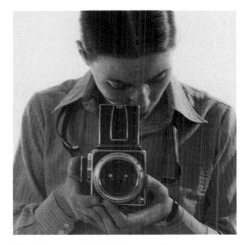 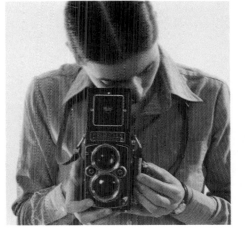

The larger single-lens reflex cameras using 2¼-inch film are popular with photographers who want a negative larger than 35mm plus the versatility of a single-lens reflex—fashion or advertising photographers, for example. Not only are lenses interchangeable but camera-backs are as well: you can expose part of a roll of black-and-white film, remove the camera-back and replace it with another loaded with color film. Size, weight and noise of operation are all greater than with a 35mm single-lens reflex and so is the price. Most cameras make a 2¼-inches square negative; a few models have a rectangular format such as 2¼ x 2¾ inches. Bronica, Hasselblad, Mamiya, Pentax and Rollei are some of the brands.

Twin-lens reflex cameras are more limited than single-lens reflexes. Most do not have interchangeable lenses (with the exception of the Mamiya), although supplementary lenses are available for close-up or long-range work. What you see on the ground-glass viewing screen is almost—but not exactly—what you get on the negative, since the viewing lens is separate from the taking lens.

What you do get is a relatively large negative (2¼ inches square) and durability, for a reasonable price. The twin-lens reflex camera is good for portraits, landscapes, better-quality snapshots and similar fairly conventional photographic situations. But don't expect it to be as fast as a rangefinder or as flexible as a single-lens reflex. Mamiya, Rollei and Yashica are some brands.

View cameras give the utmost in control over the image, even control over the apparent shape and perspective of objects *(see pages 215–233)*. The large-size negatives (4 x 5 inches and larger) make prints of maximum sharpness and minimum grain. Ordinarily, each picture is shot on a separate piece of film, but roll film and Polaroid film adapters are available. The view camera is unsurpassed for architectural work, product photography, studio work—anything where the photographer's first aim is large, carefully controlled, technically superior pictures. What you sacrifice are automatic features (there aren't any), size and weight (enough to make a tripod a necessity) and speed of operation (slow). Burke and James, Calumet, Deardorff, Omega, Sinar and Toyo are among the brands.

The press camera is the portable cousin of the view camera, designed to be hand held rather than mounted on a tripod. Once widely used by press photographers, it has been replaced in recent years by smaller formats.

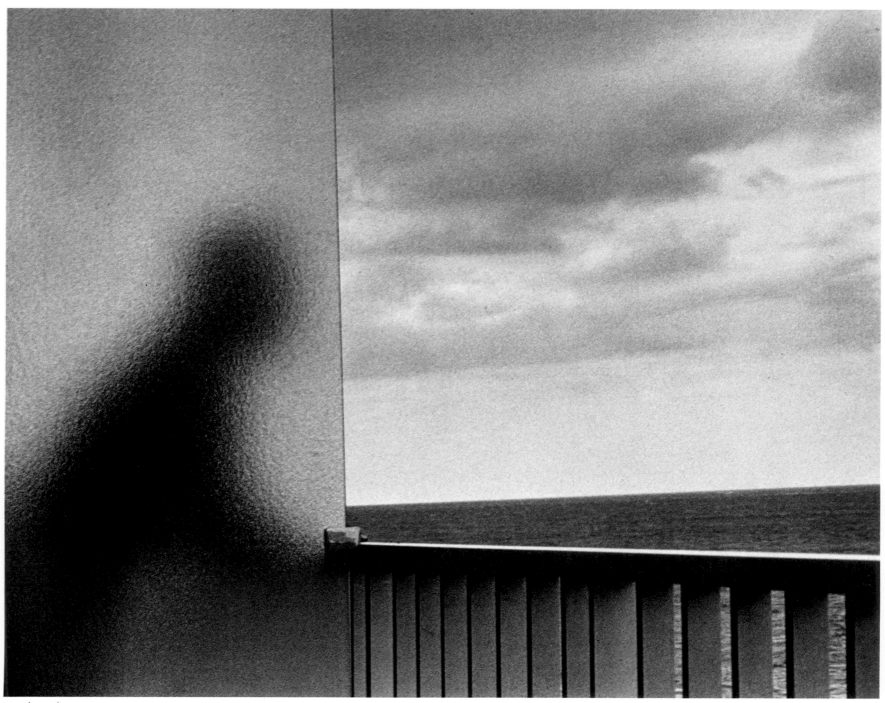

ANDRÉ KERTÉSZ: *On Martinique,* 1972

48

3 Lens

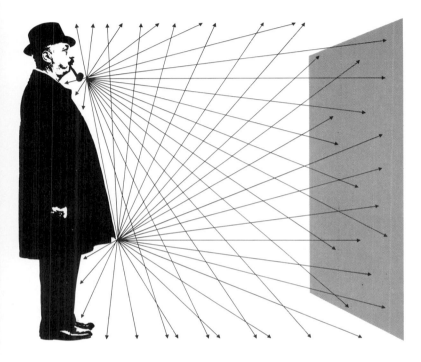

Uncontrolled light rays, shown reflected from two points—the subject's pipe and the bottom of his coat—travel in straight lines in almost all directions toward a sheet of film placed in front of the subject. Rays from the pipe strike the film all over its surface and so do rays from the coat; they never form an image of pipe or coat at any place on the film. The result is not a picture but totally exposed film.

◀ On the island of Martinique, an anonymous figure looks out over an anonymous ocean. Glass, sky, ocean and railing divide the scene in a geometry of angles and gray shapes that the eye takes pleasure in comparing and measuring. The print is relatively grainy, and the granularity of the glass echoes this quality. The scene is quite understandable—we have all seen figures or shapes behind translucent glass—but the picture invites other associations. Landscapes by the surrealist painter René Magritte come to mind, and one imagines that just out of sight a giant rock is floating across the sky.

Why Lenses Are Needed 50
 A Pinhole to Form an Image 50
 A Lens to Form an Image 52
Types of Lenses 54
 Lens Focal Length 54
 The Normal Lens 56
 The Long Lens 58
 The Short Lens 60
 Special-Purpose Lenses 62
Depth of Field 64
 When Is a Picture Sharp? 64
 How F-Stop and Focal Length Affect Depth of Field 66
 How Distance Affects Depth of Field 68
 Two Techniques to Control Depth of Field 70
Perspective 72
Getting the Most from a Lens 76
On Choosing Lenses 78

Before our eyes or our cameras can form images of objects, they must shape and control light. You can't simply place a square of sensitized film in front of a man and hope that an image of him will appear. The rays reflecting off the man would hit the film in a random jumble, resulting not in a picture but in a uniform exposure over the entire surface of the film. For simplicity's sake, the drawing at left shows only a few rays coming from only two points on the man, his pipe and his coat-tip, but their random distribution over the entire film makes it clear that they are not going to produce a useful image. The rays from the pipe, for example, will hit the film all over its surface, never creating in any one place an image of the pipe. What is needed is some sort of light-control device in front of the film that will select and aim the rays, putting the pipe rays where they belong and the ear and hat rays where *they* belong, resulting in a clear picture.

All lenses do the same basic job: they collect light rays coming from a scene in front of the camera and project them as images onto a piece of film at the back. This chapter explains how this happens and how you can use variations in lens size, lens aperture and subject distance to make the kinds of pictures you want.

Why Lenses Are Needed
A Pinhole to Form an Image

Although all the light rays reflected from an object cannot produce an image on a flat surface, a selection of rays can. Suppose there is a barrier with a small hole in it, like that in the drawing below. Now all but a few rays from each point are deflected by the barrier. Those few that do get through, traveling in straight lines from object to film, can make an image.

For example, the few rays from the man's pipe that get through the hole all fall on a certain spot near the bottom of the film. Only that one spot on the film registers an image of a pipe. Similarly, rays from the coat, the shoes, the ear, the hat brim—from every point on the man—travel to other precise points on the film. Together they form a complete image, but one which is inverted. Everything that was at the top of the man appears at the bottom of his image on the film and everything at the bottom appears at the top. Similarly, left becomes right and right becomes left.

The image-making ability of the pinhole has been known for about 2,500 years and has long been put to use in the camera obscura, a darkened room whose only light source is a small hole in one wall. On the opposite wall will appear an image of the scene outside, formed by the light rays coming through the hole.

The camera obscura is, in fact, a room-sized primitive camera. Shrink the room down to shoebox size, reduce the hole to $^1/_{50}$ inch (0.5 mm) in diameter, place a piece of film in the other end and it will make a recognizable picture; the

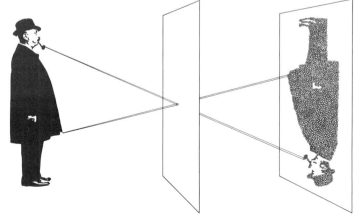

To take this picture of a fence and barn in California, photographer Ansel Adams replaced the lens of an ordinary camera with a thin metal disk pierced by a pinhole with a $^1/_{50}$ in diameter. The film was exposed for 6 sec. The way the pinhole produced an image is illustrated in the diagram at left. Only a few rays of light from each point on the subject can get through the tiny opening and these strike the film in such tight clusters that blurring is reduced to a minimum. The result is a soft but acceptably clear photograph.

For a second photograph of the same scene, Adams increased the size of the opening to $1/8$ in, which meant reducing the exposure time to $1/5$ sec. The result is an extremely out-of-focus picture. As shown in the diagram at right, the larger hole permits a greater number of rays from each point on the subject to enter the camera. These rays spread before reaching the film and are recorded as large circles. Because of their size, these circles tend to run into one another, creating an unclear image.

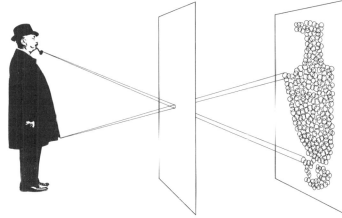

photograph opposite was made with such a camera. The trouble with this pinhole camera is its tiny opening, which admits so little light that very long exposures are needed to register an image on the film. If the hole is enlarged appreciably, the picture it makes becomes much less sharp, like the photograph on this page. Why this happens is explained in the two drawings.

Examine the image in the drawing on the opposite page. You will note that it is actually composed of a great many small areas represented by tiny circles. This is because the hole, small though it is, actually admits a cluster of light rays. Coming at slightly different angles, these rays continue through the hole in slightly different directions. They fan out, and when they hit the film they cover a small circular area on it. If the hole in the barrier is made larger (drawing below), a larger cluster of light rays from the pipe will get through to the film and cover a wider circle. The larger the circles are, the more they will overlap their neighbors and the more unclear the picture will be. These tiny circles, which make up all images, are known as circles of confusion.

In order to get sharp pictures, the circles of confusion should be as small as possible. But the only way to achieve that with a pinhole camera is to use a very small opening, which admits little light and requires long exposure times. To admit more light and to make a sharper picture, a different method of image formation is needed. That is what a lens can provide.

A Lens to Form an Image

Four centuries ago a Venetian nobleman named Daniele Barbaro tried an interesting experiment. He enlarged the opening of his room-sized camera obscura and fitted into it a convex lens taken from the spectacles of a far-sighted man. To his delight, the lens projected images much superior to those previously supplied by the simple pinhole opening.

Barbaro had found a new and better way to convert light rays into images in the camera obscura of his day. With the advent of photography, this discovery proved even more significant. For not only can a camera with a lens provide sharper images than a pinhole camera but it admits enough light to take a picture in a fraction of a second.

Most modern photographic lenses are based on the convex lens, the type used by Barbaro. Thicker in the middle than at the edges, the convex lens can collect a large number of light rays from a single point on an object and refract, or bend, them toward each other so that they converge at a single point *(diagram, right)*. This point of convergence, the focal point, falls on a surface called the focal plane. In a camera, a strip of film is stretched across the focal (or film) plane. The film records an image formed by light rays from an infinite number of points on the object, focused by the lens into an infinite number of tiny circles of confusion.

How does a lens redirect light to form an image? When light rays pass from one transparent medium, such as air, into a different transparent medium, such as water or glass, the rays may be bent, or refracted. Look at the shape of a spoon half submerged in a glass of water and you will see a common example of refraction: rays of light reflected by the spoon are bent by the water and glass so that part of the spoon appears displaced.

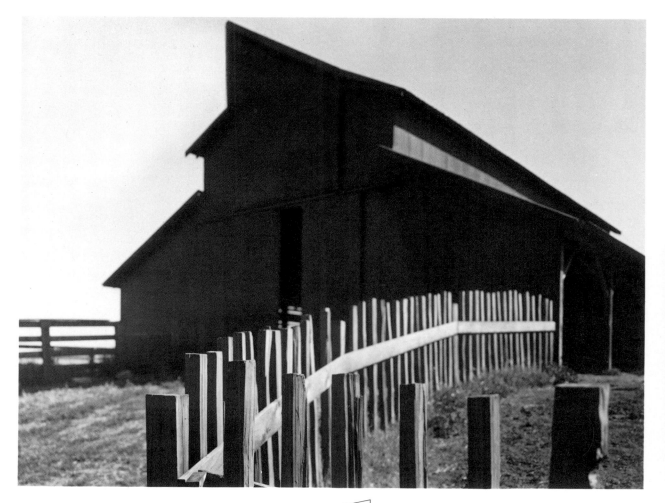

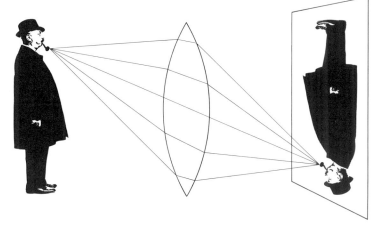

Photographed this time through a convex lens, Ansel Adams's barn scene is as good as—or better than—the one on page 50 taken with a pinhole camera. Its exposure time, instead of being 6 sec, was only $^1/_{100}$ sec. This is because the lens is much bigger than a pinhole and thus admits far more light. The diagram at left shows how the lens handles all this light by collecting many rays reflected from a single point and redirecting them to a corresponding single point on the film or focal plane.

For refraction to take place, light must strike the new medium at an angle. If it is perpendicular to the surface when it enters and leaves the medium (*below, 1*), the rays pass straight through. But if it enters or leaves at an oblique angle (*2*), the rays will be bent to a predictable degree. The farther from the perpendicular they strike, the more bent they will be.

When light strikes a transparent medium with a curved surface, for example a lens, the rays will be bent at a number of angles depending on the angle at which each ray enters and leaves the lens surface. They will be spread apart by concave surfaces (*3*), directed toward each other by convex surfaces (*4*). Rays coming from a single point on an object and passing through a convex lens (the simplest form of camera lens) will cross each other—and be focused—at the focal point.

How refraction works can be seen below in this diagram showing beams of light passing through 4 glass blocks. The beams, entering from the left, strike the first block head on and are therefore not refracted. But the next block has been placed at an angle, so that the rays are refracted, resuming their former direction on the other side. The concave surfaces of the third block spread the beams apart, but the last block—a convex lens like the basic light-gathering lenses used in cameras—draws the rays back together so that they cross each other at the focal point.

A modern compound lens, as this cutaway view shows, is usually a single convex lens sliced in two with some other lens elements placed in between to correct the aberrations or focusing defects that in any single lens affect the sharpness and sometimes the shape of the image. The front half of the convex lens (a) has a 2-piece element of special color-correcting glass (b) behind it. Farther back is another color-correcting element (c) and finally the back half of the convex lens (d). The use of optical glass manufactured with certain chemicals, such as fluoride, also improves lens performance.

Types of Lenses
Lens Focal Length

Since most cameras can be used with interchangeable lenses, a photographer often has to choose which lens to buy or use. The most important way lenses differ is in their focal length. Focal length is the distance between the lens (technically, from its rear nodal point) and the focal plane when the lens is focused on infinity (a far distance from which light reaches the lens in approximately parallel rays). A lens is often described in terms of its focal length (a 50mm lens, a 12-inch lens) or its relative focal length (short, normal or long).

Focal length controls magnification (the size of the image formed by the lens) and angle of view (the amount of the scene included in the image on a given size of film). The effect of focal length on magnification is shown at right. A lens of short focal length bends light sharply. The rays of light focus close behind the lens and form a small image of the object *(top diagram)*. The longer the focal length, the less sharply it refracts the light rays, the farther behind the lens the image is focused and the more the image is magnified *(bottom diagram)*. The size of the image increases in proportion to the focal length; if the subject remains at the same distance from the camera, the image formed by a 50mm lens will be twice as big as that from a 25mm lens.

Since a lens of long focal length forms a larger image of an object, it must include on a given size of film less of the scene in which the object appears. If you make a circle with your thumb and forefinger and hold it close to your eye you will see most of the scene in front of you. If you move your hand farther from your eye, the circle will be filled by a smaller part of the scene: you have decreased the angle of view seen through your fingers. In the same way, the longer the focal length, the smaller the angle of view seen by the lens.

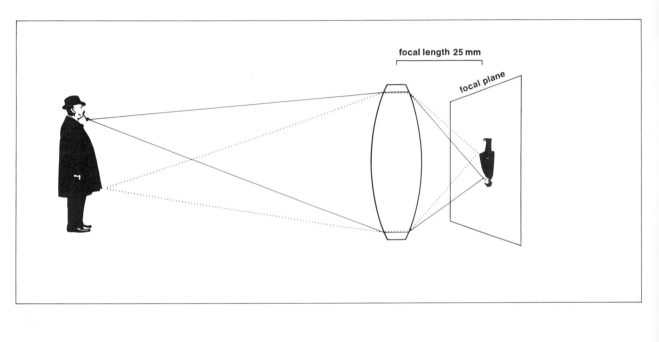

focal length 25 mm

focal plane

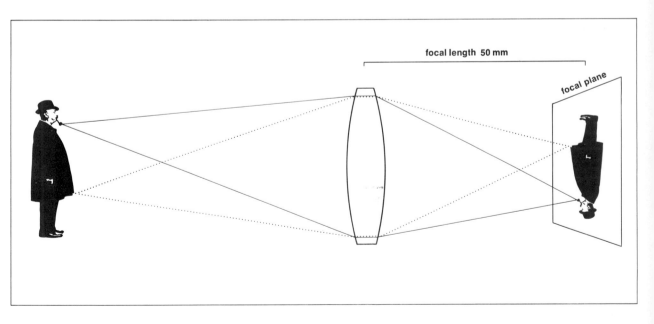

focal length 50 mm

focal plane

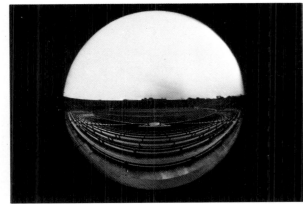

7.5mm fisheye

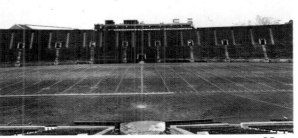

28mm

50mm

105mm

135mm

300mm

500mm

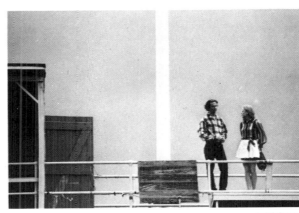

1000mm

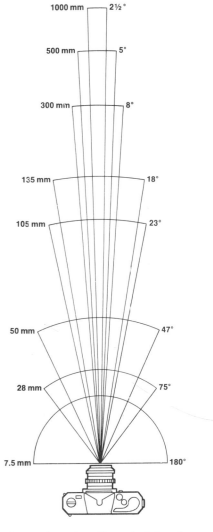

The diagram above shows the angle of view of some of the lenses that can be used with a 35mm camera. The examples at left show the effect of increasing focal length while keeping the same lens-to-subject distance: a decrease in the angle of view and an increase in magnification. Since the photographer has not changed position, the sizes of objects within the scene remain the same in relation to each other.

55

The Normal Lens

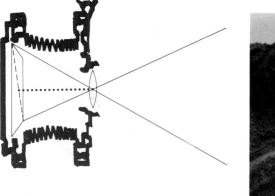

If the focal length of a lens (dotted line) is about the same as the diagonal measurement of the film (broken line), the lens is considered to be of normal (or standard) focal length for that film size. It collects light rays from an angle of view of about 50°—the same as the human eye—and projects them onto the film within the same angle. The photograph on this page was taken with a 4 x 5 view camera using a lens of 150mm; this is approximately the diagonal measurement of 4 x 5-in film but much longer than the diagonal of 35mm film (inner rectangle). A normal focal length lens for a 4 x 5 camera is 150mm. An 80mm lens is normal for a camera using 2¼ x 2¼-in film; a 50mm lens is normal for a 35mm camera.

Many photographers switch back and forth among lenses of different focal lengths in order to control depth of field or perspective or to change the size of the image without moving the camera. But one of the greatest of modern photographers almost never changed lenses. Henri Cartier-Bresson, who once described the camera as "an extension of my eye," usually did his work with a lens of normal (also called standard) focal length—one that approximates the impression human vision gives. In his picture opposite, the angle of view is about the same as what the eye can see clearly from one position, and the relative size and sharpness of near and far objects seem normal.

All these characteristics can be obtained with a lens of normal focal length.

But a focal length that makes a lens normal for one camera makes it long for another. What determines "normal" depends on the film size. The photograph above was taken with a 6-inch (150mm) lens, a normal focal length for a camera using 4 x 5-inch film. The angle of view is about 50°, which gives a view that is similar to the eye's perception of the scene. If the same lens was mounted on a 35mm camera, the smaller film size would show only part of the scene *(inner rectangle),* about a 15° angle of view—smaller than the eye's normal angle.

When the focal length of the lens approximately equals the diagonal measurement of the negative *(diagram above),* the lens is of normal focal length for that size film and will produce an image similar to the one your eye sees.

For example, a frame of 35mm film measures about 43 millimeters diagonally, so a 43mm lens is normal for that film (although lenses from 40mm to 55mm are also considered normal and most 35mm cameras are fitted with a 50mm lens as standard equipment).

Though a 50mm lens is called normal for a 35mm camera, that doesn't necessarily mean it is the one you will usually want to use on your camera. Some photographers use a shorter focal length because they want a wide angle of view most of the time; others prefer a longer focal length that narrows the angle of view to the central objects in a scene. A 50mm lens is a good focal length to start with, but the lens that turns out to be normal for you will be a matter of personal preference.

HENRI CARTIER-BRESSON: *Jerusalem*, 1967

This photograph of Hasidic Jews in Jerusalem shows how Henri Cartier-Bresson uses the normal lens to excellent advantage. All 4 figures are at different distances from the camera, yet all appear in proper size and perspective. There is no flattening or distortion, as there might have been had a lens of longer or shorter focal length been used, and almost all parts of the scene are sharp because the 50mm lens that Cartier-Bresson used on his 35mm camera provides good depth of field.

The Long Lens

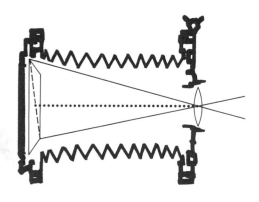

A lens is considered long for a camera if its focal length (dotted line) is appreciably greater than the picture diagonal (broken line). It then collects light over an angle that is narrower than that covered by human vision, producing an enlarged view of a restricted area. For a 35mm camera, a popular and useful long-focal-length lens is 105 mm; for a $2^1/_4$ x $2^1/_4$ reflex the comparable lens is 150 mm; and for a 4 x 5 view camera, about 300 mm.

A moderately long lens (such as an 85mm or 105mm lens on a 35mm camera) used at least 6 ft (1.8 m) from the subject (above left) makes a better portrait than a shorter lens used close to the subject (above right). Compare the sizes of nose, chin and hand in the 2 pictures. Photographing a person at too close a lens-to-subject distance makes those features nearest the camera appear too large and gives an unnatural-looking roundness to the head.

A long-focal-length lens can provide a greatly enlarged image of a distant object. Its angle of view is narrower and its magnification greater than that of a normal lens. Long lenses are excellent for situations where you cannot or do not want to get close to the subject, as in the picture opposite where the photographer seems to be in the middle of the action even though he is standing on the sidelines. They make it possible to photograph birds and animals from a distance. They are excellent for portraiture; most people get self-conscious when a camera is too close to them and their expressions become artificial. A long lens also avoids the kind of distortion that occurs when shorter lenses used close to the subject exaggerate the size of things nearest the camera—usually the nose *(see above)*.

There are also subtler qualities that can be exploited. Because a long lens has limited depth of field, objects in the foreground or background can be photographed out of focus so that the sharply focused subject stands out clearly and powerfully. Also, a long lens can be used to create an unusual perspective in which objects seem to be closer together than they really are.

Long lenses have some disadvantages, and the longer the lens the more noticeable these disadvantages become. Compared to a lens of normal focal length, they are somewhat heavier, bulkier and usually more expensive. Because of their shallow depth of field, they must be focused precisely. They can be relatively slow; a maximum aperture of f/4 is typical for a 200mm lens. And they are difficult to hand hold since

they magnify lens movements as well as the image. The shutter speed for a medium-long lens, such as a 105mm lens on a 35mm camera, should be at least $^1/_{100}$ second if the camera is hand held; otherwise camera movement may cause blurring. A tripod or some other support is even better.

Although photographers commonly call any long lens a telephoto, or tele, only some lenses are actually of telephoto design. A true telephoto lens uses either a concave lens element or a system of mirrors to enlarge the image. Telephoto construction does not require full focal-length distance from lens to film plane; thus it reduces the overall size of the lens. A tele weighs less and is faster (has a wider maximum aperture) than a lens of the same focal length but of ordinary design.

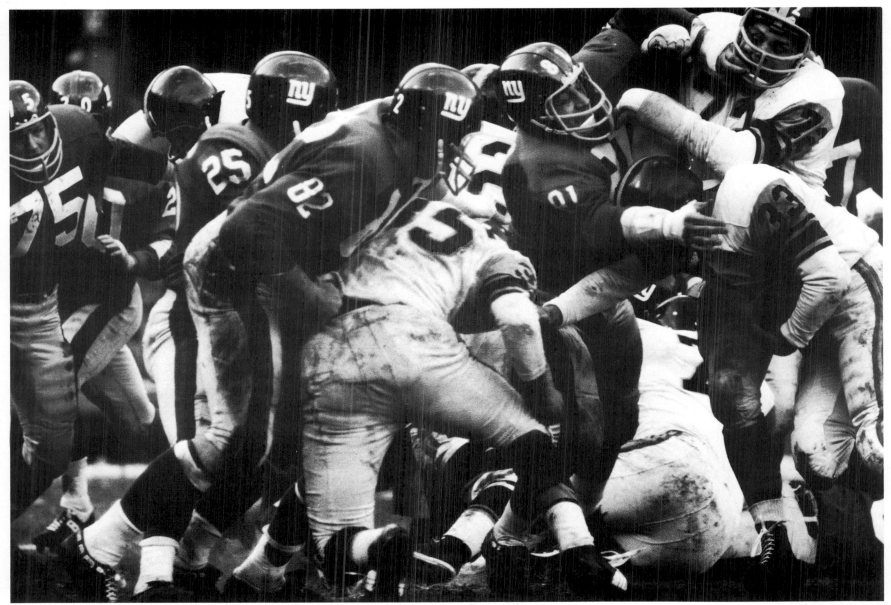

WALTER IOOSS, JR.: *Giants' Defense*, 1963

This photograph of the New York Giants' defense
line stopping Number 33 also shows 2 characteris-
tics of the long lens. Although the photographer was
standing on the sidelines, a 400mm lens on his
35mm camera includes only a 6° angle of view,
magnifying the image to fill the frame with action.
The long lens also seems to compress the space,
making the players appear to be in even more of a
crunch than they actually are.

The Short Lens

In the diagram above, the focal length of the lens (dotted line) is about ⅔ of the film diagonal (broken line). This makes it a wide-angle lens: it produces a viewing angle of 75°, or about 50 percent more than the eye could see clearly if focused on the same subject. The focal length of a commonly used wide-angle lens for a 35mm camera is 28 mm; for a 2¼ x 2¼ reflex it would be 55 mm, and for a 4 x 5 view camera, 90 mm.

The exaggerated size of the model's hand, her rapidly receding arm and her unnaturally under-sized body were all created by photographing an average-size model with the camera close to her outstretched fingertips. This kind of apparent distortion is a result of the short distance from lens to subject and is easy to achieve—intentionally or otherwise—with a wide-angle lens, which can be focused very close to a subject.

A wide-angle lens is useful for photographing in confined areas, whether a small room or the president's helicopter. There is some distortion of the arm closest to the camera, but it is partly shadowed and not as noticeable as the model's arm in the photograph at left. During President Ford's term in office, David Kennerly was his personal photographer and had access to him during many informal moments. This particular moment pairs a serious president with a well-known symbol of America, the Washington Monument. The pairing is almost too obvious; the photograph may have been unposed but somehow has an edge of contrivance to it. One imagines Kennerly saying, "Could we circle around the monument one more time, Mr. President?"

One value of a short-focal-length lens is that it includes more of a scene than a normal lens used at the same distance. This is of special importance if you are physically prevented (as by the walls of a room) from backing off as much as is necessary to take the picture with a normal lens. The short lens (commonly called a wide-angle or wide-field lens) increases the angle of view and thus reduces the size of the image compared to the image formed by a normal lens.

Wide-angle lenses also have considerable depth of field. A 24mm lens stopped down to even a medium-small aperture will show everything from 12 inches (30 cm) or so to infinity in sharp focus. News photographers or others who work in fast-moving situations at close quarters often use a moderately wide lens, such as a 35mm lens on a 35mm camera, as their normal lens. A moderately wide lens can be used quickly without refocusing for each shot. At the same time it does not display too much of a wide-angle lens's other main characteristic—distortion.

Pictures taken with a wide-angle lens can show both real and apparent distortions. Genuine aberrations of the lens itself such as curvilinear distortion are inherent in extremely curved or wide elements made of thick pieces of glass, which are frequently used in wide-angle lenses. While most aberrations can be corrected in a lens of moderate angular coverage and speed, the wider or faster the lens, the more difficult and/or expensive that correction becomes. Placing a lens of very short focal length in a single-lens reflex camera also presents difficulties, since the lens is so close to the film plane that it gets in the way of the mirror used for viewing. Retrofocus (reversed-telephoto) lenses solve this problem with a design that is the reverse of that of a telephoto lens; a concave element in the front of the lens enlarges the image, which is focused by a convex element in the rear. The result is a lens of very short focal length that can be used relatively far from the film plane and out of the way of the viewing mirror.

A wide-angle lens can also show an apparent distortion of perspective, but this is actually caused by the photographer, not the lens. An object that is close to a lens (or your eye) appears larger than an object of the same size that is farther away. Since a wide-angle lens can be focused very close to an object, it is easy to get this kind of exaggerated-size relationship *(photograph, above)*. The cure is to learn to see what the camera sees and either minimize the distortion, as in the photograph at right, or use it intentionally. More about how to control perspective and apparent distortion is on pages 72–75.

DAVID HUME KENNERLY: *President Gerald Ford Looking Down on the Washington Monument from His Helicopter, 1974*

61

Special-Purpose Lenses

HELEN BUTTFIELD: *Katydid*, 1968

A macro lens is useful for photographing very close to a subject without other accessories such as extension tubes (more about close-ups on pages 250–255). When you photograph close to a subject, as to this katydid, depth of field (the area that is sharp) is very shallow. Only part of the insect and a few of the stalks are sharp; the rest of the scene becomes increasingly out of focus. The bright oval in the background could be simply a round studio light positioned at an angle to the camera, but it is easy to imagine the insect, a kind of grasshopper, silhouetted against the sun or moon. The shape of the light is nicely repeated in the curve of light along the insect's back.

For the widest of wide-angle views, consider the fisheye lens *(opposite)*. It is not a lens for every situation, but it can produce startling and effective views. Its angle of view and depth of field are enormous—and so is its barrel distortion, which bends straight lines into curves at the edges of an image.

A zoom lens can be used at a variety of focal lengths. It works by having some of its optical elements movable in relation to one another; this changes the focal length and therefore the size of the image. To be able to frame the image precisely merely by zooming to another focal length rather than by moving physically or by changing lenses can be convenient, and particularly useful for making color slides, since cropping the image in the darkroom is not usually feasible. But it is necessary to weigh the convenience of a zoom lens against its disadvantages, among which are increased cost, size and weight and somewhat decreased image quality and speed. The greater the zooming range, the more these disadvantages increase. The best prices and sharpest images are found over a modest zooming range, from 43mm to 86mm, for example.

Where image sharpness is extremely important, as in professional copying, photoengraving or color separation work, process lenses provide the ultimate in image definition. A process lens is of relatively long focal length and small maximum aperture; it forms its image from those rays that enter near the lens center and so produces the fewest aberrations. It is apochromatic; that is, corrected to produce the absolute minimum amount of chromatic (color-related) aberration.

The opposite design is employed in a soft-focus or portrait lens. Aberrations may be deliberately introduced to produce an image that will soften details such as facial wrinkles.

A macro lens (occasionally called, somewhat inaccurately, a *micro* lens) is useful for extremely close shots such as that of the katydid above. It is usually a lens of normal focal length built into a lens barrel that can be extended extra far for focusing at very close range. It is corrected for the aberrations that occur at close focusing distances.

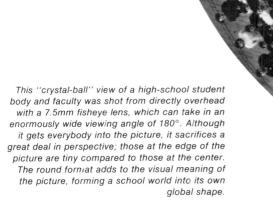

This "crystal-ball" view of a high-school student body and faculty was shot from directly overhead with a 7.5mm fisheye lens, which can take in an enormously wide viewing angle of 180°. Although it gets everybody into the picture, it sacrifices a great deal in perspective; those at the edge of the picture are tiny compared to those at the center. The round format adds to the visual meaning of the picture, forming a school world into its own global shape.

ROBERT PACKO: *Fisheye View*, 1968

Depth of Field
When is a Picture Sharp?

When part of a picture is sharp and part out of focus (or soft), a viewer looks first at the sharply focused area. In the picture opposite, your eyes are immediately drawn to the woman—the photographer has made her the obvious subject of the photograph. In another situation, however, a photographer might want to have the entire scene sharp (photograph, near right). What exactly is sharpness and how much can it be controlled?

How sharp an image appears depends on the size of the circles of confusion, the tiny, overlapping circles formed by the lens as it focuses the image. The circles are seldom actually seen as discs although occasionally, when bright points of light are photographed, individual circles do appear. The smaller the circles, the less they overlap and the sharper the image appears to be. At a viewing distance of about 10 inches (25 cm), the eye sees a circle $\frac{1}{100}$ inch (0.25 mm) in diameter or smaller as a point. An image composed entirely of such circles appears perfectly sharp.

In theory, a lens can focus the image of objects at only one distance at a time and objects at other distances will be more or less out of focus (see diagram). However, as in the photographs here, objects within a certain depth in the scene appear sharp. This "depth of field" includes the plane of critical focus—that part of the scene that is most sharply focused because its image is formed with the smallest circles of confusion. It also includes portions of the scene in front of and behind the plane of critical focus that also appear acceptably sharp because their circles of confusion are still acceptably small. There are no precise limits to the depth of field; the image gradually changes from sharp to soft as the circles of confusion get larger. Several factors control the extent of the depth of field—the f-stop used, the focal length of the lens and the lens-to-subject distance (see following pages).

Although a $\frac{1}{100}$-inch (0.25 mm) circle is acceptably small in a print, lenses are designed to form considerably smaller circles since enlarging the negative to make a print also enlarges the circles of confusion. In general, the more a print is enlarged, the less sharp it appears. But sharpness is also affected by viewing distance. A mural-size print placed high on a wall and viewed at a distance of 20 feet (6.1 m) can appear sharp even though the circles of confusion are much larger than $\frac{1}{100}$ inch (0.25 mm). In addition, the type of film used (pages 90–91), the type of enlarging equipment and printing paper (pages 148–151) and even the viewer's eyesight can all affect the apparent sharpness.

MARGARET BOURKE-WHITE: *American Woolen Co., New England,* 1935

When a lens is focused on a nearby object, the distance from lens to film is greater than when the lens is focused on an object that is farther away. Focusing on an object involves adjusting this lens-to-film distance so that the point where the light rays cross—the focal point (a)—falls on the film plane. At the focal point, the lens forms the smallest circles of confusion and so the sharpest image. The focal points of objects nearer or farther away than the object in focus will not fall on the film plane. Consequently, their circles of confusion will be larger and their images not so sharp.

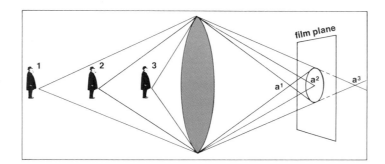

The depth of field—the area in a scene in which objects appear sharp—can be deep or shallow. In the photograph above, everything is sharp from the nearest woman to the farthest spindle. In the photograph opposite, the depth of field includes only a few soldiers, the princess and the officers, while other parts of the scene are increasingly out of focus the farther they are from the plane of critical focus.

MARK KAUFFMAN: *Princess Margaret Inspecting King's African Rifles, Mauritius*, 1956

How F-Stop and Focal Length Affect Depth of Field

One way of controlling depth of field is by adjusting the f-stop (aperture opening) of the lens. As shown on pages 40–43, the smaller the aperture, the greater the depth of field. This is because the smaller aperture produces smaller circles of confusion; so small, in fact, that even areas that are not critically focused appear sharp.

Another way of controlling depth of field is by changing the focal length of the lens. The shorter the focal length, the greater the depth of field (at the same f-stop and lens-to-subject distance). Like the smaller aperture, the short-focal-length lens produces smaller circles of confusion and so more of the image appears sharp. The two photographs opposite illustrate this. The camera was in the same position for both photographs and was focused on the floral wreath (a) in the diagram. The f-stops were the same. However, in the top photograph, taken with a 28mm lens, much of the scene is sharp, all the way from point (b) to point (c). In the bottom photograph, taken with a 135mm lens, the in-focus area is limited to the grass near the gravestone (from point (d) to point (e)).

In both diagrams opposite, the white circle at the center of the film represents what the eye will tolerate as an acceptably small circle of confusion, that is, as acceptably sharp. In the top diagram, the rays landing on this circle include much of the scene—all the way from point (b) to point (c). Not until the lens forms an image of objects past those two points does the image look out of focus. In the bottom diagram, these rays come from a much smaller area—only from point (d) to point (e). Everything else will be out of focus, just as in the photograph.

Why does the long-focal-length lens produce larger circles of confusion and therefore less depth of field? The answer is related to f-stops. A long lens magnifies the image of an object more than the short-focal-length lens because it spreads the light from that object over a larger area. Therefore the long-focal-length lens will form a dimmer image unless a greater amount of light is admitted by the lens. The f-stop scale adjusts the size of the aperture opening so that at a given f-stop the same amount of light reaches the film no matter what the focal length of the lens. The same f-stop setting is a larger actual opening on a lens of a longer focal length. F/2 on a 100mm lens, for example, is an aperture of larger diameter than f/2 on a 50mm lens.

The relationship is a simple mathematical one: the f-stop number equals the focal length of the lens divided by the aperture diameter.

$$\text{f-stop} = \frac{\text{lens focal length}}{\text{aperture diameter}}$$

If the focal length of the lens is 100mm and the actual diameter of the aperture is 50mm, the f-stop number is 2.

$$\text{f}/2 = \frac{100}{50}$$

For a 50mm lens, the aperture diameter is smaller—only 25mm at f/2.

$$\text{f}/2 = \frac{50}{25}$$

Since at the same f-stop setting the aperture diameter of the longer lens is larger than that of the shorter lens, the circles of confusion for the longer lens will also be larger and the image will have less depth of field.

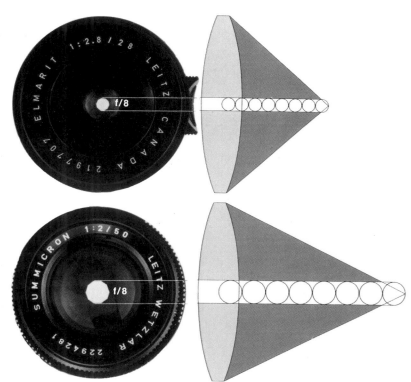

These 2 lenses show that the same f-stop requires a larger aperture diameter for a longer focal length. At top is a lens of 28mm focal length; below it is a 50mm lens. Both are set at f/8. This means that the aperture in each lens must be of such a size that its diameter will go into its focal length 8 times. The diagrams, by actually lining up 8 aperture-sized circles and fitting them into the focal length of each lens, show the larger aperture diameter for the longer focal length. This is true for any setting. The larger aperture is needed because the longer lens spreads its image over a larger area—it must collect more light rays to keep its image as bright as the image from a shorter lens set to the same f-stop.

depth of field (b) to (c) with short-focal-length lens

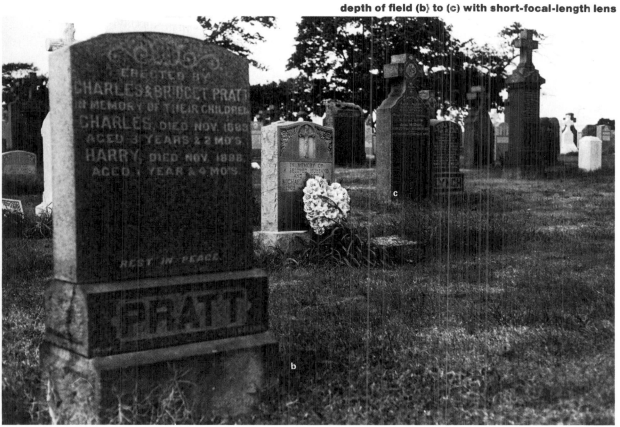

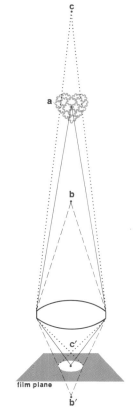

depth of field (d) to (e) with long-focal-length lens

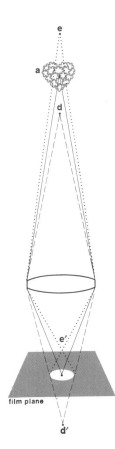

How Distance Affects Depth of Field

Depth of field is influenced not only by focal length and aperture but also by the distance from lens to subject. That part of the scene on which the lens is focused has a marked effect on how sharp the rest of the picture will be.

In general, the closer you are to the object on which you are focusing, the more out of focus everything else will be, or, put another way, the less your depth of field will be. These two pictures of a sundeck railing show this clearly. They were taken with the same lens, the same shutter speed and the same f-stop. The only difference between the two is that in the one on this page the photographer placed the camera about three feet (.9 m) from the nearest post and focused on it. The resulting depth of field is so limited that even the far side of the post is somewhat out of focus, and the rest of the picture is completely so. In the second picture, the camera was moved to 12 feet (3.7 m), but the lens was still focused on the post. The result is a considerable extension of the depth of field.

Suppose you had to achieve greater depth and yet could not move farther from the subject. One solution is to change to a shorter-focal-length lens, which even when used close up gives extended depth of field. (The magnification and angle of view of the scene would change as well as the depth of field. See pages 54–55.)

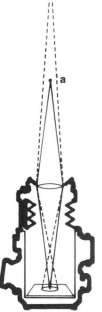

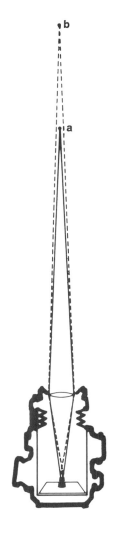

The 2 diagrams, center, explain why so much of the far photograph is out of focus, while most of the near one is not. With the camera close to object (a) (left-hand diagram) and focused so that (a) projects a sharp image on the film plane, then an object 3 times as far away—at (b)—will be out of focus because its light rays will converge considerably in front of the film plane, as the crossed broken lines show. The resulting circle of confusion on the film will be large and (b) will be out of focus. But if the camera is moved back a considerable distance, (b) is not much more distant from the lens than (a); rays entering the lens from both points form circles that are more nearly equal. As a result, focusing the camera to produce a sharp image for (a) produces only a small circle of confusion for (b)—not big enough for the human eye to detect and hence producing no noticeable softness.

Two Techniques to Control Depth of Field

ELLIOTT ERWITT: *Sunday in Hungary,* 1964

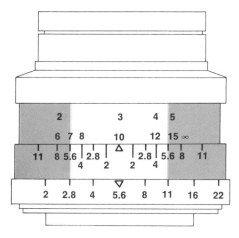

Zone focusing is a way of using a lens's depth-of-field scale to photograph a scene without focusing before every exposure. Suppose the nearest point you want sharp is 7 ft (2.1 m) away and the farthest is 15 ft (4.6 m). By setting those distances opposite a pair of bracketing marks on the depth-of-field scale, you will know what f-stop to use so that objects between those two distances are in focus. With this lens the aperture must be f/5.6 or smaller. The lens is now set so that no further focusing need be done provided the action stays between the two preset distances.

Zone focusing lets you focus and adjust the depth of field in advance of shooting. This is useful when you may need to shoot rapidly and can predict approximately where, although not exactly when, action will take place; an auto race would be one example. It is also useful if you want to be relatively inconspicuous so you don't distract your subjects, for example when photographing strangers on the street. To zone focus, use the depth-of-field scale on your lens *(shown on pages 40–41)* to set in advance the limits of the depth of field; anything photographed within those limits would then be sharp. The precise distance at which something happened would not be important since the general area would be acceptably in focus.

Focusing on the hyperfocal distance will help you get maximum depth of field

in a scene where you want everything to be in focus from the near foreground to a far-distant background. When the lens is focused on a certain distance called infinity in photographic terms (marked ∞ on the lens distance scale) everything at that distance from the lens or farther will be sharp. But for maximum depth of field, don't focus on infinity. Instead focus on a point closer to the lens, so that infinity falls just within the farthest limits of the depth of field.

This point, the hyperfocal distance, is the distance to the nearest plane that will be sharp when the camera is focused on infinity. If you focus on the hyperfocal distance, everything from half the hyperfocal distance to the farthest visible object will be sharp—a considerable increase in depth of field, as the pictures and diagram opposite show.

You can find the hyperfocal distance by using the depth-of-field scale on the lens. First set the lens to infinity, then find the nearest distance within the depth of field (the nearest distance that will be sharp) for the f-stop you are using. Focus on this distance for maximum depth of field. Another method is simply to adjust the distance scale so the infinity mark is opposite your f-stop on the depth-of-field scale.

For objects relatively far from the lens, the depth-of-field divides so that about two-thirds is behind the point focused on while one-third is in front. As you focus closer to the lens, the depth of field becomes more evenly divided so that at a very close distance (twice the lens focal length) the depth of field is half in front and half behind the point focused on.

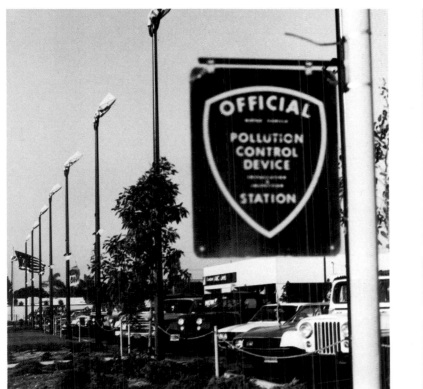

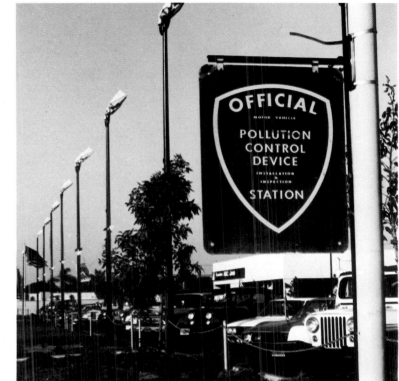

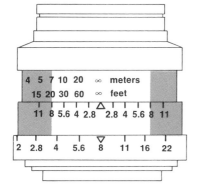

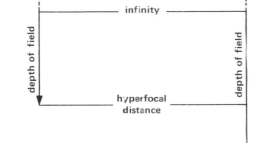

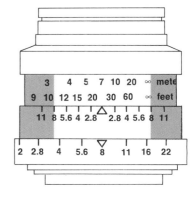

In this picture, the lens was focused on infinity (in photographic terms, a point in the far distance marked ∞ on the lens distance scale). Although everything in the far distance is sharp, the nearest distance in focus is not close enough to include the foreground, which the photographer also wanted to be sharp. When the camera is focused on infinity, the nearest distance that will be sharp (the nearest plane of the depth of field) is called the hyperfocal distance.

Here the depth of field has been increased by focusing on the hyperfocal distance (done simply by adjusting the depth-of-field scale so the infinity mark was opposite the f-stop number being used). The depth of field now begins closer to the camera (the foreground is acceptably sharp) and continues to the far distance. When the lens is set at the hyperfocal distance, everything from half that distance to the farthest visible object will be sharp.

Perspective

It is vital for a photographer to learn to see what the camera sees, since the camera image can appear surprisingly different from reality. A long-focal-length lens used far from the subject gives a so-called telephoto effect—on page 65, for example, the line of soldiers seems compressed, with the soldiers in impossibly close formation. A short-focal-length lens used close to the subject produces what is known as wide-angle distortion—on page 60 it apparently stretches a human form to unnatural proportions.

Those photographs seem to show distortions in perspective—in the relative size and depth of objects within the image. Actually, perspective is controlled solely by the lens-to-subject distance; a lens of any focal length used very close to the model on page 60 would give the same effect.

The photographs at right show how perspective changes when lens-to-subject distance is changed. The photographs in the top row were taken from the same distance but with different focal-length lenses. The shortest lens produced the widest view of the room and the smallest image of the woman; the longest lens gave the narrowest view, an enlargement of part of the original picture. The perspective remains the same: the woman's head is bigger but so is everything else—pillows, ivy, the building across the street.

Now look at the lower row. These were all taken with the same lens placed progressively closer to the woman. With decreasing lens-to-subject distance, the size of the woman increases relative to the size of the objects behind her. Since the brain judges depth in a photographed scene mostly by comparing the size of objects, the depth seems to increase as the camera moves closer. Compare the illusion of depth in the pictures far right, top and bottom.

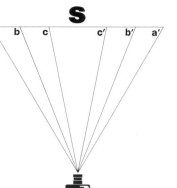

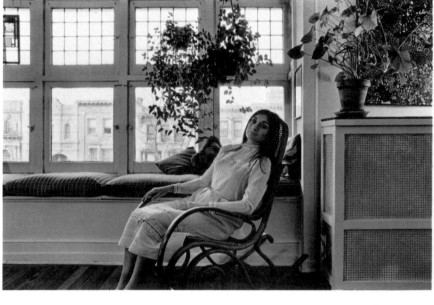

Three views of a woman, each shot from 15 ft (4.6 m), show how lenses of different focal lengths change image size but not perspective. Angles of view are reduced as larger images of the subject, (S) in the diagram, fill the film. The first picture was taken with a short-focal-length lens (angle aa'), the next with a normal lens (angle bb') and the third with a long lens (angle cc').

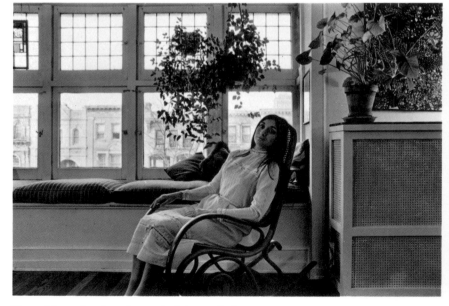

These pictures show how changes in distance affect image size and perspective as well. A decreasing lens-to-subject distance enlarged foreground images more than background ones to give 3 different perspectives.

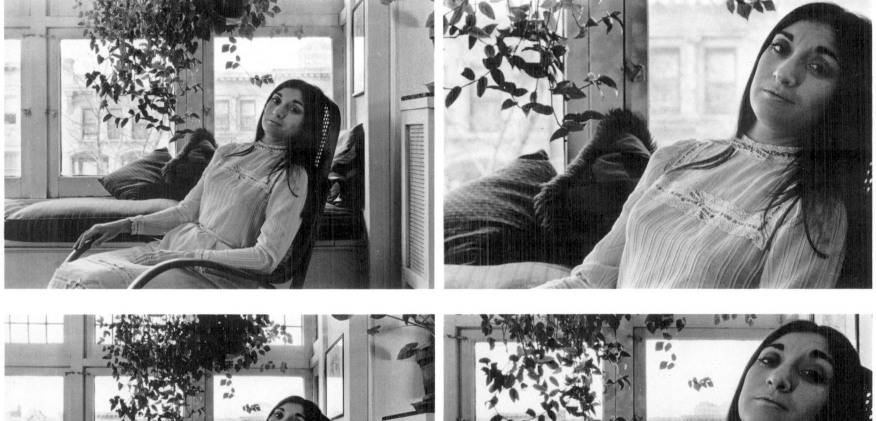
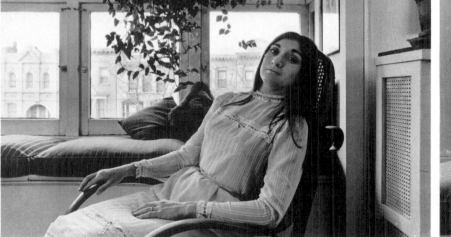
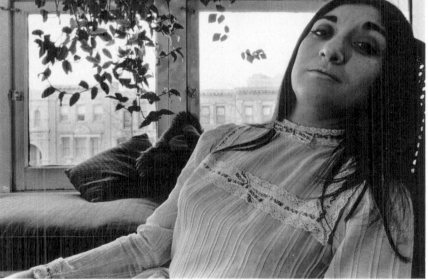

a

b

Changes in focal length have little effect on perspective as long as you do not move your camera. But if you move the camera *and* change focal length, perspective alters dramatically, as the sizes and distances of objects seem to change in relation to each other.

The picture above was taken with a normal-focal-length lens. If you were standing by the camera, your view of the scene would be about the same as that of the lens. The pictures center and opposite show how the perspective is altered, first with a short-focal-length lens used close in, then with a long lens used farther back. In each case the camera was positioned so that the same pole was shown at the edge of the image and at the same size. The short lens was used close to the pole; distant things

seem smaller and farther away. The long lens was used far from the pole and the other objects; the poles and the house appear to be about the same size, jammed into a shallow space.

Imagine the house and pole to be about the same height, with the pole standing 100 feet (30.5 m) in front of the house. If the camera is placed 10 feet (3.3 m) from the pole, the house will be 110 feet (33.5 m) from the camera—11 times as far as the pole. The image size of an object is inversely proportional to its distance from the camera (the farther from the camera, the smaller it will appear). So the house will appear much smaller than the pole even though both are the same actual height.

If the camera is placed 500 feet (152 m) from the pole, the house will be 600

feet (183 m) away. The house and pole are still 100 feet (30.5 m) apart but their positions in relation to the lens have changed. The house will be only one and one-fifth times as far from the camera as the pole, and they will appear to be nearly the same size.

To increase the difference in size between objects and so increase the apparent depth, use a lens of short focal length close to the subject—this is exactly what is done in advertising to make the interior of an automobile seem expansive and roomy. To decrease apparent differences in size and so decrease apparent depth, use a lens of long focal length far from the subject. The photograph at right could be used by the local homeowners' association to argue that the power poles are a visual blight.

Compared to the normal perspective in the picture at left, the house looks small and distant in the picture above, taken by a short-focal-length lens, and large and close in the long-focal-length picture to the right. As the diagram shows, a lens of short focal length covering a wide angle (ab) can photograph very close to the pole and still include its full height, while the house, which is several times farther away, appears very small. The long lens does the opposite. In order to include the pole within its narrow angle (cd), it must be used far from the pole. Now the house is not much farther from the lens than the pole is, so both appear nearly the same size in the picture. These changes in relative sizes seem like differences in distance to a person looking at the pictures.

a

c

d

b

10′

100′

500′

Getting the Most from a Lens

The inside of a modern compound lens is a complex structure of glass and metal designed to give precise focusing of a sharp image (see page 53). To get the best possible performance from your lens, there are a few things you can do to help it.

Even a well-designed lens may have some aberrations that were impossible to overcome in manufacture. This is especially so if it is a zoom, extremely wide-angle or telephoto lens, or if it has a very wide maximum aperture or is used very close to the subject. Stopping down the lens aperture often improves the image by eliminating rays from the edges of the lens where certain aberrations occur.

But there is a limit to the improvement that comes with stopping down. As light rays pass across a sharp, opaque edge—for example, the edge of the dia-

phragm opening—the rays bend slightly. As the lens is stopped down and the aperture becomes smaller, this edge bending or diffraction can cause a point of light to appear as a blurred circle and the whole image to appear somewhat less sharp. The optimum aperture at which most lenses perform best is two or three f-stops stopped down from the widest aperture. This will be enough to minimize aberrations but not enough to cause noticeable diffraction. Of course, in a particular situation you may prefer the increased depth of field that results if the lens is stopped down all the way.

Flare—the reflection and scattering of light within the lens and camera—is sometimes deliberately used for a special effect, but ordinarily you will want to avoid it. Ghosting (above left) occurs when you include a strong light source, such as the sun or a bright bulb, in the

picture. Ghosting is difficult to cure since its cause is within the picture itself. Sometimes you can change your position so that some object comes between the lens and the light source.

Even when the light source is not actually in the picture, light rays hitting the front surface of the lens at an angle can scatter within the lens and cause an overall fogging of the image (above right). The best way to prevent this kind of flare is to use the proper lens shade or hood. This will block any light outside the lens's angle of view that might be shining at an angle on the lens surface. Be sure the lens shade is wide enough for the lens you are using. The shorter the focal length of the lens, the wider the angle the lens sees and the more the shade must flare outward to avoid becoming part of the scene itself and vignetting or blocking the light from the

Stray light bouncing around inside the lens caused the 2 effects seen opposite. At far left, the photographer included the bright sun directly in the image. Light reflecting from the various lens elements caused multiple images in the shape of the lens diaphragm, as well as star points (streamers of light around the sun itself). Although it was not actually in the next picture, the sun caused flare in the image by shining at an angle on the front glass surface of the lens. To prevent this type of flare use a lens hood, but get the correct size hood for your lens. The vignetted photograph at right shows what happens if the lens hood is too small.

edges of the image *(above)*. Check for vignetting if you are using a wide-angle lens with both a filter and a lens shade. The filter sometimes moves the lens shade just far enough forward to be seen.

Since some reflection and scattering of light take place at every glass-to-air surface of the lens including those within the lens, manufacturers coat lens surfaces with a very thin layer of a metallic fluoride. This coating helps reduce reflections and subsequent flare.

It is important to keep lenses clean. Dust, grease, drops of moisture—all scatter the light that passes through a lens and soften the sharpness and contrast of the image. A lens surface is deli-

cate and easily marred; too frequent or too energetic cleaning can produce a maze of fine scratches or rub away part of the lens coating. Keep your lens surfaces in good condition by not getting them dirty in the first place. Keep a cap over the lens when the camera is not in use, and put the lens in a protective container if you take it off the camera.

When you must clean the lens, do so gently. Blow or gently brush any dust particles from the lens surface. To clean grease or water spots from the lens, wad a clean piece of lens tissue into a loose ball and moisten it with a drop or two of lens cleaner solution. (Don't put drops of solution directly on the lens. They can seep along the edges of the lens to the

inside.) Wipe the lens gently in a circular direction. Dry the lens by wiping gently with another clean piece of wadded lens tissue. Don't use any products designed for cleaning eyeglasses.

While you are cleaning the lens or changing film, also check inside the camera for dust that can settle on the film and cause specks on the final image. Blow or gently dust along the film path, particularly around the winding mechanisms, but be careful not to damage the shutter curtain in the body of the camera or the film pressure plate on the camera back. The shutter curtain is particularly delicate, and it is best not to touch it at all unless absolutely necessary.

On Choosing Lenses

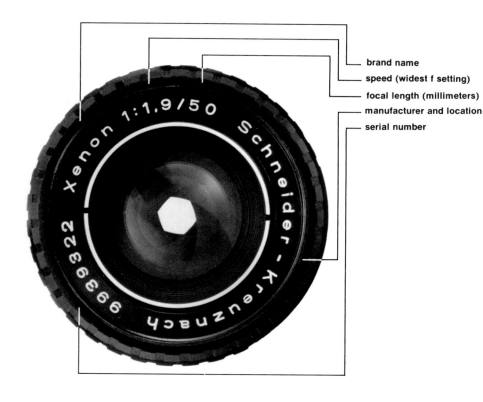

- brand name
- speed (widest f setting)
- focal length (millimeters)
- manufacturer and location
- serial number

- distance scale (feet)
- distance scale (meters)
- depth of field scale (f-stops)
- aperture setting (f-stops)

Considerable information about a lens is marked on it, as these front and side views of a lens show. On its front (top photograph) are its brand (Xenon), its speed (maximum aperture of f/1.9), its size, or focal length (50mm), its maker's name and location (Schneider, Kreuznach, Germany) and its serial number (9939322). Distance and aperture scales are marked on the side of the lens.

Since buying a lens involves a considerable investment of money, it pays to invest a little time in deciding exactly what type of lens to buy.

Lenses come in different focal lengths—normal, long, short—for different purposes. The most generally useful is the normal lens, which produces images that seem normal and lifelike in size and perspective. The short, or wide-angle, lens gives a wider view and smaller images than the eye sees. The long lens magnifies distant objects so that you can get a large image without having to be close to the object.

Lenses made by reputable manufacturers can be assumed to be reasonably good. And yet two lenses of the same focal length, perhaps even made by the same company, may vary widely in price. This price difference probably reflects a difference in the "speed" of the lens; one will be "faster"—it will have a wider maximum aperture and admit more light than the other will, permitting pictures to be taken in dimly lit rooms or

at faster shutter speeds. The faster and more expensive lens can be used over a wider range of lighting conditions than the slower one, but otherwise will perform no better. It may, in fact, perform less well at its widest aperture because of increased optical aberrations.

The kinds of pictures you want to take will ultimately determine the kinds of lenses you will want to own. A lens used for taking pictures of wild fowl in swamps at dusk must be fast in order to provide enough light to make the pictures. It will also have to be long, for ducks are shy and unless magnified by the lens will appear too small in the photograph to be clearly seen. Decide what your requirements are before you buy.

Some guidelines for buying camera lenses follow:

1) If you are getting a camera with interchangeable lenses, start with a normal lens. (This is the one that ordinarily comes with the camera, anyway.) Familiarize yourself thoroughly with it. Don't buy more lenses until you feel a strong need to take the different kinds of pictures that other focal lengths can provide.

2) Get your lenses one at a time and think ahead to what you may someday need in the way of an assortment. It is useful to begin by buying lenses in increments of two times the focal length; for example, a good combination for a 35mm camera is a 50mm normal lens for general use, a 28mm wide-angle lens for close-in work with groups of people or sometimes for photographing scenery, and a 105mm long lens for making portraits and for magnifying more distant subjects. Be wary of the ultra-wide-angle (below 25mm) and the extra long (above 200mm) lenses. They may be considerably more expensive than the less extreme types and are so specialized that their usefulness is limited. The adjustable-length zoom lenses, although becoming increasingly popular, are also expensive and tend not to produce as sharp an image as conventional lenses. Cameras using film larger than 35mm require proportionately longer lenses (see chart below).

3) Don't spend money on extra-fast lenses unless you have unusual requirements. A couple of extra f-stops may cost you an extra couple of hundred dollars. With modern high-speed film, a lens that can open to f/2.8 is adequate in all but the dimmest light.

4) Consider a second-hand lens. Many reputable dealers take used lenses in trade and they may be bargains. But look for signs of hard use, such as a dented barrel, scratched lens surface or a slight rattling that may indicate loose parts, and be sure to check the diaphragm to see that it opens smoothly to each f-stop over the entire range of settings.

5) Test your lens. The only sure way is to take pictures with it in your own camera at various f-stops, so insist on a trial period or a return guarantee. If you plan to buy several lenses eventually, a good investment is a standardized test chart that can give an accurate reading of a lens's sharpness.

The chart gives some typical focal lengths for cameras using various sizes of film. Focal lengths are sometimes stated in inches, sometimes in millimeters. There are approximately 25mm to an inch.

	film size used by camera			
	35mm	2¼ × 2¼ in	2¼ × 2¾ in	4 × 5 in
short focal length	35mm or shorter	55mm or shorter	75mm or shorter	90mm or shorter
normal focal length	50mm	75mm, 80mm	100mm	150mm (6 in)
long focal length	85mm or longer	120mm or longer	150mm or longer	250mm (10 in) or longer

CHARLES HARBUTT: *Blind Boy, New York City*, c.1960

The spectrum contains heat as well as light, and you can feel the sun even if you can't see it. Charles Harbutt's photograph is an interesting picture even without the title. But the words add a poignant meaning that greatly strengthens the photograph; without the words there is no clue that the child can't see.

This picture is one of a series Harbutt made of children at The Lighthouse in New York City, an institution for the blind. Harbutt had noticed that every day the boy used his hands to feel for the warmth created by the rays of sunlight that threaded the narrow space between two buildings each afternoon at about the same time.

4 Light and Film

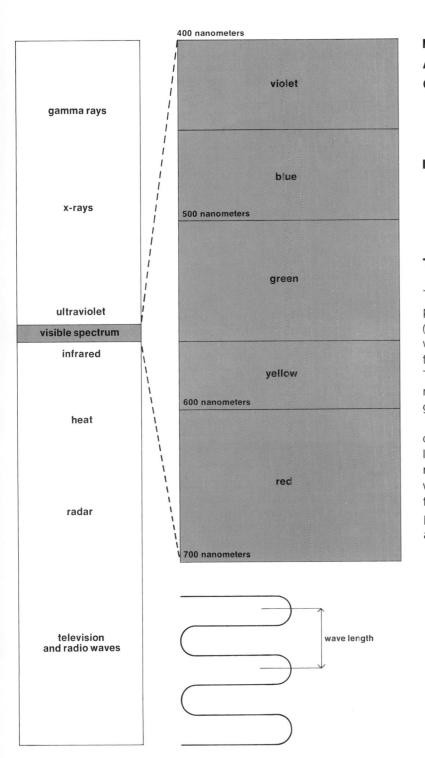

gamma rays

x-rays

ultraviolet

visible spectrum

infrared

heat

radar

television
and radio waves

400 nanometers

violet

blue

500 nanometers

green

yellow

600 nanometers

red

700 nanometers

wave length

Making an Image in Silver 82

A Characteristic Response to Light 84

Choosing a Film 86

 The Problem of Graininess 88

 For Maximum Detail, Slow and Medium-Speed Films 90

 When Speed Is Essential 92

How Black-and-White Film Sees Color 94

 Infrared Film: Seeing Beyond the Visible 96

 Changing Tones with Filters 98

 A Polarizing Filter to Reduce Reflections 100

 Filters and Their Factors 101

The Polaroid Land Process 102

The light that we see and that we use to form an image on film is only a small part of a tremendous range of energy called the electromagnetic spectrum *(diagram, left),* which also includes X-rays, heat, radar, television and radio waves. This energy can be described as waves that spread from a source in the same way that ripples spread when a stone is dropped in a pond of water. The waves can be measured; the distance from crest to crest (wavelength) ranges from one ten-thousand millionth (.000000001) of a millimeter for some gamma rays to six miles for some radio waves.

The human eye is sensitive to a very small group of waves near the middle of the spectrum whose wavelengths range from about 400 nanometers (billionths of a meter) to 700 nanometers. When waves in this range strike the retina of the eye, the brain senses light; each wavelength or combination of wavelengths produces the sensation of a slightly different color, and a mixture of all the wavelengths produces colorless or "white" light. For most purposes, photographers use films that are manufactured to be sensitive to about the same range of wavelengths that the eye sees.

Making an Image in Silver

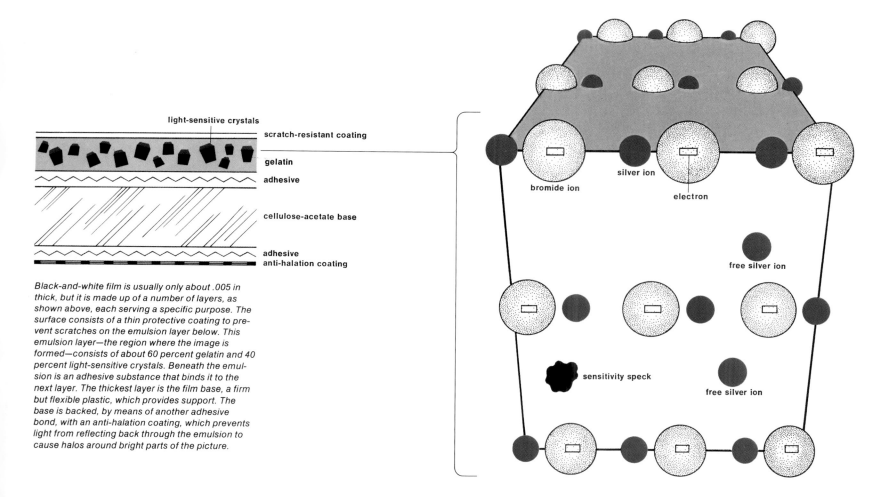

light-sensitive crystals

scratch-resistant coating

gelatin

adhesive

cellulose-acetate base

adhesive
anti-halation coating

Black-and-white film is usually only about .005 in thick, but it is made up of a number of layers, as shown above, each serving a specific purpose. The surface consists of a thin protective coating to prevent scratches on the emulsion layer below. This emulsion layer—the region where the image is formed—consists of about 60 percent gelatin and 40 percent light-sensitive crystals. Beneath the emulsion is an adhesive substance that binds it to the next layer. The thickest layer is the film base, a firm but flexible plastic, which provides support. The base is backed, by means of another adhesive bond, with an anti-halation coating, which prevents light from reflecting back through the emulsion to cause halos around bright parts of the picture.

bromide ion

silver ion

electron

free silver ion

sensitivity speck

free silver ion

The process that creates a picture on a piece of film involves a reaction between light and the crystals spread through the gelatin of the emulsion layer. According to current theory, the reaction can be set off when one crystal—only about 40 millionths of an inch across—is struck by as few as two photons of light (a flashlight bulb emits a million billion photons per second). Each crystal is made up of silver and bromine; in the crystal their atoms are electrically charged—that is, they are ions held together in a cubical arrangement by electrical attraction. If a crystal were really a perfect structure lacking any irregularities, it would not react to light. However, a number of the silver ions in the average crystal are out of place in the structure and these are free to move about to help form an image. The crystal also contains impuri-

ties, such as molecules of silver sulfide, that play a role in the trapping of light energy.

As indicated by the diagrams on the opposite page, an impurity—called a sensitivity speck—and the out-of-place silver ions work together to build a small collection of uncharged atoms of silver metal when the crystal is struck by light. This bit of metallic silver, built up with the aid of light energy, is the beginning of what is known as the latent image; it is too small to be visible under even the most powerful microscope. But when developing chemicals go to work, they use the latent image specks of metallic silver in an exposed crystal as a sort of hook to which the rest of the silver in the crystal becomes attached, forming the image.

A silver bromide crystal (above) has a cubic structure somewhat like a jungle gym, in which silver (small black balls) and bromine (larger white balls) are held in place by electrical attraction. Both are in the form of ions—atoms possessing electrical charge. Each bromide ion has an extra electron (small box)—that is, 1 more electron than an uncharged bromine atom, giving it a negative charge; each silver ion has 1 electron less than an uncharged silver atom and is positively charged. The irregularly shaped object in the crystal represents a "sensitivity speck." In actuality, each crystal possesses many such specks, or imperfections, which are essential to the image-forming process (diagrammed at right).

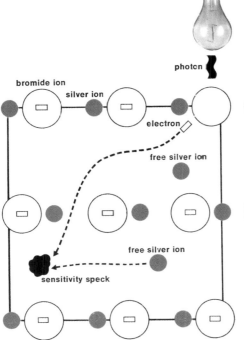

bromide ion
silver ion
electron
free silver ion
free silver ion
sensitivity speck
photon

When a photon of light strikes a silver bromide crystal, image formation begins. The photon gives its energy to a bromide ion's extra electron, lifting it to a higher energy level. Then the negatively charged electron can roam the structure of the crystal until it reaches a sensitivity speck. There, its electrical attraction pulls a positively charged free silver ion to it.

As additional photons of light strike other bromide ions in the crystal and release electrons, more silver migrates to the sensitivity speck. The electrons join up with the silver ions, balancing their electrical charges and making them atoms of silver metal. However, if the crystal were examined through a microscope at this stage, no change would be seen.

The presence of several metallic silver atoms at a sensitivity speck constitutes a latent image—an invisible chemical site that will serve as the starting point for the conversion of the whole crystal to silver during development. The developer enormously magnifies the slight chemical change caused by light energy and creates the visible photographic image.

A negative is formed when millions of exposed crystals are converted to silver metal by the developer. The result is a record of the camera's view in which the film areas struck by the most light are darkened by metallic silver, while the areas struck by no light remain transparent after processing, since they contain no silver. The intermediate areas have varying amounts of silver, creating shades of gray that depend not only on the amount of light striking the film but also on the color of the light and the type of film.

MINOR WHITE: Negative Print of Feet, 1948

When this very ordinary scene was printed as a negative image, the feet became not quite real. They seem to float above the surface of the floor, as if the subject is stepping off into space. The skin tones resemble an X-ray, so that one looks not just at the feet but into them. The diagonal lines of the floorboards add a visual tension to the picture, repeating at an angle the rectangular shape of the print format.

A Characteristic Response to Light

The pictures opposite, all taken at the same aperture and shutter speed, show that increasing the amount of light reaching the film increases the silver density of a negative. As more and more light bulbs shine on the head of Buddha, the negatives (bottom row) become denser (darker).

The response of a particular film to light can be diagrammed as its "characteristic curve," which shows to what degree silver density increases as the amount of light reaching the film increases. The graph (opposite, below) represents the characteristic curve for the film used in taking those pictures.

The curve shows graphically something you can also see if you look closely at the pictures—the density of the negatives did not increase in exact proportion to the amount of light reaching the film. Although the light was doubled for each exposure, the negative densities increased slowly for the first few exposures (the toe of the curve), increased more rapidly for the middle exposures (the straight-line portion) then leveled off again for the last exposures (the shoulder).

Here the characteristic curve plots seven different pictures. But imagine the seven pictures as all part of the same scene, each representing an object of a different brightness ranging from a dark, shadow area (Buddha at left) to a brilliant, highlight area (Buddha at right). If you take a picture of this scene, the film will record different densities depending on the brightnesses of the various objects *and* on the portion of the characteristic curve in which they fall.

In the straight-line portion of the curve, a given increase in light will cause a proportionate increase in density, but in the toe and shoulder portions an increase in light will cause a much smaller increase in density.

This means that in the straight-line portion, tones that were of different brightnesses in the original scene will look that way in the final print. The tonal separation will be good for these areas and the print will seem to represent the tones in the original scene accurately.

If the negative is underexposed, the film receives too little light. The tones move toward the toe of the curve, where only small increases in silver density occur. With considerable underexposure, shadow areas and midtones are thin, tonal separation poor and detail lost. Only the brightest areas of the original scene are on the straight-line portion and show good tonal separation and detail. Since the tones are reversed in the positive print, the print will tend to be too dark.

With considerable overexposure, the film receives too much light and the tones move too much toward the shoulder of the curve. Midtones and bright values are overly dense with silver; they "block up" without tonal separation so that details again are lost. Only the shadow values will show tonal separation and detail. The print will tend to be too light.

Pages 105–119 tell how to use a light meter to help you expose your negatives correctly. However, exposure is not the only process that affects the density of a negative. The type of developer used and the time and temperature of development also affect density, especially for bright areas in the original scene. The Zone System is one of the methods used by some photographers for controlling densities in a negative by making precise adjustments in exposure and development (pages 235–247). Some adjustments can also be made when the negative is printed, but a very thin or very dense negative will never make a print with the richness and clarity of a print made from a properly exposed negative with good tonal separation.

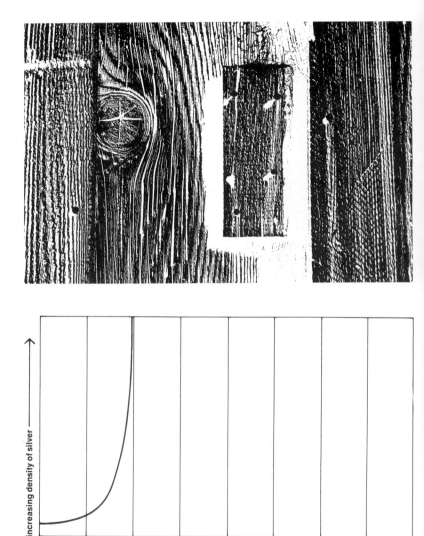

Different films have different characteristic curves. The negative above, made with high-contrast film, records a scene in virtually only 2 tones, maximum black and maximum white. High-contrast film has a curve that rises almost straight up. Silver density increases rapidly in the negative so that tones above a certain light level are recorded as very dense areas; they will appear in a print as white. Tones below a certain light level are recorded mostly as clear areas in the negative; they will appear in a print as black. Compare this to the curve for the film at right where density increases gradually and many midtones are produced.

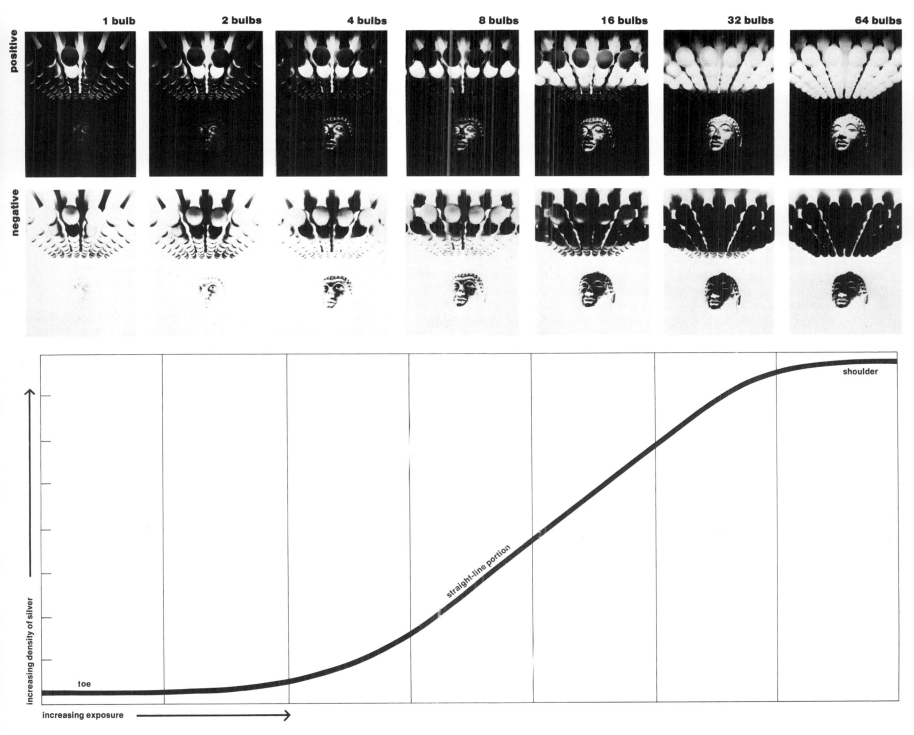

positive

negative

1 bulb 2 bulbs 4 bulbs 8 bulbs 16 bulbs 32 bulbs 64 bulbs

shoulder

straight-line portion

increasing density of silver

toe

increasing exposure

Choosing a Film

Most photo stores carry a large selection of brands and types of films. But the choice of which to use is not so complicated as it looks. General-purpose black-and-white films fall into one of three categories according to their speed or sensitivity to light: they are either slow, medium-speed or fast. The faster a film, the less light it needs to produce an image; therefore it can be used under darker lighting conditions, with faster shutter speeds or with smaller f-stops.

A film speed rating indicates how sensitive the film is to light. The faster the film, the higher the rating. Using the correct film speed with normal exposure and development should produce a negative that has midtones falling on the straight-line portion of a film's characteristic curve (see preceeding pages).

There are several systems for rating film speed. An ASA rating (commonly used in the United States) doubles each time the speed of the film doubles. If a film has an ASA rating of 200, it is twice as fast as an ASA 100 film. The ASA 200 film requires only half the exposure that the slower ASA 100 film does to produce the same negative density. A DIN film speed rating, used in Europe, adds 3 to the rating each time the film speed doubles: ASA 100 equals DIN 21, ASA 200 equals DIN 24, and so on. One recent ISO (International Standards Organization) rating combined ASA and DIN: for example, ISO 100/21. A shortened version of the ISO uses only the first part of the combined rating: for example, ISO 100. Don't worry too much about this numerical soup; almost all film and equipment sold in North America uses the ASA or short ISO rating, which are identical. Slow films are about ASA 50 (ISO 50, DIN 18) or less; medium speed films about ASA 100 (ISO 100, DIN 24); and fast films about ASA 250 (ISO 250, DIN 25) or more.

Faster films tend to produce grainier pictures, so theoretically you will get the best results by selecting the slowest film usable in each situation. In practice, however, it is inconvenient and unnecessary to work with several types of film. Some photographers use a moderately fast film, such as ASA 400, for almost all their work. This is possible because film manufacturers have greatly reduced the grain in such high-quality, moderately fast films as Kodak Tri-X and Ilford HP5. One type of film may be insufficient, but two—a slow, fine-grain one and a fast one—will be enough for most photographers.

The size of the film you will use naturally depends on the size your camera accepts. 35mm film is packaged in cassettes and produces 12, 20, 24 or 36 1 x 1½-inch negatives. Some 35mm films can be purchased in bulk rolls and then loaded by the photographer into separately purchased empty cassettes. This reduces the cost per cassette and, if you use a great deal of film, can be worthwhile. Roll film is wound around a spool and is backed with a separate strip of paper to protect it from light. (The term "roll" is also used in a general sense to refer to any film that is rolled rather than flat.) 120 roll film makes 12 2¼ x 2¼-inch negatives. 220 roll film has paper only on the end; thus enough film can be loaded onto the roll to make 24 2¼ x 2¼-inch negatives. Sheet or cut film for use in view cameras is made in 4 x 5-inch and other sizes. It is packed 10 or more sheets to a box and is loaded in a film holder before use.

When buying film, check the expiration date on the side of the film package since there is a steady decline in quality and speed after the expiration date. Heat affects film badly, so don't leave film where temperatures may be high, such as in a car's glove compartment on a hot day. Film keeps well in the refrigerator or freezer if it is in a moisture-proof wrapping, but it should be warmed to room temperature before unwrapping so that moisture does not condense on the surface. Load and unload your camera out of strong light and put exposed film where strong light won't reach it, since light leaking around the edges of a film spool can ruin your pictures by fogging them with unwanted exposure.

Philippe Halsman said that when the picture of ▶ Albert Einstein (opposite) was made in 1947, he and the scientist were discussing the atomic bomb. Einstein, caught up in the ideas they were talking over, reflected in his expression sorrow over the destructive use of his theories, and at that moment Halsman tripped the shutter. The photograph is the best-known likeness of the famous physicist and was the basis of a United States postage stamp honoring him. Having a subject stare directly into the camera lens creates an immediacy of contact that is hard for a viewer to ignore. Looking at this picture, one meets the eyes, glances at the familiar disheveled hair and wrinkled brow and returns to an encounter with the eyes.

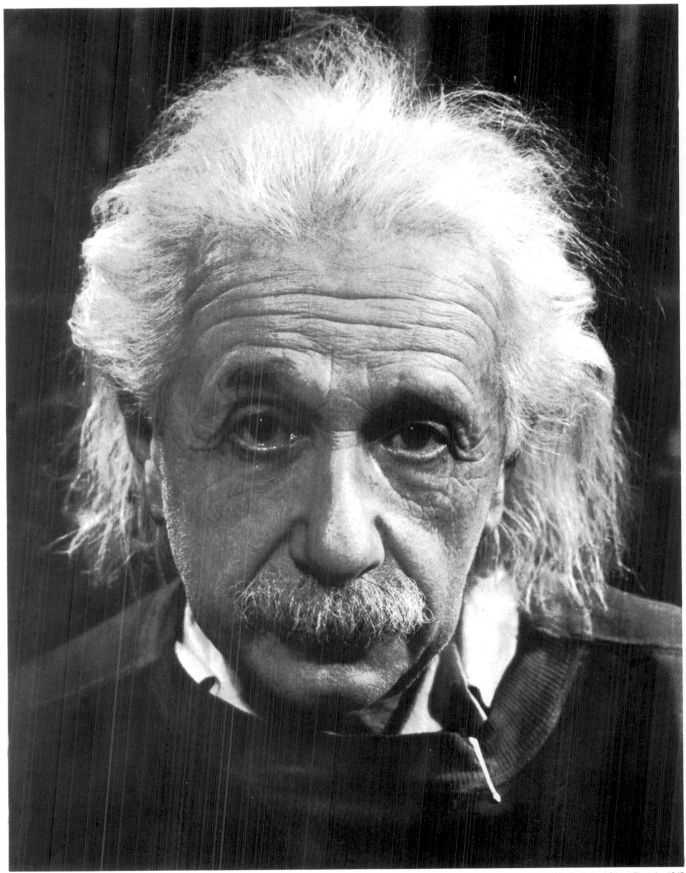

PHILIPPE HALSMAN: *Portrait of Albert Einstein,* 1947

The Problem of Graininess

Unfortunately, the faster the film, the greater its graininess—to the extent that very fast films reproduce gray shades with distinct specks that can obscure detail. Graininess is particularly obvious when a picture is greatly enlarged.

Films containing large silver bromide crystals produce coarser grain than those with small crystals, since they yield larger bits of silver when developed. (Actually, graininess is a result of uneven distribution and overlapping of many silver particles; the individual particles themselves are not visible.)

However, high sensitivity to light, or speed, *is* desirable, and in this respect the larger-crystal films perform best. A large crystal does not need any more light to form a latent image than a small crystal, but it will yield more metallic silver when developed.

The relationship between speed and graininess is shown below in the photographs of a truck windshield taken with slow ASA 32 film, medium-speed ASA 125 film and very fast ASA 1250 film. Each increase in speed also increased graininess. If maximum sharpness and

minimum graininess is your desire, select the slowest film that the situation will permit. Extreme grain is not always something to be avoided, however; occasionally some photographers use it for a special effect.

Grain is also affected by the film developer, the printing paper and the enlarger used. Graininess is increased when the negative is overexposed. If you have persistent problems with grain, check the temperatures of your developing solutions; if they vary more than a few degrees, grain can increase sharply.

ASA 32 film

ASA 125 film

Enlargements from the pictures below show how graininess increases as film speed rises. The letter "G" directly below is sharp despite enlargement, for it was photographed with slow, fine-grain film. Some mottling and loss of sharpness are apparent in the middle letter, photographed with medium-speed (ASA 125) film. The letter at right, taken with ASA 1250 film, is severely speckled and has unclear borders.

ASA 1250 film

For Maximum Detail, Slow and Medium-Speed Films

A slow film, ASA 50 or less, will be your choice when you want to show very fine detail or want to enlarge the negative considerably with a minimum of grain. A slow film's ability to render detail sharply is made possible by the small size of the silver bromide crystals and by the thinness of the emulsion. (Thin emulsions reduce the internal reflection of light among the crystals—an effect that blurs edges.)

The film is slow because smaller-sized crystals yield less silver. If you have bright sunlight or enough artificial light to illuminate the subject, however, or if you can make a long enough exposure, this will not be a problem.

The detail that a film can record can be measured by its resolving power, which is its ability to distinguish between very fine, closely spaced lines (also a test for lens quality). Another measurement is of acutance or edge sharpness. Since light scatters somewhat when it strikes film, there is always a slightly blurred boundary between light and dark edges. The narrower this boundary, the sharper the image produced by the film. Film that has good resolution and acutance can produce good definition of detail, even when the negative is enlarged to a great degree.

A medium-speed film, around ASA 100, has larger grain than slow film but maintains good sharpness. Since the film is of moderate speed, you may be able to use a relatively fast shutter speed and hand hold the camera, whereas a slower film may require a tripod to hold the camera steady during a longer exposure of the same scene. The extra film speed can be important if there are moving objects in the scene.

Medium-speed and fast films have less tonal contrast than slow films and thus may be better for photographing subjects that have both deep shadows and bright highlights.

Medium-speed film is an excellent all-around film, able to handle all but the dimmest light, capable of photographing fast-moving subjects, and producing finer grain than the fast films. However, manufacturers are steadily improving the grain of fast films, so medium-speed film seems destined for a reduced role in the future.

Imogen Cunningham made a number of close-ups of plant forms in the 1920s. Commonplace objects such as flowers and leaves were photographed in heroic terms, oversize and isolated in the picture and explored for their design and structure, not as strictly botanical specimens. Edward Weston's Pepper No. 30 (page 347) is a similar image. The photograph at right has a gently expressed voluptuous quality. Cropping into the graceful curves of the petals enfolds the viewer in the photograph much as the petals enfold the cone of the stamen and pistil. The light shines through the petals as well as on them and they are luminous with delicate tones of gray. Fine gradations of tonality are usually rendered best with slower films.

IMOGEN CUNNINGHAM: *Magnolia Blossom*, 1925

When Speed is Essential

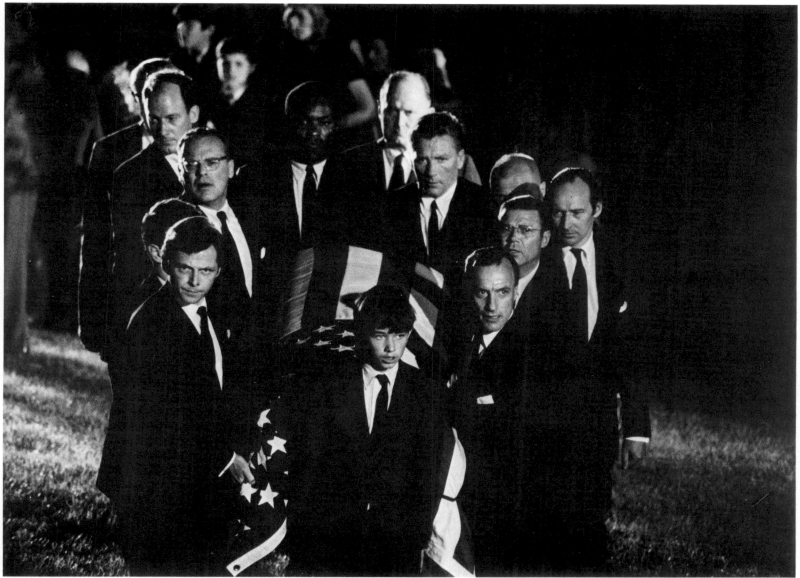

ROBERT LEBECK: *Funeral of Robert Kennedy,* 1968

A fast film, ASA 250 or higher, is useful for photographing in dim light. Even if given less exposure than the standard ASA number calls for, these films can still produce a good image. The picture above, taken at the funeral of Senator Robert F. Kennedy, was made on Tri-X film rated at ASA 1000 instead of the standard ASA 400. Fast films are frequently "pushed" during development so that photographs can be made at extremely low light levels (see page 142). In this photograph, the darker values fell on the toe of the film's characteristic curve and show no detail. But enough density developed for the brighter values to fall on the straightline portion of the curve and show good tonal separation.

JAMES DRAKE: *World Series*, 1963

With fast films' ability to cope with dim light goes their ability to stop rapid motion. In the photograph above, the photographer used a 1000mm lens from high up in the press box at Yankee Stadium. A lens of this extremely long focal length typically has a maximum aperture of only about f/8. But because the photographer was using high-speed film, he was still able to use a fast enough shutter speed to stop umpire, ballplayers and hat in mid-play.

A fast film may show increased grain and loss of image detail (especially if pushed during development), but the advantage of fast film often outweighs these disadvantages.

How Black-and-White Film Sees Color

While silver bromide crystals are extremely sensitive to light, they do not respond equally to all wavelengths of light. Since colors are actually different wavelengths within the visible part of the electromagnetic spectrum, they must be considered when making black-and-white pictures. Different types of film react to colors differently, as the three pictures at right show.

Unless silver bromide crystals are specially treated, they respond only to the shorter wavelengths of light, from ultraviolet through blue-green. The first photographic emulsions were of this type. Then, in 1873, a dye was discovered that extended the response to green and yellow wavelengths. By a mechanism still not completely understood, the dye absorbs these slightly longer wavelengths and transfers their energy to the silver bromide crystals. This sort of emulsion is called orthochromatic and is used today mostly to make photographic copies.

Panchromatic film was a further improvement, and it is now used for almost all ordinary photography. Dyes enable the film to record all colors seen by the human eye, although the film's response is still not exactly like that of the eye. Panchromatic film is more sensitive to short wavelengths (bluish colors) than to long wavelengths (reddish colors). Sometimes in a print, blue sky may appear too light or red apples may have almost the same tone as green leaves. This final imbalance can be corrected with filters *(pages 98–101)* if desired.

Special dyes have also been devised to make films respond to invisible infrared wavelengths in addition to all the visible colors, with unusual and often beautiful results *(far right and following pages)*.

In a photograph made on orthochromatic film, some of the fruits and vegetables above come out looking darker than they would to the human eye because this film responds only to shorter wavelengths— toward the violet end of the spectrum (above)—and is insensitive to reddish colors. The apple, orange and red pepper (upper right) and the red onion (lower left) all appear unnaturally dark.

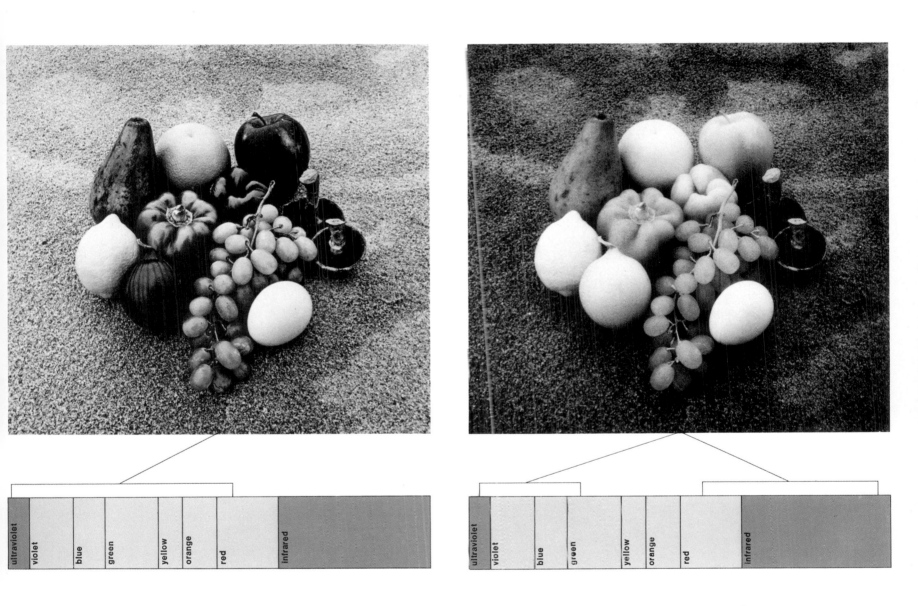

When panchromatic film is used, the tones of reddish objects are more natural in appearance because the film records almost all colors, red through violet and into the ultraviolet (above), that are seen by the eye. The egg looks even whiter than it does in the orthochromatic picture because it has added the light energy of the longer wavelengths to its blend of reflected colors.

Infrared film records visible colors as well as some longer wavelengths that are not visible. Although most natural objects strongly reflect infrared rays, there is no consistent relationship between the color of an object and the amount of infrared rays that are reflected. In the picture above, only the avocado and the mushrooms do not reflect infrared strongly; thus they appear darker than the other objects.

Infrared Film: Seeing Beyond the Visible

Infrared film can produce hauntingly beautiful outdoor photographs, giving the world a strange appearance—the sky dark, the clouds fleecy and the green foliage unexpectedly luminous. This sort of transformation was made in the picture at right, taken on 4 x 5 infrared film with a red filter placed over the lens.

Most of the infrared films that are used for nonscientific purposes not only respond to some of the visible wavelengths seen by the eye, but gain their special qualities from their additional sensitivity to invisible infrared wavelengths that are just slightly longer than the visible waves of red light.

These "near-red" waves, emitted copiously by the sun and incandescent bulbs, create bizarre photographic effects because they are not always absorbed or reflected in the same way as visible light. When a deep-red filter on the lens is used to block most visible wavelengths, so that the photograph is taken principally with near-red waves, these effects became particularly evident.

The leaves and grass in the picture came out snowy white because they reflected near-red waves very strongly. (The leaves are blurred due to their motion during the exposure.) The large water particles in clouds also reflected near-red waves quite strongly, making the clouds seem a brilliant white. But the sky turned out black, because its blue light, mainly in the short-wavelength range, was largely blocked by the deep-red filter.

Sometimes photographers use infrared film and a filter for long-distance views on hazy days. The haze results from the scattering of visible light by very small particles of water and smoke in the air—an action that does not affect the near-red radiation. Instead of being scattered by these particles, infrared waves reflected off the scenery can pass right through them as if they did not exist; a hazy scene photographed with infrared film thus looks perfectly clear.

Minor White often saw the sublime in the ordinary, ▶
and here infrared film with its altered tonalities aids in the expression of a landscape that becomes a dreamscape. The perspective of the converging lines of road and trees funnels the eye down the road to the dark mountains beyond. The brightness of the foliage increases the contrast with the dark road. The repeated shadows of the trees reinforce the depth in the scene as the distance between them apparently diminishes. Though converging lines help direct the eye, there is no sure way to make a landscape like this happen out of any road lined with trees, no matter what film you use. The landscape itself has to cooperate. White often put forth his basic rule of composition: Let the subject generate its own composition.

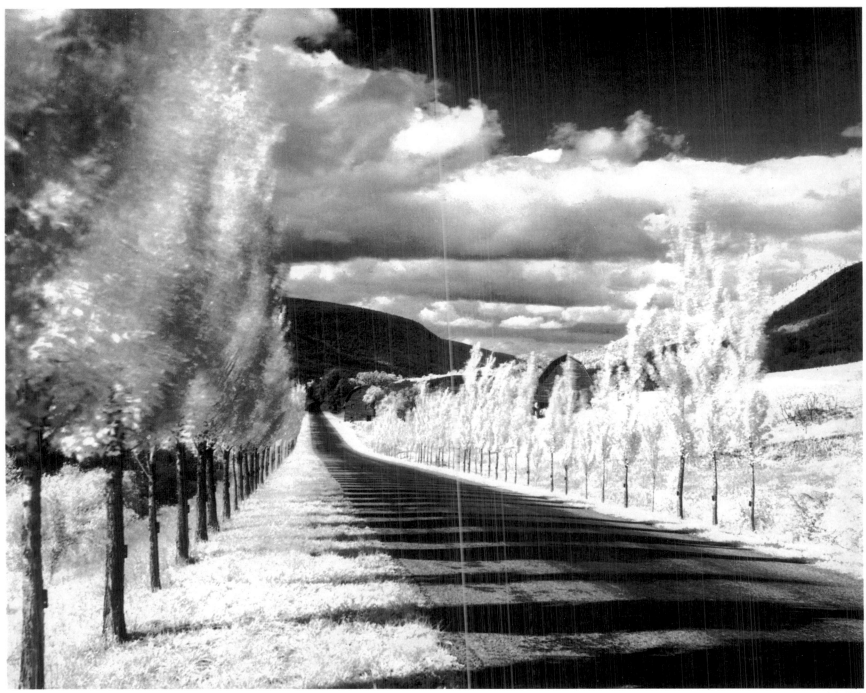

MINOR WHITE: *Road and Poplar Trees, Upstate New York*, 1955

97

Changing Tones with Filters

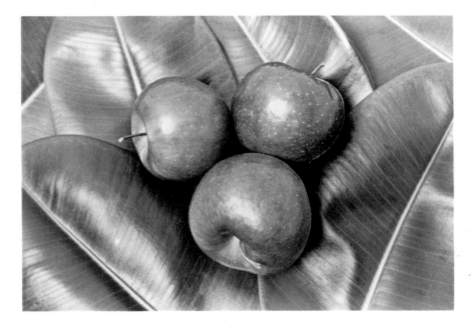 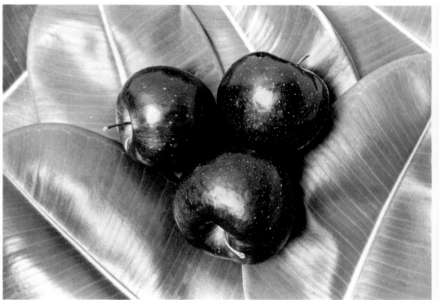

The green filter #58 used to take the picture above right absorbs much red light and makes the red apples darker than the leaves, a natural appearance. Without the filter (above, left), the tones seem confusingly similar. To make up for light absorbed by the filter, the aperture was opened 3 stops more than normal.

Because black-and-white film records the world in tones of gray, dramatic contrasts in nature's colors can be almost absent from a photograph. To the normal human eye, bright red apples are easily seen against a background of dark green leaves, but in black and white the apples and leaves can reproduce as almost exactly the same gray tone *(above left).* Color filters fitted to the lens can help produce tones that look more like the color contrast seen by the eye. Filters can also be used to exaggerate contrast—to make the sky, for example, appear darker than normal.

Objects acquire color because they reflect only part of "white" light, which is a mixture of all colors, and absorb the rest. An apple's skin appears red because it absorbs most of the light waves reaching it but reflects those in the red part of the spectrum. An egg shell looks white because it reflects all the wavelengths of white light that reach it.

Filters also absorb some of the colors in light and pass others. When the apples and leaves are photographed through a green filter *(above right),* the apples appear darker, less exposed, than the leaves because the filter absorbed red wavelengths from the apples but let green wavelengths from the leaves reach the film.

To darken bluish colors, such as those in the sky, yellow or red filters are used. Film is so sensitive to the sky's blue and ultraviolet waves that when photographed without a filter even a dark blue sky causes almost as much exposure as white clouds do *(opposite top).* By using a yellow filter, which absorbs blue, the sky is darkened and clouds become visible *(center).* The contrast between sky and clouds is even more marked if a red filter *(bottom)* is used.

Without any filter, the sky in this photograph appears very light, with clouds barely visible. Black-and-white film is very sensitive to blue and ultraviolet light; this often causes skies to appear too light in a black-and-white photograph.

A yellow filter #8 absorbs some of the sky's blue light, making the sky in the picture at right appear somewhat darker than it does above. Because the filter absorbs light, the aperture was opened 1 stop more than normal.

A red filter #25 absorbs nearly all blue as well as green light, making the sky in the picture at right much darker than it normally appears and also darkening foliage. Shadows, too, appear darker than in the unfiltered view, for they are illuminated largely by blue sky light that the red filter blocks. Because of the large amount of light absorbed by the filter, the aperture was opened 3 stops more than normal.

A Polarizing Filter to Reduce Reflections

Reflections from a shiny surface can be a distracting element in a photograph. With a polarizing filter, you can remove or reduce reflections from glass, water *(top right)* or any smooth surface except metal. This is possible because light ordinarily vibrates in all directions perpendicular to its direction of travel. But light reflected from nonmetallic smooth surfaces has been polarized—it vibrates in only one plane.

A polarizing filter contains submicroscopic crystals lined up like parallel slats. Light waves that are parallel to the crystals pass between them; waves vibrating at other angles are blocked by the crystals *(diagram, right)*. Since the polarized light is all at the same angle, the filter can be turned so as to block it. (This also blocks some waves in the general scene, but those that are parallel to the filter crystals get through.)

To use a polarizing filter, look through it and rotate it until the unwanted reflection is reduced as desired *(bottom right)*. Then place the filter in the same position over the lens. (With a single-lens reflex or view camera, the filter can be adjusted while it is in place over the lens.) Because of the partial blockage of light by the filter, the exposure must be increased by one to two stops.

The photograph at top was taken without any filter. The reflection of the house in the water was removed (bottom) by adjusting a polarizing filter (or polarizer) over the lens. The drawing shows how the polarizer works. It is adjusted to permit passage of only those desired light waves (black) oriented parallel to its picketlike aligned crystals, and to screen out all other light waves (gray) angled across the pickets.

reducing reflections from shiny surfaces

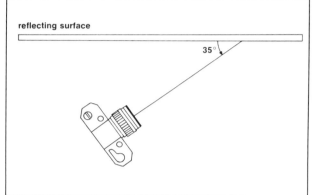

reflecting surface

35°

reducing reflections from atmosphere

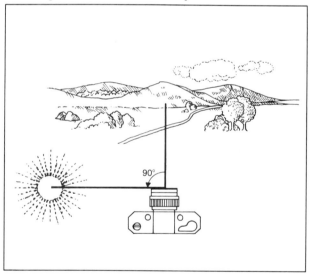

90°

▲
A polarizing filter used to block reflections from a shiny surface like glass or water is most efficient at an angle of about 35° to the reflecting surface (top diagram). Directly in front of the surface, the filter has little or no effect. A polarizing filter can be used to darken a blue sky and to reduce haze by blocking light reflected from particles in the atmosphere. In this case, the filter works best when you are taking pictures at approximately a right angle to the sun (bottom diagram).

The chart below lists the filters most often used with black-and-white film. (See pages 276–277 for filters used with color film.) Filters can be purchased as gelatin squares that are either taped to the front of the lens or placed in a filter holder. Gelatin filters are inexpensive and come in a wide range of colors, but they easily acquire scratches and fingerprints that cannot be cleaned off. Handle them carefully by the edges only. All the filters listed below are also available as glass filters that usually screw onto the lens barrel. They are convenient to use and much less easily damaged than gelatin, but are more expensive. Filters are made in various sizes to fit different lens diameters.

Since filters absorb part of the light from a scene before it reaches the film, exposures must be increased or the film will be underexposed. The filter factors listed in the chart give the approximate number of times that the exposure must be increased; check the manufacturer's instruction sheet for their recommendation. Factors vary depending on the manufacturer, the film used and the color of the light illuminating the subject. The factor for tungsten light (from lightbulbs) is different from the factor for daylight because tungsten (except for special blue bulbs) emits more red wavelengths than daylight does.

The factor tells *how many times* the exposure must be increased. A factor of two means the exposure must be doubled (the next widest f-stop or the next slowest shutter speed). A factor of four requires four times the exposure (two f-stops wider or two shutter speeds slower, or one f-stop wider plus one shutter speed slower). See pages 42–43 if you need to review the relationship between f-stops and shutter speeds.

When using two filters together, such as a polarizing filter (factor of two) and a red #25 filter (factor of eight), the factors are multiplied together, not added. The factor for the above combination is 16, not 10.

In addition to filters that absorb light, special-effect lens attachments are available. A soft-focus attachment softens details and makes them slightly hazy, an effect sometimes used for portraits. A cross-screen attachment causes streamers of light to appear to radiate from bright lights such as light bulbs or reflections.

filter number	color or name	physical effect	practical use	factor with panchromatic film	
				daylight	tungsten
8	yellow	Absorbs ultraviolet and blue-violet rays.	Darkens blue sky to bring out clouds. Increases contrast by darkening bluish shadows. Reduces bluish haze.	2	1.5
15	deep yellow	Absorbs ultraviolet, violet and most blue rays.	Lightens yellow and red subjects such as flowers. Darkens blue water and blue sky to emphasize contrasting objects or clouds. Increases contrast and texture and reduces bluish haze more than 8 filter.	3	2
25	red	Absorbs ultraviolet, blue-violet, blue and green rays.	Lightens yellow and red subjects. Darkens blue water and sky considerably. Increases contrast in landscapes. Reduces bluish haze more than 15 filter. Used with infrared film.	8	6
11	yellowish-green	Absorbs ultraviolet, violet, blue and some red rays.	Lightens foliage, darkens sky. For outdoor portraits, darkens sky without making light skin tones appear too pale. Balances values in tungsten-lit scenes by removing excess red.	4	3
47	blue	Absorbs red, yellow, green and ultraviolet rays.	Lightens blue subjects. Increases bluish haze.	8	16
1A or UV	skylight / ultraviolet	Absorbs ultraviolet rays.	More often used in color photography but also has some effect on black-and-white films. Eliminates ultraviolet that eye does not see but that film will record as haze or decreased contrast in mountain, marine or aerial scenes. Sometimes used simply as a lens protector.	1	1
	neutral density	Increases amount of exposure needed without changing tonal values.	Camera can be set to wider aperture or slower shutter speed. Can be used to photograph in bright sun with high-speed film.	varies with density	
	polarizing	Reduces reflections and unwanted glare.	Reduces reflections from non-metallic surfaces. Darkens sky at some angles. May be used as a neutral density filter.	2.5	2.5

if factor is	1	1.2	1.5	2	2.5	3	4	5	6	8	16
increase exposure this many stops	0	$1/3$	$2/3$	1	$1\frac{1}{3}$	$1\frac{2}{3}$	2	$2\frac{1}{3}$	$2\frac{2}{3}$	3	4

The Polaroid Land Process

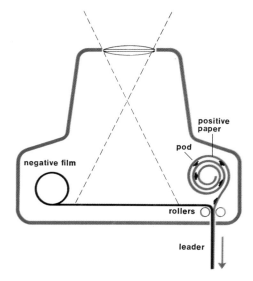

Some Polaroid Land cameras are loaded with 2 separate spools containing negative film and positive printing paper attached to a single leader. The negative is exposed simply by pressing the shutter, as in an ordinary camera. The leader is then pulled, drawing both negative and positive through a pair of steel rollers and out of the camera. The compression by the steel rollers ruptures a pod of jellylike chemicals attached to the positive paper, initiating development inside the sandwich. After 10 sec or so, the positive is peeled away from the negative, revealing a finished picture.

In the ordinary photographic process, film is exposed, later developed to produce a negative and then, even later, printed to make a positive. The Polaroid Land process however, provides both a negative emulsion and positive paper in one package. After the picture is exposed, the negative and positive are tightly sandwiched together by being pulled between two metal rollers. The image is transferred from the negative to the positive by chemicals at the center of the sandwich. The way some Polaroid Land cameras make this positive-negative sandwich is shown on this page, and the chemical transfer of the image is illustrated opposite. Polaroid's SX-70 color process is even more sophisticated: negative, positive and chemicals are built into one permanent package; the print emerges from the camera by itself with nothing to pull or time and no negative to throw away.

The prints themselves can be beautiful. Because even the fastest Polaroid film is almost completely free of graininess, the prints display an extraordinarily smooth gradation of tones. The main reason for this is the extremely narrow gap at the center of the positive-negative film sandwich. This permits the silver ions to travel in a straight line from the negative to the positive surface, and thus they are less likely to form the random clumps of silver that are the chief cause of graininess and loss of detail (diagrams and photographs opposite).

Polaroid Land film is often used by professional photographers to make a quick check of complicated setups. An exposure can be made and evaluated on the spot to avoid a mistake when the picture is taken with standard film. In addition to pack film, individual sheets of 4 x 5 or 8 x 10 Polaroid Land film can be used (with a special film holder) in a view camera. More about instant color films appears on pages 304–305.

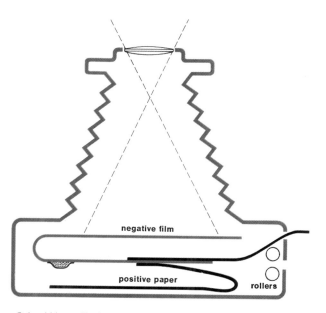

Polaroid Land film in pack form consists of a box containing flat sheets of negative and positive materials and is simply snapped into the back of the camera. First, the picture is exposed (above). The negative will then have to be turned upside down to meet properly with the positive paper. The photographer does this by simply pulling on a white tab (below).

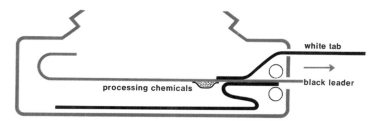

When the white tab is pulled, the exposed negative turns upside down and is brought close to the steel rollers (the positive paper has not yet moved). Next, a black leader is pulled, drawing both the negative and the positive through the rollers and breaking the pod of chemicals in the process (below). The chemicals are thus spread evenly within the sandwich to develop and fix the picture.

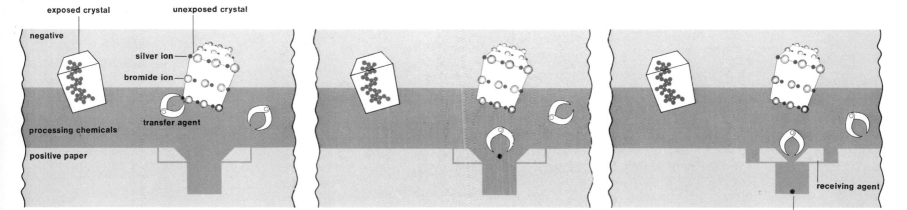

negative

exposed crystal

unexposed crystal

silver ion

bromide ion

processing chemicals

transfer agent

positive paper

receiving agent

silver metal

When Polaroid Land film is developed, exposed crystals in the negative are reduced to silver metal in the usual fashion. But the processing solution also contains a transfer agent that acts on unexposed crystals. This transfer agent, represented by pincers above, latches onto the silver ions in an unexposed crystal.

After a silver ion is snatched away from an unexposed crystal in the negative emulsion, the transfer agent carries it to the positive side of the sandwich. Because the distance from the negative to the positive paper is only about .0002 in, the silver ion travels directly across the gap, with very little sideways motion.

On the surface of the positive paper is a receiving agent, represented by a pair of sliding trapdoors, which acts as a catalyst and takes the ionic silver from the transfer agent—and at the same time changes the silver to its metallic form. The build-up of millions of silver atoms, in this way, forms a positive image.

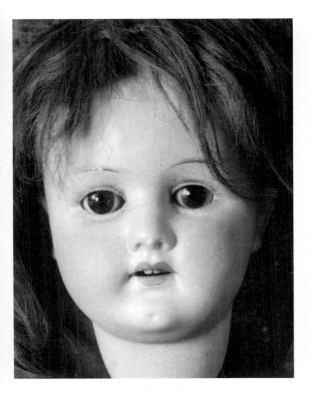

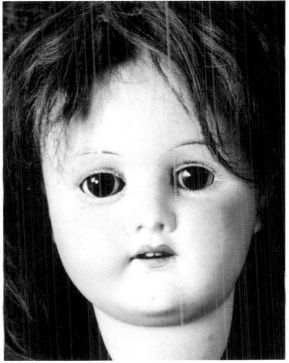

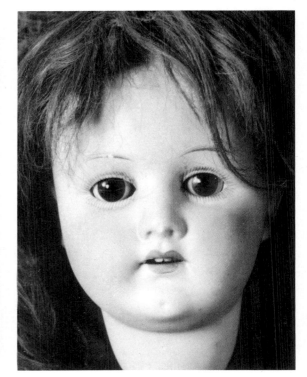

In sheet form, an ASA 50 Polaroid Land film (ASA 75 in pack form) produces grain-free pictures in 20 sec—and also provides the photographer with a usable negative from which an enlargement can be made. Other Polaroid Land films can be enlarged only by rephotographing the positive print with a camera to obtain a printable negative.

Medium-speed ASA 400 Polaroid Land film also produces a virtually grain-free image in 15 sec. It is a good choice for general purpose photography. In addition, many professionals use this film for exposure testing, taking preliminary Polaroid pictures of a subject to make sure that the lighting effect is what they desire, before shooting with ordinary film.

The extraordinarily fast ASA 3000 Polaroid Land film is remarkable not only for its great speed but for the fact that such speed is achieved without sacrificing grain quality. It is the most widely used of all the Polaroid Land films. It produces a print in about 15 sec at room temperature; a longer development time is needed to get a good image in cold weather.

HIROSHI SUGIMOTO: *Cabot Street Cinema, Beverly, Massachusetts, 1978*

5 Exposure

Light Meters and How to Use Them 106

 The Simplest Method: An Overall Reading 108

 A Luminance Range Reading 110

 Exposing for Specific Tones 112

 Spot Meters and Substitution Readings 114

 Built-in Meters 116

Out-of-the-Ordinary Exposures 118

In front of the camera is a world of rich and subtle colors, of varying brightnesses and textures, of strong and diffuse light—all to be translated, on black-and-white film, into black, white and tones of gray. But a photograph has only a limited range of grays; at best, the brightest areas of a glossy-surfaced printing paper will reflect 50 to 65 times as much light as the deepest black areas. Nature is far less limited. In an ordinary scene, the reflectance of some areas may be 200 or more times brighter than others. Because the eye can adapt itself to a wide range of brightness, it easily sees the detailed features in both dark and light areas. Photographic emulsion, however, does not have the eye's adaptability; it must compress the contrast of the scene in front of the camera, and in doing so it loses some of the details. Which details are lost and which registered depend mainly on exposure.

Most black-and-white films have a tolerance or latitude for a certain amount of exposure error; they allow for a range of exposures that will all produce satisfactory negatives. However, the best prints, especially if enlargements are made, are produced from properly exposed negatives. Overexposed negatives are difficult to print and produce grainy and unsharp prints. Badly underexposed negatives will show no detail in the shadows—something that cannot be remedied when the negative is printed. Reversal films, especially color transparency films, have very little latitude; underexposure or overexposure of only one stop makes a distinctly inferior slide.

A photographer who uses films of standardized sensitivity and an accurate exposure meter to measure light intensity can consistently obtain good negatives. Judgment is still necessary, however, even with automatic exposure cameras, and one of the best cures for exposure problems is simply the experience gained from exposing a large quantity of film and looking at the results. The most expensive meter, complicated exposure strategy or detailed charts will never replace the sureness you will have when you photograph something for the second time.

◀ *Hiroshi Sugiomoto photographs movies—but not in the usual way. He sets up his 8 x 10-in view camera, mounted on a tripod, in a theatre balcony. He positions the camera with the lens more or less equidistant from all points in the image, so that the photograph is symmetrical and evenly focused from edge to edge. The movie is the main source of light and its length determines the exposure time. The photograph, in effect shows the whole movie all at once. This is what we see at the movies, but translated into another time frame.*

Light Meters and How to Use Them

An essential piece of equipment if you want consistently accurate exposures is a good light meter, also called an exposure meter. Meters built into the camera itself are popular because they are so convenient. Yet many photographers still prefer a separate hand-held meter when they want precise control over exposure. With a hand-held meter, it is easy to move close to various parts of the scene and take light readings of specific areas.

The light-sensitive part of an exposure meter is a photoelectric cell. A selenium or silicon cell converts the energy of light into electrical energy that moves a needle across a gauge; the stronger the light the stronger the current and the more the needle moves. A cadmium sulfide (CdS) cell acts as a resistor; it lets more or less current from a small battery pass to the gauge needle depending on the amount of light that strikes the cell.

Selenium cell meters have the simplest design and, since they generate electricity directly, have no batteries to wear out. But they are relatively insensitive at low light levels. Since CdS meters are sensitive over a wider range of light levels than selenium, they can be used in very dim light, can be made small enough to be built into a camera or can be used to measure a very narrow angle. However, they tend to creep slowly to the correct reading when going from bright to dim light or vice versa. Silicon or gallium cells have all the advantages of CdS and, in addition, react quickly at all light levels. Their main disadvantage is the sophisticated circuitry design required for their use.

Light meters differ in the way they are used to measure light. Most hand-held meters, and all built-in ones, are of the reflected-light type, which measures the light reflected from the subject. The meter is pointed at the subject—or at that particular part of the subject the photographer wants to measure at close range—and the reading is made. The light-admitting opening of such meters is restricted by a hood, baffle or faceted lens so that the angle of view of the meter approximates that of a normal camera lens, about 30° to 50°. In a variation of this type of meter, a spot meter (page 114), the angle may be reduced to as little as one-half degree so that readings of very small areas can be made.

The second type is the incident-light meter, designed to have a much wider angle of view (about 180°) so that it can measure all the light incident on, or falling on, the subject from one side. This wider angle is made possible by a translucent dome of white glass or plastic, placed over the light-measuring cell to diffuse the light. The incident-light meter is held not toward the subject but directly toward the camera, so that it receives the same light as is falling on the subject. Both types of meters generally have two separate scales, one for average light and one for very dim light, so that accurate readings can be made under most conditions.

Since each type has advantages under certain conditions, some, such as the one shown on the opposite page, are designed to make both reflected and incident readings. When the sensing cell is open to direct light, it is a reflected-light meter; when the dome-like diffuser is slid into position over the sensing cell, it becomes an incident-light meter.

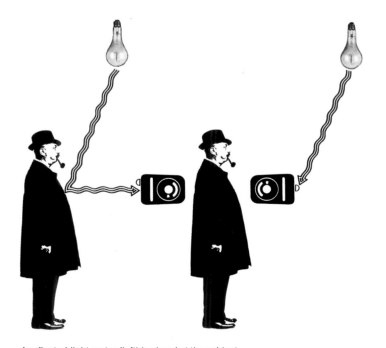

A reflected-light meter (left) is aimed at the subject. Here it measures the light bouncing off the man's clothing. The incident meter (right) is faced away from the subject and toward the camera to measure the general light falling on the man from the direction of the camera.

The opening in a reflected-light meter (left) admits light from a limited angle (usually 30° to 50°) and therefore takes in a small area of the subject when used at close range. The incident meter's coverage, or angle of acceptance (right), is 180°, to enable it to measure all light coming toward the subject from the general direction of the camera.

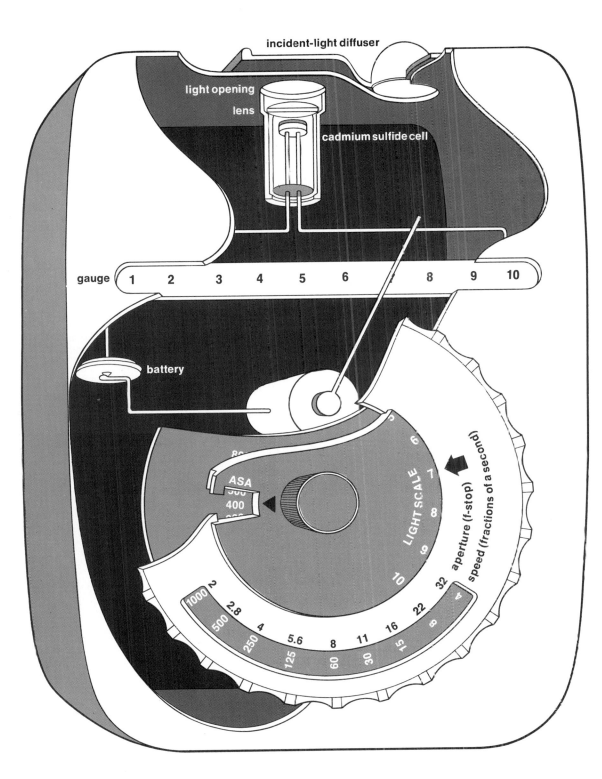

incident-light diffuser

light opening

lens

cadmium sulfide cell

gauge | 1 | 2 | 3 | 4 | 5 | 6 | 8 | 9 | 10 |

battery

ASA
400

LIGHT SCALE

aperture (f-stop)

speed (fractions of a second)

1000 2
2.8
500 4
250 5.6
125 8 11 16 22 32
60 30 15

An exposure meter measures the light, then for a given film speed computes shutter speed and f-stop combinations based on the average of brightnesses in the scene.

Measuring the light. The meter at left is set to measure reflected light. The dome-like diffuser, used to make an incident reading, has been slid away from the opening over the light-sensitive cell. How much light strikes the cell determines how much current reaches a needle that moves across a measuring gauge. The numbers on the gauge are 1 stop apart: each number indicates a light level twice as high as the preceding number. In this case, the reading is slightly over 7—about twice the light level at 6, about half the level at 8.

Film speed. The speed of the film being used must be set into the meter. Here the center knob is turned until an ASA rating of 400 is shown in the small window near the center of the dial. Some meters also have provision for setting in other types of film speed ratings such as °ASA or DIN.

Computing the exposure. To convert the light measurement into an exposure setting, the large outer dial is turned until its arrow points to the number indicated by the gauge needle. This matches apertures (f-stops) with shutter speeds at the bottom of the dials to recommend an exposure for the light intensity measured. $F/32$ at $1/4$ sec, $f/22$ at $1/8$ sec or any other combination shown would give the same exposure. Here the dial is showing the shutter speed in fractions of a second. $1/8$ sec is shown on the dial as 8, $1/4$ sec is shown as 4 and so on. The shutter-speed dial continues on into full seconds, minutes and, on some meters, hours of exposure time.

The Simplest Method: An Overall Reading

For many scenes, the correct exposure can be calculated simply by taking an overall reading using either a reflected-light meter *(right)*, which measures light reflected by the subject, or an incident-light meter *(opposite)*, which measures light falling on the subject. The basic procedure is outlined at far right. It will work well with ''average'' scenes where light and dark tones are of more or less equal distribution and interest, scenes where the light is coming from behind the camera and scenes in evenly diffused light.

A meter is only a measuring device—it cannot interpret what it reads or know whether the subject is supposed to be light or dark in the final print. You must make sure the meter is reading only the light you want it to read, and in some situations you must override the meter and adjust its recommended exposure.

A reflected-light meter averages the luminances in a scene—the light reflected or produced by all the objects in the meter's angle of view. Since this is about the same angle of view as a normal-focal-length lens, pointing the meter toward the subject from camera position (as the photographer is doing at right) will give you an approximate average of the luminances of the objects being photographed (if you are using a lens of normal focal length). All reflected-light meters are designed to give an exposure for a middle-gray tone. The assumption is that the average of all the tones in an average scene will be a middle gray and so the exposure calculated by the meter will be approximately correct. This method actually does give a good exposure in a surprisingly large number of situations.

A few precautions will increase the chances of a good exposure. If there are very bright areas (such as sky, snow, sand or white walls) or very dark areas (large shadowed areas) surrounding the main subject, do not include too much of them in the meter reading since they will influence it unduly. You can usually avoid reading them by coming close enough so that only the main subject is metered and not the background. If you are metering a landscape, tilt the meter down slightly to exclude a bright sky. It is easy to tell when the sky is no longer being read: as the meter is tilted down, the gauge needle will drop suddenly. This lower reading will give a more accurate exposure for the land elements in the scene. Of course, if your main subject is in the sky itself—such as an interesting cloud formation—take your reading directly from the sky. Also make sure that bright light is not shining directly on the meter's cell since this will inflate the reading as well. The photographer at right is shading the cell from direct sun with his hand.

Since an incident-light meter reads only the light falling on a subject, it is not misled by surrounding dark or light areas. It is preferred by many commercial photographers to balance the illumination in studio setups where lights can be arranged at will. It is also quick and easy to use and therefore useful in fast-moving situations. However, it cannot measure the actual luminances of different objects in a scene and it cannot give an exposure for an object that is itself emitting light, such as a neon sign or a lamp.

To use an incident-light meter, point it in the direction opposite from the one the lens is pointing *(see opposite page)*. This aligns the meter so that it receives the same amount of light as is falling on the subject as seen from camera position. Move close enough to your subject so that you do, in fact, read the same light that is falling on it. Indoors, for example, don't take a reading near a sunny window if your subject is standing in a darkened corner.

reflected-light meter: reads light reflected by subject

A simple overall reading made with either a re-flected-light or incident-light meter will give an accurate exposure in many situations.

1) Set the ASA pointer to the speed of the film you are using.

2) With a reflected-light meter (far left) point the light-sensitive cell at the area you want to photograph.

or

With an incident-light meter (near left) point the light-sensitive cell in the opposite direction from the lens.

3) Activate the meter and note the reading. If the light is very dim, the meter may have a screen or baffle that can be opened up to let in enough light to make a reading on a separate low-light scale.

4) Match the arrow on the calculator dial to the light reading.

5) Choose an f-stop and shutter-speed combination and set the camera accordingly.

incident-light meter: reads light falling on subject

A Luminance Range Reading

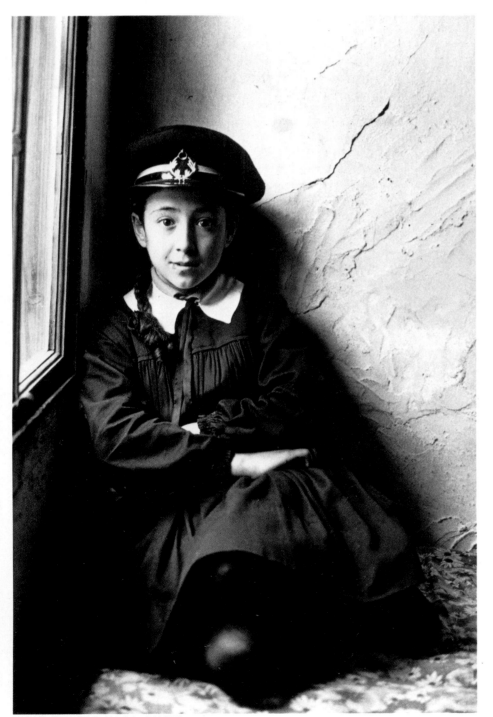

MARY ELLEN MARK: *Turkish Schoolgirl*, 1965

Although a simple overall exposure reading works well much of the time, many photographers prefer a more precise method of exposure. One method is to use a reflected-light meter to measure the luminance range of the scene. First, read the light level of the darkest important shadow area in which you want to show texture and detail, then read the light level of the lightest important highlight area in which detail should be seen. Use an exposure between the two, as demonstrated at right.

An exposure halfway between the two extremes can be used, but an exposure about two-thirds of the way toward the shadow exposure is better if the shadow detail is particularly important or covers a large area. When a print is made from the negative, detail in slightly overexposed highlights can be printed in, but detail that is completely missing from underexposed shadow areas cannot be added later on.

Measuring the luminance range is more accurate than an overall reading when the light is contrasty and when you want to maintain a sense of texture and detail in both very light and very dark areas. In the photograph at left, for example, both the light wall and the child's dark dress are realistically rendered although the light coming from the window is quite harsh. With one or two stops less exposure the photograph would have been very different—the dress would have been as dark as the featureless shadow under the windowsill. This system works well until the range of contrast between highlight and shadow becomes so great (about five stops) that it is impossible to keep detail in both.

A similar method can be used with an incident-light meter by first reading the main source of light falling on the subject, then taking a reading in the shade. Use an exposure between the two.

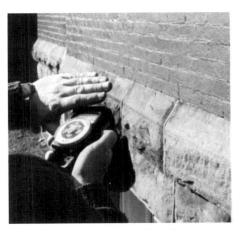

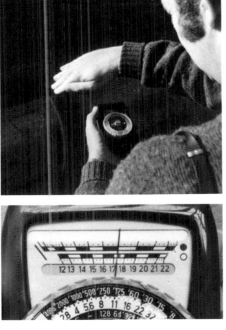

To make a luminance range reading, the photographer first measured the light reflected from the lightest part of the church wall (top), shading the meter cell from direct sunlight with his hand. The gauge (above) read just over 21. An exposure based only on this reading recorded highlights well, but shaded areas are underexposed (below).

The photographer took a second reading of a shaded section of the church wall (top). The needle on the gauge (above) pointed to just over 17. Using this reading alone, the picture (below) had good detail in shadow areas, but the highlights were overexposed.

To complete the luminance range reading, the photographer averaged the readings of the light and dark sections of the scene. He calculated his exposure from a reading of just under 19, slightly less than halfway between the 2 readings. This produced a photograph with good detail in both highlights and shadows (below).

Exposing for Specific Tones

A third method of exposure that can be even more precise than measuring the luminance range or making an overall reading involves using a reflected-light meter to measure the luminance of one important area, then finding the exposure that will render that area as dark or as light as you want it to be in the final print.

How is it possible to decide in advance what tone an important area will have in the final photograph? It is easy if you know that for any area of uniform luminance, a reflected-light meter will recommend an exposure that will render that luminance as middle gray in the print. If you take three meter readings to make three different photographs—first of white lace, then of medium-gray tweed and finally of black satin—the meter will indicate three different exposures that will record each subject as middle gray *(photographs, this page).*

However, you can choose how each subject will appear by adjusting the exposures indicated by the meter. If you give more exposure than the meter indicates, the area metered will be lighter than middle gray in the final print. Less exposure will make an area darker than middle gray. For example, if you want the white lace to appear realistically as very light but still showing substance and texture, expose two stops more than the meter recommends. If you want the black satin to appear rich and dark with full texture, expose two stops less than the meter recommends. If you want the tweed to appear as medium gray, use the exposure given by the meter.

Two areas often metered when calculating exposures this way are skin tones and shadow areas. An exposure for a portrait is often based on the skin tone of the subject. While clothing and background can vary from very light to very dark, most people's skin tones in sun or artificial light are realistically rendered within only about a three-stop spread. Very dark skins seem natural when they are printed as middle gray or slightly darker. Average light-toned skins appear natural one stop lighter than middle gray. Extremely light skins can appear as light as two stops above middle gray. If you want to use a skin tone as the basis for exposure, meter the lighter side of the face (if one side is more brightly lit than the other). Then think ahead to how you want the skin to appear in the final print. For dark skin, use the exposure indicated by the meter; for medium light, give one stop more exposure than indicated; for unusually pale, give two stops more.

The other area frequently metered as a basis for exposure is the darkest area in which the photographer wants to keep a full sense of texture and detail. In the photograph opposite, this is the woman's hair and the shadowed part of the wall to her right. If you want a shadow area to appear very dark but with objects and details still clearly visible, meter the area and then expose two stops less than the meter indicates. This is the minimum exposure that will produce full shadow detail. If less exposure is given, dark areas may be solid black in the print.

When you change the exposure indicated by the meter, remember that this system requires very careful metering of specific areas. (See the following pages for more about how to meter specific areas.) Remember also that changing the exposure affects all the values in the print, not just the one you meter. All areas will keep their luminances relative to each other—the woman's face *(right)* will always be lighter than her hair or the wall—but all will be either lighter or darker as the scene is given more or less exposure.

white lace given exposure suggested by meter

white lace given 2 stop more exposur

gray tweed given exposure suggested by meter

black satin given exposure suggested by meter

black satin given 2 stop less exposur

A reflected-light meter measures the average luminance of light reflected by an area, then indicates an exposure that will render that luminance as middle gray in the final print (see photographs above left). If you want a specific area to appear darker or lighter than middle gray, you can measure its luminance and then give less or more exposure than the meter indicates (above right). The gray scale and chart (opposite) show how much a middle-gray value would change with changes in exposure. The chart is based on material developed by Ansel Adams (see Bibliography).

Exposing Black-and-white Film for Specific Tones

Four stops more exposure than indicated by meter. Maximum white of the paper base. Whites without texture, glaring white surfaces, snow in flat sunlight, light sources.

Three stops more exposure. Near white. Highlights with first sign of texture, very bright cement, snow in diffused light. In the photograph right, the lightest parts of the flower.

Two stops more exposure. Light gray. Highlights with full texture and detail, very light skin, sand or snow lit from the side, very light fabrics with full sense of texture.

One stop more exposure. Medium-light gray. Average light-toned skin, light stone, shadows on snow in a scene that includes both shaded and sunlit snow.

Exposure indicated by meter. Middle gray. Neutral gray test card of 18 percent reflectance, dark skin, clear north sky (panchromatic rendering). The lightest part of the wall.

One stop less exposure. Medium-dark gray. Dark stone, average dark foliage, shadows in landscape scenes, recommended skin shadow value for portraits in sunlight.

Two stops less exposure. Dark gray. Shadow areas with full texture and detail, very dark soil, very dark fabrics with full texture. The woman's hair and shadowed wall to her right.

Three stops less exposure. Gray-black. Darkest gray in which any sense of texture and detail remains.

Four stops less exposure. Near black. First step above complete black in the print, slight tonality but no visible texture. The woman's black velvet dress.

Five stops less exposure than indicated by meter. Maximum black that paper can produce. Doorway or window opening to unlit building interior.

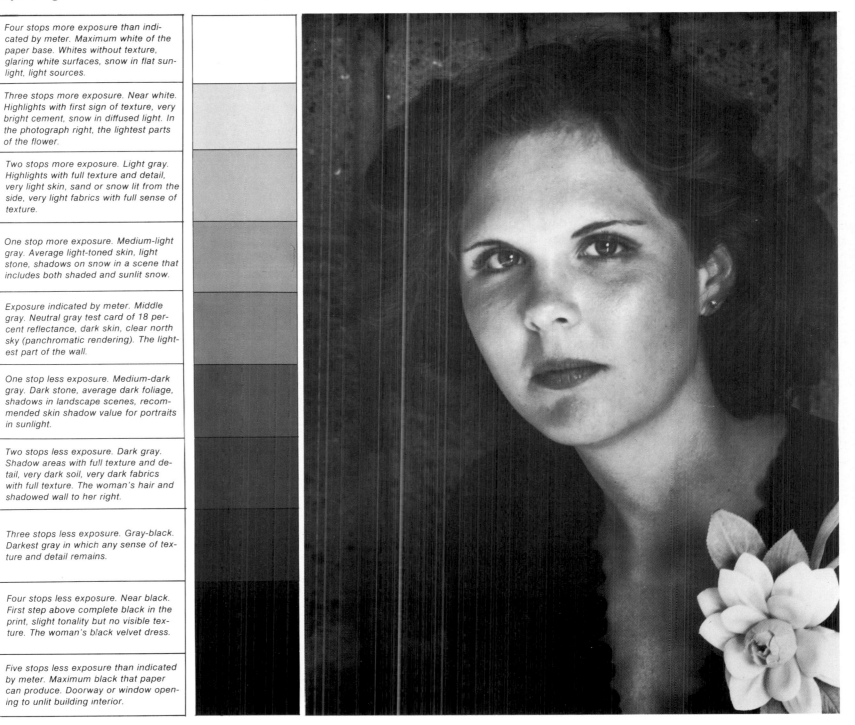

Spot Meters and Substitution Readings

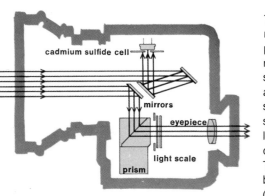

The operating principle of a spot meter such as the Minolta (below) is shown in the greatly simplified diagram above. Part of the light entering through the focusing lens is redirected by a mirror and prism to pass through the exposure scales and eyepiece lens, so that the photographer can aim the meter at his target. The rest of the light is reflected toward the light-sensitive cadmium sulfide cell. In front of the cell is a shield with a small opening, and this shield blocks most of the light; only the small fraction reflected by a small part of the scene gets through to be measured. The reading is visible over the scene as it is viewed through the eyepiece.

There are times when you will want to measure the luminance of only a small part of a scene. A spot meter measures reflected light, but of only a very small section of the scene in front of it. Where an ordinary reflected-light meter measures light over an angle of 30° to 50°, a spot meter can measure a 1° angle or less. It can read large objects at a great distance or very small objects close up. The side of a building from several blocks away, a person's face at 20 feet (6.1 m) or a dime at one and a half feet (.5 m) can all be read with a 1° spot meter. It is an often expensive tool, used primarily by professional photographers and advanced workers, but it is useful when precise meter readings of one or more key areas are required since the objects in a scene can vary considerably in luminance.

Looking through the viewfinder of one type of spot meter, you see a part of the scene *(right)* through an optical system that magnifies the image. A small circle in the center of the viewing screen indicates the precise area being measured.

A spot meter is particularly useful when you want to base your exposure on one important tone in a scene, such as the sunlit side of a person's face. It can be difficult to get close enough with an ordinary meter to take an accurate reading without shading the area with the meter or part of your body. A spot meter can make an accurate reading of a small, backlighted subject by reading only the subject and excluding the brighter background. Even areas that are relatively large can be read more accurately with a spot meter since there are often variations in surface luminance, such as small but very bright reflections, that can influence an ordinary meter's reading too much.

What do you do if you can't get close

The spot meter's lens takes in only a small section of the photographic scene, but the image observed in the eyepiece is magnified 4 times. The actual area measured for reflected light (small circle) is a very small part of the visible scene, covering just 1 degree. To use this particular meter, a photographer sets the outer dial to the film's ASA rating (bottom), and points the instrument so that the small aiming circle is on the area to be measured; the inner dial then moves automatically to line up the proper aperture-shutter speed combinations. The short, innermost scale lists frames-per-second settings for motion-picture cameras.

enough to the subject to make a reading and you don't have a spot meter that can make a reading at a distance? The solution is to take a substitution reading. Suppose you are photographing a boat, but the area of water between you and it makes it impossible for you to walk over to make a reading directly. You can often find an object with a similar tone and in similar light nearby that can be metered instead.

One object always with you that can be metered is the palm of your hand. Average light-toned skin is about one stop brighter than the middle-gray tone for which meters calibrate an exposure, so if your skin is light, give one stop more exposure than the meter indicates. If your skin is dark, use the indicated exposure. Metering your palm is a good technique when you are photographing street scenes or other fast-changing situations (top right).

Another useful substitution reading is from a standard gray test card. This is a piece of 8 x 10-inch cardboard with a gray side that reflects 18 percent of the light falling on it and a white side that reflects 90 percent of the light. Since light meters are calibrated around a middle-gray tone of about 18 percent reflectance, a reading from a gray card produces an accurate exposure if the card is placed so that it receives the same light from the same angle as the subject (bottom right). If the light is very dim, make a reading from the white side of the card; it reflects five times as much light as middle gray, so increase the indicated exposure five times (two and one-third stops).

A gray card is often used to balance the light in a studio setup or when copying an object such as a painting. It is also useful in color photography as a standard against which the color balance of a print can be matched.

For photographing fast-moving situations such as street scenes, metering the palm of your hand makes a quick substitution reading. Hold your palm so that the light on it is about the same as on the people or objects you want to photograph. If your skin is an average light tone, expose 1 stop more than the meter indicates.

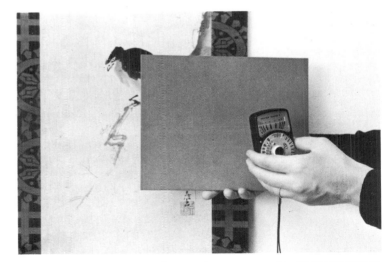

An accurate exposure can be calculated by metering the luminance of a standard gray test card. The card is placed so that it receives the same amount of light from the same angle as the subject. When you meter any object at close range, hold the meter so that it does not cast a shadow on the area being metered.

Built-in Meters

Many photographers, even some professional photographers who used to feel that only hand-held meters were accurate enough for critical metering, now use exposure meters built into cameras. Built-in meters, like hand-held, reflected-light meters, measure the light reflected or produced by objects in their view and then calculate an exposure setting.

However, most built-in meters do not average readings evenly over the entire scene. Many are center weighted and base the exposure mostly on objects at the center of the scene. It is important to know what part of the scene is being metered; if your camera has a built-in meter, consult the instruction book to find out what kind of weighting it has.

In manual camera operation you adjust the shutter speed and/or aperture until a needle pointer or other system visible in the viewfinder indicates a correct exposure for an average scene. Some cameras set the shutter speed or aperture automatically. Aperture-priority operation lets you choose the f-stop; after metering the scene, the camera sets the shutter speed. Shutter-priority operation lets you choose the shutter speed; after metering, the camera sets the aperture.

Whatever the metering system, the judgment of the photographer is still an important factor. As shown at right, you may want to alter the camera's suggested setting, and most automatic meters also allow for manual operation or are capable of being overridden. Again, the instruction book will explain how.

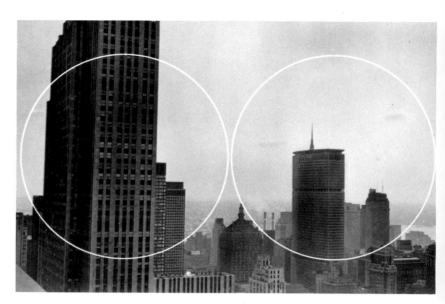

With a built-in meter, just as with a hand-held one, it is important to be aware of what areas are being metered. In an averaging meter, one cell measures light reflected from the right half of the scene (shown here by the right circle), the other from the other half. In this picture, so much light was metered from the sky that the reading indicated too little exposure; the sky is properly exposed but the buildings are too dark and lack detail.

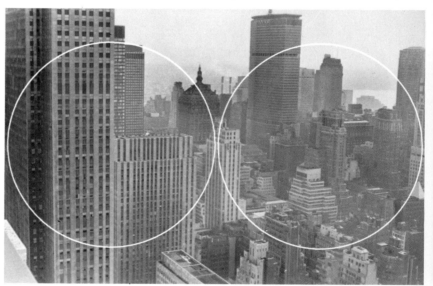

To determine the proper exposure for the buildings, light reflected from them should be dominant in the viewfinder when the reading is made. This is done simply by pointing the camera slightly down so that the meter's cells "see" less of the sky and more of the buildings, as indicated by the circles.

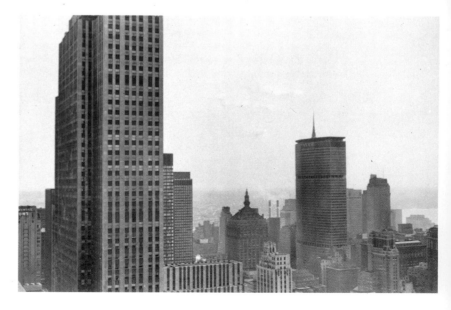

Having set the correct exposure by measuring the light reflected from the buildings, tilt the camera up once again, returning to the original composition. This time the buildings are lighter and reveal more detail. The sky is lighter also, but there is no significant detail there at either setting. Light areas, such as the sky, can easily be darkened during printing (see pages 170–171).

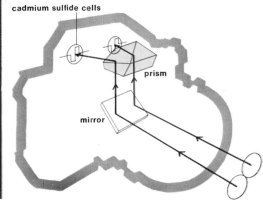

cadmium sulfide cells

prism

mirror

The sky behind this girl was included in the area metered and caused the light meter to set the exposure incorrectly. The girl's face came out too dark because the overall brightness level was high. Therefore the meter indicated too little exposure.

In an averaging-meter system in a typical single-lens reflex camera, light enters through the camera lens, strikes the angled mirror and is reflected upward to the prism. Cadmium sulfide cells are mounted on either side of the eyepiece and aimed at the prism; each measures light reflected from part of the picture area. The cells are interconnected to give an average reading of light reflected from the scene. To determine the proper exposure, the photographer generally watches a pointer or bar, visible in the viewfinder, and adjusts the f-stop or shutter speed setting. When the pointer or bar is centered or lines up with another pointer, the exposure is correctly set. Not all built-in meters are of the averaging type. Below are some of the alternate systems.

To meter for a portrait, come close enough so that the meter reads mostly skin tones but not so close that you cast a shadow on the subject. Adjust the exposure as described on pages 112–113, for light-toned skins expose 1 stop more than the meter suggests.

center weighted

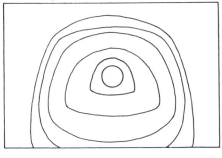

bottom weighted

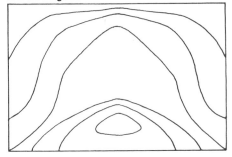

Having set the correct exposure, return to the original position to make the photograph. The girl's face was more accurately rendered by this method. An exposure meter that automatically sets f-stops or aperture must sometimes be manually overridden, as it was here, if a correct exposure is to be made.

Out-of-the-Ordinary Exposures

If there is light enough to see by, there is probably light enough to make a photograph—sometimes a very fine one. In the picture opposite, the emotion of a great conductor giving his farewell concert is revealed in a powerful and sensitive image. Factors that can be faults in other photographs came together to make a strong image in this one; lack of detail in both shadows and highlights, blur caused by motion during the exposure, graininess and poor definition all convey the emotion of the moment.

If you want to photograph under unusual lighting conditions, such as the spotlighted stage scene opposite, you may not be able to get a reading from your exposure meter if the light level is very low. Try metering a white surface such as a white paper or handkerchief; then give about two stops more exposure than indicated by the meter.

The chart opposite gives some starting points for exposures with ASA 400 film. Since the intensity of light will vary widely, bracket your exposures by making at least three pictures: (1) using the recommended exposure, (2) giving one and one-half to two stops more exposure and (3) giving one and one-half to two stops less exposure. One of the exposures should be printable, and the range of exposures will bring out details in different parts of the scene.

If the exposure time is one second or longer, you may find that the film was underexposed even though you thought you calculated the exposure correctly. In theory, a long exposure in very dim light should give the same result as a short exposure in very bright light. According to the photographic law of reciprocity, light intensity and exposure time are reciprocal; an increase in one will be balanced by a decrease in the other. But in practice the law does not hold for very long or very short exposures. At exposures of one second or longer (and at exposures much shorter than $\frac{1}{1000}$ second) you get a decrease in film speed and consequently underexposure, the so-called reciprocity effect.

To make up for the decrease in effective film speed, you must increase the exposure. The exact increase needed varies with different types of film, but the chart at right gives approximate amounts. Bracketing is a good idea here also. Make at least two exposures: one as indicated by the chart, plus one more giving additional exposure. Some meters are designed to calculate exposures of several minutes' duration or even longer, but they do not allow for reciprocity effect. The indicated exposure should be increased according to the chart.

Very long exposure times also cause an increase in contrast since the prolonged exposure has more effect on highlights than on shadow areas. This is not a problem in most photographs, since contrast can be controlled when the negative is printed. But where contrast is a critical factor, it can also be decreased by decreasing the film development time—about 10 percent for exposures of one second, up to 50 percent or more for very long exposures. The amount varies with the film; exact information is available from the film manufacturer. The reciprocity effect in color film is more complicated since each color layer responds differently, changing the color balance. See pages 284–285 for more information.

preventing reciprocity effect: corrections for very long exposures					
indicated exposure	open up aperture setting	or	increase exposure to	also	decrease development time
1 sec	1 stop more		2 sec		10%
10 sec	2 stops more		50 sec		20%
100 sec	3 stops more		1200 sec		30%

At exposure times of 1 sec or longer, film does not respond exactly as it does at shorter shutter speeds. One unit of light falling on film emulsion for 1 sec has less effect than 10 units of light falling on the same emulsion for $\frac{1}{10}$ sec. This reciprocity effect during long exposure times means that exposures must be increased or the film will be underexposed, particularly in shadow areas. To compensate for this, increase the indicated exposure as shown in the chart above. Highlights are less subject to reciprocity effect during long exposures, so in order to prevent excessive density in the highlights when you increase the exposure, decrease the development time as shown in the chart.

suggested exposures for hard-to-meter situations		
situation	approximate exposure for ASA 400 film	
stage scene, sports arena, circus event	1/60 sec	f/2.8
brightly lighted downtown street at night, lighted store window	1/60 sec	f/4
city skyline at night	1 sec	f/2.8
skyline just after sunset	1/60 sec.	f/5.6
candlelight scene	1/8 sec	f/2.8
campfire scene, burning building at night	1/60 sec	f/4
fireworks against dark sky	1 sec (or keep shutter open for more than one display)	f/16
fireworks on ground	1/60 sec	f/4
television image:		
focal-plane shutter speed must be 1/8 sec or slower to prevent dark streak on screen	1/8 sec	f/11
leaf-shutter speed must be 1/30 sec or slower to prevent streak	1/30 sec	f/5.6

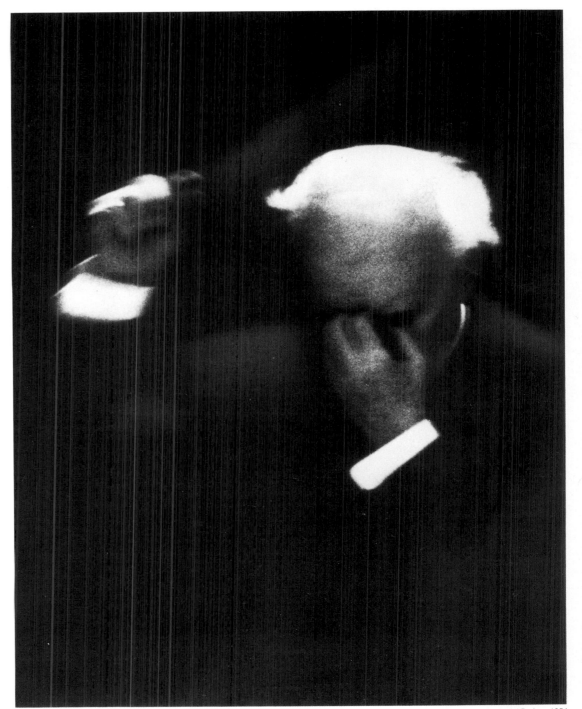

This powerful photograph of a great conductor overcome with emotion during his farewell concert is made even stronger by the harsh contrast of the overhead spotlighting. If a scene you want to photograph is difficult to meter, try one of the suggested exposures in the chart above. Make several exposures giving both more and less exposure than the chart suggests.

SY FRIEDMAN: *Arturo Toscanini Retires,* 1954

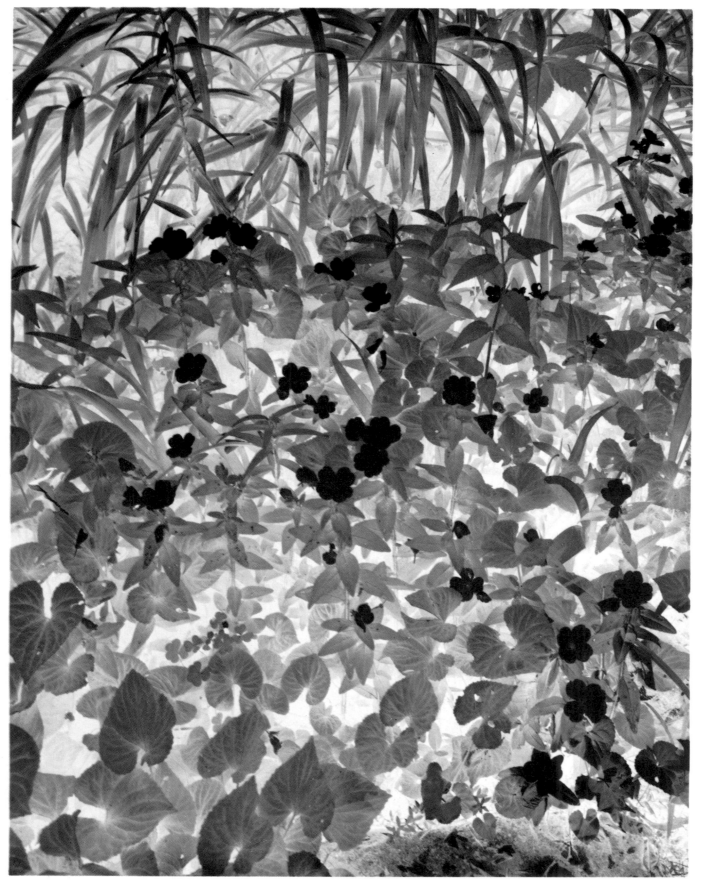

PAUL CAPONIGRO: *Negative Print*, 1963

6 Developing the Negative

How to Process Roll Film Step by Step 122

 Preparing Chemicals and Film 124

 Getting the Film into the Developer 126

 Stop Bath and Fixer Steps 128

 Washing, Drying and Protecting the Film 130

 Handling Chemicals 131

How Developer Chemicals Affect a Negative 132

 What Fixer Does 133

How Time and Temperature Affect Development 134

Exposure and Development: Under, Normal, Over 136

The Need for Proper Agitation . . . 138

. . . and Fresh Solutions 139

The Importance of Careful Washing and Drying 140

Care Prevents These Darkroom Disasters 141

Special Development Techniques 142

In one sense, the moment the camera shutter exposes the film, the picture has been made. Yet nothing shows on the film; the image is there but it is latent or invisible Not until it has been developed and printed is the image there to be enjoyed. How enjoyable it will be depends to a great extent on the care you use in darkroom work, for there are many opportunities in developing and printing to control the quality of the final photograph.

This control begins with the development of the negative. The techniques are simple and primarily involve exercising care in following standard processing procedures and in avoiding dust spots, stains and scratches. Control also includes the ability to adjust the developing process, when necessary, to suit individual taste—perhaps to produce especially fine grain.

This chapter describes both basic development techniques and somewhat more advanced material to give you greater control over your negatives. The skills needed to develop good negatives are quickly learned and the equipment needed is modest, but the reward is great—an increased ability to make the kind of pictures you want.

◀ *Printing a photograph as a negative image instead of as a positive one often makes the literal recording of a scene less important (as with the spring wildflowers, opposite) and strengthens the graphic elements of line and form. The dark shadow areas in the original scene (or in a positive print) become light so that light seems to come from behind or within the subject. The dark objects in this print (light-toned flowers in the original scene) appear to float on the surface of the print. Compare Minor White's negative print, page 83.*

How to Process Roll Film Step by Step

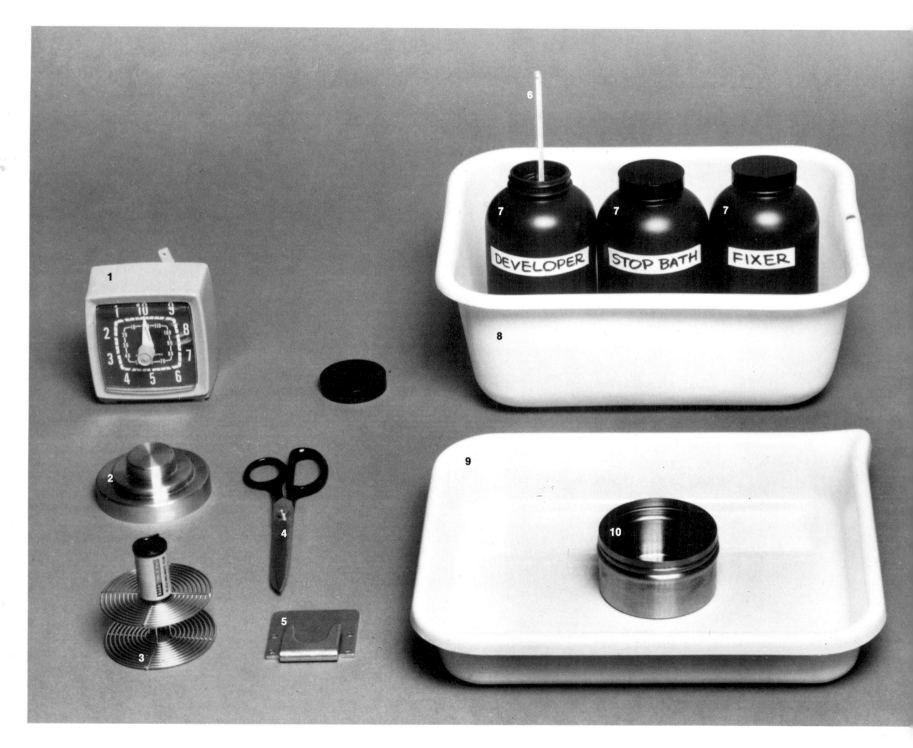

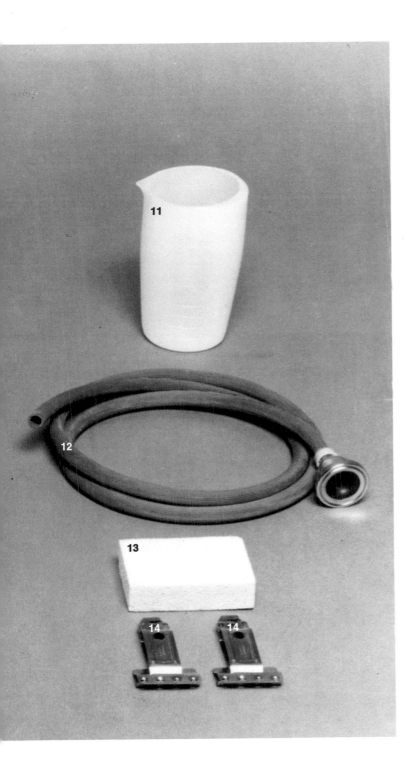

1 | interval timer
2 | developing tank cover and cap
3 | developing reel
4 | scissors
5 | film cassette opener
6 | thermometer
7 | chemical solutions
8 | temperature control pan
9 | temperature control tray
10 | developing tank
11 | one-quart graduate
12 | washing hose
13 | photo sponge
14 | film drying clips

Developing your first (and all future) rolls of film will be simplified if you arrange your equipment in an orderly and convenient way. Development begins in total darkness and the rest of the process, once begun, moves briskly.

You will need a developer to change the latent (still invisible) image on your exposed film to a visible one. There are three basic types of developers: all purpose, fine grain and high energy. All-purpose developers such as Kodak D-76 or HC-110, Ilford ID-11, Ethol TEC or UFG and Edwal FG7 work well for most uses. With most films they produce a negative of normal contrast and moderate to low graininess. High-energy developers such as Acufine and Diafine are useful for developing film exposed at very low light levels, but at the price of greater grain and some loss of sharpness. Fine-grain developers such as Kodak Microdol-X, Ilford Microphen and Edwal Super 20 and TEC all produce somewhat finer grain but with a slight loss in contrast and apparent sharpness. The dilution of certain developers can be varied to adjust grain or sharpness; see manufacturer's data. However, the developer is only one factor that influences grain (pages 88–89). The best choice for a beginner is to pick one easily available, all-purpose developer and become familiar with it before experimenting with other types.

You will also need a stop bath to halt the action of the developer. Some photographers use only a plain water rinse for a stop bath; others prefer a dilute solution of acetic acid. An "indicator" stop bath is available that changes color when it is exhausted. The fixer (sometimes called hypo) dissolves unexposed silver in the emulsion, which will darken in time unless removed. Optional, but highly recommended, are a hypo neutralizing agent (or hypo clearing agent) to aid in washing the film and a wetting agent such as Kodak Photo-Flo to prevent water from spotting the film as it dries.

Check the time and temperature recommended by the manufacturer for the film and developer combination you are using. 68° F (20° C) is generally the preferred temperature, but you may have to use a higher temperature (and a correspondingly shorter development time) if your tap water is warm. Running water is used to wash the film, and the temperatures for all solutions including wash water should be within one or two degrees of each other since excessive temperature changes can cause increased graininess in the film. After mixing and diluting the solutions (page 131) and adjusting their temperatures (step 1, next page) fill the developer tank and the temperature control pan and tray with water at the developing temperature. Place the chemical bottles in the pan and the developer tank in the tray.

Preparing Chemicals and Film

1 | adjust the temperature

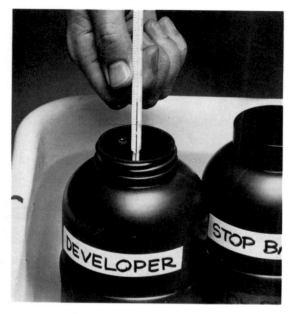

Check the temperatures of the developer, stop bath and fixer (rinse the thermometer each time). Adjust the temperature of the developer precisely; the temperatures of the other solutions should be within 1 or 2 degrees of the developer. Ideally, there should be no more than 2 degrees difference in temperature between any of the solutions.

To heat up a solution, run hot water over the sides of the container (a metal one will change temperature faster than glass or plastic) or place it in a pan of hot water. Placing a container in a tray of ice water or in a refrigerator will cool down a solution in just a few minutes; cooling by running tap water over the container can take a long time unless the tap water is very cold. Stir the solution gently from time to time; the temperature of the solution near the outside of the container will change faster than at the center.

Recheck the water in the temperature control pan and tray and adjust, if necessary, to the development temperature.

2 | fill the tank with developer

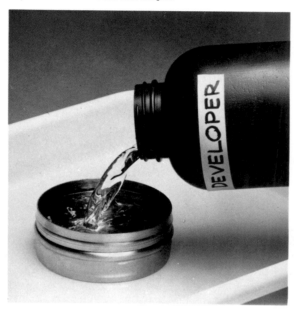

After emptying the tank of the water that was used to stabilize its temperature, fill the tank with developer. (See page 131 for information on an optional presoak of the film in water.)

3 | set the timer

The interval timer is set—but not started—in advance of development (in the processing procedure shown here), since actual development of the film begins while the room is in total darkness. Development times for various brands of film are listed in a chart for "small-tank development" in the instructions that come with the developer or film. Follow the recommended time closely or the negatives will be too thin and flat or too dense and contrasty.

4 | open the film cassette

Be sure you have a completely dark area in which to load the film into the developer tank. A room is not dark enough if you can see the objects in it after staying 5 min with all lights out. Lock the door.

In the dark, open the roll of film. To remove film from a standard 35mm cassette, find the spool end protruding from one end of the cassette. Pick up the cassette by this end, then pry off the other end with the cassette opener or a soda-bottle opener. Slide the spool out. With larger sizes of roll film, which are not contained in cassettes, break the paper seal and unwind the paper until you reach the film. Let the film roll up as you continue unwinding the paper; when you reach the other end of the film, gently pull it free of the adhesive strip that holds it to the paper. To open a plastic cartridge used in an instant-loading camera, twist the cartridge apart and remove the spool. Do not unroll film too rapidly or it may be marred by static electricity—a tiny bit of light, but enough to streak the film.

5 | square off the film end

Try to handle the film by the edges only. If you touch the surface, oils from the skin may be left there that can cause uneven development or pick up dust. With the scissors, cut off the protruding end of 35mm film to square it off. Do not try to tear the film; besides injuring the emulsion the friction or tearing could cause a flash of static electricity. Keep the scissors handy—they will be needed again.

6 | thread the film onto the reel

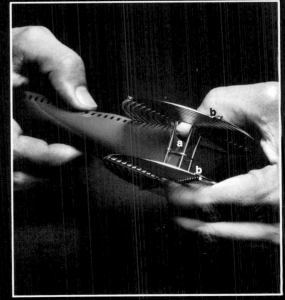

Hold the spool in either hand so that the film unwinds off the top. Unwind about 3 in (8 cm) and bow it slightly between thumb and forefinger. Don't squeeze too hard or you may crease the film and cause crescent-shaped marks in the negative.

The reel must be held properly in the other hand or the film will not slip into the grooves. Each side of the type shown is made of wire in a spiral starting at the core of the reel (a) and running to the outside: the space between the spirals of wire forms the groove that holds the film edge. Hold the reel so that the sides are vertical and feel for the blunt ends (b) of the spirals. Rotate the reel until the ends are at the top. If the ends then face the film, the position of the reel is correct.

Now insert the squared-off end of the film into the core of the reel. Rotate the reel away from the film to start the film into the innermost spiral groove. Since this and the next step must be done in the dark, practice first with a junked reel of film until you can perform both steps smoothly with eyes shut.

Other types of reels are also available, for example, plastic reels or aprons. See individual instructions for loading.

To finish threading the reel, place it edgewise on a flat surface. Continue to hold the film spool as before with thumb and forefinger bowing the film just enough to let it slide onto the reel without scraping the edges. Now unwind a short length of film and push the film so that the reel rolls forward. As it rolls it will draw the film easily onto the grooves. When all the film is wound on the reel, cut the spool free with the scissors.

Check that the film has been wound into an open spiral, each coil in its groove. Determine with a junked reel how your film should fit on your reel. If, after loading, you find more—or fewer—empty grooves than the length of your film allows for, gently unwind the film from the reel, rolling it up as it comes, then reload the reel. Unless the reel is correctly loaded, sections of film may touch, preventing development at those points (page 141).

Now actual development can begin, and you must do two things at once. With one hand drop the loaded reel gently into the developer in the tank. Simultaneously, with the other hand feel for the starting lever of the timer (you are still in total darkness). As the reel touches the bottom of the tank, start the timer.

Alternate procedure. *The reeled film is placed in an empty tank and the developer added later. This procedure can be used if your developing area is not absolutely dark or if you prefer only to load the film in the dark and then add the developer with the lights on.*

Load the film onto a developing reel in a place that is absolutely dark, such as a closet. If you cannot find any completely dark area, a changing bag can be used to reel the film; your hands fit inside the light-tight bag, along with film, reel and the empty tank and its cover.

Place the loaded reel in an empty, dry tank and put on the tank's light-tight cover. The film is shielded from light when it is inside the tank with cover in place and it can then be taken to the developing area.

Fill the tank with developer, pouring it through the special pouring opening in the tank cover. Place the central cap over the pouring opening in the cover, start the timer and proceed with step 10.

Put the light-tight cover on the developing tank. (The tank shown here has a central cap over a pouring opening in the cover. Be sure this cap is in place.) Lift the tank out of the temperature control bath immediately, and tap the bottom of the tank lightly on a hard surface. This will dislodge air bubbles and keep them from transferring to the film. Now the room lights may be turned on.

10 | agitate

As soon as the lights are on, agitate the tank. Hold it so its cover and central cap won't come off. Gently turn it upside down, then right side up again. This agitation is an essential part of the developing process because it brings fresh developer solution into contact with the film emulsion. Every 30 sec agitate for 5 sec by inverting the tank 2 or 3 times. Leave the tank in the temperature control bath between agitations. Some tanks cannot be inverted without leakage. One type has a crank in the lid that turns the reel in the solution. Others have to be used in the dark so the film can be agitated by lifting the reel in the developer.

11 | remove cap from the pouring opening

About 30 sec before development is completed, get ready to empty the developer from the tank. Remove the cap from the center pouring opening— BUT DO NOT REMOVE THE TANK COVER ITSELF.

12 | pour the developer back

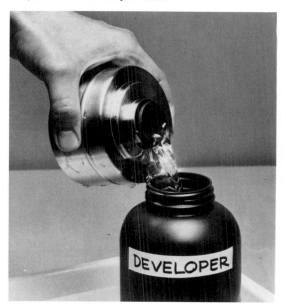

Hold the tank so the cover cannot fall off. A few seconds before the timer signals that development is completed, start pouring the developer from the tank into the developer bottle. If the bottle has a small mouth, or if the tank does not pour out smoothly, use a funnel to speed pouring. As soon as the tank is empty, proceed immediately to the next step, pouring in the stop bath. (One-shot developers are not saved. See note, page 131.)

Stop Bath and Fixer Steps

13 | fill the tank with stop bath

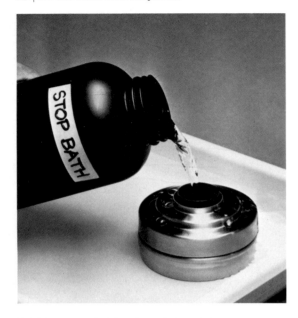

Quickly pour stop bath into the tank through the center pouring opening of the cover. *DO NOT RE-MOVE THE TANK COVER. Fill the tank just to over-flowing to make sure the film is entirely covered.* On some tanks the light baffle in the opening is ar-ranged so that the tank must be held at a slight angle to speed the filling.

14 | agitate

After replacing the pouring opening cap, agitate the tank gently for about 15 sec.

15 | pour back the stop bath

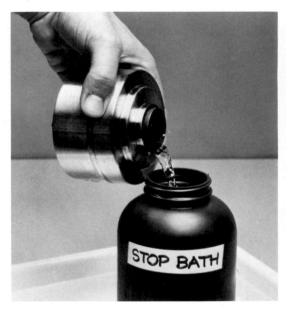

Empty the tank of stop bath. *DO NOT REMOVE THE TANK COVER.* Some photographers throw out used stop bath, since it is inexpensive and easier to store as a concentrated solution. Obviously, if you are using water as a stop bath, it need not be saved.

16 | fill the tank with fixer

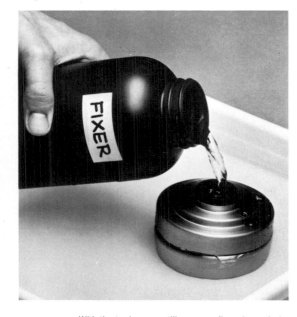

With the tank cover still on, pour fixer through the pouring opening in the cover. Fill to overflowing.

17 | set the timer

Turn the timer pointer to the fixing time recommended in the chemical manufacturer's instructions. Be sure to use the figures specified for films; most fixing solutions can also be used to process prints, but the dilutions and times required are different

18 | agitate

Agitate the fixer-filled tank several times during the fixing period as in step 10. When the timer signals that the period is up, pour the fixer back into its container. The entire cover of the tank may now be removed since the film is no longer sensitive to light. Examine a few frames at the end of the roll. Make sure they do not have a milky white appearance. A general rule is to fix for twice the time it takes to clear the film of its milky appearance. If the film still has a milky cast after fixing for the length of time suggested by the manufacturer, the fixer is very weak and should be discarded. Refix the film in fresh fixer.

Washing, Drying and Protecting the Film

19 | wash the film

An optional but highly recommended step before washing is to treat the film with a hypo neutralizing solution (hypo clearing agent). This greatly reduces washing time and removes more of the fixer (hypo) than water alone. Follow the manufacturer's directions for use.

Adjust faucets to provide running water at the development temperature. Leave the reel in the open tank in the sink and insert the hose from the tap into the core of the reel. Let the water run rather slowly; too much force can damage the film emulsion: it is relatively soft at this point. If one is available, you can use a specially designed—and more efficient—washing tank. Empty the water and refill several times; fixer is heavier than water and may settle at the bottom of the tank. About 30 min of washing is needed to prevent later deterioration of the image. Much less wash time is needed if hypo neutralizer is used.

After washing, treat the film in a wetting solution, such as Kodak Photo-Flo, to help prevent water spots. Follow the manufacturer's directions for use.

20 | dry the film

Unwind the film from the reel and hang it up to dry immediately. Unwind gently; the emulsion is wet and soft, and easily scratched. Do not be tempted to examine the negatives until they are dry; dust quickly accumulates on damp film. Attach a clip to one end of the film and hang it in a dust-free place where the temperature will remain constant during the drying period—1 or 2 hrs at average room temperature. A film-drying cabinet is the best place. At home, a good dust-free location is inside a tub or shower enclosure with shower curtain or door closed. Attach a weighted clip to the bottom of the film. Excess water can be removed from the surface by very gently drawing a damp, absolutely clean photo sponge, held at a 45° angle, down both sides of the film.

21 | protect the dry negatives

When the film is dry, cut it into appropriate lengths to fit into protective sleeves. Don't cut the film into separate frames; that will make it difficult to handle during printing. Hold film only by its edges to avoid fingerprints and scratches. Careful treatment of negatives now will pay off later when they are printed.

Developing the Negative—A Summary

Preparation. *Mix chemicals needed. Check development time and temperature recommended by film or developer manufacturer. Adjust temperatures for all solutions including water to within a degree or two of developer temperature. Fill developing tank with developer. Set timer.*

Loading film. *In total darkness, load film into developing reel.*

Development. *Put loaded reel into tank filled with developer, put cover on tank. (If sink area cannot be made completely dark, load film on reel in any area that is completely dark. Put reeled film into empty, dry tank and close with light-tight cover. Tank can now be handled with lights on. Add developer through pouring opening in cover and proceed with development.)*
Immediately start timer. Rap bottom of tank on hard surface to dislodge air bubbles and invert tank gently several times to agitate the solution. Repeat agitation for 5 sec out of every 30 sec of developing time. Lights can be turned on when tank's light-tight cover is in place. Shortly before development time is over, remove small cap from center of pouring opening of lid and pour out developer. Do not remove entire cover.

Stop bath. *Quickly fill tank through pouring opening with stop bath (plain water or stop bath solution). Replace cap and agitate 15 sec. Pour out.*

Fixing. *Fill tank with fixer. Agitate 15 sec, then occasionally during fixing time recommended by manufacturer. Tank cover can be removed after a minute or two.*

Hypo neutralizing. *An optional but highly recommended step that reduces washing time. Follow manufacturer's directions for use.*

Washing. *Run gentle flow of water into center of tank. Empty and refill tank several times. Wash 30 min, less if hypo neutralizer is used. After washing, treat film with a wetting solution to help prevent spotting as film dries.*

Drying. *Hang to dry in dust-free place. Gently wipe excess water from surface of film with clean, damp photo sponge. Hang clip on bottom of film to prevent curling. When dry, cut into convenient lengths and store in negative envelopes.*

An optional step: presoak. *Before placing film in developer, presoak film in plain water at the same temperature as the developer. This washes off any dust that may be on the negative. The water wets the emulsion uniformly, which may help prevent uneven development. Agitate gently for one minute, then drain and fill tank with developer. Extend development time by 10 percent; the developer will penetrate the wet emulsion more slowly.*

See pages 232–233 for information on developing sheet film.

Chemicals—A Summary

Record keeping. *After processing film, write down the number of rolls developed on a label attached to the developer bottle—if you are not using a one-shot developer (see below). The instructions that come with developers tell how many rolls can be processed in a given amount of solution and how to alter the procedure if the solution is reused. Each succeeding roll of film requires either extra developing time or, with some developers, addition of a replenisher. Also record the date the developer was first mixed, because even with replenishing most developers deteriorate as time passes. Check the strength of the fixer regularly with a testing solution made for that purpose.*

Replenishing developers. *Some developers may be used repeatedly before being discarded if you add additional chemicals to them to keep the solution up to full strength. Carefully follow the manufacturer's instructions for replenishment.*

One-shot developers. *If you develop a roll or two of film only occasionally, it may be more practical for you to use a one-shot developer, which is designed to be used once and then thrown away. This will give more consistent results than a developer that is used and saved, perhaps for a long period of time, before being used again.*

Mixing dry chemicals. *Add them to water at the temperature suggested by the manufacturer. Stir gently until dissolved. If some of the chemicals remain undissolved, let the solution stand for a few minutes. Be sure the solution has cooled to the correct temperature before using.*

Stock and working solutions. *Chemicals are often sold or mixed first as concentrated liquids (stock solutions). When the chemical is to be used it is diluted into a working solution, usually by the addition of water. The dilution of a liquid concentrate may be given on an instruction sheet as a ratio, such as 1:3. The concentrate is always listed first, followed by the diluting liquid. A developer to be diluted 1:3 means 1 part developer and 3 parts water. To fill a 16-oz (500 cc) developing tank with this dilution, use 4 oz (125 cc) developer and 12 oz (375 cc) water.*

Avoid unnecessary oxidation. *Oxygen speeds the exhaustion of most chemicals. Don't use the "cocktail shaker" method of mixing chemicals by vigorously shaking the solution; this rapidly adds unwanted oxygen. Store all chemicals in tightly closed containers to prevent their exposure to oxygen in the air. Developers are also affected by light and heat, so store them in dark-colored bottles at temperatures around 70° F (21° C), if possible.*

A caution about contamination. *Contamination—chemicals where they don't belong—can result in a plague of darkroom ills. Fixer on your fingers transferred to a roll of film being loaded for development can leave a neat tracery of your fingerprints on the film. A residue of one chemical in a tank can affect the next solution that comes in contact with it. Splashes of developer on your clothes will slowly oxidize to a brown stain that is all but impossible to remove. These problems and more can be prevented by taking a few precautions:*

Rinse your hands well when chemicals get on them and dry them on a clean towel; be particularly careful before handling film or paper. It isn't enough just to dip your hands in the water in a temperature control pan or print holding tray; that water may also be contaminated.

Use paper towels for drying, since cloth ones quickly become loaded with chemicals. If you are conservation minded, use a cloth towel, but wash it frequently.

Rinse tanks, trays and other equipment well both before and after use. Be particularly careful not to get fixer or stop bath into the developer; they are designed to stop developing action and that is exactly what they will do.

Wear old clothes or a lab apron in the darkroom.

Keep work areas clean and dry. Wipe up spilled chemicals and wash the area with water.

While most photographic chemicals can be handled without danger to your health, keep them out of your mouth and eyes. Some people are allergic to certain chemicals—often the Metol in developers—and develop a skin rash on contact with them. If this becomes a problem, you can wear rubber gloves when handling solutions, but see a doctor first. A few photographic chemicals are highly toxic, so read labels carefully before using a new chemical.

How Developer Chemicals Affect a Negative

Photo supply stores sell a variety of developers that simply need to be added to water; all the chemicals have been added in the proper amount. But a general knowledge of developer chemicals is useful background information since you may sometimes mix a developer from a formula.

The most important ingredient in any developer formula is the developing or reducing agent. Its job is to free metallic silver from the emulsion's crystals so it can form the image. These crystals contain silver atoms combined with bromine atoms in the light-sensitive compound silver bromide. When struck by light during an exposure, the silver bromide crystals undergo a partial chemical change. The exposed crystals (forming the latent image) provide the developing agent with a ready-made working site. The reducer cracks the exposed crystals into their components: metallic silver, which stays to form the dark parts of the image (see pictures, this page), and bromine, which unites chemically with the developer.

Some reducing agents are used alone, but often two together assist each other. Many formulas consist of a combination of the compounds Metol and hydroquinone (called M.Q. formulas). The Metol improves film speed and tonal gradation while the hydroquinone increases density and contrast. Some other reducing agents are glycin and para-aminophenol (in fine-grain formulas) and phenidone (like Metol but less irritating to the skin).

Since most reducing agents work only in an alkaline solution, an alkaline salt such as borax or sodium carbonate is usually added as an accelerator. Some developers are so active that they will develop the unexposed as well as the exposed parts of the emulsion, thus fogging the negative; to prevent this a restrainer, usually potassium bromide, is added to some formulas. The bromide that is released by the reducing agent from the silver bromide crystals also has a restraining effect. Finally, since exposure to oxygen in the atmosphere causes a developer to lose its effectiveness, a preservative such as sodium sulfite may be added to prevent oxidation.

Electron microscope pictures of 4 emulsions show how exposed crystals of silver bromide (magnified 5,000 times) are converted to pure silver during development. At first (top) the crystals show no activity (dark specks on some crystals are caused by the microscope procedure). After 10 sec parts of 2 small clusters (arrows) have been converted to dark silver. After a minute, about half the crystals are developed, forming strands of silver. In the bottom picture all exposed crystals are developed; undeveloped crystals have been removed by fixer solution and the strands now form the negative images.

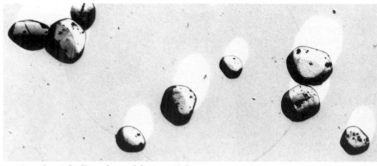
undeveloped silver bromide crystals

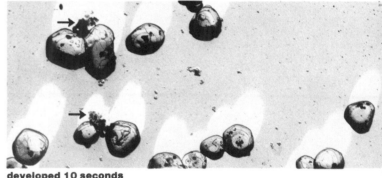
developed 10 seconds

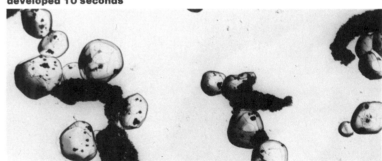
developed 1 minute

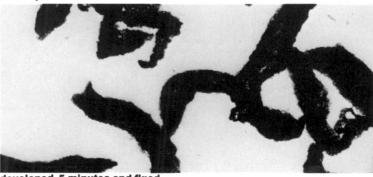
developed 5 minutes and fixed

not enough fixing

normal fixing

too much fixing

After the developer has done its work, the image on the negative is visible but very perishable. If exposed to light the entire negative will turn dark. To prevent this, the fixer sets the image permanently on the film and prepares it for printing—if it is used properly.

The fixing agent is needed because the negative image contains leftover crystals of silver bromide. They were not exposed, since they correspond to shadows in the scene, but they are still light sensitive and if allowed to remain will darken and cloud the image *(above left)*. The fixer prevents this by dissolving these crystals out of the emulsion.

The solvent for this process is sodium thiosulfate. (The early name for this substance was sodium hyposulfite, and hypo is still a common name for fixer.)

Ammonium thiosulfate, a fast-acting fixer, is also sometimes used. A hardening compound is generally part of the fixer solution. This prevents the film emulsion from becoming so soft or swollen that it is damaged during the washing that follows fixing.

Under normal conditions the fixer dissolves only the unexposed crystals of silver bromide and does not affect the metallic silver making up the image itself. But if the film is left too long in the fixer the image will eventually bleach *(above right)*.

Ordinarily, however, the danger is not too much fixing but too little. If the fixer is not given sufficient time to complete its work or if the fixer is exhausted, silver bromide crystals are left undissolved and will later darken.

How Time and Temperature Affect Development

Among the creative controls at a photographer's command, one of the most useful is development time. The longer the developer is allowed to act on the film, the greater the number of crystals converted to metallic silver and the darker the negative seems to become (opposite, left column). But the pictures show that the density of silver in the image did not increase uniformly. Increasing the development time caused a great deal of change in those parts of the negative that received the most exposure (the bright areas in the original scene—sky and house roofs). It caused some changes in those areas that received moderate exposure (the midtones—grass and side of large house), but only a little change where the negative received the least exposure (the shadow areas—trees and windows). In any negative, lengthening or shortening development time has a marked effect on contrast—the relationship between light and dark tones.

The ability of development time to control contrast and density is due primarily to the way the film emulsion is constructed. The crystals of silver bromide that will develop into the negative image lie both on and below the surface of the emulsion. As exposure increases, the number of exposed crystals and their depth in the emulsion also increase. When the developer goes to work, it gets at the surface crystals immediately but needs extra time to soak into the emulsion and develop the crystals below the surface, as illustrated in the photomicrographs on this page. Thus the total amount of time the developer is allowed to work determines how deeply it penetrates and how densely it develops the exposed crystals, while the original exposure determines how many crystals are available to be developed. See the next pages for examples of how

exposure and development time both affect the negative.

The rate of development changes during the process, as is shown in the examples opposite (left column). During the first seconds, before the solution has soaked into the emulsion, activity is very slow; the strongest highlights have barely begun to show up (top). Soon the solution soaks in enough to develop many of the exposed crystals; during this period a doubling of the development time will double the density of the negative (center). Still later, after most of the exposed crystals have been developed, the pace slows down again so that a tripling, or more, of the time will add proportionately less density than it did before (bottom).

The temperature of the developer also needs to be taken into account. Most photographic chemicals and even the wash water take longer to work as their temperatures drop. All solutions work faster at higher temperatures, but at around 80° F (27° C), the gelatin emulsion of the film begins to soften and becomes very easily damaged. The effects of temperature on the rate of development are shown opposite.

Charts that accompany films and developers show the recommended development times at various temperatures—the higher the temperature, the shorter the development time needed (chart, right). The temperature generally recommended is 68° F (20° C); this temperature combines the most efficient chemical activity with the least softening of the film emulsion and in addition is a practical temperature to maintain in the average darkroom. Higher temperatures may be recommended with very dilute developers. A higher temperature can be used when the tap water is very warm, as it is in many areas during the summer.

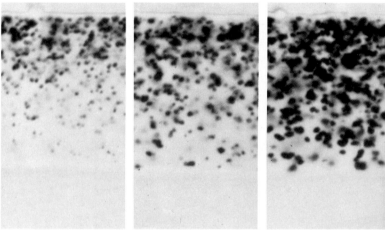

developed for 2 minutes **developed for 5 minutes** **developed for 15 minutes**

Grains of silver, enlarged about 2,500 times in this cross section of film emulsion, get denser as development is extended. Grains near the surface (top) form first and grow in size. As developer soaks down, subsurface grains form.

KODAK TRI-X PAN FILM

KODAK Packaged Developers	Developing Times (in Minutes)*									
	SMALL TANK—(Agitation at 30-Second Intervals)					LARGE TANK—(Agitation at 1-Minute Intervals)				
	65°F 18.5°C	68°F 20°C	70°F 21°C	72°F 22°C	75°F 24°C	65°F 18.5°C	68°F 20°C	70°F 21°C	72°F 22°C	75°F 24°C
HC-110 (Dilution B)	8½	7½	6½	6	5	9½	8½	8	7½	6½
POLYDOL	8	7	6½	6	5	9	8	7½	7	6
D-76	9	8	7½	6½	5½	10	9	8	7	6
D-76 (1:1)	11	10	9½	9	8	13	12	11	10	9
MICRODOL-X	11	10	9½	9	8	13	12	11	10	9
MICRODOL-X (1:3)	—	—	15	14	13	—	—	17	16	15
DK-50 (1:1)	7	6	5½	5	4½	7½	6½	6	5½	5
HC-110 (Dilution A)	4¼	3¾	3¼	3	2½	4¾	4¼	4	3¾	3¼

*Avoid development times of less than 5 minutes if possible, because poor uniformity may result.
Note: Do not use developers containing silver halide solvents.

This time-and-temperature chart is part of the film manufacturer's instruction sheet. 68° F (20° C) is shown in bold-face type and is the recommended temperature to be used with the developers listed on the left. The exception is with Microdol-X at high dilution where the recommended temperature increases to 75° F (24° C). A change in temperature of even a few degrees can cause a significant change in the rate of development and therefore requires a change in the development time. For best results all the solutions—developer, stop bath, fixer, wash water—should be within a few degrees of each other.

negative developed for 45 seconds

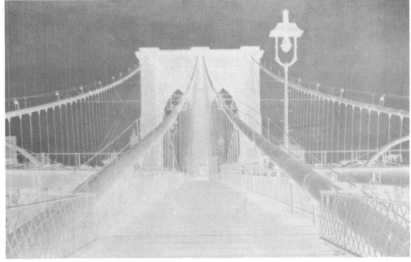

negative developed at 40° F

negative developed for 7½ minutes

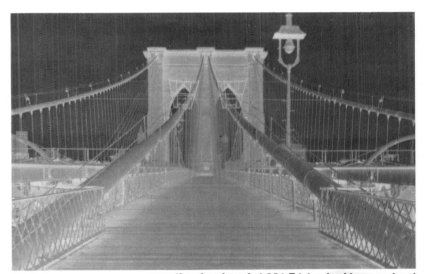

negative developed at 68° F (standard temperature)

negative developed for 30 minutes

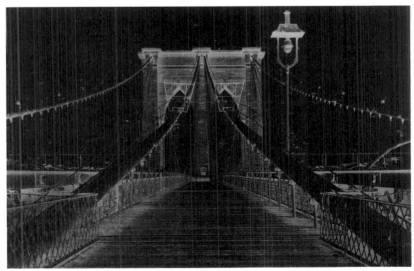

negative developed at 100° F

Exposure and Development: Under, Normal, Over

After developing a roll of film, how do you evaluate it? The negatives may look too pale and thin. Were they underexposed or could something have gone wrong in development so that the negatives were underdeveloped? They may look too dark and dense. Were they overexposed or overdeveloped? Comparing the negatives with those at the right will help in evaluating them.

Notice that overdeveloping film that was underexposed will not produce a negative of normal density and contrast. Nor will underdeveloping cure mistakenly overexposed film. However, improperly exposed negatives can be improved to a certain extent. By increasing development time, density can be added mostly in the highlights, and to a lesser extent in the midtones, of a negative that would be too thin because of underexposure. By decreasing development time, density can be decreased—again mostly in the highlights, but somewhat in the midtones—in a negative that would otherwise be too dense from overexposure. But a price is paid for this—a change in contrast and sometimes damaging changes in graininess, detail and sharpness.

One of the best ways to learn how a particular film-developer combination responds to variations in exposure and development is to make a series of negatives like these. You may find, for example, that the combination you are using has very little tolerance for errors in exposure. Or perhaps it increases contrast considerably with overdevelopment. Try the series under different lighting conditions—in soft, flat light in the shade or when the sky is overcast, and in contrasty light on a brilliant, sunny day when there are deep shadows and bright highlights. The normally developed negatives are developed at the manufacturer's suggested time and temperature, the overdeveloped negatives for twice the suggested time, the underdeveloped negatives for half the time. The overexposed negatives are given 1 1/2 stops more than the normal exposure, the underexposed negatives 1 1/2 stops less.

Underexposed, underdeveloped. *Little detail in shadow areas; highlights too thin. Overall very thin with low contrast.*

Underexposed, normally developed. *Little detail in shadow areas. Somewhat low contrast.*

Underexposed, overdeveloped. *Little detail in shadow areas; highlights of normal density. Excessive contrast.*

Normally exposed, underdeveloped. *Good shadow detail. Overall reduction in contrast.*

Overexposed, underdeveloped. *Average density. Low overall contrast. Some loss of sharpness in highlights noticeable in an enlargement.*

Normally exposed, normally developed. *Good separation in all tonal values. Prints on normal contrast paper. Normal grain for film.*

Overexposed, normally developed. *Highlights too dense. Density increased overall. Grain increased. Some loss of sharpness in an enlargement.*

Normally exposed, overdeveloped. *Good shadow detail; too much density in highlights. Excessive contrast.*

Overexposed, overdeveloped. *Lack of separation in highlights. Excessively dense. Quite grainy. Distinct loss of sharpness in an enlargement.*

The Need for Proper Agitation . . .

too little agitation in developer

too much agitation in developer

A source of trouble often overlooked is improper agitation of the tank while the film is being developed. As the examples above show, too little agitation or too much agitation can cause development problems.

The purpose of agitation is to move the solution inside the tank so that a steady supply of fresh developer reaches the emulsion at regular intervals during the development period. If this is not done, the chemicals next to the emulsion, after performing their share of the chemical reaction, stop working and form a stagnant area where development activity slows down and eventually stops. Exhausted chemicals are also heavier than the rest of the solution and will slowly sink to the bottom of the tank, causing what is called bromide drag—streaks of uneven development as the exhausted chemicals slide down the surface of the film.

Too much agitation creates as many problems as too little agitation. In addition to general overdevelopment, turbulence patterns force extra quantities of fresh developer along the edges of the film, causing uneven development.

To avoid these problems, agitate gently at regular intervals. A pattern often recommended is to agitate for five out of every 30 seconds. Follow the manufacturer's directions if another pattern is recommended for a specific product. If possible, agitate in two or more different directions during each agitation period. This avoids setting up a repetitive pattern of flow across the face of the film, as might happen if the solution were set in motion in the same direction, and with the same degree of force, every time. If you are developing one reel of film in a two-reel tank, put in an extra empty reel so that the loaded one does not bounce up and down excessively.

The photographs above show some of the problems caused by poor agitation of film during development. Above left, the film was not agitated enough. Exhausted chemicals from dense areas of the negative (the white letters in the positive print shown here) slid down the surface of the film, causing streaks of uneven development below the letters. Above right, a roll of film was agitated too much and too vigorously. Fresh developer forced along the spirals of the developing reel caused the edges of the film to be overdeveloped (denser in the negative) and consequently lighter in the print.

. . . and Fresh Solutions

developer exhaustion

fixer exhaustion

You may be tempted some day to try to process one or two more rolls or sheets of film in exhausted developer or fixer rather than remixing fresh solutions. The consequences, as shown here, can be serious. A properly exposed negative can be damaged or completely ruined because the chemicals in the solutions are exhausted from overuse or aging.

An exhausted developer produces underdeveloped negatives; there is just not enough active developing agent left to build up density. With partially exhausted developer, details, particularly in shadow areas, may be weakened, but with more serious exhaustion the image is all but lost *(this page, top left)*. Damage may be worse than that caused by underdevelopment because impurities in the exhausted solution may stain the negative.

An exhausted fixer produces a negative *(top right)* that seems overdeveloped compared to a normal one. The solution is unable to dissolve unexposed silver bromide crystals from the negative. These leftover crystals turn dark and cause the negative to grow denser. As shadow areas (in the model's hair, for example) darken, the overall image grows flat; details such as individual strands of hair are obscured and a grayish density fogs the entire negative, even clouding unexposed borders.

Preventing these problems is easy enough. Developer manufacturers specify how much film may be processed per quart of solution and, usually, how long the solution can be stored. Fixers can be checked for strength with an inexpensive testing solution.

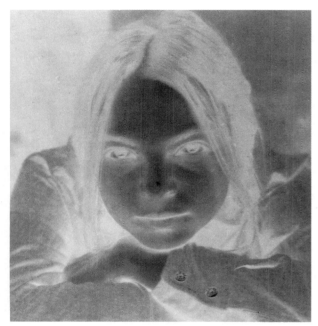

negative developed in exhausted solution

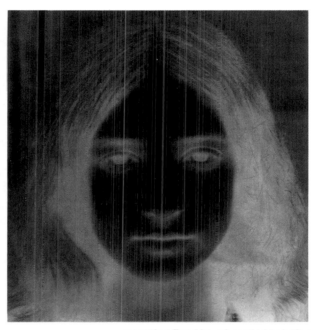

negative fixed in exhausted solution

negative developed in fresh solution

negative fixed in fresh solution

The Importance of Careful Washing and Drying

Film can fade or turn yellow if not thoroughly washed after fixing. The cause of this damage is the fixer itself. The fixing solution contains dissolved sulfur compounds that tarnish the silver image of the negative if they are not removed. It is exactly the same kind of reaction that causes silverware to tarnish. The unexposed silver bromide crystals that are dissolved in the fixer tarnish too. Worse still, the tarnish often becomes soluble in the moisture in the air, gradually causing the negative image to dissolve and fade.

Another cause of damage to negatives—one that shows immediately—is careless drying. Just-washed film is delicate and easily scratched. Dust clings to wet film, sometimes implants itself in the emulsion, and can be impossible to remove even with rewashing.

Of all the misfortunes that can befall the photographer, these are the easiest to avoid. All that is needed is careful washing and drying. Water for washing must be clean, near the temperature of the earlier solutions, and, perhaps most important, kept constantly moving across the surface of the film to flush away fixer that has soaked in. Dump the water and refill the tank often; fixer is heavier than water and accumulates at the bottom of the tank. Although much of the fixer can be washed away with water alone if the film is washed long enough, it is best to use a hypo neutralizing (or clearing) agent. In addition to working more efficiently than plain water, it greatly reduces washing time and avoids the swelling caused by a long washing period.

Damage during drying is even easier to avoid. Handle the film as little as possible while it is wet and hang to dry in a clean place free from drafts and temperature changes.

carelessly handled negative normal negative

Care Prevents These Darkroom Disasters

A bizarre affliction that can strike the negative during development is *reticulation,* a crinkling of the entire gelation emulsion, as shown at left. It occurs when the negative is abruptly moved from a very warm solution, which softens and expands the gelatin, into a very cool solution, which hardens and shrivels it up. The crinkling is so evenly textured (inset) that reticulation is sometimes done on purpose for special effect. But once done it cannot be undone, and in regular work, especially with small negatives that must be greatly enlarged, reticulation is disastrous. It can be avoided by keeping all solutions, from developer to washing bath, at or very near the same temperature.

A segment of totally undeveloped negative resulted when two parts of the film stuck together during the initial stage of development. The photographer's carelessness in winding the film onto the wire reel of the developing tank caused one loop of film to rest against the loop next to it, thus preventing the chemicals from reaching the emulsion at the area of contact.

Special Development Techniques

A standard developer used at the time and temperature recommended by the manufacturer will generally give you good results. But special situations may come up when you want to depart from the standard procedure.

One common situation arises when the light is too dim for a reasonably fast shutter speed, even with the aperture wide open. In that case, you can "push" the film (shoot at a higher-than-normal ASA rating), and then adjust the development accordingly. You can either increase the development time or temperature or use a special high-energy developer such as Acufine or Diafine. Some developers can be used at concentrations that permit shooting at higher-than-normal film speeds for example, Edwal FG7 diluted 1:3. The chart *(right)* gives some suggested combinations, but you should make your own tests.

Generally, increasing the development time by 50 percent will let you shoot at twice the normal ASA rating—in effect, underexposing and overdeveloping the film. The pictures on pages 136–137 show that this produces a negative with more contrast than a normally exposed, normally developed negative. You can expect a certain loss of detail in shadow areas when compared to a normal negative. Actually, this is caused by too little exposure and not by the increased development; the exposure simply was not great enough for the shadow details to register on the film. In addition, the print will probably be grainier and somewhat less sharp than a print from a normal negative (compare the two prints at right); the greater the enlargement, the more this is noticeable. But these disadvantages are offset by the increased film speed, which may let you work in situations that would otherwise be impossible to photograph.

"Pushing" Film Speed

	normal development[1]	to double film speed[2]	to quadruple film speed[2]
Ilford HP 4 (ASA 400)	Microphen, 5³/₄ min at 68° F(20° C)	Microphen, 8¹/₂ min at 68° F(20° C)	Ethol UFG, 6 min at 68° F(20° C)
Kodak Tri-X (ASA 400)	D-76, 8 min at 68° F(20° C)	D-76, 12 min at 68° F(20° C)	D-76, 13 min at 75° F(24° C) or HC-110(A), 8 min at 68° F(20° C)

[1] Specifications for normal development are manufacturers' recommendations.
[2] Specifications for developing films exposed at higher ASA ratings are suggestions only; for best results make your own tests.

When taking pictures in poor light, many photographers deliberately underexpose the film—that is, they assume its ASA rating is double or even quadruple the normal rating—and then compensate by giving it special treatment during development. This is called "pushing." It can be done as the chart above shows: by increasing development time in a normal developer; by increasing temperature in a normal developer; or by switching to a high-energy developer. Pushing film is a valuable technique, but it increases graininess and contrast and decreases shadow detail. This is not very serious if the ASA rating is doubled. Beyond that, quality begins to fall off fast, especially with small negatives (see prints at right).

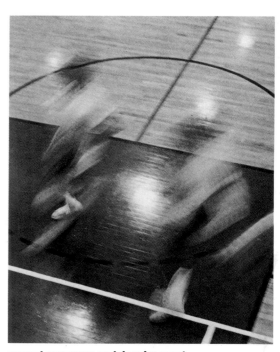

normal exposure and development

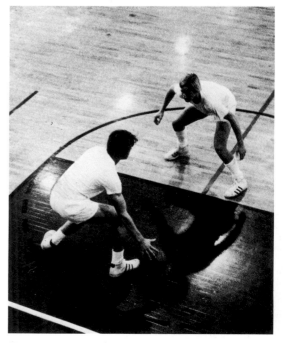

film pushed to four times normal ASA

Low-Contrast Development

high-contrast scene, regular development

high-contrast scene, low-contrast development

two-bath development: D-23 and Kodalk

First bath: D-23
Mix in the order given:

Water 125° F (52° C)	750 cc	(24 oz)
Metol (Kodak Elon)	7.5 gm	(0.25 oz)
Sodium sulfite (desiccated)	100 gm	(3.25 oz)
Water to make	1000 cc	(32 oz)

Second bath: 1 percent Kodalk solution

Kodalk Balanced Alkali	10 gm	(0.3 oz)
Water to make	1000 cc	(32 oz)

Bring solutions to 68° F (20° C). Place film in first bath and agitate continuously for first 30 sec, then for 5 out of every 30 sec. Remove film from first bath and place gently, without agitation, in second bath. When developing roll film, invert reel in second bath after 15 sec (this helps prevent uneven development).

For moderate reduction of contrast, develop:
First bath: 6 min Second bath: 3 min
For greater reduction of contrast, shorten the time in the first bath:
First bath: 4 min Second bath: 3 min

water-bath development: D-76 and water

First bath: Kodak D-76 full strength
Second bath: plain water

Bring solutions to 68° F (20° C). Round 1: place film in developer and agitate continuously for 30 sec, then for 5 out of every 30 sec. After 1 min, place film gently, without agitation, in water.

Round 1:
Developer 1 min
Water 2 min

Round 2 (and additional rounds):
Developer 30 sec
Water 2 min

Increasing the number of times Round 2 is repeated will raise the overall density of the negative without unduly increasing the contrast. Reverse the reel on each round when developing roll film.

When photographing in high-contrast situations you can reduce the contrast of the negative by using a 2-bath or water-bath developer. In the 2 procedures above, the negative is partially developed in the first solution. In the second solution, the shadow areas continue developing while the highlight areas quickly exhaust the available developing agents and stop development. The result is reduced density in the highlights and reduced contrast. The times given above are suggestions only.

Development can also be altered to adjust the contrast of the negative. The contrast of a flat scene (where the important highlight areas meter within two or three stops of the important shadow areas) can be strengthened by increasing the development time. If you think a scene will be too flat, you can try exposing it normally and then increasing the normal development time by one and one half times. Harsh contrast in a scene (bright areas meter six or more stops from dark ones) can be reduced by decreasing the development time. To decrease contrast, try developing for about two-thirds of the normal time. See also information on the Zone System (pages 235–247).

Two-bath development also decreases contrast. In the first bath, the film emulsion absorbs developing agents that are activated in the second bath, an alkaline solution. But the developing agents are quickly exhausted in the highlight areas and, since there is no new developer to replace them, stop working. The developing agents in the shadow areas continue working longer since there are not so many exposed silver bromide crystals to use them up. The result is a compensating effect—the shadows receive more development than the highlights and contrast is reduced. In the D-23 and Kodalk variation (left), development begins in the D-23, then continues in the Kodalk.

Water-bath development has a similar effect. The film is partially developed in the first solution, then transferred to a tank of plain water. A water-bath process is also given at left.

For two-bath or water-bath development to work properly, the emulsion must be relatively thick or it will not absorb enough developing agents. Therefore, a thick-emulsion film like Tri-X responds better than a thin-emulsion film like Panatomic-X.

KENNETH JOSEPHSON: *Postcard Visit, Drottningholm, Sweden,* 1967

*Kenneth Josephson often plays with what he calls
the "special reality of photographs." Here, he has
carefully aligned a postcard view with the "real"
scene. The postcard is like a hole cut in the scene
that lets you see past gray winter sky, bare trees
and boxed statues to another time, another reality.*

7 Printing the Positive

How to Process Prints **146**

 The Darkroom **146**

 The Enlarger: Basic Tool of the Printmaker **148**

 Printing Papers **150**

 The Contact Sheet: A Whole Roll at Once **152**

 Preparing the Negative for Enlargement **156**

 Making a Test Print **158**

 The Final Print **160**

 Processing Prints—A Summary **163**

How to Judge a Test Print **164**

Papers That Control Contrast **166**

The Versatility of Variable Contrast Paper **168**

Dodging and Burning In **170**

How to Make Better Prints **172**

Archival Processing for Maximum Permanence **174**

Printmaking is one of the most pleasurable parts of photography. Unlike film development, which requires rigid control, printmaking lends itself to leisurely creation. You can shape and tune the image—by enlarging it, altering the tones of light and dark, increasing or reducing the contrast between them and cropping the edges—and in other ways ready the print for final viewing.

Like film, printing paper is coated with a light-sensitive emulsion containing crystals of silver atoms combined with bromine or chlorine atoms or both. Light is passed through the negative and onto the paper. After exposure, the paper is placed in a developer where chemical action converts into dark metallic silver those crystals in the emulsion that have been exposed to light. It is next transferred to a stop bath to halt the action of the developer, then into fixer which removes undeveloped and unexposed crystals, and finally it is washed and dried.

The negative is a reversal of the tones in the original scene. Where the scene was bright, the negative develops many dense, dark grains of silver. These dense areas hold back light from the paper, prevent the formation of silver in the paper's emulsion and so create a bright area in the print corresponding to the bright area in the scene. Where the scene was dark, the negative is thin or even clear. It passes much light to the paper and dark silver is formed in the emulsion, resulting in a dark area in the print.

During printing you make a number of decisions that determine how the print will look. Mistakes are inevitable at first, but a wrong choice can be easily repaired by simply making another print.

How to Process Prints
The Darkroom

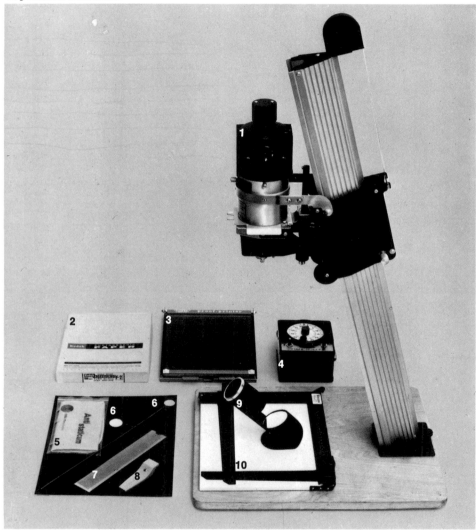

1 | **enlarger**

2 | **printing paper**

3 | **contact printing frame**

4 | **enlarger timer**

5 | **antistatic cleaning cloth**

6 | **dodging and burning-in tools**

7 | **negatives**

8 | **antistatic cleaning brush**

9 | **magnifier**

10 | **printing-paper easel**

While printmaking procedures vary somewhat depending on whether you are using your own equipment or sharing facilities in a school, darkrooms are usually set up with dry and wet sides.

On the dry side (materials shown above), photographic paper is exposed to make a contact print or an enlargement. Cleanliness as well as dryness is important. Chemical contamination can cause even more problems in printing than in negative development, since a typical printing session involves a number of trips from enlarger to developing trays and back again with many chances to get traces of chemicals where they don't belong. The commonest problem on the dry side, though, is dust. Every dust speck on your negative produces a light spot on your print. Remove dust with an antistatic brush or a blast of compressed gas (sold in spray cans in photo stores). Handle negatives by their edges to avoid fingerprints. If absolutely necessary, wipe negatives gently with lens tissue or an antistatic cloth; liquid film cleaner is sometimes useful. Dust and fingerprints on enlarger lenses or condensers decrease the contrast and detail in a print. Clean them as

11 | three 8 x 10 trays,
 one 11 x 14 washing tray

12 | blotter roll or other means of
 drying

13 | safelight

14 | safelight filter

15 | chemical solutions

16 | graduate

17 | timer

18 | washing siphon

19 | sponge

20 | squeegee

21 | developer tongs

22 | stop bath-fixer tongs

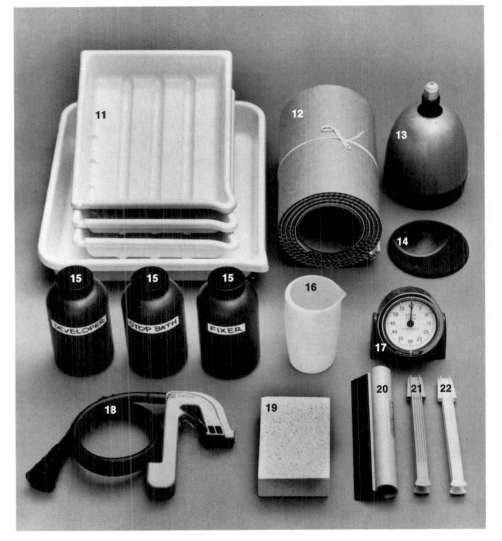

you would a camera lens *(page 77)*.

On the wet side of the darkroom (materials shown above), the exposed paper is processed in chemicals similar to those used in developing negatives. See page 163 for a summary of the process.

Photographic paper is sensitive to only a portion—usually the blue end—of the visible light spectrum. So while development of printing paper cannot be carried out in ordinary room light, it can be performed under safelight. For most papers this is a 15-watt bulb in a fixture covered with a light amber filter (such as a DuPont S-55X or Wratten OC) and placed at least four feet from working surfaces. This light will be bright enough so you can see what you are doing but not so bright that the print is fogged with unwanted exposure. Check the manufacturer's instructions if you use any special-purpose papers, since safelights vary for different materials.

A safelight will not be bright enough for you to judge accurately the quality of a print after it has been developed and fixed. You will want to do that under ordinary room light. If you carry a wet print away from the wet side of the darkroom, put it in an empty tray so it doesn't drip.

The Enlarger: Basic Tool of the Printmaker

Strictly speaking, an enlarger is more accurately called a projection printer since it can produce a print of any size—larger or smaller than the negative. Most often, however, it is used to enlarge an image.

An enlarger operates like a slide projector mounted vertically on a column. Light from an enclosed lamp shines through a negative and is then focused by a lens to expose an image of the negative on printing paper placed at the foot of the enlarger column. Image size is set by changing the distance from the enlarger head (the housing containing lamp, negative and lens) to the paper; the greater the distance, the larger the image. The image is focused by changing the distance between the lens and the negative. The length of the exposure time is adjusted by a timer. To regulate the intensity of the light, the lens has a diaphragm aperture control marked with f-stops like those on a camera lens.

An enlarger must spread the light rays uniformly over the negative. It can do this in several ways. In a diffusion system, a sheet of opal glass (a cloudy, translucent glass) is placed beneath the light source to scatter the light evenly over the negative. In a condenser system, lenses gather the rays from the light source and send them straight through the negative. Sometimes, a combination of the two systems is used (*see diagrams, right*).

The most noticeable difference between diffusion and condenser systems is in contrast. A diffusion enlarger produces about one grade less contrast than a condenser enlarger (see pages 164–169 for more about contrast). A diffusion system has the advantage of minimizing faults in the negative such as minor scratches, dust spots and grain by lessening the sharp contrast between,

for example, a dust speck and its immediately surrounding area. Some photographers believe that this decreasing and smoothing of contrast can also result in a loss of fine detail and texture in a print, especially when a negative is greatly enlarged; however, many photographers find no evidence to support this. Many modern enlargers combine characteristics of both systems.

If an enlarger accepts more than one size negative, the focal length of the lens must be matched to the size of the negative as shown in the chart at right. If the focal length is too short, it will not cover the full area of the negative and the corners will be out of focus or, in extreme cases, vignetted and too light. If the focal length is too long, the image will be magnified very little unless the enlarger head is raised very high.

Also, when a condenser enlarger accepts different sizes of film, the condensers must be matched to negative and lens to obtain even illumination. Depending on the enlarger, this is done by changing the position of the negative or condensers or by using condensers of different sizes.

The light in an enlarger is usually a tungsten bulb, although in some diffusion enlargers a cold-cathode or cold light source (fluorescent tubing operated at high voltage) is used. Fluorescent light is usually not recommended for use with variable contrast papers (*pages 168–169*) or color printing papers. See page 288 for information on enlargers for printing color.

Although an enlarger is a relatively simple machine, it is a vital link in the photographic process: the best camera in the world will not give good pictures if they are printed by an enlarger that shakes when touched, has a poor lens or tends to slip out of focus.

In the diffusion type of enlarger, a sheet of cloudy glass scatters light from the lamp in many directions so that the negative will be uniformly illuminated. But many light rays overlap so that contrast in the print is softened.

The condenser type of enlarger uses two lenses to collect light and to concentrate it directly on the negative. Light rays go straight through and produce increased contrast.

Combination diffusion-condenser enlargers offer a compromise solution. In this design condenser lenses collect light and focus it through the negative; a sheet of ground glass diffuses the light somewhat and eliminates excessive contrast.

negative size	focal length of enlarger lens
35 mm	50–63 mm
2¼ x 2¼ in	75–80 mm
2¼ x 2¾ in	90–105 mm
4 x 5 in	135–160 mm

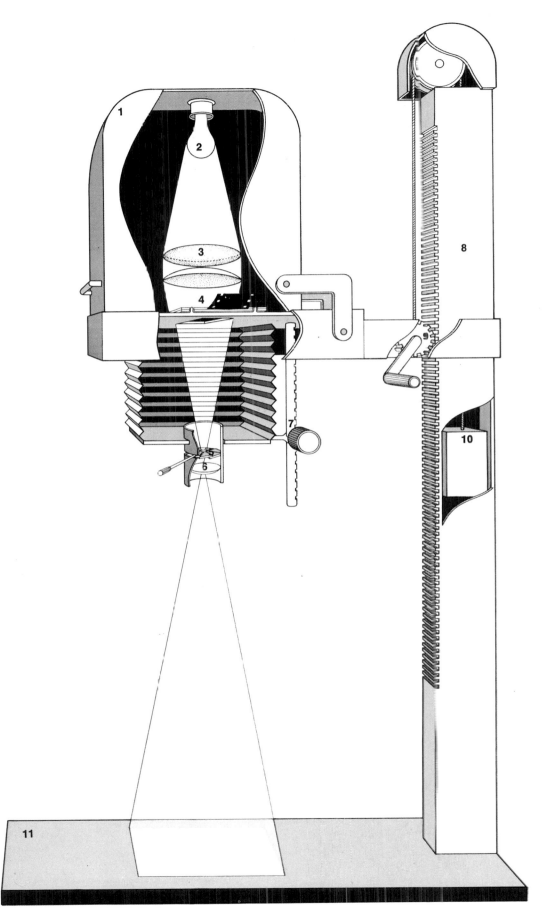

1 | **The enlarger head** *contains the main working parts: light source, a carrier for the negative, and lenses. It is cranked up or down to set the enlarged image's size.*

2 | **The lamp,** *which supplies the light to expose the printing paper, is usually a tungsten bulb similar to a household lamp. Some enlargers contain tubular fluorescent lamps, which give a more diffuse light.*

3 | **The condenser lens,** *a pair of convex elements, spreads light uniformly over the negative. In some types of enlargers, a different system—a flat piece of diffusing glass used alone or in combination with a condenser—serves the same purpose (see diagrams opposite).*

4 | **The negative carrier,** *which holds the negative flat and level, fits into an opening between condenser and main lens.*

5 | **A diaphragm,** *an adjustable opening like that in a camera lens, controls the amount of light passing through the lens.*

6 | **The lens** *bends light rays passing through the negative to form an enlarged image.*

7 | **The focusing control** *moves the lens up or down to focus the projected image. The type shown here—a geared wheel and track shifting a bellows-mounted lens—is a common one, but other kinds are used.*

8 | **The supporting column** *holds the enlarger head out over the baseboard and printing paper and serves as a rail on which the head can be moved up or down.*

9 | **The height adjustment** *raises or lowers the entire enlarger head to set image size. Instead of the geared wheel and track shown in the drawing, some enlargers have a clamp that slides on the supporting column and is tightened to hold the enlarger head at the desired position.*

10 | **The counterbalance** *compensates for the weight of the enlarger head, permitting it to be raised or lowered effortlessly.*

11 | **The base board** *is the foundation supporting the whole unit; it also holds the easel on which printing paper is placed.*

Printing Papers

Black-and-white printing papers vary in texture, color, contrast and other ways *(see box, opposite)*. While the number of choices is wide, the best plan is to start with one type of paper and explore its capabilities before trying others.

Many photographers prefer a smooth-surfaced, glossy paper since this type of surface has the greatest tonal range and brilliance. Prints are seen by reflected light, and a rough or matte finish scatters light and so decreases the tonal range between the darkest blacks and the whitest highlights. A typical reflectance range for a glossy print is 1:50 (whites reflect 50 times the light that blacks do), compared to as low as 1:15 for a rough-textured, matte print.

Resin-coated (RC) papers require much less washing time than regular-base papers so they are often used in school darkrooms. They are also popular for contact sheets and general printing. However, many photographers do not use RC papers for their better prints because they prefer the tonality and surface quality of regular-base papers. The latter are also better for long-term archival preservation, a factor primarily of interest to museums and photographic collectors.

Store paper in a light-tight box in a cool, dry place. Stray light fogs paper, giving it an overall gray tinge. Time and heat do the same. Most papers will last about two years at room temperature, considerably longer if kept refrigerated.

The difference between matte and glossy surfaces is revealed in two prints of the interior of a modern building in Germany, photographed by Dmitri Kessel. The picture at right, above, reproduced to show a matte effect, scatters reflected light and produces less intense blacks than the glossy print next to it.

Characteristics of Printing Paper

Physical characteristics

Texture. The surface roughness of the paper. Ranges from smooth to fine grain to rough. Some finishes resemble canvas, silk or other materials. Smoother surfaces reveal finer details and any graininess of the negative more than rougher surfaces do.

Gloss. The surface sheen of the paper. Ranges from glossy (greatest shine) to lustre (medium shine) to matte (dull). Regular-base glossy papers can be ferrotyped (page 179) for maximum sheen; resin-coated glossy papers air dry to a very high sheen. The dark areas of glossy papers appear blacker than those of matte papers, therefore the contrast of a glossy paper appears greater. Glossiness shows the maximum detail and grain in a print. Very high gloss (as from ferrotyping) can cause distracting reflections.

Paper base tint. The color of the paper stock. Ranges from pure white to off-white tints such as cream, ivory or buff.

Image tone. The color of the silver deposit in the finished print. Ranges from warm (brown-black) to neutral to cold (blue-black). Can be emphasized by the print developer used; a developer that helps produce a noticeably warm or cold tone will indicate this on the package.

Weight. The thickness of the paper stock. Single weight and double weight are the most common. Single-weight papers are suitable for contact sheets and small prints. Double-weight papers are easier to handle during processing and mounting of large prints.

Size. 8 x 10 in size is standard. You can cut this into four 4 x 5-in pieces for small prints. Some other commonly available precut sizes include 4 x 5, 5 x 7, 11 x 14, 14 x 17, 16 x 20 and 20 x 24 in. (Comparable European sizes range from 8.9 x 12.7 cm to 50.8 x 61 cm.)

Resin coating. A water-resistant coating applied to some papers. Resin-coated (RC) papers absorb very little moisture, so processing, washing and drying times are shorter than for regular-base papers. They also dry flat and stay that way, unlike regular-base papers, which tend to curl. Too much heat during drying or mounting RC papers can damage the surface; see manufacturer's directions.

Photographic characteristics

Printing grade. The contrast of the emulsion. **Graded papers** are available in packages of individual contrast grades ranging from grade 0 (very low contrast) through grade 6 (very high contrast). Grade 2 or 3 is used to print a negative of normal contrast. With a **variable contrast paper**, only one kind of paper is needed; contrast is changed by changing filters on the enlarger. The range of contrast is not so great with variable contrast papers as with graded papers—about the equivalent of grades 1 to 4 can be produced. See pages 164–169 for more about contrast.

Speed. The sensitivity of the emulsion to light. Papers designed solely for contact printing are slow—they require a large amount of light to expose them properly. Papers used for enlargements are faster since only a rather dim light reaches the paper during the projection of the image by the enlarger. Enlarging papers are also commonly used for contact prints.

Color sensitivity. The portion of the light spectrum to which the emulsion is sensitive. Papers are sensitive to the blue end of the spectrum—this makes it possible to work with them under a yellowish safelight. Variable contrast papers are also somewhat green sensitive, with contrast being controlled by the color of the filter used on the enlarger. Panchromatic papers are sensitive to all parts of the spectrum; they can be used to make black-and-white prints from color negatives.

Latitude. The amount that exposure or development of the paper can vary from the ideal and still produce a good print. Most printing papers (especially high-contrast papers) have little exposure latitude; even a slight change in exposure affects print quality. This is why test strips (pages 158–159) are useful in printing. Development latitude varies with different papers. Good latitude means that print density (darkness) can be increased or decreased somewhat by increasing or decreasing development time. Other papers have little development latitude; changing the development time to any extent causes uneven development, fogging or staining of the print.

The Contact Sheet: A Whole Roll at Once

When they first begin to process their own prints, many people are tempted to skip the contact printing stage and select the negative to be enlarged by looking at the film itself. But in the negative state pictures are often difficult to judge, and in the case of 35mm negatives small size compounds the difficulty. Even experts insist on making their choices by studying contact prints.

Although these small prints are produced mainly to serve as a guide for later preparation of an enlargement, it is necessary to make them carefully enough to permit comparison between similar pictures. Many of the negatives are likely to differ only slightly from one another, particularly if several shots of the same scene were taken. The sheets are easy to make. An entire roll (36 negatives of 35mm or 12 of $2\frac{1}{4}$ x $2\frac{1}{4}$ inches) can be fitted onto a single sheet of 8 x 10 paper. The contact sheet then becomes a permanent file record of negatives on that roll.

The procedure for making a contact print shown on the following pages uses an enlarger as a light source. Another method uses a contact printer—a box containing a light and having a translucent surface where the negatives and paper are placed.

1 | set out trays and tongs

Four trays are needed—1 each for developer, stop bath and fixer plus 1 filled with water to hold prints after fixing until they are ready for washing.

If you use tongs, you will need two pairs: one for the developer, one for stop bath and fixer. Do not interchange them. See page 163 for chemicals needed.

2 | prepare the solution

Solution temperatures are not as critical as in film development. Manufacturers often recommend about 68° F (20° C) for the developer, 65° to 75° F (18° to 24° C) for stop bath and fixer.

3 | assemble the negatives

Collect the negatives to be printed. If you have used care in handling and storing them, they will be free of fingerprints and dust.

4 | dust the negatives

Remove any dust from negatives with an antistatic brush or compressed air. If necessary, wipe gently with an antistatic cloth to remove fingerprints.

5 | identify the emulsion side

Film curls toward the emulsion, which has a duller sheen than the film base. The emulsion side must face the paper during printing.

6 | clean the contact frame

Clean the printing-frame glass with water or cleaner sold for this purpose. A plain sheet of glass can be used if a printing frame is not available.

7 | prepare to insert negatives

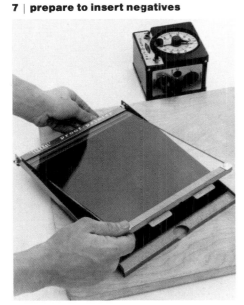

Now open up the cover of the contact frame all the way, taking care to keep fingers from leaving any marks on the glass; they may show.

8 | place the negatives in the frame

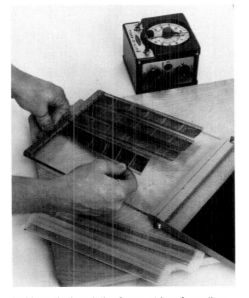

In this particular printing frame, strips of negatives snap under clips on the glass cover. Face the emulsion side away from the glass, toward the paper.

9 | position the enlarger head

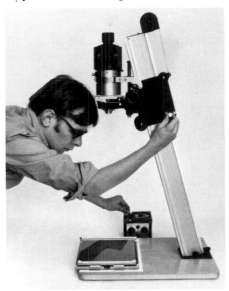

Switch on the enlarger lamp and raise the enlarger head until the light that is projected covers the contact frame. Switch the lamp off.

153

With room lights off and safelight on, remove from its box a sheet of printing paper, contrast grade 2. Close the box to keep out stray light.

Paper emulsion must face the negative. Paper curls to the emulsion side, which is smooth and shiny. RC papers curl little; backing side has imprint.

Slide the paper into the slot on the hinged side of the glass lid, making sure that the emulsion side of the paper faces the negatives.

13 | close the frame lid

Holding the printing paper in place with a finger, close the glass lid of the frame. Its weight holds it shut and presses negatives against paper.

14 | adjust the lens aperture

Open the diaphragm on the enlarger lens to f 8 as a trial exposure. After developing and evaluating the print, you may need to change to another setting.

15 | set the timer

For an 8 x 10 test print of negatives of average density, turn the timer pointer to 5 sec as a starting point for a correct exposure.

16 | make the exposure

After placing the frame under the enlarger, press the timer button; the timer shown automatically shuts off the lamp after exposure.

17 | withdraw the paper

Take the printing paper out of the frame, but leave the negatives in place, ready for another attempt if the first print does not turn out.

18 | begin processing

Slip the paper smoothly into the developer, emulsion side up, immersing the surface quickly. Agitate the print by rocking the tray or with the tongs.

19 | conclude development

Develop for the time recommended with developer—usually about 2 min. Lift the paper out by a corner and let it drain into the tray.

20 | transfer to stop bath, then fixer

Slip print into stop bath; agitate 5 to 15 sec. Place in fixer for 5 to 10 min (2 min for RC papers), agitating occasionally. View by white light after 2 min.

21 | evaluate the print

If print is too light, make another giving more exposure; if too dark, give less exposure. If okay, wash and dry (steps 57–59) after fixing.

Preparing the Negative for Enlargement

Personal judgments count the most when selecting the negatives for enlargement from many of the same scene. Which had the most pleasing light? Which captured the action most dramatically? Which expressions were the most natural or most revealing? Which is the best picture overall?

There are technical points to consider as well. For example, is the negative sharp? With a magnifying glass examine all parts of the contact prints of similar negatives to check for blurring caused by poor focusing or by movement of the camera or subject. If the negative is small—particularly if it is 35mm— even seemingly slight blurring in the contact print will be quite noticeable in an 8 x 10-in enlargement since the defects will be enlarged as well. Extreme underexposure or overexposure (shown on the contact sheet as pictures that are very dark or very light) will make the negative difficult or even impossible to print. Minor exposure faults, however, can be remedied during enlargement. While studying the selected contact print, use a light-colored grease pencil to mark the area to be included in the enlargement as a rough guide for later steps.

22 | select a negative for printing

Under a white light, examine the processed contact sheet with a magnifying glass to determine which negative you want to enlarge.

23 | extract the negative carrier

Lift up the lamp housing of the enlarger and remove the negative carrier—2 sheets of metal that hold the film between them.

24 | insert the negative

Place the chosen negative in the carrier and center it carefully. The emulsion side must be facing down when the carrier is replaced.

25 | clean the negative

Before printing, hold the negative at an angle under the enlarger lens with the lamp on so that the bright light reveals any dust; brush it off.

26 | replace the negative carrier

Tilt the lamp housing and place the negative carrier in position. Switch off room lights so that the image can be seen clearly for focusing.

Taking care not to touch the lens surface, make sure the aperture is at its largest f-stop to supply a maximum of light for focusing.

Insert a piece of white paper under the masking slides of the easel. Paper shows the focus more clearly than even a white easel surface.

Adjust the movable masking slides on the easel, first to hold the size of paper being used (in this case, 8 x 10 in) and later to crop the image.

Raise or lower the enlarger head to get the desired degree of image enlargement, adjusting the easel as needed to compose the picture.

Focus by turning the knob that raises and lowers the lens. Don't shift the enlarger head except to re-adjust size if this is necessary.

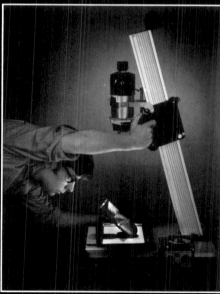

A magnifier helps to make the final adjustments in focus. Some types magnify enough for you to focus on the grain in the negative.

The best way to tell how long to expose an enlargement is to make a test print. This will look like a striped version of the final print (step 43, opposite). The strips are sections of the print, each strip exposed under the enlarger longer than its neighbor to the left. The test print is then judged for exposure and contrast (pages 164–165).

The method shown here exposes each strip 5 sec longer than its neighbor and produces strips exposed for a total of 5, 10, 15, 20 and 25 sec. Some photographers prefer another method that gives a wider range of exposures by doubling the exposure for each strip. For example, exposing the strips for 2½, 2½, 5, 10 and 20 sec gives strips that show total exposures of 2½, 5, 10, 20, and 40 sec.

Make the exposure with the lens stopped down a few stops from its widest aperture. This gives good lens performance plus enough depth of focus to minimize slight errors in focusing the projected image. Time, rather than aperture setting, is generally changed when adjusting the exposure. If the negative is badly overexposed or underexposed, however, change the lens aperture to avoid impractically long or short exposure times.

A full-sized sheet of printing paper is used here, but a smaller strip of paper placed across an important area of the image will usually be enough for test purposes.

33 | close down the aperture

When focus is sharp, reduce the aperture of the enlarger lens to about f/11. The relatively small opening offsets slight focusing errors.

34 | insert printing paper

With room lights and enlarger lamp off, slip a piece of contrast grade 2 or 3 printing paper, emulsion side up, under the masking slides of the easel.

35 | set the timer

Set the timer by turning its pointer to 5 sec. This test print will receive a series of 5 exposures of 5 sec each.

36 | first exposure

Cover four-fifths of the printing paper with a piece of cardboard and press the button to expose the uncovered section for 5 sec.

37 | second exposure

Slide the cardboard to cover only three-fifths of the paper and press the button. The timer makes another 5-sec exposure automatically.

38 | third exposure

Move the cardboard and expose again. The first section has now been given 15 sec of exposure, the second 10 and the third 5.

39 | fourth and fifth exposures

Make two more 5-sec exposures in the same manner, first revealing four-fifths of the paper, then exposing the entire sheet.

40 | remove the exposed paper

Take the paper from the easel for development. It will now have strips bearing 5 different exposures that range from 5 to 25 sec.

41 | develop the test

Develop for the recommended time with constant, gentle agitation. Various degrees of darkening—due to the different exposures—are clearly visible.

42 | transfer to the stop bath

Using developer tongs and stop bath-fixer tongs, immerse the print in stop bath, agitating it for 5 to 15 sec.

43 | select the best exposure

After fixing for about 2 min (washing is unnecessary), make sure paper box is closed, turn on room lights and evaluate the test print (see next page).

Before making a final print, take a moment to evaluate the test print carefully under ordinary room light. Darkroom safelight illumination makes prints seem darker than they actually are. Details on how to judge a test print appear on pages 164–165.

Exposure. Is one of the exposures about right—not too dark or too light? Or should an entire series of longer or shorter test times be made?

Contrast. Is the test print too contrasty, with inky black shadows, harsh white highlights and little detail showing in either? Or is the print too flat—muddy and gray with dingy highlights and dull shadows? If you change print contrast, the printing time may change so make another test print for the new contrast grade.

Dodging and burning in. Most prints require some local control of exposure, which you can provide by holding light back (dodging) or adding light (burning in). See page 170 for more information.

44 | expose the print

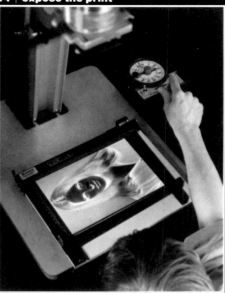

Recheck the focus. Then, after setting the timer to the exposure indicated by the test and inserting fresh paper in the easel, press the button for final exposure.

45 | dodge if necessary

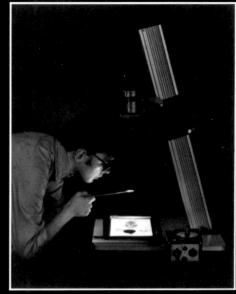

Dodging, or blocking light during part of the exposure, lightens areas that would otherwise print too dark. Often, shadow areas are dodged.

46 | burn in if necessary

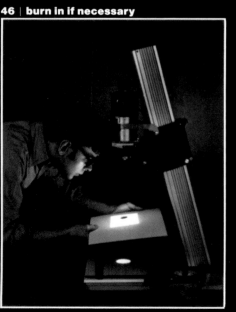

Some areas may need burning in (extra exposure to darken them). A dark cardboard shield with a hole is a useful tool.

47 | develop the print

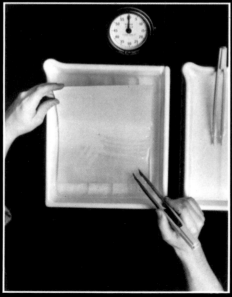

Slip the paper quickly into the developer, making sure it is entirely immersed. To match the test print, develop for the same length of time as the test.

48 | agitate gently

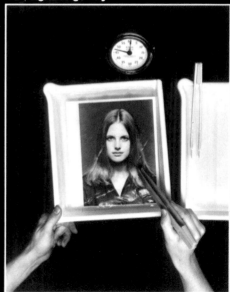

Rock the tray gently and continuously to agitate the print. Touch the surface of the print as little as possible with the tongs; they can leave marks.

49 | complete development

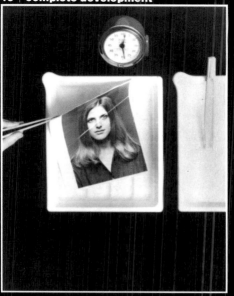

If the print develops too rapidly or too slowly, process for the standard time anyway. Then examine the print and change exposure as needed.

50 | drain off developer

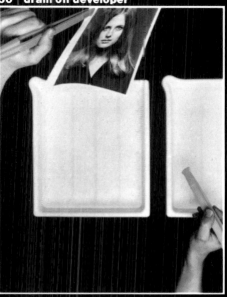

Hold the print above the tray for a few seconds so that the developer solution, which contaminates stop bath, can drain away.

51 | transfer to the stop bath

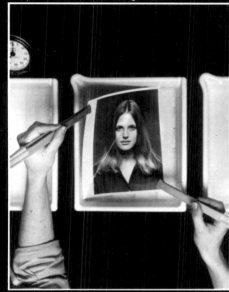

The stop bath chemically neutralizes the developer on the print, halting development. Keep developer tongs out of stop bath.

52 | agitate

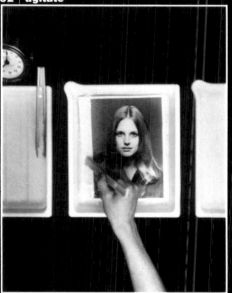

Keep the print immersed in the stop bath for 5 to 15 sec, agitating it gently. Use stop bath-fixer tongs in this solution.

53 | drain off stop bath

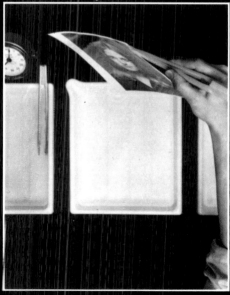

Again lift the print so that solution can drain into the stop-bath tray. Don't let stop-bath solution splash into developer.

54 | transfer to the fixer

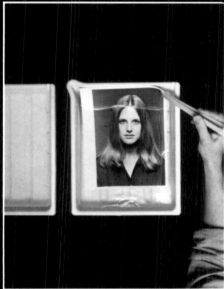

Slip the print into the fixer and keep it submerged. The same tongs are used for stop bath and fixer, which are compatible solutions.

55 | agitate

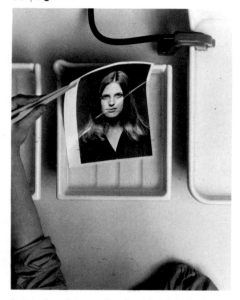

Agitate the print occasionally while it is in the fixer. Room lights can be turned on after a minute or so and the print examined.

Take time again at this point to evaluate the print. Don't be discouraged if the print is less than perfect on the first try. Often several trials must be made.

Exposure and contrast. *Could the print be improved by adjusting the exposure or contrast? It is not always possible to tell from a test strip how all areas of the print will look. Skin tones are important if your print is a portrait. Give more exposure if skin tones look pale and washed out. Beginners tend to print skin tones too light, without a feeling of substance and texture.*

Dodging and burning in. *Examine the print again for areas that could be improved by dodging or burning in. Often several trials are needed to get all the tones just where you want them.*

56 | remove the print

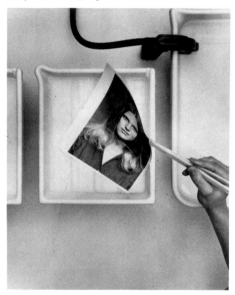

After fixing, transfer the print to the washing tray. Follow manufacturer's fixing recommendations or the image may fade and stain.

57 | wash

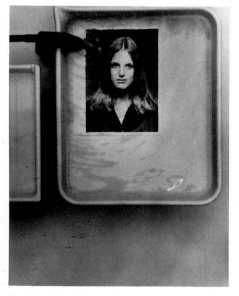

Wash for 60 min in running water; much less washing is needed if hypo neutralizer is used. RC papers need no neutralizer and only 4 min washing.

58 | remove the surface water

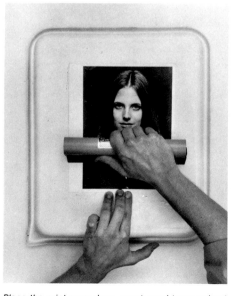

Place the print on a clean, overturned tray or sheet of glass or plastic and gently squeegee off most of the water from front and back.

59 | dry

A blotter roll is one way to dry regular-base papers. You can dry RC papers simply by placing them face up on a clean surface. See page 178.

normal density, normal contrast

too light

too dark

flat

contrasty

A full-scale print of normal density and normal contrast, with texture and detail in the major shadow areas and important highlights, is shown above. Decreasing the exposure produced a lighter print (top left); increasing the exposure gave a darker version (top right). Printing the same negative on a lower-contrast grade of paper produced a flat print (bottom left); printing on a higher-contrast grade made a contrasty print (bottom right).

Papers That Control Contrast

Contrast—the relative lightness and darkness of different areas in a scene—is a crucial characteristic of any photograph. Frequently you will want normal contrast—a full range of tones from black through many shades of gray to pure white. Sometimes, however, you may feel that a particular scene requires low contrast—mostly a smooth range of middle grays (such as the scene in the fog on page 244). Or you may want high contrast—deep blacks and brilliant whites and limited detail in between (such as the ferry scene on page 245).

By the time you are ready to make a print, the contrast of the negative has been set, mostly by the contrast in the subject itself, the type of film and the way it was developed. But you can still adjust the contrast of the final print by changing the contrast grade of the printing paper used. As shown opposite, a paper of normal contrast produces a print of normal contrast from a negative of normal contrast. A paper of high contrast increases the contrast, a paper of low contrast decreases it. This can help when printing a problem negative. A high-contrast paper increases contrast for underdeveloped negatives, which are usually too flat, and adds sparkle to scenes shot in dull light. A low-contrast paper decreases contrast for overdeveloped negatives, which are often too contrasty, and can soften overly harsh shadows and highlights.

These changes are caused by responses in the paper emulsion. With a paper of high contrast, only a small increase in exposure is needed to cause a relatively great increase in density in the paper emulsion. A low-contrast negative has relatively small differences between its thinnest and densest areas. If it is printed on a high-contrast paper, however, these small differences are enough to produce relatively large differences in lightness and darkness in the print, and therefore more contrast.

The reverse is true for a paper of low contrast. A large increase in exposure produces only a relatively small increase in print density. A high-contrast negative has great differences between its thinnest and densest areas; printed on a low-contrast paper, these differences become only moderate in the final print.

Papers of graded contrast range from grades 0 and 1 (low or soft contrast), through grade 2 (normal or medium contrast), grade 3 (often the normal contrast grade chosen for 35mm negatives) and grades 4, 5 and 6 (high or hard contrast). Not all papers are made in all contrast grades and not all manufacturers use the same grading system, so some experimentation may be needed with a new brand of paper.

To some extent the contrast of the print is affected by the enlarger used, by the surface finish of the paper and by the type of paper developer used (Kodak Selectol Soft, for example, lowers contrast). But the basic way of changing contrast in a print is to change the contrast grade of the paper.

How can you tell if your negative is of normal contrast? There are laboratory instruments—densitometers—that measure contrast, but there is also an old rule-of-thumb measure. Lay the negative on the type on this page. The negative has normal contrast if you can barely read the type through the highlights and the shadows and highlights both have visible detail. A normal negative makes a good print on grade 2 or 3 paper.

Contrast is the relative lightness or darkness of different parts of a scene. Depending on the contrast grade of the printing paper used, a print will show more, less or about the same amount of contrast as is present in the negative. Compare the range of tones in the 3 prints at far right. The normal print contains small areas of black and white plus a wide range of gray tones. A low-contrast print has tones that cluster mostly around middle gray. A high-contrast print has large areas that are strongly black or brilliantly white plus relatively few gray tones in between. ▶

low-contrast negative

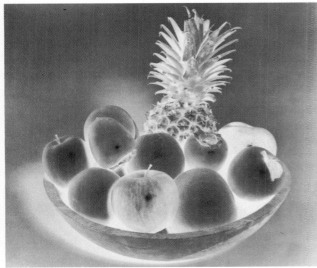

low-contrast print

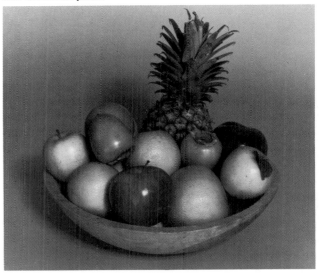

normal-contrast paper

high-contrast paper

low-contrast paper

normal-contrast negative

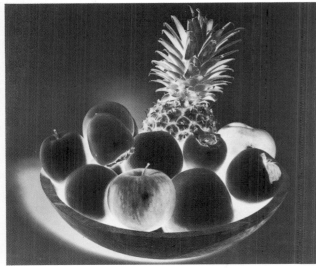

normal contrast print

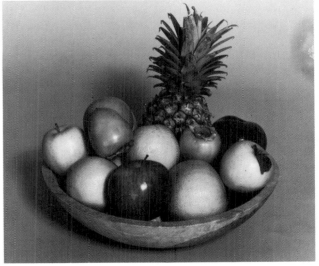

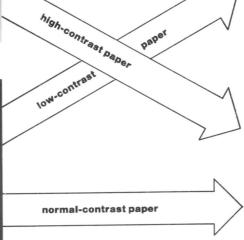

low-contrast

normal-contrast paper

high-contrast negative

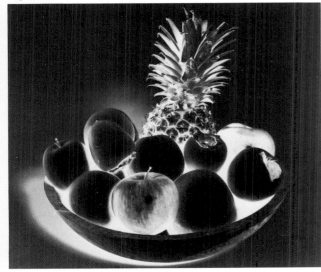

high-contrast print

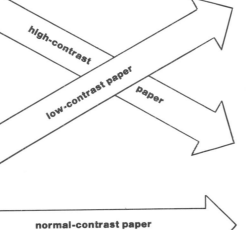

high-contrast

low-contrast paper

paper

normal-contrast paper

The Versatility of Variable Contrast Paper

number 1 filter

number 1½ filter

number 2 filter

number 2½ filter

Instead of stocking a number of different contrast grades, many photographers prefer to use a single type of paper that has adjustable contrast. Most such papers are coated with two emulsions. One, sensitive to yellow-green light, yields low contrast; the other, sensitive to blue-violet light, produces high contrast. The degree of contrast is varied simply by inserting appropriately colored filters in the enlarger *(far right)*. The filter governs the color of the light that reaches the printing paper and thus controls contrast.

With only one type of paper and a set of filters, you can attain finer gradations of contrast than might be possible with papers of different contrast grades. Furthermore, the contrast of localized sections of the image can be controlled. This is done by masking the paper so that the sections can be printed separately, each with the contrast filter its tones call for. A low-contrast part of the image, for example, could be enlivened by printing it with blue-violet light; a harsh part could be softened by printing in yellow-green.

The 3 versions at right of a New Hampshire mill scene show how a print can be improved with local contrast control using variable contrast paper. In the version made with a number 3 filter (upper right), the water and sky seem too contrasty; in the version made with a number 1 filter (bottom right), the mill is too dark and flat.

The final print (opposite page) was made by exposing the mill with the number 3 filter while shielding the water and sky, then exposing the water and sky with the number 1 filter while shielding the mill. It is tricky to blend the lines where the different areas of contrast meet, but when done successfully it achieves a balance of contrast impossible with paper of a single contrast grade.

number 3 filter

number 3½ filter

number 4 filter

◄ Variable-contrast paper can produce different degrees of contrast, as shown at left. This particular filter set has 7 filters. The contrast range is approximately equal to paper grades 1 through 4—rising by half steps. The number 2 filter produces contrast equal to a grade 2 paper.

Two ways of inserting filters in enlargers are shown below. A filter holder can be attached below the enlarger lens, and a filter can then be slipped into the holder (below, top). Focus with the filter in place when using this system. Some enlargers have a filter drawer (below, bottom) between the lamp and the negative; an acetate filter is used here. This latter system is preferable. Since the filter is above the lens, it interferes less with the focused image.

Dodging and Burning In

Dodging (far left) holds back light during the basic printing exposure in order to lighten an area. Burning in (center) adds light after the basic exposure in order to darken an area. Flashing (near left) exposes part of the print to direct light and adds an overall dark tone wherever the light strikes the paper.

Sometimes the overall density of a print seems about right but part of the picture appears too light or too dark—an extremely bright sky, for example, or a very dark shadow area. Dodging and burning in are two methods of giving different exposures to different parts of a print.

If an area is too dark, dodging is called for. That portion of the print is simply shadowed during part of the initial exposure time. A dodging tool (above le .) is useful; it is simply a piece of cardb rd attached to the end of a wire. Your hand (opposite), a finger, a piece of cardboard or any other appropriately shaped object can be used. Dodging works well when detail in the shadows is visible in the negative image. Dodging of areas that have no detail or dodging for too long a time merely produces a murky gray tone in the print.

Burning in is the opposite procedure, used when part of a picture is too light. After the entire negative has received an exposure that is correct for most areas, the light is blocked from most of the print while the area that is too light receives extra exposure. A large piece of cardboard with a hole in it (above center) works well. A piece of cardboard can be cut to an appropriate shape (opposite) or your hands can be used—cupped or spread so that light reaches the paper only where you want it to.

Areas that need considerable darkening can be flashed—exposed directly to white light from a small penlight flashlight. Unlike burning in, which darkens the image, flashing fogs the paper: it adds a solid gray or black tone. Tape a cone of paper around the end of the penlight so it can be directed at a small area. Some method should be devised so that you can see exactly where you are pointing the light. Either flash during the initial exposure or hold an orange or red filter under the lens and add the flash exposure afterwards.

Whether you are dodging, burning or flashing, it is important to keep the dodging or burning tool, your hands or the penlight in constant motion from side to side so that the tones of the affected area blend into the rest of the print. If you simply hold a dodging tool under the light source, an outline of the tool will be printed on the paper.

The photograph opposite was both dodged and burned. Depending on the print, shadow areas or dark objects may need dodging to keep them from darkening so much that important details are obscured. Sometimes shadows or other areas are burned in to darken them and make distracting details less noticeable. Light areas may need burning in to increase the visible detail. Skies are often burned in, as they were opposite, to make clouds more visible. Even if there are no clouds, skies are sometimes burned in because they simply seem distractingly bright. They are usually given slightly more exposure at the top of the sky area than near the horizon. Whatever areas you dodge or burn, blend them into the rest of the print so that the changes are a subtle improvement rather than a noticeable distraction.

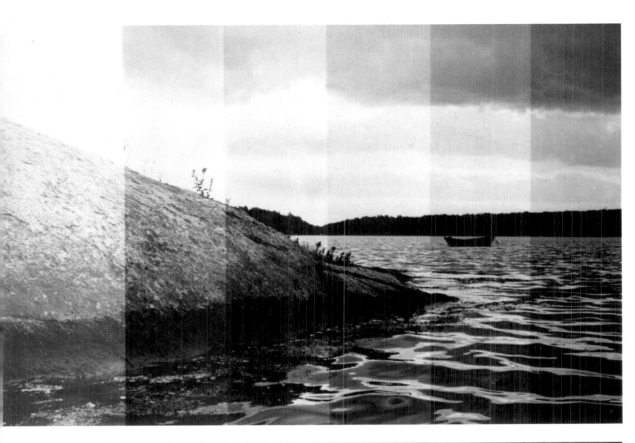

This photograph of a Maine inlet was dodged to lighten certain areas and burned in to darken others. The exposures for the test print (top left) ranged from 3 to 18 sec. The dark rock showed the best detail and texture at an exposure of about 6 sec, the water looked best at about 9 sec and the sky needed about 18 sec of exposure to bring out detail in the clouds. The photographer gave the print a basic exposure of 9 sec, while dodging the rock for 3 sec (top right). Then the sky was burned in for another 9 sec while the rock and water were shielded from light with a shaped cardboard mask (above). In order to blend the tones of the different areas, the photographer's hand and the cardboard mask were kept moving during the exposures.

How to Make Better Prints

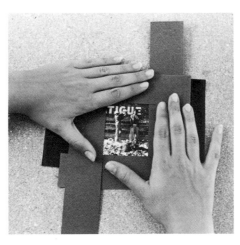

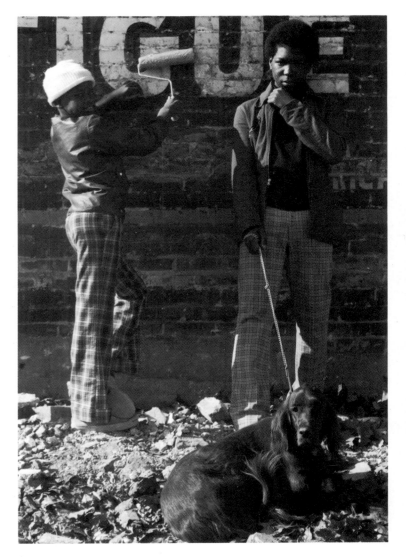

Sometime during the picture-making process you must make a decision about cropping—what to include and what to leave out of the frame that forms the edges of the photograph. John Szarkowski, director of photography at the Museum of Modern Art, wrote: "To quote out of context is the essence of the photographer's craft. His central problem is a simple one: what shall he include, what shall he reject? The line of decision between in and out is the picture's edge. While the draughtsman starts with the middle of the sheet, the photographer starts with the frame. The photograph's edge defines content. It isolates unexpected juxtapositions. By surrounding two facts, it creates a relationship. The edge of the photograph dissects familiar forms, and shows their unfamiliar fragment. It creates the shapes that surround objects. The photographer edits the meanings and patterns of the world through an imaginary frame. This frame is the beginning of his picture's geometry. It is to the photograph as the cushion is to the billiard table."

Some photographers, like Edward Weston (*page 347*) and Henri Cartier-Bresson (*page 57*), have preferred to crop with the camera and use the ground glass or viewfinder to frame the subject precisely. In their photographs, the image was completely visualized at the moment the shutter was released. Most photographers, however, do not hesitate to crop while printing if the image can be improved.

Enlarging a very small part of a negative can create problems since the greater the enlargement, the more grain becomes noticeable and the more the image tends to lose definition and detail. But within reasonable limits, many photographs can be improved by cropping.

To help you decide how to crop a picture, make two L-shaped guides and place them over the photograph to try various croppings, as shown above. Think of the photograph as a window and notice how the edges of the frame cut or encircle the objects in the picture. You can experiment to some extent on the contact sheet although the image there is small, but you will probably want to refine your cropping when the image is enlarged. Making an enlargement of the entire negative before doing any cropping is also useful, since there may be potentials in the print you would not otherwise see.

Cropping a photograph—that is, adjusting its edges to eliminate some parts—is done frequently. Sometimes cropping simply improves a picture by eliminating distracting elements. Sometimes a negative is cropped to fill a standard paper size; square negatives (above left) are often cropped so that when enlarged they fill a rectangular format (above right). Cropping directs the viewer's attention to the forms and shapes as the photographer sees them and can strengthen the meaning of a photograph. Two L-shaped guides (above center) will help you visualize different croppings.

Troubleshooting Prints

It is to be hoped that your prints will be perfect. But if spots, stains or other ailments cause problems, check below. You may find a simple cure.

Small white spots. Due to dust on the negative, printing frame glass or glass negative carrier. Prevent by dusting these surfaces carefully before printing. Fuzzy-edged spots are sometimes caused by dust on enlarger condensers, check and clean if needed. The print can be improved by darkening the spots with dyes (see spotting, page 180).

Small black spots. Due to dust deposited on the film prior to exposure, causing tiny clear spots in the negative. Prevent by keeping dust away from unexposed film. Dust the inside of the camera. With sheet film, dust holders carefully and load film in a dust-free place. The spots can be etched or bleached to remove them (pages 180–181).

Dark scratch lines. Due to scratches on negative emulsion caused by rough handling. Always handle film with extreme care and avoid cinching roll film, sliding sheet film against a rough surface or otherwise abrading the film in any way. If no scratches are visible on negative, lines are due to abrasion of the print emulsion. Commonly occurs when tongs are scraped, even gently, along the print surface. Prevent by handling paper with greater care. Grip paper with tongs in the print margin so tong marks can be trimmed off if necessary.

Light scratch lines. Usually due to hairline scratches on the backing side of the negative. Prevent by more careful handling or storing of the negative. An already scratched negative can be improved somewhat by a light coating of oil. An oily "scratch remover" is sold for this purpose. You can also rub your finger on your nose or forehead to pick up a light coating of oil. Then gently smooth the oil over any fine scratches that are visible. This should at least partially improve the next print by filling in the scratch. It works only with scratches that print as white. The oil attracts dust so wipe the negative clean and store carefully.

Mottled, mealy or uneven development of print. Caused by too short a time or inadequate agitation in the developer. Prevent by developing with constant agitation for at least the time recommended by the manufacturer.

Fingerprints. Due to touching film or paper emulsion with greasy or chemical-contaminated hands. Fingerprints on negative will appear enlarged. Prevent by rinsing and drying hands after they have been in any chemical solutions. Hold film and paper by edges.

Fading of prints. Prints that fade immediately after washing were bleached by a too-strong or too-warm fixer or by too long a period in the fixer. Fading of prints later is caused by inadequate fixing or washing. Prevent by following recommended fixing and washing procedure.

Yellowish stains. Due to any of a number of processing faults: too long a time in the developer, exhausted or too-warm developer, contamination of developer with fixer, exposing paper to air during development by lifting it out of developer too often, exhausted stop bath, not using stop bath, not placing print promptly into fixer, exhausted fixer, inadequate agitation or too short a time in fixer, inadequate washing. Inadequate fixing also causes brownish-purple stains. Review processing techniques on page 163 and information about contamination on page 131.

Overall gray cast in highlights or paper margins. Due to fogging of print by light leakage into darkroom from outside, by stray light from enlarger, by too strong a safelight, by too long or too close an exposure to a proper safelight, by storage of paper in a package that is not light tight, by too long in developer, by light on too soon after print placed in fixer. Check all of the above. Fogging affects highlights first, so prints may be reduced in brilliance before the cause becomes apparent in a definite tinge in print margins. This is because the light from very slight fogging may be too weak by itself to cause any visible response in the paper's emulsion. But when added to the slight exposure received by the highlights, it may be enough to appear as a distinct gray tone. Compare highlights that should be pure white in the print with the white test patch described at right.

Only part of negative image can be focused at any one time. Due to enlarger being out of alignment. Stopping down the lens may produce enough depth of focus to bring the image into acceptable focus, but aligning the enlarger is better.

Entire print out of focus, sharp negative image. Due to vibration of enlarger during exposure. Prevent by eliminating the source of vibration. Placing the paper in the easel can be enough to cause a wobbly enlarger to vibrate; pause a few seconds before exposure to let it come to a rest. Avoid touching the enlarger during exposure.

Part of the print out of focus, sharp negative image. In contact printing, due to poor contact between negative and paper. Prevent by increasing or evening the pressure on the sandwich of glass, negative, paper and backing. In enlargements, due to negative buckling caused by heat generated during a long exposure time. Prevent by using a glass negative carrier or cold-light enlarger.

Two small pieces of printing paper, one developed to the darkest black and the other to the brightest white that the paper can produce, are an aid when you are first learning how to print as well as later on when you want to make a particularly fine print.

To judge the density and contrast of a print you need standards against which you can compare the tones in your print, since the eye can be fooled into accepting a very dark gray as black or a very light gray as white. As much as a full grade of contrast can be involved and will make the difference between a flat, dull print and a rich, brilliant one. By placing a black or white patch next to an area, you can make an accurate judgment of how light or dark the tone actually is. As a bonus, the black patch indicates developer exhaustion; the developer should be replaced when you are no longer able to produce a black tone in a print as dark as the black patch no matter how much exposure you give the paper. The white patch will help you check for the overall gray tinge caused by safelight fogging.

Make the patches at the beginning of a printing session when developer and fixer are fresh. Cut two two-inch-square (50-mm-square) pieces from your printing paper. Use the enlarger as the light source to make the black patch. Set the enlarger head about a foot and a half (0.5m) above the baseboard. The patch should be borderless, so do not use an easel. Expose one patch for 30 seconds at f 5.6; do not expose the other. Develop both patches with constant agitation for two and a half minutes or as recommended by the manufacturer. After stop bath, place in fixer for five minutes, then store in fresh water. To avoid any possible fogging of the white patch, cut and process the paper in a minimum amount of safelight.

Archival Processing for Maximum Permanence

How long does a photograph last? Some of the first ever made have held up perfectly, their images as durable as if they had been carved in stone. Around the turn of the century, some of the most beautiful photographic prints ever made were produced on platinum paper, which has a light-sensitive coating that contains no silver and produces an image of platinum metal. Frederick H. Evans, a photographer active at the turn of the century, made masterful platinum prints (photograph opposite). Their subtle gradations of tone and delicately smooth, glare-free surfaces give unsurpassable clarity and depth. And since platinum is immune to almost all chemical action, the images are virtually indestructible. Other photographs not nearly so old have faded to a brownish yellow, their scenes lost perhaps forever.

Today, many museums and individuals are collecting photographs and, understandably, they want their acquisitions to last. Ordinary silver prints have a long life if they are processed with even moderate care. But for maximum permanence, archival processing techniques can be used. For black-and-white pictures, archival processing is not very different from the customary method of developing, fixing and washing. It is basically an extension of the ordinary procedures, involving a few extra steps, some additional expense and careful attention to the fine details of the work. Its principal aim is the total removal of chemicals that, although essential to the picture-making operation, can ruin the image if allowed to remain in a finished negative or print.

Among the potentially harmful substances that archival processing seeks to remove are the very ones that create the normal black-and-white image: salts of silver, such as silver bromide or silver chloride. During development, those grains of silver salts that have been exposed to light are reduced to black metallic silver, which forms the image; but unexposed grains are not reduced and remain in the form of a silver compound. If not removed, they will darken when struck by light and blot out the image. The chemical used to remove these unexposed grains is fixer, or hypo as it is sometimes called, which converts them into soluble compounds that can be washed away. The fixer, however, must also be removed. It contains sulfur and, if allowed to remain in a picture, will tarnish the metallic silver of the image just as sulfur in the air tarnishes a silver fork. Also, fixer can become attached to silver salts and form complex compounds that are themselves insoluble and difficult to remove. When these silver-fixer complexes decompose they produce a brown-yellow sulfide compound that may discolor the entire picture. Archival processing includes procedures that eliminate the traces of residual chemicals that washing alone cannot entirely remove.

The final step in the archival procedure is to protect the image with a special treatment using a gold or selenium compound. Either of them unites with the silver in the image to act as a shield against damage from external contaminants, such as the sulfur that is part of the pollution in the air. One way of archivally processing prints is summarized at right. See the Bibliography for more information.

Archival Print Processing

Following is one standard procedure for archival processing. Ilford has developed another method that shortens processing times considerably. Details with their Ilfobrom Galerie printing paper.

Paper. *Use a regular-base paper. RC papers are not yet recommended for archival processing because of the instability of the resin compounds that coat them.*

Exposure and development. *Expose the print with a wide border—at least 1 in (25mm)—around the edges. Develop for the full length of time in fresh developer at the temperature recommended by the manufacturer.*

Stop bath. *Agitate constantly for 30 sec in fresh stop bath.*

Fixing. *Use 2 baths of fresh fixer. Agitate constantly for 4 min in each bath. You can agitate a print in the first bath and store it in gently running water (or in several changes of water) until a number of prints have accumulated. Then all prints can be treated for 4 min in the second bath by constantly shuffling one print at a time from the bottom to the top of the stack.*

Protective toning. *Use the selenium toner formula on page 181, which includes a hypo neutralizer. If no change in image tone is desired, reduce the selenium to 40 cc per 4 liters (1⅓ oz per gal) and treat prints 3 to 5 min.*

Washing. *Rinse toned prints several times. Wash at 75° to 80° F. (24° to 27° C). Separate the prints frequently if the washer does not. Ideally, the water in the washer should be completely changed every 5 min. Wash until the prints test acceptably free of hypo (see test procedure below), which will take 30 min to 1 hr or longer, depending on the efficiency of the washer.*

Testing for hypo. *Mix the hypo test solution below. Cut off a strip from the print's margin and blot dry. With a dropper, place a drop of test solution on the strip and allow to remain for 2 min. Blot off the excess and compare the stain that appears with the Kodak Hypo Estimator, an inexpensive series of comparison patches that is available from some camera stores or from Eastman Kodak, Rochester, N.Y. The stain should be lighter than the lightest test patch.*

Kodak formula HT-2, residual hypo test solution
750 cc (24 oz) distilled water
125 cc (4 oz) 28 percent acetic acid (3 parts glacial acetic acid diluted
 with 8 parts distilled water)
7.5 gm (¼ oz) silver nitrate
distilled water to make 1000 cc (32 oz)

Kodak formula HE-1 (hypo eliminator treatment). *Even though the hypo test shows no stain, a trace remains. This treatment removes it completely. To treat a dozen 8 x 10 prints or their equivalent:*

500 cc (16 oz) water
125 cc (4 oz) 3 percent drugstore hydrogen peroxide
100 cc (3¼ oz) dilute ammonia solution (1 part 28 percent drugstore ammonia mixed with 9 parts water)
water to make 1000 cc (32 oz)

Mix immediately before using. Keep in an open container; gases created by the solution can crack a closed bottle. Agitate prints for 6 min, rinse, then wash 20 min.

Drying and mounting. *Dry on fiberglass drying screens. Leave unmounted or slip print corners into white photo corners (used for snapshot albums) attached to mounting stock, then overmat. A special mounting stock is available in art supply stores. Ask for 100 percent rag, acid-free boards. Separate prints with sheets of 100 percent rag, acid-free paper.*

Wavelike patterns call to mind the surging flow of an ocean swell in Frederick Evans's picture of a stairway in Wells Cathedral, England. The angle of the steps at right sweeps up like a wave. A rim of light outlines the rippling edge of each step.

The illusion of depth in the picture is considerable. The steps indicate distance as they decrease in size from foreground to background. Ordinarily, light areas in a photograph tend to come forward, but here the bright area framed by the dark archway, with a darker door beyond, creates a feeling of deep space.

FREDERICK EVANS: *Sea of Steps*, 1903

STEPHEN SPRAGUE: *The King of Ila-Orangun*, 1975

8 Finishing and Mounting

Drying Your Prints 178
Spotting and Toning 180
How to Dry Mount 182
Cutting an Overmat 185

Several steps are involved in finishing a photograph, some of them optional. All prints are eventually dried; the most important precaution is to dry them in a way that does not stain or otherwise damage them. Most prints need some spotting—minor repair of small white or black specks caused by dust. Toning is an optional procedure; it can change the color of the image considerably (sepia toning, for example) or it can change the tone only slightly, deepening and enriching the blacks of the image.

Mounting a print on a stiff backing protects it from creases and tears and prevents curling of regular-base papers. Dry mounting, using a special dry-mount tissue, is the most common method; when heated, the tissue attaches the print to the backing in a perfectly smooth bond. An overmat can also be cut to help protect the photograph.

Although much of the pleasure of photography lies in the taking of pictures, the real reward lies in displaying and viewing the results. Yet many photographers never seem to finish their images; they have a stack of dogeared workprints but few pictures they have been willing to carry to completion. Properly finishing and mounting a photograph is important because it says to viewers: This image is worth your attention. And you yourself will see new aspects in your photographs if you take the time to complete them.

◀ *The regal Oba, or king, of a Yoruba town in Nigeria sat for a portrait during a project to study the way the Yoruba people have incorporated photography into their culture. The Oba's pose, repeated in the cutout photographs of him decorating the room, is traditional for ceremonial occasions.*

Drying Your Prints

A book of blotters may be used for print drying, provided the blotting material used is the kind sold expressly for photographic use and has not been contaminated by previous use.

The print is rolled into the rotary dryer by turning the large knob on the side. The cylinder's surface heats electrically while a cloth cover holds the print securely against the metal. It is not recommended for RC prints.

This flat-bed electric dryer can be used to process 2 prints at once—1 on each side. A cloth apron closes down over each print as it lies face up on the electrically heated metal surface. It is not recommended for RC prints.

With a screen dryer, the prints are placed on contamination-resistant fiberglass screens. They are then left there to air dry at room temperature. You can make your own racks from wood frames covered with fiberglass screening purchased at a lumberyard or hardware store. This type of screening is replacing the older wire-mesh window screen, so you can often buy ready-made screens. ▶

How to Dry Resin-coated (RC) Papers

These papers have a plastic-like coating that makes them resistant to water. Since water does not soak into the paper (as it does with regular-base papers), RC prints dry well if surface water is simply sponged or squeegeed off and the print is placed face up on a clean surface such as a fiberglass screen (opposite). The process can be speeded by blowing the print with a hairdryer set at medium or low heat. RC papers should not be ferrotyped; the glossy-type surface will air dry to a high gloss. See manufacturer's instructions for more information.

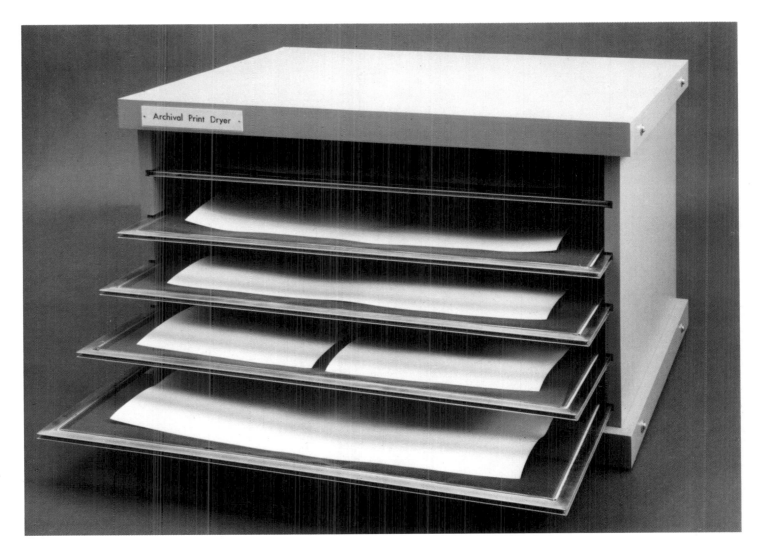

Archival Print Dryer

Probably the chief goal in drying prints is to avoid permanently damaging them and wasting all the effort that has gone into making them up to this point. The commonest source of trouble is that familiar enemy, contamination. One improperly washed print still loaded with fixer and placed on a dryer will contaminate every other print that is dried in that position. And with contamination come stains—either immediately or eventually. If blotters or cloths from heat dryers be-

come tinged with yellow, they have been contaminated with fixer that was not completely washed from prints. Replace blotters and wash the dryer cloths or they will contaminate other prints with which they come in contact. Wash fiberglass screening from time to time or whenever you suspect contamination.

The drying method can affect the surface gloss of the print. A glossy-surfaced, regular-base (not RC) paper dried on a rack, in blotters or on a heat dryer

with the emulsion against the dryer cloth will dry to a semi-gloss finish. A high gloss can be obtained if a regular-base glossy print is ferrotyped—dried with the emulsion pressed against a smooth metal plate, usually the hot metal drum or plate of a heat dryer; soaking the print first in a glossing solution helps prevent sticking and uneven drying. Do not ferrotype RC papers; simply use an RC glossy surface. See opposite for more about RC papers.

Spotting and Toning

Even after clean and careful processing, your prints may have small imperfections that you would like to remove. It is almost impossible to produce a print without a few white specks caused by dust on the negative or paper during printing. Black specks or scratches can be very noticeable in a light-toned area. Spotting a print improves its overall appearance by removing these distracting marks. Most spotting is done after the print has been completely processed and dried; the exception is local reduction or bleaching, which is done while the print is still wet. Practice is essential with all these techniques.

White spots are removed by adding dye to the print until the tone of the area being spotted matches the surrounding tone (bottom left). Liquid photographic dyes, such as Spotone, sink into the emulsion and match the surface gloss of unspotted areas. They are usually available in sets of at least three colors—neutral, warm (brown-black) and cool (blue-black)—so that the tones of different papers can be matched. Spotting colors that are packaged as dry pigments coated on small cards and watercolor paints tend to stay on top of the emulsion and may leave the spotted area duller than the rest of the print. You will need one or more soft, pointed brushes, size 00 or smaller (some workers like a brush as small as size five zero, 00000), facial tissue to wipe the brushes, a little water, a small, flat dish to mix the colors and a scrap print or a few margin trimmings to test them.

Pick up a drop of the neutral black on a brush and place it in the mixing dish. Spread a little on a margin trimming and compare the dye color to the color of the print to be spotted. If necessary, add some of the warmer or cooler dyes to the

mixing dish until the spotting color matches the print. Spot first with undiluted dye in any completely black areas of the print. Dip the brush into the dye, wipe it almost dry and touch it gently to the print. Several applications with an almost dry brush will give better results than overloading the brush and making a big blob on the print. Spread out the dye in the mixing dish and add a drop of water to part of it to dilute the dye for lighter areas. Since the dyes are permanent once they are applied to the print, it is safer to spot with a light shade of dye—you can always add more. Spot from the center of a speck to the outside so that the dye doesn't overlap tones outside the speck.

A small or thin black mark that obviously doesn't belong where it is, such as a dark scratch in a sky area, can be removed by etching (top right). Gently stroke the sharp tip of a new mat knife blade or a single-edge razor blade over the black spot. Use short, light strokes to scrape off just a bit of silver at a time so that the surface of the print is not gouged. Etching generally does not work as well with resin-coated (RC) papers as with regular-base papers.

Local reducers, such as Farmer's Reducer (diluted 1:10) or Spot Off, bleach out larger areas than can be etched and can also be used to brighten highlights in a print (bottom right). Prints are reduced while they are wet. Squeegee or blot off excess water and apply the reducer with a brush (used for this purpose only), a cotton swab or a toothpick wrapped in cotton. If the print does not lighten enough within a minute or so, rinse, blot dry and reapply fresh reducer. Refix the print for a few minutes before washing as usual.

before and after spotting

Shown above is part of an extremely dirty print before spotting (left) and after (right). Before using any spotting technique on your good prints, practice first on some rejects; you will have a better idea how various procedures can change a print.

spotting with dyes

White specks, lines or even large spots can be blended into the surrounding tones of the print by spotting with dyes that darken the area. The dyes are used straight from the bottle for the darkest areas, diluted with water for lighter ones.

Small black specks or scratches can be removed by etching the surface of the print with a sharp blade until the darkened silver of the speck is removed. The roughened surface of the print is not objectionable if the speck is small and if you etch gently.

local reduction

This bleaching process works well with larger dark spots. It does not mar the surface of the print, but it is not recommended in combination with toning. Flush the surface of the print with water between applications and then to stop the bleaching process.

Toning, which involves immersing the print in a chemical toner solution, is an optional process that can have several effects on a print. Sometimes a print is toned in order to cause a distinct change in the color of the silver image. Commercially available toners can change the image color to various shades of sepia (yellowish-brown), brown, blue, red or orange. Some toners, such as gold toner GP-1 or a very dilute selenium toner, are used primarily to increase the life of the print by preventing deterioration of the silver image *(page 174)*. A third kind of toning, used for intensification, changes the print color very little, just enough to remove the slight color cast present in most prints and leave a deep, neutral black image. While the color is changed only slightly, the richness and brilliance of the print are increased noticeably, an effect that is easily seen if the toned print is compared to a similar one that is untoned. A procedure for toning prints for intensification is described below.

The color of any toned print depends on many factors, such as the type of paper, type of developer, development time, type and dilution of toner and toning time, so it's a good idea to experiment to get the combination that gives you the exact tone you want.

Careful work pays off in toning; a poorly processed print is likely to stain or tone unevenly. Use only scrupulously clean, rust-free trays and containers. Prints that have been locally reduced may not tone evenly.

Toning for Intensification

Selenium toning for intensification deepens blacks in a print by removing the slight color cast present in many printing papers, leaving a rich, neutral black image. The toner formula below also shortens the washing time by including a hypo neutralizing agent.

Mixing the solution

4 liters (1 gal) freshly mixed hypo neutralizing solution, working strength (such as GAF Quix, HEICO Perma-Wash or Kodak Hypo Clearing Agent)

200 cc (7 oz) selenium toner concentrate (such as GAF Flemish Toner or Kodak Rapid Selenium Toner)

75 gm (2.5 oz) Kodalk Balanced Alkali

Store in a clean bottle. One gal of toner treats about 50 8 x 10 prints or the equivalent. To tone 12 prints, pour out 1 qt of toning solution and discard after use.

Preparing to tone

Develop prints for the full length of time and fix in a 2-step fixing bath. Kodak recommends transferring prints directly from the fixer to the toning solution to prevent staining, but this is not always a workable procedure. Instead, prints can be rinsed thoroughly and held up to 24 hr in a tray of water, or they can be completely washed and dried for later toning. Rinse the prints briefly in fixer just before toning.

Set up 3 clean trays in a well-lighted area. A regular tungsten bulb will make the toning easier to see; a blue bulb will show what the print will look like under daylight viewing conditions. Fluorescent light is not recommended. Place the prints in water in one tray, the toner at 75° F (24° C) in the middle tray, and fill the third tray with water—gently running, if possible.

Toning

Place a print in the toning solution. Agitate constantly until a slight change is visible, usually within 3 to 5 min. Don't stare at the toning print; to judge how much the color has changed, look at a wet untoned print, then glance at the print in the toner. Very little change is needed, just enough so that the print looks neutral or very slightly purplish in the middle-gray areas when compared to an untoned print. Immediately rinse the print in the third tray of clean water. Wash prints 30 min or longer.

How to Dry Mount

1 | metal ruler
2 | mat knife
3 | tacking iron
4 | dry-mount tissue
5 | print
6 | mat board
7 | press
8 | paper for cover sheet

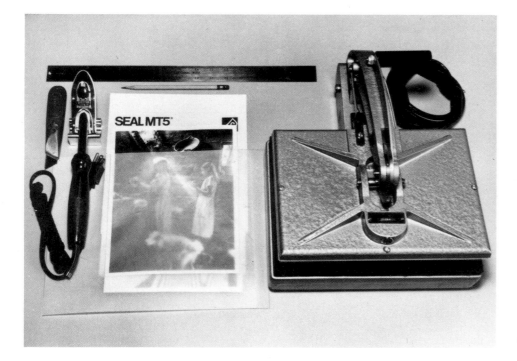

1 | dry the materials

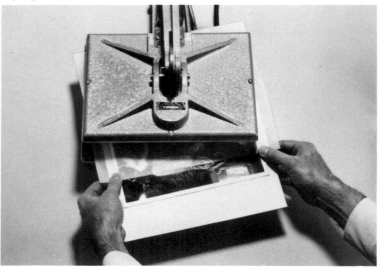

Heat the press to 200°–275°F (93°–135°C), or 180°–210°F (82°–99°C) for RC papers. Use the lowest setting that bonds print to mount. Predry mount board and print, with cover sheet on top, in press for 30 sec (do not predry an RC print).

2 | wipe materials clean

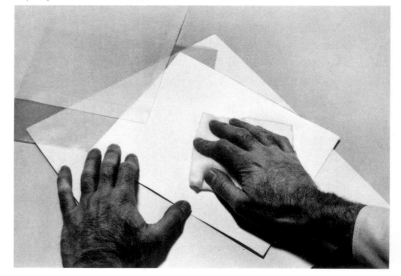

After the materials have been baked dry, let them cool for a few min, and then wipe away any loose dirt with a cloth; examine them for cleanliness under a strong light. Always use clean cloth, and take care not to grind dirt into the board.

The fastest and neatest mounting method uses dry-mount tissue, a thin sheet coated with an adhesive that becomes sticky when heated. The molten adhesive penetrates the fibers of both mounting board and print and forms a tight, perfect bond.

Dry mounting works best if two items are used: a small tacking iron to position the tissue on board and print and a press to dry the materials and affix the print to the board. The press has a heating plate hinged to a bed plate; in it, the adhesive melts uniformly and is pressed into the board and print. (For occasional mounting jobs, a household iron can be used as shown on page 184.)

Parts of the procedure change (especially the temperatures used) depending on whether you are mounting a print made on a regular-base paper or one made on resin-coated (RC) paper. Basically, though, the methods are alike.

The mount board, print and cover sheet should be bone dry before mounting. A regular-base print plus the mount board and cover sheet are placed in a heated press to drive out any residual moisture. An RC print does not have to be heated since it will not have absorbed any atmospheric moisture.

All materials must be absolutely free of dirt; even a small dirt particle trapped between print and board causes an unsightly, and permanent, lump in the print.

The print shown here is bleed mounted—trimmed so that the edges of the image are even with the edges of the mounting board. Another method is to mount the print with a wide border around the edges. Some photographers like a border that is the same width all around the print. Others prefer to have the side margins equal but the bottom margin slightly larger than the top.

3 | tack the mounting tissue to the print

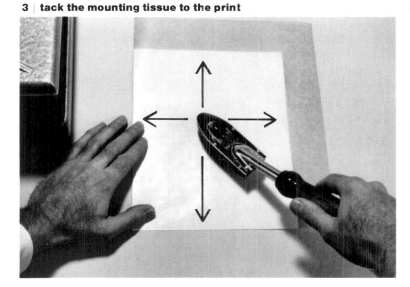

With the print face down and mounting tissue on top of it, tack the tissue to the print with a hot tacking iron by moving the iron from the center of the print to the sides. Do not tack at the corners.

4 | trim the mounting tissue

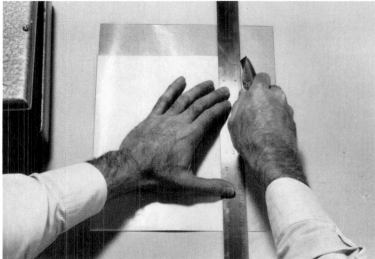

After placing a piece of smooth cardboard under the print, trim off the excess mounting tissue and a bit of the print margin, using the ruler as a guide. Press firmly on the ruler to prevent slipping. Don't cut into the image area of the print.

5 | attach mounting tissue and print to the board

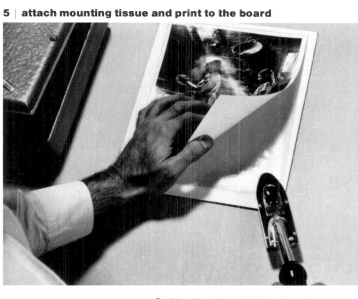

Position the print and tissue, face up, on top of the mount board. Slightly raise one corner of the print and tack the corner of the tissue to the board; tack the opposite corner next, then the remaining two. The tissue must lie flat to prevent wrinkles.

6 | mount the print

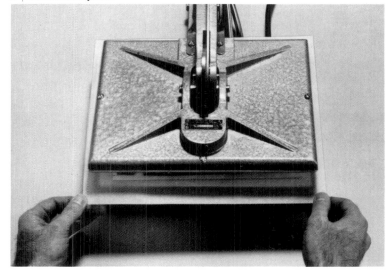

Put the sandwich of board, tissue and print (with cover sheet on top) into the press. With RC prints, quickly open and close the press several times to drive out any moisture. Then clamp in the press for about 30 sec (or longer).

Dry Mounting with an Iron

If you are mounting a small print, a clothes iron can substitute for the mounting press and tacking iron. Clean the base plate well, empty it of water if it is a steam iron and set the controls for synthetic fibers.

7 | trim the mounted print

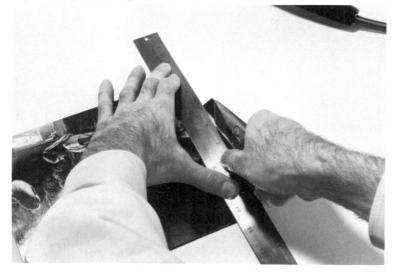

Trim the edges of the mounted print with the mat knife. The blade must be sharp to make a clean cut. Several light slices often work better than only 1 cut. Press down firmly on the ruler so it does not slip—and be careful not to cut your fingers.

1 | tack the mounting tissue to the print

After drying the materials with the hot iron, use the tip to tack the mounting tissue to the back of the print. Don't press so hard as to crease or dent the print. Turn the print face up and trim away print margins and extra tissue with the ruler and mat knife.

8 | the finished print

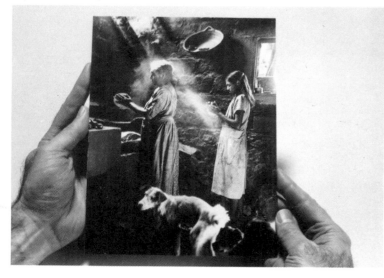

The print above is bleed mounted, trimmed to leave no border. If you want a wide border of mounting board around the edges of the print, as at right, trim away the print margins and extra tissue before tacking down the print in step 5.

2 | seal the print to the mount board

After positioning the print on the mount board, tack down the mounting tissue corners. Place a cover sheet over the print (tracing paper is shown but heavier paper is better). Seal the print to the board with light strokes from the center outward.

Cutting an Overmat

1 | T square
2 | metal ruler
3 | art gum eraser
4 | paper for cover sheet
5 | mat board
6 | mat cutter
7 | single-edge razor blade
8 | print to be displayed
9 | pencil

1 | measure the picture

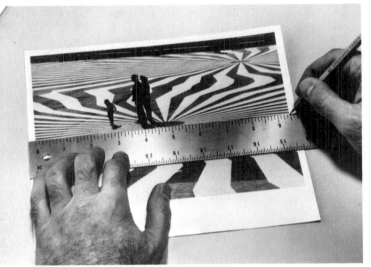

Decide on cropping and measure the resulting image. This picture was cropped to 9³/₈ by 5³/₄ in (23.8 x 14.6 cm). If the picture is not to be cropped, measure a fraction of an inch within the image area to make sure the print margin will not show.

2 | figure the dimensions

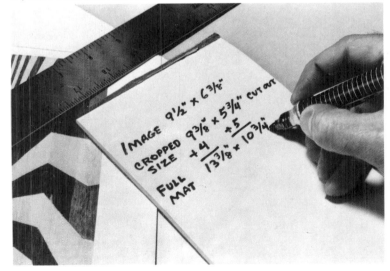

To find the size of the mat, add the dimensions of border and cropped image. Here the border is 2 in (5.1 cm) on the sides and top and 3 in (7.6 cm) on the bottom, requiring a mat 13³/₈ by 10³/₄ in (34 x 27.3 cm). Cut 2 boards: 1 for backing, 1 for mat.

A mat is simply a cardboard rectangle with a hole cut in it; placed over a print that has been mounted to a backing board, it provides a raised border around the photograph. One of the practical advantages of the raised border is that it protects the surface of the print emulsion, which can be easily scratched by something sliding across it—such as another print. This can still happen with a matted print, but is less likely. And, since the mat is replaceable, a new one can be cut and mounted without damage to the picture if the original mat becomes soiled. One of the great pleasures of photography is showing your prints to other people—but one of the great irritations is having someone leave a fingerprint on the mounting board of your best print. A soiled overmat can be replaced with relatively little

trouble. Prevent problems by handling your own and other people's pictures only by the edges.

The most difficult part of matting is cutting the inner edges of the mat with precision. It becomes easier after a few tries, so spend some time practicing with scrap board to get the knack of cutting perfectly clean corners. A mat cutter is a useful aid. A simple, heavy metal device designed to fit into the palm of the hand, it holds a knife blade that can be rotated to cut either a beveled (angled) edge or a perpendicular one. Mat cutters, like the other tools and materials shown above, are available at most art or photographic supply stores. They are a worthwhile investment because they can make the difference between a ruined board, cut freehand with an unbraced knife, and a perfectly cut mat.

3 | mark the mat board

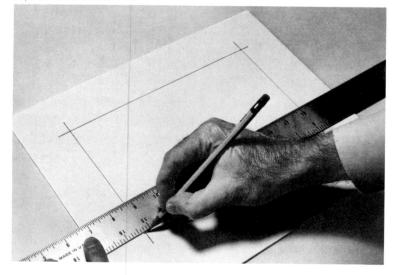

Mark the back of one board for the inner cut, using the dimensions of the image that will be visible. Measure with the ruler, but in drawing the lines use the T square firmly braced to align with the mat edge to be sure the lines are square.

4 | set the cutting blade

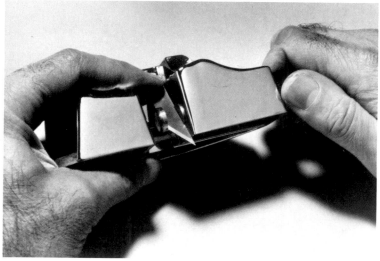

Insert the knife blade in the mat cutter, sliding it into the slot on the inner end of the movable bolt. Adjust the blade so that it extends far enough to cut through the board, then tighten, using the threaded knob on the bolt's outer end.

5 | cut the mat

Get a firm grip on the mat cutter and brace it against the ruler. Cut each of the inside edges on a line, stopping short of the corners; finish the corners with the razor blade; do not cut too far, but take care to maintain the angle of the cut.

6 | position and attach the print

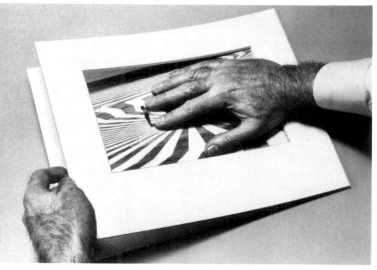

Ways of attaching the print to the backing board are shown at right. Slip the print between the backing board and the mat. Align the print with the inner edge of the mat. Then remove the mat and attach the print.

7 | attach the mat to the backing board

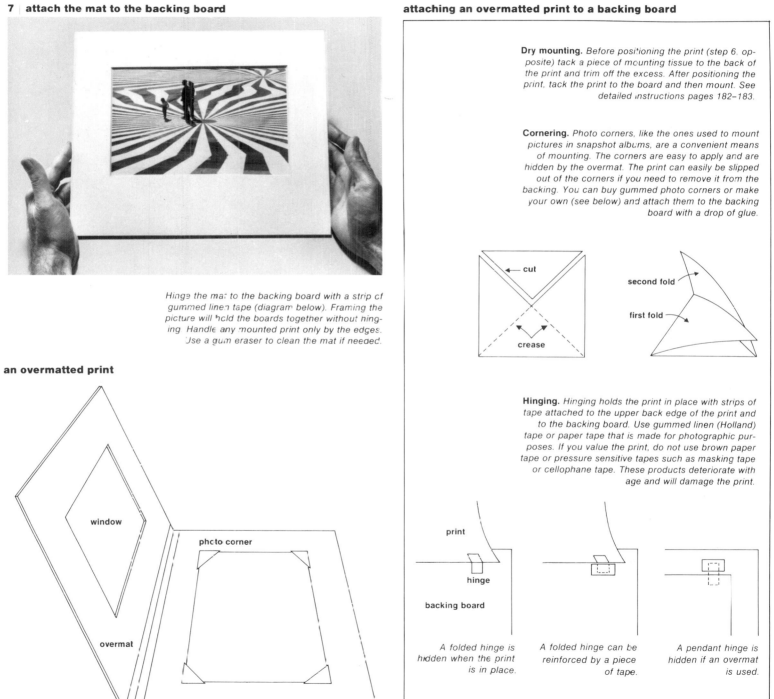

Hinge the mat to the backing board with a strip of gummed linen tape (diagram below). Framing the picture will hold the boards together without hinging. Handle any mounted print only by the edges. Use a gum eraser to clean the mat if needed.

an overmatted print

window

photo corner

overmat

backing board

hinge

attaching an overmatted print to a backing board

Dry mounting. *Before positioning the print (step 6. opposite) tack a piece of mounting tissue to the back of the print and trim off the excess. After positioning the print, tack the print to the board and then mount. See detailed instructions pages 182–183.*

Cornering. *Photo corners, like the ones used to mount pictures in snapshot albums, are a convenient means of mounting. The corners are easy to apply and are hidden by the overmat. The print can easily be slipped out of the corners if you need to remove it from the backing. You can buy gummed photo corners or make your own (see below) and attach them to the backing board with a drop of glue.*

← cut

crease

second fold

first fold

Hinging. *Hinging holds the print in place with strips of tape attached to the upper back edge of the print and to the backing board. Use gummed linen (Holland) tape or paper tape that is made for photographic purposes. If you value the print, do not use brown paper tape or pressure sensitive tapes such as masking tape or cellophane tape. These products deteriorate with age and will damage the print.*

print

hinge

backing board

A folded hinge is hidden when the print is in place.

A folded hinge can be reinforced by a piece of tape.

A pendant hinge is hidden if an overmat is used.

Y. R. OKAMOTO: *Arnold Newman Photographing President Lyndon B. Johnson*, 1963

9 Lighting

Direct Light 190

Directional-Diffused Light 191

Fully Diffused Light 192

Silhouette 193

Light as You Find It—Outdoors 194

Light as You Find It—Indoors 196

The Main Light: The Most Important Source 198

The Fill Light: Modifying Shadows 200

Lighting a Portrait 202

Lighting Translucent Objects 204

Lighting Textured Objects 206

Lighting Shiny Objects 207

Lighting with Flash 208

Six Ways to Use Flash 210

Calculating Exposures with Flash 212

Avoiding Common Mistakes with Flash 213

Photography is dependent on light, even for its name—photo-graphy: light-writing. The physical process is activated by light striking the light-sensitive emulsion of film or paper. The informational or emotional process—what people learn or feel when they look at a photograph—is activated in part by the quality of light the photographer recorded. Harsh or gentle, ominous or peaceful, the variations are limited only by the photographer's ability to capture them. Light can even be the main subject of the photograph, more interesting than the objects in the picture themselves.

All light has certain fundamental qualities, whether it comes directly from the sun, already exists in a room or is brought into the room by the photographer. The kind of lighting used, whether it be sun, photoflood or flash, is not so important as what that light is doing to the subject, since any type of light can be used to create identical qualities.

While the lighting setup shown opposite looks complicated, its intention was quite simple—to illuminate the subject in a way that resembled ordinary daytime lighting. This type of lighting looks natural and realistic because it is the kind people see most often. It consists of one main source of light coming from above (usually cast by the sun, here cast by the large umbrella reflector) plus additional fill light to illuminate shadow areas (in nature, light from the entire dome of the sky or from other reflective surfaces; here, cast by the smaller light sources).

◀ When Arnold Newman was asked to make a portrait of President Lyndon B. Johnson in the Oval Room at the White House, Newman was given 90 min to arrange his equipment, but only 15 min for the actual shooting. The photographer covered the windows with cloths to block unwanted light, mounted 2 view cameras—a 4 x 5 and an 8 x 10— and arranged his lights and reflectors, using an assistant as a stand-in. While making his picture (opposite) Newman coaxed the President into the poses and facial expressions he wanted, as a Secret Service man watched in the background.

Direct Light

How does light shape and reveal a subject? Here and on the following pages are four lighting situations: direct light, directional-diffused light, fully diffused light and a silhouette. The kind of light, the subject and its surroundings, as well as the exposure and development chosen by the photographer, all affect the final image.

Direct light creates hard-edged, dark shadows. The rays of light are parallel (or nearly so), striking the subject all from one direction. The smaller the light (relative to the size of the subject) or the farther the light is from the subject, the sharper and darker the shadows will be. Very sharp shadows are created by a point source, a single point of light. A stage spotlight, which could have been used for the photograph on this page, is small, rather far away and often has a built-in lens to focus the light even more directly. Notice the small, sharp catchlight—the reflection of the light source in the subject's eye. The shadows here are empty of detail: there were no reflective areas near the subject to bounce light into the shadows to add fill light *(pages 200–201)*. The contrast (the difference in tone between light and dark areas) may also have been increased by underexposure and overdevelopment of the negative or by printing on a high-contrast paper.

The sun on a clear day is another source of direct light. Although the sun is large in terms of actual size, it is so far away that it occupies only a small area of the sky and casts sharp, dark shadows. It does not cast direct light when its rays are scattered in many directions by clouds or other atmospheric matter: then its light is directional-diffused or even fully diffused.

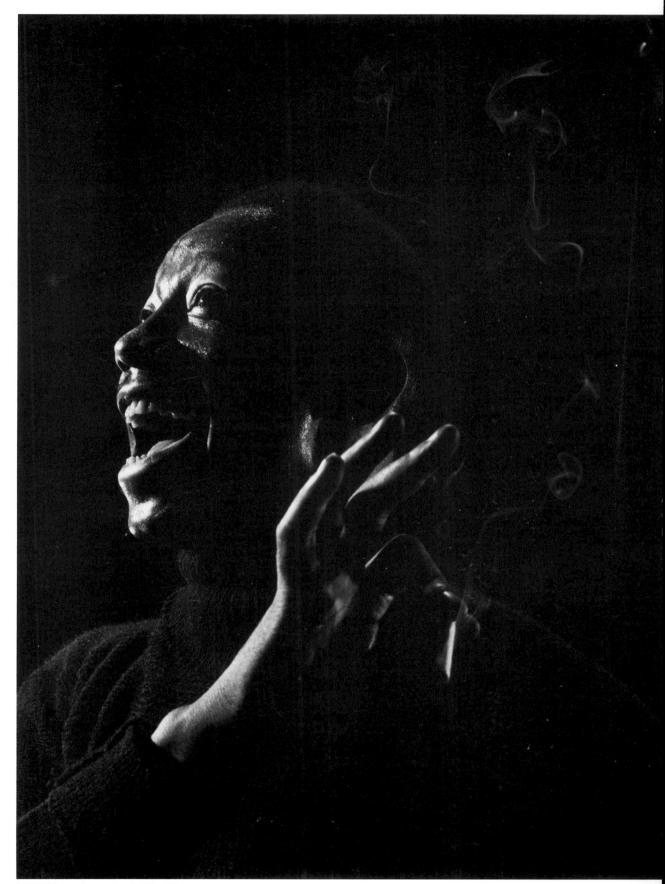

GJON MILI: *Avon Long as Sportin' Life,* 1942

Directional-Diffused Light

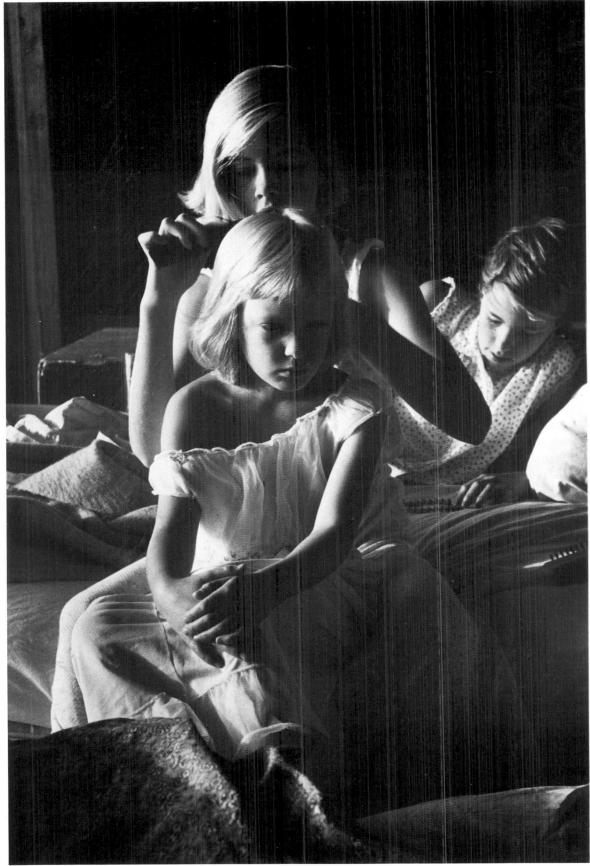

Directional-diffused light has some rays of direct light plus some that have been diffused or scattered at various angles. It appears to come from a definite direction and creates distinct shadows, but with edges that are softer than those of direct light *(photograph this page)*. The shadow edges change smoothly from light to medium-dark to dark and the shadows tend to have more visible detail.

Sources of directional-diffused light are relatively broad. Indoors, windows or doors are sources when sunlight is bouncing in from outdoors rather than shining directly into the room. Floodlights used relatively close to the subject are also sources; their light is even more diffused if directed first at a reflector and bounced onto the subject (like the umbrella light on page 188) or if partially scattered by a diffusion screen placed in front of the light. Outdoors, the usually direct light from the sun is broadened on a moderately overcast day, when the sun's rays are partially scattered and the surrounding sky becomes a more important part of the light source. Bright sunlight can also produce directional-diffused light when it shines on a reflective surface such as concrete and then bounces onto a subject shaded from direct rays by a tree or building.

In the photograph on this page, the light is probably coming from one or more large windows. The shadows show full details because the white sheets and nightgowns bounce the light back to open up the shadows. Notice the brightness of the left cheek of the child in the background, caused by the light bounced up by the pillow. The contrast of the scene may also have been decreased by slightly overexposing and underdeveloping the negative or by printing it on a low-contrast paper.

WAYNE MILLER: *Morning Repose, Orinda, California,* 1957

Fully Diffused Light

DANNY LYON: *Sparky and Cowboy (Gary Rogues)*, 1965

Fully diffused light scatters onto the subject from many directions and shows very little or no directionality. In the photograph on this page, light is coming from above, as can be seen from the brightly lighted foreheads, noses and cheekbones, but light is also bouncing in from both sides and probably from below. Shadow edges are indistinct and subjects seem surrounded by light.

Sources of fully diffused light are very broad relative to the size of the subject—a heavily overcast sky, for example, where the sun's rays are completely scattered and the entire sky becomes the source of light. Fully diffused light indoors would require a very large, diffused light source close to the subject plus reflectors or fill lights to further open the shadows. Tenting *(page 207)* is one way of fully diffusing light.

JOHN LOENGARD: *Portrait of Bill Cosby,* 1969

In a silhouette, the subject is in deep shadow against a brightly lighted background. A silhouette is created if the subject is underexposed because of a great difference in brightness between the subject and the background.

In the photograph above, the wall was actually a brilliant, glaring white, but exposing it as a middle-gray tone caused the subject to be grossly underexposed. Four stops' more exposure would have produced a normal portrait. This is the same effect that underexposes the subject if a bright background such as the sky is metered instead of the subject *(page 117).*

Indoors, a subject can also be silhouetted by placing a bright light behind the subject so that the background is brightly lighted while the part of the subject facing the camera is in shadow.

Light as You Find It—Outdoors

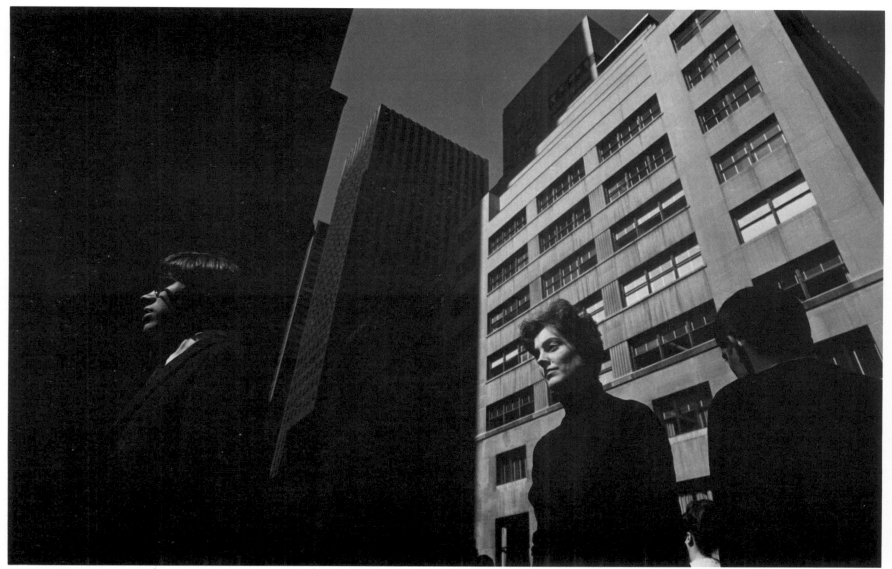

HARRY CALLAHAN: *New York*, 1968

What kind of light will you find when you photograph outdoors? It may be any of the lighting situations shown on the preceding pages, so it is important to stop for a moment to look at the light and see how it affects the photograph.

It may be a clear sunny day with bright,

direct light creating bright highlights and dark, hard shadows *(above)*. The dark shadows here are an important part of the image. They are both solid shapes and empty holes in the cityscape. What would a portrait look like made in this kind of light? You might want to lighten

the shadows in a portrait by adding fill light, or by taking your subject out of the sun and into the shade where the light is not so contrasty. What direction is the light coming from? Can you move around your subject or move the subject itself so that the light better reveals its

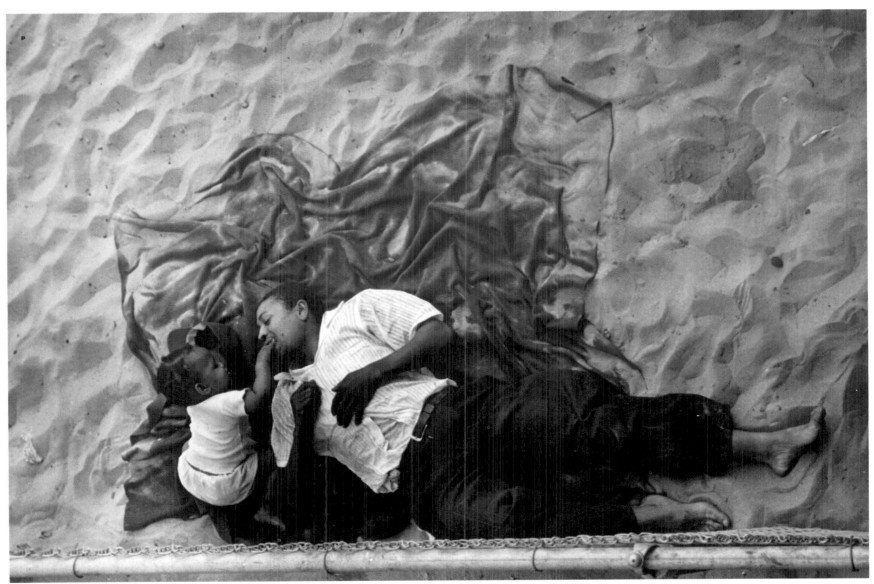

shape or texture as seen by the camera?

On an overcast day or at dusk, the light will be diffused and soft, as in the photograph above. This s a revealing light that illuminates all parts of the scene and shows every step in the sand and wavy wrinkle in the blanket. It is a beautiful light for portraits, gently modeling the planes of the face.

As the time of day changes and the sun gets higher and then lower in the sky, the light also changes. If the day is sunny, many photographers prefer to work in the early morning or late afternoon; when the sun is close to the horizon it casts long shadows and rakes across the surface of objects, increasing the sense of texture and volume.

Light as You Find It—Indoors

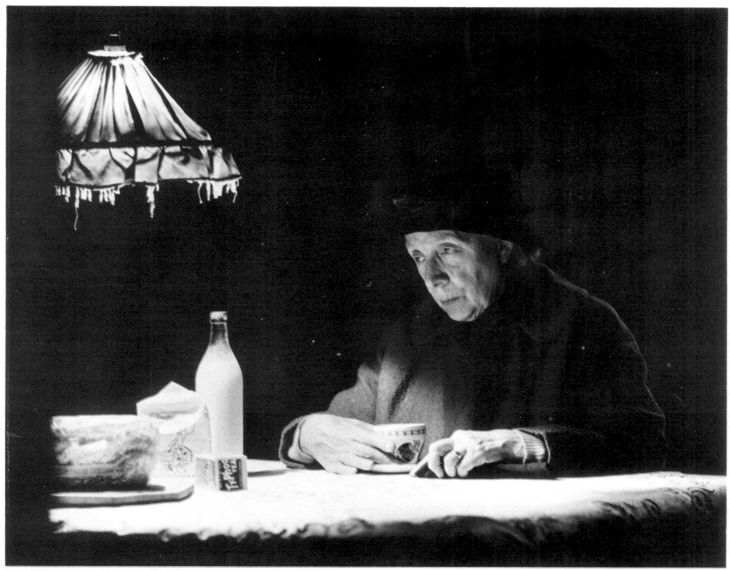

IRWIN DERMER: *Dame Edith Evans in "The Whisperers,"* 1966

Indoors, bright areas usually fade off quickly into shadow. In a room with only one lighting fixture, re-created above in a scene from a movie, the light is directional and contrasty. The only areas that are illuminated are those directly in the light of the lamp or close enough to the tablecloth to receive light bounced up from it. If there are many light fixtures, however, as in the subway station opposite, the light can be diffused and flat. In both cases the light sources themselves are key elements of the pictures.

With a fast film it is often possible to photograph in the light that already exists in a room without bringing in additional lighting, but it is important to meter carefully and expose for the most important parts of the picture. The eye adapts easily to variations in light; it can glance at a light area then quickly see detail in a nearby dark area. But there will often be a greater range of contrast indoors than film can record.

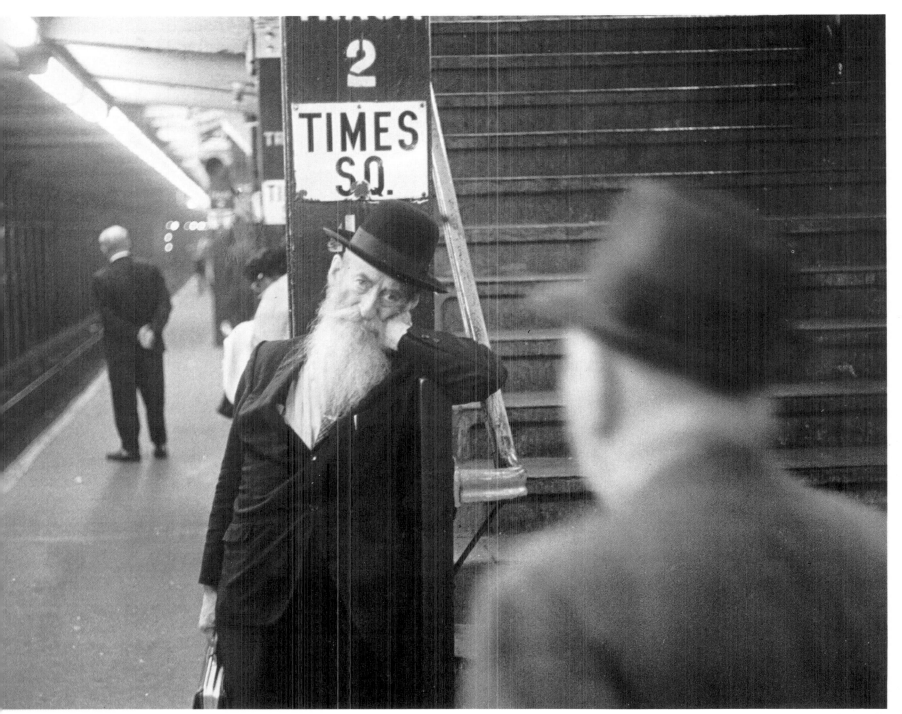

GARY RENAUD: *In the Subway*, 1965

The Main Light: The Most Important Source

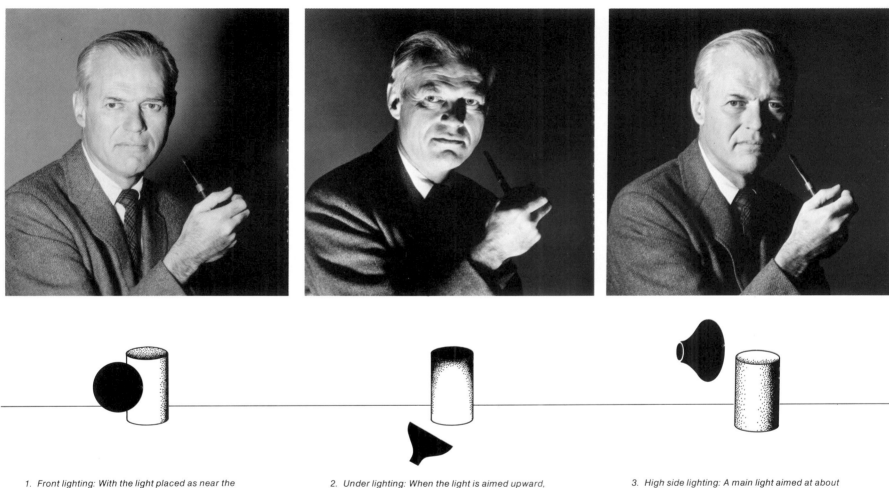

1. Front lighting: With the light placed as near the lens axis as possible (here just to the left of the camera), only thin shadows are visible from camera position. This axis lighting seems to flatten out the volume of the subject and minimize textures.

2. Under lighting: When the light is aimed upward, the subject's face assumes unnatural shadows and a faintly evil look. In special circumstances this kind of lighting can be put to use to give the picture an aura of mystery.

3. High side lighting: A main light aimed at about 45° to the subject has long been the classic angle for portrait lighting, one that seems most natural for the majority of people. It models the face into a three-dimensional form.

Making a photograph by natural or available light is relatively easy. You begin with the light that is already there and observe what it is doing to the subject. But where do you begin when making a photograph by artificial light? Since the most natural-looking light imitates that from the sun—one main light source casting one dominant set of shadows— the place to begin is by positioning the main light. This light, also called the key light, should create the only visible shadows, or at least the most important ones, if a natural effect is desired. Two or three equally bright lights producing crisscrossing shadows create a definite feeling of artificiality and confusion.

The pictures above demonstrate how the position of the main light affects the texture and volume that appear in a photograph. Flat frontal lighting (photograph 1) decreases both texture and volume while lighting that grazes across surface features as seen from camera position increases it. Since lighting conveys emotional information as well as factual data, the pictures also show how the mood of a photograph can be influenced merely by changing the position of one light. If photographs never

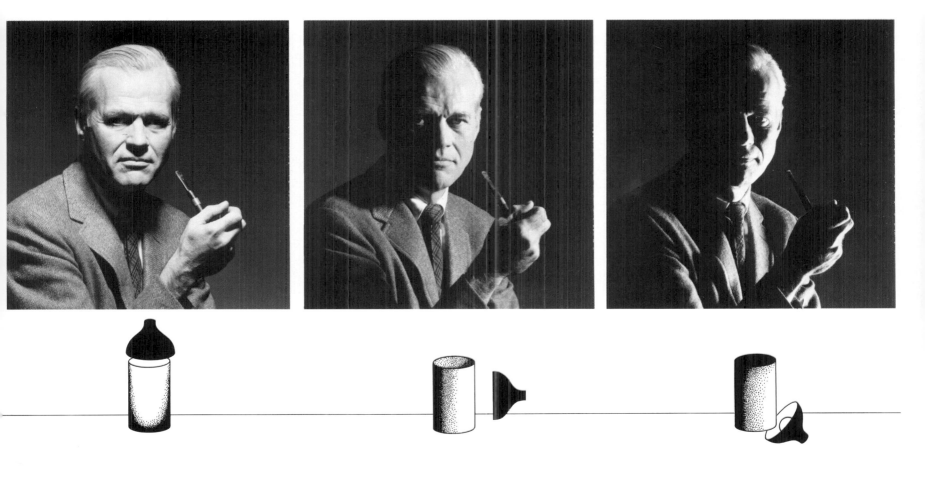

4. Top lighting: A light almost directly above the subject creates deep shadows in the eye sockets and under the nose and chin. This effect is often seen in pictures made outdoors at noon when the sun is overhead.

5. Side lighting: Sometimes called "hatchet" lighting because it appears to split the subject in half, this type of lighting can be useful in emphasizing rugged masculine features or in revealing the texture of skin or fabrics.

6. Side-rear lighting: A light to the side and slightly behind the subject yields an even more dramatic effect. If the light were directly behind it would bring out the shape or silhouette of the subject and turn the hair into a halo.

lie, some of the ones above at least bend the truth about the subject's personality.

Since natural light usually comes from overhead, this is the most common location for the main source of artificial light. Lighting from a very low angle or from below suggests mystery, drama or even menace just because it seems unnatural. The grisly demon in a horror movie is typically lighted from below.

Other types of lighting have come to be associated with "glamour" poses. One example is butterfly lighting, which is named for the symmetrical shadow underneath the nose similar to, though not as long as, the one in photograph 4. The main light is placed high and in front of the subject to produce sculptured facial shadows (page 203, far right).

Most photographs made with artificial light employ more than one light source: almost always a fill light is used to lighten shadows and often two more lights are added: an accent light to produce bright highlights, plus a background light to create tonal separation between the subject and the background. Pages 202–203 show standard lighting setups using these lights.

The Fill Light: Modifying Shadows

Although great pictures have been taken with a single main light source (Julia Margaret Cameron's portrait of Sir Henry Taylor, for example, on page 328), most artificial lighting and some scenes in daylight require some addition of light in shadow areas—called fill light—to reduce harsh contrasts and bring out details that would otherwise be lost. The human eye looking at a scene automatically adjusts for differences in brightness—as it glances to a shadowed area the pupil opens up to admit more light. But since photographic film records only the existing levels of light, shadows that appear reasonably bright to the eye may appear on the film as black areas that are empty of detail.

One way to tell if shadow areas are too dark is to squint while looking at the scene; shadow areas will appear darker, thus more noticeable. Viewing the scene through the camera's lens with the aperture stopped down also helps. But a more accurate way is to measure the light with an exposure meter. If large shadow areas measure three stops or more darker than midtones, they will be almost black or black in the final print. Portraits are conventionally made with the shadowed side of the face between one and one-half and two stops darker than the bright side of the face. Color transparencies show the need for fill light more than prints do. Color transparencies have very little exposure latitude so that more than about one stop difference between highlights and shadows can make shadows look very dark.

In addition, the film in the camera is the final product, so corrections can't be made later during printing.

The simplest, least expensive and often most effective way to add fill light is to use a reflector to bounce the main light into areas where it is needed (pictures opposite). A simple reflector, or flat, can be made from a piece of stiff cardboard, about 16 by 20 inches (41 x 51 cm), with a soft matte white finish on one side. The other side can be covered with kitchen aluminum foil that has first been crumpled and then partially smoothed flat. The white side will give a soft, diffused, even light suitable for lightening shadows in portraits, still lifes and other subjects. The foil side reflects a more brilliant, hard-edged light.

A floodlight can also be used for fill lighting. It could have lower wattage than the main light, be placed farther away from the subject or have a translucent diffusing screen placed in front of it. Outdoors, in addition to a reflector, flash can be used (see page 212). The fill is usually not intended to eliminate the shadow altogether, so it is normally of less intensity than the main light. A light source used as a fill is generally placed close to the lens so that any secondary shadows will not be visible.

A black reflector is useful at times. it can create shadows by absorbing light and preventing it from reaching the subject. You may want to darken a shadow; a black reflector will remove fill light by absorbing light from the main light.

No reflector: A single floodlight is positioned in front of the sculptured head, above and to 1 side of it (see drawing above). The light reveals rounded contours but leaves the right side of the face hidden in dark shadow.

White reflector: A flat piece of white matte cardboard has been placed to the right of the head, held in a clamp stand and angled so that the light bounces back into the shadow areas on the right cheek and chin to add fill light.

Lighting a Portrait

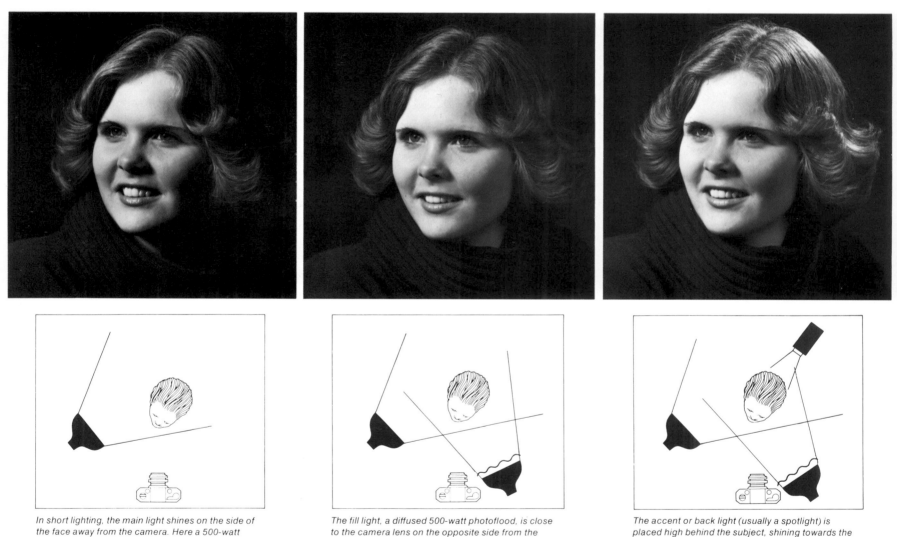

In short lighting, the main light shines on the side of the face away from the camera. Here a 500-watt photoflood is placed at a 45° angle at a distance of about 4 ft. The main light is positioned high, with the catchlight reflection in the eyes at 11 or 1 o'clock.

The fill light, a diffused 500-watt photoflood, is close to the camera lens on the opposite side from the main light. Since it is farther away than the main light, it lightens but does not eliminate the main light shadows. Catchlights from the fill are usually spotted out in the final print.

The accent or back light (usually a spotlight) is placed high behind the subject, shining towards the camera but not into the lens. It rakes across the hair to emphasize texture and bring out sheen. Sometimes a second accent light places an edge highlight on hair or clothing.

If you went to a portrait studio to have your picture made, the photographer would probably arrange the lights somewhat as they are shown in the diagrams above. The goal of the commercial portrait photographer is usually to create a realistic but rather idealized image, and these lighting setups do just that. They model most faces in a pleasing manner and can be used to improve some features—for example, using broad lighting to widen a thin face. Obviously a good portrait does not need to be lighted in a standardized manner (none of the pictures on pages 190–193 are conventionally lighted) but it is useful to know how to do so. First of all, sometimes you will want to make a conventional portrait with unobtrusive lighting. Secondly, if you want to produce an unconventional portrait, knowing the rules will give you a better idea of how to break them.

The photographs on these pages show how some typical studio portraits

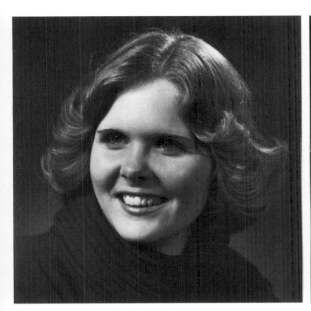

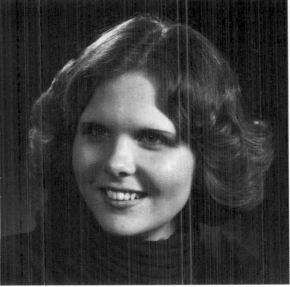

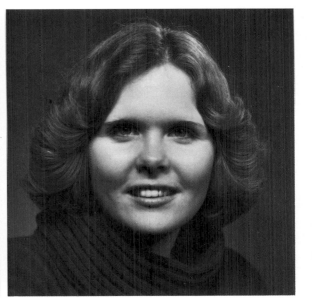

The background light helps separate the subject from the background. Here it is a small photoflood on a short stand hidden behind the subject. A larger photoflood or spot could be used, placed to one side. In this final print, the secondary catchlight from the fill has been spotted out.

In broad lighting, the main light shines on the side of the face towards the camera; again it is placed high so the catchlight is at 11 or 1 o'clock. The main light in this position may make the side of the head, often the ear, too bright. A "barn door" on the light will shade the ear

Butterfly lighting is conventionally used as a glamour lighting for women. The main light is placed directly in front of the face, positioned high enough to create a symmetrical shadow under the nose but not so high that the upper lip or the eye sockets are shadowed.

are made. A moderately long camera lens is used so that the subject can be placed about six feet (1.8 m) from the camera; this avoids the distortion that would be caused by having the camera too close to the subject. The subject's head is often positioned at a slight angle to the camera—turned just enough to hide one ear. The first four photographs show a short or narrow lighting setup where the main light is directed toward the side of the face away from the camera; this is the most common type of lighting, used with average oval faces as well as to thin down a too-round face.

The fifth photograph shows a broad lighting setup where the side of the face turned toward the camera is illuminated by the main light. This type of lighting tends to widen the features, so it is used mainly with thin or narrow faces. The last setup shows butterfly lighting; the main light is placed high—directly in front of the face.

Lighting Translucent Objects

Translucent or partially transparent objects like glassware, ice, thin fabrics and sometimes leaves and flowers can be lighted beautifully if the light comes from behind the object. The light seems to shine from within, giving the object a depth and luminance that could not be achieved with flat frontal lighting. If the background is illuminated (as is done in the lighting setup below) instead of shining the light directly on the object, the lighting will be soft and diffused. Glassware is almost always lighted from behind since frontal illumination usually causes distracting reflections.

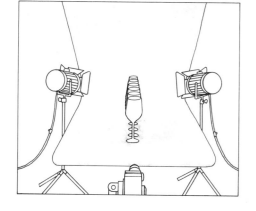

A row of crystal glasses (right) is softly lighted from the back by 2 large spotlights whose joined beams bounce off a sheet of seamless white paper, as shown above. The shadow that surrounds the bases of the glassware provides contrast with the brilliance cast by the reflected light and lends an air of cool elegance to the photograph.

ERICH HARTMANN: *Crystal Glassware*

Josef Sudek sought to photograph the poetic and extraordinary qualities in ordinary objects. Here, a quiet still life of 2 glasses of water and 2 eggs is more complex than it looks at first glance. Shapes reflect, refract and multiply themselves. Light glows on and within the objects. Sudek once said, "I like to tell stories about the life of inanimate objects, to relate something mysterious."

JOSEF SUDEK: *Glasses and Eggs,* 1952

Lighting Textured Objects

How do you light a textured object? That depends on whether or not you want to emphasize the texture. Every ripple of paint shows in the photograph at right because the light is raking across the object at a low angle to the surface and creates shadows that underline every bump and ripple. The same principle can be put to work with any textured object, such as rocks, textured fabrics or facial wrinkles. Simply aim a source of direct light so it skims across the surface, choose a time of day when the sun is at a low angle in relation to the object or arrange the object so light strikes it from the desired direction.

The shadows must be seen in the photograph if the texture is to be prominent, which is why side or back lighting is used when a pronounced texture is desired; the shadows cast will be visible from camera position. A light pointed at an object from the same direction as the lens, called axis light, may also produce shadows, but they will be just barely visible from camera position if at all. Axis light tends to produce the least sense of texture *(see photograph 1, page 198, and diagrams at right)*. If you want to minimize textures in a portrait because your subject is self-conscious about facial wrinkles, place the main light close to the lens.

side lighting

back lighting

axis lighting

Texture is emphasized in a photograph when light skims across the surface at a low angle and produces shadows that are visible from camera position. For most objects this requires side or back lighting. Axis lighting, which comes from the camera direction, produces the least texture.

SEBASTIAN MILITO: *Doorknob,* 1970

Lighting Shiny Objects

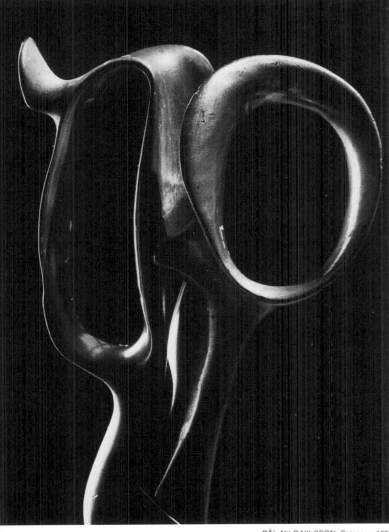

PÅL-NILS NILSSON: *Scissors,* 1959

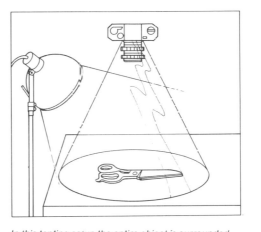

In this tenting setup the entire object is surrounded with a cone of translucent plastic specially made for photographic tenting. A hole is left at the top for the camera lens. The object is lighted from the outside of the tent.

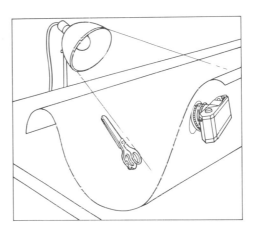

Here the object is partially tented with white paper, again with a hole cut for the lens. What is actually being photographed is the reflection of the lighted paper in the object. It is necessary with this type of setup to make sure the light does not shine directly into the lens.

Photographing shiny objects with glossy metal, ceramic or plastic surfaces poses a problem rather like that of photographing a mirror. The highly polished pieces reflect every detail of their surroundings, a distracting trait when the surroundings include such irrelevant items as lights, photographer and camera. Sometimes reflections work well in a photograph, making interesting patterns, but usually it is necessary to eliminate at least some of them. To some extent this can be done by moving the equipment or the object around until reflections are no longer distracting.

If the reflections must be reduced still further, two methods are available. You can use matte spray, a special dulling agent available in art supply stores. Use it sparingly or it will produce a flat, lifeless image. Another solution is to tent the object, that is, surround it with plain surfaces like large sheets of paper that are then lighted and whose reflections in the object are photographed *(diagrams at left)*. You can also hang strips of paper just outside the picture area to place reflections where you want them. When checking a shiny object for reflections, through-the-lens viewing is best. Even a slight change in position can change the pattern of reflections.

Lighting with Flash

In the early days of photography, taking pictures with flash was something of a gamble. Flash powder, an early source of artificial light, was a dangerously explosive mixture that could easily burn or blind the photographer. Not until the 1930s did flash photography become simple and safe with the mass production of flash bulbs. Today, flash bulbs, flash cubes or electronic flash units (also called strobes) provide a measured quantity of intense light that can be synchronized to flash when the camera shutter is open.

To synchronize flash and shutter an electrical connection is needed between them. If a camera has a socket in which a flash bulb or cube is inserted directly, the connection is made within the socket. Some cameras have a hot shoe, a bracket on top of the camera that both attaches a suitable flash unit and has a built-in electrical connection to the shutter. Other cameras have a synchronization socket to which one end of an electrical wire or synch (pronounced "sink") cord is connected; the other end of the cord attaches to the flash.

An electronic flash reaches its peak brilliance almost instantly and has a very brief duration (faster than the fastest shutter speed on a camera), so the flash is synchronized to fire when the shutter is fully open. A camera with a leaf shutter can be used with electronic flash at any shutter speed when the camera is set for "X" synchronization. A camera with a focal-plane shutter is used with electronic flash only at relatively slow shutter speeds since the shutter is fully open only at 1/60 second (sometimes 1/125 second) or slower.

Flash bulbs have a slight delay between ignition and their peak of usable light. The most commonly used bulbs, Class M, have a medium peak delay. A

camera with a leaf-type shutter set at M synch can be used with an M bulb at any shutter speed; however, the full light from the bulb will not be used if the shutter speed is faster than the usable duration of the flash (about 1/60 second). A focal-plane shutter can be set to X synch and used with Class M bulbs at slow shutter speeds (up to about 1/30 second). Class FP (focal-plane) bulbs have a flash of long duration and uniform brightness to provide even illumination for focal-plane shutters at all shutter speeds. Class S (slow peak) bulbs give the maximum light output and are used either at very slow shutter speeds (about 1/15 second) or are fired after the shutter is manually opened.

Not all cameras synchronize in all modes, so consult the manufacturer's instructions for synching your camera. X synch at 1/15 second shutter speed will work with all types of flash.

Two effects of flash are shown in the picture opposite. One is the flatness of modeling and lack of texture that occur when flash is pointed directly at the subject from camera position. There is nothing wrong with this kind of lighting. Weegee was a master of it, habitually using direct flash on camera to skewer his subjects flat on the picture plane. But there are other positions for the flash (see next pages).

Also shown opposite is the effect of the inverse square law, which in simple terms means that the amount of light hitting an object decreases rapidly as the distance from the light source increases. This is why the three people in the foreground are adequately exposed while the background is almost completely black; by the time the light from the flash reached the background, it was too dim to illuminate it.

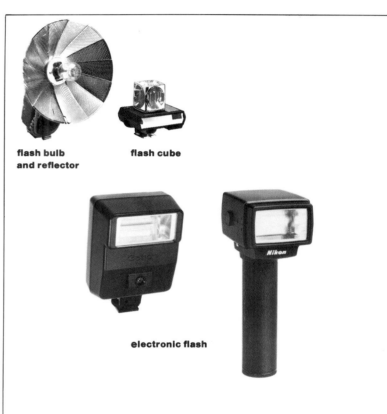

flash bulb and reflector　　　**flash cube**

electronic flash

Flash Equipment

Bulbs *consume their filaments when flashed and can be used only once. They are often used in reflectors that have a polished or a textured finish.*

A cube *is 4 tiny bulbs built into a single unit with a reflector behind each bulb and a plastic shield in front. The unit is turned after each flash, so that 1 cube can be used 4 times.*

Electronic flash—*or strobe—is a tube containing gas that glows brightly when electrified. It is reusable and can be fired thousands of times, drawing power from either household current or batteries. The circuit that causes the gas tube to glow must rebuild its voltage after each firing; this recovery time may be 10 sec or longer.*

An automatic flash unit *has a built-in photoelectric sensor that, within certain* limits, *measures the amount of light reflected by the subject during the flash and then terminates the flash when proper exposure is reached.*

A dedicated (or designated) flash unit *is designed to be used with a particular camera. When connected to that camera's hot shoe, the shutter is automatically set to the correct speed for flash and a signal appears in the camera's viewfinder when the flash is ready to fire. A dedicated unit can also be used as an ordinary flash with any camera.*

A bounce flash *has a head that tilts (usually up, but sometimes to the side) so that the flash can be used on camera but still provide bounced or indirect light.*

WEEGEE: *The Critic*, 1943

Six Ways to Use Flash

A small flash unit, either bulb or electronic, mounted on top of the camera provides an easy means of lighting a scene. An adequately exposed picture is almost guaranteed if the simple instructions that come with the unit are followed. But the trouble is that the picture almost always comes out flat, the subject two dimensional, with details bleached out by the head-on burst of light. The fault lies not with the flash itself but with using it on the camera. More natural-looking results can be obtained by employing techniques such as those demonstrated at right.

Basically these are techniques similar to those used with photofloods: they make the lighting more nearly resemble natural illumination. Since almost all natural lighting—whether supplied by the sun, a window, a household lamp or a ceiling fixture—comes from above the subject, the most natural-looking pictures will result from a flash held above the level of the lens and slightly to one side or bounced in such a way that light comes from above. But while the main light should be the most important light, natural lighting, indoors or outdoors, rarely strikes a subject exclusively from one direction; covering the flash with a diffusing screen, bouncing some of its light off walls and adding a second or third flash will create softer shadows, more interesting textures and more lifelike depth.

The duration of flash is so brief that you can't really see the effect different flash positions will have on a subject, and you must point the flash carefully so the light doesn't "fall off," that is, illuminate only part of the subject. Some electronic flash units try to solve this problem by incorporating modeling lights—small tungsten lights that are turned on so you can judge the effect of different lighting setups before you make the exposure.

1 | *Direct flash on camera: This is the quickest and simplest method, allowing the photographer to move around and shoot quickly. But the light tends to be flat, producing few of the shadows that add volume and texture. (See the Weegee photograph on the preceding page.)*

4 | *Diffused flash on camera: For a softer effect, the harshness and intensity of the flash can be reduced by placing a spun-glass filter in front of the unit, or by simply draping a handkerchief over it. This is a particularly useful way of preventing glaring white features in close-ups.*

2 | *Direct flash off camera: When using a single light source, this is one way to get more interesting shadows and a three-dimensional feeling. The flash here is connected to the camera by a long synch cord and held a distance of about a foot and a half above the camera and slightly to the right.*

3 | *Multiple flash: This gives good dimensionality and separates the subject from the background. Three flash units were linked by extension cables: the main light was placed to the right; a second flash lighted the background; a unit on the camera provided fill light for facial shadows.*

5 | *Flash bounced from side: For soft, natural-looking lighting, with good modeling of features, the flash unit can be pointed so that its light does not reach the subject directly but is reflected from a white or light-colored wall or from an umbrella reflector like the one shown on page 188.*

6 | *Flash bounced from above: In a room with a relatively low ceiling, the flash can be pointed upward and bounced off the ceiling. This type of flash lighting is easy if you are using a unit with a head that swivels upward. The light is soft and natural-looking; compare to illustration 5.*

Calculating Exposures with Flash

The farther away an object is from a light source, the less light it receives (the inverse square law diagrammed at right). When flash is used, the correct exposure can be determined by measuring the distance from flash to subject and dividing it into the guide number (a rating supplied by manufacturers for different combinations of flash and film). The result is the f-stop setting to be used. Often two guide numbers are given: one is used if the flash-to-subject distance is measured in feet, an equivalent one is used if the distance is measured in meters. If the guide number is 32 for flash-to-subject distance in feet, the equivalent guide number would be 10 for distance in meters. With a guide number of 61 (for feet) at a flash-to-subject distance of 10 feet, the f-setting is f/6.1—slightly smaller than f/5.6.

$$\text{f-stop} = \frac{\begin{array}{c}\text{guide number}\\\text{(for feet)}\end{array}}{\begin{array}{c}\text{flash-to-subject}\\\text{distance (in feet)}\end{array}} = \frac{61}{10} = \text{f}/6.1$$

Guide numbers should be considered as guides only. If you find you are consistently underexposing flash shots, use a lower guide number; if consistently overexposing, use a higher number. If the room where you are photographing is very small, with white walls and ceilings, close down the aperture one extra stop. If the room is very large or you are using the flash outdoors at night, open up the aperture one stop. When firing a diffused or reflectorless flash, open up about one stop since only part of the

light will reach the subject. Bouncing the light also requires a wider aperture; the flash-to-subject distance is counted from flash to bouncing surface to subject—plus something allowed for light absorbed by the reflecting surface.

There are two alternatives to this method: a strobe meter that reads the actual strength of the flash at different distances, or an automatic flash unit with a built-in sensor, plus circuitry to stop the light after sufficient exposure.

As shown at right, a flash can be a convenient fill light when photographing in direct sun. Flash used right on camera opens up the empty black shadows produced in direct sun so that they show printable detail. It is better not to overpower the sunlight with the flash, but to add just enough fill so that the shadows are still somewhat darker than the highlights—for portraits, about one or two stops darker. The exposure takes a little juggling. First meter the scene for a normal exposure without flash. Now choose an f-stop and shutter-speed combination where the f-stop is one or two stops smaller than the one you would use if you were relying on flash alone. If your camera has a focal-plane shutter (most 35 mm cameras do), choose a shutter speed that synchs with the flash, 1/60 second (1/125 second with some cameras) or slower. You can also cut the intensity of the flash by moving it farther back or by draping a white handkerchief over it (one layer of handkerchief decreases the intensity by about one stop).

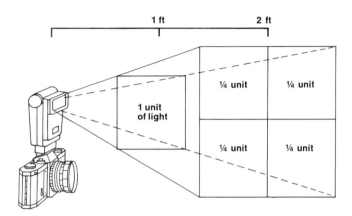

The level of light drops rapidly as the distance increases between light and subject; at twice a given distance from a light source, an object receives only one-fourth the light. This is the inverse square law: intensity of illumination is inversely proportional to the square of the distance from light to subject.

A photograph made in direct sun often has harsh black shadows (top). A synchro-sun exposure uses flash as a fill light to decrease the contrast between shadows and highlights (bottom).

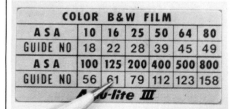

COLOR B&W FILM						
ASA	10	16	25	50	64	80
GUIDE NO	18	22	28	39	45	49
ASA	100	125	200	400	500	800
GUIDE NO	56	61	79	112	123	158

Guide numbers for different film speeds (ASA numbers) are found on the flash (shown here), in its instruction book or with instruction sheets for films and flash bulbs. For this unit in combination with an ASA 125 film, the guide number is 61 when the flash-to-subject distance is measured in feet. The guide number divided by the distance gives the f-stop setting.

Avoiding Common Mistakes with Flash

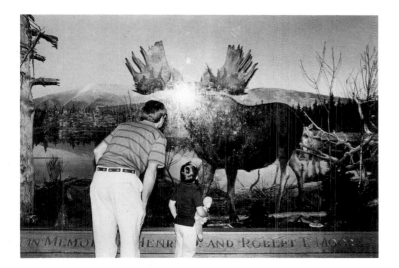

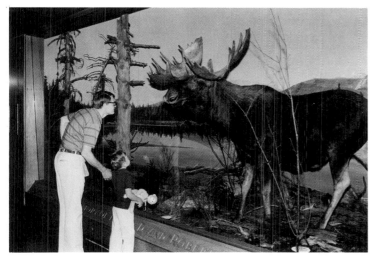

Until you have used flash often, it is difficult to tell exactly how its light will look. Shadows and reflections are nonexistent until the flash goes off and even then they disappear too quickly to be seen. The film sees them, though, sometimes with the results shown here.

Shadows are very noticeable with a single, direct flash (rather than a bounced or open flash). Sighting along a line from flash to subject will help predict how the shadows will be cast and might have prevented the looming ones in the photograph below.

Reflections of the flash itself can shine back from a smooth surface such as metal, glass, a mirror or enameled or paneled walls (left). They are prevented by photographing or lighting at an angle to the surface instead of straight at it. Flash illumination for color film calls for precautions against redeye, a reflection of the flash from the blood-rich retina inside the eye. It can be avoided if the subject looks away from the camera or if the flash is off the camera axis.

One of the commonest problems occurring with flash is also the easiest to prevent (below right): make sure your shutter is set to the correct speed to synchronize with flash. If you set a focal-plane shutter faster than the correct speed for flash, only part of the film frame will be exposed. Most 35mm cameras have a focal-plane shutter and synchronize with electronic flash at $\frac{1}{60}$ second (some synch at $\frac{1}{125}$ second) or slower shutter speeds.

The light from flash comes and goes so fast that problems can be unseen until they turn up on the film. Shooting directly at a shiny surface like glass can cause the light from the flash to reflect back to the camera (top). If you shoot at an angle to the surface the unwanted light will reflect away from the camera (above).

The ominous shadow behind the subject could have been eliminated by aiming the flash so that the shadow fell either behind him or out of the picture. Also, the light is placed peculiarly low, producing unattractive facial shadows.

Shooting at too fast a shutter speed with a camera that has a focal-plane shutter will expose only part of the frame. See manufacturer's instructions for the correct setting for your camera with flash.

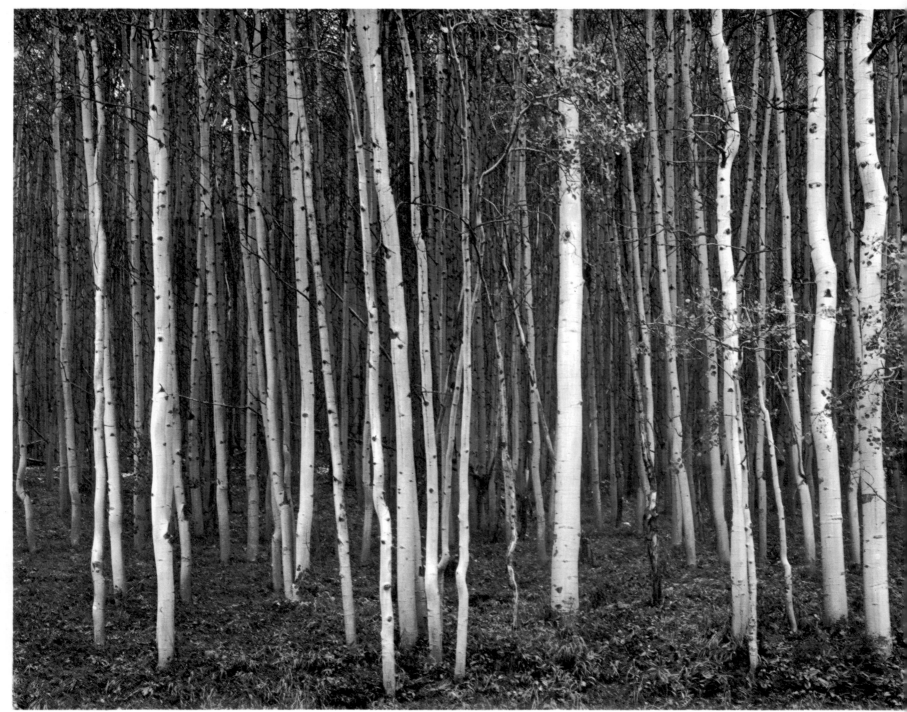

GEORGE TICE: *Aspen Grove, Aspen, Colorado,* 1969

10 View Camera

Inside the Modern View Camera 216

The Four Camera Movements 218

 Rise and Fall 218

 Shift 220

 Tilt 222

 Swing 224

Controlling Plane of Focus and Depth of Field 226

Controlling Perspective 228

Dealing with Distortion 230

What to Do First—and Next 231

Loading and Processing Sheet Film 232

In today's world of small, hand-held cameras that are fast working and convenient to use, why would a photographer use a bulky, heavy, slow-working view camera—a camera that has few or no automatic features, that must almost always be used with a tripod, that shows you an image that is upside down and backwards and so dim that you need to put a dark cloth over the camera and your head to see it? The answer is that the view camera does some jobs so well that it is worth the trouble of using it.

The view camera's back (film plane) and front (lens board) can be independently moved in a number of directions: up, down or sideways, tilted forward or back, swiveled to either side These movements give you an extraordinary amount of control over the image. They can eliminate or increase distortion, control the extent of the depth of field, alter perspective and change the area of the scene recorded on the negative.

Another advantage of the view camera is the large size of the film that can be used. The most common size is 4 x 5 inches; 5 x 7, 8 x 10 inches and sometimes larger sizes are also used. (Comparable European sizes range from 9 x 12 to 18 x 24 cm and larger.) While modern small-camera films (1 x 1½ inches is the size of 35mm film) can make excellent enlargements, the greatest image clarity and detail and the least grain are produced by a contact print or a moderate enlargement from a large-size negative. The photograph opposite, made with an 8 x 10-inch view camera, has an infinitely rich texture that is even more apparent in the original print than here.

A view camera is the most satisfactory camera to use where control of the image is vital, as in architectural or product photography. Some photographers use one in all but the fastest-moving situations because they feel that the control gained, plus the detail a large-size negative records, more than compensate for any disadvantages.

◀ *George Tice's photograph (opposite) of an aspen grove invites the viewer to wander deep among the trees. The photographer cropped the tops of the trees but left visible their connection to the forest floor. The bottoms of the trunks draw the viewer's eye into the picture, while the lighter trunks seem to move forward as the darker ones recede. The tree trunks undulate gently, rhythmically repeating their vertical lines.*

Inside the Modern View Camera

The ability of a view camera to change and control an image is due to its movements. Unlike most cameras, which are permanently aligned so that lens and film are exactly parallel, a view camera can be deliberately unaligned.

Two basic movements are swings and tilts. Swings are movements around the vertical axis of either lens or film, that is, when either is twisted to the left or right. Tilts are movements around the horizontal axis of lens or film, that is, when either is tipped forward or backward. Many view cameras provide two other movements. One is a sideways movement of lens or film to either left or right, known as shift. The other is a raising or lowering of lens or film, known as rise or fall. The movements and their effects, explained on the following pages, are easier to understand if you have a view camera at hand so you can demonstrate the effects for yourself.

In order to make full use of a view camera's movements, you must use it with a lens of adequate covering power, that is, a lens that produces a large image circle. As shown below, a lens projects a circular image that decreases in sharpness and illumination at the edges. If a camera has a rigid body, the image circle needs to be just large enough to cover the size of the film being used. But a view camera lens must produce an image circle larger than the film size so that there is plenty of room within the image circle for various camera movements. If the movements are so great that the film comes too close to the edge of the image circle, the photograph will be vignetted—out of focus and dark at the edges. Covering power increases—the usable image circle gets larger—as the lens is stopped down.

parts		movements	
A	lens	1	back-rise
B	aperture scale	2	back-fall
C	shutter-speed scale	3	front-rise
D	lens board	4	front-fall
E	lens-board-adjustment knob	5	back-shift left
F	front-standard	6	back-shift right
G	front-standard-adjustment knob	7	front-shift left
H	shutter-release cable	8	front-shift right
J	bellows	9	back-tilt backward
K	tripod mount	10	back-tilt forward
L	ground glass	11	front-tilt backward
M	back-adjustment knob	12	front-tilt forward
N	back	13	back-swing left
O	back standard	14	back-swing right
P	back-standard-adjustment knob	15	front-swing left
Q	dark slide	16	front-swing right
R	film holder	17	front focusing
S	film sheet	18	back focusing

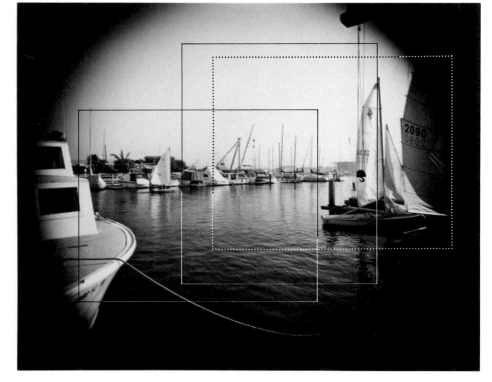

This simplified cutaway of a view camera makes clear its basic relationship to all cameras; it is a box with a lens at one end and a sheet of film at the other. Unlike other cameras, however, the box is not rigid. The front face, to which the lens is fastened, can be moved independently—up or down, forward or back—by loosening a pair of knobs (E). A second pair of knobs (M) permits similar movements of the back. Knobs (as in G and P) permit front or back to be shifted, swung or focused. The camera-back (N) can be rotated to take a picture in either a horizontal or vertical format. In addition, different sizes of film can be used by substituting film holders and camera-backs that are designed for those sizes. The front end of the camera will accept different lenses. Extra bellows can be inserted for extreme extensions in close-up work (pages 252–253), or if the focal length of the lens is so short that the regular bellows cannot be squeezed tight enough, a bag bellows can be used (shown on page 226).

◀ *A lens with good covering power (producing a large image circle) is needed for view-camera use. Camera movements such as rise, fall or shift move the position of the film within the image circle (as shown at left), so the lens should produce an image that is larger than the actual size of the film. The corners of the viewing screen must be checked before exposure to make sure the camera movements have not placed the film outside the image circle, vignetting the picture (dotted lines).*

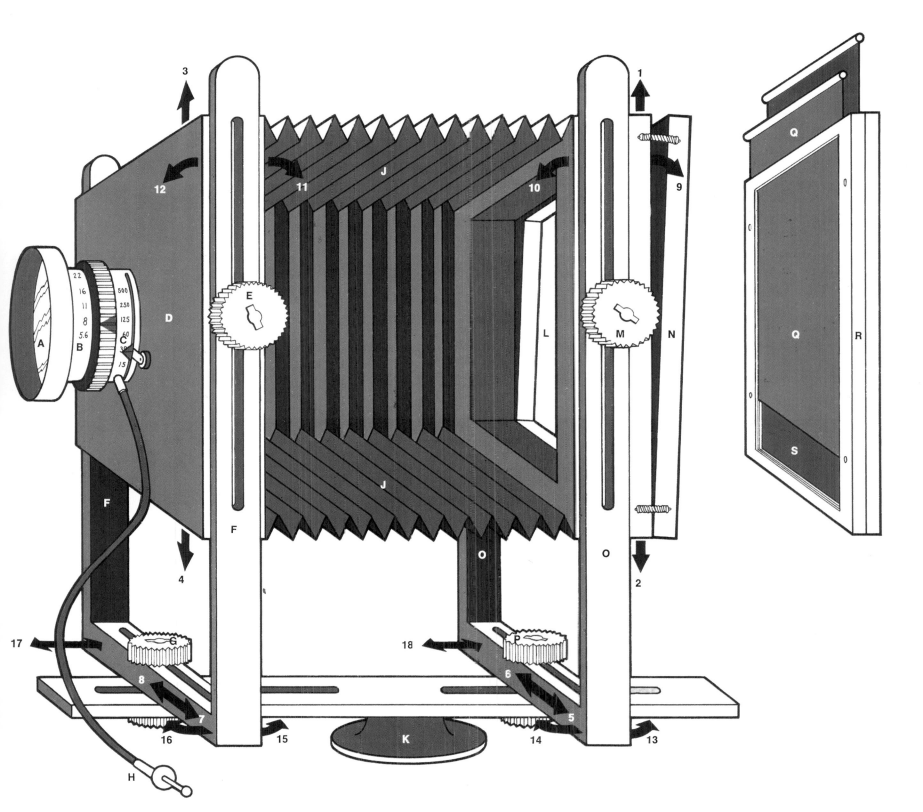

The Four Camera Movements
Rise and Fall

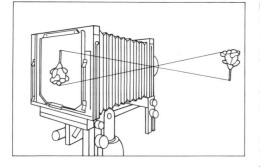

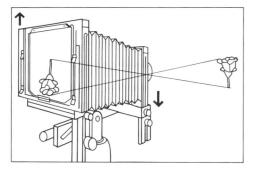

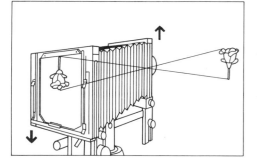

The diagrams above show how rise or fall of the camera's front or back changes the position of the image on the negative. In the top diagram, the object being photographed appears in the center of the ground-glass viewing screen. It is inverted (upside down and reversed left to right). In the center diagram, the object has been moved to the bottom of the viewing screen (the top of the picture when viewed right side up); this is accomplished by either raising the back or lowering the lens. To move the object to the top of the viewing screen (the bottom of the actual picture), lower the back or raise the lens (bottom diagram).

It is easier to understand the effect each movement has on a negative if you first look at a picture where no movement has been set into any part of the camera. This has been done with the first cube at right. Camera position was centered on the cube. All controls were set at zero. Focus was on the top front edge.

The result is an image that falls in the center of the picture frame. The cube's top front edge, being closest to the camera, is the largest. It is also the sharpest, since it lies along the focal plane. The two visible surfaces of the cube fall away in size and sharpness at an equal rate. With this reference cube as a standard, changes in its shape, sharpness and position as a result of camera movements can be explained.

For the sake of simplicity, the pictures and text at right relate not to the inverted (upside down and backwards) image seen on the ground-glass viewing screen, but to the photograph as you would see it after it was printed. The diagrams at left show the image as you would see it while you were focusing and adjusting the camera.

The first movements, rise and fall, change the placement of the image on the film by changing the position of film and lens relative to one another. The film can be moved to include various parts of the image circle. Or the lens can be moved so that a different part of the image circle falls on the film.

Rise or fall of the back changes the location of the image but does not affect its shape. Front movement changes the point of view and to some extent the shape. In these pictures, the change in shape is too slight to be seen in the cube, but the difference in point of view is visible in the change of relationship between the cube and the small post.

The reference cube was shot with all camera adjustments set at zero position, looking downward, as the diagram shows, from an angle of 45°. This puts the cube in the center of the film, and produces a symmetrical figure. The next 2 pictures, although they move the cube around on the film through rise and fall of the back, make no changes in the shape of the cube's image on the film. The last 2 pictures move the cube through rise and fall of the lens and, in addition, change the point of view. These pictures show the cube as it appears, right side up, in the final prints. The view on the ground glass would be inverted, as shown in the diagrams at left.

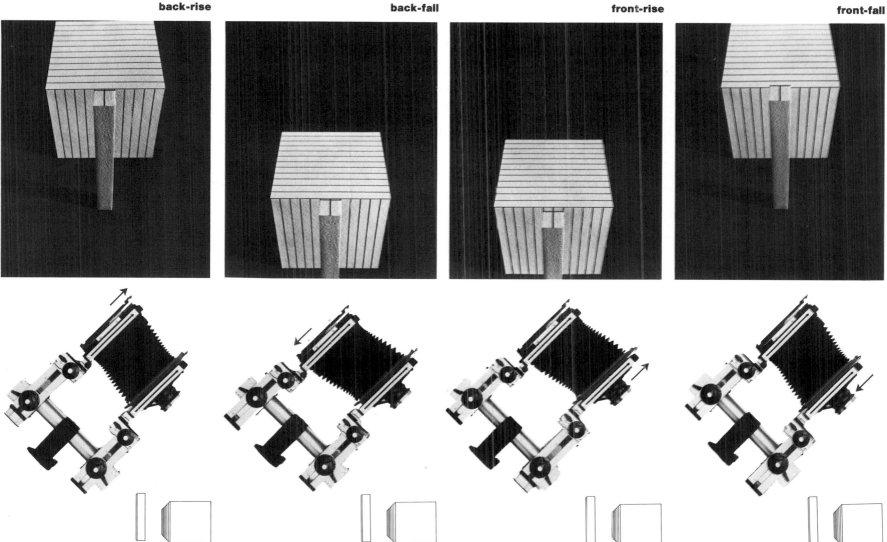

back-rise **back-fall** **front-rise** **front-fall**

Raising the back of the camera moves the cube higher on the film without changing its shape. Nor does this movement affect the position or shape of the small post that has been centered exactly in front of the cube, with its top in line with the cube's front edge—as comparison with the photograph of the reference cube will show.

Lowering the back of the camera lowers the position of the cube on the film. Otherwise, as before, there is no change in the shape of the cube or in its relationship with the post. This happens because the film, though raised or lowered, still gets the same image from the lens, which has not moved relative to the original alignment of cube and post.

Raising the lens lowers the image of the cube on the film. In this its effect is the same as back-fall. However, lens movement causes a change that does not occur with back movement: it affects the relationship between cube and post because the lens is now looking at them from a slightly different position. Compare the apparent height of the post here with its height in the 2 pictures at left.

As expected, a drop in the lens has raised the image on the film. As expected also, lens movement has affected the space relationship between cube and post. Now the post top appears to have moved above the front edge of the cube, whereas in the previous picture it dropped below the edge.

Shift

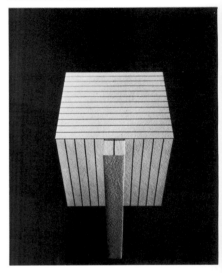

controls zeroed

back-shift left or front-shift right

back-shift right or front-shift left

Shift is a sideways movement of either the front or the back of the camera. It is exactly the same as rise and fall except the movement takes place from side to side. If you were to lay the camera on its side and raise or drop the back, you would have back-shift.

The reason that rise and shift are the same is that neither changes the angle between the planes of film, lens and subject. Raise or shift the back of the camera, and the film is still squarely facing the lens; the only difference is that a different part of the film is now directly behind the lens.

Since shift is simply a sideways version of rise and fall, the results are similar. Back movement to the left moves the subject to the left; back movement to the right moves it to the right. Left or right lens movements have just the opposite results. Image shape does not change with back-shift, but does change slightly with front-shift.

Again in common with rise and fall, shift of the lens affects the spatial relationship of objects because the lens is now viewing them from a different point. The examples at right illustrate these movements, with the reference cube included for comparison.

Remember that the cubes are shown right side up as they would appear in the final prints. On the ground glass the image is inverted as shown in the diagrams at left.

In the diagrams above, the position of the cube on the negative is moved by shifting the camera's front or its back to the side. In the top diagram, the controls are zeroed and the image is in the center of the viewing screen. In the center diagram, the object has been moved to the right side of the viewing screen (left side of the actual photograph) by moving the camera-back to the left or the lens to the right. To move the object to the other side of the picture, move the back to the right or the lens to the left (bottom diagram).

To help establish the point that shift, like rise and fall, has no perceptible effect on the shape of an object, the reference cube is repeated here. Compare it with the 4 cubes to the right of it. It is clear that while they have been moved back and forth on the film, they continue to look very much the same.

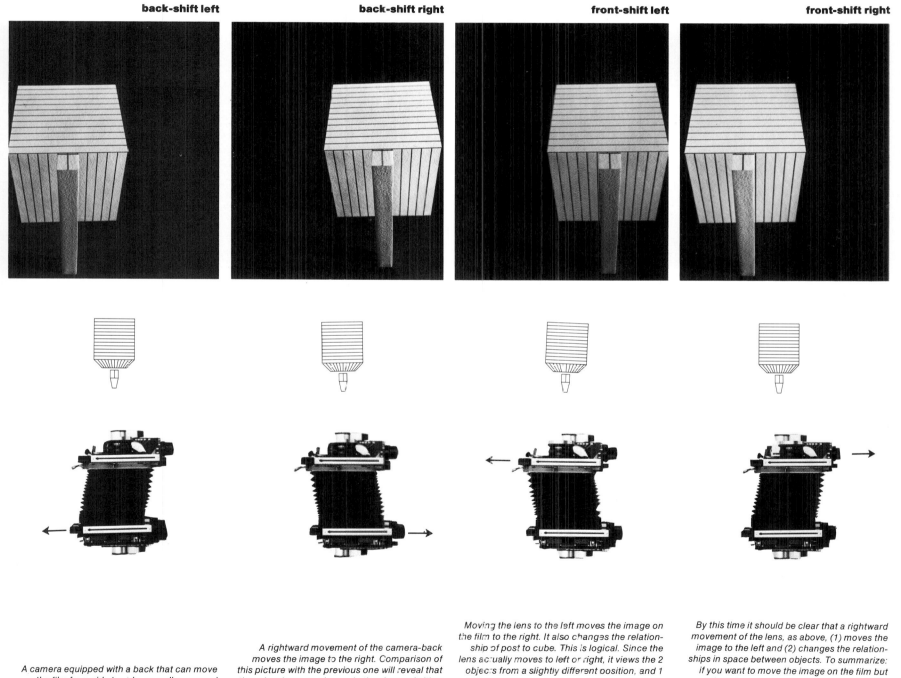

back-shift left **back-shift right** **front-shift left** **front-shift right**

A camera equipped with a back that can move the film from side to side, as well as up and down, can place an object wherever desired on a sheet of film. Here a shift of the camera-back to the left moves the cube to the left on the film.

A rightward movement of the camera-back moves the image to the right. Comparison of this picture with the previous one will reveal that there has been no change in the shape of either the cube or the post in front of it. Their spatial relationship has remained unchanged also, despite the movement of the image on the film.

Moving the lens to the left moves the image on the film to the right. It also changes the relationship of post to cube. This is logical. Since the lens actually moves to left or right, it views the 2 objects from a slightly different position, and 1 object appears to have moved slightly with respect to the other. Check the position of the post against the vertical lines on the cube, in this picture and the next, to confirm this movement.

By this time it should be clear that a rightward movement of the lens, as above, (1) moves the image to the left and (2) changes the relationships in space between objects. To summarize: if you want to move the image on the film but otherwise change nothing, raise or shift the back. If you want to move the image and also change the spatial relationship of objects, do it by raising or shifting the lens.

Tilt

controls zeroed

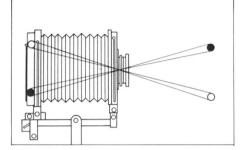

back-tilt of camera-back

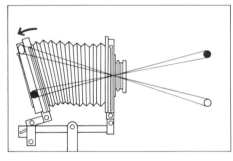

forward-tilt of camera-back

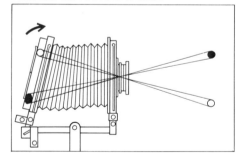

The diagrams above show how the shape of objects can be changed by tilting the camera-back and thus changing the angle between it and the lens. In the top diagram, 2 objects of identical size, placed the same distance from the camera, are being photographed. When the camera controls are zeroed, the objects appear the same size on the viewing screen.

In the center diagram, the camera-back has been tilted back. Now when the image leaves the lens, it has to travel farther to reach the top of the viewing screen than it does to reach the bottom. As the light rays travel, they spread apart, increasing the size of the object on the top of the viewing screen (the bottom of the actual photograph). To increase the size of an object on the bottom of the viewing screen, tilt the camera-back forward (bottom diagram).

The preceding pages show that rise, fall and shift have little or no effect on the shape of an object being photographed because they do not change the angular relationship of the planes of film, lens and object. But what happens if the angle is changed by tilting the camera-front or camera-back?

Two things happen: (1) When the angle between film and lens is changed by tilting the back of the camera, the shape of the object changes considerably and the focus changes somewhat. (2) When the angle between lens and object is changed by tilting the front of the camera, the focus on the object changes distinctly without changing the shape of the object.

To understand why this happens, look again at the reference cube. In that picture the bottom of the film sheet was the same distance from the lens as the top of the film sheet. As a result, light rays coming from the lens to the top and the bottom of the film traveled the same distance, and the top back edge and the bottom front edge of the cube are the same size in the photograph. But change those distances by tilting the camera-back and the sizes change. The rule is: the farther the image travels inside the camera, the larger it gets. Since images appear upside down on film, tilting the top of the camera-back to the rear will make the bottom of the cube bigger in the photograph *(diagrams, left)*.

A front-tilt, on the other hand, does not change distances inside the camera and thus does not affect image size or shape. But it does affect focus by altering the lens's focal plane. Tilting the lens will bring the focal plane more nearly into parallel with one cube face or the other and thereby will improve the focus on that face and worsen it on the other.

reference cube

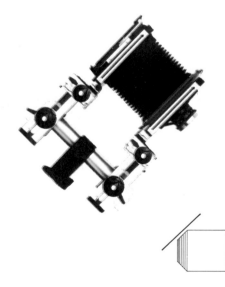

Checking the reference cube again, note that the 45° angle of view has produced an image that falls off in both size and sharpness at an equal rate on both the top and the front faces. As a result the 2 faces are exactly the same size and shape. Note also that the vertical lines on the front face are in a diminishing perspective downward; they are not parallel.

back-tilt of the camera-back	**forward-tilt of the camera-back**	**back-tilt of the camera-front**	**forward-tilt of the camera-front**

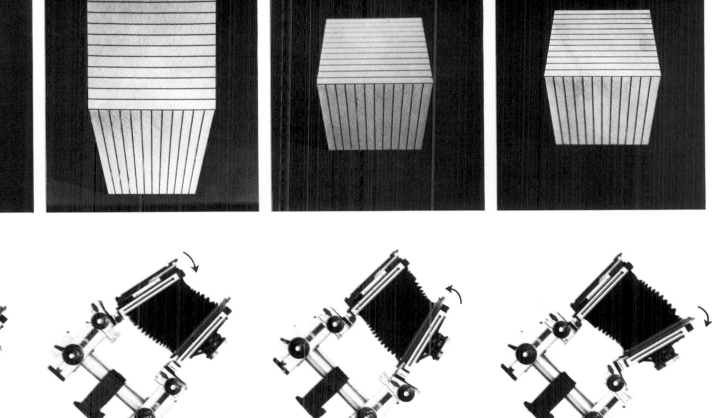

When the back of the camera is tilted so that the top of the film is farther away from the lens than in the reference shot, this movement enlarges the bottom of the cube and tends to square up its front face, bringing its lines more nearly into parallel. At the same time this tilt has moved the bottom of the film closer to the lens than it was in the reference shot, shrinking the top back edge of the cube and heightening the perspective effect.

If the back of the camera is tilted the other way, so that the top of the film is forward and the bottom is moved away from the lens, the top of the cube tends to square up and the front falls into sharply diminishing perspective. Squaring up 1 face of the cube results in increasing light loss and increasing fuzziness toward the far edge of the squared face. In this case the back edge of the top face is affected. In the picture at left the bottom edge of the front face is affected.

When the lens is tilted, there is no change in the distance from lens to film; thus there is no change in the shape of the cube. However, there is a distinct change in focus. Here the lens has been tipped backward. This brings its focal plane more nearly parallel to the front face of the cube, pulling all of it into sharp focus. The top of the cube, however, is now more blurred than in the reference shot.

If the lens is tilted forward, the top of the cube becomes sharp and the front more blurred. The focus control that lens-tilt gives can be put to excellent use when combined with back-tilt. Look again at the 2 back-tilt shots at the left; consider how much sharper their squared—and blurry—sides could have been made by tilting the lens to improve their overall focus.

223

Swing

controls zeroed

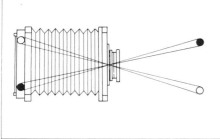

left-swing of camera-back

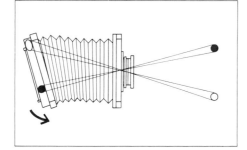

right-swing of camera-back

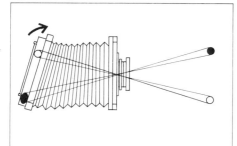

Swinging the camera-back changes the shape of objects by changing the angle between the camera-back and the lens. As with back-tilt, if part of an image has to travel farther to reach the camera-back, it will increase in size. In the top diagram, both objects are the same size and the camera's controls are zeroed. In the center diagram, the image on the left side of the viewing screen (the right side of the actual photograph) has been increased in size by swinging the camera-back to the left. To change the size of the image on the right side of the viewing screen, swing the camera-back to the right (bottom diagram).

Swing is a sideways twisting of either the front or the back of the camera around the vertical axis. Like the three movements discussed so far, it has different effects depending on whether it is the back of the camera that is being swung or the front.

A back-swing—just like a back-tilt—moves one part of the film closer to the lens while moving another part farther away. These changes in distance (again, just as in a tilt) result in changes of shape in the image plus some change in focus *(diagrams, left)*.

Front-swing, since it involves swiveling the lens to left or right, skews the focal plane of the lens to one side or another. The general effect of this is to create a sharply defined zone of focus that travels at an angle across an object. A careful examination of the two right-hand cubes on the opposite page reveals this. There is a narrow diagonal path of sharp focus traveling across the top of each cube and running down one side of the front.

The practical applications of the four camera movements are virtually endless. Some are subtle and complex, particularly when used in combination. Others are obvious. For example, assume that the reference cube is a house with a large garden in front of it. Raising the back of the camera *(page 219, first picture)* will raise the image on the film and permit more of the garden to be seen. Or, assume that you wish to increase the apparent height of the cube. Forward-tilt of the back *(second picture, page 223)* is one way to produce that effect. The following pages show how swings, tilts, rises and shifts can be applied in real situations to solve specific photographic problems.

reference cube

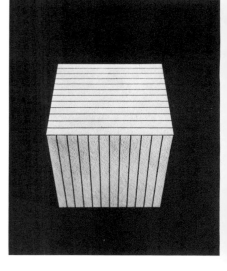

It is worth taking a last look at the reference cube to appreciate the distortions in shape that can be made by changing the angle of film to lens. Compare the cube to the first 2 pictures to its right. It is hard to believe that these swing shots—or the 2 back-tilt shots on the previous page—are all of the same object, taken from the same spot with the same camera and lens.

| **left-swing of the camera-back** | **right-swing of the camera-back** | **left-swing of the camera-front** | **right-swing of the camera-front** |

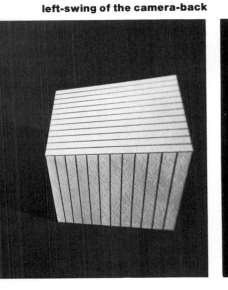

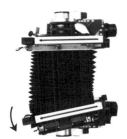

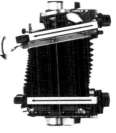

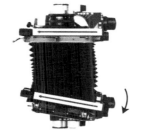

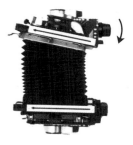

This movement of the camera-back swings the left side of the film away from the lens and the right side closer to it, making the left side of the cube smaller and the right side larger. (Remember, the image is inverted on the ground glass.) This effect is the same as tilt, but sideways instead of up and down. To grasp this better, turn this picture so that its right side becomes the top. Now it becomes an angle shot of a building, with the camera-back tilted forward to enlarge the top.

Here the right side of the film is swung away from the lens and the left side closer to it The results are the opposite of those in the previous picture. In both of them it can be seen that there is a falling-off of sharpness on the ''enlarged'' edges of the cube. This can be corrected by swinging the lens or by closing the aperture a few stops in order to increase depth of field

Since it is the lens that is being swung, and not the film, there is no change in the cube's shape. However, the position of the focal plane has been radically altered. In the reference shot it was parallel to the rear edge of the cube, and that edge was sharp from one end to the other. Here the focus is skewed. Its plane cuts through the cube, on a course diagonally across the top and down the left side of the cube's face.

Here is the same phenomenon as in the previous picture, except that the plane of sharp focus cuts the cube along its right side instead of its left. This selectivity of focus, particularly when tilt and swing of the lens are combined, can move the focal plane around very precisely to sharpen certain objects and throw others out of focus. For a good example of this, see page 227.

225

Controlling Plane of Focus and Depth of Field

The photograph above is partly out of focus because the camera-back (line aa') and lens plane (line bb') are parallel to each other but not to the subject plane (line cc').

If the lens is tilted forward so its plane is changed and lines aa', bb' and cc' all meet at the same point, the picture will be sharp overall. The diagrams show a loose bag bellows on the camera instead of a regular accordion bellows.

Controlling the plane of focus—the part of a scene that is most sharply focused—is easy with a view camera. Not only can you see on the ground-glass viewing screen exactly where the plane of focus is, but you can adjust it precisely by using lens tilts and swings (sometimes assisted by tilts and swings of the camera-back).

If the important part of the subject is more or less parallel to the camera-back (as in the skyscraper photographs on page 229), then that part of the subject will be in focus if the lens is parallel to the camera-back. With a camera that does not have swings and tilts, the lens is always parallel to the back, and the plane of focus is parallel to both. You

increase or decrease the depth of field by stopping down or opening the lens aperture.

But a disadvantage of using a camera without swings and tilts becomes evident when photographing something like the rare book shown above, where the subject is not parallel to the camera. You angle the camera down at the book.

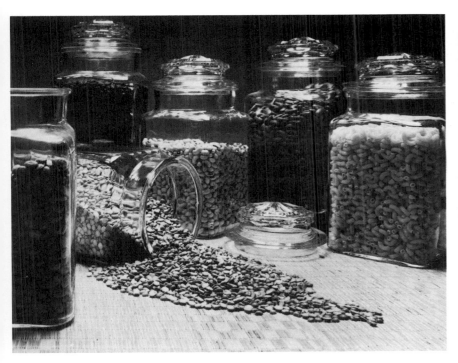

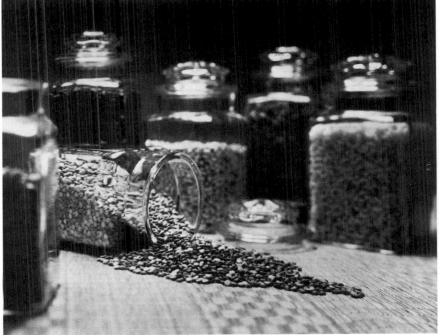

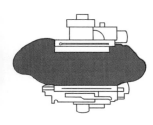

With the camera's back and front in zero position, a close-up shot of some spilled beans requires that the lens be stopped down for both the foreground beans and those in the jar to be perfectly sharp. This also brings the other jars into focus—which the photographer did not want.

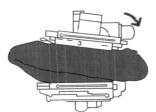

A simple swing of the lens to the right brings its focal plane parallel to the receding pile of beans—all the way from the right foreground back through the tipped-over jar. Now the photographer can focus on the beans and open up the lens to its maximum of f/5.6, which throws the other jars completely out of focus and directs attention to the beans.

If you focus on the part of the book close to the camera, the top of the book is blurred, and vice versa. A compromise focus on the middle of the page might not give enough depth of field even if you stopped the lens all the way down.

The view camera can get around this problem. It permits sharp focus from foreground to infinity at maximum apertures. If the planes of the film, lens and subject all meet at a common point, a picture of the subject will be sharp from near edge to far. Known as the Scheimpflug condition for its discoverer, the result is demonstrated by the two photographs opposite. In the first, the lens was focused on the foreground. No tilts or swings were made. As a result, the planes of lens and film are parallel. They do not come together and the re-sulting picture is not sharp overall. But tilting the lens forward causes the planes to meet, and careful focusing can make a picture of overall sharpness possible.

If you want only part of the picture to be sharp, this too is adjustable with a view camera. By swinging or tilting the lens, the plane of focus can be angled across the picture as in the photographs above of the spilled beans.

Controlling Perspective

A view camera is often used in architectural photography because it can control perspective. Tall buildings, in particular, are almost impossible to photograph without distortion unless a view camera is used. You don't *have* to correct the distortion—many advertising photographs, for example, do not—but a view camera provides the means if you want to do so.

Suppose you wanted to photograph the building at right with just one side or face showing. If you leveled the camera and pointed it straight at the building, you would show only the bottom of the building *(first photograph, right).* Tilting up the camera shows the entire building but introduces a distortion in perspective *(second photograph):* the vertical lines seem to come together or converge. This happens because the top of the building is farther away and so appears smaller than the bottom of the building. When you look up at any building your eyes also see the same converging lines, but the brain compensates for the convergence and it usually passes unnoticed. In a photograph, however, it is immediately noticeable. The view-camera cure for the distortion is shown in the third photograph. The camera is adjusted to remain parallel to the building (eliminating the distortion), while still showing the building from bottom to top.

Another problem arises if you want to photograph a building with two sides showing. In the fourth photograph, the vertical lines appear correct but the horizontal lines converge. They make the near top corner of the building seem to jut up unnaturally sharp and high in a so-called ship's-prow effect. Swinging the back more nearly parallel to one of the sides (usually the wider one) reduces the horizontal convergence and with it the ship's prow *(last photograph).*

Standing at street level and shooting straight at a skyscraper produces too much street and too little building. Sometimes it is possible to move far enough back to show the entire building while keeping the camera level, but this adds even more foreground and usually something gets in the way first.

Tilting the whole camera up shows the entire building but distorts its shape. Since the top is farther from the camera than the bottom, it appears smaller; the vertical lines of the building seem to be coming closer together or converging near the top. This convergence gives the illusion that the building is falling backwards—an effect particularly noticeable when only one side of the building is visible.

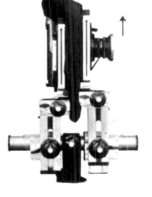

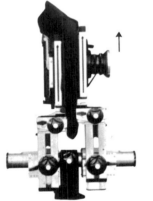

To straighten up the converging vertical lines, keep the camera-back parallel with the face of the building. To keep all parts of the building in focus, make sure the lens is parallel to the camera-back. One way to do this is to level the camera, then use the rising-front or falling-back movements or both.

Another solution is to point the camera upwards towards the top of the building, then use the tilting movements—first to tilt the back to a vertical position (which squares the shape of the building), then to tilt the lens so it is parallel to the camera-back (which brings the face of the building into focus). You may need to finish by raising the camera front somewhat.

In this view showing two sides of a building, the camera has been adjusted as in the preceding picture. The vertical lines of the building do not converge, but the horizontal lines of the building's sides do, since they are still at an angle to the camera. This produces an exaggeratedly sharp angle, called the ship's-prow effect, at the top right front corner of the building.

Two more movements are added as shown in this top view of the camera. The ship's-prow effect is lessened by swinging the camera-back so it is parallel with one side of the building. Here the back is parallel to the wider side. The lens is also swung so it is parallel with the camera-back, which keeps the entire side of the building in focus. It is important to check the edges of the image for vignetting when camera movements are used.

Dealing with Distortion

Every attempt to project a three-dimensional object onto a two-dimensional surface results in a distortion of one kind or another. Yet cleaning up distortion in one part of a photograph will usually produce a different kind of distortion in another part. The book and orange in the two still lifes at right are examples of this. In the first picture, shot from above with all camera adjustments at zero, the book shows two kinds of distortion. Since its bottom is farther away from the camera than the top, the bottom looks smaller. Also the book seems to be leaning slightly to the left. These effects would have been less pronounced if the camera had been farther away from the book—the farther away an object is from a lens, the smaller will be the differences in distance from the lens to various parts of the object. It is these differences that cause distortions in scale.

Can they be corrected? They can with a view camera, using a combination of tilts, swings and falls. Back-tilt of the camera-back straightens the book's left edge. A left-swing of the camera-back squares up the face of the book. Since these tilts have enlarged the image somewhat, back-fall was added to show all of the book.

Is the result a less distorted picture? That depends. The book is certainly squared up nicely, as if it were being looked at head on, but the spine, oddly enough, is still visible. Furthermore, the round orange of the first picture has now become somewhat melon-shaped. All pictures contain distortions; what you must do is manipulate them to suit your own taste.

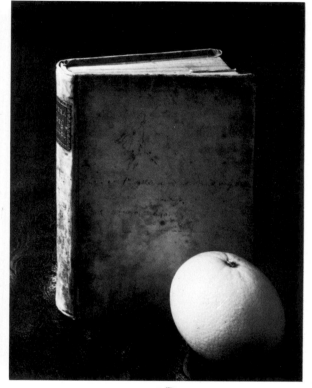

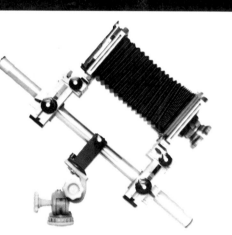

With camera settings at zero, a downward view of a book makes the upper part seem larger than the lower part—just as the top front edge of the first cube on page 222 was larger than the bottom edge. The book also appears to be tipping to the left. The orange, on the other hand, a sphere seen straight on in the center of the picture, exhibits no noticeable distortion.

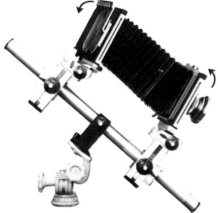

The book is straightened by back-tilt and left-swing of the back, but this forces the orange out of shape. These back movements also affected the focus; it was necessary to back-tilt the lens and swing it to the left to bring the lens—and so the plane of focus—into better line with the book's face.

Because a view camera is so adjustable, its use requires the photographer to make many decisions. A beginner can easily get an I-don't-know-what-to-do-next feeling. So, here are some suggestions.

First, set the camera on a sturdy tripod, attach a cable release to the shutter mechanism, point the camera toward the scene, zero the controls and level the camera (this page, left). Open the lens for viewing and open the diaphragm. You will almost always need to use a focusing cloth to see the image clearly (center).

Adjust the back for a horizontal or vertical format and roughly frame the image on the ground glass. Roughly focus by adjusting the distance between the camera-front and camera-back. The closer you are to the subject, the more you will need to increase the distance between front and back. After the subject is approximately framed and focused, you can make more precise adjustments. Moving the camera-front forward or back has the most effect on magnification of the image. Moving the camera-back has the most effect on focus. To change the shape or perspective of the objects in the scene, tilt or swing the camera-back. You may also want to move the position of the image on the film by adjusting the tripod or using the rising, falling or shifting movements. Now check the focus (right). If necessary, adjust the plane of focus by tilting or swinging the lens. You can preview the depth of field by stopping down the lens diaphragm.

When the image is the way you want it, tighten all the controls. Check the corners of the viewing screen for possible vignetting. You may need to decrease some of the camera movements (especially lens movements) to eliminate vignetting.

When you are ready to make an exposure, close the shutter, adjust the aperture and shutter speed and cock the shutter. Now insert a loaded film holder until it reaches the stop flange that positions it. Remove the holder's dark slide to uncover the sheet of film facing the lens, make sure the camera is steady and release the shutter. Replace the dark slide so the all-black side faces out. Your exposure is now complete.

leveling camera

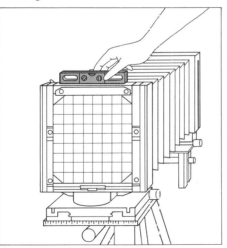

Zero the controls and level the camera before making any other adjustments. Zeroing is important because even a slight tilt or swing of the lens, for example, can distinctly change the focus. Vertical leveling is important if you want the camera to be parallel to a vertical plane such as a building face. Horizontal leveling (above) is vital; without it the picture may seem off balance even if there are no horizontal lines in the scene.

using focusing cloth

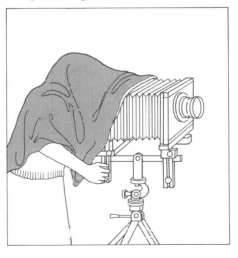

The view camera's ground glass shows a relatively dim image. A focusing cloth that covers the camera-back and your head makes the image much more visible by keeping out stray light. You may not need the cloth if the subject is brightly lighted in an otherwise darkened room, but in most cases it is a necessity. Some photographers like a two-layer cloth—black on one side and white on the other—to reflect heat outdoors and to double as a fill-light reflector.

checking focus

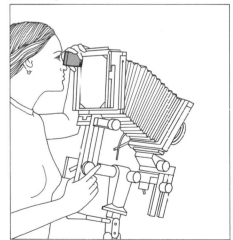

A hand-held magnifier, sometimes called a loupe, is useful for checking the focus on the ground glass. Check the depth of field by examining the focus with the lens stopped down. The image will be dim but can usually be judged if you let your eyes become accustomed to the lower level of illumination. Using a focusing cloth helps. Examine the ground glass carefully for vignetting if camera movements (especially lens movements) are used.

Loading and Processing Sheet Film

Handling sheet film is easy once you have practiced the procedures a few times, but you do have to pay attention to some important details. For example, film is loaded in total darkness into sheet film holders that accept two sheets of film—one on each side. Each sheet is protected by a light-tight dark slide that is removed when the holder is inserted in the camera for exposure. The film must be loaded with the emulsion side out; film loaded with the backing side out will not produce a usable image. The emulsion side is identified by a notching code; when the film is in a vertical position, the notches are in the upper right-hand (or lower left-hand) corner when the emulsion side of the film faces you. After exposure but before you remove the holder from the camera, insert the holder's slide with the all-black side facing out; this is the only way to tell that the film has been exposed and to avoid an unintentional double exposure. Some points on loading film holders are given in the pictures and captions on this page.

Developing sheet film follows the same basic procedure as developing roll film *(page 131)*, but three tanks or trays are used—for developer, stop bath and fixer. Some photographers add a fourth step, a water presoak before development. The film is agitated and transferred from one solution to the next in total darkness; it is not feasible to do this with just one tank as is possible with roll film. Fill tanks with enough solution to more than cover film in the hanger. Fill trays deep enough for the number of sheets to be developed—one inch (25 mm) is probably a minimum.

Check the instructions carefully for the proper development time. It will depend on whether you use intermittent agitation in a tank or constant agitation in a tray.

dusting holders

It is a good idea to dust the film holders each time before loading them. This is much less trouble than trying to etch off a dark spot on your print caused by a speck of dust on the unexposed film. A soft, wide paintbrush (used only for this purpose) or an antistatic brush works well. Dust both sides of the dark slide, under the film guides and around the bottom flap.

checking notching code

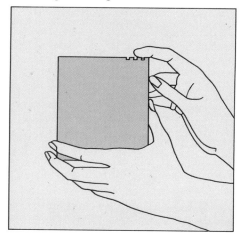

Sheet film has a notching code—different for each type of film—so you can identify it and determine the emulsion side. The notches are always located so the emulsion side is facing you when the film is in a vertical position and the notches are in the upper right-hand corner. Load the film with the holder in your left hand and the film in your right with your index finger resting on the notches. (If you are left handed you may want to load with the holder in your right hand and the film in your left.)

checking film insertion

The film is inserted in the bottom (flap) end of the holder underneath narrow metal guides. If you rest your fingers lightly on top of the guides you can feel even in the dark if the film is loading properly. Also make sure that the film is inserted all the way past the raised ridge at the flap end. When the film is in, hold the flap shut with one hand while you push the dark slide in with the other.

unexposed / exposed film

The dark slide has 2 different sides—one all black, the other with a shiny band at the top so you can tell if the film in the holder is unexposed or exposed. When you load unexposed film, insert the slide with the shiny side out. After exposure, reinsert the slide with the all-black side facing out. The shiny band also has a series of raised dots or a notch so you can identify it in the dark.

loading hangers

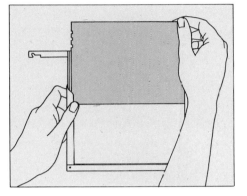

Tank development using film hangers is a convenient way to develop a number of sheets of film at one time. The hanger is loaded in the dark. First spring back its top channel. Then slip the film down into the side channels until it fits into the bottom channel. Spring back the top channel, locking the film in place. Stack loaded hangers upright against the wall until all the film is ready for processing.

tank development

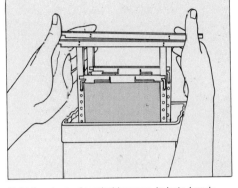

Hold the stack of loaded hangers in both hands with your forefingers under the protruding ends. Don't squeeze too many hangers into the tank; allow at least $\frac{1}{2}$ in of space between each hanger. To start development, lower the stack into the developer. Tap the hangers sharply against the top of the tank to dislodge any air bubbles from the film (this is not necessary if the film has been presoaked in water before development). Make sure the hangers are separated.

tank agitation

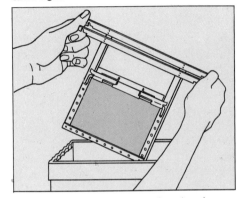

Agitation for tank development takes place for about 8 sec, once for each min of development time. Lift the entire stack of hangers completely out of the developer. Tip it almost 90° to one side to drain the developer from the film. Replace it in the developer. Immediately lift the stack again and tilt almost 90° to drain to the opposite side. Replace in solution. Make sure the hangers are separated. Always remove and replace hangers slowly.

tray development

Tray development is easy if you have just a few sheets of film to process. Fan the sheets so that they can be grasped quickly one at a time. Hold the film in one hand. With the other hand take a sheet and completely immerse it, emulsion side up, in the developer. Repeat until all sheets are immersed. (A water presoak before development is useful to prevent the sheets from sticking to each other.) Touch the film as little as possible—especially the emulsion side—to avoid scratches.

tray agitation

All the film should be emulsion side up toward one corner of the tray. Slip out the bottom sheet of film and place it on top of the pile. Gently push it under the solution. Continue shuffling the pile of film a sheet at a time until the end of the development period. If you are developing only a single sheet of film, agitate by gently rocking the tray back and forth, then side to side.

washing and drying

Film in hangers can be washed and then hung up to dry right in the hangers or it can be dried on a line as shown above. Separate the film enough so that the sheets do not accidentally stick together. A few loose sheets of film at a time can be washed in a tray, but the water flow must be regulated carefully to avoid excessive swirling that could cause scratching.

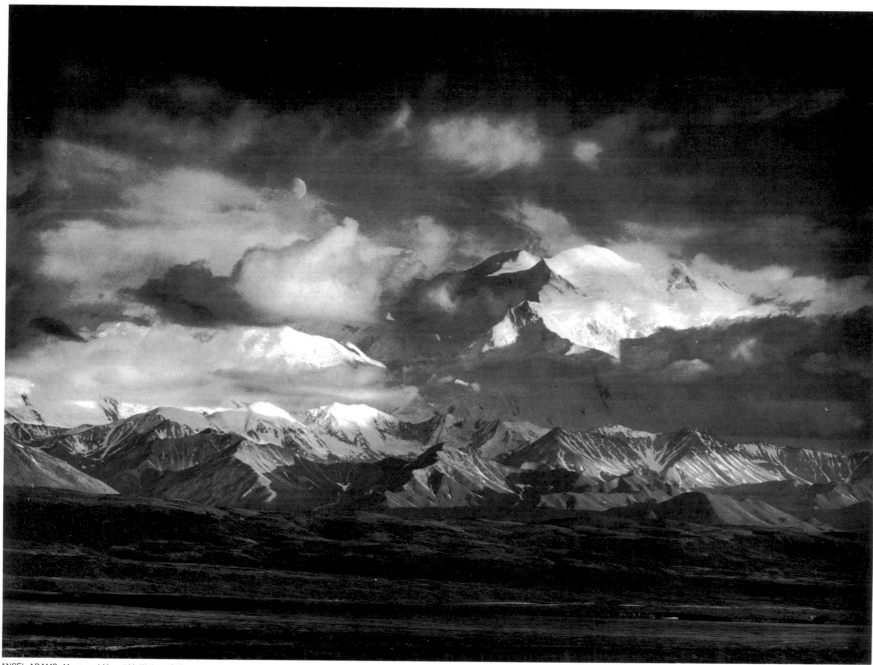

ANSEL ADAMS: *Moon and Mount McKinley*, 1948

11 Zone System

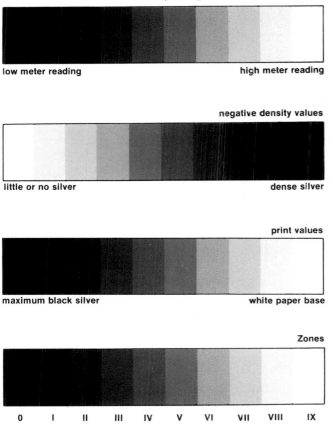

subject brightness values (luminances)

low meter reading high meter reading

negative density values

little or no silver dense silver

print values

maximum black silver white paper base

Zones

| 0 | I | II | III | IV | V | VI | VII | VIII | IX |

Most subjects contain an infinite number of brightnesses or values, ranging from deepest black to pure white plus all levels in between. The tones in a scene can be divided into steps of brightnesses called subject values *or* luminances *(top band, above) and can be measured by a reflected-light meter. The range of values in a scene is usually greater than can be fully shown on photographic materials. During exposure and upon development of film, differences in subject values cause differences in* negative density values—*varying amounts of dark silver in the negative that stop or pass light during printing (next band). These in turn cause differences in* print values—*varying amounts of dark silver in the print (next band). In the Zone System, a scale of exposure* zones *(bottom band) provides a way of describing, comparing and controlling subject values, negative density values and print values. The zones are labeled in Roman numerals with the darkest, Zone 0 (zero), representing the maximum black that a printing paper can produce and the lightest, Zone IX, representing the pure white of the paper base.*

Learning the Zone Scale 236
Zone Scale and Exposure Meter for Precise Exposure 238
How Development Controls Contrast 240
A Full-Scale Print 242
A Flat or a Contrasty Print—When You Want One 244
Putting It All Together 246

Have you ever looked at a scene and known just how you wanted the final print to appear? Sooner or later every photographer does. Sometimes the image turns out just the way you expected, but as often as not for the beginning photographer, the negative you end up with makes it impossible to produce the print you had in mind. When you expose and develop a negative, you build into it certain shadow and highlight values that can only be partially changed during printing. In other words, the negative sets limits on the kind of print you can make.

The Zone System is a method conceived by Ansel Adams *(photograph opposite)* and Fred Archer for controling the black-and-white photographic process. It applies the principles of sensitometry (the measurement of the effects of light on light-sensitive materials), and it organizes into one coherent procedure the many decisions that go into exposing, developing and printing a negative. Briefly, it works this way. You make exposure meter readings of the luminances (the brightnesses) of important elements in the scene. You decide what print values (shades of gray) you want these elements to have in the final print. Then you expose and develop the film to produce a negative that can, in fact, produce the print you had visualized.

Luminances in a scene can be pegged to precise values through the systematic application of an old photographic rule of thumb: expose for the shadows and develop for the highlights. Exposure largely controls density and detail in thin areas of the negative (which produce dark or shadow areas in the print), whereas exposure *plus* development affect negative density and detail in the dense areas (which produce light areas in the print). In effect, development controls contrast in a negative and you can increase contrast by increasing development or decrease it by decreasing development. Pages 240–241 explain this further.

The Zone System allows you to previsualize how the tones in any scene will look in a print and to choose either a realistic interpretation or a departure from reality. Even if you continue to use ordinary exposure and development techniques, understanding the Zone System will help you apply them more confidently. This chapter is only a brief introduction to show the usefulness of the Zone System. Other books that tell how to put it into full use are listed in the Bibliography.

Learning the Zone Scale

In order easily to control the value (lightness or darkness) of an area, you must first find a way to name and describe how light or how dark the area is. There are four times during the production of a black-and-white print when such a description is useful; the Zone System has four scales to use for this purpose (diagram, page 235).

1. *Subject value scale.* The steps on this scale describe the amounts of light reflected or emitted by various objects in a scene. Subject values or luminances can be measured by a reflected-light meter: a low or dark subject value produces a low meter reading; a high or bright subject value produces a high meter reading.

2. *Negative density value scale.* Divisions of this scale describe the amounts of silver in various parts of the negative after it has been developed. Clear or thin areas of a negative have little or no silver; dense areas have a great deal of silver. These values can be measured by a densitometer, a device that gauges the amount of light stopped or passed by different portions of the negative.

3. *Print value scale.* These steps describe the amounts of silver in various parts of a print. The darkest areas of a print have the most silver, the lightest areas the least. These values can be measured by a reflection densitometer if desired, but are ordinarily simply evaluated by eye in terms of how light or dark they appear.

4. *Zone scale.* This scale is crucial becaUse it links the values on the other three scales. It provides fixed descriptions of values to which subject values, negative density values and print values can be compared. Each zone is one stop away from the next (it has received either twice or half the negative exposure). The divisions of all the scales are labeled with Roman numerals to avoid confusion with f-stops or other settings.

Familiarizing yourself with the divisions of the zone scale (opposite) is important because it gives you a means of previsualizing the final print: the zones aid you in examining subject values, in deciding how you want them to appear as print values and in then planning how to expose and develop a negative that will produce the desired print.

The zone scale at right has 10 steps and is based on Ansel Adams's description of zones in his book *The Negative*. Some commonly photographed surfaces are listed in the zones where they are often placed if a realistic representation is desired; average light-toned skin in sunlight, for example, appears realistically rendered in Zone VI.

Zone 0 (zero) relates to the deepest black print value that photographic printing paper can produce, resulting from a clear area (a low negative density value) on the corresponding part of the negative, which in turn was caused by a dark area (a low subject value) in the corresponding part of the scene that was photographed.

Zone IX relates to the lightest possible print value—the pure white of the paper base, a dense area of the negative (a high negative density value) and a bright area in the scene (a high subject value).

Zone V corresponds to a middle gray, the tone of a standard-gray test card of 18 percent reflectance. A reflected-light exposure meter measures the brightnesses of all the objects in its field of view, then gives an exposure recommendation that would render the average of all those brightnesses in Zone V middle gray.

There are, of course, more than 10 shades of gray in a print—Zone VII, for example, represents all tones between Zones VI and VIII—but the 10 zones do provide a convenient method of visualizing and identifying tones in the subject, the negative and the print.

Zone IX: 4 (or more) stops more exposure than Zone V middle gray. Maximum white of the paper base. Whites without texture: glaring white surfaces, snow in flat sunlight, light sources.

Zone VIII: 3 stops more exposure than Zone V middle gray. Near white. High values with delicate texture: very bright cement, snow in diffused light, the lightest wood at right.

Zone VII: 2 stops more exposure than Zone V middle gray. Light gray. High values with full texture and detail: very light fabrics with full sense of texture, sand or snow lighted from the side.

Zone VI: 1 stop more exposure than Zone V middle gray. Medium-light gray. Average light-toned skin in sunlight, light stone or weathered wood, shadows on snow in a scene that includes both shaded and sunlit snow.

Zone V: middle gray. The tone that a reflected-light meter assumes it is reading and for which it gives exposure recommendations. 18 percent reflectance neutral-gray test card, clear north sky, dark skin.

Zone IV: 1 stop less exposure than Zone V middle gray. Medium-dark gray. Dark stone, average dark foliage, shadows in landscapes, shadows on skin in sunlit portrait.

Zone III: 2 stops less exposure than Zone V middle gray. Dark gray. Shadow areas with full texture and detail: very dark soil, very dark fabrics with full texture, the dark boards at right.

Zone II: 3 stops less exposure than Zone V middle gray. Gray-black. Darkest area in which any sense of texture will remain in the print.

Zone I: 4 stops less exposure than Zone V middle gray. In theory, a near black with slight tonality but no visible texture. Some modern enlarging papers do not show any difference between Zones 0 and I.

Zone 0: 5 (or more) stops less exposure than Zone V middle gray. Maximum black that photographic paper can produce; the opening to a dark interior space, the open windows at right.

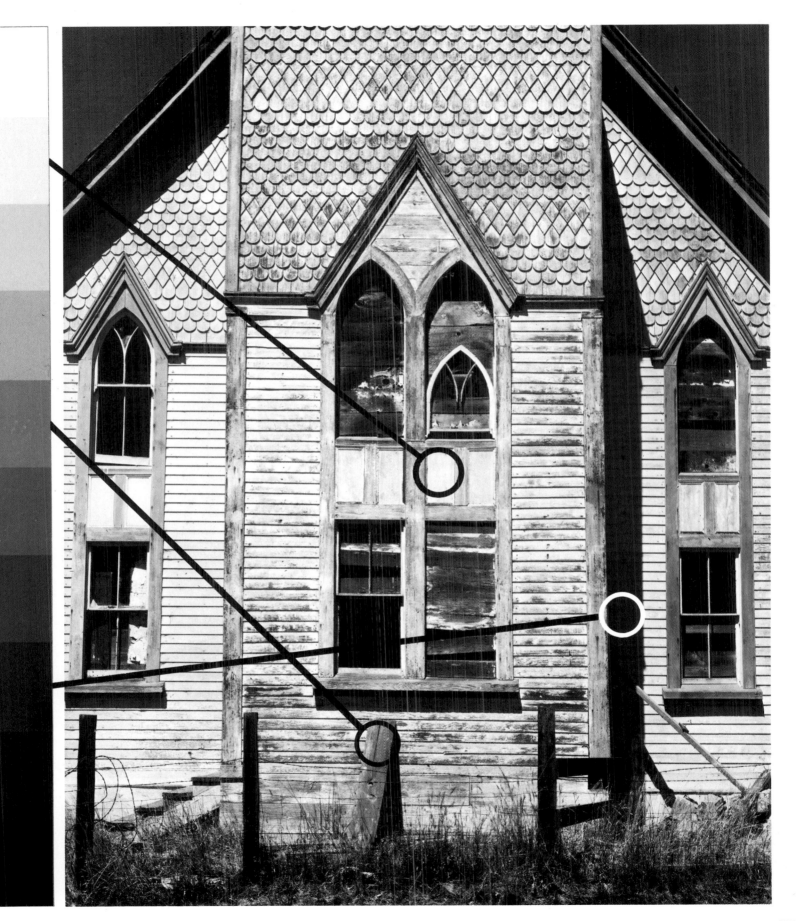

Zone Scale and Exposure Meter for Precise Exposure

When you are standing in front of a subject and previsualizing how it might look as a black-and-white print, you have to take into account that ordinary photographic materials cannot record with realistic texture and detail the entire range of luminances (subject brightnesses) in many scenes. For example, a scene in bright sunlight can generally be rendered with texture and detail in either dark shadows or bright highlights but not both. Usually, you have to choose those areas in which you want the most detail in the print, and then expose the negative accordingly.

You can accurately previsualize the black-and-white tones in the final print by using the zone scale described on the preceding pages plus a reflected-light exposure meter. (An incident-light meter cannot be used because it measures the light falling on the scene and you will need to measure the luminances of individual areas.) Compare the meter readings of different areas to each other to find where each lies on the zone scale for any given exposure. Then, with standardized negative development and printing (more about those later), you can determine the precise print value (shade of gray) that each area will have in the final print. Metering must be done carefully in order to get consistent results. Try to read areas of more or less uniform tone; the results from an area of mixed light and dark tones will be more difficult to predict. A spot meter is useful for reading small areas.

The meter does not know what area is being read nor how you want it rendered in the print. It assumes it is reading a uniform middle-gray subject tone (such as a neutral-gray test card of 18 percent reflectance) and gives exposure recommendations accordingly (see page 112). The meter measures the total amount of light that strikes its light-sensitive cell, then calculates f-stop and shutter speed combinations that will produce a Zone V negative exposure.

If you choose one of the f-stop and shutter speed combinations recommended by the meter, you will have "placed" the metered area in Zone V and it will reproduce as middle gray in the print (Print Value V). By altering the negative exposure you can place any one area in any zone you wish. One stop difference in exposure will produce one zone difference in tone. For example, one stop less than the recommended exposure places a metered area in Zone IV; one stop more places it in Zone VI.

Once one tone is placed in any zone, all other luminances in the scene "fall" in zones relative to the first one depending on whether they are lighter or darker and by how much. Suppose a medium-bright area gives a meter reading of 7 (see meter and illustration, near right). Basing the exposure on this value (by setting 7 opposite the arrow on the meter's calculator dial) places this area in Zone V. Metering other areas shows that the brightest wood reads three stops higher (10) and falls in Zone VIII, three stops above Zone V. An important dark wood area reads two stops lower (5) and falls in Zone III.

A different exposure could have been chosen, causing all of the zones to shift equally lighter or darker (illustrations, far right). For instance, by giving one stop more exposure you could have lightened the tones of the dark wood, placing them in Zone IV instead of III, but many of the bright values in the lightest wood would then fall in the undetailed white Zone IX. That might be the way you want the print to look; the Zone System simply allows you to visualize your options in advance.

Each position on an exposure meter gauge measures a luminance (subject brightness) 1 stop or 1 zone from the next position. Metering a medium-bright area (near right) gives a reading of 7. Setting 7 opposite the arrow on the calculator dial places this area in Zone V. Since the brightest wood meters 10, it will fall 3 zones lighter—in Zone VIII. A dark wood area meters at 5 and falls in Zone III. The first area metered will appear in the print as middle-gray Print Value V, the bright wood as near-white Print Value VIII, and the dark wood as dark-gray Print Value III (with standard negative development and printing).

With some meters (such as the one diagramed above), the difference in luminances, and therefore the difference in zones, can be read directly off the dial. With other meters (those that match arrows, for example), you must count the full stops of exposure difference to find the difference in zones. Suppose that metering the scene at right gives suggested exposures of f/5.6 at 1/60 sec for one area and f/16 at 1/60 sec for a brighter area. In this example, f/16 gives 3 stops less exposure than f/5.6 (f/5.6 to f/8 is 1 stop less; f/8 to f/11, 2 stops; f/11 to f/16, 3 stops). Placing the first area in Zone V will cause the other to fall 3 zones higher in Zone VIII.

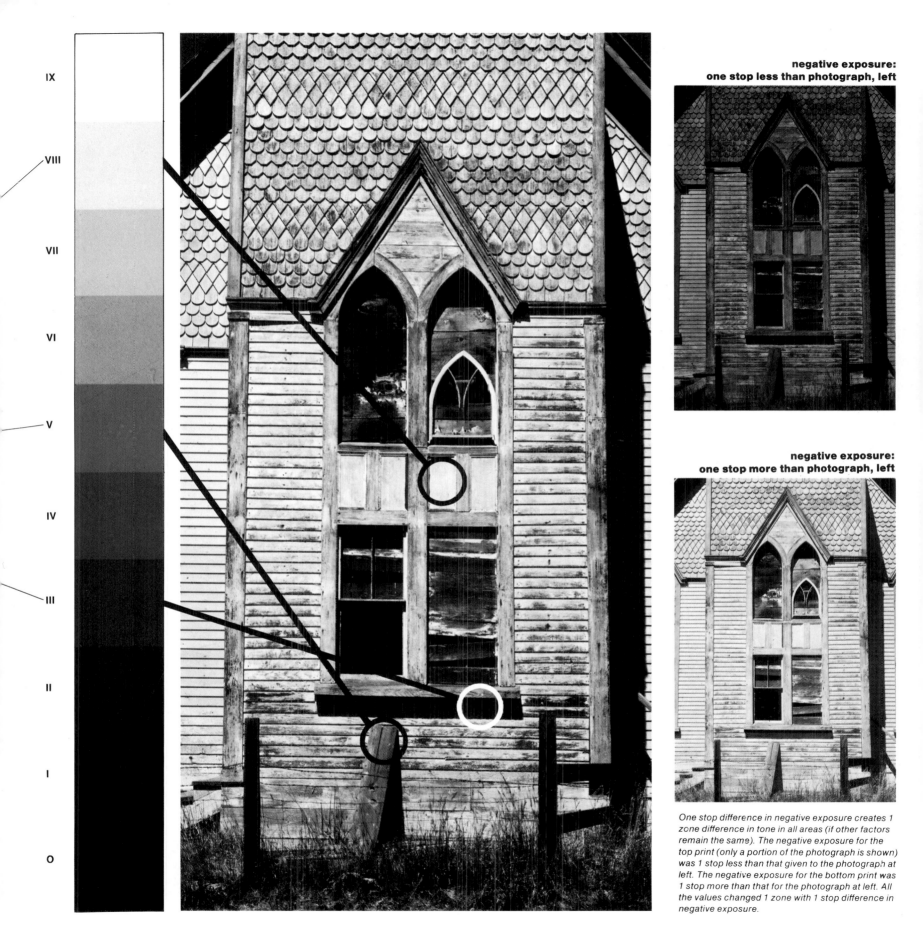

IX

VIII

VII

VI

V

IV

III

II

I

O

**negative exposure:
one stop less than photograph, left**

**negative exposure:
one stop more than photograph, left**

*One stop difference in negative exposure creates 1
zone difference in tone in all areas (if other factors
remain the same). The negative exposure for the
top print (only a portion of the photograph is shown)
was 1 stop less than that given to the photograph at
left. The negative exposure for the bottom print was
1 stop more than that for the photograph at left. All
the values changed 1 zone with 1 stop difference in
negative exposure.*

239

How Development Controls Contrast

normal development

expanded development

The length of time a negative is developed has an important effect on the contrast. The 3 versions of this scene received indentical negative exposures and identical printing; only the development time was changed. At left, normal development was given to the negative. Center, more development time expanded the contrast by increasing the density of the high values in the negative. As a result, high values, such as the sidewalk, are lighter in the print. At right, less development time compacted the contrast by decreasing the density of high values, which now appear darker in the print. Low shadow values were basically set during exposure and remained the same with any development.

You can, with careful metering and exposure choice, place any one luminance (subject brightness value) in any zone you desire. You can also predict in which zones the other subject values will fall. But exposure is still only half of the story in producing a negative. Development can also be used to adjust certain values and, as a result, to control the overall contrast of the negative. You may want to decrease contrast if the subject has a greater range of tones than the paper can print. Or, if the subject has only a narrow range of tones, you may want to increase contrast so that the print doesn't look flat and dull.

The most common way to adjust contrast is to change the contrast grade of the paper—print a high-contrast negative on a low-contrast paper and vice versa. But another way is to change the development time of the negative. In general, increasing the negative's development time increases its overall contrast range, while decreasing the development time decreases contrast. There are advantages to adjusting the negative's contrast. A negative that

prints with a minimum of dodging and burning on a normal-contrast grade of paper is simply easier to print than, for example, a contrasty negative with dense highlight values that require considerable burning in even on a low-contrast grade of paper. And some scenes are so contrasty that the negative does not print well on the lowest-contrast grade of paper available.

A film's response to changes in development time is strong in the areas of greatest exposure (high, bright values) and weak in areas of little exposure (low, shadow values). This happens because the developer quickly reduces to silver the relatively few silver bromide crystals that were struck by light in the slightly exposed shadow areas. Development of shadow areas is completed long before all the crystals in the greatly exposed highlight areas are converted to silver. The longer a negative is developed (up to a limit), the greater the silver density that develops in high values, while the shadow densities remain about the same. Contrast increases as the spread between high value and low value densities increases, and it decreases as the spread decreases.

Development control of high values (the upper zones of the zone scale) can be quite precise. If an area is placed in Zone VIII during exposure, it will produce a Negative Density Value VIII if the film is given normal development. That same area could be developed to a Negative Density Value VII with less development or to a Negative Density Value IX with more development.

The process by which subject brightness values increase to higher values on the negative through increased development time is termed normal-plus or expansion, since the contrast range of the negative is increased or expanded. The reverse process, in which brightness values (and contrast) are reduced by decreasing the development time, is called normal-minus, contraction or compaction.

In Zone System terms, N stands for normal development. With normal development, values remain where they were placed or fell during exposure; an area falling in Zone VII would appear as

compacted development

a Negative Density Value VII and (given normal printing) as Print Value VII.

N + 1 (normal-plus-one) indicates expanded development; a Zone VII value would be increased one zone to Zone VIII *(diagram, right)*. N + 2 indicates a greater expansion; a Zone VII value would be increased two zones. N − 1 (normal-minus-one) indicates contracted development; a Zone VII value moves one zone down to Zone VI. N − 2 is a greater contraction.

Although the upper values shift considerably with changes in development time, the lower values change little or not at all. Middle values change somewhat, although not as much as the upper ones. Therefore, the low value densities in a negative (dark or shadow areas in the original scene) are the result of the amount of exposure while high value densities are the product of both exposure and development. Changing the development time is simple with sheet film, since each exposure can be given individual development. With roll film, changing the contrast grade of the paper is often more practical.

Expansions Compactions

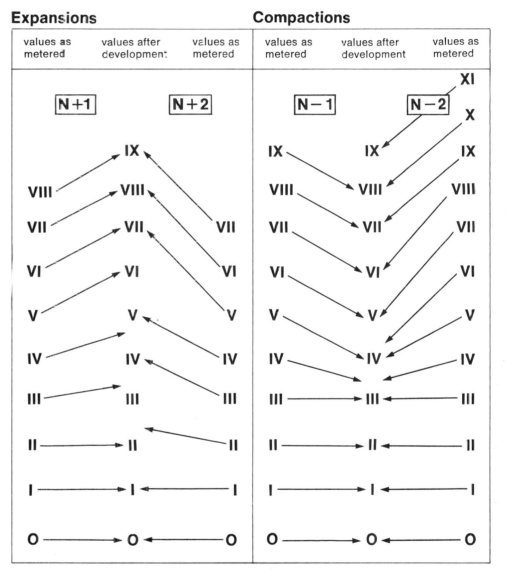

values as metered	values after development	values as metered	values as metered	values after development	values as metered

If a negative is given normal development, the densities of various areas in the negative will correspond to the relative luminances of those areas in the original scene. But if the development time is increased (N + 1 or N + 2 in the chart above), the differences between densities will be expanded, especially in the upper zones, V to IX, and the contrast of the negative will be increased. If development time is decreased (N − 1 or N − 2), the differences between densities will be compacted, especially in the upper zones, and negative contrast will be decreased. See page 246 for how much to increase or decrease development.

A Full-Scale Print

Often (although not always) photographers want to make a full-scale print with normal contrast, that is, with a full range of values from black through many shades of gray to white and considerable texture and detail showing in important areas.

If a black-and-white print is to have substantial detail in both shadows and highlights, then the darkest area in which important details are to be preserved should be no darker than Zone III and the lightest area where considerable texture is to be seen should be no lighter than Zone VII *(illustration, right)*. Areas lighter or darker than these values will be at the edge of the printing paper's ability to render good detail.

Since detail in low values is determined by exposure, Zone III placement for the darkest part of the scene in which you want to show detail will guarantee that enough density will develop in the negative to make details and texture in that area visible in the print. If you used the Zone System to calculate the exposure for the scene at right, you could place the dark wood boards in the windows in Zone III by metering them, then giving two stops less exposure than the meter calls for (remember that meters calculate exposures for Zone V—see page 238). Suppose the boards read 5 on the meter gauge. Placing 5 opposite the arrow on the calculator dial (the zone V position) would place the boards in Zone V. Since you want the boards in Zone III, place 5 two stops from the calculator arrow toward underexposure, as shown at right.

Now the lightest areas in which you want texture and detail can be metered to see in which zones they fall. Some small, very bright areas might read 10 on the meter dial and fall in Zone VIII, while larger bright areas might read 9 and fall in Zone VII. Is this the way you want the

print to look? If so, developing the film normally would produce a negative that, when printed on a normal-contrast grade of paper, would show the dark boards as dark but with good detail, the brightest areas just showing texture and larger bright areas light but with full detail.

Suppose the scene was more contrasty and the dark boards metered 5, large bright areas metered 10 and the brightest boards metered 11. If you placed the dark boards in Zone III, the brightest areas would fall in pure white Zone IX, while much of the scene would fall in almost-white Zone VIII. Giving N–1 (compacted) development would reduce the brightest areas to Value VIII and other bright areas to a fully textured Value VII, while the Value III dark boards would not change. The contrast would have been compacted by reducing the development time. The negative would print well on a normal-contrast grade of paper with the important areas rendered as you previsualized them.

Another way to reduce the contrast would be to plan to use a low-contrast grade of paper during printing. The advantage of analyzing the exposure in Zone System terms is that you know in advance what the range of contrast is in the scene in terms of the print's ability to show detail.

In a photograph that is a portrait, the face is often the first area that a viewer notices, so it is important to meter skin tones carefully and see that they will have the desired rendering—either by placing them in the zone where you want them or seeing that they fall there, or by developing them to that value. Normal values for the sunlit side of a face are V for dark skin, VI for medium-light skin and VII for very light skin. The shaded side of a face in sunlight usually appears normally rendered as Value IV.

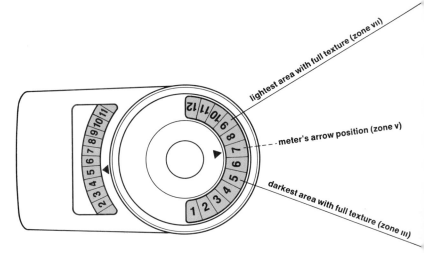

Opposite is a full-scale print of normal contrast. The tones range from black through many shades of gray to white, and full texture is visible in both the darkest and lightest areas in which texture is important. Some readings that you might have registered for the scene are shown on the meter above. Dark board areas metered at about 5. They were placed in Zone III (the darkest value that can show full texture) by positioning the meter arrow (which indicates Zone V) 2 stops higher on the calculator dial. Large bright areas metered 9 and fell in Zone VII (very light but with full texture). Smaller brighter areas metered 10 and fell in Zone VIII (near-white). A spread of 4 or 5 zones between the darkest textured shadow and the lightest textured white will produce a full-scale, rich print on a normal-contrast grade of paper.

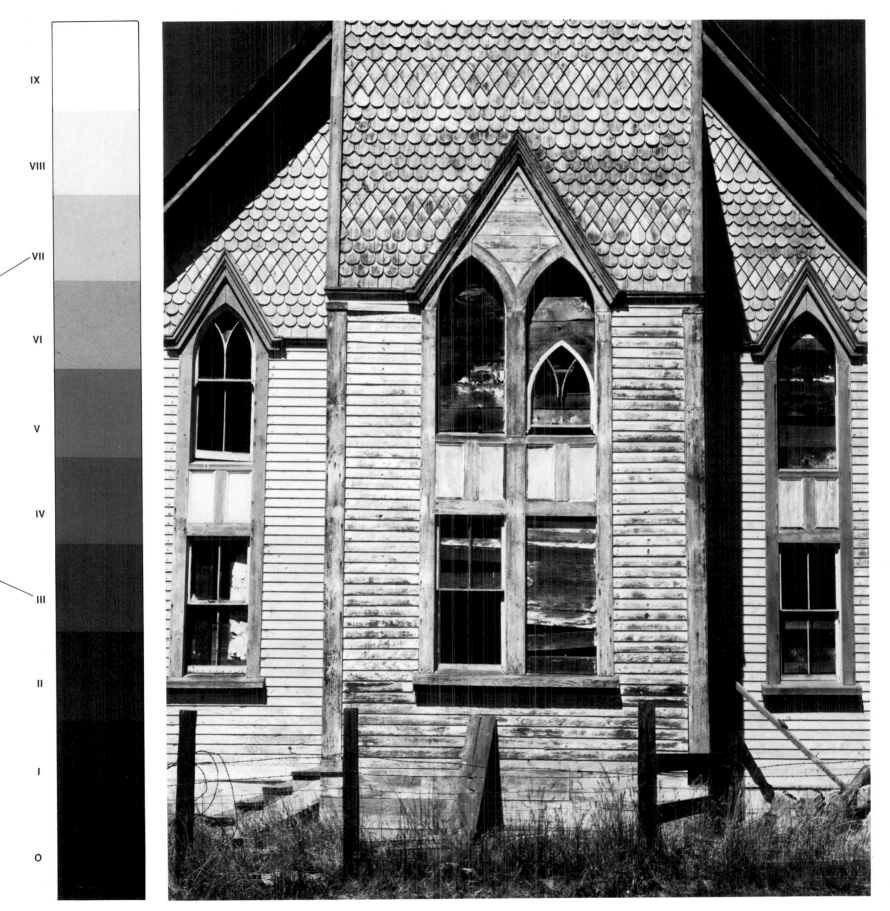

IX

VIII

VII

VI

V

IV

III

II

I

O

A Flat or Contrasty Print—When You Want One

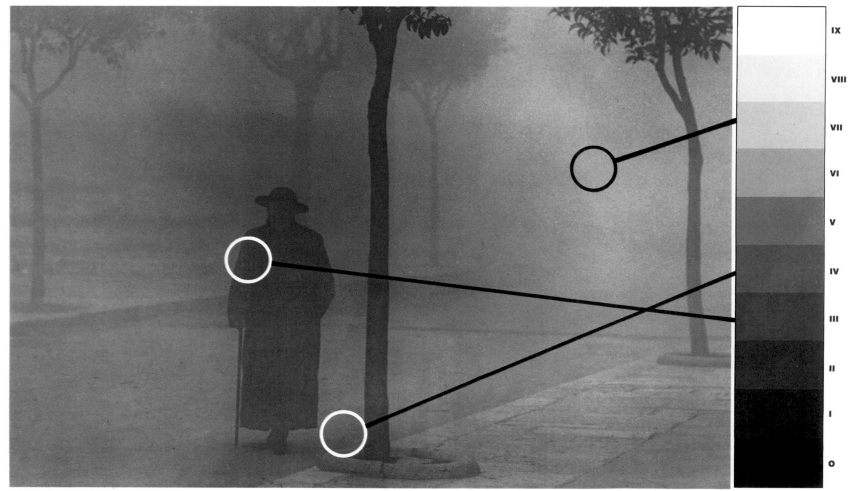

MICHAEL SEMAK: *Italian Village*, 1962

The Zone System can be used not only to plan exposure and development for a normal-contrast negative, but also to plan unusually low or high contrast. In the scene above, the photographer liked the luminous but flat light of the fog-shrouded street. Metering the scene showed that the lightest value was the foggy atmosphere and that the darkest value was only four stops lower. The photographer placed the fog in Zone VII (by metering the fog, then giving two stops more exposure than the meter indicated). Since the darkest areas metered four stops (four meter positions) lower, they would fall in Zone III. There would be no brilliant whites (Zones VIII, IX) nor very dark blacks (Zones 0, I, II). Giving the film normal development produced a flat negative that would make a flat print on normal-contrast paper.

In the scene at right, the photographer wanted to preserve the harsh and contrasty lighting. The high values of

Because a flat negative, lacking Zones 0, I, VIII and IX densities, would maintain the soft, luminous, low-contrast feeling of this scene, the photographer based the exposure on the lightest area, the fog, placing it in Zone VII. All of the other tones in the scene fell between Zones III and VII. Normal development of the film produced a flat negative.

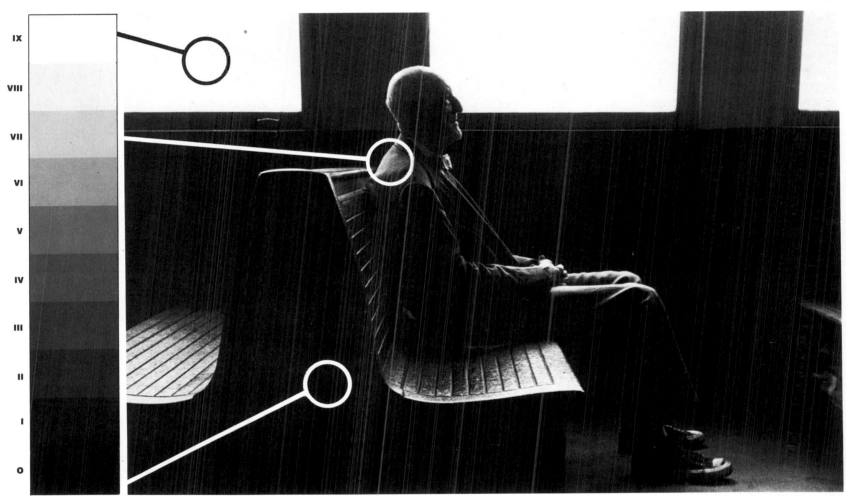

NEAL SLAVIN: *On the Staten Island Ferry*, 1967

Seeking a harsh, high-contrast, limited tonal range, with little detail, the photographer placed the windows in a blank Zone IX. Nearly all of the shadows fell in equally featureless Zones 0 and I, leaving only a small area of the bench and the man's clothing in the grayer middle zones.

the windows metered eight or nine stops brighter than the shadow areas so that even with the windows placed in pure-white Zone IX, the shadows fell in deep-black Zones 0 and I. Only very small areas, such as parts of the man's coat, which metered between the two extremes, would show any detail at all. To calculate the exposure, the photographer metered the windows, then gave four stops more exposure than the meter called for (placing the windows in

Zone IX). Normal development of the film produced a very contrasty negative.

These scenes could have been interpreted differently had the photographers chosen to do so. Contrast could have been decreased in the scene above, for example, by increasing the exposure (shadows placed in Zones II and III) and decreasing the development (the man's coat, now falling in all-white Zone IX, brought back to a printable density by the decrease in development).

Putting It All Together

The Zone System procedure has three basic steps.

Step 1: Meter the most important area in the scene and place it in the zone where you want it rendered. Often this is the darkest area in which you want full texture (usually placed in Zone III). Placing a value determines your exposure.

Step 2: Meter other areas (especially the lightest area in which you want full texture) to see in which zones they fall in relation to the area you have placed.

Step 3: Previsualize the final print and finalize negative exposure and development choices. If you want the negative densities to correspond to the relative luminances of various areas in the scene, you can develop the negative normally. Change the development time if you want to change the densities of the upper values while leaving the lower values about the same. Increasing the time increases the negative densities of the high values (which will make those areas lighter in the print) and also increases the contrast. Decreasing the development time decreases the negative densities of the high values (they will be darker in the print) and decreases contrast.

You could also plan to print on a contrast grade of paper that was higher or lower than normal in order to control densities and contrast. A change of one contrast grade in printing paper causes approximately a one-zone shift in the high values (when low values are matched in tone).

You can best determine normal development time by a series of tests, which also establish the changes in development needed to move a value precisely from one zone to another. The tests, covered in detail in the books listed in the Bibliography, establish five standard elements for the individual photogra-

pher: actual film speed, normal development time, expanded development times, compacted development times and standard printing time.

Personal testing is recommended since cameras, meters, films, enlargers, papers, developers and personal techniques all differ and will affect the results. However, there are some general guidelines for expanded and compacted development that you can use without testing, and that will be helpful for approximate control of contrast. First, use the manufacturer's stated ASA rating to calculate the exposure. For normal development, use one of the manufacturer's suggested time and temperature combinations.

For an N + 1 expanded development, increase the development time by half. If the recommended development time is 8 minutes for a given film-developer-temperature combination, then the high values can be shifted up one zone each by a 12-minute development. For an N + 2 expansion, double the development time; for an N + 3, triple it.

For a compacted N − 1 development, which will shift the high values downward one zone each, develop for three-quarters of the normal time. For an N − 2 compaction, develop for two-thirds of the normal time.

These are only suggestions and you may need to adjust them. The results from the more extreme changes (N − 2 or N + 3) should be checked against your expectations. N + 3 may produce more grain in the image than you want, especially with small negatives. Very short developing times may result in uneven development, so an N − 2 compaction is often best done with a two-bath or water-bath development *(page 143)*.

Changing the development time is

easy with view camera photography, where sheets of film can be processed individually. But it can also be valuable with roll film even though a whole roll of exposures is processed at one time. Sometimes a single image or situation is so important that it deserves special development; the other images on the roll will probably still be printable on a different grade of paper. Or, an entire roll may be shot under one set of conditions and so can be exposed and processed accordingly.

With roll film, Zone System metering and control of negative contrast is often combined with changes in printing-paper contrast. The primary objective is to give enough exposure to dark areas to produce printable densities in the negative while at the same time keeping bright areas from becoming too dense to be printable. For example, if you are shooting on the street on a generally sunny day and trial metering indicates about one stop too much contrast (i.e., with shadows placed in Zone III, the high values in which you want full detail fall in Zone VIII or IX), compacted development for the entire roll will be useful. Most of the frames shot will then print on a normal-contrast grade of paper; those shot under more contrasty conditions will print on a low-contrast grade; those shot in the shade (now low in contrast because of compacted development) will print on a high-contrast grade.

The advantage in using the Zone System is that you have better control over the final print. Many photographers are satisfied with their technique without using the Zone System. But if you feel you want to add more precision to your photography, the Zone System gives you a way to do so.

ANSEL ADAMS: *Moonrise, Hernandez, New Mexico,* 1941

RALPH WEISS: *Queen Anne's Lace,* 1966; magnified 1.2x, here enlarged to 11.2x

12 Special Techniques

The World in Close-Up 250

 How to Use Supplementary Lenses 251

 How to Use Extension Tubes and Bellows 252

 Close-Up Exposures: Greater than Normal 254

Special Printing Techniques 256

 The Photogram's Shadow Picture 256

 A Sabattier Print—Part Positive, Part Negative 258

Techniques Using High-Contrast Film 260

 A Line Print 263

 A Posterization 264

Xerography—Prints from an Office Copy Machine 266

In addition to taking pictures with standard photographic techniques, you can also explore images that are created by using special equipment or materials. This chapter shows some of these alternate ways of taking photographs or making prints.

In close-up photographs, for example, things take on qualities beyond simple magnification. Objects are revealed for scientific study, such as the Queen Anne's lace opposite, but there is also pleasure and magic just in seeing something larger and in greater detail than it is ordinarily seen.

You can also manipulate a photograph and radically change the image formed in the camera (or make a print entirely without a camera) in order to make a print that is more interesting or exciting to you or to express a personal viewpoint that could not be conveyed by conventional methods. Probably the main pitfall in manipulating a print is changing it merely for the sake of change instead of making alterations that actually strengthen the image. But you will never know what the possibilities are until you have used different techniques with your own images.

There are many techniques besides those described here—nonsilver processes such as cyanotyping and photo silk-screening *(page 358),* multiple imagery *(page 362),* collaging and hand-painting.

Ultimately, the success of a photograph depends not on the technique used but on your taste and judgment in fulfilling its potential—whether through a straight, full-scale black-and-white print or a manipulated image.

The World in Close-Up

If you want to make a large image of a small object, you can, at the simplest level, enlarge an ordinary negative. However, this is not always satisfactory because of the loss of image quality in extreme enlargements. A much better picture results from using close-up techniques to get a large image on the negative to begin with.

In close-up photography, the subject is focused closer than normal to the camera. This can be done by fitting a supplementary lens over the front of the regular lens *(opposite)*, by increasing the distance from lens to film with the insertion of extension tubes or bellows between the lens and the camera-back *pages 252–253)* or by using a macro lens that is designed for close-up work *(page 62)*. Each method can focus a larger-than-normal image on the film *(diagram, below)*.

Working close up is somewhat different from working at normal distances. As the subject comes closer to the lens, focusing becomes more and more critical because depth of field is very shallow at close working distances. A 50mm lens at a distance of about 12 inches (30.5 cm) from the subject has a depth of field

of one-sixteenth inch (1.6 mm) when the aperture is set at f/4. At f/11 the depth of field increases—but only to one-half inch (12.7 mm).

After the image has been roughly focused and composed, it is usually easier to focus precisely by moving the entire camera or the subject farther away or closer rather than by racking the lens in or out. And depth of field is different too: in a close-up (1:10 and closer) it extends half in front and half behind the plane of focus; at normal working distances it is one-third in front and two-thirds behind the plane of focus. The highly magnified image is very sensitive to camera movement, so a tripod is almost a necessity. A tripod also assists precise focusing, since even a slight change in subject-to-lens distance changes the focus.

For close-up work, there are many advantages to using a single-lens reflex or view camera—mostly because of their through-the-lens viewing. You can see exactly where the lens is focused and preview depth of field by stopping down the lens, which is important with so shallow a depth of field. You can frame the image precisely and see just how the subject relates to the background.

Many single-lens reflex cameras have through-the-lens metering, which can solve some close-up metering problems (more about metering on page 254).

Twin-lens reflex and rangefinder cameras are less convenient to use mainly because it is difficult for you to see the image exactly as the lens sees it. If you have a twin-lens reflex, you can buy twin supplementary lenses that fit over the camera's viewing and taking lenses; a built-in prism changes the angle of the viewing lens so it sees the same area as the taking lens (although from a slightly higher point of view, which changes the relationship of subject to background). It is also possible to measure the distance from the center of the taking lens to the center of the viewing lens, then raise the tripod head exactly that much; a tripod accessory is available for this.

Rangefinder cameras are even harder to use since the rangefinder mechanism will not focus at very close distances nor will the viewfinder show the exact area being photographed. You may be able to buy an accessory close-up rangefinder attachment; a more expensive alternative is a reflex housing to turn the camera into a single-lens reflex.

In normal photographic situations, the size of the image produced on the film is less than one-tenth the size of the object being photographed. Close-up images where the subject is closer than normal to the camera can range from about one-tenth to about 50 times life size. Beyond about 10 times life size, however, it is often more practical to take the photograph through a microscope. The relative sizes of image and subject are expressed as a ratio with the relative size of the image stated first: a 1:10 ratio means the image is one-tenth the size of the subject. Or the image size can be stated in terms of magnification: a 50x magnification means the image is 50 times the size of the subject. The magnification of an image smaller than life size (actually a reduction) is stated as a decimal: a .10 magnification produces an image one-tenth life size. The term photomacrograph (sometimes macrophotograph) refers to close-ups that are life size or larger. Pictures taken through a microscope are photomicrographs.

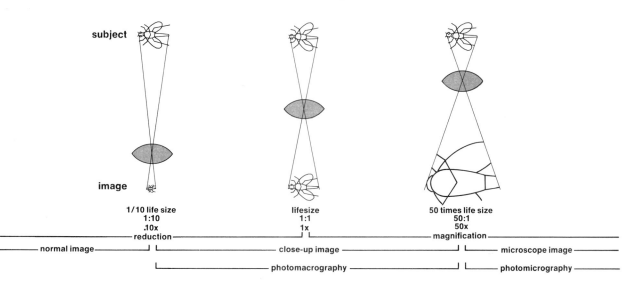

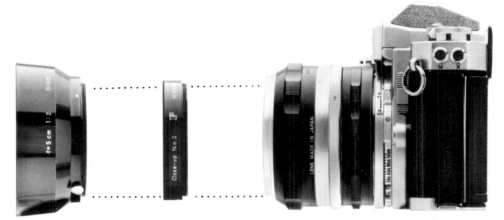

lens hood **supplementary lens** **35mm SLR camera with 50mm lens**

50mm lens alone

50mm lens and + 1.5 diopter lens

50mm lens and + 4.5 diopter lens

The simplest devices for making close-ups are supplementary lenses. These are magnifying glasses of varying powers, and are attached to the front of regular lenses. Supplementary lenses enlarge an image in two ways: they add their own power to that of the regular lens, and they change the focusing distance of the regular lens so that it can move closer to an object than it normally could.

The power of a supplementary lens is expressed in diopters, an optical term used to describe both the focal length and the magnifying power of the lens. Thus a 1-diopter lens (expressed as + 1) will focus on a subject one meter (100 cm, or 3.25 ft) away. A + 2 diopter focuses at half that distance (50 cm) and magnifies twice as much; a + 3 diopter focuses at 33 cm and magnifies three times as much, and so on. Lenses of varying diopters can be added to each other to provide greater magnification, as long as the stronger lens is attached to the camera first. Image quality tends to suffer, however, when more than one supplementary lens is used.

When a supplementary lens is attached to a camera lens set at infinity, the new focusing distance will be the focal length of the supplementary lens. This is true no matter which camera lens is being used. For example, with the lens at infinity a + 2 lens will always focus on a subject 50 cm (19.5 in) away with a 50mm lens, a 135mm lens or any other lens—provided that the regular lenses are set at infinity. The ultimate image size, however, still depends on the focal length of the camera lens. This happens because the degree of enlargement is determined by the diopter of the supplementary lens plus the magnifying power of the regular lens. Thus a + 2 diopter gives a bigger image with a 135mm lens than with a 50mm lens. Also, a supplementary lens will give varying degrees of enlargement depending on the distance setting of the lens. With the lens set for a distance closer than infinity, an object can be brought into focus closer than the regular diopter distance to create an even larger image. Charts provided with the supplementary lenses give details.

An advantage of supplementary lenses is that they do not change exposure readings. Also, they are small, inexpensive and can be used with any kind of camera, including those without interchangeable lenses.

Because of their design, however, the lenses can provide acceptable sharpness only when used with small apertures. Their surfaces, not bonded to the regular lens, may cause reflections and other aberrations. And overall sharpness of focus decreases at + 5 diopters or stronger.

How supplementary lenses enlarge: The top picture shows a cluster of petunias as seen by a 35mm single-lens reflex with a 50mm lens. The lens, set at its closest focusing distance (about 18 in, or 46 cm) produces an image on the film about one-tenth (.10x) life size. (The pictures here are enlarged slightly above actual film size.) With a + 1.5 diopter supplementary lens (center), camera-to-subject distance is reduced to 15 in (38 cm) for a larger image, about .20x life size With + 4.5 diopters the distance is 10 in (25 cm), and the image of a blossom is enlarged to about .33x life size.

How to Use Extension Tubes and Bellows

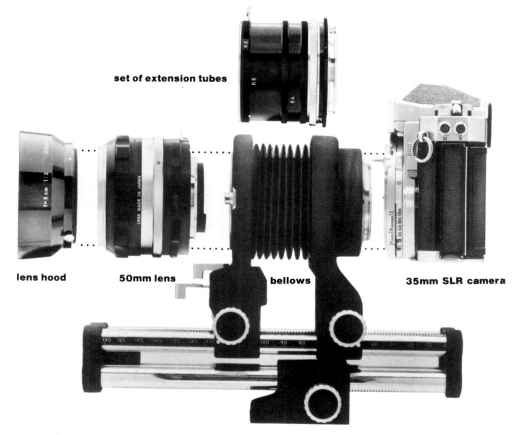

set of extension tubes

lens hood **50mm lens** **bellows** **35mm SLR camera**

50mm lens on 35mm SLR camera

50mm lens and full extension-tube set

50mm lens reversed and extension tubes

50mm lens and fully extended bellows

Extension tubes and bellows help make close-up pictures in essentially the same manner. Either accessory is mounted between camera body and lens, extending the lens nearer to the subject and farther from the film. This has a magnifying effect because the lens is now focused on a smaller portion of the subject but projects the image of that portion onto the same area of film. The farther a lens is extended, the larger the image size on the film.

The major differences between extension tubes and bellows are the degree of versatility they offer in providing varying amounts of magnification, and the price. Tubes are rigid rings of metal that extend the lens in predetermined, graduated steps depending on the length of each ring and on how many of them are used. They are light and relatively inexpensive but not so convenient as bellows because they come only in fixed lengths.

Bellows are made of a flexible material and provide continuously variable magnifications over their entire extendable range. A good quality bellows is a precision instrument, more expensive but more versatile than an extension tube.

An advantage of tubes and bellows is that they maintain the optical quality of the camera system by eliminating the need for supplementary lenses. They provide a wide range of magnifications and are the only attachments that will produce high-quality, larger-than-life images.

Since they are inserted between the lens and the camera body, however, tubes and bellows can be used only with cameras that have interchangeable lenses. Also, as the distance between lens and film increases, a dimmer image is projected and the exposure must be increased.

Some different degrees of magnification using extension tubes and bellows are shown in the pictures at left. At the top is a view of some petunias taken with a 50mm lens alone. The image on the film is about one-tenth (.10x) the actual size of the flowers. (The pictures here are enlarged slightly above the film size.) Next is a view taken with a basic set of extension tubes: a life-size image (1x) of part of a single blossom is produced. Greater or lesser magnification could be obtained by changing the number of rings used in the tube set. The next picture was taken with the same basic extension-tube set but with the 50mm lens reversed: the front end of the lens instead of the back was attached (with a special ring) to the extension tube. Because of the asymmetrical design of the lens elements, this improved the quality of the image, and, incidentally, provided somewhat greater magnification (here 1.5x). At magnifications greater than life size, many lenses perform better if they are reversed in this way. The bottom picture was taken with the 50mm lens attached to a fully extended bellows. This shows the center of a single flower, magnified to 5x life size.

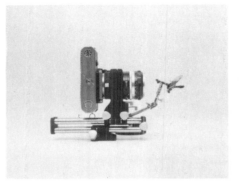

The focal length of a lens determines how far it must be extended for a certain degree of magnification. The focal length also determines the "working distance" between lens and subject. Thus, a 50mm lens requires a 75mm bellows extension (above) for a 1.5x life-size image of a cicada (right). Lens-to-subject distance is about 3½ in (9 cm). The shorter the focal length, the smaller this distance.

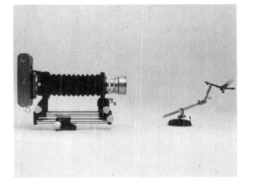

With a 135mm lens the bellows must be extended to its farthest limit (about 190mm) for the same magnification. But the working distance increases to about 9 in (23 cm), which makes it easier to light the image and adjust camera settings. Also, the longer lens improves the perspective, with less foreshortening of the cicada, particularly of its swept-back wings. Thus long lenses (90mm to 135mm) are preferable if tubes or bellows can be extended far enough. Notice that the depth of field is identical, it does not depend on the focal length of the lens but on image magnification and the f-stop used (the same for both pictures).

Close-Up Exposures: Greater than Normal

Two possible exposure problems arise when photographing close up. One is getting an accurate light reading in the first place and the other is adjusting that reading when the lens is extended farther than normal from the film.

The difficulty in making an accurate reflected-light reading is that the subject is usually so small you can end up reading more background than subject. A spot meter is one solution; it can read very small objects with great accuracy. Or you can make a substitution reading from a gray card *(page 115)*. Another possibility is to use an incident-light meter to read the light falling on the subject. This will give a usable average exposure no matter what the size of the subject.

Once you have made an accurate reading of the light and decided on an f-stop and shutter speed combination, you need one extra calculation if bellows or extension tubes are used to increase the distance of the lens from the film. As the distance between lens and film increases, the intensity of the light that falls on the film decreases, and the image becomes dimmer. Therefore, to prevent underexposure in close-up photographs, the exposure must be in-·creased. Accessory bellows and extension tubes come with charts that are supplied by the manufacturer for this purpose, or you can calculate the new exposure yourself. Whichever method you use, it's a good idea to bracket your exposures. First make the exposure you think is correct, then make one or two more with increased exposure.

The easiest way of finding the exposure increase for a close-up uses an exposure meter dial as shown in the diagrams at right. All the corrected f-stop and shutter-speed combinations are immediately readable on the dial.

If you want to do the arithmetic yourself, there are several formulas. Be sure

the bellows extension and the focal length are in the same units of measure—either in inches, centimeters or millimeters (1 in = 2.5 cm = 25 mm).

$$\frac{\text{indicated f-stop}}{\text{adjusted f-stop}} = \frac{\text{bellows extension}}{\text{focal length of lens}}$$

Meter the subject and choose an f-stop and shutter-speed combination. If the f-number indicated by the meter is f/16 at ⅛ sec, the focal length of the lens is two inches and the distance from the lens diaphragm to the film plane measures 10 inches, then:

$$\frac{16}{x} = \frac{10}{2} \qquad 10x = 32 \qquad x = 3.2$$

The new exposure combination is f/3.2 (a slightly larger aperture than f/4) at the original shutter speed. Set f/3.2 opposite the shutter speed on the meter dial to read off equivalent combinations.

You can also calculate a bellows extension factor that tells how many times the exposure must be increased (similar to the method for changing exposures used with filter factors, page 101):

$$\text{factor} = \frac{\text{bellows extension}^2}{\text{focal length}^2}$$

$$\text{factor} = \frac{10^2}{2^2} = \frac{100}{4} = 25$$

Increase the exposure about 25 times (about 4½ stops).

You don't have to do any calculating at all if your camera has a through-the-lens meter that reads the light that actually reaches the film, as many single-lens reflex cameras do. If the object is magnified enough to fill the viewing screen (or that part of the screen that shows the area being read), the meter will calculate an exposure that is already corrected for bellows extension.

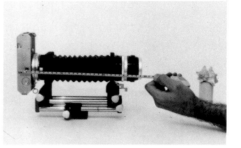

When making a close-up, you need to increase the exposure because the lens is farther than normal from the film and produces a dimmer-than-normal image. First measure the bellows extension, the distance from the lens to the film.

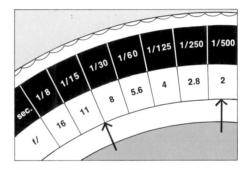

Meter the subject and calculate an exposure as you normally would. Now find 2 numbers on the f-stop scale on the meter dial to stand for the bellows extension measured above and the focal length of the lens. Have both measurements either in inches or in metric units (1 in = 2.5 cm = 25 mm). Here the bellows extension was 10 in (25 cm) and the focal length of the lens was 2 in (5 cm).

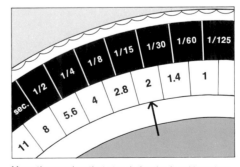

Move the number that stands for the focal length to the position occupied by the number that stands for the bellows extension. Read off the new f-stop and shutter-speed combinations.

A kohlrabi is a prosaic root vegetable, but in this close-up Ralph Weiss has shown it in an uncommon way. Isolating it against black separates it and causes the viewer to examine its shape in detail. There are no visual clues to its actual size (though the caption will tell you), and it is shown upside down from the way it grows: the photograph presents it as a visual experience rather than as something to eat. It becomes a sea creature, with trailing tentacles undulating through dark waters.

RALPH WEISS: *Kohlrabi*, 1966; magnified 0.6x, here enlarged to 3.4x

Special Printing Techniques
The Photogram's Shadow Picture

Long before the invention of a practical method for making photographs with a camera, people were experimenting with what are today called photograms— shadow pictures made by placing an object on a piece of light-sensitive material and exposing it to light. In the 1920s, about 80 years after the first camera photographs were made, photograms and other print manipulations such as solarization became popular with the painter-photographers Man Ray and László Moholy-Nagy, who sought to explore the "pure" actions of light in space. In Man Ray's Rayograph (as he named his photograms) at right, he uses the Surrealist technique of combining unrelated objects.

The photographer opposite used a piece of marsh grass to make a photogram. Any object that comes between the light source and the sensitized material can be used: two-dimensional objects like cut paper, three-dimensional opaque objects that block the light completely, transparent or translucent objects like a pitcher or a plastic bottle that bend the light rays, objects laid on glass and held at different levels above the paper, moving objects, smoke blown over the surface of the paper during the exposure—the possibilities are limitless. Light can be added to the paper as well as held back: for example, a penlight flashed at the paper or suspended from a string and swung across the surface.

The photogram can be made directly on a piece of printing paper or on a negative that then can be printed. Color photograms can be made by exposing color paper through different color filters or by using translucent tinted objects to modulate the light. Essentially photograms are produced with light modulators—objects that change the light on its way to the print.

MAN RAY: *Rayograph*, 1924

Here a simple photogram is being made by placing a piece of marsh grass on a sheet of grade 5 printing paper. The head of the enlarger is positioned far enough above the baseboard to light the paper completely. After exposure, the paper is developed, fixed and washed in the usual manner to produce a life-size print of the grass, bright and clear on a rich, deep black background. Experiment with different exposures—longer ones will penetrate some objects more and create a different effect.

◀ Ordinarily a photographer uses a camera to select and frame a portion of an existing scene. But in a photogram, objects are arranged directly on light-sensitive material. The objects are transformed in shape or tonality and the photograph does not show them as they ordinarily look. Which objects were actually used is less important than what you see when you look at the picture.

Man Ray arranged string, a toy gyroscope and the end of a strip of movie film on a piece of photographic paper, then exposed the paper to light. The resulting image (opposite) is as open to interpretation as you wish to make it. You can see it simply as an assemblage of forms and tones. Or if you see the large black background as a person's head in silhouette (like the silhouetted head in the movie film), then the strip of film might be a dream seen by the internal gyroscope of the brain.

257

A Sabattier Print—Part Positive, Part Negative

Making a Sabattier Print

The print shown at far right was produced by re-exposing the paper to light during processing. This gave the print both negative and positive qualities and added halo-like Mackie lines between adjacent highlight and shadow areas. The technique is commonly known as solarization, although, strictly speaking, solarization (which looks somewhat similar) takes place only when film is massively overexposed. The correct name for the phenomenon shown here is the Sabattier effect.

The unusual appearance of a Sabattier print results from a combination of effects. When the print is re-exposed to light during processing, there is little effect on the dark areas of the print because most of the crystals there have already been exposed and reduced to black silver by the developing process. The bright areas, however, still contain many sensitive crystals that can respond to light and development. The bright areas therefore turn gray, but usually remain somewhat lighter than the shadows. Between the light and dark areas, by-products remaining from the first development retard further development; these border regions remain almost white, forming the Mackie lines.

The simplest way to produce a Sabattier print, but the most difficult to control, is simply to turn on a light briefly while the print is in the developer. A procedure which gives much more control is described in the box at right. With this method the exposure times for the final print are chosen from a test print.

Printing from a negative will give a positive image plus negative effects from the second exposure, as in the print at right. You can also print from a positive color slide, which will give a negative image plus some positive effects. Printing paper responds differently to colors in the slide: blue prints as black, yellow prints as white.

Basic procedure

Materials needed. *A negative of normal to high contrast. Normal print processing chemicals. High-contrast paper (prints, right, made with Agfa Brovira grade 6; other high-contrast papers such as Kodabromide grade 5 also work).*

First exposure. *Put negative in enlarger and focus. Expose a test print with a slightly lighter than normal series of test exposures. (Test print, near right, received first exposures of 5, 10, 15 and 20 sec.)*

First development. *Develop for the standard time in normal developer.*

Rinsing. *Wash in water for 30 sec to remove the surface developer. Do not use an acid stop bath. Remove excess water from the front and back of the print with a squeegee or soft paper towels. Handle gently to avoid scratching the fragile surface of the wet print.*

Second exposure. *Remove the negative from the enlarger. Stop down the aperture about 2 stops. Re-expose the test print in strips at right angles to the first exposures. (Test print, lnear right, given second exposures of 5, 10, 15 and 20 sec.)*

Second development. *Develop for the standard time in normal developer.*

Finishing processing. *Treat print with stop bath and fixer; wash and dry as usual.*

Final print. *Examine the test print and choose the square that gives the desired effect. Note the combination of exposure times, apertures and development times. Make a print under these conditions.*

Variations

Set the enlarger slightly out of focus. This will broaden the Mackie lines without making the image noticeably out of focus. The Mackie lines will also be broader with a less contrasty negative.

Develop for less than the standard time. Remove the print quickly from the developer when the desired effect is visible.

Develop in a more dilute developer (if the normal dilution is 1:2, try 1:4, 1:10 or even greater dilutions to produce color shifts).

Develop in 2 different developers. A cold-tone developer for 1 development and a warm-tone developer for the other will give color shifts.

Some workers report better results if the print is aged at this point in a dark place (a photo blotter book works well). Aging times vary from 15 min to a week.

See variations under first development.

Dodging or burning in during the first and/or second exposures will give different results. The Mackie lines can be lightened by bleaching. The reducing formula given by Ansel Adams in his book The Print *is recommended. You can also try local reduction or an overall immersion in Farmer's Reducer (diluted 1:10).*

This test for a Sabattier print was given first exposures of 5, 10, 15 and 20 sec (left to right). After a first development, the print was exposed again to light from the enlarger, but without the negative in place. The second exposures were 5, 10, 15 and 20 sec (bottom to top). The test was then developed again, fixed and washed.

The exposures for the final print were chosen from the test print at left: a first exposure of 20 sec and a second exposure of 5 sec (the bottom right square of the test). The enlarger was deliberately set very slightly out of focus in order to broaden the Mackie lines, and the print was later bleached in order to lighten them.

Techniques Using High-Contrast Film

Some basic materials of the printing industry can transform a single black-and-white picture into a series of variations on a theme. The pictures on the following pages show methods of using such materials to change the conventional portrait at right into a high-contrast print, a line sketch, a posterlike patchwork of grays and finally color versions.

As a starting point, the original negative was enlarged onto lith film, a high-contrast copying film, sold under different trade names (Kodak Kodalith, Agfa Gevalith), for use in photo-offset printing. One of its properties is that it can convert the range of tones in an ordinary print into solid black and pure white. This produces a dropout, an image with only black or white areas and no intermediate gray tones. Because it can eliminate middle grays, lith film can render invisible any slight smudges on a page of type that is being copied for a printing plate. The same property enables the graphic artist or photographer to convert any continuous-tone picture, made on ordinary film, into a pattern of black and white. And by altering the exposure time in the copying process, you can produce images with differing amounts of black—even to the extreme of a practically solid black silhouette pierced only by the brightest highlights.

Because lith film produces black-and-white transparencies, several can be superimposed in printing to achieve a range of effects. Lith film lends itself to various color-printing techniques, including the use of color printing paper. Step-by-step demonstrations of techniques using these materials appear on the following pages.

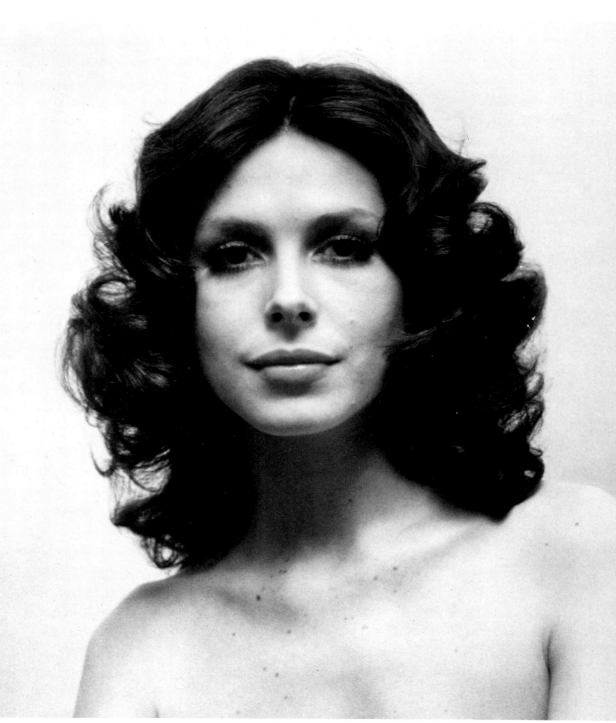

FRED BURRELL: *Portrait of Ann Ford,* 1971

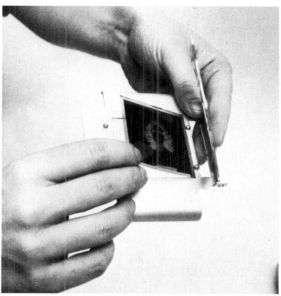

To start off the printing processes shown on these pages, place the original negative within the enlarger's negative carrier, ready to be inserted in the enlarger for reproduction on high-contrast graphic arts film such as Kodak Kodalith Ortho Film 2556, Type 3. If the manufacturer describes the film as ortho or orthochromatic, it can be processed under red safelight; you will be able to see what you are doing and how the film is developing. Check the instructions.

The negative, projected onto the easel on the baseboard, is enlarged to fill an 8 x 10 sheet of film. The first reproduction will be a positive transparency and from that a negative will be contact printed. Try an exposure time of between 10 and 20 sec with the enlarger lens wide open; make a test strip to check the effect of different exposures—slight increases in exposure extend the dark areas.

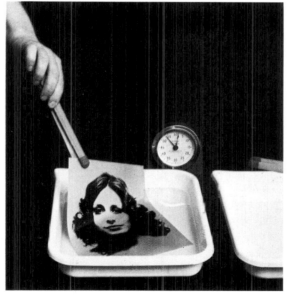

Process as for regular photographic films, but use chemical dilutions for graphic arts films if they are listed separately. Use a developer designed for lith film. Check the instruction sheet for development time—with Kodalith Super Developer it is about 2 3/4 min at 68° F (20° C) with constant agitation. Agitate in fresh stop-bath solution for about 10 sec. Then agitate in fresh fixer for about 4 min. Wash for 10 min in running water at 65° to 70° F (18° to 21° C).

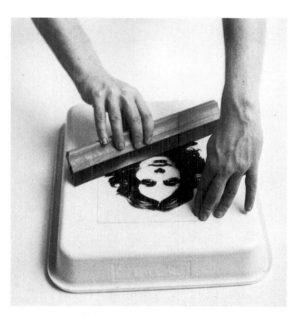

To prevent water spots or streaks, gently draw a squeegee or sponge across each side of the wet positive—placed on the bottom of an unturned tray—to wipe off most of the water. Or treat in a wetting solution. Then hang the positive up to dry, after which a high-contrast negative can be made from it (following pages).

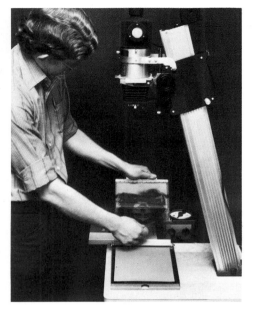

A negative can be produced from a positive transparency by using standard contact printing techniques (pages 152–155). First make sure the enlarger head is raised enough so the light will cover the contact frame. Then (above) clip the positive to the glass cover of a printing frame, emulsion side away from the glass. Insert, emulsion side up, an unexposed sheet of high-contrast copying film.

Try an exposure between 5 and 10 sec with the aperture wide open; a test strip will give an exact exposure. You may find in comparing the high-contrast positive to the high-contrast negative that the negative has dropped out more tones than the positive. If so, you can contact the negative onto another sheet of high-contrast film to make a positive that is an exact opposite of the negative, which you'll need if you want to make a line print.

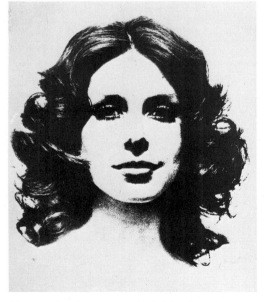

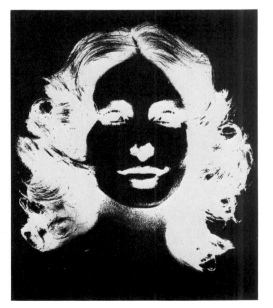

Above are the high-contrast negative and positive transparencies, ready for use in the printing processes demonstrated on the following pages. They have no middle-gray tones, only black and white.

Check for pinholes—clear specks caused by dust on the film or by underexposure. Paint them out with a fine brush dipped in a gooey blocking-out material called opaque. Large areas can also be painted out, if desired. Black specks or large black areas can be removed with a strong solution of Farmer's Reducer, a chemical bleaching agent. A weak solution of Farmer's Reducer removes yellow processing stains.

To make a line print, an image composed of dark lines on a white background or white lines on a dark background, place the positive and negative over a light and carefully align them so that the 2 images overlap exactly. The result, looked at straight on, will be solid black. However, light can pass through the two copies at an angle, along the outlines of the paired images. Tape the copies together.

Put the sandwich into a printing frame with an unexposed sheet of film. A lazy susan or a turntable rotates the frame so that light can come in from all sides at an angle. The light source shown is a 100-watt frosted bulb placed at a 45° angle 3 ft (1m) above a rotating turntable for a 15-sec exposure. You could also rotate the printing frame by hand under an enlarger.

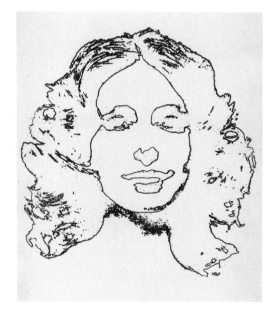

The line picture, a thin black outline of the subject on clear film, resembles a pen-and-ink sketch. A thin sheet of acetate or of unexposed, fully processed film between the negative and positive would have made thicker lines. The line picture can be copied directly onto another sheet of high-contrast film to make a clear-line-on-black-background transparency. Either image can be printed on printing paper to make an opaque, white or black image.

A Posterization

The 2 positive images above were produced on high-contrast film from the same negative. The first, which has more dark area than the second, simply received more exposure.

Posterization gives an image with distinctly sepa-rated grays, or colors that look like the flat shades of poster paints. The image above was made from the 3 high-contrast copies at left: 2 positives plus a neg-ative made from a third positive, each having dif-ferent dark areas. The 3 were carefully aligned, then fastened with tape hinges (above left) so that each positive could be laid over or lifted away from the negative. The negative at the bottom of this stack was then taped on 2 sides to the enlarger base-board. Printing paper was slipped under the un-taped sides and a piece of glass held all the sheets flat.

Three exposures were made. The first exposure. for 60 sec, was through all 3 copies and gave the black tones of the final print. Then the darker positive was flipped back, and an exposure of 1 sec was made through the lighter positive and the nega-tive so as to start the dark-grey tone. A final expo-sure of 1 sec through the negative alone gave the light grey and completed the dark grey. The amount of exposure needed was determined by test strips.

The starting point for the color posterization shown above is much the same as for the black-and-white examples on the opposite page (high-contrast copies, 1 negative and 2 positives of unequal dark areas), but the line image shown on page 263 is also used. The color is introduced by a color filter inserted into the enlarger's filter drawer that shines colored light through the copies onto a sheet of color printing paper (ordinarily used with color negative films).

For this posterization, the line print and the lighter positive were used for an exposure with a blue filter, to get yellow. The darker positive was added next and 3 exposures were made, through red, green and blue filters, for 3, 5 and 6 sec respectively. The resulting color, mixed with the yellow, gave the russet hue. The final exposure, with the negative copy added, was through a red filter and produced cyan, which gave the greenish cast that is most visible in the features of the face.

Xerography—Prints from an Office Copy Machine

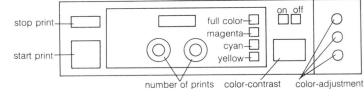

stop print

start print

full color
magenta
cyan
yellow

on off

number of prints

color-contrast control

color-adjustment dials

The images on these pages were made on a standard office machine that produces color copies. Such machines are widely available in commercial copy centers and are simple to use. Set a few dials, press a button and out come opaque paper copies, in color, of transparencies *(top row, left)*, prints *(top row, right)* or three-dimensional objects *(bottom row)*.

Anything you can bring to the copier's document glass—including people—you can copy *(see pages 360–361)*. You can display copies as is or make a transfer copy from which the image can be pressed onto another sheet of paper or onto cloth, for example onto a T-shirt. The adjustment dials and accessory equipment give considerable control over the image's color and even its shape.

In planning effects such as those in the bottom row, it is important to analyze the colors in the original and to know how the machine reproduces them. The original is scanned three times through filters that separate the colors into primary hues. The machine applies corresponding layers of color toner during each of the three cycles. In copying a white area, for example, the machine withholds the colored toners, leaving the paper there blank. For black areas, the machine deposits full layers of toner in all three primary colors. To accurately reproduce the color of a banana (first example in each row), the toners are laid down in varying proportions—a light deposit of magenta, a much heavier layer of yellow and a small amount of cyan.

The instant feedback from the machine and its ability to alter images have made it popular with many photographers. Black-and-white copiers also offer opportunities for experimentation. They are much less expensive to operate and even more widely available than color copiers.

Copying a Transparency

To make this natural reproduction of a 35mm transparency, the slide was inserted in the slide projector attached to the machine, which projected it onto a plastic screen laid on the document glass. The button for full color was pressed and the color-adjustment dials set to 3, which generally gives accurate reproductions. Then the start-print button was pressed to make the print. The dials can be readjusted—higher to intensify color, lower to lessen it—if the 3 setting proves to be unsatisfactory.

This copy of the same slide reproduced at left, but with colors that are muted, was made simply by turning the color-adjustment dials down to 1 before the start-print button was pressed. This setting causes the machine to release all three pigments in lower quantities.

Copying Objects

For this picture, real fruit was arranged on the document glass. When the lid over the document glass is up, the background comes out black—nothing in the spaces between the pieces of fruit reflects light to the copier's lens, causing the machine to distribute full amounts of toner in all three colors in these spaces.

Any object in the composition can be given a false color by removing it between passes of the light bar. To produce the green banana in this example, the banana was lifted off the document glass after the second pass. The machine had already deposited a small amount of magenta and a heavy layer of yellow on the paper. If the banana had been on the glass during the third pass, only a tiny amount of cyan would have been added. But with the banana gone, the machine read that area as black, and applied a heavy layer of cyan on top of yellow. This combination forms green.

The console of a popular color copier, the Xerox 6500, displays 2 systems to control color. The top button of the color-selection panel sets the machine for copying in full color; each lower button copies a black-and-white original in one primary color. Color is also controlled by three dials, marked 1 to 5, that vary the intensity of primary hues. The contrast control is usually employed to reduce contrast.

Copying a Copy

Contrasting colors and increased graininess are created by successive copying. For this example, a full-color copy was produced from the transparency used at left, then the copy was copied; this new copy again was copied. This effect is caused by slight fading and magnification that occurs each time the image is reproduced; after one run, these flaws are hardly visible, but each successive reproduction exaggerates them until the image begins to break down.

Copying a Photographic Print

To distort the shape of 1 part of the picture—the banana and apple—a photographic print was copied but moved while the machine operated. The light bar that provides illumination for exposure can be seen through the glass plate as it makes its 3 passes across the plate (1 pass for each primary color). After the bar moved about halfway on its first pass, the print was slid a few inches in the direction the bar was traveling. In the 3-second interval between the first 2 passes, the print was placed in its initial position. This process was repeated during the second and third passes.

To create multiple images of the banana, each a different color, the banana was shifted between the second and third light-bar passes. During the third pass, a heavy cyan layer was applied in the area uncovered by moving the banana, making a green image. But part of the banana stayed in the same place, and was copied in its natural color. Another part of it now occupied a spot that had been empty. This area, treated as black during the first 2 passes, got equal amounts of magenta and yellow. With the banana there it got only a little cyan—causing the third, red banana.

A rendition of the fruit with a light background was made by draping a white paper towel over the object's before copying them. During exposure, the machine withholds toner from any white area. So, where the white towel touched the glass the corresponding space on the print became white.

This picture displaying an intensely yellow banana calls for a white backdrop and precise coordination. After the fruit was arranged on the glass, the banana was removed and a white paper towel placed over the copying area. Between the first and second passes, the towel was lifted and the banana put into position. The color of the banana in the final print is the result of toner distributed only during the second and third passes—yellow and cyan. Magenta is absent because none was distributed during the first pass.

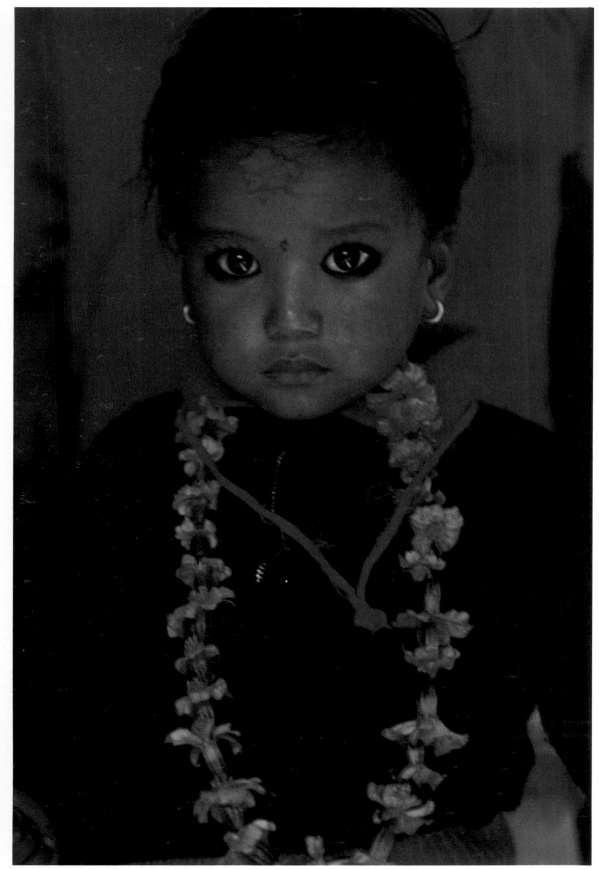

LUIS VILLOTA: *Nepalese Girl at Katmandu Shrine,* 1971

13 Color

To Make Colors, Add or Subtract 270

Color Photographs: Three Image Layers 272

Matching Film to the Light Source 274

Filters to Balance Color 276

Color Casts 278

Shooting Color Early or Late 280

Shifted Colors from Reciprocity Effect 283

Bold Use of Direct Light/Delicate Tones in Indirect Light 284

Processing Your Own Color 286

Making a Color Print from a Negative 288

 Materials Needed 288

 Exposing a Test Print 290

 Processing 292

 Judging Density in a Print Made from a Negative 295

 Judging Color Balance in a Print Made from a Negative 296

 More About Color Balance/Print Finishing 298

Making a Color Print from a Transparency 300

 Judging a Print Made from a Transparency 302

Instant Color Film 304

◄ A warm glow suffuses the picture opposite of a girl at a Hindu shrine in Nepal. Color pictures made at sunset often take on tones such as these, because the light is more reddish then. The girl's eyes are particularly compelling: not only does she stare straight at the camera and viewer, but the bright reflections in her eyes are the most sharply focused part of the picture. Photographers often focus on the eyes when making a portrait.

Color films take advantage of the fact that nearly all colors can be produced by mixing only a few basic or primary colors. Color films are made with three color-sensitive layers; each records the wavelengths of light in a different third of the spectrum. The processed film contains varying proportions of the three primary colors and thus duplicates the colors of the original.

Two basic color films are made. Color negative film is processed to be the opposite in colors and density of the original scene; then it is printed onto a sheet of sensitized paper to make a positive color print. Reversal film is processed so that the negative image produced in the camera is reversed back to a positive transparency with the same colors and density of the scene. Positive transparencies (such as slides) can be projected or viewed directly and can also be printed onto reversal paper to make a positive print.

The characteristics of color films are linked to film speed. Slow films appear sharper, have more delicate colors with subtler gradations and have less apparent graininess. Faster films appear less sharp, with less color saturation and more apparent graininess. But even within the same speed range, different films produce different color balances. One film may have an overall reddish cast, while another may look slightly blue-green. These differences may be quite noticeable when reversal film is projected as a slide. If a print is made, however, the color balance can be adjusted.

To Make Colors, Add or Subtract

There are two basic ways to create colors that will match those of the world's visible objects. One method, called additive, starts with three basic colors and adds them together to produce some other color. The second method, called subtractive, starts with white light (a mixture of all colors in the spectrum) and, by taking away some colors, leaves the one desired.

In additive mixing *(right),* the basic or primary colors generally used are red, green and blue lights (each providing about one-third of the wavelengths in the total spectrum). Mixed in varying proportions, they give nearly all colors—and the sum of all three primaries is white. In the subtractive method *(opposite),* the primaries are the pigments or dyes that absorb red, green and blue wavelengths, thus subtracting them from white light. These dye colors are cyan (a bluish green), magenta (a purplish pink) and yellow—the "complementary" colors to the three additive primaries. Properly combined, the subtractive primaries can absorb all colors of light, producing black. But, mixed in varying proportions, they too can produce nearly any color in the spectrum.

Whether a particular color is obtained by adding colored lights together or by subtracting some light from the total spectrum, the result will look the same to the eye. The additive process was employed for early color photography. But the subtractive method, while requiring complex chemical techniques, has turned out to be more practical in use and is the basis of all modern color films.

In the additive method, separate colored lights combine to produce various other colors. The three additive primary colors are green, red and blue. Green and red light mix to produce yellow; red and blue light mix to produce magenta; green and blue mix to produce cyan. When equal parts of all three of these primary-colored beams of light overlap, the mixture appears white to the eye. A color television produces its color by the additive system. The picture tube consists of green, red and blue phosphors that can be mixed in various combinations to produce any color including white.

cyan filter blocks red

magenta filter blocks green

yellow filter blocks blue

White light is a mixture of all wavelengths. In the subtractive process, colors are produced when a dye (as in paint or color photographic materials) absorbs some wavelengths and so passes on only part of the spectrum. Above, the three subtractive primaries—yellow, cyan and magenta—are seen placed over a source of white light. Where two overlap, they pass red, green and blue light. Where all three overlap, all wavelengths are blocked. At right, each subtractive primary transmits two-thirds of the spectrum and blocks one-third. Notice that the color often called blue is named cyan.

Color Photographs: Three Image Layers

Color photographs begin as black-and-white negatives. Color film consists of three layers of emulsion, each layer basically the same as in black-and-white film, but responding to only one-third of the spectrum. The top layer responds to blue light, the middle layer to green light and the bottom layer to red light. When this film is exposed to colored light and then developed, the result is a multi-layered black-and-white negative.

As the developer converts the light-sensitive silver halide compounds to metallic silver, it becomes oxidized and combines with "coupler" compounds to produce dyes. (Some processes use dyes built into the layers of silver halides.) The three dyes formed, one in each emulsion layer, are the subtractive primaries yellow, magenta and cyan. The blue-sensitive layer of the film forms a yellow image, the green layer forms a magenta image and the red layer forms a cyan image. All the silver is then bleached out and each layer is left with only a color image. This basic process is used in the production of color negatives, positive color transparencies (slides) and color prints (see illustrations, right).

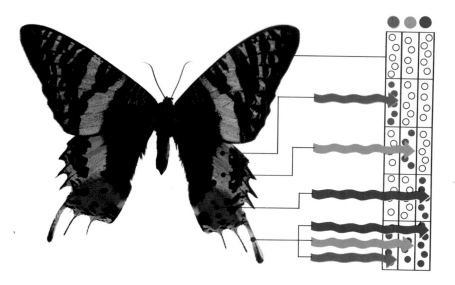

Color film consists of three layers of emulsion, each sensitive to blue, green or red (as diagrammed above by color dots over a film cross section). During exposure, light of each color of the moth shown above produces an invisible latent image on the emulsion layer or layers sensitive to it. Where the moth is black, no emulsion is exposed; where it is white, all three layers are exposed equally. This results in three superimposed latent images.

During development of the film, each latent image is converted into a metallic silver negative image. Thus, three separate negative images indicate by the density of the silver they contain the amount of each primary color in the moth. The images are shown separately here but are, of course, superimposed on the film.

color negative

color transparency

color print

When exposed color negative film is developed, a colored dye is combined with each black-and-white negative image. The dyes are cyan, magenta and yellow—the complements of red, green and blue. The silver images are then bleached out, leaving three layers of superimposed negative dye images (shown separately above). The color negative also has an overall orange color or "mask" (top) to compensate for color distortions that would otherwise occur in printing.

The positive color image of a transparency or slide (top) is created in exposed film by a reversal process. After a first development, the emulsion is either exposed a second time to light or is treated with a chemical that produces the same effect. Silver is deposited by a second development to form black-and-white positive images in the emulsion. Dyes then combine with the metallic silver positive images to form three positive color images. In each layer the dye produced is the complement of the color of the light that was recorded there—yellow dye is formed in the blue-sensitive layer, magenta in the green-sensitive layer and cyan in the red-sensitive layer. The black-and-white silver images are then bleached out, leaving the positive color images in each layer (shown separately, above). When a beam of white light is projected through these superimposed color images, each of the colors of the moth is reproduced by the subtraction of the other colors from white light. To reproduce blue, for example, magenta and cyan dye images are formed, but no yellow image. The greens and reds of the light are subtracted by the magenta and cyan dyes, leaving only blue as visible color. Similarly, varying mixtures of dyes in the transparency produce the whole range of colors of the moth. Black is produced where all the colors of white light are subtracted by dyes, and white where no color is subtracted.

The most common method of color printing uses paper with three emulsion layers like those in film. In a negative/positive printing process, the paper is exposed to light passed through a color negative. During development of the paper, three positive images are produced, each consisting of dye plus silver. The silver is then bleached out, leaving the color images. In a reversal process, light is passed through a positive transparency onto reversal paper; the result is a positive image. The colors that appear in a color print are those reflected back to the eye from white light falling on the print. A blue spot on the moth, for example, looks blue in the print because cyan and magenta dyes in the emulsion layers of the paper absorb red and green wavelengths from the white light falling on the paper, and only blue lengths are reflected. The full-color image of the print (top) is a product of the colors subtracted from white light by the three superimposed dye images (shown separately, above).

Matching Film to the Light Source

Color films sometimes record colors that the photographer did not see. Though the picture may look wrong, the film is not at fault. The brain remembers the colors that things ought to have and automatically compensates to some extent when shifts in color take place. Although a white shirt looks white both outdoors in daylight and indoors in artificial light, light from ordinary tungsten bulbs has more red wavelengths and fewer blue wavelengths than daylight; thus the white shirt reflects more red light indoors than outdoors and has a golden cast. Color film records such subtle differences. Therefore, several different color emulsions are made, each designed for a different balance of wavelengths.

The balance of colors in light is measured as color temperature. This temperature is given on the Kelvin scale, commonly used by physicists, and serves as a standard comparative measure of wavelengths present in the light we see. The ordinary description of colors as warm or cool doesn't match their actual color temperature. Red is called a warm color although it is low on the scale. Blue is called a cool color but is high on the scale. (See illustrations of warm and cool colors on pages 278–279.)

Daylight film is balanced for the relatively high color temperature of midday light, electronic flash and blue flash bulbs (5500K on the Kelvin scale). Indoor films are balanced for incandescent light sources of lower temperatures. Most indoor films are tungsten balanced—designed specifically for light of 3200K color temperature, but producing acceptable results in any type of tungsten light. A few (Type A films) have a slightly different balance for use with 3400K photolamps.

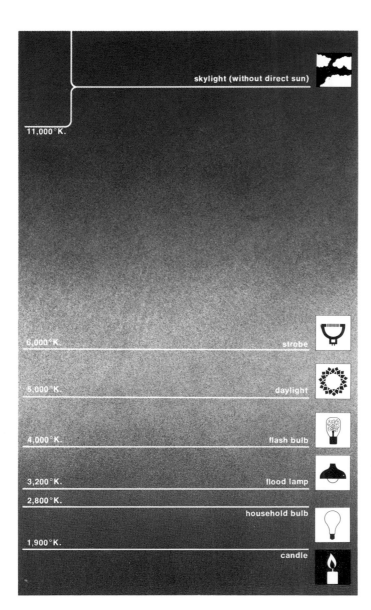

11,000°K. skylight (without direct sun)

6,000°K. strobe

5,000°K. daylight ← daylight film 5500K

4,000°K. flash bulb

3,200°K. flood lamp ← Type A (indoor) film 3400K
← tungsten (indoor) film 3200K

2,800°K. household bulb

1,900°K.

candle

The chart above indicates the approximate color temperatures of "white" light sources. Light of low color temperature has more red wavelengths; light of high color temperature has more blue. Unless the color temperatures of color film and illumination are matched, the resulting picture will have an unnatural color cast—either too red or too blue.

The pictures opposite illustrate how different types ▶ of color film record different colors when exposed to the same light. The top pictures were all taken in daylight (color temperature 5500K). Photographed with daylight film (left), the colors of the bus look normal. When shot with indoor (tungsten) film designed for 3200K (center), the bus takes on a heavy bluish cast. If a corrective 85B filter is used, however, indoor film can produce normal colors from outdoor light (right). The bottom pictures were all taken indoors in 3200K light. The bride looks normal when photographed with indoor film (left), but daylight film in the same light produces a yellowish cast (center). A corrective 80A filter produces a near-normal color rendition when daylight film (right) is used with the light from a tungsten bulb. Since the filter blocks part of the light reaching the film, the exposure must be increased (about ⅔ stop with an 85B filter, 2⅓ stops with an 80A filter). This can create inconveniently long exposures, so it is more efficient to use the correct type of film when possible.

daylight film in daylight

tungsten film in daylight

tungsten film with 85B filter

tungsten film in tungsten light

daylight film in tungsten light

daylight film with 80A filter

Filters to Balance Color

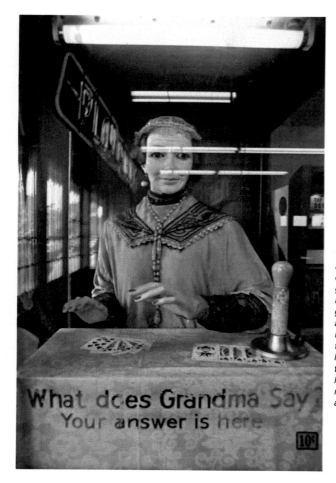

The penny arcade fortune-telling machine (left) was lighted mostly with fluorescent lights. The greenish cast in the picture is due to the concentration of green wavelengths in fluorescent lighting. A combination of pale filters—magenta (which absorbs greens) and blue (which absorbs reds and greens)—alters the light exposing the film so that the color image will look closer to normal (right). It is difficult to give exact filter recommendations for fluorescent light because the color balance varies depending on the type of lamp, the manufacturer, how old the lamp is and even voltage fluctuations. An FL (fluorescent) filter improves the color balance for average scenes.

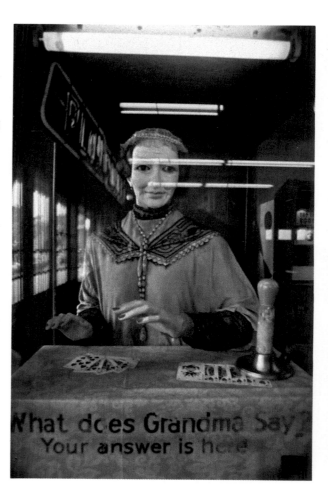

Most color films are balanced to match the color temperatures of one of three possible light sources—midday sunlight and two types of incandescent lamp. Any other lighting conditions may give an unusual color balance. Sometimes you may want this imbalance. But if preferred, you can use filters to correct to a more standard color balance.

Unbalanced light conditions are not unusual. For example, the light is reddish late in the day because the low-lying sun is filtered by the earth's atmosphere to a color temperature lower than 5500K. You may want to photograph this scene unfiltered to keep a reddish cast that looks like sunset.

In a picture of a field of snow having a dark shadow, the shadow area will be illuminated mainly by clear blue skylight of a very high color temperature. The shadowed snow comes out blue when photographed with ordinary daylight film. A pale "skylight" filter, designed to block some of the sky's light, would reduce the bluish cast of the shadows as the film records it. Actually, very careful examination of a snowfield under such conditions will disclose the bluish cast in the shadows—but, ordinarily, the brain adapts what the eye sees to what it expects the snow to look like.

A similar problem is posed when a light source does not emit a smooth distribution of colors across the spectrum, but gives off concentrations of one or a few colors. Fluorescent lights are examples of this kind of "discontinuous" spectrum, having, in addition to other

filter number	color or name	type of film	physical effect	practical use	increase in stops	factor
1A or UV	skylight / ultraviolet	daylight	Absorbs ultraviolet rays.	Eliminates ultraviolet that eye does not see but that film records as blue. Useful for snow, mountain, marine and aerial scenes, on rainy or overcast days, in open shade.	–	–
81A	yellow	daylight	Absorbs ultraviolet and blue rays.	Stronger than 1A filter. Reduces excessive blue in similar situations. Use with electronic flash if pictures are consistently too blue.	$\frac{1}{3}$	1.2
		tungsten		Corrects color balance when tungsten film used with 3400K light sources.	$\frac{1}{3}$	1.2
82A	light blue	daylight	Absorbs red and yellow rays.	Reduces warm color cast of early morning and late afternoon light.	$\frac{1}{3}$	1.2
		Type A		Corrects color balance when Type A film used with 3200K light source.	$\frac{1}{3}$	1.2
80	blue	daylight	Absorbs red and yellow rays	Stronger than 82A. Corrects color balance when daylight film used with tungsten light. Use 80A with 3200K sources and with ordinary tungsten lights. Use 80B with 3400K sources.	$2\frac{1}{3}$(A) 2 (tungsten)	5 4
85	amber	Type A or tungsten	Absorbs blue rays.	Corrects color balance when indoor films are used outdoors. Use 85 filter with Type A film, 85B filter with tungsten film.	$\frac{2}{3}$	1.5
FL	fluorescent	daylight or tungsten	Absorbs blue and green rays.	Approximate correction for excessive blue-green cast of fluorescent lights. FL-D used with daylight film, FL-B with tungsten film.	1	2
CC	color compensating			Used for precise color balancing. Filters come various densities in each of six colors—red, green, blue, yellow, magenta, cyan (coded R, G, B, Y, M, C). Density indicated by numbers—CC10R, CC20R, etc.	varies	

colors, large amounts of blues and greens. Although the eye compensates for such uneven distribution, photographic emulsions cannot, and there are no color films that can record such light as the eye sees it.

The examples opposite and on page 275 show the imbalance that occurs when films are not matched to the light. In each case, you can use a corrective filter to adjust the balance of the light so that the image that you produce more nearly matches what your eye sees.

It is particularly important to balance the light the way you want it when making color slides, because the film in the camera is the final product that will be directly projected for viewing. With color negative film used for color prints exact balancing is not so critical because some corrections can be made during the printing process. Printing will be easier, though, with a properly balanced negative.

For the most accurate color rendition it is necessary to match the film to the color temperature of the illumination and sometimes to add a filter as well. The color temperature is marked on most electronic flash units and on photographic bulbs. Some commonly used filters are listed above; more detailed information is supplied by film and filter manufacturers. Color temperature meters are also available to help gauge unusual lighting conditions.

Color Casts

In these pictures, the photographer wanted intensified colors rather than completely accurate color renditions. The predominant colors of the objects were given a color cast, a slight color shift, in one case by reflections from colored foil, in the other by light beamed through a colored filter. The diagramed setups show how this was done. Color-compensating (CC) filters could also have been used over the lens to tilt the color balance slightly.

Practically every photographer has, at one time or another, found that a subject has taken on the colors cast by a nearby wall, drape or other colored object. Portraits shot beneath trees offer the most familiar example of this problem. People photographed under such seemingly flattering conditions can appear a sea-sick green, since the sunlight that reaches them is filtered and reflected by the green foliage. The eye tends to see almost every scene as if it were illuminated by white light, whereas color film shows the true color balance of the light.

Colors actually seem to add temperature to a picture. Because they trigger mental associations, golden yellows and reds appear distinctly warm, while blues and yellowish greens seem cool. But the impressions go beyond mere illusions of temperature. Warm colors, especially if they are dark, can make an object seem heavy and dense. Pale, cool colors, on the other hand, give an object a light, less substantial appearance. Furthermore, warm colors can appear to be farther forward, cool colors farther back. You can use this distance effect to increase the illusion of depth within a picture by placing warm-colored objects against a cool-colored background.

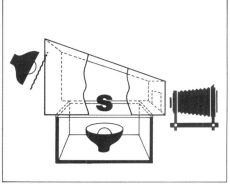

Because of their warm colors, the fruits above have a succulent-looking weightiness and seem to press toward the viewer. To enhance the naturally warm colors of the subject, Richard Steinberg enclosed the fruit in a specially constructed tunnel (left) lined with gold foil, which strongly reflected yellow and red wavelengths, to suffuse the entire scene with very warm golden light. Light entering at the far end of the tunnel was bounced down on the fruit from the slanting roof. A second light, positioned directly under the glass table supporting the fruit, illuminated the arrangement from below.

Although the vegetables in the picture above are on the same scale as the fruit opposite, they seem more remote and less substantial in part because of their cool colors. Here, too, Richard Steinberg heightened the effect through lighting. The vegetables were backlighted by a lamp positioned behind a sheet of blue gelatin-filter material; a reflector board bounced some of this blue-tinted light onto the front of the vegetables (the camera was aimed through a hole cut in the reflector). Two other lights, one above the subject and the other below its glass support, gave mostly untinted illumination. To add a hint of warmth, Steinberg included a pale brown onion, flecked with droplets of water that suggest garden freshness.

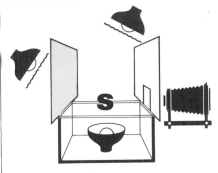

Shooting Color Early or Late

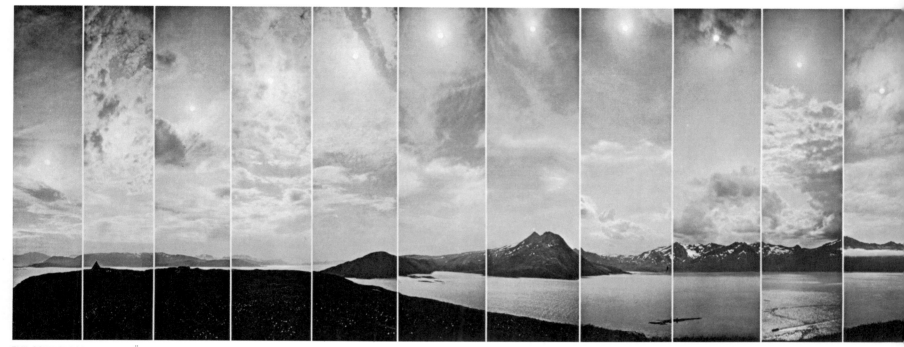

EMIL SCHULTHESS and EMIL SPÜHLER: *A Day of Never-setting Sun*, 1950

Photographic film for use in daylight is balanced for midday sunlight. Photographing very early or late in the day can produce strikingly beautiful pictures simply because the light is not its usual "white" color.

In the earliest hours of the day, before sunrise, the world is essentially black and white. The light has a cool, shadowless quality. Colors are muted. They grow in intensity slowly, gradually differentiating themselves. But right up to the moment of sunrise they remain pearly and flat.

The instant the sun comes up, the light changes dramatically. Because of the great amount of atmosphere that the low-lying sun must penetrate, the light that gets through is much warmer in color than it will be later in the day—that is, more on the red or orange side be-

cause the colder blue hues are filtered out by the air. Shadows, by contrast, look blue, because they lack gold sunlight and also because they reflect blue from the sky.

The higher the sun climbs in the sky, the greater the contrast between colors. At noon, particularly in the summer, this contrast is at its peak. Since there is no color in the white light coming from the noonday sun, there will be no distortion of the relationships between colored objects. Each stands out strongly in its own true hue. Shadows at noon are black.

As the sun goes down, the light will begin to warm up again. This occurs so gradually that you must remember to look for it; otherwise the steady increase of red in the low light will do things to your film that you do not expect. Luckily,

these things can be beautiful. If the evening is clear and the sun remains visible right down to the horizon, objects will begin to take on an unearthly glow. Shadows lengthen and become blue. Surfaces become strongly textured and interesting.

After sunset there is a good deal of light left in the sky, more often than not reflected in sunset colors coming from the clouds. This light can be used, with longer and longer exposures, almost up to the point of darkness, and it sometimes produces pinkish or even greenish-violet effects that are delicate and lovely. Just as before sunrise, there are no shadows and the contrast between colors lessens. Finally, just before night, with the tinted glow gone from the sky, all colors disappear; the world once again becomes black and gray.

The sun never sinks below the horizon in this time-lapse sequence of photographs taken on a Norwegian island far above the Arctic Circle during the summertime period of the midnight sun. The changing colors of light are clearly visible, however, as the sun rises and sets. Objects seem to be more realistically colored when the sun is high in the sky than when it is close to the horizon; compare the color of the water in the segments on this page with its color in the segments opposite

The brisk yellow light of early morning is a clear, invigorating color, its freshness reinforced in this picture by the newly painted porch. The scene's portrayal of time is related to its evocation of place. This is New Hampshire, but it might be any small town in the New England mountains where the air is pure and children get up early. ▶

BILL BINZEN: *Morning, New Hampshire*, 1965

281

DAVID MOORE: *Torchlight Procession of Skiers, Australia,* 1966

Shifted Colors from Reciprocity Effect

The warm purple tint over the snow (left) and the 2 toned sky (above) were produced by the reciprocity effect that causes shifts in color balance during exposures that are longer than about 1 sec. Both pictures were shot in the dim light of dusk and given lengthy exposures; David Moore exposed the film for the full 5 minutes it took the skiers to run the trail (the zigzag thread of light that bisects his picture).

At dusk, at dawn, sometimes indoors, the light may be so dim that exposure times become very long, even with the lens aperture wide open. Very long exposures produce the same reciprocity effect that takes place with black-and-white films *(page 118)*—the exposure must be increased even more or the film will be underexposed. Various types of film react differently to long exposures; check the manufacturer's instructions for recommended exposure increases. Very long exposures are not recommended at all for some color films. In general, however, increase the exposure about one stop for a one-second exposure, two stops for a 10-second exposure, three stops for a 100-second exposure. Bracket the exposures by making a shot at the calculated exposure, plus another at one-half stop more and a third at one stop more. Underexposure is more likely to be a problem than overexposure.

Reciprocity effect with color films is even more complicated than with black-and-white. Since color films contain three separate emulsion layers, each layer may be affected differently, and the varied speed losses will change the color balance of the film. The result is color shifts like those shown here. Often the shifts are pleasing, but if you want a more accurate color rendition, use the color filters listed in the film's instruction sheet.

Bold Use of Direct Light/Delicate Tones in Indirect Light

Strong, direct sunlight is usually the worst possible illumination for pictures of people (it can create dark shadows across a face or cause the subject to squint), but it can perform magic as well. In the photograph of a child on her way to a school ceremony *(right)*, the direct rays of the morning sun evoke a very special mood, a lovely mix of happiness and shyness expressed by her luminous, averted face. Shooting from another angle would have emphasized the brilliance of the costume, but keeping the dress in shadow calls attention to her face, lighted up as if by the excitement of a festive moment. The low-lying sun shining directly into her face casts no facial shadows, and since she was turned away from the camera the photographer did not have to worry about her squinting against the light.

Color film is not able to record color accurately in both bright highlights and dark shadows because the acceptable exposure range is so short. Here the photographer has chosen to meter the high values as the basis for the exposure, letting the dark values go black. An alternative might have been to add fill light to lighten the shadows. (See fill light, pages 200–201, and synchro-sun exposures, page 212.)

The diffuse quality of reflected light is kind to the human face, giving it subtle tones and a soft glow that are always complimentary. For the picture opposite, the photographer utilized sunlight that was bouncing off the wall of a nearby building. If you try this, make sure the wall is a warm or neutral color—otherwise the face may gain an unexpected, undesirable hue from the reflection of a strong color off the wall.

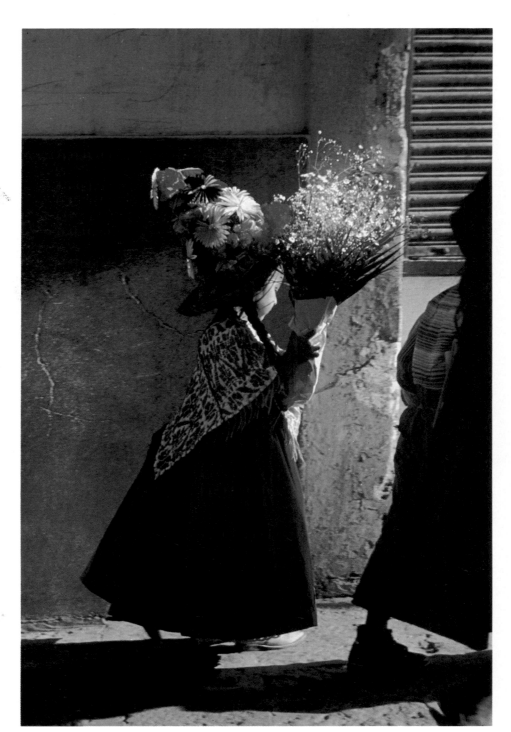

JOHN DOMINIS: *Mexican Schoolgirl,* 1968

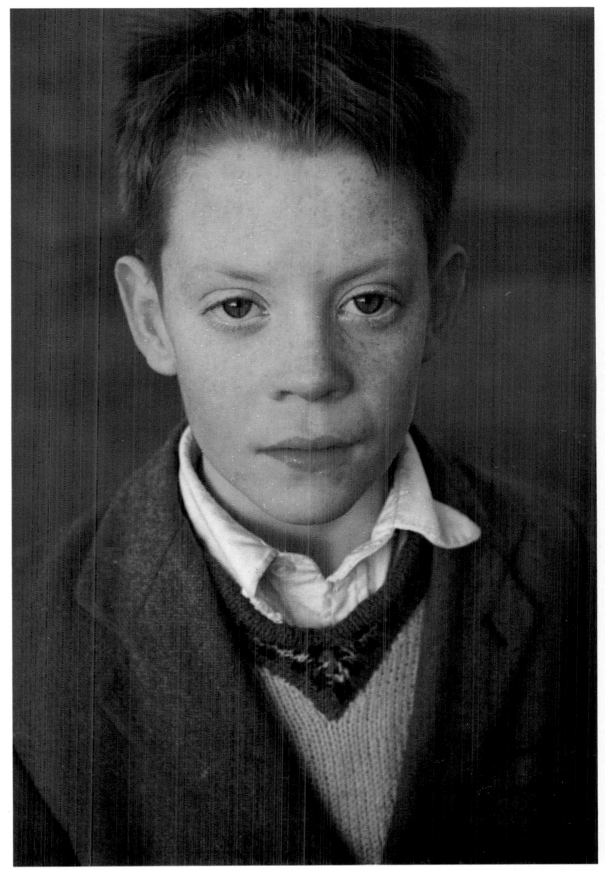

Color film, especially for slides, can handle accurately only a narrow range of contrast between bright and dark areas. In the photograph opposite, the photographer successfully used the harsh contrast of direct sunlight by exposing for the bright highlight areas, which included the important area of the girl's face, while letting the shadow areas go very dark. In diffused light (right) contrast is usually lower. Light from early-morning sun was reflected onto the boy's face from a building across the street.

HUMPHREY SUTTON: *Galway Boy*, 1966

Processing Your Own Color

JOHN DEEKS: *Desert Divide*, 1970

◀ *Like flat paper cutouts, overlapping mountain peaks become a study of patterns in this photograph. A 105mm long lens that flattened the perspective of the scene, combined with backlighting from the rising sun that turned the mountains into silhouettes, created the two-dimensional effect.*

The strong patterns and exact alignments, the ▶ milk as unappetizing as chalk, and the fried egg looking as hard and shiny as china make this meal somewhat unsettling. The photographer positioned his view camera above the table, slightly ahead of the table's front edge, to take the picture from an angle rather than from squarely overhead. A single spotlight was placed below the camera to cast the dark shadows of the bottle and glass against the background.

Processing color materials is similar to processing black-and-white materials. There is one crucial difference, however. Color materials are more sensitive to changes in processing times, temperatures and other variables; they produce unwanted shifts in the color balance and density with even slight variations in processing.

Photographers more often send their color film to a commercial lab for processing than they do their black-and-white film. Many feel that a commercial lab with sophisticated equipment for temperature control produces more consistent results than they could in their own darkrooms. In addition, some films, such as Kodak Kodachrome, have a complicated processing procedure that is designed for automated commercial equipment.

Nonetheless, some photographers prefer to do their own color film processing. They want to maintain their own standards of quality control and perhaps to be free to alter processing procedures for special situations. Doing your own film processing may be less expensive than lab work. It may be faster than a lab if you are in a hurry to get your film developed. Some popular and readily available color negative films that you can develop are Kodak Vericolor II, Kodacolor II and Kodacolor 400. Among the reversal (slide) films that you can process yourself are Agfa Agfachrome, Fuji Film Fujichrome, GAF Color Slide Film and Kodak Ektachrome. See the film manufacturer's instructions for the processing chemicals and procedures to use.

The real advantage in doing your own color processing comes in making your own prints from color negatives or transparencies. Although making color prints is somewhat more exacting than making black-and-white prints, it is not really difficult to learn and you have the advantage of full control over the final image. Only the most expensive professional printing labs will give you color prints made to your specifications. A much less expensive alternative—and one that produces a print exactly to your taste—is to make your own.

HENRY SANDBANK: *Egg and Milk,* 1968

Making a Color Print from a Negative
Materials Needed

The materials needed to make color prints are shown opposite (details at right). Once you have them together, the first step is to make test prints to establish a standard filter pack.

The color balance of color prints is adjusted by inserting colored filters between the enlarger's beam of light and the paper. Paper manufacturers suggest combinations of filters to produce a print of normal color balance from a normal negative or transparency. However, these suggestions are only a starting point for your own tests to determine a standard filter pack for your particular combination of enlarger, film, paper, processing chemicals and technique. Personal testing is essential because so many variables affect the color balance of prints. Once your standard filter pack has been established, only slight changes in filtration will be needed for most normal printing.

It is essential to make your processing consistent. The temperature of the developer is critical and must be maintained within the limits suggested by the manufacturer. The same pattern of agitation should be used for all tests and final prints. Even the time between exposure and development must be fairly uniform with some processes.

The following pages show the steps in making your first test prints. You will need a negative (or a transparency, if you are using reversal materials) that is of normal density and color balance. It should be a simple composition and contain a range of familiar colors plus flesh tones or neutral grays. Do not use a sunset or other scene in which almost any color balance would be acceptable. Your aim is to find a starting filter pack for most negatives.

The following pages discuss producing and evaluating a print from a negative and from a positive transparency.

color printing: materials needed

Color printing paper and processing chemicals. *Two basic types are available. Color prints can be produced from color negatives with negative/positive processes such as Agfacolor MCNIII or Color by Beseler materials or Kodak Ektacolor paper with Ektaprint 2 chemicals. Color prints can also be made from positive color transparencies by using reversal processes such as Cibachrome materials or Kodak Ektachrome 2203 paper with Ektaprint R-1000 chemicals. Not all processing chemistries can be used with all papers; make sure the paper and chemicals are compatible. See the manufacturer's instructions regarding storage of unexposed paper. Most papers should be stored in a refrigerator at 50° F (10° C) or lower. Remove the package from the refrigerator several hours before opening it; this will bring the paper to room temperature and prevent moisture from condensing.*

Enlarger. *Any enlarger that uses a tungsten or tungsten-halogen lamp may be used. A fluorescent enlarger lamp is not recommended.*

Filtration. *The color balance of the print is adjusted by placing filters of the subtractive primaries—yellow (Y), magenta (M) and cyan (C)—between the enlarger lamp and the paper. The strength of the filtration is indicated by a density number: the higher the number, the stronger the filter. For example, 20M means a magenta filter with a density designated 20; it is 4 times denser than an 05M filter.*

If your enlarger, like the one shown here, has built-in dichroic filters, the strength of each color is adjusted simply by turning knobs or other controls on the enlarger to dial in the desired filtration. Without dial-in filtration, some means must be provided to hold filters in place.

If your enlarger has a drawer for holding filters between the lamp and negative, acetate "color printing" or CP filters can be used. Filters of the same color can be added to provide a stronger density of a color: 20Y + 20Y gives the same density of yellow as a filter marked 40Y. Any number of filters can be positioned above the negative to create the color balance desired, although the least number that is convenient should still be used.

If your enlarger is an older model that does not have a filter drawer, a filter holder can be attached below the lens. In this position, acetate filters cause optical distortions, so the more expensive gelatin "color compensating" or CC filters must be used. To preserve good optical quality do not use more than 3 CC filters below the lens at any one time.

Kodak recommends the following CP or CC filters as a basic kit: 05, 10, 20, 40Y; 05, 10, 20M; 40R (a red filter equivalent to a 40Y + 40M).

Heat-absorbing glass. *The light sources of many enlargers give off enough heat to damage color negatives and filters unless some of the heat is absorbed. To prevent this, a piece of heat-absorbing glass is often placed in the enlarger head if it isn't built in. See enlarger manufacturer's instructions.*

Voltage control. *Electric current varies in voltage from time to time, and a change of only 5 volts will cause a change in the color of the enlarger light— and a visible change in the color of the print being made, so although you can print without it, some type of voltage control is desirable. A voltage stabilizer or regulator automatically maintains a steady output of power if the line voltage fluctuates. A manually adjustable variable transformer is less expensive; you turn a control knob as necessary to maintain uniform voltage. Either type plugs into a wall outlet, then the enlarger plugs into it. Some enlargers have built-in voltage control.*

Analyzers and calculators. *A color analyzer is an electronic device that reads the density and color balance of a negative, compares it to a preprogrammed standard, then recommends exposure and filtration. Good ones are very expensive, and while they make printing easier, you can work without one. Another type of printing aid is a color matrix or subtractive color calculator. Some printers find these useful, others do not. Briefly, you use this device to make a test print in which colors are scrambled to an overall tone. You compare this test to a standard tone to determine exposure and filtration.*

Processing drum. *A tube-shaped plastic processing drum is an inexpensive and popular device for color print processing. Each print is processed in small quantities of fresh chemicals, which are discarded after use. This provides economical use of materials as well as consistent processing. Once the drum is loaded and capped, room lights can be turned on so you don't have to work in the dark. See manufacturer's instructions for the correct method of sealing, filling and draining solutions and for agitating.*

Miscellaneous. *Most of the other materials needed are also commonly used in black-and-white printing: darkroom timer, accurate thermometer, trays and so on.*

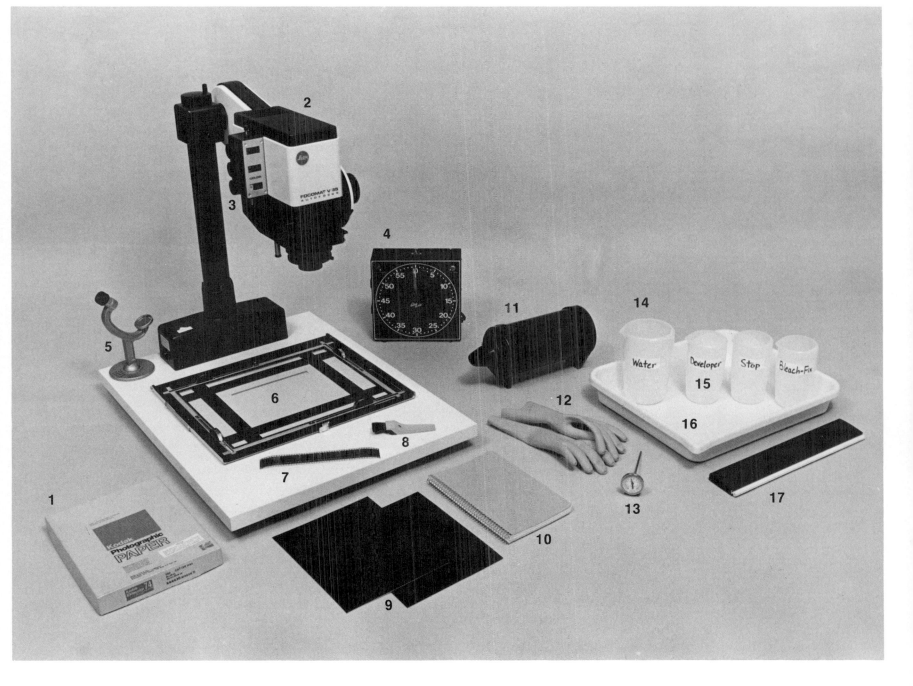

1 | color print paper
2 | enlarger with heat-absorbing glass
3 | dichroic color head or filters
4 | timer with sweep-second hand
5 | focusing magnifier
6 | printing-paper easel
7 | color negatives
8 | antistatic brush
9 | two masking cards for test prints
10 | notebook for record keeping
11 | processing drum
12 | rubber gloves
13 | photographic thermometer
14 | graduates for premeasuring solutions
15 | print-processing chemicals
16 | temperature control and washing tray
17 | squeegee or photographic sponge

Exposing a Test Print

The following pages show how to make prints from a color negative onto Kodak Ektacolor print paper processed in Ektaprint 2 chemicals. Other papers and developers also work well. Read the manufacturer's directions carefully, because filtration, safelight recommendations, processing and so on vary considerably with different materials.

It is not difficult to work with the paper in total darkness, and once the paper is loaded in the drum, room lights can be turned on. If you need some light before then, the recommended safelight for Ektacolor 74 paper is a Number 13 amber safelight filter (7½ watt bulb) used at least four feet (1.2 meters) from the paper for no more than three minutes.

1 | clean the negative

Clean dust off the negative and carrier. Place negative (dull, emulsion side toward paper) in carrier and insert in enlarger. Set out a clean, dry processing drum and its cap.

2 | set up the enlarger

Insert the 2B (ultraviolet) filter and heat-absorbing glass, if required. Dial in filtration (or insert CP or CC filters) for the test: 50M (magenta) and 90Y (yellow).

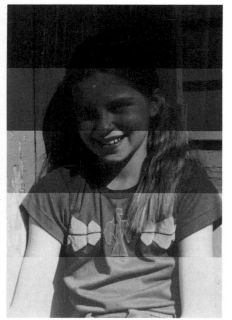

f/4	10 sec
f/5.6	10 sec
f/8	10 sec
f/11	10 sec
f/16	10 sec

Five exposures of the same negative are made in the testing procedure shown at left, producing a range of densities from light to dark. See the manufacturer's suggestions for a starting point for filtration. For Ektacolor 74 paper, Kodak recommends a starting filter pack of 50M + 90Y + 2B. (The 2B ultraviolet-absorbing filter is always part of the pack.)

When feasible it is better to change the aperture while keeping the exposure time the same. This is to avoid reciprocity effect caused by extremely long or extremely short exposures (pages 282–283) which could change the color balance and make test results difficult to interpret. In this test each successive strip receives one additional full stop of exposure, but the best exposure for a particular negative is often between two of the stops. Exposure times between 5 sec and 30 sec generally do not create noticeable reciprocity effect, so after you get an approximate exposure you can fine tune by changing the time.

Keep notes of time, aperture and filtration for each print if you want to save time and materials at your next printing session.

3 adjust the image size

Turn off the room lights. Project the image onto the back of a sheet of double-weight paper placed in the easel. Raise or lower the head until the image is the desired size—here 8 x 10 in.

4 focus the image

Looking through a focusing magnifier (if you use one) adjust the focus control of the enlarger until the image is sharp. Focus on the edge of an object since a color negative has no easily visible grain.

5 set the lens aperture

Stop down the lens to f/16. Set the timer for 10 sec. Turn off the enlarger light. Place a sheet of printing paper on the easel, emulsion side up.

6 make the first test exposure

Hold a masking card over all but about ⅕ of the paper and expose the first test wedge. Cover the first wedge with another masking card. Move the first card to uncover the next ⅕ of the paper.

7 reset aperture, complete the test

Open the aperture one stop. Reset the timer and expose the next wedge. Continue moving the masking cards, opening the aperture one stop and exposing until the last ⅕ of the paper is exposed.

8 load the paper in the processing drum

Insert the paper in the processing drum with the emulsion (exposed) side curled to the center of the drum. Put the cap on the drum and secure it carefully. Turn on the room lights.

Processing

With the exposed print stored in the drum away from light, prepare the chemicals for processing. Shown here is processing in Kodak Ektaprint 2 chemicals. Dilute the chemicals as the instructions direct, protecting your hands with rubber gloves. Color chemicals are stronger than black-and-white chemicals; read instructions and warnings carefully. Contamination will cause trouble: don't splash one chemical into another or on the dry side of the darkroom. Kodak recommends mixing Ektaprint 2 Bleach-Fix using separate equipment since even very small quantities of it in other solutions will cause very large variations in the print. Wash tools carefully after use.

Read the manufacturer's directions regarding solution temperatures (particularly for the developer) during processing. With some processes, prints exhibit unpredictable shifts in color and density if the developer varies even slightly from the recommended temperature. If temperature control is critical, the best control is obtained from a processing drum that can be agitated while immersed in a constant temperature water bath. In practice, however, you can deviate somewhat from the exact temperature if you do the same thing every time.

1 | mix and measure out solutions and check temperatures

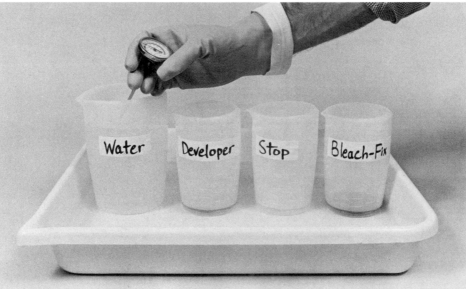

Wearing gloves, mix and measure out the required amounts of solutions. Use the same container each time for a solution in order to avoid contamination. Bring solutions to the recommended temperature and place them in a water bath at that temperature. Check and keep handy the times for each step.

2 | pour in prewet

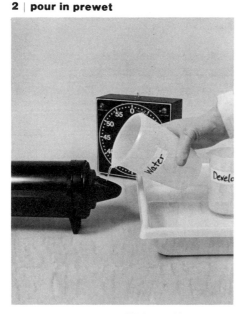

Set timer for prewet time. Fill drum with prewet water, start timer and begin agitation. (Prewet warms up the paper and softens the emulsion so chemicals can penetrate easily.)

3 | agitate the prewet

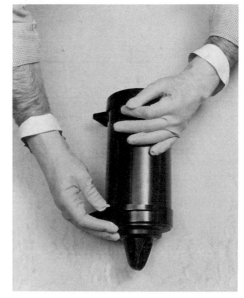

Solutions are agitated across the surface of the paper by rolling or rotating the drum. Use a consistent pattern of agitation to prevent unwanted variations in prints.

4 | drain the prewet

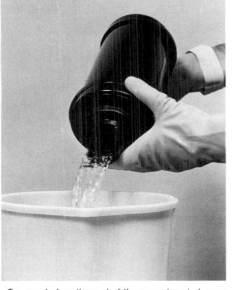

Ten sec before the end of the prewet period, pour out the prewet. Become familiar with your drum; some take slightly longer to drain or need a tilt or shake to drain thoroughly.

5 | development

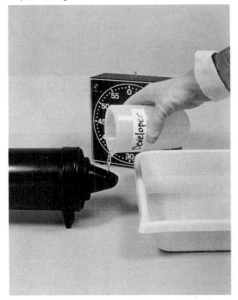

Set timer for development time. Pour in developer, start timer and agitate as before. Ten sec before the end of the development period, pour out the developer.

6 | stop bath

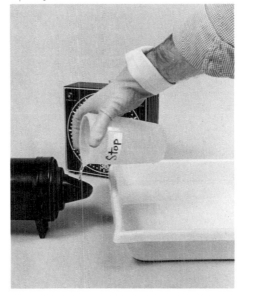

Set timer for stop bath time. Pour in stop bath, start timer and agitate. Ten sec before the end of the period, pour out the stop bath.

7 | washing prior to bleach-fix

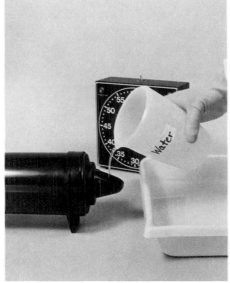

Set timer for wash time. Fill drum with wash water, start timer and agitate. Ten sec before the end of the period, pour out the wash water.

8 | bleach-fix

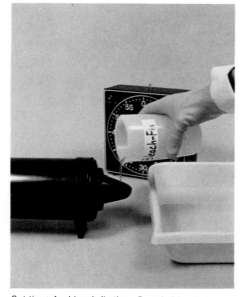

Set timer for bleach-fix time. Pour in bleach-fix, start timer and agitate. Ten sec before the end of the period, pour out bleach-fix. The drum can now be opened.

9 | wash

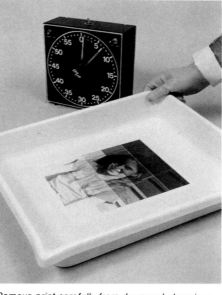

Remove print carefully from drum and place in a tray of water. Wash by rocking the tray, dumping and refilling with water. Repeat 3 more times for the recommended wash period.

10 | dry

Sponge or squeegee excess water gently from print and hang or place in dust-free place to dry. Warm air, as from a hair dryer, will hasten drying. Do not use a hot drum dryer.

11 | clean up

Wash all equipment that has come in contact with chemicals. Be particularly careful to wash and dry the processing drum thoroughly so that no trace of bleach-fix remains.

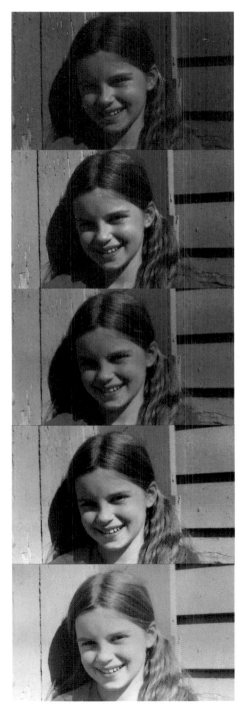

1 stop too dark
*Give ½ the previous exposure: close enlarger lens
1 stop or multiply exposure time by .5*

½ stop too dark
*Give ¾ the previous exposure: close enlarger lens
½ stop or multiply exposure time by .75*

correct density

½ stop too light
*Give 1½ times the previous exposure: open en-
larger lens ½ stop or multiply exposure time by 1.5*

1 stop too light
*Give twice the previous exposure: open enlarger
lens 1 stop or multiply exposure time by 2*

Judging a color print is similar to judging a black-and-white print in that you have to judge two characteristics separately. In a black-and-white print you judge density first, then contrast. In a color print, you judge density first (shown at left), then color balance (see pages 296–297).

The color balance of a test print will probably be off, so you need to try to disregard it and look only at the density or darkness of the print. Look for the exposure that produces the best overall density in midtones such as skin or blue sky. Important shadow areas should be dark but with visible detail, textured highlights should be bright but not burned-out white. (Some local control with burning and dodging may be needed; see page 298.)

The light under which you evaluate a color print affects not only how dark the print looks but also its color balance. Ideally you should evaluate prints using light of the same intensity and color balance under which the print finally will be seen. Since this is seldom practical, some average viewing conditions have been established. Fluorescent tubes are recommended such as Westinghouse Living White bulbs or Deluxe Cool White bulbs made by various manufacturers. You can also combine tungsten and fluorescent light with one 75-watt tungsten bulb used with every two 40-watt Deluxe Cool White fluorescent tubes. You will want to examine prints carefully, but when judging density, don't view a print very close to a very bright light. Average viewing conditions are likely to be less bright and the final print may then appear too dark.

Judging Color Balance in a Print Made from a Negative

Almost always, the first print you make from a negative can be improved by some change in the color balance. You adjust the color balance of the print by changing the filtration of the enlarger light. If your enlarger has a dichroic head, just dial in the filter change. If you are using CP or CC filters, you must replace individual filters in the pack. You will need to decide what color is in excess in the print and how much it is in excess, then change the strength of the appropriate filters accordingly. Ordinarily it is best to evaluate prints when dry, since wet prints have a bluish color cast and appear slightly darker than they do when dry.

You can check your print against pictures whose colors are shifted in a known direction, such as the ringaround test chart, opposite. The chart helps identify color shifts, but since printing inks seldom exactly match photographic dyes, a better method is to view the prints through colored filters to see which improves the color balance. Kodak makes a Color Print Viewing Kit for this purpose; a smaller set of filters is available in Kodak's Color Darkroom Dataguide.

Find the viewing filter that makes the print look best. Hold the filter away from the print, not directly on top of it, and flick the filter in and out of your line of vision. Look at light midtones in the print such as light grays or flesh tones rather than dark shadows or bright highlights. Follow the directions with the filters but, in general, change the enlarger filtration half the value of the viewing filter. If you lay the filter on top of the print the color change increases. If the print looks best this way, change the enlarger filtration the same value as the viewing filter.

To correct the color balance of a print made from a negative, make the *opposite* color change in the enlarger filtration from the color change you want in the print. In other words, if you want to remove a color from a print, add that color to the enlarger filtration. Almost always, you should change only the magenta or yellow filters, either subtracting the viewing filter color that corrects the print or adding the complement (the opposite on the color wheel) of the viewing filter color that corrects. See chart and color wheel right. Kodak's Color Print Viewing Kit also tells you exactly which colors to change.

The cure for a print with too much magenta is to add—not decrease—the magenta in the filter pack; more magenta in the printing light produces a print with less of a magenta cast. A green viewing filter will correct a print that is too magenta, so you add magenta (the complement of green) to the filter pack.

Similarly, excess blue is corrected by lightening the filter that absorbs blue, the yellow filter; the filter pack will then pass more blue light, so the print (reacting in an opposite direction) will show less blue. A yellow viewing filter will correct a too blue print, so subtract yellow (the complement of blue) from the filter pack.

Color printing is a skill that requires both experience and written information from a book or manufacturer's literature. Once you have made a few prints, not only is written information easier to understand but the whole process of printing becomes easier. Help from someone who knows how to print and who can help you judge your prints is invaluable.

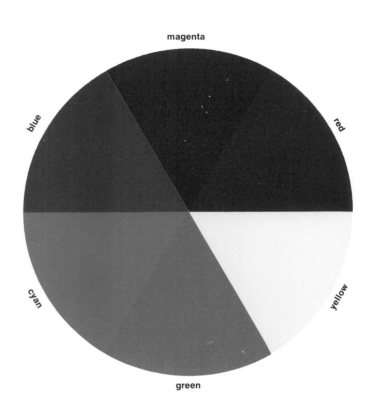

The primary colors of light are shown here arranged in a circle—a color wheel. Each color is composed of equal amounts of adjacent colors (red is composed of equal parts of magenta and yellow). Each color is complementary to the color that is opposite (magenta and green are complementary).

balancing a print made from a negative

To adjust the color balance of a print made from a negative, change the amount of the subtractive primary colors (magenta, yellow and cyan) in the enlarger printing light. Usually, changes are made only in magenta and yellow (M and Y).

Print is	Do this	Could also do this
Too magenta	Add M	Subtract C + Y
Too red	Add M + Y	Subtract C
Too yellow	Add Y	Subtract C + M
Too green	Subtract M	Add C + Y
Too cyan	Subtract M + Y	Add C
Too blue	Subtract Y	Add C + M

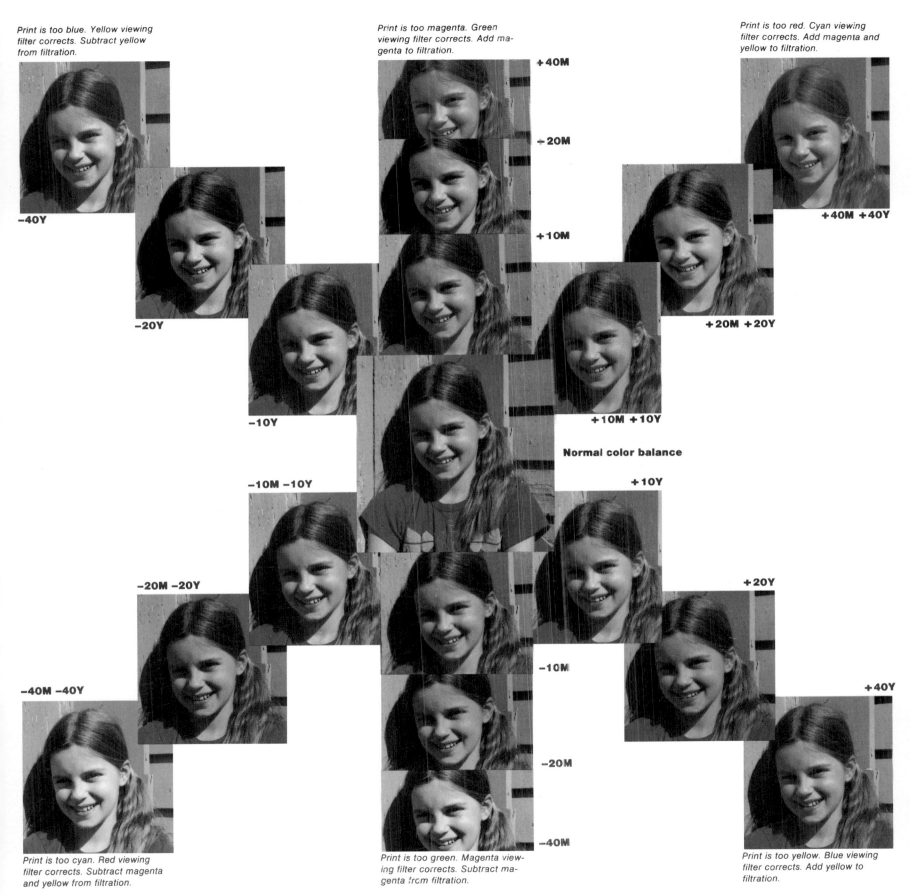

Print is too blue. Yellow viewing filter corrects. Subtract yellow from filtration.

Print is too magenta. Green viewing filter corrects. Add magenta to filtration.

Print is too red. Cyan viewing filter corrects. Add magenta and yellow to filtration.

−40Y

+40M

+20M

+10M

+40M +40Y

−20Y

+20M +20Y

−10Y

+10M +10Y

Normal color balance

−10M −10Y

+10Y

−20M −20Y

−40M −40Y

−10M

+20Y

−20M

+40Y

−40M

Print is too cyan. Red viewing filter corrects. Subtract magenta and yellow from filtration.

Print is too green. Magenta viewing filter corrects. Subtract magenta from filtration.

Print is too yellow. Blue viewing filter corrects. Add yellow to filtration.

More About Color Balance/Print Finishing

After you change the filtration of a test print, you may then need to adjust the exposure, because the filtration affects the strength of the exposing light and so the density of the print. When feasible, adjust aperture rather than time.

Dichroic filters need minimum exposure adjustment. See manufacturer's literature or make no adjustment for yellow filter change, 1 percent adjustment for each 01M change. CP or CC filters require exposure adjustment for changes in both filter density and the number of filters. See manufacturer's literature or Kodak Color Darkroom Dataguide, which contains a computing wheel that simplifies calculation of new exposures with Kodak materials. As a rough guide, ignore yellow changes, adjust exposure 20 percent for every 10M change, then adjust 10 percent for changes in the number of filter sheets (including yellow).

As the result of making filter corrections, you may end up with all three subtractive primaries (Y, M, C) in your filter pack. This condition produces neutral density—a reduction in the intensity of the light without any accompanying color correction and may cause an overly long exposure. To remove neutral density without changing color balance, subtract the lowest filter density from all three colors.

70Y	30M	10C	working pack
10Y	10M	10C	subtract
60Y	20M		new pack

You can dodge and burn a color print to some extent, as in black-and-white printing, to darken or lighten an area. For example, you may want to darken the sky or lighten a face or shadow area. If you dodge too much, an area will show loss of detail and color (smoky-looking is one description), but some control is possible.

You can also change color balance locally. To improve shadows that are too blue, which is a common problem, keep a blue filter in motion over that area during part of the exposure. Burning-in can cause a change in color balance in the part of the print that receives the extra exposure. If a burned-in white or very light area picks up a color cast, use a filter of that color over the hole in the burning-in card to keep the area neutral. Try a CC30 or CC50 filter of the appropriate color. CP filters should not be used for this purpose.

Like black-and-white prints, color prints may need spotting to remove white or light specks caused by dust on the negative. Retouching colors made for photographic prints come in liquid or cake form. Either can be used to spot out small specks. The dry cake colors are useful for tinting large areas. Black spots on a print are more difficult to correct. One way is to apply white opaquing fluid to the spot, then tint to the desired tone with colored pencils.

Color prints can be dry mounted, though low temperatures are recommended—no higher than 210° F (99° C) for RC paper. Since the thermostat settings on dry-mount presses are seldom accurate, use the lowest setting that is effective. Preheat the press, the mount board, and the protective cover sheet placed on top of the print, then insert the print for the minimum time that will fuse the dry-mount tissue to print and mounting board.

Color prints fade over a period of time, particularly on exposure to ultraviolet light. Prints will retain their original colors longer if protected from strong sources of ultraviolet light such as bright daylight.

WHITE	CC	-10 M
LIGHT	CC	00 Y
DATA	Ex. Factor	70

The color response of color-printing paper varies slightly from batch to batch. Manufacturers test each batch and list on the label of the box or package the emulsion batch number plus white-light data—the changes in filtration and exposure you should make in order to get the same results from one batch to the next. Here's how to make the changes:

Filtration. *Subtract the old white-light data from your working filter pack (or from the pack for a given negative), then add in the new data.*

40M	70Y	working pack
00M	+15Y	subtract old white-light data
40M	55Y	
−10M	00Y	add new white-light data
30M	55Y	new working pack

Exposure. *Divide the new exposure factor (ex. factor) by the old ex. factor and multiply by the old exposure time to get the new exposure time.*

$$\frac{\text{new ex. factor}}{\text{old ex. factor}} \times \text{old time} = \text{new time}$$

$$\frac{70}{90} \times 10 \text{ sec} = 8 \text{ sec}$$

For the monumental iced drink opposite Richard Steinberg used a single backlight pointed toward the camera from behind a piece of translucent glass. A glass table supported the subject and provided a reflection of the bottom of the glass. The photograph seems simple but was demanding: Steinberg spent 3 days getting the reflections and light the way he wanted them and used ice cubes made of plastic to prevent a meltdown.

RICHARD STEINBERG: *Iced Drink*

Making a Color Print from a Transparency

A | processing chemicals
B | measuring cups
C | printing paper
D | filters
E | manual
F | processing drum

G | timer
H | half-gallon container
I | graduates
J | solution storage bottles
K | washing tray
L | washing siphon

M | gloves
N | clothes pins
O | thermometer
P | stirring rod
Q | squeegee

1| *Begin by preparing the solutions, which are easily mixed. Follow the manufacturer's instructions and cautions carefully, particularly with the bleach, which is a corrosive substance.*

Color prints can be made from transparencies (slides) as well as from negatives. Reversal materials like Cibachrome (shown here) or Kodak Ektachrome 2203 paper produce a positive print directly from a positive color transparency.

The materials needed to make Cibachrome prints are shown above. At left are specifically Cibachrome materials: a chemical kit with measuring cups (A and B); color-print paper (C); and a book of instructions (E). Cibachrome also provides general color-printing supplies: color-printing filters (D) and a light-tight processing drum (F). The remaining materials on the right-hand side of the picture (G to Q) are standard for black-and-white processing.

Cibachrome prints are noted for their brilliant, saturated colors, good detail and sharpness, and excellent color dye stability. For best results, print from a fully exposed (not dense) transparency with low to normal contrast; a contrasty image generally does not print well with this process because the print material is already quite contrasty. However, if you want relatively high contrast in a print, this process is ideal. Cibachrome's pearl surface printing paper shows less apparent contrast than their glossy paper.

2| *Place a transparency in the enlarger. The first print should be a test to determine the exposure and filtration (see manufacturer's instructions). Because making a print directly from a slide is a positive-to-positive process (unlike printing from a negative), greater exposure will make the print lighter; heavier filtration will add more of that filter's color to the print (see page 302).*

3| Curl the exposed print toward the emulsion side and put it into a dry, clean drum. Seal the drum. Turn on the lights.

4| Measure out each solution—developer (1), bleach (2) and fixer (3)—into its own measuring cup. Adjust temperatures to recommended range. Note the times for each processing step.

5| Used Cibachrome solutions must be neutralized before being discarded. Each package of Cibachrome chemistry contains materials and directions for preparing a neutralizing container.

6 | Set the timer and pour the developer from cup to drum. When using Cibachrome's drum, start timer when drum is laid on its side. Solutions do not contact the print until then.

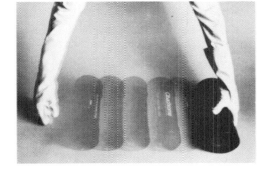

7 | To prevent streaking caused by uneven spread of the solutions, agitate the processing drum smoothly back and forth by rolling it on a level, even surface

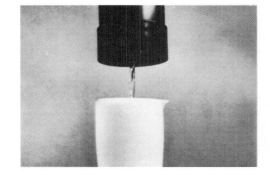

8 | Begin draining the drum about 10 sec before the end of the timed period. Drain the solution into the neutralizer container. Repeat steps 6, 7 and 8 for bleach, then again for fixer.

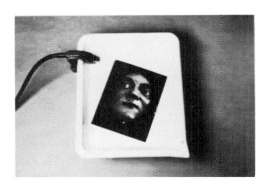

9 | Carefully remove the print from the drum and wash it in rapidly flowing water. Do not let the stream of water strike the print surface directly.

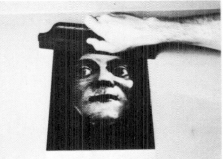

10 | Squeegee the print gently. Evaluate the print after drying. It will look somewhat red while it is still damp.

11 | For final drying, hang the print or place on a screen or absorbent surface. Warm air, as from a hair dryer, will speed drying. Do not use a hot drum dryer.

Judging a Print Made from a Transparency

Evaluating a reversal print—one made from a transparency or slide—is similar to evaluating a print made from a negative *(pages 295–297)*. View the print when it is dry, in light similar to that under which you will view the finished print.

Evaluate and adjust density first, because what looks like a problem in filtration may simply be a print that is too dark or too light. Evaluate color balance by examining the print with viewing filters or by comparing the print against ring-around prints *(right)*.

The most important difference between reversal printing and negative/positive printing is that reversal prints respond to changes in exposure or filtration in the same way that a slide does when you expose it in the camera. If the print is too dark, increase the exposure (don't decrease it as you would in negative/positive printing). Adjust the color balance by making the same change in the filter pack that you want in the print. Adding a color to the filter pack will increase that color in the print; decreasing a color in the pack will decrease it in the print. For example, if a print is too yellow, remove Y from the filtration *(see chart and prints, right)*.

The suggested beginning filter pack for a print made from a transparency has yellow and cyan filtration. (This is different from the beginning pack for a print made from a negative, which has yellow and magenta filtration.) When feasible, adjust the balance by changing only the Y and C filtration in order to avoid the neutral density caused by having all three primary colors in the same pack *(see page 298)*.

One thing is the same in both processes: keep notes—on the print, on the negative envelope or in a notebook.

Print is too magenta. Green viewing filter corrects. Add yellow and cyan to filtration.

Print is too blue. Yellow viewing filter corrects. Add yellow to filtration.

Print is too red. Cyan viewing filter corrects. Add cyan to filtration.

normal color balance

Print is too cyan. Red viewing filter corrects. Subtract cyan from filtration.

Print is too yellow. Blue viewing filter corrects. Subtract yellow from filtration.

Print is too green. Magenta viewing filter corrects. Subtract yellow and cyan from filtration.

balancing a print made from a slide

	Print is	Do this	Could also do this
To adjust the color balance of a print made from a positive transparency, change the amount of the subtractive primary (yellow, cyan and magenta) filtration. Make changes first in Y or C filtration.	Too dark	Increase exposure	—
	Too light	Decrease exposure	—
	Too magenta	Add Y + C	Subtract M
	Too red	Add C	Subtract Y + M
	Too yellow	Subtract Y	Add C + M
	Too green	Subtract Y + C	Add M
	Too cyan	Subtract C	Add Y + M
	Too blue	Add Y	Subtract C + M

In 1963 Glen Canyon on the Colorado River was dammed as part of a hydroelectric and irrigation project. Before scenic sites such as Dungeon Canyon (right) were submerged and destroyed, Eliot Porter photographed them for a book published by the Sierra Club, The Place No One Knew. The overlapping planes of Porter's photograph begin to shift position as you look at them. Light objects in photographs tend to appear closer than darker ones, and the light central wall can appear either in front of or behind the dark wall at left. See Timothy H. O'Sullivan's sky and dark wall in his photograph of Black Canyon (page 333).

ELIOT PORTER: *Dungeon Canyon in Glen Canyon, Colorado River*, 1961

Instant Color Film

Instant film color pictures have been a favorite with amateur photographers since 1962, when Polaroid's Polacolor film was first announced. The processing takes care of itself and within seconds a finished print is ready. Although processing instant color film involves at most simply pulling on a film tab at one end of the camera, the chemistry on which the film is based is extremely complex. It involves a multilayered negative of light-sensitive silver halides and developer-dyes sandwiched with printing paper and an alkaline developing agent when the print is pulled from the camera. Film such as Polaroid's SX-70 or Kodak's PR10 is even more complex: the processing takes place within the print itself.

Instant film is not just for amateurs. Marie Cosindas makes elegant use of the rich tones that Polacolor film provides. Her photographs, like the ones at right, are given long exposure times (as much as 10 seconds) and extended developing times (as much as 90 seconds, instead of the regular 60 seconds). The results of these deviations from standard exposure and development are muted, soft tones that she feels give a sense of quiet and timelessness to the image. (Extended development cannot be used with SX-70 film, because the processing takes place automatically.)

In portraits, the long exposures also force subjects to hold still longer, involving them more in the photograph. Cosindas's portraits are often reminiscent of photographs made in the 19th century, when exposures were also long and sitters often projected a quiet seriousness due at least in part to staying still for a long time.

MARIE COSINDAS: *Maria, Mexico,* 1966

MARIE COSINDAS: *Sailors, Key West*, 1966

Marie Cosindas uses longer-than-normal exposure
and development times to produce rich, muted
colors in her Polaroid photographs. Her portraits
often project an atmosphere of quiet that is caused
in part by the subject's having to hold still during a
long exposure.

W. EUGENE SMITH: *Tomoko and Her Mother*, 1972

14 Camera Vision

The Frame: The Whole Scene or a Detail 308
The Frame: The Edges of the Image 310
Point of View: Seeing from Another Angle 312
Sharpness—or the Lack of It 314
Photographing the Light—or the Dark 316

How do you learn to make better pictures? Once you know the technical basics where do you go from there? Every time you make an exposure you make choices, either deliberately or accidentally. Do you show the whole scene or just a detail? Do you make everything sharp from foreground to background or is only part of the scene in focus? Do you use a fast shutter speed to freeze motion sharply or a slow shutter speed to blur it? These are only some of your choices, and you can't expect to get immediate control over all of them. Photography is an exciting and sometimes frustrating medium just because there are so many ways to deal with a subject.

So your first step is to become more aware of your options. Before you make an exposure, try to previsualize the way the scene in front of you will look as a print. Looking through the viewfinder or at the ground glass helps. The scene is then at least reduced to a smaller size and confined within the edges of the picture format, just as it will be in the print. As you look through the viewfinder, pretend you are looking at a print, but remember that you can still change it. You can eliminate a distracting background by making sure it will be out of focus, change your position to a better angle and so on.

In the 19th century, rules of photographic composition were proposed based on techniques used by certain painters of the period. The rule of thirds, for example, was (and still is for some photographers) a popular compositional device. Draw imaginary lines dividing the image area into thirds horizontally, then vertically. Important subject areas should, according to this rule, fall on the intersections of the lines or along them. It is interesting to look at a picture, for example the one opposite, to see if it fits the rule—or breaks it and is still a fine image. Rules are only occasionally useful because you have to work with the untidy visual phenomena of the real world, a situation in flux with people and light changing, plus your own personal approach.

Edward Weston said, "Good composition is only the strongest way of seeing the subject. It cannot be taught because, like all creative effort, it is a matter of personal growth." It cannot be taught, but it *can* be learned—by looking at photographs, responding to them, asking questions, looking at the world in front of your camera, trying something, seeing how it looks, trying again—and, in general, letting your sense of composition and your camera vision develop on its own.

◀ *This somber study of a Japanese mother tenderly bathing her deformed 16-year-old daughter is from* Minamata, *W. Eugene Smith's study of industrial pollution. Chemical waste dumped into fishing waters near the town of Minamata had contaminated fish eaten by the mother when she was pregnant, causing her daughter to suffer a progressively crippling disease. The picture is also known as the Minamata Pietà, after a representation of the dead Christ supported by a mourning Mary. Smith combined an intense concern for human life with an equally strong desire to create compelling images. As in this print, he frequently chose to let shadows go black and expose for the highlights, often bleaching the highlights to lighten them.*

The Frame: The Whole Scene or a Detail

One of the first choices a photographer has to make is how much of a scene to show. If you look at snapshot albums, you will see that people often photograph a subject in its entirety—Grandpa is shown from head to toes even if that makes his head so small that you can't see his face well. Something similar happened in early motion pictures: in the first movies the camera showed the entire scene of action from a distance, much like the view an audience has of a stage play. Only as cinema technique evolved did closeups of faces or details of objects begin to be used as well.

Whether the subject is a person, a house or a tree, beginners often are reluctant to show anything less than the whole thing. However, in many cases it was some particular aspect of a subject, such as the expression on the face of the person, the shuttered window of the house or a bent branch of the tree, that attracted the photographer's attention in the first place.

Before you take a picture, stop a moment to determine the part you really want to show. Move around a bit as you look through the viewfinder; you might want to take one picture of the whole scene, then try a few details. Certainly there is no need to always show details; just keep in mind that you have the option to do so.

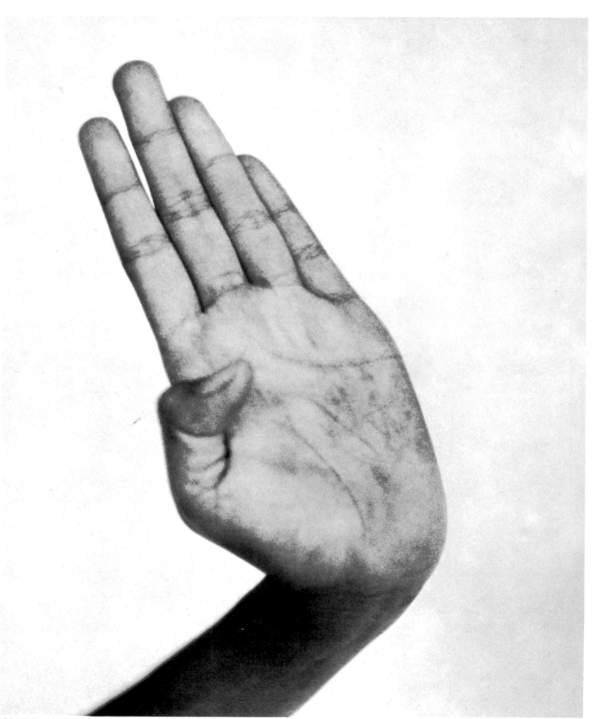

You have the choice when making photographs to show an object in its entirety or to move in to show one particular part of it. Dorothea Lange's photograph of the tautly stretched hand of an Indonesian dancer (this page) was not meant to be a document of a particular dancer engaged in a specific dance. Instead it is an expressive detail, a gesture chosen to convey an essential feeling of the dance itself. Barbara Morgan chose to show the entire figure of Martha Graham (opposite). In one sense, however, it is also a detail—a fraction of a second intended to suggest the emotional meaning of the entire dance.

DOROTHEA LANGE: *Hand, Indonesian Dancer, Java,* 1958

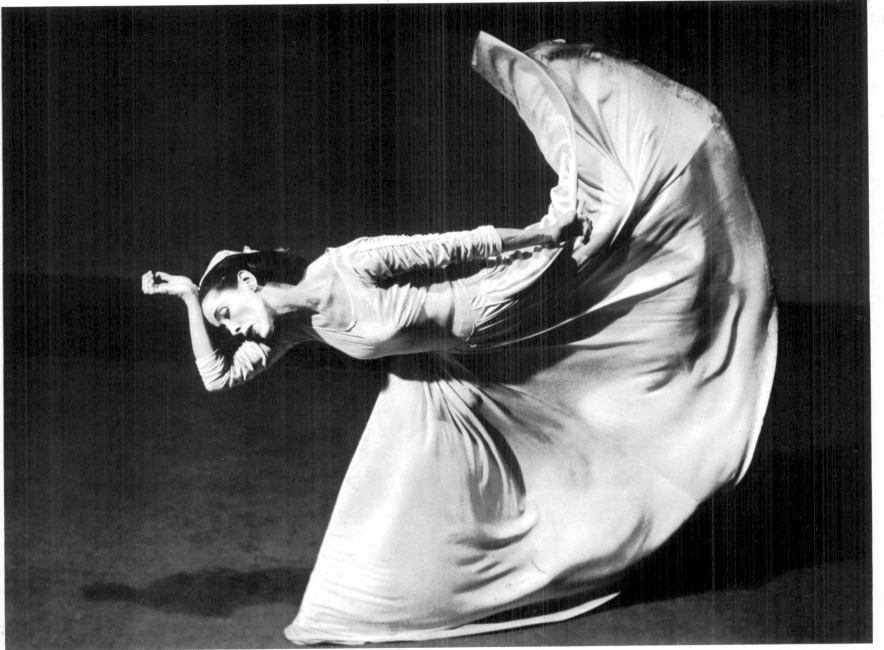

BARBARA MORGAN: *Martha Graham in "Letter to the World,"* 1940

The Frame: The Edges of the Image

Photography is different from other visual arts in the manner in which a picture is composed. A painter starts with a blank canvas and places shapes within it. A photographer generally uses the frame of the viewfinder or ground glass to select a portion out of the surrounding visual possibilities. A choice has to be made, consciously or not, as to how the frame—the edges of the format—will relate to that portion of the scene that is shown.

You can choose to leave considerable space between the frame and a particular shape, bring the frame very close so it almost touches the shape or use the frame to cut into the shape. This decision is important because when you look at a photograph you do not see the surrounding area that was left out; you *do* see the four straight edges of the frame and how they meet the shapes in the picture.

There is no need to be overly analytical about this. Try looking at the edges of the viewfinder image as well as at the center of the picture and moving the frame around until the image as seen through the viewfinder feels good to you. Much of composition stems from the human body and its experiences of balance, space and so on. If you give your body a chance, it will tell you when the picture is doing what you want it to do.

Visual tension in a photograph can be increased or decreased simply by moving the edge of the picture area—the frame—nearer to or farther from a form. In the photograph by Paul Caponigro (this page) two leaves are surrounded by a dark, neutral background. The leaves are completely enclosed and isolated within the frame, a type of composition (called closed form) that often emphasizes the outline of an object. The interaction with the frame edge is less important than the overall shape of the leaves. Edward Weston's cabbage leaf (opposite) is an example of open form: the frame cuts into the subject. The eye follows the ridges of the leaf and repeatedly encounters the frame.

PAUL CAPONIGRO: *Two Leaves,* 1963

EDWARD WESTON: *Cabbage Leaf,* 1931

Point of View: Seeing from Another Angle

Before the invention of photography, artists usually presented their visions of the world from a more or less earth-bound and eye-level viewpoint. They looked straight ahead, just as people do most of the time. But in the early days of photography, even before cameras became small and mobile, photographers began to seek other viewpoints, from tall buildings, for example, and, as early as 1856, a bird's-eye view from a balloon.

An eye-level vantage point is unobtrusive in a photograph; the viewer probably won't think about the point of view one way or the other. Looking up at a subject can give it an imposing air as it looms above the viewer. The effect is particularly noticeable with human subjects, because it can evoke childhood memories of being small and powerless. Vertical lines, for example in a building, appear to converge when the camera is pointed up, and as a result the feeling of height is increased. Looking straight down on a subject produces the opposite effect: objects are flattened out.

Moderate tilts up or down can give a slight shift, making a subject appear somewhat bigger or somewhat smaller without unduly attracting the viewer's attention. Advertising photographs often utilize subtle, and not so subtle, effects of this kind.

When photographing, the effect of an unusual perspective is easier to see if you look at the scene through the camera's viewfinder. Alexander Rodchenko often photographed from unexpected angles (this page). Here he pointed the camera up at a man on a fire-escape ladder. The effect is disorienting because at the same time that we know the ladder goes up, it visually appears to be horizontal, more like railroad tracks. The man, already partly abstracted by being silhouetted, seems to cling to the underside of the ladder. André Kertész's high vantage point (opposite) also abstracted a scene, transforming the street life of a provincial French town into a flat pattern that emphasizes the geometry of the view rather than the individuals present.

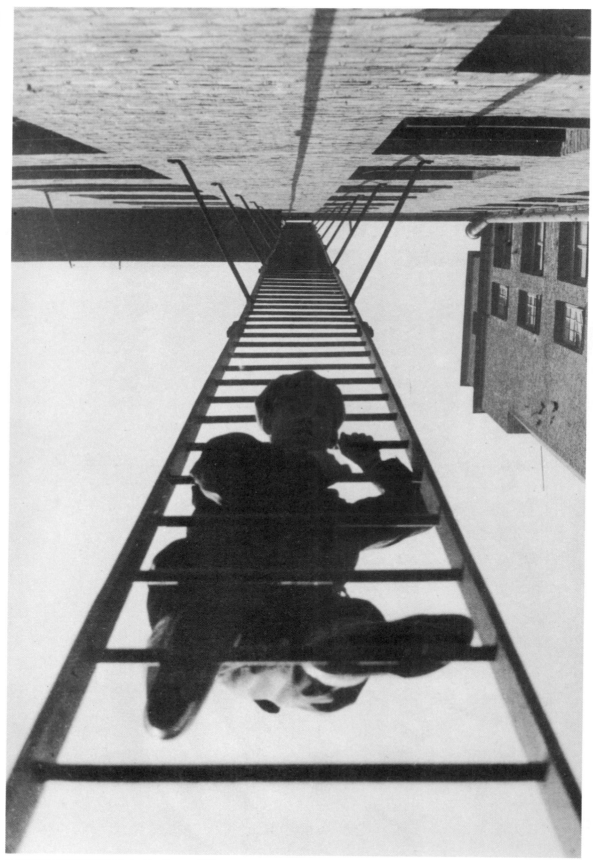

ALEXANDER RODCHENKO, *The Ladder, Moscow,* 1925

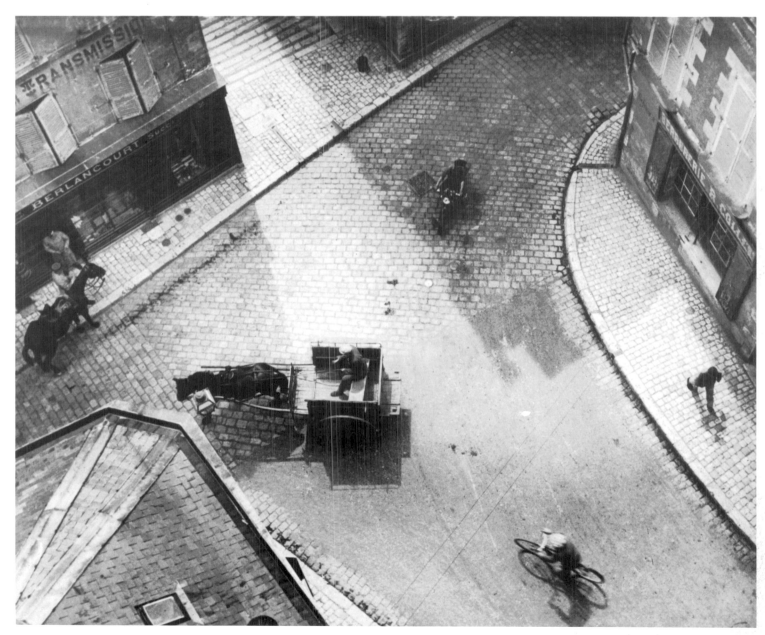

ANDRÉ KERTÉSZ: *Touraine, France,* 1930

Sharpness—or the Lack of It

In ordinary life, if your eyes are reasonably good, you seldom have to consider whether things are sharp or not. The human eye, like a camera lens, must refocus for objects at different distances, but the eye scans and refocuses so quickly that you rarely are aware of the process. However, the sharpness of a photograph, or of the various parts of it, is immediately noticeable, and the eye almost always looks first at the most sharply focused part of the image. You can emphasize some part of a subject by focusing on it and decreasing the depth of field (the acceptably sharp area in a photograph) so that the background and/or foreground are out of focus.

As you look around, even moving objects appear sharp unless they are moving extremely fast, like a hummingbird's wings for example. But in a photograph you can use a fast shutter speed to freeze the motion of a moving object, whether it be a rapidly moving bird or a slow moving cloud. Or you can use a slow shutter speed to deliberately blur the motion—just enough to indicate movement or so much that the subject's shape is altered.

If you change to a faster shutter speed, you have to open to a larger aperture in order to keep the overall exposure the same. But since the larger the aperture the less the depth of field, you may have to decide whether the sharpness of a moving object is more important than the sharpness of depth of field; it may be impossible to have both. (To review the relation of shutter speed to sharpness of motion and of aperture to depth of field see pages 42–43.)

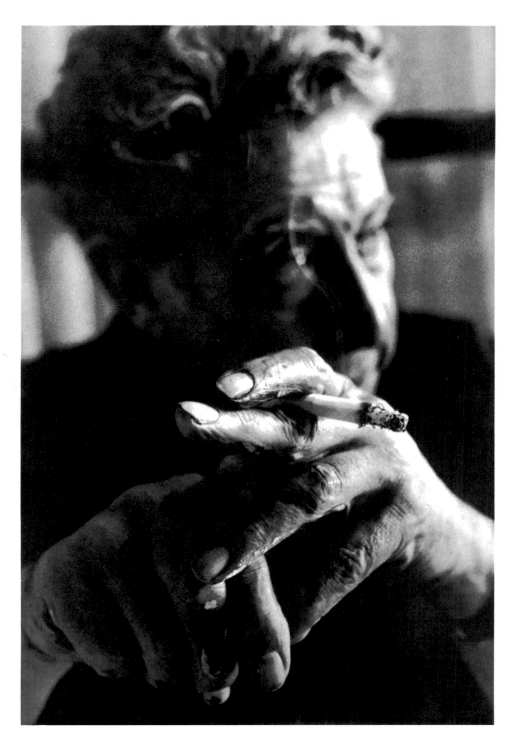

FARRELL GREHAN: *David Alfaro Siqueiros*, 1966

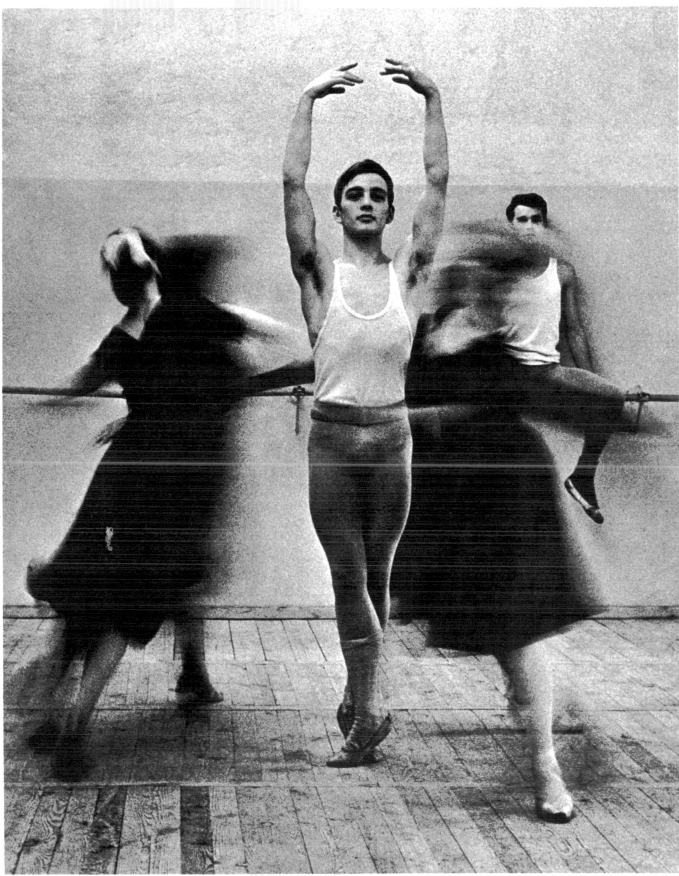

Your pictures don't have to be dead sharp—if you blur them for a purpose. For the portrait of a painter (opposite) Farrell Grehan opened the lens to a wide aperture and focused on the artist's expressive, paint-splotched fingers. The fingers are sharp but the face, only inches away, is not. This unconventional treatment of a portrait emphasized the artist's most important tools, his hands. In his photograph of dancers (this page), Herbert List used a relatively slow shutter speed. The blur of the moving dancers in contrast to the sharpness of the two that are not moving gives an impression of time and movement that belies the term "still" photograph.

HERBERT LIST: *Training in the State Ballet School, East Berlin,* 1966

Photographing the Light—or the Dark

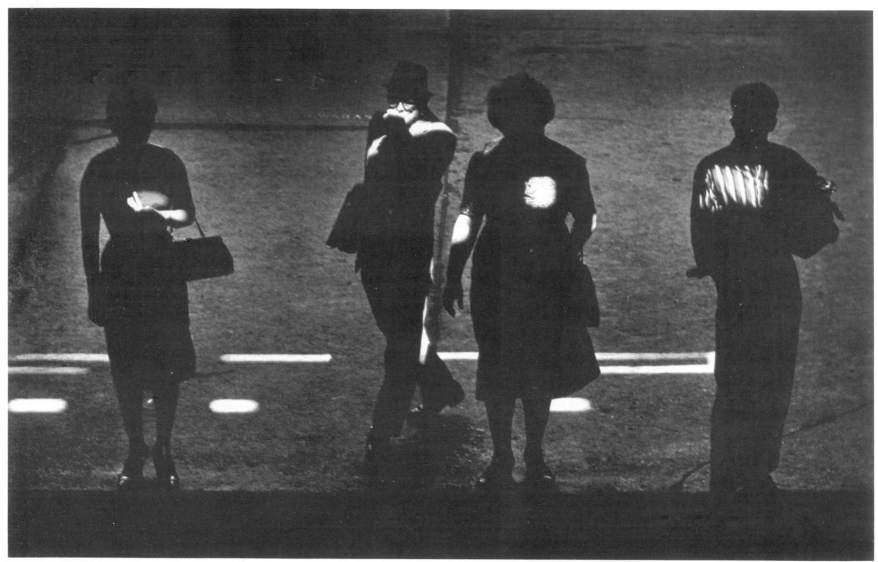

KENNETH JOSEPHSON: *Chicago,* 1961

Photography is unique in its ability to suggest the presence and feeling of light in a two-dimensional image. You can use light simply to illuminate the subject enough to record it on film. Or you can make light itself the subject of the photograph.

The contrast range of many scenes is too great for photographic materials to record realistically both dark shadows and bright highlights in one picture. This can be a problem, but it also gives you the option of deliberately using black shadows or white highlights as independent forms. (Pages 113–114 tell how to expose for specific tones.)

Light and shadow in a photograph can be a relatively subtle part of a scene or, as here, can dominate the picture. In Kenneth Josephson's photograph made under an elevated railway (this page) the shapes of the light spots on the figures and on the ground appear to have more substance and significance than the shadowy, anonymous figures. Edward Weston used the dark shadows of an egg slicer (opposite) as an extension of the slicer itself, transforming an ordinary kitchen gadget into a rhythmic, abstract form.

EDWARD WESTON: *Egg Slicer,* 1930

317

PHOTOGRAPHER UNKNOWN: *Daguerreotype of couple holding a daguerreotype,* c. 1850

15 History of Photography

The Invention of Photography 320

Daguerreotype: "Designs on Silver Bright" 322

Calotype: Pictures on Paper 324

Collodion Wet-Plate: Sharp and Reproducible 326

Early Portraits 328

Images of War 330

Early Travel Photography 332

Gelatin Emulsion/Roll-Film Base: Photography for Everyone 334

Time and Motion in Early Photographs 336

The Photograph as Document 338

Photography and Social Change 340

The Photograph as Art in the 19th Century 342

Pictorial Photography and the Photo-Secession 344

The Direct and Unmanipulated Image 346

The Quest for a New Vision 348

Photojournalism 350

The 1950s and After 352

The 1960s and After 354

Of all the many inventions of the 19th century—the electric lamp, the safety pin, dynamite and the automobile are just a few—the invention of photography probably created the most astonishment and delight. Today most people take photographs for granted, but early viewers were awed and amazed by the objective records the camera made: ". . .We distinguish the smallest details; we count the paving-stones; we see the dampness caused by the rain; we read the inscription on a shop sign. . . ."

Photography gradually took over what previously had been one of the main functions of art—the recording of factual visual information, such as the shape of an object, its size and how it related to other objects. Instead of having a portrait painted, people had "Sun Drawn Miniatures" made. Instead of forming romantic notions of battles and faraway places from paintings, people began to see first-hand visual reports. Photographs recorded images that the unaided eye could not see and social miseries that the eye did not *want* to see. And photography began to function as an art in its own right.

This chapter touches on only a few of the categories into which the history of photography can be divided. Others, equally interesting, have been omitted only because of limitations of space. Throughout the technical chapters, however, and in a gallery of photographs at the end of the book, examples of many photographers working in many styles are shown.

◀ *In the 19th century photographs of people who were dead or unable to be present were often included in family photographs. It is tempting to try to interpret the relationships among the people shown opposite. The man holds the daguerreotype carefully, his fingers loose and relaxed; he even touches his head to the frame. The woman makes a minimum of contact with the photograph with her right hand and clenches her left hand into a fist. She stares directly into the lens, the corners of her mouth pulled down, unlike the man who softly gazes into space as if recalling a dear memory. The photograph is revealing, but still unexplained.*

The Invention of Photography

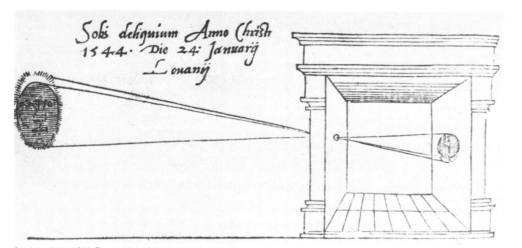

A solar eclipse, 1544. First published illustration of a camera obscura.

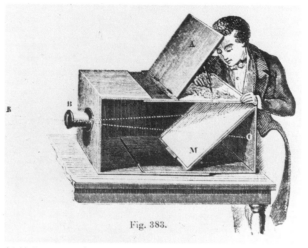

Fig. 383.

A table-top camera obscura.

"The wish to capture evanescent reflections is not only impossible, as has been shown by thorough German investigation, but the mere desire alone, the will to do so, is blasphemy. God created man in His own image, and no man-made machine may fix the image of God." Thus thundered a German publication, *Leipziger Stadtanzeiger,* in 1839 in response to the first public announcement of the invention of a successful photographic process. The *Stadtanzeiger* held that if such wise men of the past as Archimedes and Moses "knew nothing of mirror pictures made permanent, then one can straightway call the Frenchman Daguerre, who boasts of such unheard of things, the fool of fools."

Such a supreme disbelief is surprising, since most of the basic optical and chemical principles that make photography possible had long been established. Since at least the time of Aristotle, it had been known that rays of light passing through a pinhole would form an image *(page 50).* The 10th-century Arabian scholar Alhazen described the effect in detail and told how to view an eclipse of the sun in a camera obscura (literally, "dark chamber"), a darkened room with a pinhole opening to the outside.

By the time of the Renaissance, a lens had been fitted into the hole to improve the image and the camera obscura was becoming smaller and more portable; it shrank from a fixed room to a small hut, to a kind of sedan chair, to a small tent and finally to a small box that could easily be carried about *(above).* In the 16th century, Giovanni Battista della Porta suggested in his book *Natural Magic* that artists use a camera obscura. "If you cannot paint, you can by this arrangement draw [the outline of the images] with a pencil. You will have then only to lay on the colours. This is done by reflecting the image . . . on to a drawing-board with paper." The suggestion was taken up with enthusiasm because the realistic portrayal of objects and their correct positioning to create an illusion of depth were important goals of artists in the Western world at that time. The camera obscura became such a useful aid that by the 18th century an art

expert was writing, "The best modern painters among the Italians have availed themselves greatly of this contrivance; nor is it possible that they should have otherwise represented things so much to the life."

Probably many users of the camera obscura dreamed of a way of fixing its image permanently. The darkening of certain silver compounds by exposure to light had been observed as early as the 17th century, but the unsolved and difficult problem was how to halt this reaction so that the image would not darken completely. At the beginning of the 19th century, Thomas Wedgwood, son of the famous British pottery manufacturer, was the first to attempt to record the images created by a lens in a camera obscura. He was unsuccessful with the camera, but he did make negative silhouettes of leaves and insect wings by placing them on white paper or white leather sensitized with silver nitrate and exposing them to the sun. The paper darkened where it was exposed to light but not where it was shielded by the object placed on top. Wedgwood tried

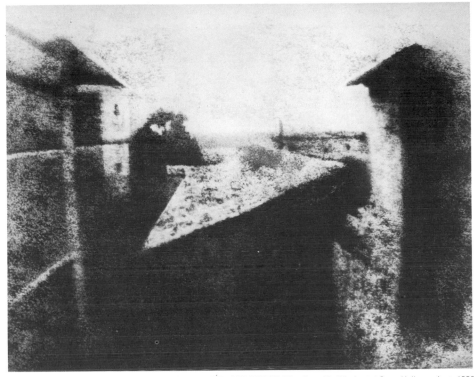

JOSEPH NICÉPHORE NIEPCE: *View from His Window at Gras.* Heliograph, c. 1826

◄ *Long before the invention of photography, many artists used a camera obscura (opposite) as an aid in drawing. An image that the artist could trace was formed as rays of light passed through a pinhole opening or a lens. The table-top model shown works exactly like a modern reflex camera; the rays are reflected by a mirror onto a ground-glass viewing screen.*

Niépce produced the world's first photographic image—a view of the courtyard buildings on his estate (right) in about 1826. It was made on a sheet of pewter covered with bitumen of Judea, a kind of asphalt that hardened when exposed to light. The unexposed, still soft bitumen was then dissolved, leaving a permanent image. The exposure time was so long (8 hr) that the sun moved across the sky and illuminated both sides of the courtyard.

many ways to make these silhouettes permanent, but nothing worked. When light struck the images, they began to darken like the rest of the coating.

Although Wedgwood had been working along the right lines with his investigations of silver compounds, silver played no part at all in the first permanent picture that can be called a true photograph. This was made no later than 1826 by Joseph Nicéphore Niépce, a gentleman inventor living in central France. Niépce had become interested in the new process of lithography, which at that time required that drawings first be copied by hand in reverse onto a printing plate. Niépce decided to devise an automatic method of transferring drawings and soon extended that idea to an attempt to take views directly from nature by using the camera obscura. Niépce first experimented with silver chloride, but by the early 1820s he had turned his attention to bitumen of Judea, a kind of asphalt that hardened when exposed to light.

Niépce dissolved the bitumen in lavender oil, a solvent used in varnishes, then coated a sheet of pewter with the mixture. He placed the sheet in a camera obscura aimed through an open window at his courtyard and exposed it for eight hours. The light forming the image on the plate hardened the bitumen in bright areas, while leaving it soft and soluble in dark areas. Niépce then washed the plate with lavender oil. This removed the soft, soluble bitumen that had not been struck by light. Niépce had succeeded where Wedgwood had failed; he had found a way to remove the unexposed and still light-sensitive material so that the image remained permanent.

The result *(above)*, which Niépce called a heliograph (from the Greek *helios*, "sun," and *graphos*, "drawing"), was crude, but it spurred him to continue his experiments. Meanwhile news of his work reached another Frenchman, Louis Jacques Mandé Daguerre. Daguerre had developed a popular Diorama display, a spectacle in which famous scenes, such as panoramas of the Swiss Alps, were re-created with illusionary effects through the use of huge translucent paintings and special lighting. Daguerre used the camera obscura in sketching scenes for the Diorama and had also become interested in trying to preserve its images. He wrote Niépce suggesting an exchange of information and eventually became his partner in 1829.

The mid-19th century was ripe for an invention like photography. In Western countries a rising middle class with money to spend wanted pictures, especially the family portraits that until that time only the rich had been able to afford. People were interested in faraway places; they traveled to them when they could and bought travel books and pictures when they couldn't. Niépce did not live to see the impact that photography was to have. He died in 1833, several years before Daguerre perfected a process that he considered different enough from Niépce's to be announced to the world as the daguerreotype.

Daguerreotype: "Designs on Silver Bright"

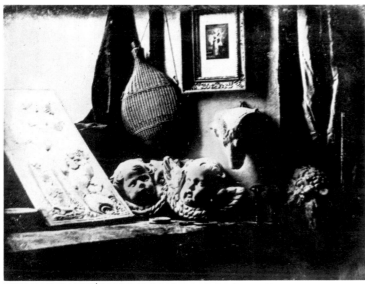

LOUIS JACQUES MANDÉ DAGUERRE: *Still Life in the Artist's Studio,* 1837

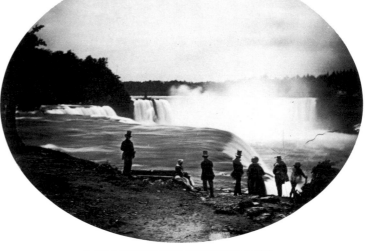

PLATT D. BABBITT: *Group at Niagara Falls,* c. 1855

After experimenting for many years, both with Niépce and alone, Daguerre was finally satisfied with his new daguerreotype process, and it was announced before the French Academy of Sciences on January 7, 1839. The response was sensational. "What fineness in the strokes! What knowledge of chiaroscuro! What delicacy! What exquisite finish! . . . How admirably are the foreshortenings given: this is Nature itself!" rhapsodized a French newspaper. A British scientist was more specific: "The perfection and fidelity of the pictures are such that on examining them by microscopic power, details are discovered which are not perceivable to the naked eye in the original objects: a crack in plaster, a withered leaf lying on a projecting cornice, or an accumulation of dust in a hollow moulding of a distant building, are faithfully copied in these wonderful pictures. . . ." One feels a genuine wonder and pleasure in examining a daguerreotype closely. Several are reproduced here, but no printing process can re-create the luminous tonal range and precise detail of an original.

The daguerreotype was made on a highly polished surface of silver that was plated on a copper sheet. It was sensitized by being placed, silver side down, over a container of iodine crystals inside a box. Rising vapor from the iodine reacted with the silver, producing the light-sensitive compound, silver iodide. During exposure in the camera, the plate recorded an image that at this stage was latent—a chemical change had taken place, but no evidence of it was visible. To develop the image the plate was placed, again silver side down, in another box containing a dish of heated mercury at the bottom. Vapor from the mercury reacted with the exposed areas of the plate. Wherever light had struck the plate, mercury formed a frostlike amalgam, or alloy, with the silver. This amalgam made up the bright areas of the image. Where no light had struck, no amalgam was formed; the unchanged silver iodide was dissolved in sodium thiosulfate fixer, leaving the bare metal plate, which looked black, to form the dark areas of the picture.

Almost immediately after the process was announced, daguerreotype studios were opened to provide "Sun Drawn Miniatures" to a very willing public. By 1853 an estimated three million per year were being produced in the United States alone—mostly portraits but also scenic views.

In spite of its superb quality, the daguerreotype was a technological dead end. There were complaints about the difficulty of viewing, for the image on the highly polished metal could be viewed only from certain angles. The mercury vapor necessary for the process was highly poisonous and probably shortened the life of more than one daguerreotypist. But the most serious drawback was that each plate was unique; there was no way of producing multiple copies except by rephotographing the original. What was needed was a negative-positive process where any number of positive images could be made from a single negative. Just such a process had already been invented.

The earliest daguerreotype known to exist (opposite, far left) is by the inventor of the process, Louis Daguerre. The exposure was probably several minutes long—much less than the 8 hr required by Niépce's heliograph. The enthusiastic reception of Daguerre's process extended to poetry: "Light is that silent artist/Which without the aid of man/Designs on silver bright/Daguerre's immortal plan." Niagara Falls (near left) was already a world-famous tourist attraction when Platt Babbitt made this daguerreotype about 1855.

It was in America that the daguerreotype reached the height of its popularity. Millions of Americans, famous (right) and obscure, had their portraits made. Although the exposure time was reduced to less than a minute, it was still long enough to demand a quiet dignity on the part of the subject. This portrait, taken by an itinerant daguerreotypist, is the only known photograph of the 19th-century poet, Emily Dickinson. Just like her poems, it seems direct on the surface but elusive on more intimate levels. Dickinson later described herself as "small, like the wren; and my hair is bold, like the chestnut burr; and my eyes, like the sherry in the glass that the guest leaves."

PHOTOGRAPHER UNKNOWN: *Emily Dickinson at Seventeen*, c. 1847

323

Calotype: Pictures on Paper

Talbot's photographic establishment, c. 1844

On January 25, 1839, less than three weeks after the announcement of Daguerre's process to the French Academy, an English amateur scientist named William Henry Fox Talbot appeared before the Royal Institution of Great Britain to announce that he too had invented a way to fix the image of the camera obscura. Talbot was a disappointed man when he gave his hastily prepared report; he admitted later that Daguerre's prior announcement "frustrated the hope with which I had pursued, during nearly five years, this long and complicated series of experiments—the hope, namely, of being the first to announce to the world the existence of the New Art—which has since been named Photography." Although this dream could not be fulfilled, Talbot was still determined to establish that his process was wholly independent of Daguerre's.

Talbot's first experiments had been similar to Wedgwood's; he had made negative silhouettes by placing objects on paper sensitized with silver chloride and exposing them to light. Then he experimented with images formed by a camera obscura. The light-sensitive coating used in his early experiments was exposed long enough for the image to become visible during the exposure. In June, 1840 Talbot announced a technique that not only shortened the exposure time considerably but also became the basis of modern photographic chemistry: the paper was exposed only long enough to produce a latent (still invisible) image, which then was chemically developed. Talbot reported that nothing could be seen on the negative after exposure, but "the picture existed there, although invisible; and by a chemical process . . . it was made to appear in all its perfection." To make the latent image visible, Talbot used silver iodide (the light-sensitive element of the daguerreotype) treated with gallo nitrate of silver. He called his invention a calotype (after the Greek words *kalos*, "beautiful," and *typos,* "impression").

Talbot realized the value of having photographs on paper rather than on metal: his images were easily reproducible. He placed the fully developed negative in contact with another sheet of sensitized paper and exposed both to light, a procedure now known as contact printing. The dark areas of the negative blocked the light from the second sheet, while the clear areas allowed it through. The result was a positive image resembling the natural tones of the original scene.

Because of its reproducibility, the calotype had a major advantage over the one-of-a-kind daguerreotype. It never became widely popular, however, primarily because the calotype image seemed inferior to many viewers. The fibers in the paper produced a soft, slightly textured photograph that has been compared to a charcoal drawing. The calotype is beautiful in its own way, but viewers comparing it to a daguerreotype were disappointed in its lack of sharp detail.

Some of the activities at Talbot's establishment in Reading, near London, are shown in this early calotype taken in 2 parts and pieced together. At left, an assistant copies a painting. In the center, possibly Talbot himself prepares a camera to take a portrait. At right, the technician at the racks makes contact prints and another assistant photographs a statue. At far right, the kneeling man holds a target for the maker of this photograph to focus on. The prints for the first book to be illustrated with photographs, The Pencil of Nature, were made at Reading. In a "Notice to the Reader," Talbot gave his assurance that "The plates of the present work are impressed by the agency of light alone, without any aid whatever from the artist's pencil. They are the sun pictures themselves, and not, as some persons have imagined, engravings in imitation."

Miss Murray

William Leighton Leitch

In a brief but productive collaboration between 1843 and 1847, landscape painter David Octavius Hill and photographer Robert Adamson made elegant use of the soft texture characteristic of the calotype's paper negative, basing their compositions on broad masses of light and shade. Their photographs of mid-19th-century Scotland include masterfully composed portraits that almost always display character and naturalness, despite the fact that their subjects were carefully posed and braced to prevent them from moving during long exposures.

Bonaly Tower

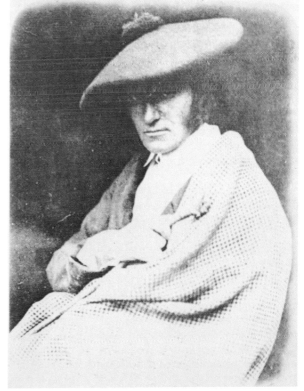

John Brown, M.D.

DAVID OCTAVIUS HILL AND ROBERT ADAMSON: 1843–1847

Collodion Wet-Plate: Sharp and Reproducible

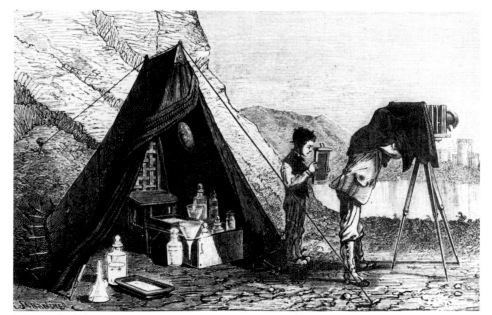

A photographer in the field, c. 1865

The collodion wet-plate process combined so many advantages that despite its drawbacks virtually all photographers used it from its introduction in 1851 until the development of the gelatin dry plate about 30 years later. It had the best feature of the daguerreotype—sharpness—and the best of the calotype—reproducibility. And it was more light sensitive than either of them, with exposures as short as five seconds.

For some time, workers had been looking for a substance that would bind a light-sensitive emulsion to a glass plate. Glass was better than paper or metal as a support for emulsion since it was textureless, uniformly transparent and chemically inert. A cousin of Niépce, Abel Niepce de Saint-Victor, found that egg white could be used, but since his albumen glass plates required very long exposures the search for a better substance continued. Even the slime exuded by snails was tried. One suggested material was the newly invented collodion (nitrocellulose dis-

solved in ether and alcohol), which is sticky when wet and dries into a tough, transparent skin. Frederick Scott Archer, an English sculptor who had been making calotypes of his sitters to use as studies, discovered that the collodion was an excellent basis for an emulsion. But the plate had to be exposed and processed while it was still wet.

Coating a plate required nimble fingers, flexible wrists and practiced timing. A mixture of collodion and potassium iodide was poured onto the middle of the plate. The photographer held the glass by the edges and tilted it back and forth and from side to side until the surface was evenly covered. The excess collodion was poured back into its container. Then the plate was sensitized by being dipped in a bath of silver nitrate. It was exposed for a latent image while still damp, developed in pyrogallic acid or iron sulfate, fixed, washed and dried. All this was done right where the photograph was taken, which meant wherever

the photographer was able to lug a complete darkroom (above).

Collodion could be used to form either a negative or a positive image. Coated on glass it produced a negative from which a positive could be printed onto albumen-coated paper (opposite, top). If the glass was backed with a dark material like black velvet, paper or paint, the image was transformed into a positive ambrotype image (opposite, bottom), a kind of imitation daguerreotype. Coated on dark enameled metal it also formed a positive image—the durable, cheap tintype popular in America for portraits to be placed in albums, on campaign buttons and even on tombs.

By the 1860s the world had millions of photographic images; 25 years before there had been none. Photographers were everywhere—taking portraits, going to war, exploring distant places and bringing home pictures to prove they had been there.

A popular home entertainment during the 1850s and 1860s was looking at stereographic photographs like the one at right. If two photographs are taken side by side and then viewed through a stereoscope (a device that presents only one photograph to each eye), the impression is of a 3-dimensional image. The stereo cards were inexpensive enough for almost everyone to own, and millions were sold. Rather like television today, stereographs brought the world into every person's home. "Oh, infinite volumes of poems that I treasure in this small library of glass and pasteboard!" exclaimed Oliver Wendell Holmes of his collection of stereographs. With it, he wrote, "I stroll through Rhenish vineyards, I sit under Roman arches, I walk the streets of once-buried cities, I look into the chasms of Alpine glaciers, and on the rush of wasteful cataracts. I pass, in a moment, from the banks of the Charles to the ford of the Jordan."

An ambrotype (right) is a collodion-on-glass negative backed with a dark material such as black cloth or varnish. Half of the plate shown here has not been backed and looks like an ordinary negative. The dark backing behind the other half causes a positive image to appear.

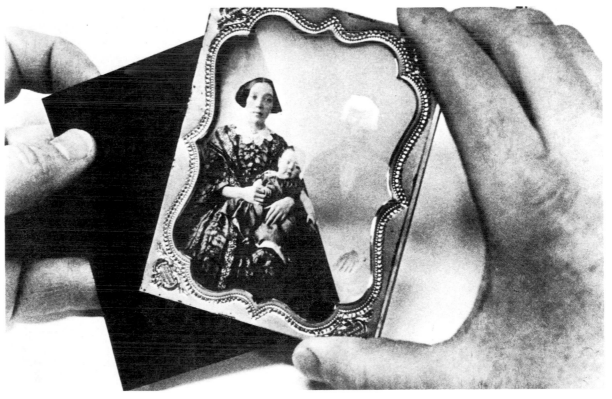

Early Portraits

After seeing some daguerreotype portraits, the poet Elizabeth Barrett wrote to a friend in 1843, "several of these wonderful portraits . . . like engravings—only exquisite and delicate beyond the work of graver—have I seen lately—longing to have such a memorial of every Being dear to me in the world. It is not merely the likeness which is precious in such cases—but the association and the sense of nearness involved in the thing . . . the fact of the *very shadow of the person* lying there fixed for ever! . . . I would rather have such a memorial of one I dearly loved, than the noblest artist's work ever produced. I do not say so in respect (or disrespect) to Art, but for Love's sake. Will you understand?—even if you will not agree?" The couple on the opening page of this chapter would have understood.

People wanted portraits. Even when exposure times were long and having one's portrait meant sitting in bright sunlight for several minutes with eyes watering, trying not to blink or move, people flocked to portrait studios to have their likenesses drawn by "the sacred radiance of the Sun." Images of almost every famous person who had not died before 1839 have come down to us in portraits by photographers like Nadar and Julia Margaret Cameron *(right)*. Ordinary people were photographed as well—in Plumbe's National Daguerrian Gallery where hand tinted "Patent Premium Coloured Likenesses" were made, and in cut-rate shops where double-lens cameras took them "two at a pop." For pioneers moving West in America, the pictures were a link to the family and friends they had left behind; two books went West with the pioneers—a Bible and a photograph album.

JULIA MARGARET CAMERON: *Sir Henry Taylor,* c. 1865

André Adolphe Disdéri, popularizer of the carte de visite

Small portraits called cartes-de-visite were immensely popular in the 1860s. They were taken with a camera that exposed only 1 section of the photographic plate at a time. Thus the customer could strike several different poses for the price of one. At left is shown a print before it is cut into separate pictures. People collected cartes-de-visite in albums, inserting pictures of themselves, friends, relatives and famous people like Queen Victoria. One album cover advised: "Yes, this is my Album, but learn ere you look;/that all are expected to add to my book./You are welcome to quiz it, the penalty is,/that you add your own Portrait for others to quiz." André Adolphe Disdéri, who popularized these multiple portraits, is shown above on a carte-de-visite, Carte portraits became a fad when Napoleon III stopped on the way to war to pose for cartes-de-visite at Disdéri's studio.

Images of War

ROGER FENTON: *Cavalry Camp, Balaklava*, 1855

Until the invention of photography, wars often seemed remote and rather exciting to the people at home. Details of war were learned only from delayed news accounts, or even later from returning soldiers or from paintings or poems. The British campaigns in the Crimean War of the 1850s were the first to be extensively photographed. It was a disastrous war for Great Britain. The ill-fated Charge of the Light Brigade was only one of the catastrophes; official bungling, disease, starvation and exposure took more British lives than did the enemy. However, Roger Fenton, the official photographer, generally showed views of the war *(above)* as idealized as Tennyson's poem about the Charge *(top caption)*.

Not until the American Civil War did many photographs appear that showed a less romantic side of war *(opposite)*. Mathew B. Brady, a successful portrait photographer, conceived the idea of sending photographic teams to document the war. Photographing during a battle was difficult. The collodion process required up to several seconds' exposure and the glass plates had to be processed right on the spot, which made the photographer's darkroom-wagon a target for enemy gunners. Although Brady had hoped to sell his photographs, they often showed what people wanted only to forget *(bottom caption)*.

Roger Fenton took many picturesque views of the Crimean War such as the one at left. The Charge of the Light Brigade, a military blunder that needlessly took the lives of hundreds of men, occurred during this war. The famous Charge was immortalized in Tennyson's equally famous poem. Like Fenton's views, the poem deals only with the palatable aspects of war.

> *Half a league, half a league,*
> *Half a league onward,*
> *All in the valley of Death*
> *Rode the six hundred.*
> *"Forward, the Light Brigade!*
> *Charge for the guns!" he said:*
> *Into the valley of Death*
> *Rode the six hundred.*
> *. . .*
>
> *When can their glory fade?*
> *O the wild charge they made!*
> *All the world wonder'd.*
> *Honour the charge they made!*
> *Honour the Light Brigade,*
> *Noble six hundred!*

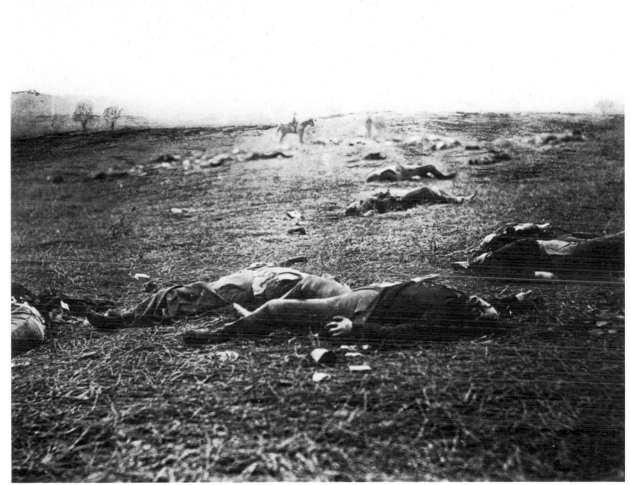

TIMOTHY H. O'SULLIVAN: *A Harvest of Death, Gettysburg,* July 1863

Brady took only a few, if any, photographs himself, and some of his men (Alexander Gardner and Timothy H. O'Sullivan among them) broke with him and set up their own operation. But it was Brady's idea and personal investment that launched an invaluable documentation of American history.

Another view of war was shown by Civil War photographers such as Brady, Gardner and O'Sullivan (above). Oliver Wendell Holmes had been on the battlefield at Antietam searching for his wounded son and later saw the photographs Brady made there. "Let him who wishes to know what war is look at this series of illustrations. . . . It was so nearly like visiting the battlefield to look over these views, that all the emotions excited by the actual sight of the stained and sordid scene, strewed with rags and wrecks, came back to us, and we buried them in the recesses of our cabinet as we would have buried the mutilated remains of the dead they too vividly represented."

331

Early Travel Photography

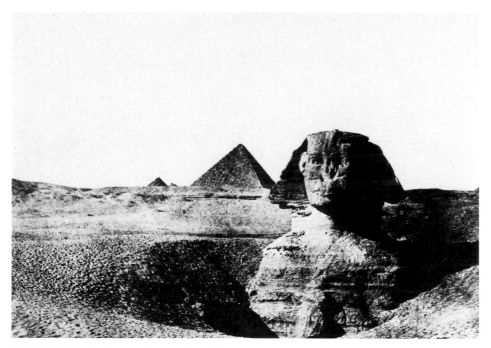

MAXIME DU CAMP: *The Sphinx and Pyramids, Egypt,* 1851

Expeditions to take photographs of faraway places were begun almost as soon as the invention of photography was announced. In addition to all the materials, chemicals and knowledge needed to coat, expose and process their photographs in remote places, expeditionary photographers also had to have considerable fortitude. Timothy H. O'Sullivan, whose darkroom on a boat appears opposite, described an area called the Humboldt Sink: "It was a pretty location to work in, and viewing there was as pleasant work as could be desired; the only drawback was an unlimited number of the most voracious and particularly poisonous mosquitoes that we met with during our entire trip. Add to this . . . frequent attacks of that most enervating of all fevers, known as the 'mountain ail,' and you will see why we did not work up more of that country."

In the middle of the 19th century, the world seemed full of unexplored wonders. Steamships and railroads were making it possible for more people to travel, but distant lands were still exotic and mysterious and people were hungry for photographs of them. There had always been drawings portraying unfamiliar places, but they were an artist's personal vision. The camera seemed an extension of one's own vision; a photograph was accepted as real, a faithful image created by a mechanical process.

The Near East was of special interest. Not only was it exotic, but its association with Biblical places and ancient cultures made it even more fascinating. Within a few months of the announcement of Daguerre's process in 1839, a photographic team was in Egypt: "We keep daguerreotyping away like lions, and from Cairo hope to send home an interesting batch." Since there was no way of reproducing the daguerreotypes directly, they had to be traced and reproduced as copperplate engravings. With the invention of the calotype and later the collodion processes, actual pictures from the Near East taken by photographers like Maxime Du Camp *(above)* and Francis Frith were soon available.

One of the most spectacular regions of all, the western frontier of the United States, remained largely unphotographed until the late 1860s. Explorers and artists had been in the Rocky Mountain area long before this time, but the tales they told of this region and the sketches they made were often thought to be exaggerations. After the Civil War, when several government expeditions set out to explore and map the West, photographers accompanied them, not always to the delight of the other members: "The camera in its strong box was a heavy load to carry up the rocks," went a description of a Grand Canyon trip in 1871, "but it was nothing to the chemical and plate-holder box, which in turn was featherweight compared to the imitation hand organ which served for a darkroom." Civil War photographers O'Sullivan *(opposite)* and Gardner both went West with government expeditions. William Henry Jackson's photographs of Yellowstone helped convince Congress to set the area aside as a National Park, as did the photographs of Yosemite made by Carleton Eugene Watkins.

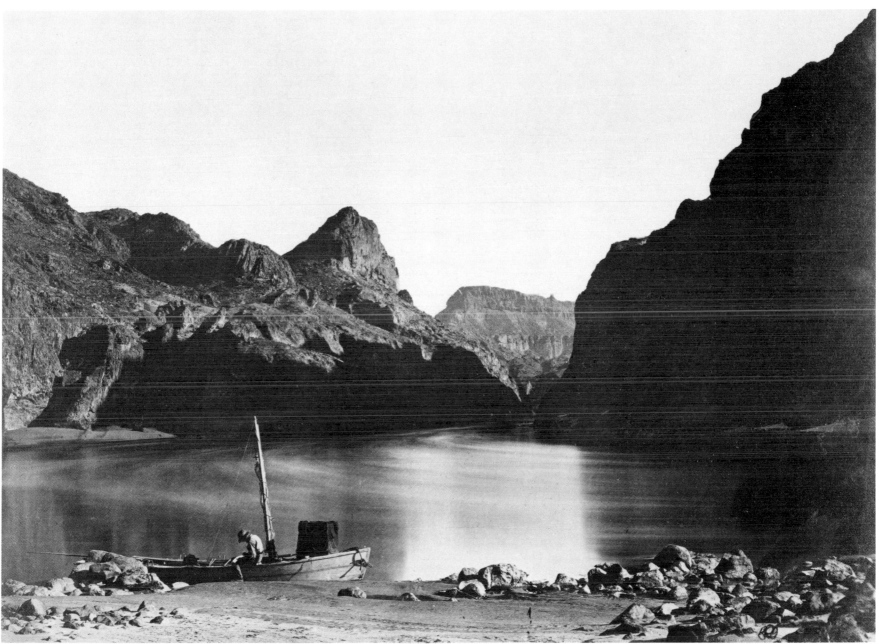

TIMOTHY H. O'SULLIVAN: *Black Canyon, Colorado River*, 1871

Gelatin Emulsion/Roll-Film Base: Photography for Everyone

By the mid-1870s, about 35 years after the invention of photography, almost everyone had been photographed at one time or another, certainly everyone had seen photographs and probably many people had thought of taking pictures themselves. But the technical skill and the large quantity of equipment needed for the collodion wet-plate process restricted photography to the professionals and the most dedicated amateurs. Even they complained of the inconvenience of the process and made many attempts to improve it.

By the 1880s, the perfection of two techniques not only made possible a fast, dry plate but also eliminated the need for the clumsy, fragile glass plate itself. The first development was a new emulsion in which the light-sensitive silver salts could be suspended. It was based on gelatin—a jellylike substance processed from cattle bones and hides. It retained its speed when dry and could be applied on the other invention—rolls of film. Roll film revolutionized photography by making it simple enough for anyone to enjoy.

Much of the credit for popularizing photography goes to one man, George Eastman, who began as a bank clerk in Rochester, New York, and built his Eastman Kodak Company into one of the country's foremost industrial enterprises. Almost from the day Eastman bought his first wet-plate camera in 1877, he searched for a simpler way to take pictures. "It seemed," he said, "that one ought to be able to carry less than a pack-horse load," Many people had experimented with roll film, but no one was able to produce it commercially until Eastman invented the equipment to manufacture film on a mass basis. The result was Eastman's American Film, a roll of paper coated with a thin gelatin emulsion. The emulsion had to be stripped from the opaque paper backing to provide a negative that light could shine through for making prints. Most photographers had trouble with this operation, as the negative often stretched when removed from the paper, so the film was usually sent back to the company for processing.

The new film created a great stir among photographers, but it had little immediate meaning for the general public since the heavy, expensive view camera was still necessary for taking pictures. But roll film made possible a new kind of camera—inexpensive, light and simple to operate—that made everyone a potential photographer. Eastman introduced the Kodak in 1888. It came loaded with enough film for 100 pictures. When the roll was used up, the owner returned the camera with the exposed film still in it to the Eastman company in Rochester. Soon the developed and printed photographs and the camera, reloaded with film, were sent back to the owner.

The roll-film Kodak became an international sensation almost overnight. With the invention by Hannibal Goodwin of a truly modern roll film (a transparent, flexible plastic, coated with a thin emulsion and sturdy enough to be used without a paper support), a new photographic era, of simple, light cameras and easy-to-handle roll film, had begun. The Eastman Kodak Company knew very early who would be the main users of its products and they directed their advertising accordingly: "A collection of these pictures may be made to furnish a pictorial history of life as it is lived by the owner, that will grow more valuable every day that passes."

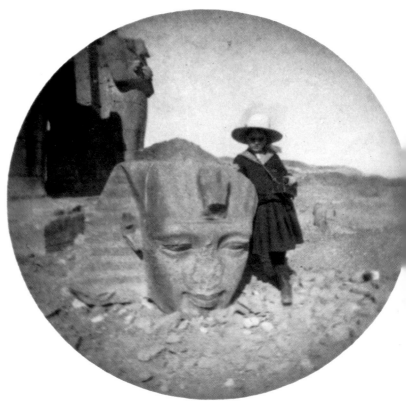

PHOTOGRAPHER UNKNOWN: *Ruth at Thebes*, c. 1890

Striking a casual pose that was to be repeated in countless tourist snapshots, a camera-carrying girl traveling in Egypt arranged herself by a stone head of Ramses II as a companion immortalized the scene in the round frame that early Kodak cameras produced (above). The photographer is unknown, but the handwritten note in the album from which this picture came indicates that the girl's name was Ruth. Compared to the photograph of the sphinx and pyramids on page 332, this snapshot of a traveler in a middy blouse and wearing a Kodak brings the mysteries of unknown lands down to human size and suddenly makes them seem much less mysterious.

FRED CHURCH: *George Eastman with a Kodak*, 1890

George Eastman, who put the Kodak box camera on the market and thereby put photography into everybody's hands, stands aboard the S.S. Gallia in the act of using his invention (above). Roll film made the camera small enough to carry about easily. Fast gelatin emulsions permitted $\frac{1}{25}$-sec exposures so subjects did not have to strain to hold still. The Kodak slogan was, aptly: "You press the button, we do the rest."

Time and Motion in Early Photographs

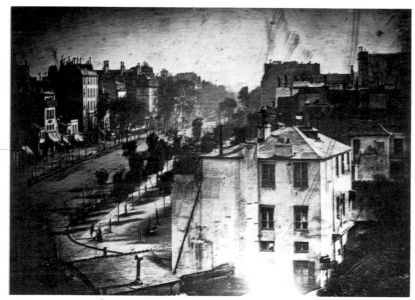

LOUIS JACQUES MANDÉ DAGUERRE: *Parisian Boulevard,* 1839

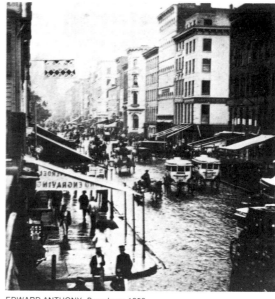

EDWARD ANTHONY: *Broadway,* 1859

Today, photographers using modern high-speed films consider an exposure of one second's duration to be relatively long. But photographers using earlier processes had to put up with much slower emulsions, and an exposure of several seconds was considered quite short. People or objects that moved during the exposure were blurred or, if the exposure was long enough, disappeared completely; busy streets sometimes looked deserted *(above left)* because most people had not stayed still long enough to register an image.

Stereographic photographs *(above right)* were the first to show action as it was taking place, such as people in mid-stride or horses and carts in motion. This was possible because the short-focal-length lens of the stereo camera produced a bright, sharp image at wide apertures and thus could be used with very brief exposure times. "How infinitely superior to those 'cities of the dead' with which we have hitherto been compelled to content ourselves," commented one viewer.

These "instantaneous" photographs recorded such a short moment of time that they revealed aspects of motion that the unaided eye was not capable of seeing. Some of the arrested motions were so different from the conventional artistic representations that the photographs looked wrong. A galloping horse, for example, had often been drawn with all four feet off the ground—the front legs extended forward and hind legs extended back. When Eadweard Muybridge's photographic motion studies of a horse, published in 1878, showed that all four feet were off the ground only when they were bunched under the horse's belly, some suspicion arose that Muybridge had altered the photographs. Using the new and fast gelatin emulsion and specially constructed multi-lens cameras, Muybridge compiled hundreds of studies of different animals and humans in action *(right).*

The busy streets of a Parisian boulevard (far left) appear depopulated because of the long exposure this daguerreotype required. Only a person getting a shoeshine near the corner of the sidewalk stood still long enough to be recorded; all the other people, horses and carriages had blurred so much that no image of them appeared on the plate. By contrast, the relatively fast collodion process combined with the fast lens of a stereo camera froze the action on another busy street (above, 1 of a pair of stereo views).

The pictures at right were part of Eadweard Muybridge's project Animal Locomotion, *which analyzed the movements of humans and many animals. The sequence was made with 3 special cameras, each with 12 lenses and shutters synchronized to work together so that each stage of the movement was recorded simultaneously from 3 sides.*

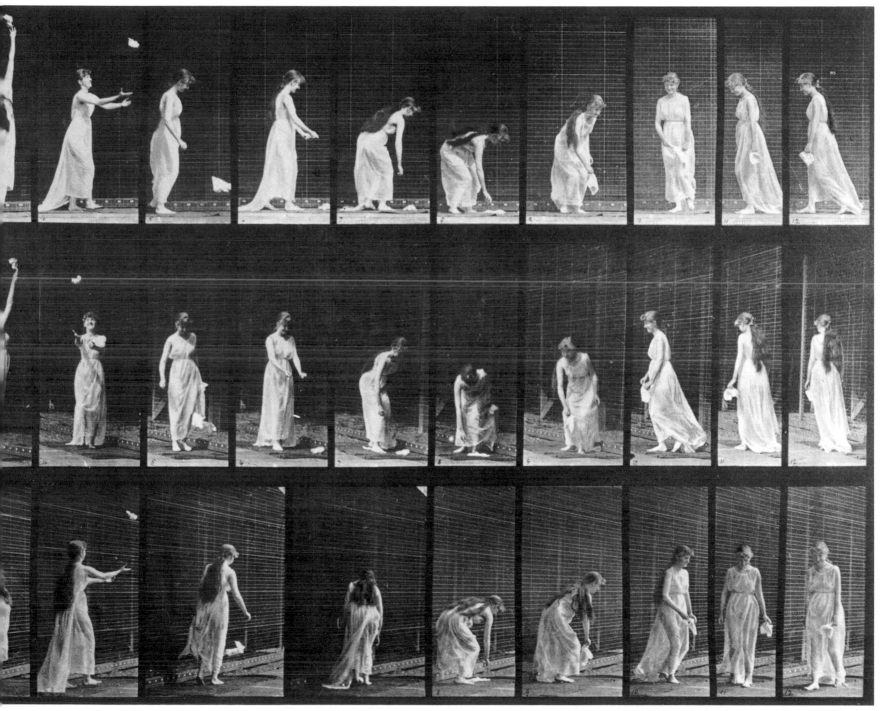

EADWEARD MUYBRIDGE: *Motion Study of a Girl Playing with a Handkerchief*, c. 1885

The Photograph as Document

To early viewers, the most wonderful aspect of photography was its ability to show an immense amount of literal and exact detail. "This is the Daguerreotype! . . . There is not an object . . . which was not in the original [scene]; and it is impossible that one should have been omitted. Think of that!" Faith in the camera as a literal recorder gave rise to a belief, still persisting today, that the camera does not lie; and it provides photographs themselves with the great psychological strength of appearing to tell the truth.

Photographs can be documents on many levels. Most snapshots record a particular scene or event simply to help the participants remember it later. A news photograph implies that this is exactly what you would have seen if you had been there yourself. On yet another level, a photograph can record reality and at the same time communicate the photographer's comment on that reality. Lewis Hine said of his work: "I wanted to show the things that had to be corrected. I wanted to show the things that had to be appreciated." His statement describes the use of photography as an instrument of social change, a style that has come to be known as documentary (see next pages).

Eugène Atget was a document-maker in the early part of this century. A sign on his door read "Documents pour Artistes" and, according to a friend, Atget's ambition was "to create a collection of all that which both in Paris and its surroundings was artistic and picturesque. An immense subject." Atget made thousands of photographs of the streets, cafés, shops (opposite), monuments, parks and people of the Paris he loved. His pictures won him little notice during his lifetime; he barely managed to eke out a living by selling them to artists, architects and others who wanted visual records of the city. Many photographers can record the external appearance of a place, but Atget did more than that. He conveyed the atmosphere and mood of Paris.

August Sander chose to document a people rather than a city—the citizens of pre-World War II Germany. His pictures were not meant to reveal personal character but to show the classes making up German society of that period. He photographed laborers (right), soldiers, business people and provincial families, all formally posed. The portraits are so utterly factual and unsentimental as to be chilling at times; the individual disappears and only the type remains.

AUGUST SANDER: Laborer, 1927

August Sander's photographs are documents of social types rather than portraits of individuals. This photograph of a Cologne laborer with a load of bricks was one among hundreds of studies Sander made of the types he saw in pre-World War II Germany. Holding his pose as if standing still for a portrait painter, the subject displays his trade with dignity and without becoming a stereotype. The man has paused between taking up his burden and laying it down, but there is no indication of time or even place. In fact, the background is deliberately absent; Sander eliminated it from the negative.

Eugène Atget artfully revealed the essence of Paris while seeming merely to document its external appearance. Here the shop window display and the dummies merge so that the photograph seems to show a ghostly view of Paris populated only by a group of urbane and smartly dressed mannequins.

EUGENE ATGET: *Avenue des Gobelins,* c. 1910

339

Photography and Social Change

Photography has been called the mirror with a memory, and in addition to merely reflecting the world, it can also mirror it with a purpose. Jacob Riis, a Danish-born newspaper reporter of the late 19th century, was one of the first to show how photographs could become social documents. Riis had been writing about the grinding brutality of life in New York City's slums and began to take pictures to show, as he said, what "no mere description could, the misery and vice that he had noticed in his ten years of experience . . . and suggest the direction in which good might be done."

Lewis W. Hine was a trained sociologist with a passionate social awareness, especially of the abuses of child labor *(right)*. This evil was widespread in the early 20th century, and Hine documented it to provide evidence for reformers. With sarcastic fury he wrote of " 'opportunities' for the child and the family to . . . relieve the over-burdened manufacturer, help him pay his rent, supply his equipment, take care of his rush and slack seasons, and help him to keep down his wage scale."

During the Depression of the 1930's, the nation's entire economic structure was in deep trouble and farm families were in particular need. Assistant Secretary of Agriculture Rexford G. Tugwell realized that the government's program of aid to farmers was expensive and controversial. To prove both the extent of the problem and the effectiveness of the cure, he appointed Roy Stryker to supervise photographic coverage of the program. Stryker recruited a remarkable band of talent, which included Dorothea Lange *(opposite),* Walker Evans, Ben Shahn, Russell Lee and Arthur Rothstein. Their work for the Resettlement Administration (later the Farm Security Administration) produced a classic collection of documentary photographs.

LEWIS W. HINE: *Victim of a Mill Accident,* c. 1910

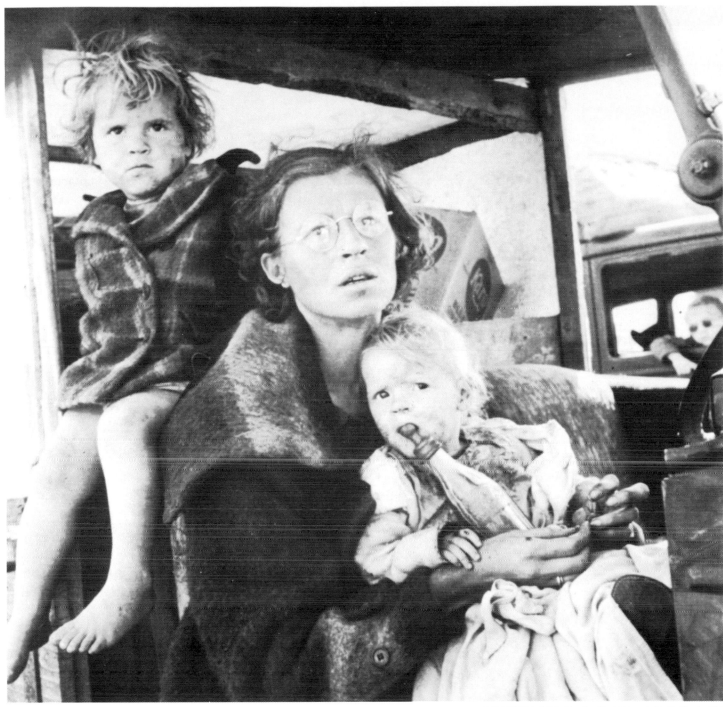

DOROTHEA LANGE: *Heading West, Tulare Lake, California,* 1939

◀ Between 1908 and 1921, Lewis Hine made 5,000 pictures for the National Child Labor Committee documenting the abuses of child labor. This one-armed boy, a casualty of a mill accident, posed for Hine in about 1910. "We don't have many accidents," one foreman said at the time. "Once in a while a finger is mashed or a foot, but it doesn't amount to anything."

In showing the plight of "one third of a nation" during the Depression of the 1930s, the documentary photographers of the Farm Security Administration produced a monumental collection of images. Dorothea Lange had a unique ability to photograph people at the moment that their expressions and gestures revealed their lives and feelings. Here the woman looks haunted by the memory of a time when things were better or by her concern for a bleak future. Lange's photographs were ordinarily direct and unambiguous, but in this one a child in another truck—out of focus and a little dreamlike—adds to the feeling of uneasiness.

The Photograph as Art in the 19th Century

Almost from the moment of its birth, photography began staking out claims in areas that had long been reserved for painting. Portraits, still lifes, landscapes, nudes and even allegories became photographic subject matter. Some artists bristled at the suggestion that photography itself might be considered an art. In 1862 a group of French artists formally protested that photography was a soulless, mechanical process, "never resulting in works which could . . . ever be compared with those works which are the fruits of intelligence and the study of art. . . ."

Photographers resented such assertions, but they in turn simply regarded photography as another kind of painting. The oldest known daguerreotype *(page 322),* taken by Daguerre himself in 1837, reveals this clearly. It is a still life self-consciously composed in the style of neoclassical painting.

Many photographers adapted styles of painting to the photographic print. From the 1850s through the 1870s there was a rage for illustrative photographs similar to a storytelling style of painting popular at the time. Julia Margaret Cameron, in addition to producing elegant and powerful portraits *(page 328),* indulged in romantic costume scenes such as illustrations for Tennyson's *The Idylls of the King.* Oscar G. Rejlander pieced together 30 negatives to produce an allegorical pseudo-painting entitled *The Two Ways of Life*—one way led to dissolution and despair, the other to good works and contentment.

The most famous, and commercially the most successful, of those intending to elevate photography to an art was Henry Peach Robinson. Robinson turned out many illustrative and allegorical photographs, carefully plotted in advance, in which several negatives were combined to form the final print *(photograph and drawing, right).* Robinson be-

HENRY PEACH ROBINSON: *Fading Away,* 1858

Inspired by romantic literature, the British photographer Henry Peach Robinson perfected a composite photographic technique that allowed him to produce imaginary scenes. Fading Away (above) was staged by posing models separately and piecing together the images. Robinson usually planned such compositions in considerable detail: at right, a half-finished composite for another print shows a cut-out photograph of a reclining woman superimposed on a preliminary pencil sketch.

HENRY PEACH ROBINSON: *Preliminary sketch with photograph inserted,* c. 1860

came the leader of a so-called High Art movement in 19th-century photography, one which advocated beauty and artistic effect no matter how it was obtained. In his *Pictorial Effect in Photography,* Robinson advised: "Any dodge, trick and conjuration of any kind is open to the photographer's use. . . . It is his imperative duty to avoid the mean, the bare and the ugly, and to aim to elevate his subject, to avoid awkward forms and to correct the unpicturesque. . . ."

By the 1880s a new movement was coming to the fore led by Peter Henry Emerson, the first to campaign against the stand that "art" photographers had taken. He felt that true photographic art was possible only through exploiting the camera's unique ability to capture reality in a direct way *(left).* He scorned the still-popular pictorial school, especially such practices as composite printing, costumed models, painted backdrops and sentimental views of daily life.

Emerson laid down his own rules for what he called naturalistic photography: simplicity of equipment; no "faking" by means of lighting, posing, costumes or props; free composition without reliance on classical rules; and no retouching ("the process by which a good, bad or indifferent photograph is converted into a bad drawing or painting"). He also promoted what he believed was a scientific focusing technique that imitated the way the eye perceives a scene: sharply focused on the main subject, but with the foreground and especially the background slightly out of focus.

Despite the fact that Emerson later became convinced that photography was not an art at all but only "a handmaiden to science and art," his earlier ideas had already influenced a new generation of photographers who no longer felt the need to imitate painting but began to explore photography as an art in its own right.

PETER HENRY EMERSON: *The Poacher—A Hare in View,* c. 1885

Peter Henry Emerson rejected the methods of the High Art photographers and insisted that photography should not imitate art but should strive for a naturalistic effect that was not artificially contrived. He illustrated his theories with his own photographs of peasants on the East Anglian marshes in England.

Pictorial Photography and the Photo-Secession

Was photography an art? Photographers were still concerned with this question at the turn of the century, and the pictorialists or art photographers wanted to separate their photographs from those taken for some other purpose—ordinary snapshots, for example. The *American Amateur Photographer* suggested: "If we had in America a dignified 'Photographic Salon,' with a competent jury, in which the only prizes should be the distinction of being admitted to the walls of the 'Salon,' we believe that our art would be greatly advanced. 'Art for art's sake' should be the inspiring word for every camera lover." The pictorial movement was an international one. Exhibitions and salons where photographs were judged on their aesthetic and artistic merits were organized by the Vienna Camera Club, The Linked Ring Brotherhood in England, the Photo-Club de Paris, the American Photo-Secessionists and others.

Many pictorialists believed the artistic merits increased if the photograph looked like some other kind of art—charcoal drawing, mezzotint or anything other than photography—and they patterned their work quite frankly on painting, especially the work of the French Impressionists, for whom mood and a sense of atmosphere and light were important. The pictorialists favored mist-covered landscapes and soft cityscapes *(right);* the light was diffused, the line was soft and details were suppressed.

To achieve these effects, many pictorialists adopted printing techniques to which handwork was added, for example, gum-bichromate printing, where the image was transferred onto a thick, soft, often tinted coating that could easily be altered as the photographer wished. One critic was delighted: "The results no longer have anything in common with what used to be known as photog-

ALVIN LANGDON COBURN: *The Bridge, Venice,* 1905

Works by pictorialist photographers at the turn of the century often resembled Impressionist paintings, with light and atmosphere more important than specific subjects. "Sunshine and water form, I believe, the landscape photographer's finest subject matter," wrote Alvin Langdon Coburn about the gum-platinum print above.

ALFRED STIEGLITZ: *The Steerage*, 1907

Although Alfred Stieglitz championed pictorialist works that resembled paintings, his own photographs (except for a brief early period) did not include handwork or other alterations of the direct camera image. Above, the patterns made by the people and machinery compelled him to make this photograph. "I saw a picture of shapes and underlying that the feeling I had about life."

raphy. For that reason, one could proudly say that these photographers have broken with the tradition of the artificial reproduction of nature. They have freed themselves from photography. They have sought the ideal in the works of artists. They have done away with photographic sharpness, the clear and disturbing representation of details, so that they can achieve simple, broad effects." Not everybody agreed. This did not fit at all into Peter Henry Emerson's ideas of naturalistic photography: "If pure photography is not good enough or 'high' enough . . . by all means let him become an artist and leave us alone and not try and foist 'fakes' upon us."

In America, one person, Alfred Stieglitz, was the leader and catalyst for pictorialists, and his influence on photography as an art form is hard to overestimate. For more than 60 years he photographed *(left)*, organized shows and published influential and avantgarde work by photographers and other artists. In his galleries—the Little Gallery of the Photo-Secession (later known simply by its address, 291), the Intimate Gallery and An American Place—he showed not only what he considered the best photographic works but also, for the first time in the United States, the works of Cezanne, Matisse, Picasso and other modern artists. In his magazine *Camera Work,* he published photographic criticism and works whose only requirement was that they be worthy of the word "art." Not only did he eventually force museum curators and art critics to grant photography a place beside the other arts, but by influence, example and sheer force of personality he twice set the style for American photography: first toward the early pictorial impressionistic ideal; and later toward sharply realistic, "straight" photography *(see next pages).*

345

The Direct and Unmanipulated Image

PAUL STRAND: *The White Fence,* 1916

While many pictorialists were making photographs that looked very much like paintings, a few were seeking ways to utilize characteristics unique to the photographic process itself. They wanted to return to the direct and unmanipulated photographs that characterized so much of 19th-century imagery. In 1917 Stieglitz devoted the last issue of *Camera Work* to Paul Strand, whose photographs he saw as representing a powerful new approach to photography as an art form. Strand believed that "objectivity is of the very essence of photography. . . . The fullest realization of this is accomplished without tricks of process or manipulation, through the use of straight photographic methods."

Stieglitz's own photographs were direct and unmanipulated. He felt that many of them were visual metaphors, accurate representations of objects in front of his camera and at the same time external counterparts or "equivalents" of his inner feelings. Since 1950, Minor White *(pages 83, 97, and 352)* carried on and expanded Stieglitz's concept of the equivalent. For White, the goal of the serious photographer was "to get from the tangible to the intangible," so that a straight photograph of real objects functions as a metaphor for the photographer's or the viewer's state of mind.

The direct or "straight" approach that dominated photography as an art form from the 1930s to the 1950s is exemplified by Edward Weston. He used the simplest technique and a bare minimum of equipment: generally, an 8 x 10 view camera with lens stopped down to the smallest aperture for sharpness in all parts of the picture, and contact-printed negatives that were seldom cropped. "My way of working—I start with no preconceived idea—discovery excites me to focus—then rediscovery through the lens—final form of presentation seen on ground glass, the finished print previsioned complete in every detail of texture, movement, proportion, *before exposure*—the shutter's release automatically and finally fixes my conception, allowing no after manipulation—the ultimate end, the print, is but a duplication of all that I saw and felt through my camera." Weston's photographs were both objective and personal. "Clouds, torsos, shells, peppers *(opposite, far right)*, trees, rocks, smokestacks are but interdependent, interrelated parts of a whole, which is life." Many other photographers, such as Ansel Adams *(pages 234, 247),* Imogen Cunningham *(page 91)* and Paul Caponigro *(page 120),* have used the straight approach.

EDWARD WESTON: *Pepper No. 30,* 1930

Edward Weston wrote of this photograph: "It is classic, completely satisfying,—a pepper—but more than a pepper: abstract, in that it is completely outside subject matter."

The Quest for a New Vision

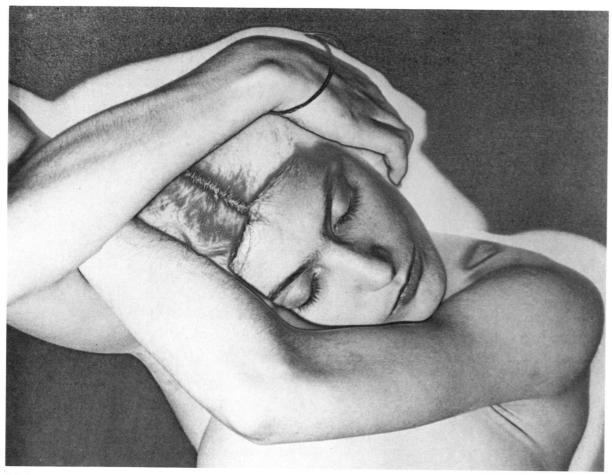

MAN RAY: *Solarization, 1929*

The beginning of the 20th century was a period of great revolution in many areas, including science, technology, mathematics, politics and also the arts. Movements like Fauvism, Expressionism, Cubism, Dada and Surrealism were permanently changing the meaning of the word "art." The Futurist art movement proposed "to sweep from the field of art all motifs and subjects that have already been exploited . . . to destroy the cult of the past . . . to despise utterly every form of imitation . . . to extol every form of originality. . . ." At the center of radical art, design and thinking was the Berlin

Bauhaus, a school to which the Hungarian artist László Moholy-Nagy came in 1922. He attempted to find new ways of seeing the world, and experimented with radical uses of photographic materials in an attempt to replace 19th-century pictorialist conventions with a "new vision" compatible with modern life. Moholy explored many ways of expanding photographic vision, through photograms, photomontage *(opposite, far right),* the Sabattier effect (often called solarization), unusual angles *(opposite, near right),* optical distortions and multiple exposures. He felt that "properly used,

they help to create a more complex and imaginary language of photography."

Another artist exploring new art forms was Man Ray, an American expatriate in Paris. He was particularly drawn to Dada, a philosophy that commented on the absurdities of modern existence by introducing even greater absurdities. "I like contradictions," he said. "We have never obtained the infinite variety and contradictions that exist in nature." Like Moholy, Man Ray utilized many techniques, including solarizations *(this page and page 258)* and photograms *(page 256).*

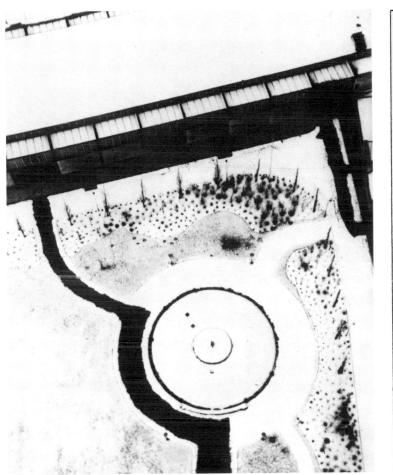

LÁSZLÓ MOHOLY-NAGY: *From the Radio Tower,* 1928

Photographers like László Moholy-Nagy and Man Ray used many techniques in their explorations of real, unreal and abstract imagery. The dark lines along the woman's hand (opposite) as well as other altered tones are due to solarization, exposing the image to light during development. In the photograph above, the extreme angle of the camera pointing straight down onto a snow-covered courtyard merged the walkways, trees and building into a single abstract design. The photomontage (right) combines pieces of several photographs. Moholy defined photomontage as "a tumultuous collision of whimsical detail from which hidden meanings flash," a definition that fits this ambiguous picture.

LÁSZLÓ MOHOLY-NAGY: *Jealousy,* 1927

Photojournalism

GEORGE SILK: *Johansson-Patterson Bout,* 1961

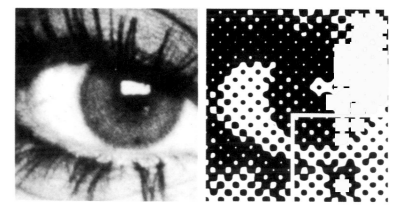

The halftone process converts the continuous shades of gray in a photograph into distinct units of black and white that can be printed with ink on paper. First, the original (above left) is rephotographed through a "screen"—a plate of clear plastic crosscut with a grid pattern. The grid, by optical principles still not fully understood, breaks the continuous tones of the picture into dots (above right). This scheme of dots is then transferred chemically onto a printing plate.

This detail of the printing plate, which shows the portion of the picture outlined at top right, indicates how the chemicals have etched a pattern that conforms to the dot scheme. Only the dots transfer ink to the paper in most printing processes. Since the dots are larger and thus their edges closer together in areas that were dark in the original, those areas transfer more ink to the paper—and print darker—than other sections, approximating the shading in the original photograph.

Today we take photographic reporting for granted, and whether it be a prizefight or a war, we expect to see pictures of the event. But news and pictures were not always partners. Drawings and cartoons appeared only occasionally in the drab 18th-century press. The *Pennsylvania Gazette* in the 1750s printed a woodcut of a snake chopped into many pieces over the caption, "Join, or die." That was scarcely spot news, but it touched on one of the major concerns of the time: the necessity for unity in the American colonies. The 19th century saw the growth of illustrated newspapers such as the *Illustrated London News* and, in America, *Harper's Weekly* and *Frank Leslie's Illustrated Newspaper.* Because the shades of gray needed to reproduce a photograph could not be printed simultaneously with ordinary type, photographs had to be converted into drawings and then into woodcuts before they could appear as news pic-

tures. The photograph merely furnished material for the artist.

The perfection in the 1880s of the halftone process *(diagram, right)* permitted photographs and type to be printed together, and photographs became an expected addition to news stories. "These are no fancy sketches," the *Illustrated American* promised, "they are the actual life of the place reproduced upon paper. . . ." The photo essay—a sequence of photographs plus brief textual material—came of age in the 1930s. It was pioneered by Stefan Lorant in European picture magazines and later in America by a score of publications. LIFE magazine stated its purpose as "To see life; to see the world . . . to see and to take pleasure in seeing; to see and be amazed; to see and be instructed." One memorable photo essay was W. Eugene Smith's *Spanish Village,* from which two pages appear opposite.

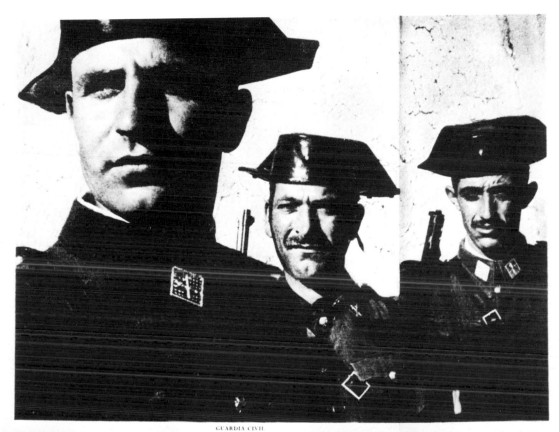

GUARDIA CIVIL

These stern men, enforcers of national law, are Franco's rural police. They patrol countryside, are feared by people in villages, which also have local police.

VILLAGE SCHOOL

Girls are taught in separate classes from the boys. Four rooms and four teachers handle all pupils, as many as 200 in winter, between the ages of 6 and 14.

◄ FAMILY DINNER

The Curials eat thick bean and potato soup from common pot on dirt floor of their kitchen. The father, mother and four children all share the one bedroom.

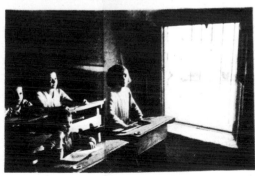

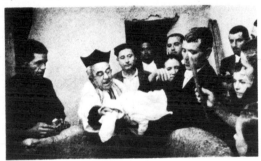

A CHRISTENING

THE THREAD MAKER

CONTINUED ON NEXT PAGE 127

126

351

The photo essay—pictures plus supporting text — was the mainstay of mass-circulation picture magazines such as LIFE and Look. Above are 2 pages from Spanish Village, *photographed for LIFE by W. Eugene Smith, whose picture essays are unsurpassed in their intensity and photographic beauty.*

The 1950s and After

Before World War II most photographers either were self taught or had learned their profession by apprenticeship. In the 1950s after the war, many returning veterans, aided by education benefits of the GI bill, entered trade schools to prepare for careers in photography. A few pioneering art schools and colleges also began to offer photography courses, a foretaste of the surge of college courses to come in the 1960s.

Photography as an art had not yet achieved the wide acceptance that it would in the 1960s. Minor White used to say that photographers functioning as artists during this time were so few that they used to clump together for warmth. American work of the 1950s was often described in terms of regional styles. The straight photography of Ansel Adams *(pages 234, 247)*, Wynn Bullock, Minor White *(this page and pages 83, 97)* and others was referred to as a west coast style. The more abstract work of Harry Callahan *(page 194)*, Arthur Siegel, Aaron Siskind and Henry Holmes Smith was identified with Chicago and the mid-west. Many of these photographers had been influenced by László Moholy-Nagy *(page 349)* when he began a New Bauhaus in Chicago in 1937. New York was thought of as the center for social documentation, particularly the work of photographers in the politically active Photo League, for example Lou Bernstein *(page 195)*.

Meanwhile, tied to no particular region, Robert Frank, a Swiss, was traveling across the United States photographing the mundane and often drab aspects of life in the 1950s. The resulting book, *The Americans,* was at first bitterly attacked by critics for its ironic view of America *(opposite)*, but it was to exert an extraordinary influence on the photographers of the 1960s.

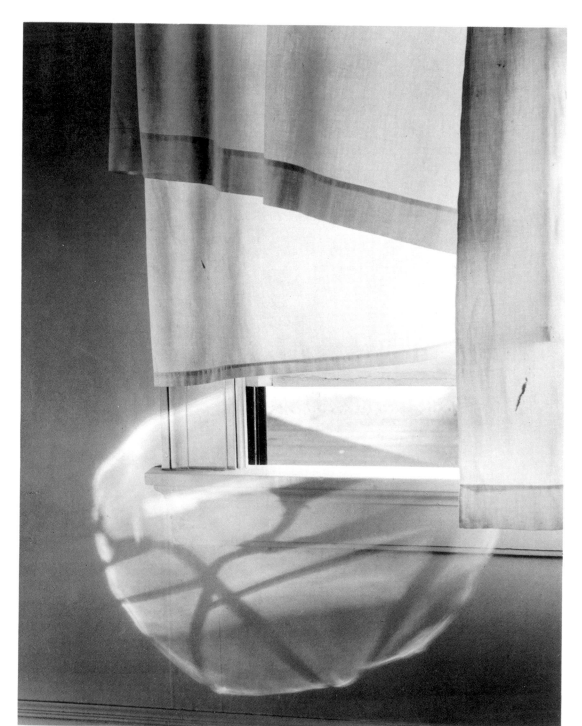

MINOR WHITE: *Windowsill Daydreaming,* 1958

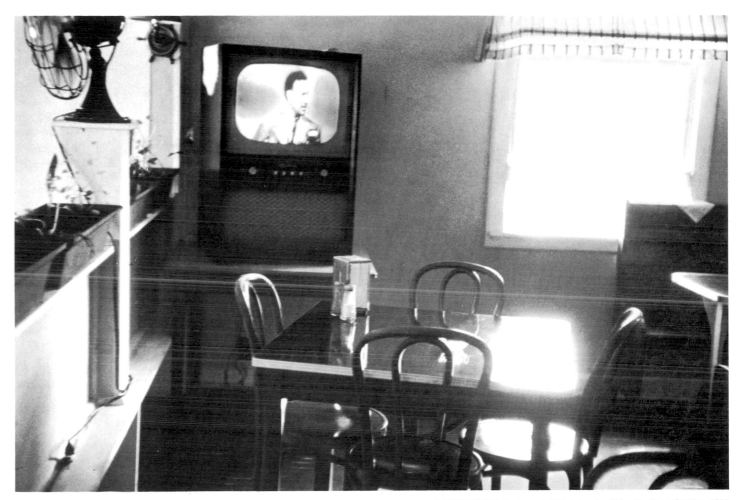

ROBERT FRANK: *Restaurant—U.S. 1, Leaving Columbia, South Carolina,* 1955

◄ *Minor White was extremely influential as a photographer, editor for many years of* Aperture *magazine, teacher and exhibition designer. He expounded the transcendental philosophy expressed in Alfred Stieglitz's idea of equivalence: the photograph as a visual metaphor. As White conceived it, an equivalent was an unmanipulated photograph in which the subject may be seen both as a natural object and as a symbol. In the photograph opposite the pattern of sunlight on the windowsill is nothing but sunlight and at the same time can be seen as a living and spiritual presence.*

The very ordinariness of the scene—a television set no one is watching, unoccupied tables and chairs in a customerless cafe—is what makes Robert Frank's photograph (above) such an unsettling comment on the emptiness of modern society. The picture is even more disturbing if you recognize the face on the screen. Oral Roberts, evangelical minister and faith healer, preaching to a nonexistent flock. The harsh sunlight from the unshaded window, the barren interior of the roadside restaurant and even the glare of the television screen all add to the air of desolation, as if human life had disappeared from the earth.

The 1960s and After

In the 1960s the long battle over whether photography was an art, a battle that had been waged almost from the invention of the medium, seemed finally to have been resolved; the winners were those who thought that it was. An increasing number of photography courses were taught at colleges and art schools, and many of the students in these new programs were interested in photography as personal expression rather than as a vocational skill.

These courses often were in the art departments of the schools, which encouraged a cross fertilization of ideas between photographers and artists working in traditional art media. Courses were taught in the history and aesthetics of photography and the medium's relationship to 19th and 20th century art. An interest grew in mixed media, the combination of photographic images with painting, sculpture, printmaking and other media, as for example in the work of Robert F. Heinecken (right). Older photographic processes were revived such as gum bichromate printing (page 344), cyanotyping (non-silver processes that could be hand-coated on paper or cloth) and platinum printing (page 175). New technologies, like office copy machines (pages 360–361), were employed in the search for new forms of picture making.

The interest in experimental approaches co-existed with traditional unmanipulated photography. Documentary photographers continued to bring significant social issues to the public's consciousness, but a new direction began to emerge, sometimes referred to as photography of the social landscape. Like Robert Frank's photographs (page 353), the work of Lee Friendlander (opposite), Garry Winogrand, Diane Arbus and others were photographs that were not intended as social documents but instead were personal observations of the ironic and sometimes grotesque aspects of American society.

Art museums, in response to the growing interest in creative photography, increased the number of exhibitions of photography. Toward the end of the decade a few galleries began to specialize in the sale of photographs and by the early 1970s, galleries had opened in a number of cities. Many books by photographers were published, and along with the growth of mass circulation photography magazines, art magazines such as *Artforum* and *Art in America* began to publish photographs and essays about the medium. Photography has many aspects and now clearly accepted as one of them was photography as an art form.

As an artist and teacher Robert Heinecken has been a catalyst for many photographers working in experimental directions. This photo-sculpture, shown actual size, consists of picture segments mounted on all sides of wooden blocks, which may be stacked in any order on a vertical peg. The segments are of landscape details such as clouds, grass and wood and of a female nude. Even where the nude is not seen, shadows against clouds or grass impart her presence no matter how the blocks are stacked or twisted.

ROBERT F. HEINECKEN: *Figure Sections/Beach*, 1966

LEE FRIEDLANDER: *Hillcrest, New York*, 1970

Many of Lee Friedlander's photographs convey a feeling of the visual fragmentation and disorientation of our modern urban environment. Yet Friedlander denies that he is documenting 20th century unease. He says he just likes to take pictures; whatever viewers see in them is their own business. Friedlander frequently has been identified with photographers of the social landscape.

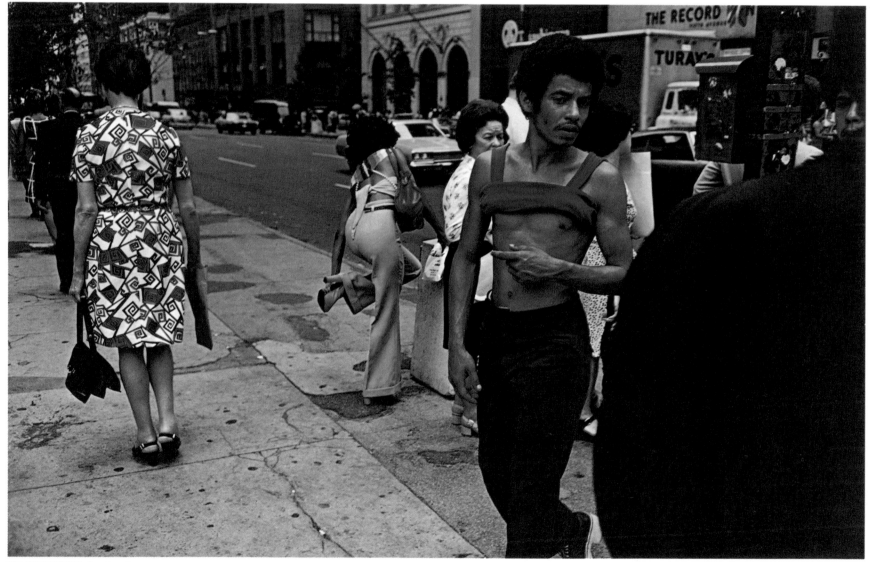

JOEL MEYEROWITZ: *New York City*, 1975

16 Gallery

This chapter is a sampler of contemporary photographers whose work reflects the diversity of personal styles that characterize photography as an art form today. This selection is not an inclusive survey; its purpose is simply to indicate the broad potential of photography as a means of personal expression. There is no easy definition of when a photograph is art or when it is not, any more than there is an easy rule that separates a painting that is a work of art from one that is not. Certainly W. Eugene Smith *(page 351)* is as much an artist as he is a photojournalist. Whether one style is better than another is not so important as whether the photographer has produced a powerful statement within that style.

The understanding of a particular photograph, like the understanding of a piece of music, a poem or a painting, is enhanced when you consider *how* the work means in addition to *what* it means. For example, the appreciation of music is intensified if you understand something of its craft, such as harmony, counterpoint, rhythm and the other elements of musical composition. Photographs, like music, have elements of composition such as structural, tonal or color relationships, point of view, illusionistic space and other visual characteristics *(see pages 306–317)*. Photographers use these pictorial elements in order to suggest a feeling or mood, or to state an idea.

Photographers also work from a variety of philosophical attitudes. Some are picture-*makers*: they build their photographs like tableaux, and control or sometimes even physically make every part of their picture. They may alter the photographic image or photographic materials in order to present their personal vision, and may use non-photographic media such as drawing, painting or printmaking. Other photographers are picture-*takers*: they prefer to select or frame their images from the flux of the world around them. They may work in a so-called straight style and believe that a direct and unmanipulated photograph is an inherently aesthetic object.

Knowledge about the photographer, technique, or situation will help you as a viewer to respond more intelligently to a photograph, but ultimately you have to trust your own response to the picture itself. And any photograph—from a snapshot to a work of art—if examined openly and without prejudice, can help you to see with a more sophisticated eye.

◀ *Joel Meyerowitz has been described as a photographer of the "decisive moment," like Henri Cartier-Bresson and Garry Winogrand, photographers he admires. Meyerowitz observes the flux of urban life and with uncommon agility, speed, and precision he frames and fixes images of commonplace events that unite people and their environments in a mysterious choreography.*

In the picture opposite, the colors intensify the enigmatic feeling of the scene. The man with the rolled-up shirt seems to be pointing, although the direction and intent of his gesture is ambiguous. He could be pointing to 1 woman, 2 women or neither. His expression might be anxious, incredulous or noncommittal. The red colors in his shirt, one woman's dress and the other's handbag add a link among the three. It is the viewer who completes the picture and in doing so invests it with meaning.

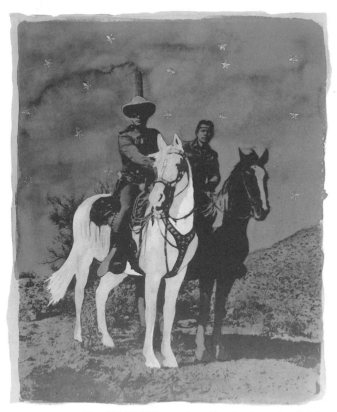

Starry Night III, 1975, cyanotype with watercolors and applied stars

Blue Sky Variation and Erased, 1977, vandyke print with pencil and watercolors

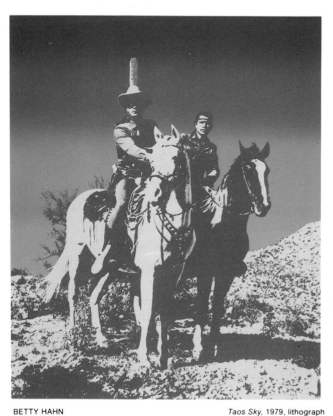

BETTY HAHN

Taos Sky, 1979, lithograph

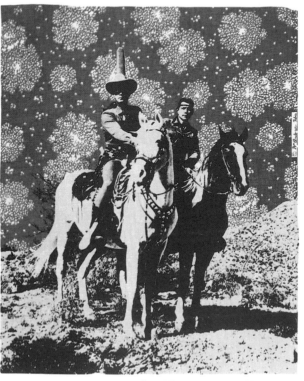

Starry Night Variation #2, 1977, silkscreen

In recent years the definition of the word "photographer" has expanded to include anyone who makes images with light-sensitive materials. Betty Hahn's work represents an approach in which the photographic image itself becomes only one aspect of the artist's expressive intent.

Hahn began with a publicity photograph of the mythic heroes the Lone Ranger and Tonto as a motif for prints made in various techniques. The cyanotype and vandyke processes, photographic printing processes invented in the 19th century, utilize light-sensitive iron salts to form the image. The lithograph and silk screen are traditional fine-art printmaking processes. Each print is enjoyable in its own right, but when the versions are placed together, the eye jumps back and forth among them comparing skies, colors and other traces of the artist's intervention in the original photograph. A bonus is the cactus growing out of the Lone Ranger's head.

Robert Fichter, like Hahn, combines drawing and hand-applied color with photographic processes and materials. However, Hahn began here with a photograph and expanded on it, while Fichter composed a tableau of figurines, a flower and his own drawings in order to make a photograph. The Polaroid Land process that Fichter used produced a 20 x 24-in instant print. In 1979 this was a one-of-a-kind camera as well as a one-of-a-kind print, available only at Polaroid's corporate headquarters.

Fichter's title alludes to the popular Mexican comic books that use photographs to illustrate their stories. The housewife figurine is of a Mexican soap opera star, the Minute Man is reincarnated as a cowboy and as to the reason for or the outcome of the faceoff between the two—viewers have to draw their own conclusions. This image is typical of Fichter's use of toys, popular novelties and his own drawings to produce a playful surrealism.

ROBERT FICHTER: *Mexican TV Housewife Meets the Minute Man,* 1979

359

DAVID ROOT: *Ballerina*, 1978

ELLEN LAND-WEBER: *The Natural Selection of Haeckel*, 1979

◀ *The 7 x 7 foot mosaic of a ballet dancer at left was produced by David Root from 60 color copies. For each of the 49 prints that make up the figure, he placed a different portion of the dancer's body on the machine and gradually built up the picture by fastening the prints to a wall. To make the mural square, he added 11 prints of the gauzelike fabrics used in dancer's costumes, plus postcard reproductions of paintings by the French artist Edgar Degas.*

To create multiple views of the same two pieces of seaweed, Ellen Land-Weber used a copy paper from which the image can be transferred to another surface when heat and pressure are applied. First, she pressed the seaweed to make it translucent. Then she laid the strands on a copy machine that has a second light source in its cover; using the cover light, she backlighted the seaweed to enhance its translucence. She copied each strand twice, cut out the images and transferred them to a large sheet of paper.

BART PARKER: *Patches/Pens: Laguna Niguel*, 1976

Bart Parker's photograph of a barren and somewhat colorless range of hills is obviously not a traditional landscape. Like John Pfahl (opposite), Parker introduced elements that were not part of the original scene. However, instead of adding objects to the scene, Parker added to the original picture by multiple printing. Both photographers are more concerned with the psychology of seeing and with the camera's interpretations than they are with traditional landscape photography. Parker has often photographically joined previously unrelated realities. Here his print is about color as imagined and as seen: hands hold photographic color scales and colored pens in a landscape of few colors, pairing color references with the natural colors we experience and photograph.

John Pfahl physically alters or embellishes the ▶ landscape itself. Here, lace pinned along the edge of a coastal bluff imitates the frothy surf several hundred feet below. The visual similarity of the lace and the surf creates the illusion that the space between them is less than it really is. A barely visible beach stroller, who appears to be almost a part of the cliff's vegetation near the center, provides a clue to the actual distance between foreground and background. In other photographs Pfahl has added masking tape, cord, aluminum foil and even bagels to various scenes to create illusions in which he plays with the 3-dimensional scene as it is transformed into a 2-dimensional photograph.

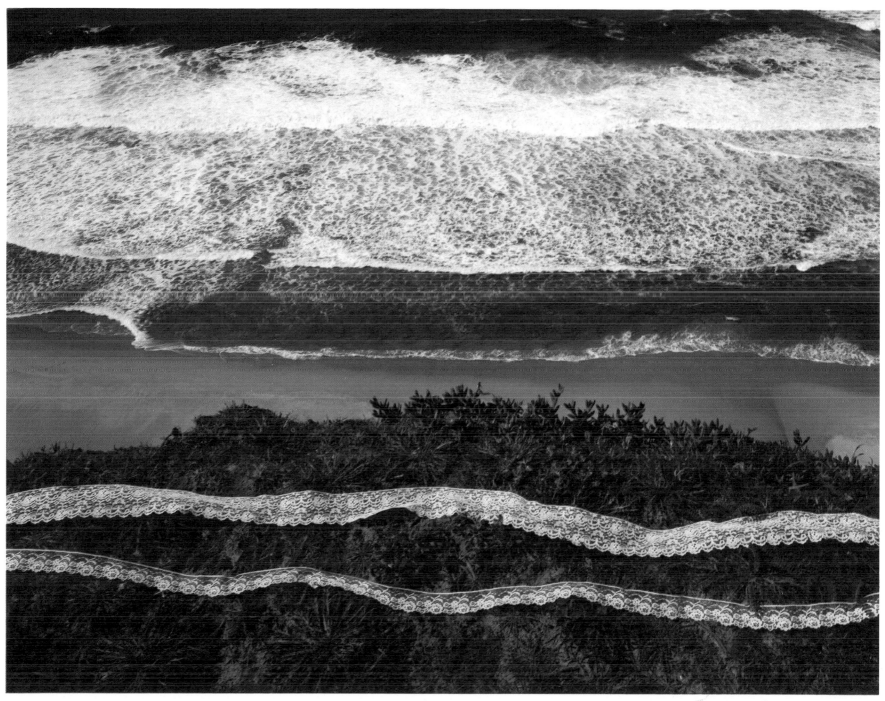

JOHN PFAHL: *Wave, Lave, Lace, Pescadero Beach, California,* 1978

LELAND RICE

◀ Leland Rice is one of many photographers who formerly worked in black and white and who now work primarily in color. Rice has often photographed empty interiors, particularly in artists' studios. But where or what he photographs is less important than the interplay of space, shapes, colors and textures within each picture. The photograph above is of a wall, but it is about subtle variations in color, ambiguous space and the relationship of shapes.

William Eggleston's parking lot is curiously unreal. Three cars wait in blue-green light. A streak and burst of light seem inexplicable at first glance. The mind plays with the contradictions and puzzles in the photograph even after understanding how it was made: a long exposure in dim light, with the streak caused by the street lamp as the camera was moved.

STEPHEN SHORE: *Holden Street, North Adams, Massachusetts*

There is a tradition of documentary photography in which the ordinary and everyday appearance of life is shown rather than picturesque and dramatic special moments, for example the photographs of Eugène Atget (page 339) and Robert Frank (page 353). These photographers were not concerned with notions of artistic photography, nor were they *particularly interested in personal expression. In-stead they sought to make photographs that were descriptive and lucid.*

The work of Stephen Shore is clearly linked to this tradition. Like Frank he has traveled throughout the United States training his camera on the ordi- *nary, even shabby, facade of American life and landscape. However, Shore works in color rather than black and white. As you look at his picture try to imagine how it would appear in black and white; not only do the colors disappear but also much of the depth and mood imparted by them.*

ROBERT ADAMS: *Denver, Colorado,* 1973

The area near Denver, Colorado where Robert Adams made this photograph was photographed extensively about 100 years ago by William Henry Jackson, Timothy O'Sullivan, whom Adams greatly admires (page 333), and a number of other topographical photographers working for the railroads or with United States government geological sur-vey teams. Adams, like his early predecessors, makes photographs that appear, as one critic said, to be "without author or art." Adams seems to share the ideal of the conscientious journalist who tries to describe places and events with objective accuracy and clarity.

This photograph, made in a suburb of Denver, evokes the same feeling of infinite space that is so often seen in 19th-century landscape photographs of the West. However, here the poetic evocation of the infinite contrasts with a modern phenomenon —suburban sprawl.

LEWIS BALTZ: *South Wall, Xerox Warehousing, 1821 Dyer Road, Santa Ana, California (during construction), 1974*

All artists must deal with certain elements of form, such as the way a subject is organized, its texture and shape or the effect of having to represent a three-dimensional object on a two-dimensional surface. How an artist manipulates these formal elements—the choices that are made—is as much a part of the work as the subject matter itself. Some artists, in fact, have no other subject matter.

Lewis Baltz (above) and John Gossage (opposite) do not solve the problems of form in conventional photographic ways. For example, their photographs have no ''center of interest''; they are not about one particular thing but about everything that is in them. The whole image is a balance of tension and visual energy and the eye does not focus on one element that is more important than any other element.

There is also social information in these works. Baltz has made many photographs documenting the gigantic Irvine industrial complex in California. Its corporate underpinnings seem revealed in the severe angles and lines of its constructions. Gossage's Cultivation and Neglect perhaps shows the future of Baltz's building; it is overgrown without plan—or even in spite of plan.

JOHN R. GOSSAGE: *Cultivation and Neglect, Washington, D.C.,* 1974

369

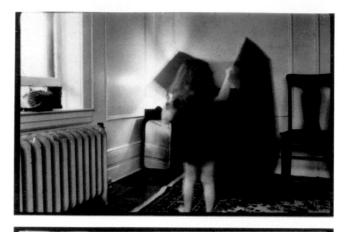
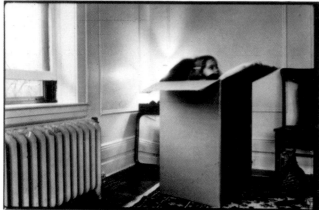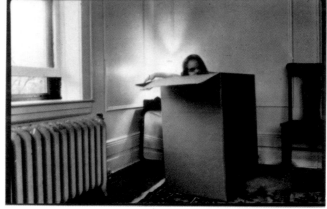

Serial imagery is popular with photographers who are stimulated by the opportunity to escape the confinement of the single photograph and (like all photographers) to impose their own order on the chaotic flow of life. Serial images sometimes borrow from the movies, from comic strips and from the motion studies of photographers like Eadweard Muybridge (pages 336–337). Sometimes the camera moves, sometimes the subject does, sometimes time is the changing factor. Duane Michals's sequence (left) is a kind of cryptic fantasy. Did Margaret fly the box away or did it fly away with her?

DUANE MICHALS: *Margaret Finds a Box*, 1971

ROBERT CUMMING: *Blast Sequence*, 1973

Robert Cumming also photographs fantasies (like Michals, opposite), either singly or in series, but his are disguised as factual documents. On first appearance the series above seems to be an example of a high-speed, photographic analysis of a projectile in flight. However, clues indicate that the exposure was lengthy (it would have to be since it is lit by floodlights) and the flying fragments of board are supported by wires. Cumming's factual document is, in fact, an elaborately staged and drily humorous fiction.

JOANN CALLIS

JoAnn Callis works in a manner similar to a motion picture or theatre director, in what has been called the "directorial mode" of photography. Her scripts are her own dreams or fantasies, and she carefully selects the appropriate models, costumes, props and settings in order to materialize the images of her imagination. Many photographers have used the visible world as if it was a mirror of an internal or psychological reality, a metaphor of personal

feelings or intangible experiences rather than a description of a particular subject (see page 23).

The photograph above can be interpreted as a fantasy, a dream image, or a multi-level symbol. The figure, surrounded by darkness, might be symbolic of the unconscious mind itself, the hidden or buried self whose shape is barely perceptible to the conscious mind.

Jan Groover, like Callis (opposite), also constructs her images. Groover's still life is recognizably of ordinary kitchen utensils and household plants, but the objects themselves are not important. The actual subject of the photograph is its compositional elements—the shapes, colors, scale and spatial placement of the objects and their relationship to the rectangle of the picture format.

JAN GROOVER: *Untitled*, 1978

MARY ELLEN MARK: *Ward 81*

These photographs by Mary Ellen Mark and Danny Lyon are about life in institutions: a mental hospital and a prison. They relate to a tradition of social documentation, similar to the work of Jacob Riis, Lewis Hine and Dorothea Lange (pages 340–341), speaking directly to the viewer's conscience by establishing an emotional sympathy with the subjects of the photographs.

Lyon (opposite) is more formal in his use of composition and tonal contrast than is Mark. The prisoners and guard almost appear to have been posed in order to symbolically define their relationship. The mounted guard, darkly silhouetted against the sky at the top of the picture is set over the row of subservient prisoners in white who hunch forward with their eyes to the ground. The photograph is a powerful statement of regimentation and, ultimately, dehumanization. Lyon, like

Dorothea Lange, is able to convey the nature of the relationships between people by recognizing and photographing revealing gestures.

Mark (above) has also captured a revealing gesture that establishes empathy between viewer and subject. However, her flash photograph of a couple in a mental hospital appears less formally organized than Lyon's work, a glimpsed moment of poignant contact between two patients.

DANNY LYON: *Hoe Sharpener and the Line, Ferguson Prison Farm, Texas*

Glossary

aberration An optical defect in a lens causing it to form an image that is not sharp or one that is distorted. See astigmatism, barrel distortion, chromatic aberration, coma, field curvature, pincushion distortion, spherical aberration.

acid A substance with a pH below 7. Since an acid neutralizes an alkali, a stop bath is usually an acidic solution that stops the action of the alkaline developer.

additive color A way to produce colors of light by mixing light of the three additive primary colors—red, green and blue. Each primary color contains about one-third of the wavelengths in the visible spectrum. Varying proportions of the additive primaries can be combined to create light of all other colors, including white, which is a mixture of all wavelengths.

agitate To move a solution over the surface of film or paper during the development process so that fresh liquid comes into contact with that surface.

albumen Egg white. Used in early photographic emulsions as a coating for glass plates (1850s) and, more commonly, for printing paper (1850–c. 1900).

alkali A substance with a pH above 7. Developers are usually alkaline solutions.

ambrotype A collodion wet-plate process in which the emulsion was coated on a glass plate. The negative image produced was visible as a positive image when the glass was backed with a dark material.

angle of view The amount of a scene covered by a lens or viewfinder or read by a light meter.

aperture The size of the lens opening through which light passes. The relative aperture is measured as the focal length of the lens divided by the diameter of the aperture; this is expressed as an f-number: f/8, f/11 and so on.

archival processing Processing designed to protect a print or negative as much as possible from premature deterioration due to chemical reactions.

artificial light Light from an electric lamp, a flash bulb or electronic flash. Often implies lights that the photographer has set up to illuminate a scene.

ASA A rating that describes the sensitivity of a film to light. The ASA rating doubles as the sensitivity of the film doubles.

astigmatism A lens aberration or defect that is caused by the inability of a simple lens to focus oblique rays uniformly.

available light A general term, implying relatively dim light that already exists where a photograph is to be made.

axis lighting Light pointed at the subject from a position close to the lens.

B *See bulb.*

back lighting Light that comes from behind the subject, toward the camera.

barrel distortion A lens aberration or defect that causes straight lines to bow outward, away from the center of the image.

bellows A flexible, light-tight and usually accordion-folded part of a view camera that connects the lens board in front to the viewing screen in back. Also used on a smaller camera when the lens must be positioned farther than normal from the film.

bleed mount To mount a print so that there is no border between the edges of the print and the edges of the mounting surface.

blocked up A portion of an overexposed and/or overdeveloped negative so dense with silver that texture and detail in the subject are unclear.

blotters Sheets of absorbent paper made expressly for photographic use. Wet prints will dry when placed between blotters.

bounce light Light that does not travel directly from its source to the subject but is first reflected off another surface.

bracket To make several exposures, some greater and some less than the exposure that is calculated to be correct. This allows for error and permits selection of the best exposure after development.

broad lighting Portrait lighting in which the main source of light illuminates the side of the face turned most toward the camera.

built-in meter A reflected-light exposure meter built into a camera so that light readings can be made directly from camera position.

bulb A shutter setting marked B at which the shutter remains open as long as the shutter release is held down.

burn in To darken a specific area of a print by giving it additional printing exposure.

butterfly lighting Portrait lighting in which the main source of light is placed high and directly in front of the face.

cable release A long coiled wire with a plunger at one end and a socket at the other that attaches to a camera's shutter release. Pressing the plunger releases the shutter without touching (and possibly moving) the camera.

calotype The first successful negative/positive photographic process; it produced an image on paper. Invented by Talbot; also called Talbotype.

camera A picture-taking device usually consisting of a light-tight box, a film holder, a shutter to admit a measured quantity of light and a lens to focus the image.

camera obscura Latin for "dark chamber": a darkened room with a small opening through which rays of light could enter and form an image of the scene outside. Eventually, a lens was added at the opening to improve the image, and the room was replaced by a small, portable box.

carrier A frame that holds a negative flat in an enlarger.

carte-de-visite A small portrait, about the size of a visiting card, popular during the 1860s. People often collected them in albums.

cartridge *See below.*

cassette A light-tight metal or plastic container that permits a roll of 35mm film to be loaded into a camera in the light. Also called a cartridge.

catchlight A reflection of a light source in a subject's eye.

changing bag A light-tight bag into which you can insert your hands to handle film when a darkroom is not available.

characteristic curve A diagram of the response to light of a photographic material, showing how increasing exposure affects silver density during development. Also called the D log E curve, since density is plotted against the logarithm of the exposure.

chromatic aberration A lens defect that bends rays of different colors at different angles and therefore focuses them on different planes.

circle of confusion The tiny circle of light formed by a lens as it projects the image of a single point of a subject. The smaller the diameters of all the circles of confusion in an image, the sharper the image will be.

close up A larger-than-normal image that is formed on a negative by focusing the subject closer than normal to the lens with the use of supplementary lenses, extension tubes or bellows.

cold-light enlarger A diffusion enlarger that uses a fluorescent tube instead of a tungsten bulb as the light source.

collodion A transparent, syrupy solution of pyroxylin (a nitrocellulose) dissolved in ether and alcohol. Used as the basis for the emulsion in the wetplate process.

color-compensating filters Gelatin filters used to adjust the color balance in color printing. More expensive than acetate color printing filters, they can be used below the enlarger lens if the enlarger has no other place for filters. Abbreviated as CC filters.

color-printing filters Acetate filters used to adjust the color balance in color printing. They must be used with an enlarger that can hold filters between the enlarger lamp and the negative. Abbreviated as CP filters.

color temperature A numerical description of the color of light. It is the temperature in degrees Kelvin (K) to which a perfect black-body radiator (an object that does not reflect any light falling on it) would have to be heated to produce a given color.

coma A lens aberration or defect that causes rays that pass obliquely through the lens to be focused at different points on the film plane.

complementary colors 1) Any two colors of light that when combined include all the wavelengths of light and thus produce white light (*see additive color*). 2) Any two dye colors that when

combined absorb all wavelengths of light and thus produce black (see subtractive color). A colored filter absorbs light of its complementary color and passes light of its own color.

condenser enlarger An enlarger that illuminates the negative with light that has been concentrated and directed by condenser lenses placed between the light source and the negative.

contact printing Placing a negative in contact with sensitized material, usually paper, and then passing light through the negative onto the material. The resulting image is the same size as the negative.

contamination Traces of chemicals that are present where they don't belong, causing loss of chemical activity, staining or other problems.

continuous tone An image containing a range of tones from black through many intermediate shades of gray to white.

contrast The difference in darkness or density between one tone and another.

contrast grade The contrast of a printing paper emulsion. Systems of grading contrast are not uniform, but in general Grades 0 or 1 have low or soft contrast; Grades 2 or 3 have normal or medium contrast; Grades 4, 5 or 6 have high or hard contrast.

contrasty A scene, negative or print with very great differences in brightness between light and dark areas. Opposite: flat.

cool Bluish colors that, by association with common objects (water, ice and so on), give an impression of coolness.

coupled rangefinder See rangefinder.

covering power The area of the focal plane over which a lens projects an image that is acceptably sharp and uniformly illuminated.

crop To trim the edges of an image, often in order to improve the composition. Cropping can be done by moving the camera position while viewing a scene, by adjusting the enlarger or easel during printing or by trimming the finished print with a paper cutter.

curvilinear distortion See barrel distortion and pincushion distortion.

cut film See sheet film.

daguerreotype The first practical photographic process, invented by Daguerre and described by him in 1839. The process produced a positive image formed by mercury vapor on a metal plate coated with silver iodide.

darkroom A room where photographs are developed and printed, sufficiently dark to handle light-sensitive materials without causing unwanted exposure.

daylight film Color film that is balanced to produce accurate color renditions when the light source illuminating the photographed scene has a color temperature of about 5500K, like midday sunlight, electronic flash or a blue flash bulb.

dense A negative or an area of a negative in which a large amount of silver has been deposited. A dense negative transmits relatively little light. Opposite: thin.

densitometer An instrument that measures the darkness or density of a negative or print.

density The relative amount of silver present in various areas of film or paper after exposure or development. Therefore, the darkness of a photographic print or the light-stopping ability of a negative or transparency.

depth of field The area between the nearest and farthest points from the camera that are acceptably sharp in the focused image.

depth of focus The small range of error within which an acceptably sharp image is produced when a lens is focused.

developer A chemical solution that changes the invisible, latent image produced during exposure into a visible one.

development 1) The entire process by which exposed film or paper is treated with various chemicals to make an image that is visible and permanent. 2) Specifically, the step in which film or paper is immersed in developer.

diaphragm The mechanism controlling the brightness of light that passes through a lens. An iris diaphragm has overlapping metal leaves whose central opening can be adjusted to a larger or smaller size. See aperture.

diffuse Scattered, not all coming from the same direction. For example, the light on a cloudy day.

diffusion enlarger An enlarger that illuminates the negative by scattering light from many angles evenly over the surface of the negative.

diopter An optician's term to describe the power of a lens. In photography, it mainly indicates the magnifying power and focal length of a supplementary close-up lens.

distortion 1) A lens aberration that causes straight lines at the edge of an image to appear curved. 2) The apparent changes in perspective that take place when a lens is used very close to (wide-angle effect) or very far from (telephoto effect) a subject.

dodge To lighten an area of a print by shading it during part of the printing exposure.

dropout An image with black and white areas only and no intermediate gray tones. Usually made by using high-contrast lith film.

dry down To become very slightly darker and less contrasty, as most photographic printing papers do while they dry after processing.

dry mount To attach a print to another surface, usually cardboard, by placing a sheet of dry-mount tissue between the print and the mounting surface. This sandwich is placed in a heated mounting press to melt an adhesive in the tissue.

easel A holder to keep sensitized material, normally paper, flat and in position on the baseboard of an enlarger during projection printing. It may have adjustable borders to frame the image to various sizes.

electronic flash A tube containing gas that produces a brief, brilliant flash of light when electrified. Unlike a flash bulb, an electronic flash unit is reusable. Also called a strobe.

emulsion A light-sensitive coating applied to photographic films or papers. It consists of silver halide crystals and other chemicals suspended in gelatin.

enlargement An image, usually a print, that is larger than the negative. Made by projecting an enlarged image of the negative onto sensitized paper.

enlarger An optical instrument ordinarily used to project an image of a negative onto sensitized paper. More accurately called a projection printer, because it can project an image that is either larger or smaller than the negative.

etch To remove a small, dark imperfection in a print or negative by scraping away part of the emulsion.

exposure 1) The act of letting light fall on a light-sensitive material. 2) The amount of light reaching the light-sensitive material; specifically, the intensity of light multiplied by the length of time it falls on the material.

exposure meter An instrument that measures the amount of light falling on a subject (incident-light meter) or emitted or reflected by a subject (reflected-light meter), so that aperture and shutter speed settings can be computed. Also called a light meter.

extension tubes Metal rings that can be attached between a camera body and lens for close-up work. They extend the lens farther than normal from the film plane, so that the lens can focus closer than normal to an object.

factor A number that tells how many times exposure must be increased in order to compensate for loss of light (for example, due to use of a filter).

Farmer's reducer A solution of potassium ferricyanide and sodium thiosulfate that is used to decrease the amount of silver in a developed image.

fast 1) A film or paper that is very sensitive to light; 2) a lens that opens to a very wide aperture; and 3) a short shutter speed. Opposite: slow.

ferrotype To give a glossy printing paper a very high sheen by drying the print with its emulsion pressed against a smooth metal plate, usually the hot metal drum or plate of a heat dryer.

field curvature A lens aberration or defect that causes the image to be formed along a curve instead of on a flat plane.

fill light A source of illumination that lightens shadows cast by the main light and thereby reduces the contrast in a photograph.

film The material used in a camera to record a photographic image. Generally it is a light-sensitive emulsion coated on a flexible acetate or plastic base.

film holder A light-tight container to hold the sheet film used in a view camera.

film plane *See focal plane.*

film speed The relative sensitivity to light of a film. There are several rating systems: ASA (the most common in the United States and Britain), DIN (common in Europe) and others. Film speed ratings increase as the sensitivity of the film increases.

filter 1) A piece of colored glass, plastic or other material that selectively absorbs some of the wavelengths of light passing through it. 2) To use such a filter to modify the wavelengths of light reaching a light-sensitive material.

fisheye lens A lens with an extremely wide angle of view (as much as 180°) and considerable barrel distortion (straight lines at the edges of a scene appear to curve around the center of the image).

fixer A chemical solution (sodium thiosulfate or ammonium thiosulfate) that makes a photographic image insensitive to light. It dissolves unexposed silver halide crystals while leaving the developed silver image. Also called hypo.

flare Unwanted light that reflects and scatters inside a lens or camera. When it reaches the film, it causes a loss of contrast in the image.

flash 1) A light source, such as a flash bulb or strobe, that emits a very brief, bright burst of light. 2) To blacken an area in a print by exposing it to white light, such as from a penlight flashlight.

flash bulb A bulb containing a mass of aluminum wire, oxygen and an explosive primer. When the primer is electrically fired, it ignites the wire, which emits a brief burst of brilliant light. A flash bulb is used once, then discarded.

flash cube Four very small flash bulbs built into a single unit, producing four separate flashes before the unit is discarded.

flat 1) A scene, negative or print with very little difference in brightness between light and dark areas. Opposite: contrasty. 2) *See reflector.*

floodlight An electric light designed to produce a broad, relatively diffused beam of light.

f-number A number that equals the focal length of a lens divided by the diameter of the aperture at a given stop. Theoretically, all lenses at the same f-number produce images of equal brightness.

focal length The distance from the lens to the focal plane when the lens is focused on infinity. The longer the focal length, the greater the magnification of the image.

focal plane The plane or surface on which a focused lens forms a sharp image. Also called the film plane.

focal-plane shutter A camera mechanism that admits light to expose film by moving a slit or opening in a roller blind just in front of the film (focal) plane.

focal point The point on a focused image where the rays of light intersect after reflecting from a single point on a subject.

focus 1) The position at which rays of light from a lens converge to form a sharp image. 2) To adjust the distance between lens and image to make the image as sharp as possible.

focusing cloth A dark cloth used in focusing a view camera. The cloth fits over the camera back and the photographer's head to keep out light and to make the ground-glass image more visible.

fog An overall density in the photographic image caused by unintentional exposure to light or unwanted chemical activity.

f-stop *See f-number and stop.*

full-scale A print having a wide range of tonal values from deep, rich black through many shades of gray to brilliant white.

gelatin A substance produced from animal skins and bones, it is the basis for modern photographic emulsions. It holds light-sensitive silver halide crystals in suspension.

glossy A printing paper with a great deal of surface sheen. Opposite: matte.

graininess In an enlarged image, a speckled or mottled effect caused by clumps of silver in the negative.

gray card A card that reflects a known percentage of the light falling on it. Often has a gray side reflecting 18 percent and a white side reflecting 90 percent of the light. Used to take accurate exposure meter readings (meters base their exposures on a gray tone of 18 percent reflectance) or to provide a known gray tone in color work.

ground glass 1) A piece of glass roughened on one side so that an image focused on it can be seen on the other side. 2) The viewing screen in a reflex or view camera.

guide number A number used to calculate the f-setting (aperture) that correctly exposes a film of a given sensitivity (ASA rating) when the film is used with a specific flash unit at various distances from flash to subject. To find the f-setting, divide the guide number by the distance (usually in feet).

gum-bichromate process An early photographic process revived by contemporary photographers. The emulsion is a sensitized gum solution containing color pigments. The surface can be altered by hand during the printing process.

halftone An image that can be reproduced with ordinary type on the same printing press. The tones of gray in the photograph are screened to a pattern of dots (close together in dark areas, farther apart in light areas) that give the illusion of continuous tone.

hanger A frame for holding sheet film during processing in a tank.

hard 1) A scene, negative or print of high contrast. Opposite: soft or low contrast. 2) A printing paper emulsion of high contrast such as Grades 5 or 6.

heliography An early photographic process, invented by Niépce, employing a polished pewter plate coated with bitumen of Judea, a substance that hardens on exposure to light.

highlight A very bright area in a scene, print or transparency; a very dense, dark area in a negative. Also called a high value.

hyperfocal distance The distance to the nearest plane of the depth of field (the nearest object in focus) when the lens is focused on infinity. Also the distance to the plane of sharpest focus when infinity is at the farthest plane of the depth of field. Focusing on the hyperfocal distance extends the depth of field from half the hyperfocal distance to infinity.

hypo A common name for any fixer; taken from the abbreviation for sodium hyposulfite, the previous name for sodium thiosulfate (the active ingredient in most fixers).

hypo neutralizing agent A chemical solution used between fixing and washing film or paper. It shortens the washing time by converting residues from the fixer into forms more easily dissolved by water. Also called hypo clearing agent.

incandescent light Light emitted when a substance is heated by electricity: for example, the tungsten filament in an ordinary light bulb.

incident-light meter An exposure meter that measures the amount of light incident to (falling on) a subject.

indoor film *See Type A and tungsten film.*

infinity The farthest position (marked ∞) on the distance scale of a lens. It includes all objects at the infinity distance (about 50 feet) from the lens or farther. When the infinity distance is within the depth of field, all objects at that distance or farther will be sharp.

infrared The band of invisible rays just beyond red, which people perceive somewhat as heat. Some photographic materials are sensitized to record infrared.

intensification A process increasing the darkness of an already developed image. Used to improve negatives that have too little silver density to make a good print.

interchangeable lens A lens that can be removed from the camera and replaced with another lens, usually of a different focal length.

inverse square law A law of physics stating that the intensity of illumination is inversely proportional to the square of the distance between light and subject. This means that if the distance between light and subject is doubled, the illumination will drop to one quarter of the original. The exposure must be increased accordingly for consistent results.

ISO a film speed rating similar to an ASA rating.

Kelvin temperature *See color temperature.*
key light *See main light.*

latent image An image formed by the changes to the silver halide grains in photographic emulsion upon exposure to light. The image is not visible

until chemical development takes place.

leaf shutter A camera mechanism that admits light to expose film by opening and shutting a circle of overlapping metal leaves.

lens A piece or several pieces of optical glass shaped to focus an image of a subject.

lens shade A shield that fits around a lens to prevent unwanted light from hitting the front of the lens and causing flare. Also called a lens hood.

light meter *See exposure meter.*

light-tight Absolutely dark. Protected by material, overlapping panels or some other system of baffles through which light cannot pass.

line print An image resembling a pen and ink drawing, with black lines on a white background (or white lines on a black background). It is made with high-contrast lith film. Also called tone line print.

lith film A type of film made primarily for use in graphic arts and printing. It produces an image with very high contrast.

local reduction *See reduction (3).*

long lens A lens whose focal length is longer than the diagonal measurement of the film with which it is used. The angle of view with such a lens/film size combination will be narrower at a given distance than the angle that the human eye sees.

luminance meter *See exposure meter.*

macro lens A lens designed for taking close-up pictures. Sometimes called a micro lens.

macrophotograph *See photomacrograph.*

main light The principal source of light in a photograph, casting the dominant shadows and defining the texture and volume of the subject. Often refers to a studio setup. Also called key light.

mat A cardboard rectangle with an opening cut in it that is placed over a print to frame it. Also called an overmat.

mat knife A short knife blade (usually replaceable) set in a large, easy-to-hold handle. Used for cutting cardboard mounts for prints.

matte A printing paper with a relatively dull, nonreflective surface. Opposite: glossy.

micro lens *See macro lens.*

midtone An area of medium brightness, neither a very dark shadow nor a very bright highlight. A medium gray tone in a print.

modeling light A small tungsten light built into some flash units. It helps the photographer to judge the effect of various light positions, as the duration of flash light is too brief to be judged directly.

mottle A mealy gray area of uneven development in a print or negative. Caused by too little agitation or too short a time in the developer.

narrow lighting *See short lighting.*

negative 1) Any image with tones that are the reverse of those in the subject. Opposite: positive. 2) The film in the camera during exposure and subsequently developed to produce a negative image.

normal lens A lens whose focal length is about the same as the diagonal measurement of the film with which it is used. The angle of view with this lens/film size combination is roughly the same at a given distance as the angle that the human eye sees clearly.

notching code Notches cut in the margin of sheet film so that the type of film and its emulsion side can be identified in the dark.

one-shot developer A developer used once and then discarded.

opaque 1) Any substance or surface that will not pass light. 2) A paint used to block out portions of a negative so that they will not pass light during printing.

open up To increase the size of a lens aperture. Opposite: to stop down.

orthochromatic Film that is sensitive to blue and green but not to red wavelengths of the visible spectrum. Abbreviated as ortho.

overdevelop To give more than the normal amount of development.

overexpose To give too much exposure to film or paper. The resulting silver density is too great for best results.

oxidation Loss of chemical activity due to contact with oxygen in the air.

pan 1) To follow the motion of a moving object with the camera. This will cause the object to look sharp and the background blurred. 2) *See panchromatic.*

panchromatic Film that is sensitive to all (or almost all) wavelengths of the visible spectrum. Abbreviated as pan.

parallax The difference in point of view that occurs when the lens (or other device) through which the eye views a scene is separate from the lens that exposes the film.

perspective The apparent size and depth of objects within an image.

photoflood An incandescent lamp that produces a very bright light but has a relatively short life.

photogram An image formed by placing material directly onto a sheet of sensitized film or printing paper and then exposing the sheet to light.

photomacrograph A close-up photograph that is life size or larger. Also called macrophotograph.

photomicrograph A photograph that is taken through a compound microscope.

photomontage A composite image made by cutting out and assembling parts of several photographs.

pincushion distortion A lens aberration or defect that causes straight lines to bow inward toward the center of the image.

pinhole 1) A small clear spot on a negative, usually caused by dust on the film during exposure or development or by a small air bubble that keeps developer from the film during development. 2) The tiny opening in a pinhole camera that produces a blurred but recognizable image.

plane of critical focus The part of a scene that is most sharply focused.

plate In early photographic processes, the sheet of glass or metal on which emulsion was coated.

polarizing filter A filter that reduces reflections from non-metallic surfaces such as glass or water by blocking light waves that are vibrating at selected angles to the filter.

Polaroid Land process Trade name for a process that produces a print (sometimes a negative or positive transparency) when negative, positive and developing chemicals are sandwiched together in a packet, usually by rollers in the camera immediately after exposure.

positive Any image with tones corresponding to those of the subject. Opposite: negative.

posterization An image with a flat, poster-like quality. High-contrast lith film is used to separate the continuous gray tones of a negative into a few distinct shades of gray.

presoak To soak film briefly in water prior to immersing it in developer.

primary colors Basic colors from which all other colors can be mixed. *See subtractive, additive.*

print 1) A photographic image, usually a positive one on paper. 2) To produce such an image from a negative by contact or projection printing.

printing frame A holder designed to keep sensitized material, usually paper, in full contact with a negative during contact printing.

projection printing To project an image of a negative onto sensitized material, usually paper. The image may be projected to any size, usually an enlargement.

projector An optical instrument for forming the enlarged image of a transparency or a motion picture on a screen.

push To expose film at a higher ASA rating than normal, then to compensate in part for the resulting underexposure by giving greater development than normal. This permits shooting at a dimmer light level, a faster shutter speed or a smaller aperture than would otherwise be possible.

rangefinder 1) A device on a camera that measures the distance from camera to subject and shows when the subject is in focus. 2) A camera equipped with a rangefinder focusing device.

RC paper *See resin-coated paper.*

rear nodal points The point in a lens from which lens focal length (distance from lens to image plane) is measured. Undeviated rays of light cross the lens axis and each other at this point.

reciprocity law The theoretical relationship between length of exposure and intensity of light, stating that an increase in one will be balanced by a decrease in the other. For example, doubling the light intensity should be balanced exactly by halving the exposure time. In fact, the law does not hold true for very long or very short exposures. This reciprocity failure causes underexposure unless the exposure is increased. It

also causes color shifts in color materials.

reducing agent The active ingredient in a developer. It changes exposed silver halide crystals into dark metallic silver. Also called the developing agent.

reduction 1) A print that is smaller than the size of the negative. 2) The part of development in which exposed silver halide crystals forming an invisible latent image are converted to visible metallic silver. 3) A process that decreases the amount of dark silver in a developed image. Negatives are usually reduced in order to decrease density. Prints are reduced locally (only in certain parts) in order to brighten highlights. Opposite: intensification.

reel A metal or plastic reel with spiral grooves into which roll film is loaded prior to development.

reflected-light meter An exposure meter that measures the amount of light reflected or emitted by a subject. Sometimes called a luminance meter.

reflector 1) A reflective surface, such as a piece of white cardboard, that can be positioned to redirect light, especially into shadow areas. Also called a flat. 2) A reflective surface, often bowl-shaped, that is placed behind a lamp to direct more light from the lamp toward the subject.

reflex camera A camera with a built-in mirror that reflects the scene being photographed onto a ground-glass viewing screen. See *single-lens reflex and twin-lens reflex.*

regular-base paper Formerly the standard type of paper available; now being replaced to a certain extent by resin-coated papers. Printed instructions for washing, drying and so forth refer to regular-base papers, unless resin-coated papers are specifically mentioned.

replenisher A substance added to some types of developers after use, to replace exhausted chemicals so that the developer can be used again.

resin-coated paper Printing paper with a water-resistant coating that absorbs less moisture than uncoated paper, consequently reducing some processing times. Abbreviated as RC.

reticulation A crinkling of the gelatin emulsion on film that can be caused by extreme temperature changes during processing.

reversal A process for making a positive image directly from film exposed in the camera; also for making a negative image directly from a negative or a positive image from a positive transparency.

roll film Film that comes in a roll, protected from light by a length of paper wound around the film. Loosely applies to any film packaged in a roll rather than in flat sheets.

Sabattier effect A partial reversal of tones that occurs when film or paper is re-exposed to light during development. Commonly called solarization.

safelight A light used in the darkroom during

printing to provide general illumination without giving unwanted exposure.

sharp An image or part of an image that shows crisp, precise texture and detail. Opposite: blurred or soft.

sheet film Film that is cut into individual flat pieces. Also called cut film.

short lens A lens whose focal length is shorter than the diagonal measurement of the film with which it is used. The angle of view with this lens/film combination will be greater at a given distance than the angle seen by the human eye. Also called a wide-angle or wide-field lens.

short lighting A portrait lighting setup in which the main source of light illuminates the side of the face partially turned away from the camera. Also called narrow lighting.

shutter A mechanism that opens and closes to admit light into a camera for a measured length of time.

silhouette A scene or photograph in which the background is much more brightly lit than the subject.

silver halide The light-sensitive part of common photographic emulsions; the compounds silver chloride, silver bromide and silver iodide.

single-lens reflex A camera in which the image formed by the taking lens is reflected by a mirror onto a ground-glass screen for viewing. The mirror swings out of the way just before exposure to let the image reach the film. Abbreviated as SLR.

slide 1) A transparency (often a positive image in color) mounted between glass or in a frame of cardboard or other material so that it may be inserted into a projector. 2) A protective cover that is removed from a sheet film holder when film in the holder is to be exposed.

slow See fast.

sodium thiosulfate The active ingredient in most fixers.

soft 1) An image that is blurred or out of focus. Opposite: sharp. 2) A scene, negative or print of low contrast. Opposite: hard or high contrast. 3) A printing paper emulsion of low contrast, such as Grade 0 or 1.

solarization A reversal of image tones that occurs when film is massively overexposed. See *Sabattier effect.*

spectrum The forms of radiant energy arranged by size of wavelength ranging from thousand millionths of a millimeter (gamma rays) to several miles (radio waves). The visible spectrum is the part that the human eye sees as light: wavelengths of 400 to 700 nanometers (billionths of a meter), producing the sensation of the colors violet, blue, green, yellow and red.

speed 1) The relative sensitivity to light of film or paper. 2) The relative ability of a lens to admit more light by opening to a wider aperture.

spherical aberration A lens defect that causes rays that strike at the edges of the lens to be bent more than rays that strike at the center.

spot To remove small imperfections in a print

caused by dust specks, small scratches or the like. Specifically, to paint a dye over small white blemishes.

spotlight An electric light that contains a small, bright lamp, a reflector and often a lens to concentrate the light. Designed to produce a narrow beam of bright light.

spot meter A reflected-light exposure meter with a very small angle of view, used to measure the brightness of a small portion of a subject.

stereograph A pair of photographs taken side by side and seen separately by each eye in viewing them through a stereoscope. The resultant image looks three-dimensional.

stock solution A concentrated chemical solution that must be diluted before use.

stop 1) A diaphragm setting on a lens at one of its apertures. 2) A change in exposure by a factor of two. One stop more exposure doubles the light reaching film or paper. One stop less halves the exposure. Either the aperture or the exposure time can be changed. 3) See below.

stop bath An acid solution used between the developer and the fixer to stop the action of the developer and to preserve the effectiveness of the fixer. Generally a dilute solution of acetic acid; plain water is sometimes used as a stop bath for film development.

stop down To decrease the size of a lens aperture. Opposite: open up.

strobe See electronic flash.

subtractive color A way to produce colors by mixing dyes that contain varying proportions of the three subtractive primary colors—cyan, magenta and yellow. Each dye subtracts its color from white light, leaving a balance of colored light. Dyes that absorb all wavelengths of light produce black.

supplementary lens A lens that can be added to a camera lens for close-up work. It magnifies the image and permits focusing closer to an object than normal.

synch cord An electrical cord connecting a flash unit with a camera so that the two can be synchronized. See below.

synchronize To cause a flash unit to fire at the same time as the camera shutter is open.

synchro-sun A way to use flash lighting as fill light in a photograph made in direct sunlight. The flash lightens the shadows, decreasing the contrast in the scene.

T See time.

tacking iron A small, electrically heated tool used to melt the adhesive in dry mount tissue, attaching it partially to the back of the print and to the mounting surface. This keeps the print in place during the mounting procedure.

taking lens The lens on a camera through which light passes to expose the film.

tank A container for developer or other processing chemicals into which film is placed for development.

telephoto effect *See distortion.*

telephoto lens Loosely, any lens of very long focal length. Specifically, one constructed so that its effective focal length is longer than its actual size.

tenting A way to light a highly reflective object. The object is surrounded with large sheets of paper or translucent material lighted so that the object reflects them and not the lamps, camera and other items in the studio.

thin Describes a negative or an area of a negative where relatively little silver has been deposited. A thin negative transmits a large amount of light. Opposite: dense.

time A shutter setting marked T at which the shutter remains open until reclosed by the photographer.

tintype An old collodion wet-place process in which the emulsion was coated onto a dark metal plate. It produced a positive image.

tone To change the color of a print by immersing it in a chemical solution.

transparency An image set on a transparent base, such as film or glass, and viewed by transmitted light. *See slide (1).*

tripod A three-legged support for a camera. Usually the height is adjustable and the top or head is movable.

tungsten film Color film balanced to produce accurate color renditions when the light source that illuminates the scene has a color temperature of about 3200K as do certain tungsten photographic lamps. Also called Type B film. See Type A film.

tungsten light Light such as that from an ordinary light bulb containing a thin tungsten wire that becomes incandescent (emits light) when an electric current is passed along it. Also called incandescent light.

twin-lens reflex A camera in which two lenses are mounted above one another. The bottom (taking) lens forms an image on the exposed film. The top (viewing) lens forms an image that reflects upward onto a ground-glass viewing screen. Abbreviated as TLR.

Type A film Color film balanced to produce accurate color renditions when the light source that illuminates the scene has a color temperature of about 3400K, as does a photolamp. *See tungsten film.*

Type B film *See tungsten film.*

ultraviolet The part of the spectrum just beyond violet. Ultraviolet light is invisible to the human eye but strongly affects photographic materials.

underdevelop To give less development than normal.

underexpose To give too little exposure to film or paper. The resulting silver density is less than necessary for best results.

value The relative lightness or darkness of an area. Low values are dark; high values are light.

variable contrast A type of printing paper that produces different contrast grades depending on the color of the filter used between the enlarger light source and the paper.

view camera A camera in which the taking lens forms an image directly on a ground-glass viewing screen. A film holder is inserted in front of the viewing screen before exposure. The front and back of the camera can beßsetat various angles to change focus and perspective.

viewfinder A device on a camera through which the subject is seen and framed.

viewing lens The lens on a camera through which the eye views the subject.

viewing screen In a reflex or view camera, the ground-glass surface on which the image is seen and focused.

vignette To underexpose the edges of an image. Sometimes done intentionally but more often caused accidentally by a lens that forms an image covering the film or paper only partially.

warm Reddish colors that by association with common objects (fire, sun and so on) give an impression of warmth.

wet-plate process A photographic process in which a glass or metal plate was coated with a collodion mixture, then sensitized with silver nitrate, exposed and developed while the collodion was still wet. It was popular from the 1850s until the introduction of the gelatin dry plate in the 1880s.

wetting agent A chemical solution used after washing film. By reducing the surface tension of the water remaining on the film, it speeds drying and prevents water spots.

white light A mixture of all wavelengths of the visible spectrum. The human eye sees the mixture as light that is colorless or white.

wide-angle distortion *See distortion.*

wide-angle lens *See short lens.*

working solution A chemical solution diluted to the correct strength for use.

zone focus To preset the focus of a lens so that some future action will take place within the limits of the depth of field.

Zone System A way to plan negative exposure and development in order to achieve precise control of the darkness of various areas in a print.

zoom lens A lens adjustable to a range of focal lengths.

Bibliography

This bibliography is only a sampling of the literature of photography, which is so extensive that it requires two volumes of its own: *Photographic Literature* and *Photographic Literature 1960–1970*, edited by Albert Boni (Dobbs Ferry, N.Y.: Morgan & Morgan, 1962 and 1972). The Boni bibliographies list more than 32,000 works under 2900 headings and include works on photographic techniques, theory, chemistry, physics, history, biography, aesthetics and many other subjects.

Another useful listing of information is available free from the Eastman Kodak Co. (Rochester, N.Y. 14650). Their *Index to Kodak Information* lists the more than 800 books and pamphlets that they publish for a variety of photographic interests ranging from *Good Color Pictures—Quick and Easy* to *Photography Under Arctic Conditions*.

Technical Information: Basic

This book is a basic introductory text in photography, and you will find that other basic textbooks generally cover the same topics. However, you may want to consult one or more additional beginner's texts because authors explain material in individual ways and may emphasize different points. The following books are of about the same level of difficulty as this one.

Blaker, Alfred A. *Photography: Art and Technique*. San Francisco, W. H. Freeman and Co., 1980.

Craven, George M. *Object and Image: An Introduction to Photography*. Englewood Cliffs, N.J.: Prentice-Hall, 1975.
Explores various styles—reportorial, symbolistic and so on.

Davis, Phil. *Photography*, 3rd edition. Dubuque, Iowa: William C. Brown Co., 1979.
Covers technical material more extensively than the others.

Sussman, Aaron. *The Amateur Photographer's Handbook*. New York: Thomas Y. Crowell Co., 1973.

Swedlund, Charles. *Photography*. New York: Holt, Rinehart and Winston, 1974.

Vestal, David. *The Craft of Photography*. New York: Harper & Row, 1974.

Technical Information: Advanced or Specialized

The following books will be useful when you are familiar with the basic material in this text.

Adams, Ansel. *Basic Photo Series. The Negative*, 1968. *The Print*, 1968. *Natural-Light Photography*, 1971. *Artificial-Light Photography*, 1968. *The New Ansel Adams Photography Series*, with Robert Baker, will supercede the *Basic Photo Series*. Currently available: *The Camera*, 1980. *Polaroid Land Photography*, with Robert Baker. Boston: New York Graphic Society, 1978. Stresses full technical control of the photographic process as an aid to creative expression.

Clerc, L. P. *Photography: Theory and Practice*. Garden City, N.Y.: Amphoto, 1973.
A detailed technical reference.

Crawford, William. *The Keepers of Light. A History and Working Guide to Early Photographic Processes*. Dobbs Ferry, New York: Morgan & Morgan, 1979.
The history of early photographic media such as the ambrotype, cyanotype, platinum print, gum bichromate print and others, plus clear directions on how to make these prints yourself.

Eaton, George T. *Photographic Chemistry*. Dobbs Ferry, N.Y.: Morgan & Morgan, 1965.
Understandable without formal training in chemistry or physics.

The Focal Encyclopedia of Photography. New York: McGraw-Hill Book Co., 1971.
Alphabetical arrangement of general technical information plus some historical material.

Gassan, Arnold. *Handbook for Contemporary Photography*. Athens, Ohio: Handbook Co., 1974.
A general, advanced workbook with information on nonsilver processes.

Kobre, Kenneth. *Photojournalism: The Professionals' Approach*. Somerville, Mass.: Curtin & London, Inc., 1980.
A comprehensive and readable overview of equipment, techniques and approaches used by photojournalists.

Larmore, Lewis. *Introduction to Photographic Principles*. New York: Dover Publications, 1965.
An inexpensive paperback covering basic chemical and physical theory.

Morgan, Douglas O.; Vestal, David; and Broecker, William L., eds. *Leica Manual*. Dobbs Ferry, N.Y.: Morgan & Morgan, 1973.
Useful information about a specific camera and 35mm photography in general. Other manufacturers also publish comprehensive manuals.

Neblette, C. B. *Photography: Its Materials and Processes*. New York: Van Nostrand Reinhold Co., 1962.
A complete, general reference to photographic technology.

Pittaro, Ernest M., ed. *Photo-Lab-Index*. Dobbs Ferry, N.Y.: Morgan & Morgan, updated yearly.
An extensive looseleaf storehouse of information provided by manufacturers of photographic products. Contains full descriptions of their materials and recommended procedures for their use.

Stone, Jim, ed. *Darkroom Dynamics: A Guide to Creative Darkroom Techniques*. Somerville, Mass.: Curtin & London, Inc., 1979.
Illustrated instructions on how to expand your imagery with multiple printing, toning, hand coloring, high contrast and other techniques.

Stroebel, Leslie. *View Camera Technique*. New York: Hastings House Publishers, 1967.

Todd, Hollis N. and Zakia, Richard D. *Photographic Sensitometry: The Study of Tone Reproduction*. Dobbs Ferry, N.Y.: Morgan & Morgan, 1969.
Measuring, analyzing and applying data on the effects of light on photographic materials.

Color

See also general photographic books, which often have sections on color photography.

de Mare, Eric. *Colour Photography*. Baltimore: Penguin Books, 1968.

Eastman Kodak Co. *Color as Seen and Photographed*. Rochester, N.Y.: Eastman Kodak Co., 1966.
A readable introduction to the basic principles of color photography.

———. *Kodak Color Darkroom Dataguide*. Rochester, N.Y.: Eastman Kodak Co., 1980.
Gives Kodak's recommended procedures for exposing, processing and printing Kodak color materials. Includes a gray card, color patches and color viewing filters.

———. *Printing Color Negatives*. Rochester, N.Y.: Eastman Kodak Co., 1978.
Useful information on how to make color prints in general using Kodak materials in particular.

Evans, Ralph M. *Eye, Film, and Camera in Color Photography*. New York: John Wiley & Sons, 1959.
Includes material on how to manipulate the differences between what the eye sees and what the camera sees.

Feininger, Andreas. *Successful Color Photography*. Englewood Cliffs, N.J.: Prentice-Hall, 1969.

Zakia, Richard D. and Todd, Hollis N. *Color Primer I & II*. Dobbs Ferry, N.Y.: Morgan & Morgan, 1974.
A programmed instruction book about additive and subtractive color mixing.

Zone System

Adams, Ansel. *Basic Photo Series* (see Technical Information: Advanced or Specialized). *The Negative*, *Natural-Light Photography* and *Artificial-Light Photography* give detailed information by one of the originators of the system.

Dowdell, John J., III and Zakia, Richard D. *Zone Systemizer*. Dobbs Ferry, N.Y.: Morgan & Morgan, 1973.
A dial-type device to aid in computing Zone System exposure and development. Includes detailed instructions on how to use the dial.

Morgan, Douglas O., et al. *Leica Manual* (see Technical Information: Advanced or Specialized). Contains chapter by Ansel Adams on "The Zone System for 35mm Photography."

Picker, Fred. *The Zone VI Workshop: The Fine Print in Black and White Photography*. Garden City, N.Y.: Amphoto, 1974.
Introduction to Zone System exposure plus the author's personal printing techniques.

White, Minor. *Zone System Manual*. Dobbs Ferry, N.Y.: Morgan & Morgan, 1972.
How to use the Zone System as a creative tool.

History, Criticism, Collections

Beaton, Cecil and Buckland, Gail. *The Magic Image*. Boston: Little, Brown and Co., 1975.
Biographies of and pictures by more than 200 photographers including much anecdotal material.

Buckland, Gail. *Reality Recorded: Early Documentary Photography*. Boston: New York Graphic Society, 1974.
Calotype and wet-plate documentary photographs.

Doty, Robert, ed. *Photography in America*. New York: Random House, 1974.
Pictures by 86 American photographers from the 1840s to today.

Edey, Maitland. *Great Photographic Essays from LIFE*. Boston: New York Graphic Society, 1978.
Twenty-two photographic essays including work by Abbott, Adams, Bourke-White, Cartier-Bresson and others.

The Family of Man. New York: The Museum of Modern Art, 1955.
Edward Steichen organized this show, which was probably the most publicized and widely seen photographic exhibition ever mounted.

Gassan, Arnold. *A Chronology of Photography*. Athens, Ohio: Handbook Co., 1972.
A survey of various themes in the history of photography—the portrait, the cityscape, etc.—plus a chronology that compares "events in the development of photography with events in other arts and in the world."

Gernsheim, Helmut and Gernsheim, Alison. *A Concise History of Photography*. New York: Grosset and Dunlap, 1965.
A chronological overview.

———. *The History of Photography 1685–1914*. New York: McGraw-Hill Book Co., 1969.
A detailed history "from the camera obscura to the beginning of the modern era." Considerable information on European, particularly British, photography.

Green, Jonathan, ed. *Camera Work: A Critical Anthology*. Millerton, N.Y.: Aperture, 1973.
Extensive selections from *Camera Work*, "the photographic quarterly published by Alfred Stieglitz, illustrating the evolution of the avant garde in American art and photography from 1903–1917."

Hodgson, Pat. *Early War Photographs*. Boston: New York Graphic Society, 1974.
The first 50 years of war photography including coverage of the Crimean War and the American Civil War.

Life Library of Photography. New York: Time-Life Books, 1970–1975.
Seventeen volumes plus yearbooks, all profusely illustrated. The books generally contain historical material, technical information and discuss current trends.

The Literature of Photography Series. New York: Arno Press, 1973.
Sixty-two long out-of-print technical manuals, historical accounts and aesthetic treatises, including, for example, the 1858 *American Hand*

Book of the Daguerreotype, which gives "the most approved and convenient methods for preparing the chemicals and combinations used in the art."
Other publishers that have reprinted early photographic books include Morgan & Morgan (Dobbs Ferry, N.Y.) and Dover Publications (New York).

Lyons, Nathan, ed. *Photographers on Photography: A Critical Anthology*. Englewood Cliffs, N.J.: Prentice-Hall, 1966.
Twenty-three well-known photographers (1880s to 1960s) discuss their own work and photography in general.

———. *Photography in the Twentieth Century*. New York: Horizon Press, 1967.
The work of 150 photographers is represented in this collection, which was "intended to provide a visual anthology of the picture making concerns of photographers in the Twentieth Century."

Naef, Weston J., and Wood, James N. *Era of Exploration: The Rise of Landscape Photography in the American West, 1860–1885*. New York: The Metropolitan Museum of Art, 1975.
Extensive treatment of the subject with emphasis on the photographers Watkins, O'Sullivan, Muybridge, Russell and Jackson.

Newhall, Beaumont. *The History of Photography from 1839 to the Present Day*. New York: The Museum of Modern Art, 1964.
The most widely used basic text on the history of photography.

———. *Latent Image: The Discovery of Photography*. Garden City, N.Y.: Doubleday & Co., 1967.
An interesting account of early photographic research and discoveries.

Pollack, Peter. *The Picture History of Photography*. New York: Harry N. Abrams, 1969.
Useful for its many illustrations.

Rudisill, Richard. *Mirror Image: The Influence of the Daguerreotype on American Society*. Albuquerque, N.M.: University of New Mexico Press, 1971.
Fascinating social history of the cultural, commercial and social effects of the daguerreotype on mid-19th century America.

Scharf, Aaron. *Art and Photography*. Baltimore: Penguin Books, 1974.
The interrelationship of photography and painting.

Steichen, Edward, ed. *The Bitter Years, 1935–1941. Rural America as Seen by the Photographers of the Farm Security Administration*. New York: The Museum of Modern Art, 1962.

Szarkowski, John, ed. *From the Picture Press*. New York: The Museum of Modern Art, 1973.
A splendid collection of news photographs illustrating the universal front-page themes of "ceremonies, winners, losers, heroes, good news, alarums, confrontations, and disasters."

———. *Looking at Photographs*. New York: The Museum of Modern Art, 1973.
Szarkowski discusses 100 pictures from the museum's collection. An insightful, very readable and highly recommended book.

———. *Mirrors and Windows: American Photography Since 1960*. New York: The Museum of Modern Art, 1978.

———. *The Photographer's Eye*. New York: The Museum of Modern Art, 1966.
Five major concerns of photographers—the photograph itself, the detail, the frame, time and vantage point—with excellent illustrations for each concept.

Taft, Robert. *Photography and the American Scene*. New York: Dover Publications, 1964 reprint of 1938 edition.
A detailed account of photography's introduction and growth in the United States between 1839 and 1889.

Tucker, Anne. *The Woman's Eye*. New York: Alfred A. Knopf, 1973.
Biographies and statements of ten American women photographers and a portfolio of photographs by each. The book explores "the role played by sexual identity both in the creation and the evaluation of photographic art."

Witkin, Lee and Barbara (Upton) London. *The Photograph Collector's Guide*. Boston: New York Graphic Society, 1979.
Information of general photographic interest as well as for collectors, such as: biographical entries with illustrations for over 200 photographers; lists of over 8000 other photographers, museums, galleries and so on.

Individual Photographers

The photographers listed below have pictures in this book.

Ansel Adams
———. *Ansel Adams: Images 1923–1974*. Foreword by Wallace Stegner. Boston: New York Graphic Society, 1974.
———. *Yosemite and the Range of Light*. Intro. by Paul Brooks. Boston: New York Graphic Society, 1979.

Robert Adams
———. *The New West: Landscapes Along the Colorado Front Range*. Intro. by John Szarkowski. Boulder: Colorado Associated University Press, 1974.

Eugène Atget
Abbott, Berenice. *The World of Atget*. New York: Horizon Press, 1964.

Lewis Baltz
———. *The New Industrial Parks near Irvine, California*. New York: Castelli Graphics, 1974.

Margaret Bourke-White
———. *The Photographs of Margaret Bourke-White*. Ed. by Sean Callahan. Greenwich, Conn.: New York Graphic Society, 1972.
Theodore M. Brown. *Margaret Bourke-White: Photojournalist*. Ithaca, N.Y.: Cornell University Press, 1972.

Harry Callahan
———. *Callahan*. Ed. and intro. by John Szarkowski. Millerton, N.Y.: Aperture, 1976.
———. *Harry Callahan*. Intro. by Peter C. Bunnell. New York: American Federation of Arts, and Rizzoli International, 1978.

Julia Margaret Cameron
Gernsheim, Helmut. *Julia Margaret Cameron: Her Life and Photographic Work*. Millerton, N.Y.:

Aperture, 1975.

Graham Ovenden, ed. *A Victorian Album: Julia Margaret Cameron and Her Circle.* New York: Da Capo, 1975.

Paul Caponigro

_____. *Paul Caponigro.* Millerton, N.Y.: Aperture, 1972.

Henri Cartier-Bresson

_____. *Henri Cartier-Bresson.* Millerton, N.Y.: Aperture, 1976.

_____. *Henri Cartier-Bresson: Photographer.* Essay by Yves Bonnefoy. Boston: New York Graphic Society, 1979.

Alvin Langdon Coburn

_____. *Alvin Langdon Coburn, Photographer: An Autobiography.* Ed. by Helmut and Alison Gernsheim. London: Faber & Faber, and New York: Praeger, 1966.

Marie Cosindas

_____. *Marie Cosindas: Color Photographs.* Essay by Tom Wolfe. Boston: New York Graphic Society, 1978.

Robert Cumming

_____. *Cumming Photographs.* Text by James Alinder. Carmel, California: The Friends of Photography, 1979.

Imogen Cunningham

_____. *Imogen! . . . Photographs 1910–1973.* Intro. by Margery Mann. Seattle: University of Washington Press, 1974.

Judy Dater. *Imogen Cunningham: A Portrait.* Boston: New York Graphic Society, 1979.

L. J. M. Daguerre

Helmut and Alison Gernsheim. *L. J. M. Daguerre: The History of the Diorama and the Daguerreotype.* London: Secker & Warburg, 1956. Bibliography. U.S. ed., New York: Dover, 1968.

Maxime Du Camp

Francis Steegmuller, trans. and ed. *Flaubert in Egypt: A Sensibility on Tour—A Narrative Drawn from Gustave Flaubert's Travel Notes and Letters.* Boston: Little, Brown, 1972.

Includes photographs and extracts from Du Camp's descriptions of the trip.

Harold Edgerton

_____. *Moments of Vision: The Stroboscopic Revolution in Photography.* With James R. Killian, Jr. Cambridge, Mass.: MIT Press, 1979.

William Eggleston

_____. *William Eggleston's Guide.* Text by John Szarkowski. New York: Museum of Modern Art, 1976.

P. H. Emerson

Newhall, Nancy. *P. H. Emerson: The Fight for Photography as a Fine Art.* Millerton, N.Y.: Aperture, 1975.

Peter Turner and Richard Wood. *P. H. Emerson: Photographer of Norfolk.* Boston: Godine, 1975.

Elliott Erwitt

_____. *Photographs and Anti-Photographs.* Texts by Sam Holmes and John Szarkowski. Greenwich, Conn.: New York Graphic Society, 1972.

Frederick H. Evans

Newhall, Beaumont. *Frederick H. Evans.* Millerton, N.Y.: Aperture, 1973.

Roger Fenton

_____. *Roger Fenton: Photographer of the Crimean War. His Photographs and His Letters from the Crimea.* New York: Arno Press, 1973 reprint of 1954 edition.

John Hannavy. *Roger Fenton of Crimble Hall.* Boston: Godine, 1976.

Robert Frank

_____. *Les Américains.* Ed. by Alain Bosquet. Paris: Delpire, 1958. U.S. ed., *The Americans.* Intro. by Jack Kerouac. New York: Grove, 1959. Rev. eds., Millerton, N.Y.: Aperture, 1969, 1978.

_____. *Robert Frank.* Intro. by Rudolph Wurlitzer. Millerton, N.Y.: Aperture, 1976.

Lee Friedlander

_____. *Lee Friedlander Photographs.* New City, N.Y.: Haywire Press, 1978.

_____. *Self Portrait.* New City, N.Y.: Haywire Press, 1970.

Philippe Halsman

_____. *Sight and Insight.* New York: Doubleday, 1972.

Charles Harbutt

_____. *Travelog.* Cambridge, Mass.: MIT Press, 1974.

David O. Hill and Robert Adamson

Bruce, David. *Sun Pictures: The Hill/Adamson Calotypes.* Boston: New York Graphic Society, 1974.

An Early Victorian Album: The Hill/Adamson Collection. Ed. and intro. by Colin Ford. Commentary by Roy Strong. London: Cape, 1974. U.S. ed., New York: Knopf, 1976.

Lewis W. Hine

Gutman, Judith M. *Lewis W. Hine and the American Social Conscience.* New York: Walker & Co., 1967.

Walter Rosenblum, Naomi Rosenblum, and Alan Trachtenberg. *America & Lewis Hine: Photographs 1904–1940.* Millerton, N.Y.: Aperture, 1976.

Mark and Dan Jury

_____. *Gramp.* New York: Penguin, 1978.

Yousuf Karsh

_____. *Karsh Portraits.* Toronto: University of Toronto Press, and Boston: New York Graphic Society, 1976.

David Hume Kennerly

_____. *Shooter.* New York: Newsweek Books, 1980.

André Kertész

_____. *André Kertész: Sixty Years of Photography 1912–1972.* New York: Grossman Publishers, 1972.

_____. *André Kertész.* Intro. by Carole Kismaric. Millerton, N.Y.: Aperture, 1977.

Dorothea Lange

Dorothea Lange. Intro. by George P. Elliott. New York: Museum of Modern Art, 1966.

Milton Meltzer. *Dorothea Lange: A Photographer's Life.* New York: Farrar, Straus & Giroux, 1978.

Russell Lee

F. Jack Hurley. *Russell Lee: Photographer.* Dobbs Ferry, N.Y.: Morgan & Morgan, 1978.

Danny Lyon

_____. *Conversations with the Dead.* New York: Holt, Rinehart & Winston, 1971.

_____. *Danny Lyon: Ten Years of Photographs.* Text by Thomas H. Garver. Newport Beach, Calif.: Newport Harbor Art Museum, 1973.

Man Ray

Roland Penrose. *Man Ray.* Boston: New York Graphic Society, 1975.

Arturo Schwarz. *Man Ray: The Rigour of Imagination.* New York: Rizzoli, 1977.

Joel Meyerowitz

_____. *Cape Light. Color Photographs.* Boston: Museum of Fine Arts, 1978. Includes interview by Bruce K. MacDonald.

Duane Michals

_____. *Duane Michals: The Photographic Illusion.* New York: Crowell, 1975.

László Moholy-Nagy

_____. *Vision in Motion.* Chicago: Paul Theobald, 1947.

Photographs of Moholy-Nagy. Ed. by Leland D. Rice and David W. Steadman. Claremont, Calif.: Galleries of the Claremont Colleges, 1975.

Barbara Morgan

_____. *Barbara Morgan.* Intro. by Peter C. Bunnell. Hastings-on-Hudson, N.Y.: Morgan & Morgan, 1972.

Eadweard Muybridge

_____. *Animals in Motion* (1957) and *The Human Figure in Motion* (1955). New York: Dover Publications.

Robert Bartlett Haas. *Muybridge: Man in Motion.* Berkeley: University of California Press, 1976.

Timothy H. O'Sullivan

Alexander Gardner. *Gardner's Photographic Sketch Book of the War.* 2 vols. Washington, D.C.: Philp & Solomons, 1866. 45 albumen prints by O'Sullivan. Reprint, 1 vol. New York: Dover, 1959.

Horan, James D. *Timothy O'Sullivan: America's Forgotten Photographer.* Garden City, N.Y.: Doubleday & Co., 1966.

Irving Penn

_____. *Worlds in a Small Room.* New York: Grossman/Viking, 1974.

Eliot Porter

_____. *The Place No One Knew: Glen Canyon on the Colorado.* Ed. by David Brower. San Francisco: Sierra Club, 1963.

O. G. Rejlander

Jones, Edgar Y. *Father of Art Photography: O. G. Rejlander 1813–1875.* Boston: New York Graphic Society, 1973.

Leland Rice

Charles W. Millard. *Leland Rice.* Washington, D.C.: Hirshhorn Museum and Sculpture Garden, 1977.

Henry P. Robinson

_____. *Pictorial Effect in Photography: Being Hints on Composition and Chiaroscuro for Photographers.* Pawlet, Vt.: Helios, 1971 reprint of 1869 edition.

August Sander

_____. *Men Without Masks: Faces of Germany 1910–1938.* Boston: New York Graphic Society, 1973.

W. Eugene Smith

_____. *W. Eugene Smith: His Photographs and Notes.* Millerton, N.Y.: Aperture, 1969.

_____. *Minamata*. With Aileen M. Smith. New York: Holt, Rinehart & Winston, 1975.

Alfred Stieglitz

Frank, Waldo, *et al.*, eds. *America and Alfred Stieglitz*. Garden City, N.Y.: Doubleday, Doran & Co., 1934.

Alfred Stieglitz. Intro. by Dorothy Norman. Millerton, N.Y.: Aperture, 1976.

Paul Strand

Paul Strand: Sixty Years of Photographs. Profile by Calvin Tomkins. Millerton, N.Y.: Aperture, 1976.

Josef Sudek

Sonja Bullaty. *Sudek*. Intro. by Anna Fárová. New York: Potter, 1978.

William Henry Fox Talbot

André Jammes. *William H. Fox Talbot: Inventor of the Negative-Positive Process*. New York: Macmillan, 1974.

George A. Tice

_____. *George A. Tice Photographs 1953–1973*. New Brunswick, N.J.: Rutgers University Press, 1975.

Jerry N. Uelsmann

_____. *Jerry N. Uelsmann: Silver Meditations*. Intro. by Peter C. Bunnell. Dobbs Ferry, N.Y.: Morgan & Morgan, 1975.

Weegee (Arthur Fellig)

Weegee. Ed. by Louis Stettner. New York: Knopf, 1977.

Weegee (Arthur Fellig). Intro. by Allene Talmey. Millerton, N.Y.: Aperture, 1977.

Brett Weston

_____. *Brett Weston: Voyage of the Eye*. Millerton, N.Y.: Aperture, 1975.

Edward Weston

_____. *The Daybooks of Edward Weston* (2 vols.). Millerton, N.Y.: Aperture, 1973.

Ben Maddow. *Edward Weston: Fifty Years*. Millerton, N.Y.: Aperture, 1973. Bibliography. Another ed., Boston: New York Graphic Society, 1978.

Minor White

_____. *Mirrors Messages Manifestations*. Millerton, N.Y.: Aperture, 1969.

Minor White: Rites & Passages. Text by James Baker Hall. Millerton, N.Y.: Aperture, 1978.

Garry Winogrand

_____. *Public Relations*. Texts by Tod Papageorge and John Szarkowski. New York: Museum of Modern Art, 1977.

Periodicals

Afterimage, 4 Elton St., Rochester, New York 14607. A newspaper-format monthly from the Visual Studies Workshop. Often includes scholarly articles about photography.

American Photographer, 485 Fifth Ave., New York, New York 10017. Photography as a fine art, with emphasis on contemporary American work.

Aperture, Elm Street, Millerton, N.Y. 12546. A superbly printed quarterly dealing with photography as an art form. Many issues are monographs on individual photographers.

Artforum, 667 Madison Avenue, New York, N.Y. 10021. This magazine and *Art in America* have occasional articles about photography as an art form in addition to reviews of photographic shows.

Art in America, 150 East 58th Street, New York, N.Y. 10022.

Camera, C. J. Bucher Ltd., Lucerne, Switzerland. Features high-quality reproductions of current and historical material.

Camera Arts, One Park Avenue, New York, N.Y. 10016. Emphasis on photography as an art.

Camera 35, One Park Avenue, New York, N.Y. 10016. *Camera 35, Modern Photography, Petersen's Photographic* and *Popular Photography* are aimed at the amateur audience. They feature information about new products, how-to-do-it articles and portfolios by various photographers.

Creative Camera, 19 Doughty Street, London WC1N2PT, England. Published by the International Federation of Amateur Photographers, this magazine publishes the work of a broad range of photographers.

Image, 900 East Avenue, Rochester, N.Y. 14607. The publication of the International Museum of Photography at George Eastman House. Interesting contemporary and historical material.

Modern Photography. 130 East 59th Street, New York, N.Y. 10022.

Petersen's Photographic, 8490 Sunset Boulevard, Los Angeles, California 90069.

Popular Photography, One Park Avenue, New York, N.Y., 10016.

Index

Page numbers in italics refer to illustrations of the subject or by the photographer mentioned.

Accelerator, in developer, 132
Accent light, 202, *202*
Acutance, 90
Adams, Ansel, *50, 51, 52, 234*, 235, 236, *246, 247, 346*, 352
Adams, Robert, *367*
Adamson, Robert, *325*
Additive color, 270, *270*
Agitation: of black-and-white prints, 155, 161, *161*, 162, *162*; of color prints, 292, 301; of film, 127, 129, 138, *138*; of sheet film, 233, *233*
Albumen, 326
Alhazen, 320
Alkali, 132
Ambrotype, 326, *327, 327*
American National Standards Institute, 86
Anderson, Ruth C., *3*
Angle of view: and fisheye lens, 62, *63*, and lens focal length, 54, *54*, 55, *55*, 56
Animal Locomotion (Muybridge), 336, *337*
Anthony, Edward, *336*
Antistatic brush or cloth, 146, 232
Aperture, 26, 34; and depth of field, 40–41, *40–41*; for light control, 38–39; and shutter speed combination, 42, *42–43. See also* f-stop
Aperture magazine, 353
Aperture-priority operation, 116
Arbus, Diane, 354
Archer, Fred, 235
Archer, Frederick Scott, 326
Archival print processing, 174
Artforum, 354
Artificial light. *See* Lighting
Art in America, 354
ASA rating, 86. *See also* Film speed
Atget, Eugène, 338, *339*, 366
Axis lighting, 198, *198*, 206, *206*, 208, *209*, 210, *210*

Babbitt, Platt D., *322*
Background light, 203, *203*
Back lighting, 202, *202*, 206, *206*
Bag bellows, 226
Baltz, Lewis, *368*
Barbaro, Daniele, 52
Barn door, 203
Barnett, Ron, *10*
Bellows, for close-ups: 252–253, *252–253*, 254; for view cameras: *28*
Bellows extension factor, 254
Bernhardt, Reto, *17*
Bernstein, Lou, *195*, 352
Binzen, Bill, *281*
Bitumen of Judea, 321
Black reflector, 200
Bleaching, 180–181, *181*
Bleed mounting, 182–184, *182–184*
Blotters, 178, *178*
Blur. *See* Motion of camera; Motion of subject
Bounced flash, 208, *211*, 212
Bounced light, 191, 192, 196, 284

Bourke-White, Margaret, *64*
Bracketing, 118, 254, 283
Brady, Mathew B., 330
Brightness. *See* Luminance
Broad lighting, 203, *203*
Bromide drag, 138, *138*
Brown, Debra J., *3*
Bullock, Wynn, *352*
Burning in: of black-and-white prints, 160, 170–171, *170–171*; of color prints, 298
Burrell, Fred, *260*
Butterfly lighting, 199, *199*, 203, *203*
Buttfield, Helen, *62*

Cable release, 44, *45*
Callahan, Harry, *194*, 352
Callis, JoAnn, *372*
Calotype, 324–325, *324–325*, 332
Camera: basic parts of, 26–27, *27*; bellows for, 252–253, *252–253*; body of, *27*; built-in exposure meters for, 116, *117, 117*; buying 46–47; cleaning of, 77; extension tubes for, 252–253, *252–253*; focusing systems of, 32–33, *32–33*; f-stops on, 39 (*see also* f-stop); loading of, 86; pinhole, 50–51; Polaroid Land, *102, 102*, types of, 26, 28–31. *See also specific types*
Camera motion. *See* Motion of camera
Camera obscura, 50–51, *52*, 320, *320*, 321
Camera Work, 345, 346
Cameron, Julia Margaret, *328*, 342
Caponigro, Paul, *120, 310*
Carte-de-visite, 329, *329*
Cartier-Bresson, Henri, 46, 56, *57*, 172, 357
Catchlight, 190, *190*, 202–203, *202–203*
Changing bag, 126
Characteristic curve, of film, 84, *84–85.* 9
Chemicals: for archival print processing, 174; for black-and-white printing, 163; for color printing, 288, 300; exhausted, 138, 139; for film processing, 123; handling, 131; temperature of, 134. *See also specific chemicals*
Church, Fred, *335*
Cibachrome materials, 300–301, *300–301*
Circles of confusion, 51, 64; and depth of field, 69, *69*
Closed form, 310, *310. See also* Composition
Close-up photography, 62, *62*, 250–255, *251–253, 255*; supplementary lenses for, 251
Coburn, Alvin Langdon, *344*
Collodion wet-plate process, 326–327, *326–327*, 330, 332, 334
Color(s), 269–305; complementary, 270; cool, 274, 278–279, *279*; and infrared film, 94–95, *95*; and light source, 284–285, *284–285*; and orthochromatic film, 94, *94*; and panchromatic film, 94–95, *95*;

photograms in, 256; primary, 270–271, *270–271*, 296, *296*; processing, 286–302, *286–302*; and reciprocity effect, 282–283; warm, 274, 278, *278*
Color balance: in color printing, 296–298, *296–297*, 302, *302*; filters for, 276–277, *276*; of light and film, 274–275, *274–275*
Color-compensating (CC) filters, 277, 278, 288, 298
Color-printing (CP) filters, 288, 298
Color temperature of light, 274
Color wheel, 296, *296*
Compactions, in zone system, 241
Compensating development, 143, *143*
Composition, photographic: closed form, 310, *310*; detail of a scene in, 308–309, *308–309*; elements of, 357; frame in, 308–309, *308–309*, 310–311, *310–311*; light and dark in, 316; open form, 310, *311*; point of view in, 312, *312–313*; rules of, 307, and sharpness, 314–315, *314–315. See also* Zone system
Compound lens, 53
Condenser enlarger, 148, *148*
Contact printing: step-by-step procedure, 152–155, *152–155*
Contact sheet, 152–155, *152–155*
Contamination: in black-and-white printing, 173; in color printing, 292; and drying of prints, 179; preventing, 131
Contrast: in color photographs, 284, *284–285*; and directional-diffused light, 191; in direct light, 190; fill light for reducing, 200–201, *201*; and film development, 134–137, *135–137*, 143, *143*; and indoor lighting, 196, *196–197*; judging, with black and white patches, 173; and outdoor lighting, 194–195, *194–195*; in print, 164–165, *164–165*; and printing paper, 166–169, *167–169. See also* Zone system
Convergence, 228, *228, 229*
Copy machine, prints made from, 266–267, *266–267*, 360–361
Cosindas, Marie, *304, 305*
Coupled rangefinder, 29, 32
Cropping, 172
Cross-screen lens attachment, 101
Cumming, Robert, *371*
Cunningham, Imogen, 90, *91*
Cyanotype process, 358

Dada, 348
Daguerre, Louis Jacques Mandé, 320, 321, *322, 336*
Daguerreotype, *318*, 321, 322–323, *322–323*
Darkroom equipment, for black-and-white printing, 146–147, *146–147*; for collodion wet-plate process, 326, *326*; for color printing, 288,

289; for developing film, 123, *122–123*
Dataguide, Kodak Color Darkroom, 298
Daylight: photographing in, 194–195, *194–195*, 280–281, *280–281*; simulating, *188,* 189. *See also* Sunlight
Deeks, John, *286*
DeLory, Peter, *283*
Densitometers, 166
Density: in black-and-white prints, 164–165, *164–165*; in color prints, 295, *295*, 302; judging, with black and white patches, 173; in negatives, 134–137, *135–137. See also* Zone system
Depth of field: aperture (f-stop) control of, 40–43, *40–43*, 66, *66–67*, 314, *314*; in close-up photography, 250; controlling, 70–71, *70–71*; effect of distance on, 68–69, *68–69*; and fisheye lens, 62, *63*; and image sharpness, 64, *64–65*; and lens focal length, 57, 58, 60, 66, *66–67. See also* View camera
Dermer, Irwin, *196*
Detail: and film speed, 90; of a scene in photographic composition, 308–309, *308*
Developer(s): in exhaustion of, 139, *139*; influence on grain, 123; and temperature, 134, *135. See also* Chemicals
Developing process: agitation in, 138, *138* (*see also* Agitation); for black-and-white film, step by step, 122–130, *122–130*, Summary, 131; for black-and-white prints, step by step, 152, *152*, 155, *155*, 159, *159*, 160–162, *160–162*, Summary, 163; for color prints, 292–294, *292–294*, 300–301, *300–301*; for color film, 292, *292–293*; effect of temperature on, 134, *134–135*; effect of time on, 134, *134–135*; fresh solutions for, 139; low-contrast, 143; overdevelopment, 136, *136–137*; presoaking of film, 131; pushing, 92, 142, *142*, for sheet film, 232–233, *232–233*; two-bath, 143; underdevelopment, 136, *136–137*; water-bath, 143
Diaphragm, 26, *27*
Dichroic filters, 298
Diffraction, 76
Diffused light, 191, *191*, 192, *192*, 195, *195*; with flash, 210, *210*
Diffusion enlarger, 148
Diopter of close-up lenses, 251, *251*
Directional-diffused light, 191, *191*
Direct light, 190, *190*, 194, *194*, 196, *196*, 284, *284*
Disdéri, André Adolphe, *329*
Distance: flash-to-subject, 212; hyperfocal, 70–71, *71*

Distortion: and lens construction, 62, 63; and lens-to-subject distance, 58, 58, 60, 60–61, 72, 72–73, 74, 74–75; view-camera control of, 222–225, 222–225, 228–230, 228–230; and wide-angle lens, 60
Document, photograph as, 338–339, 338–339
Dodging: of black-and-white prints, 160, 170–171, 170–171; of color prints, 298; of test print, 164
Dominis, John, 284
Drake, James, 93
Dresser, Cynthia, 4
Dropout, 260
Drying: of black-and-white prints, 162, 162, 178–179, 178–179; of color prints, 294, 294, 301, 301; of film, 130, 130
Dry mounting, 182–184, 182–184; and matting, 187
DuCamp, Maxime, 332
Dust, 146, 148, 173, 180
Dyes, photographic, for spotting, 180, 298

Eastman, George, 334, 335
Edgerton, Harold E., 19
Eggleston, William, 365
Electromagnetic spectrum, 81; and black-and-white pictures, 94
Electronic flash, 208, 208; modeling lights on, 210. See also Flash
Emerson, Peter Henry, 343, 345
Emulsion: of black-and-white film, 82, 82; of color film, 272, 272; effect of developer chemicals on, 132, 132; gelatin, 334; orthochromatic, 94
Enlarger: basic parts, 148–149, 148–149; cleaning of, 146; for color printing, 288, 289; condenser, 148, 148; diffusion-type, 148; for variable contrast printing, 169, 169
Enlarging, 156–162, 156–162
Erwitt, Elliott, 70
Etching, 180–181, 181
Evans, Frederick, 175
Evans, Walker, 340
Exhaustion, chemical, 139
Expansions, in zone system, 241
Expiration date, for film, 86
Exposure: of black-and-white film, 105–119, 104–119, 136, 136–137; of black-and-white prints, 154–155, 154–155, 158–159, 158–159, 160, 160; bracketing of, 118; camera motion during, 44; for close-up photography, 254–255, 254–255; and color film, 283; in color printing, 290, 298; flash calculations for, 212; for hard-to-meter situations, 119; out-of-the-ordinary, 118–119, 119; for specific tones, 112, 113. See also Zone system
Exposure meter(s): basic parts of,

106–107, 106–107; built-in, 116–117, 117; incident light, 108, 109, 110; luminance range reading with, 110–111, 111; overall reading with, 108–109, 108–109; reflected, 108–109, 108; spot-type, 114–115, 114–115; sensitivity of, 81; substitution reading with, 115, 115
Extension tubes, 252–253, 252–253, 254

Facio, Sara, 24
Fall. See View camera
Fall (exposure calculation). See Zone system
Farmer's Reducer, 180
Faulkner, Douglas, 9
Fenton, Roger, 330
Ferrotyping, 178, 179
Fetterer, Lynn M., 5
Fichter, Robert, 359
Fill light, 200–201, 201, 202, 202; with flash outdoors, 212, 212
Film(s), 27; characteristic curve of, 84, 84–85; choosing, 86; drying of, 140; and graininess, 88–89, 88–89; high-contrast, 260–265, 261–265; infrared, 94, 95, 96, 97; Polaroid Land, 102–103, 102–103; pushing of, 92, 142, 142; sensitivity of, 81; sizes of, 86; storage of, 86; for view camera, 28, 232–233, 232–233; washing of, 140
Film(s), black-and-white: buying, 86; characteristic curve, 84, 84–85; color response 94, 94–95; developing, 121–143, 232–233; fast-speed, 86, 88–89, 88–89, 92–93, 92–93, 194; filters used with, 98–101; infrared-sensitive, 94, 95, 96, 97; medium-speed, 86, 88–89, 88–89, 90, 91; orthochromatic, 94, 94; panchromatic, 94, 95; processing of, 122–131; slow-speed, 86, 88, 88, 90, 91. See also High-contrast materials; Sheet film
Film(s), color, 269, 272, 272; and color of light, 274, 275; daylight, 274–275, 274–275, 276; developing, 292–293, 292–293; exposure latitude, 284; instant, 304; indoor, 274, 274–275; and light source, 274–275, 274–275, 276; processing of, 286; reciprocity effect with, 282–283, 282–283
Film advance mechanism, 27
Film notching code, 232, 233
Film speed: and color film, 269; and exposure meter, 107; fast, 92–93; and flash, 212; and graininess, 88–89, 88–89; and light sensitivity, 86; of Polaroid Land films, 103, 103; pushing, 92, 142, 142; slow, 90
Filter pack, for prints made from transparencies, 302
Filter(s): to balance color, 276–277, 276; with black-and-white film, 98–101, 98–100; for color print

evaluation, 296; for color printing, 288, 298, 302; exposure increase needed with, 101; factors for, 101; polarizing, 100, 100; for variable-contrast printing, 168–169, 168–169. See also Color-compensating (cc) filters, color-printing (cp) filters
Finishing and mounting, 177–187, 178–187
Fisheye lens, 62, 63
Fixer, 133, 133; in early photographic processes, 321, 322; exhaustion of, 139, 139
Flare, 76, 90
Flash: automatic, 208; bounced, 208, 211, 211, 212; calculating exposures with, 212; common mistakes with, 213, 213; diffused, 210, 210; direct, 210, 210, 211, 211; lighting with, 208–209, 208–209, 210–211, 210–211; multiple, 211, 211
Flash bulbs, 208, 208
Flash cube, 208, 208
Flashing, 170
Flash powder, 208
FL (fluorescent) filter, 276, 276
Floodlight, 200–201, 201
Fluorescent lighting: for color print evaluation, 295; photographing in, 276
Focal length. See Lens focal length
Focal plane, 52, 54
Focal-plane shutter, 34, 35, 35
Focusing: in enlargement process, 149, 157; on camera ground glass, 32, 32; rangefinder, 30; with view camera, 231; zone, 70, 70
Focusing cloth, 231
Focusing control, 27
Focusing system: for rangefinder cameras, 33, 33; for reflex cameras, 32, 32
Forman, Stanley, 13
Frame, in photographic composition, 308, 310–311, 310–311. See also Composition
Frank, Robert, 352, 353, 354, 366
Friedlander, Lee, 354, 355
Friedman, Sy, 119
Frith, Francis, 332
Front lighting, 198, 198
f-stops, 38, 39; and depth of field, 41, 66. See also Aperture
Gardner, Alexander, 331, 332
Ghosting, 76, 76
Glassware, photographing, 204, 204–205, 298, 299
Glossy surface printing papers, 150, 150, 179
Goertel, Thomas, vi
Goodwin, Hannibal, 334
Gossage, John R., 368, 369
Graham, Martha, 308
Graininess, 49; and developers, 123; and developing process, 136, 136–137; and film speed, 88, 88–89; and Polaroid film, 102

Gray scale, 112, 113. See also Zone system
Gray test card, 115, 115, 236, 238, 254
Grehan, Farrell, 314, 315
Groover, Jan, 373
Ground glass focusing, 32, 32
Guide numbers, for flash calculations, 212, 212
Gum-bichromate process, 344, 344, 354
Gum-platinum process, 344, 344
Guncotton (nitrocellulose), 326

Hahn, Betty, 358, 359
Halftone process, 350, 350
Halsman, Philippe, 87
Harbutt, Charles, 80
Hartmann, Erich, 204
Haze, photographing in, 96, 100
Heat, effect on film, 86. See also Temperature
Heat-absorbing glass in enlarger, 288, 289
Heinecken, Robert, 354
Heliograph, 321
High-contrast materials: film, 98, 98; techniques using, 260–265, 261–265
Hill, David Octavius, 325
Hine, Lewis W., 338, 340, 340, 374
Hinging, 187
Hodges, Janet Henry, 4
Holmes, Oliver Wendell, 331
Hot shoe, 208. See also Flash
Hydroquinone, 132
Hyperfocal distance, 70, 71
Hypo, 123, 133. See also Fixer
Hypo neutralizing agent (or hypo clearing agent), 123, 130, 140, 162

Incandescent light. See Tungsten light
Incident-light meter, 106. See also Exposure meter
Indoor lighting, 196, 196–197
Infinity (lens setting), 70; focus on, 71
Infrared film, 95, 96, 97
Intensification, toning for, 181
Inverse square law, effect of, 208, 212, 212
Iooss, Walter, Jr., 59

Jackson, William Henry, 332, 367
Josephson, Kenneth, 144, 316
Jury, Dan, 22
Jury, Mark, 22

Karsh, Yousuf, 20
Kauffman, Mark, 65
Kelvin scale, 274, 274
Kennerly, David Hume, 61
Kertész, André, 48, 312, 313
Kessel, Dmitri, 150
Key light. See Lighting, main light

Land-Weber, Ellen, 361
Lange, Dorothea, 308, 340, 341, 374
Latent image, 82
Latitude: exposure of film, 105, 284; exposure and development of printing paper, 151

388

Leaf shutter, 34, *34*
Lebeck, Robert, *92*
Lee, Russell, 340
Lens(es), *27*; aberrations, 76; in camera obscura, 52; care of, 77; choosing, 78–79; for close-up photography, 250, *250*; compound, 53; fisheye, 62, *63*; f-stops on, 39 (*see also* f-stop); image formed by, 49, 52–53; long, 58–59, *58–59*; normal, 56–57, *56*; macro, 62; portrait, 62; process, 62; retrofocus, 60; short, 60–61, *60–61*; soft-focus, 62; special-purpose, 62; stopping down of, 38; supplementary, 251; telephoto, 58; for view camera, 216, *216*, 221, *221*; wide-angle, 60–61, *60–61*; zoom, 62
Lens focal length, 54–55, *54–55*; and depth of field, 56–57, *56–57*, 64, *64*; in enlarging process, 148; and film size, 79; long, 58–59, *58–59*, 67; and magnification, 253, *253*; normal, 56–57, *56–57*; and perspective, 72, *72–73*; short, 60–61, *60–61*
Lens shade, *101*
LIFE magazine, 350
Light: aperture as control of, 38–39; and film speed, 90, 92; measuring, 107; shutter as control of, 34–35, *34–35*; ultraviolet, *81*, 94, 98, 101, 277; wavelength, 81, *81*, 94, 98, 270, *270–271*, 274, *274*, 280. *See also* Exposure; Lighting
Lighting, 189–213; diffused, 195, *195*; directional-diffused, 191, *191*; direct light, 190, *190*, 284, *284*; fill light, 200–201, *201*; with flash, 208–209, *208–209*, 210–211, *210–211*; front, 198, *198*; fully-diffused light, 192, *192*; high side, 198, *198*; indoor, 196, *196–197*; main light, 188, 189, 198–199, *198–199*, 200, *201*, 202–203, 203, 210, *210–211*; for portraits, 198–199, *198–199*, 202–203, *202–203*; of shiny objects, 207, *207*; side, 199, *199*; side rear, 199, *199*; for silhouette, 193, *193*; of textured objects, 206, *206*; top, 199, *199*; of translucent objects, 204–205, *204–205*; under, 198
Light intensity, and exposure time, 118
Light meters, 106–117. *See also* Exposure meter
Light source(s): and color film, 276; of directional-diffused light, 191; for fill light, 200–201, *201*; for fully diffused light, 192; main light, 198–199, *198–199*; matching film to, 274–275, *274–275*
Line print, 263, *263*
List, Herbert, *315*
Lith film, techniques using, 260, *261–265*
Loading, of sheet film, 232, *232*
Loengard, John, *193*

Loftus, Shirlee K., *4*
Long lens. *See* Lens
Lorant, Stefan, 350
Loupe, 231, *231*
Luminance(s): 108, 112, 114; range reading, 110–111, *111*. *See also* Zone system
Lyon, Danny, *192*, 374, *375*

Mackie lines, 258, *277*
McNamee, Wally, *12*
Macro lens, 62
Macrophotography, 250
Magnification: in close-up photography, 254; and depth of field, 68–69, *68–69*; and lens focal length, 253, *253*
Main light. *See* Lighting
Man Ray, 256, *256, 257*, 348, 349
Mark, Mary Ellen, *110*, 374
Mat cutter, 185, *186*
Matte spray, 207, *207*
Matte surface printing papers, 150, *150*
Matting, 185–187, *185–187*
Metol, 132
Meyerowitz, Joel, *356*, 357
Michals, Duane, *370*
Micro lens. *See* Macro lens
Mili, Gjon, *190*
Milito, Sebastian, *206*
Miller, Wayne, *191*
Modelling light, 210
Moholy-Nagy, László, 256, 348, *349*, 352
Monopod, 44
Moore, David, *282*
Morgan, Barbara, 308, *309*
Motion of camera, 44; panning, 36–37, *37*; preventing unwanted, 44–45
Motion of subject, 36–37, *36–37*; in early photographs, 336, *336–337*; and film speed, 93
Mounting: bleed mounting, 182–184, *182–184*; dry mounting, 182–184, *182–184*; overmatting, 185–187, *185–187*
Mounting press, 182, *182–183*
Mutch, Timothy, *16*
Muybridge, Eadweard, 336, *337*, 370

Narrow lighting, *202–203*, 203
Negative(s), 145; cleaning, 146; color, 272–273, *273*; processing black-and-white, 121–143, *122–143*; processing color, 286; effect of developer on, 132, *132*, 136, *136–137*; effect of exposure on, 84, *84–85*, 136, *136–137*; high-contrast, 262, *262*; image formation, 82–83, 84, *82–85*; reticulation of, 141, *141*. *See also* Zone system
Negative density values. *See* Zone system
Neutral density filter, 101
Newman, Arnold, 188
Newton, Helmut, *15*
Niépce, Joseph Nicéphore, 321, *321*
Nilsson, Lennart, *8*

Nillson, Pal-Nils, *207*
Nonsilver processes. *See* Cyanotype process; Gum-bichromate process
Normal lens. *See* Lens
Notching code, for sheet film, 232, *232*

Office copy machines, prints from, 266–267, *266–267*, 354, *360–361*
Okamoto, Y. R., *188*
Open form, 310, *311*. *See also* Composition
Orthochromatic emulsion, 94
O'Sullivan, Timothy, 303, 331, *331*, 332, *333*, 367
Outdoor light. *See* Daylight; Sunlight
Outdoors, and fill light, 200, 212, *212*
Overexposure. *See* Exposure
Overmat, cutting, 185–187, *185–187*

Packo, Robert, *63*
Panchromatic film, 94, *94*
Panning, 36, 37, *37*
Parallax error, 29, 31, 46
Parker, Bart, *362*
Permanence, archival processing for, 174
Perspective, 72–75, *72–75*; with long lens, 58, *58–59*; with normal lens, 56, *56–57*; with short lens, 60, *60–61*, *63*; unusual, 312, *312*; view camera control of, 228–229, *228–229*
Pfahl, John, 362, *363*
Photo essay, 350, *351*
Photoflood, 210
Photogram, 256–257, *256–257*, 348
Photograph(s): as art in 19th century, 342–343, *342–343*; as document, 338–339, *338–339*; finishing, 177–187, *178–187*; stereographic, 327; world's first, 321, *321*
Photography: as art form, 354, 357; astronomy, 16; courses in, 352, 354; of decisive moment, *356*, 357; directorial mode of, 372; fashion, *12*; invention of, 319, 320–321; naturalistic, 343, 354; pictorial, 344–345, *344–345*; and social change, 340–341, *340–341*; of social landscape, 354, 355, *355*; stereographic, 336; straight, 345, 346–347, *346–347*
Photojournalism, 350–351, *350–351*
Photomacrograph, 250
Photomicrograph, 250
Photomontage, 348, 349, *349*
Photo-Secession, 345, *345–346*
Pictorial photography, 344–345, *344–345*
Pinhole, image-making ability of, 50–51
Place (exposure calculation). *See* Zone system
Platinum prints, 174, *175*
Point of view, in photographic composition, 312, *312–313*. *See also* Composition

Point source (of light), 190. *See also* Light
Polarizing filter, 100–101, *101*,
Polaroid Land process, 359; black-and-white, 102–103, *102–103*; color, 304, *304–305*
Porta, Giovanni Battista della, 320
Porter, Eliot, *303*
Portrait lens, 62
Portrait photography: with calotypes, 325, *325*; early, 321, 328–329, *328–329*; with flash, 210, *210–211*, 213, *213*; lens for, 58, 58; lighting for, 198–199, *198–199*, 202–203, *202–203*; long exposures and, 304, *304, 305*; soft-focus attachment for, 62, 101
Posterization, 264–265, *264–265*
Preservative, in developer, 132
Press, for dry mounting, 183, *183*
Press camera, 47
Previsualization. *See* Zone system
Primary colors, 270, *270*. *See also* Color
Print(s): drying, 178–179, *178–179*; mounting of, 182–187, *182–187*; problems with, 173; reversal, 302; Sabattier, 258–259, *259*; spotting of, 180, *180*; toning of, 181, *181*; xerography, 266–267, *266–267*, values (*see* Zone system)
Print(s) color, 272–273, *273*; evaluation of, 295, *296–297*, 302
Print dryers, *178–179*
Printing: with high-contrast film, 260–265, *261–265*; photograms, 256–257, *256–257*; Sabattier, 258, *259*; special techniques, 256–259, *256–257, 259*
Printing, black-and-white, 145–175; contact sheet, 152–155, *152–155*; enlarger in, 148–149, *148–149*; equipment for, 146–147, *146–147*; final print, 160–162, *160–162*; summary of, 163; test print, 158–159, *158–159*
Printing, color, 286–302; from a negative, 288–298; test print, from a transparency, 300–302
Printing papers, for archival processing, 174; for black-and-white printing, 150, 151; for color, 288, 298, 300; and contrast control, 166–169, *167–169*; resin-coated (RC), 150, 151, 178, 179
Process lens, 62
Pushing film, 92, 142, *142*,
Rangefinder: coupled, 29, 32; versus viewfinder, 32
Rangefinder camera, 29, *29*; buying, 46; and close-up photography, 250; focusing system for, 33, *33*
Ray, Man. *See* Man Ray
Rayograph, 256
RC (resin-coated) papers, 150, 151, 162; drying of, 178, 179; mounting of, 182
Reciprocity effect, 118; preventing,

118; shifted colors from, 282–283, *282–283*
Reducing agent: in developer, 132
Reducers, local, 180–181, *181*
Reflectance range. *See* Contrast
Reflected-light exposure meter. *See* Exposure meter
Reflections: from colored surfaces, 278; and flash lighting, 213, *213*; and polarizing filter, 100, *100*
Reflector(s): for fill light, 200–201, *201*; for flash, 208, *208*
Reflex camera: focusing system of, 32, *32*; single-lens, 30, *30*; twin-lens, 31, *31*. *See also* Single-lens reflex, Twin-lens reflex
Refraction, 53
Rejlander, Oscar G., 342
Renaud, Gary, *197*
Replenishers (for developer), 131
Resin-coated papers. *See* RC papers
Resolving power, 90
Restrainer, in developer, 132
Reticulation, 141, *141*
Retrofocus lens, 60
Reversal color materials, 273, *273*, 300–303, *300–303*
Rice, Leland, *364*, 365
Riis, Jacob, 340, 374
Rise. *See* View camera
Robinson, Henry Peach, *342*, 343
Rodchenko, Alexander, *312*
Roll film, 86; introduction of, 334; processing of, 122–131. *See also* Film
Root, David, *2*
Rothstein, Arthur, 340

Sabattier print, 258–259, *259*, *348*
Safelight, for black-and-white printing, 147; for color printing, 290
Saint-Victor, Abel Niépce de, 326
Sandbank, Henry, *16*, *287*
Sander, August, 338, *338*
Saul, David, F., *2*
Schulthess, Emil, *280*
"Scratch remover," 173
Selenium cell meters, 106
Selenium toning, 181
Semak, Michael, *244*
Sensitometry, 235
Serial imagery, 370
Shadows: and color film, 284, *284*; in daylight lighting, 194, *194*; in direct light, 190, *190*; exposures for, 112–113, *113*; with flash, 213; in indoor lighting, 196, *196–197*; modifying with fill light, 200–201, *201*; and photographic composition, *306*, 307, 316, *316–317*; and textured objects, 206, *206*
Shahn, Ben, 340
Sharpness, 314–315, *314–315*; and circles of confusion, 64–67. *See also* Depth of field
Sheet film, 86, 232, *232–233*
Shift. *See* View camera
Shiny objects, lighting, 207, *207*

Ship's prow effect, 228
Shore, Stephen, *366*
Short lens. *See* Lens
Short lighting, 202, *202*
Shrout, Bill, *11*
Shutter, 26, *27*; focal plane, 35; leaf, 34, *34*; and light control, 34; and motion control, 36–37; in single-lens reflex camera, 30
Shutter curtain, 77
Shutter-priority operation, 116
Shutter speed: and aperture combination, 42, *42–43*; and exposure, 107; and flash, 208, 213; and keeping camera steady, 44; and sharpness, 314, *314*
Side lighting, 199, *199*, 206, *206*
Side rear lighting, 199, *199*
Siegel, Arthur, 352
Silhouette, 193, *193*
Silk, George, *350*
Silver compounds: in black-and-white emulsion, 82, 132, *132*; in color photographs, 272; in exhausted chemicals, 139; in fixing process, 133; in instant color film, 304; and invention of photography, 320; in Polaroid Land film, 104–105, *104–105*; in printing paper, 145
Single-lens reflex camera, 30, *30*; averaging-meter system in, 116–117, *116–117*; buying, 46–47; and close-up photography, 250; depth of field control in, 40; filter for,100
Siskind, Aaron, 352
Skin tones, 236; exposures for, 112–113, *113*, 115
Sky: burning in of, 170; photographing, 98, 99, *99*, 101, 108
Skylight filter, 276
Slavin, Neal, *245*
Slides. *See* Transparency
Smith, Henry Holmes, 352
Smith, W. Eugene, *306*, 307, 350, *351*, 357
Sodium thiosulfate, 133. *See also* Fixer
Soft-focus lens, 62
Soft-focus lens attachment, 101
Solarized print. *See* Sabattier print
Space, ambiguous, 365. *See also* Composition
Spanish Village (Smith), 350, *351*
Split image rangefinder, 33
Spot meter, 114–115, *114–115*. *See also* Exposure meter
Spotting, 177, 180, *180–181*
Sprague, Stephen, *176*
Spühler, Emil, *280*
Starr, Nina Howell, *21*
Steinberg, Richard, *278*, *279*, 298, *299*
Stereographic photographs, 327, 336
Stieglitz, Alfred, *345*, 346, 353
Stop, as measure of exposure, 38. *See also* f-stop
Stop bath, 123

Stopping down, 76
Straight photography, 345, 346–347, *346–347*
Strand, Paul, *346*
Strobe, 208. *See also* Electronic flash
Stryker, Roy, 340
Subject values. *See* Zone system
Substitution reading, 115
Subtractive color, 270–271, *271*
Sudek, Josef, *205*
Sugimoto, Hiroshi, *104*
Sunlight, color photography in, 284. *See also* Daylight
Sunset, color pictures made at, *268*, 269, 280
Supplementary lenses, in close-up photography, 251, *251*
Sutton, Humphrey, *285*
Swing. *See* View camera
Synch cord, 208
Synchronization (for flash), 35, 208
Synchro-sun exposure, 212, *212*

Tacking iron, 182–183, *182–184*
Talbot, William Henry Fox, 324, *324*
Telephoto effect, 72
Telephoto lens, 58; retrofocus design in, 60
Temperature: for black-and-white film processing, 123, 134, *134–135*; for black-and-white print processing, 163; for color print processing, 292; and reticulation, 141, *141*
Tenting, 192, 207, *207*
Test patches, black and white, 173
Test print. *See* Printing, black-and-white; Printing, color
Textured objects, lighting, 206, *206*
35mm film, 86. *See also* Film
Through-the-lens metering, 117, 254
Tice, George, *214*, 215
Tilt. *See* View camera
Time, and development process, 134, *134–135*
Tintype, 326
Tone(s), changing with filters, 98–101, *98–100*
Toners, 181
Toning, 177, 181, *181*; selenium, 181
Top lighting, 199, *199*
Translucent objects, lighting, 204–205, *204–205*
Transparency: color, 272–273, *273*; color prints from, 300–301, *300–301*
Travel photography, early, 332–333, *332–333*
Tripod, 44, *45*, 58
Tugwell, Rexford G., 340
Tungsten light, 274, *274–275*
Turbeville, Deborah, *14*
Twin-lens reflex camera, 31, *31*; buying, 47; and close-up photography, 250

Two-bath film development, 143

Uelsmann, Jerry N., *23*
Ultraviolet (UV) filter, 101, 277
Umbrella reflector, *188*, 189
Underexposure. *See* Exposure
Under lighting, 198, *198*

Vandyke process, 358
Vargas, Kathy, *1*
Variable-contrast paper, 168–169, *168–169*
View camera, 28, *28*, 215–233; advantages of, 28, 215; basic parts of, 216–217, *216–217*; buying, 47; depth of field control in, 40, 226–227, *226–227*; disadvantages of, 28; and distortion, 230, *230*; film for, 232–233, *232–233*; lenses for, 216, 221, *221*; movements of, 218–225, *218–225*; perspective control, 228–229, *228–229*; using, 231, *231*
Viewfinder: for framing composition, 310; versus rangefinder, 32. *See also* Rangefinder
Viewing system, 27, 32; of rangefinder camera, 29; of single-lens reflex camera, 30; of twin-lens reflex camera, 31
Vignetting, 76–77, *77*, 216, *216*, 231
Villota, Luis, *268*
Voltage control, for color printing, 288

War photography, early, 330–331, *330–331*
Washing, of film, 140
Water-bath film development, 143
Watkins, Carleton Eugene, 332
Wedgwood, Thomas, 320, 321
Weegee (Arthur Fellig), 208, *209*
Weiss, Ralph, *248*, *255*
Weston, Edward, 90, 172, 307, *311*, *316*, *317*, 346, *347*
Wet plate. *See* Collodion wet-plate process
Wetting agent, 123
White light, 81, 98, 271; sources of, 274
White, Minor, *83*, 96, *97*, 346, 352, 353
Wide-angle distortion, 58, *58*, 60, *60*
Wide-angle lens, 60–61, *60–61*
Wide-field lens. *See* Wide-angle lens
Winogrand, Garry, 354, 357
Wrinn, Joe, *6*

Xerography, 266–267, *266–267*

Zone focusing, 70, *70*
Zone system, 84, 235–247; contrast control, 244–245; and exposure meter, 238; place and fall, 238, *238–239*, 240, 242, *242–243*, 244–245, *244–245*, 246; procedural steps for, 246; roll film applications, 246; scale of tonal values, 235, *235*, 236
Zoom lens, 62